THE PRADO

THE PRADO

SANTIAGO ALCOLEA BLANCH

Translated from the Spanish by
Richard-Lewis Rees and Angela Patricia Hall

ABRADALE PRESS
HARRY N. ABRAMS, INC., PUBLISHERS

Editor, English-language edition: Beverly Fazio

Library of Congress Cataloging-in-Publication Data
Museo del Prado.
 [Museo del Prado. English]
 The Prado / Santiago Alcolea Blanch ; translated from the Spanish
by Richard-Lewis Rees and Angela Patricia Hall.
 p. cm.
 Translation of: Museo del Prado.
 Originally published: New York : Abrams, 1991.
 Includes bibliographical references and index.
 ISBN 0–8109–8147–5
 1. Museo del Prado. 2. Painting—Spain—Madrid. I. Title.
[N3450.A9513 1996]
759.94'074'4641—dc20 96–3896

Photos: Oronoz, S. A., Madrid; Ampliaciones y
Reproducciones Mas, Barcelona
Color separations by Reprocolor Llovet, S. A., Barcelona
Printed and bound in Spain by La Polígrafa, S. A.,
Parets del Vallès (Barcelona)
Dep. Leg.: B. 16.557-1996

CONTENTS

The titles of the works appearing in the text are followed in brackets by their corresponding number in the inventory of the Prado Museum, established in 1910. When the work in question is reproduced in this book, the plate number follows.

THE ROYAL COLLECTIONS

Gold- and silversmithing, sculpture, painting, tapestry, and other sumptuous arts have from time immemorial been appreciated and protected by both sensitive souls and members of the ruling classes. Aware of the importance of the arts in court ceremonials, monarchs, nobles, and prelates, whose main objective was the reaffirmation of an authority based on dynastic transmission and divine designation, figure among artists' main customers. There are notable examples of such patrons of the arts among the medieval sovereigns of the Christian Iberian Peninsula.

Peter the Ceremonious (1319–1387) maintained goldsmiths, sculptors, and painters ''of the house of the lord king,'' setting a precedent for what would be the court artists of subsequent centuries. He maintained artistic contact with Flanders, Brabante, the north of France, and the territories bordering present-day Germany, fundamentally through artists from these lands who were in his service (the goldsmith Coli de Namur, the painters Juan de Brujas and Enrique de Bruselas, the sculptor Aloy de Montbray, among them) or through the jewel merchants of Troyes and tapestry traders from Arras and Paris. One of the major commissions Peter the Ceremonious gave his artists was the majestic group of royal sepulchers for the monastery of Poblet; outstanding also is the series of alabaster sculptures with portraits of his nineteen predecessors in the county house of Barcelona and in the crown of Aragon. He was also generous in the decoration of the chapels in his several royal palaces and in that of the considerable number of churches in his kingdoms, for which he ordered a large number of altarpieces and pieces of goldsmithing.

Alphonso the Magnanimous (1396–1458), a genuine prince of the Renaissance, converted Naples into one of the centers of artistic and cultural diffusion of the time. In 1431 he sent the Valencian painter Lluís Dalmau to Flanders. In Italy he acted as patron for artists such as Pisanello, Donatello, Francesco Laurana, and Colantonio; there is evidence of the presence of Jean Fouquet in Naples around 1444–45. It is known also that in 1444 the monarch acquired a panel of three by four spans depicting Saint George and attributed to the brush of Jan van Eyck.

For her part, Isabella the Catholic (1451–1504) left on her death not only a great number of *objets d'art* but also 370 tapestries and a magnificent collection of some 350 paintings. Most of these are works of devotion, but there are also some family portraits and a small number of nonreligious scenes — *The Story of Lucretia Who Slays Herself with a Dagger, Two Battles with Small Images, A Procession of Captive Moors Bound in Chains,* and a *Figure of Death* — by such outstanding names of Flemish, Italian, and Spanish painting as Rogier van der Weyden, Michel Sittow, Hans Memling, Hieronymus Bosch, Juan de Flandes, Sandro Botticelli, Perugino, Pedro Berruguete, and Bartolomé Bermejo.

These extraordinary collections were, however, mostly of short-lived works of art. Pieces of gold and silver could easily be melted down or sold when the monarch

was short of funds. Tapestries were objects of daily use and therefore exposed to constant wear and tear in itinerant courts that had in an improvised manner used them to condition cold palaces and mansions. As for paintings, some were ceded to churches, monasteries, and convents, while others were sold at public auctions on the death of their owner in order to settle outstanding debts.

It was during the reign of Charles I (1500–1558) that collections of *objets d'art* began to become stabilized within the artistic heritage of the Spanish Crown. The emperor was a sensitive art lover and passionate collector who liked to deal personally with his favorite artists, namely Lucas Cranach and especially Titian, whom he attempted to bring to Spain. Besides the numerous works he commissioned from these painters, he also bought many canvases from masters such as Michel Coxcie, Antonio Moro, and Giacomo Bassano. His sister, Mary of Hungary, was also a discerning collector who placed her treasures in the palaces of Mariemont and De Binche and in the castle of Turnhout. When she retired to Yuste in the company of her brother she took with her some one hundred pieces, including a score of portraits by Titian, four by Moro, one by Van Eyck, and the *Descent from the Cross* (plate 189) by Van der Weyden, along with about thirty other paintings and seventeen sculptures, as well as maps, plans of cities, and family trees.

Philip II (1527–1598) inherited from his father and his aunt not only a substantial number of these paintings but also their enthusiasm for painting and admiration for Titian. His complex psychology is revealed clearly through his art acquisitions, which represent personalities as diverse as the Venetians Tintoretto and Veronese, the Flemish visionary Hieronymus Bosch, the Italian Mannerists called to decorate the Monastery of El Escorial, and the Expressionist who in Spain received the name of El Greco. This major collection of paintings, 725 in number, was divided into three large blocks: 358 canvases are in the Alcázar, Madrid, 117 in the Palace of El Pardo, and the remaining 250 in the Monastery of San Lorenzo del Escorial.

Philip III (1578–1621) contributed little during his short reign, which was also unfortunately darkened by a fire that broke out in the queen's chambers in the Palace of El Pardo on March 10, 1604, at about one o'clock in the afternoon and was not extinguished until the early hours of the morning. Numerous paintings were lost, among them fifty portraits that were in the ''king's high gallery''and twelve Flemish paintings in the so-called corridor of the sun. Another outstanding event during the time of Philip III, for which the king was not even remotely responsible, was the first visit to Spain of Peter Paul Rubens, in 1603.

Among Spanish monarchs, the most sophisticated and refined art lover and the most passionate collector was undoubtedly Philip IV (1605–1665). Under his patronage, the main representatives of the Golden Age in Spanish painting were able to flourish at court: Diego Velázquez, Francisco de Zurbarán, Francisco de Herrera ''the Elder,'' Alonso Cano, Juan Bautista Maino, Vicente Carducho, Antonio de Pereda, and Jusepe Leonardo, whose ranks were swelled by international artists of the stature of Rubens.

Philip IV did not, however, increase the royal collections only through commissions awarded to artists; he also purchased works, both ancient and modern, from other collections. His representatives were present at all major sales organized throughout Europe. Thus at the auction that took place in Antwerp in 1640 on the death of Rubens, the Cardinal Prince Ferdinand of Austria acquired on behalf of his brother the king thirty-two of the best pieces in Rubens's collection, among them eighteen by the late artist himself including *The Three Graces* (plate 214), *The Garden of Love* (plate 213), *Saint George's Fight with the Dragon* (plate 211); a *Self-Portrait* by Titian (plate 156); and *The Crown of Thorns* by Anthony van Dyck (plate 222). In 1649 the puritan revolutionaries organized the auction of the worldly goods of Charles I of England, administered by the rebels themselves. Alonso de Cárdenas, the Spanish

ambassador in London, given wide powers when it came to deciding what to buy and enjoying unlimited funds, acquired for Philip IV works of first-class quality: *The Death of the Virgin* by Andrea Mantegna (plate 140), a *Holy Family* (no. 301) called "The Pearl" by Raphael, *Venus Entertaining Herself with Music* (no. 420) and *Portrait of Charles V with a Hound* (no. 409), both by Titian, the grandiose *Maundy* by Tintoretto (plates 159 and 160), and many more. In 1650, Velázquez himself was entrusted by his king with the mission of traveling to Italy and acquiring canvases and statues for the royal collections. The painter returned with a precious cargo including *Venus and Adonis* by Veronese.

Anyone who wished to make the king a gift that would surely be enthusiastically received needed only to offer him a good painting. In this way Philip IV's collection was enriched with works of such quality as *The Fall on the Road to Calvary* by Raphael (plate 144), presented to the king by the Olivetan order of Palermo; *The Bacchanal* (plate 152) and the *Offering of the Goddess of Love* (no. 419), both by Titian, gifts from the Pamphili family, Rome; and the splendid panels by Albrecht Dürer representing *Adam* (plate 238) and *Eve* (plate 239), sent by Queen Christina of Sweden.

Philip IV was responsible for the decision to entail the paintings, glassware, and writing desks of the Alcázar of Madrid to the crown, thus preventing their "most minimal isolation or separation." This constituted the first known measure to avoid the dispersal of such a rich heritage. And it was fortunate that this law was passed; otherwise Philip IV's unfortunate successor would have had to face even more difficult times.

Despite his limitations, Charles II (1661–1700) was sufficiently clear-sighted to recognize the importance of a heritage that on his death had reached the extraordinary figure of 5,539 paintings. It would also be fair to say that the "Bewitched One" was bold enough to defend the integrity of this heritage against the greed for works of art that consumed several members of his close circle, above all his second wife, Mariana of Neoburg, who attempted to use the canvases as currency in her international dealings. Taking advantage of the precedent set by his predecessor, Charles II extended the entailment of the crown to include the tapestries, mirrors, and other furnishings not only of the Alcázar but also of all the other royal sites.

On acceding to the Spanish throne, Philip V (1683–1746) found himself in possession of a fabulous art collection that he did not hesitate to continue enlarging. One of his acts was to summon artists from his home country of France, such as Michel-Ange Houasse, Jean Ranc, and Louis-Michel van Loo, so that the hitherto somewhat scant representation of the French school began to acquire greater consistency. An initiative by the Bourbon king that was to have a permanently positive effect on the Spanish art scene of the eighteenth century was the foundation in 1720 of the Real Fábrica de Tapices de Santa Bárbara (Royal Tapestry Manufactory of Santa Bárbara). The new sovereign was also a keen collector; in 1724 he purchased the canvases that had belonged to the Italian painter Carlo Maratta, among which, apart from works by the artist himself, were paintings by Raphael, Andrea del Sarto, Titian, Rubens, and Nicolas Poussin. On another occasion sixty paintings by the Flemish artist David Teniers were added to the royal picture library.

Philip V's wife, Isabel Farnese, also played an active role in enriching the crown's collections; as the result of a single journey to Seville, thirty works by Bartolomé Esteban Murillo were purchased, further contributing to the appreciation of this artist, who was until then relatively unknown outside his native city. It is also thanks to the queen that the two exquisite canvases by Antoine Watteau that today figure among the gems of the Prado came to Madrid. As if such enthusiasm for beauty aroused the destructive envy of the forces of nature, the irresponsible behavior of the painter Jean Ranc's servants during their joyful celebration of Christmas in 1734 led to a

great fire in the Alcázar of Madrid during which, despite innumerable acts of heroism by soldiers and civilians alike, 537 paintings were burnt.

Philip V was succeeded by Ferdinand IV (1713–1759), whose ephemeral reign was notable mainly for the fact that it had no consequences of any kind. The flame of enthusiasm for painting was rekindled when his stepbrother Charles III (1716–1788) came to the throne. Among the first initiatives taken by Charles III was the purchase of the Marquis of La Ensenada's collection, which contained works such as the *Equestrian Portrait of the Count-Duke of Olivares* by Velázquez, Rembrandt's *Artemis* (plate 246), and Tintoretto's *Judith and Holofernes*. He also managed to surround himself with outstanding painters; in his service were two of the most prestigious masters (consummate fresco painters both) in Europe at the time: the Bohemian Anton Raphael Mengs and the Venetian Giovanni Battista Tiepolo. One possible criticism of the good king would be that he allowed himself to be blinded by the German's rationalist purism, which impaired Charles III's appreciation of Tiepolo's superior vitality and caused him to fail to take full advantage of the Venetian's uncommon artistic talents.

An episode that was on the point of darkening the reputation of Charles III as a patron of the arts might have had graver consequences. Already in the time of the Emperor Charles V, the Spanish royal collections contained canvases, fundamentally mythological in theme, with nude figures, most of them feminine. These paintings were by the hands of a wide variety of masters, including Dürer, Hans Baldung Grien, Titian, Veronese, Tintoretto, and Rubens. Charles III, a sanctimonious man, intended to burn these works; fortunately Mengs managed to dissuade him by stressing their unquestionable artistic value. Be that as it may, however, the king's conscience continued to prick him, and just before his death he instructed his son, Charles IV, to destroy these "impertinent paintings."

Charles III maintained the entailment only of the furnishings and jewels, leaving the remainder of the *objets d'art* included in the decoration of the several royal palaces free to be disposed of at will. Despite this, there is no record of any portioning out of goods among the king's heirs, or that his successor paid his brothers any kind of indemnity for them. No one questioned the indivisibility of a heritage that in paintings alone consisted of 4,717 works.

As in the case of Philip IV and Velázquez, Charles IV (1748–1819) had the good fortune to be on the throne when a genius of Spanish painting was at his most active: Francisco Goya. This circumstance alone would be enough to endow his reign with prestige; however, the Bourbon king lacked the Hapsbourg's enthusiasm for painting. As a result he contributed little to the royal gallery, although he did manage to acquire a few truly outstanding pieces: *Portrait of a Cardinal* by Raphael (plate 142), *The Sacrifice of Isaac* (no. 336) by Andrea del Sarto, and José de Ribera's group of Apostles.

THE ANTECEDENTS TO THE
PAINTING MUSEUM

THE ROYAL COLLECTIONS OPEN

The innate desire of every collector to exhibit his or her most treasured possessions began to manifest itself in Spain during the reign of Philip IV. In his *Diálogos de la Pintura*, published in 1633,[1] Vicente Carducho reveals that artists were occasionally authorized to visit the royal palaces and study the paintings and other objects that decorated them:

> Pupil: Tell me of the Palace and the good Paintings there, for since my arrival from Rome I have not been able to see it, and I have heard that it has improved greatly in habitation and comfort and in number of Paintings, and those which I saw I scarcely remember.
> Master: Those that are there are under the care of the Keeper of the Jewels, as befits their status. . . . Once when His Majesty was absent I was shown all that are there. . . . The Palace has many Paintings, all very good and highly esteemed.

For his part, Luis Méndez de Haro, one of Philip IV's ministers, wrote around 1654 to the Royal Ambassador, Alonso de Cárdenas, in the following terms:

> Although in San Lorenzo el Real there are so many great works by Titian, there is also a great deal of very bad painting, unworthy to be shown in that place and among the others; and as the palace is a theatre where all year round so many foreigners continually visit and admire it for the great marvel it is, I should be delighted if all the bad were removed and replaced, since as this is not possible with works by great masters, at least with others (of greater quality).[2]

He further observed

> that the paintings hidden and concealed are deprived of value, which consists in other eyes and the judgments made of them by men of good taste and imagination, and this is only possible when they are exhibited in places where on occasions they can be seen by many.[3]

In this sense it is worth bearing in mind canvases such as *The Archduke Leopold Wilhelm in His Gallery of Paintings in Brussels* (plate 231), preserved today in the Prado Museum. In this work, painted by David Teniers "the Younger" around 1647 and given as a gift by the archduke to Philip IV before 1653, the then-governor of Flanders appears surrounded by his esteemed collection, showing it to visitors in the company of his art curator, Teniers himself.

Around this same time, in 1656, possibly as the consequence of the suggestion of Méndez de Haro, the reorganization of the paintings in the chapter halls of the Monastery of El Escorial commenced. None other than Velázquez himself was commissioned to determine the order in which the works should be hung and to prepare the explanatory texts to accompany each of the canvases.[4]

Fr. Andrés Ximénez, in his monograph on the Monastery of San Lorenzo del Escorial published in 1764, refers to Velázquez's tasks as curator of the king's paintings:

> Twice was Velázquez in those fecund Provinces [Italy]; and on his second visit he brought back by order of Philip the Fourth many exquisite Paintings and prodigious Statues, with which the Royal Palaces were ennobled and Spanish Artificers received new enlightenment. In that Royal House forty Original Paintings were hung, by order of the King, some of those brought from Italy and the rest from the auction of the goods of the king of England, Charles Stuart, the First of that name; others were given to His Majesty by Don García de Avellaneda y Haro, who had been Viceroy of Naples.[5]

THE EDUCATIONAL IDEALS OF THE ENLIGHTENMENT

Gaspar Melchor de Jovellanos also referred to the idea of forming a painting gallery in the Monastery of El Escorial, seeing in this the possibility of providing the academic training characteristic of the times: "Philip IV, always desirous of promoting the arts, created the project of forming a collection of ancient and modern models, so that his subjects were freed of the necessity of going in search of them in Italy."[6]

This desire was generally felt during the Enlightenment, as revealed by Anton Raphael Mengs, one of the foremost among European neoclassical painters, in a letter he wrote in 1775 to the erudite essayist Antonio Ponz: "I should like to see gathered together in this royal palace [of Madrid] all the precious paintings that now hang in all the other Royal Sites, and that they should hang in a gallery worthy of such a great monarch, so that your honor might . . . be able to establish a discourse that would guide the curious observer on an itinerary from the works of the earliest painters of whom we have knowledge to the latest who have been worthy of praise, in order to make clearer the difference between them and to clarify my own ideas."[7]

Given such antecedents it is by no means surprising that within the framework of the French Revolution, Bertrand Barère proposed to France's Constituent Assembly of May 26, 1791, that a public museum be set up with works of art from the royal palaces, from collections of the nobility, and from closed monasteries. The idea was very well received, and, scarcely two years later, on August 10, 1793, the Louvre museum opened its doors.

THE FRUSTRATED MUSEUMS

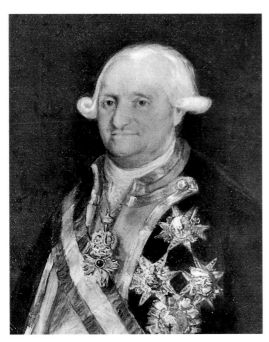

Charles IV

THE FIRST PROJECT FOR A ROYAL MUSEUM IN MADRID

The idea of a "royal museum" soon spread throughout Europe. At the close of the eighteenth century Charles IV sponsored what was apparently an attempt to set up such a painting museum in Madrid. On September 1, 1800, that is, three and a half months before his dismissal as First Secretary of State, Mariano Luis de Urquijo ordered copies to be made of a series of paintings by Murillo in the Hospital de la Caridad in Seville so that the originals could be sent to Court "as is the practice observed in all cultured nations in Europe. There endeavors are made to form at Court schools and museums that cannot be maintained in the provinces."[8]

Not surprisingly, the project was not well received by the members of the Sevillian brotherhood, who, with the prime minister Manuel Godoy as middleman, appealed to the royal authorities asking that the works by Murillo should remain in the setting for which they had been conceived. Their request was finally met, on June 28, 1803, with the signing of an order that revoked the previous one.

What has never been thoroughly clarified is the scope of Urquijo's project. Available documentation speaks of a permanent "museum." Thus, in Godoy's revokation order, reference is made to the "Royal Command issued in 1800 by which eleven original paintings by the celebrated painter Murillo are to be brought to His Majesty's museum."[9]

Ten days later, on July 8, Godoy, known as the Prince of Peace, on acknowledging his acceptance as member of the Brotherhood of the Hospital de la Caridad, once again employed similar terms, reporting that "I recommended to His Majesty the question of the Paintings, and obtained from his benevolence the suspension of the Order according to which they were to be brought to the museum of this Court."[10] Nevertheless, the erudite essayist Agustín Ceán Bermúdez wrote the following lines to José de Vargas Ponce on August 17, 1803:

> I hereby inform Your Honor, for your consolation and satisfaction, that the command has been revoked that in the time of Mr. Urquijo ordered that copies should be made of works by Murillo in this city, and that the copies should occupy the frames and places where the originals now are, and the originals should be taken to Madrid to decorate the Royal Palace.[11]

Thus, it is possible that the idea was to gather together the most outstanding works of the country's painting, not for decorative purposes but rather in obeyance of a methodical collector's spirit. And if this painting gallery was called a "museum," this did not necessarily mean that it would be open to the general public, as the modern notion of the word would suggest. Neither should it be assumed that the intention was to make its use strictly private; very probably the gallery was conceived as an exemplary fund of paintings destined for the training of up-and-coming artists.

Despite everything, however, the idea of assembling in Madrid under royal patronage a representative selection of the masterpieces of Spanish painting was decidedly attractive to the spirits of the Enlightenment, undoubtedly due to the educational aspect of the project. Even José de Vargas Ponce, in reply to the letter from his friend Ceán, while celebrating not without a certain irony the revocation of Urquijo's decree, clearly manifested his approval of the idea:

> I am glad to hear about Murillo, since St. Peter is better off in Rome, even if he does go hungry there. All told, as a result of the latest august journey he [Murillo] has gained much prestige and is beginning to be considered as one of the best of known painters. Some examples of his best work would certainly not look out of place in one of the best of our galleries, particularly in the as yet unprepared wing of the new Palace.[12]

THE JOSEPHINE MUSEUM

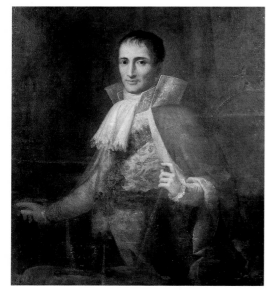

Joseph Bonaparte

After the Napoleonic invasion and the deposition of Charles IV, the self-designated French emperor placed his brother Joseph Bonaparte on the Spanish throne. During his reign (1809–14), the new king enjoyed wide powers, which he did not hesitate to use. Thus one of the first decrees he signed, on August 20, 1809, promulgated the suppression of all religious orders and prescribed the confiscation of their goods, including paintings and other *objets d'art*.

A few months later, on December 20, 1809, using the title of King of Spain, Joseph Bonaparte signed a decree endorsed by his minister Mariano Luis de Urquijo by which a painting museum was founded, at least on paper. The text of the decree, published in the Madrid *Gazette* of December 21, is as follows:

> It is our wish, in benefit of the fine arts, to have at our disposal the multitude of paintings which, hidden from the eyes of connoisseurs, were hitherto kept in cloisters; that these examples of the most perfect ancient works should be prime models for and guides to talents; that the merit of celebrated Spanish painters, little known in neighboring nations, should shine and at the same time earn immortal glory so justly deserved for the names of Velázquez, Ribera, Murillo, Rivalta, Navarrete, Juan de San Vicente (*sic*) and others. To this end we have decreed the following:
>
> Article 1. — In Madrid a museum will be founded containing collections of the different schools, and to this end paintings will be taken from all public establishments and even from our palaces to complete the collection we have decreed.
>
> Article 2. — A general collection will be formed of works by celebrated painters of the Spanish school, which we shall offer to our august brother the Emperor of the French, expressing at the same time our desire to see it exhibited in one of the halls of the Napoleon Museum, where being a monument to the glory of Spanish artists it will serve as a token of the most sincere union between the two nations.
>
> Article 3. — From among all the paintings at our disposal shall be chosen those judged necessary to decorate the palaces destined for the Court and the Senate.
>
> Article 4. — Our Home Secretary and Chancellor of the Exchequer and the general superintendent of the royal house will agree upon the necessary measures for the execution of the present decree.[13]

The decision seems somewhat precipitous, since there is no mention even of the location of the future museum. A short time afterward, in 1810, the suggestion was made to adapt the Convent of the Salesas *reales* for the purpose, and Silvestre Pérez, subdirector of the San Fernando Academy of Fine Arts and architect of the Ministry and the city of Madrid, was entrusted with the task of studying ways to combine the museum with the monastic life of the nuns. It seems that the project was not considered viable, however, since a new decree by Bonaparte, dated

August 22, 1810, and published in the *Gazette* two days later, ceded the Palace of Buenavista as the seat of the institution:

> In our palace of Madrid, August 22, 1810. Don Joseph Napoleon, by the Grace of God and the constitution of the State King of Spain and of the Indies.
>
> We have decreed and declare the following:
>
> Article I. — The Palace of Buenavista is hereby designated as the painting museum we ordered to be established in our decree of December 20, 1809.
>
> Article II. — In consequence, the building will be placed at the disposal of the Minister of the Interior as soon as the belongings pertaining to our royal house, stored therein, have been removed.
>
> Article III. — As is established in our aforementioned royal decree, the painting museum will contain those paintings from the suppressed convents and monasteries considered worthy of study or to be exhibited to the public.
>
> Article IV. — It will also contain the paintings chosen from our palaces in order to complete the collections of the different schools of painting.
>
> Article V. — The inventory of these paintings, approved by our Minister of the Interior and superintendent of our house, will be submitted for our consent.
>
> Article VI. — Our Minister of the Interior will determine by private regulation the interim regime of the museum, appointing the curator and other employees and deciding the days on which it can be opened to the public. This regulation will similarly be submitted for our approval.
>
> Article VII. — Our Minister of the Interior and the general superintendent of our royal house are hereby entrusted, each one in those aspects concerning him, to carry out the present decree.
>
> > Signed THE KING
> > For H.M., the minister secretary of State:
> > Signed: Luis de Urquijo.[14]

Finally, however, the idea of using this palace was also dismissed, the reason apparently being the impossibility of adapting its structure to the needs of a museum. There was a preliminary decree to install the museum in the building which, destined to house the Museum of Natural Science, was constructed by Charles III in the Paseo del Prado between 1785 and 1808, according to the project by and orders of the illustrious architect Juan de Villanueva, and which at the time was being used as the barracks for the French occupation forces. On September 20, 1811, the French ambassador in Madrid, the Count of La Forêt, informed his superior, the Duke of Bassano, Napoleon's Minister of Foreign Affairs, of the matters dealt with at the meeting of the Josephine Council of State held four days earlier. He included the following report:

> The reading for the enactment of another project — prepared by the Ministry of the Interior — was called. . . . Its issue was the completion of the Prado Museum. General derision prevented the reading from going on. And, indeed, no expense related to embellishing a project seemed more out of place.[15]

THE FERDINANDINE MUSEUM
AND THE ACADEMY OF FINE ARTS

Upon the close of the War of Independence and the restoration of Ferdinand VII to the Spanish throne, the monarch returned to Madrid, entering the city on May 13, 1814. The project of creating a public museum, formed on the basis of the funds of pictures from the suppressed convents and monasteries and completed by a selection of canvases pertaining to the royal palaces, must have been very much on the king's mind. The idea of linking the museum to the San Fernando Academy

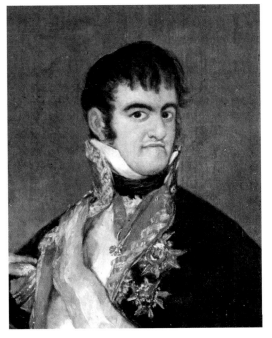

Ferdinand VII

of Fine Arts would have emerged almost automatically, since one of the main purposes intended for the gallery was, as in the Josephine project, that of perfecting the training of young artists.

One of the most instrumental figures involved with the project was Isidoro Montenegro y Marentes, an enigmatic man who enjoyed the king's absolute confidence and who between 1806 and 1820 was constantly at his side.[16] Born in Barcelona around 1770, Montenegro became the valet to the Infante Don Ferdinand from September 22, 1806, and as such he accompanied his master when Napoleon sent him into exile in Valençay. Once the Spanish court had been re-established, on May 15, 1814 (that is, two days after Ferdinand VII's return to Madrid), he was appointed the king's squire. On June 16 he was assigned a salary of 33,000 *reales*, the same amount he had earned in exile as master of the wardrobe. An honorary member of the San Fernando Academy from June 25, 1816, he was made counsellor of that institution on November 17, 1817. As a result of the liberal uprising of 1820, which forced the king to reorganize his most immediate circle of collaborators, Montenegro was appointed Spanish Consul in Bordeaux; he later became head of the General Consulate in Genoa. On the death of Ferdinand VII, Montenegro refused to swear fealty to Isabella II and was removed from office without stipend. Years later, having been granted an amnesty and reinstated in the palace employ, he requested receipt of all his outstanding back pay (September 5, 1855). The palace authorities drew up a report on him, in which the following is said:

> On the return of our August King and his loyal servant, the latter obtained positions of confidence, so strictly respected that, as is well known, he was entrusted with the keeping of objects of great value, such as the Crown Jewels and the paintings in the Museum, of which Montenegro was the founder. Furthermore, his condition of poverty verifies his integrity in the handling of funds as Treasurer of the Privy Purse.[17]

Two major points transpire from this report. First, it is evident that in 1855 in palace circles Montenegro was considered the founder (read ''instigator'') of the Royal Painting Museum; second, and more significant, he was the treasurer of His Majesty's ''privy purse.'' As we shall see subsequently (from a report drawn up on September 22, 1818, by the Marquis of Santa Cruz and addressed to the king), from this fund were supplied the 24,000 *reales* granted monthly by Ferdinand VII for the restoration of the Villanueva building where the museum was housed.

The fact is that hardly one month after the return of the ''Desired One'' to the country's capital, the members of the San Fernando Academy of Fine Arts met on June 15, 1814, and it having come to their notice that Montenegro, ''who has His Majesty's full confidence, is prepared to give greater scope to the Academy, establishing there a painting Museum or Gallery,'' agreed to study which building would be the most ideal to house the new institution. They proposed as possible locations the Palace of La Aduana and the Palace of Buenavista. The academics' interest in the project must have been a lively one, since ten days later, on June 25, 1814, the governors of the academy met and, having read the report by the architects Antonio López Aguado and Juan Antonio Cuervo on the two buildings proposed to house the future museum, agreed to request the Palace of Buenavista from the king. This building, built by the Duke and Duchess of Alba in what is now the Plaza de la Cibeles in Madrid, was acquired by the City Hall and subsequently donated by the institution to Manuel Godoy in 1805. Three years later, the palace, along with the other worldly goods of the ''Prince of Peace,'' was confiscated by the state and kept under the direct custody of the Supreme Royal Council of Castile until such time as its fate should be decided.

The king was also particularly interested in the subject, despite the fact that the country had urgent problems to solve arising from the war against the French

invaders. On July 5, 1814, at a solemn academic session attended by Ferdinand VII and the Infantes Charles and Anthony, the Royal Command of July 4, 1814, was read, by which the monarch,

> desirous to express his distinguished appreciation for the noble arts, by virtue of the much they contribute to the different branches of industry and to the luster and splendor of the Monarchy, ceded to the Palace Academy the Palace of Buenavista so that a gallery of paintings, engravings, statues, architectural plans, and other artistic beauties be established there with suitable comfort and decorum, both for the education and profit of pupils and teachers and to satisfy the noble curiosity of those from home and abroad and give to Spain the glory she so justly deserves.[18]

The king similarly observed that he would offer to the museum "... the paintings, statues, busts, bas-reliefs, and any other effect of the noble arts not essential to the adornment and decoration of his Royal Palaces."

On July 12 the academy took possession of the building. That same day Pablo Recio was entrusted with the task of planning the remodeling of the palace and of organizing the museum. Two months later, in September 1814, the general director of the academy, Antonio López Aguado, was commissioned to carry out a technical survey of the palace. In his report he warned that the building was in imminent danger of ruin if the roofs were not repaired before the beginning of the rainy season. In view of the huge expenditure this would entail, the academy, expressing their gratitude for royal generosity, refused the building, although they did offer to carry out the necessary work with the proviso that they be granted a budget of 3,000 *reales* per week, supplied from the goods confiscated from Godoy. This amount, in addition to what could be obtained from the sale of transferred goods, would enable the academy to complete the restoration of the building before the onset of winter. Having accepted the proposal, the king dictated an order on September 21, 1814, by which the *Junta de Secuestros* (Confiscation Board) was required to make the payment requested by the academy.

The president of the *Junta de Secuestros* and member of the Supreme Royal Council of Castile, José María Puig Samper, warned, however, that the junta could not dispose of the money, since all issues relating to Godoy depended directly on the Council. On October 20, 1814, José Antonio Mon y Velarde, Count of Pinar and "Minister of His Majesty's Supreme Council of Castile, entrusted with the deposit and embargo of the Palace of Buenavista and other goods confiscated from Don Manuel Godoy," drew up a report regarding the planned Fernandine Museum. The count made it clear that he had no intention of entering into the question whether

> it be of greater benefit to the fine arts that there should be at Court a Museum containing the best work of Spanish painters, or whether these should be distributed among the capitals of provinces and exhibited in the places for which they were destined, giving renown and prestige to the cities, towns, churches, palaces, convents, and houses in which they were always hung.

Rather, he would restrict himself to offering a number of observations regarding the need to determine which artistic objects were to be included in the future museum before proceeding to examine the question of the building destined to house them. As regards these works, he classified them into four groups:

> 1. Those preserved in the Cathedrals or Collegiate Churches, as a general rule respected during the invasion. ... If at the time there was moderation, there is much more reason for this now. 2. Those of the Parish Churches, which were preserved as a general point, but many of the town and villages were sacked and their altarpieces destroyed. The paintings were mistreated, for which reason they were not collected. 3. The most numerous, consisting of those contained in the convents, monasteries, and their

respective churches. These were stacked in the capitals, especially in the deposits of Madrid, and were set aside by the intruding Government also with the intention of forming a Museum. A Frenchman[19] was entrusted with these operations of storage and classification, who was later formally accused of being a thief, since he had sent the best of them to France, England, and other European kingdoms. Many canvases remained in Madrid, but of such low quality that they were sold in San Francisco for only the value of the canvas material, which having been washed in the river was then used for new paintings. There were also a few good ones, but these were subsequently taken to the Academy of San Fernando, but through royal decrees they were ordered to be sent back to their legitimate owners, so that the Monastery of El Escorial recovered 184, the nuns of Fuensaldaña, the three celebrated canvases by Rubens, and La Caridad, Seville, those by Murillo. The other few remaining works of quality were also returned to the convents, monasteries, and churches of Madrid. 4. Those confiscated from the great and others proscribed by the intruding government, whose whereabouts is unknown but which were probably sent to France.

Supposing that this account is true, what panels, canvases, and sculptures remain in Spain to be able to form a Museum? Those of people of intelligence and art lovers, works well-known from before and therefore whose legitimacy is easily verified, and those of the Academy. Are these worthy to enter into a select collection? The most important of them belonged to the Jesuits, but what if their former owners should come forward? Is it therefore credible that on the basis of such a scant collection it has been thought to erect such a building, unless in order to decorate it the King should decide to divest his Palace of the treasures contained therein, which distinguish it so much from those of other nations? Good judgment, reason, and intelligence cannot possibly be in favor of such a strange project.[20]

For their part, the attorneys of the Supreme Royal Council of Castile — Manuel de Torres, Ramón López Pelegrín, and Francisco Gutiérrez de la Huerta — presented their conclusions in a text dated November 29, 1814:

> No one can deny that a magnificent Museum honors and distinguishes a nation when it is more complete and richer compared to those of others, and it is essential to the progress and advancement of Arts and Sciences. However, this is only when a Nation has managed to cover all her essential obligations and objectives of happiness, preservation, and peace and to ensure the means by which to achieve her prosperity and defense against foreign invasion. Even in this case, this should be done in buildings and with all those precious objects with which it should be composed, left over from those necessary for essential purposes. The Academy is thinking about an untimely and unreasonable work that in no way should be housed in a public possession. Since it is the case of a museum, it would be much better to use to this end the famous building built at great expense for this purpose by the magnificence of the august grandparents and father of Your Majesty in the Paseo del Prado, rather than let it fall into ruins by procuring another one for the sake of greater convenience.[21]

The proposal, very possibly looked upon favorably by Isidoro Montenegro y Morentes, was accepted by Ferdinand VII who, on December 26, dictated the following order: "I conform to the wishes of the Council, who through my first Secretary of State will know what I order the Royal Academy."[22]

The monarch ordered the academy to once again place the Palace of Buenavista under the guardianship of the Supreme Royal Council of Castile, which would assume responsibility for the completion of the restoration already begun on the building. On January 5, 1815, the academy acknowledged receipt of the king's order and informed the board at a meeting on the afternoon of the same day.

Thus it can be seen that as a result of a series of unconnected causes the project to create a fine arts museum in Madrid once again met with failure. One obstacle was the very structure of the Palace of Buenavista, which, as we have already seen, also forced Joseph Bonaparte to give up the idea of installing the museum there. Furthermore, after the expulsion decreed by the Napoleonic Government of Occupation, the religious orders returned to their convents and monasteries and demanded the return of their goods, among them some five hundred paintings left

by the invaders that had been planned as the nucleus of the museum. Finally, and perhaps most importantly, Ferdinand VII was forced to accept the Supreme Royal Council of Castile's opposition to the project being carried out with public funds and in a public building when the country had other more pressing issues to solve.

In order to compensate the academy for its efforts in favor of the failed attempt to create the Ferdinandine Museum, on June 11, 1816, the king ordered that the institution be given a series of paintings from the Royal Palace. One week later, on June 20, the monarch decreed that the academy and Vicente López should together choose the works. The operation was concluded on August 19 with the dispatch of nineteen paintings,[23] among them several by Velázquez.

THE PRADO MUSEUM

CONCEPTION (1816–18)

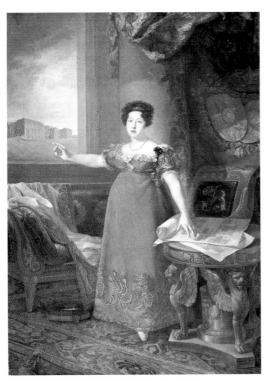

María Isabel de Braganza (see plate 105)

Shortly after having given up the project of creating a museum under the supervision of the Fine Arts Academy, on September 28, 1816, Ferdinand VII took a second wife, his niece, the Portuguese princess María Isabel de Braganza. Although the king had already spent two years attempting to set up the Ferdinandine Museum before he married María Isabel, it has been suggested that the new queen was the true driving force behind the foundation of the Royal Painting Museum, and that the king simply supported the project as a convenience. Such arguments are based on four fundamental points of fact that nevertheless supply no solid evidence in this sense: an article that appeared in the Madrid *Gazette* on March 3, 1818; the funeral oration in memory of the queen, pronounced on February 15, 1819, by Dean Fernández Varela in the Cathedral of Lugo[24]; the posthumous portrait of María Isabel de Braganza painted by Bernardo López in 1829; and statements by Richard Ford in his *Hand-Book for Travellers in Spain*,[25] which it is assumed were taken from sources close to Ferdinand VII himself during the author's visit to Spain between November 1830 and October 1833.[26]

The article in the *Gazette*, relating the royal decision to restore the building in the Paseo del Prado in order for it to house the gallery of noble arts, states that Ferdinand VII was also pleased

> that our Lady the Queen, faithful emulator of her parents' concern for the well-being of her vassals, has generously agreed to cooperate with him. In this sense, and in view of His Majesty's high appreciation of the tender homage of the love of his august wife . . . His Majesty has seen fit to order that to the scant funds lately granted to this building in order to prevent that the rains should accelerate its ruin, and to which the generosity of our Lady the Queen has contributed, should be added a further contribution from his own Royal heritage so that the project may be carried out.

It must be pointed out that this article is nothing more than an announcement of what the king and queen *planned* to do, rather like a declaration of intentions. Six months later, on September 22, we see that the Marquis of Santa Cruz, on drawing up his report on the economic situation of preparations for the museum, mentions only the 24,000 *reales* paid monthly from the treasury of the king's "privy purse." In this same document he suggests that the different expenses for personnel (curator, assistants, restorers, etc.) and transfer of works should be covered from the Royal Treasury. Nowhere is there documentary evidence of a direct and effective collaboration on the part of the queen, while there is evidence of this on the part of Ferdinand VII.

As to the funeral oration by Dean Fernández Varela, on the whole the text is excessively eulogistic and, as if this were not enough, imprecise in its details (it is hardly likely that, as he claimed, before its inauguration the museum would have more than 1,300 paintings hanging in its collection — "more than two hundred from

the Spanish school, and one thousand one hundred from those of other nations'' — when in 1828 there were only 757). Furthermore, the fears he expressed regarding a possible interruption in the project proved to be thoroughly unfounded.

The portrait (plate 105) painted by Bernardo López Piquer in 1829, ten years after the death of the queen, is similarly elegeaic. In it the queen is depicted with the iconography of all the founders, pointing with her left hand to the plans of the building, in which the layout of the canvases is shown, and with her right to the Palace of El Prado, visible through one of the hall windows. With his canvas, the artist undoubtedly wished to express the sensitive spirit of María Isabel de Braganza. Perhaps her interest in the museum was the only recourse at the artist's disposal to exalt the figure of a woman who, in the words of her biographer, Manuel de Saralegui,

> never had occasion to shine . . . in anything that, beyond a purely ordinary level, could be invoked as the foundation of great eloquence. . . . María Isabel de Braganza was a virtuous woman like thousands of others who live on this earth without leaving traces of brilliance or providing a motive for justifying extremes of admiration or warm orations.[27]

The final argument is based on the writings of Richard Ford. According to Ford, the king had ordered the old paintings removed from the walls in the aim of covering them with French wallpaper, which was the latest craze of the time. He adds furthermore that "the queen, well advised, considered it a pity that they should be abandoned and exposed to the weather and the possibility of being stolen from corridors and attics where they had been stacked." I must confess my sympathy toward the romantic English traveler, in whose book are striking and incontrovertible observations concerning the idiosyncrasies of the country he visited, the fruit of both overwhelming common sense and a sharp capacity for analysis. Nevertheless, I believe that in the case of Ferdinand VII he let himself be carried away by his own prejudices. In any case, Ford makes no reference whatsoever to the circumstances of the founding of the museum, limiting himself to revealing the queen's interest in the preservation of the paintings.

What cannot be denied, however, is that María Isabel de Braganza was a sensitive art lover. It is also irrefutable that the queen gave her determined support to the project of creating a museum containing only the paintings from the royal collection (not counting on those belonging to monasteries and convents), using funds supplied from the king's treasury and housing the museum in the magnificent building constructed by Charles III and Charles IV in the Paseo del Prado, based on the plans by Juan de Villanueva. As Michael J. Quin[28] points out, referring to Isidoro Montenegro, "Queen María Isabel enjoyed on her arrival in Spain the affection her husband professed for her." Let it not be forgotten that Montenegro, the king's favorite, was one of the main instigators of the idea of the museum and also the treasurer of His Majesty's "privy purse," from which funds were provided for the restoration of the Palace of El Prado. In other words, in 1817 and 1818, when the decision was made to create the Royal Painting Museum and refurbishing work had begun on the building designated to house it, Ferdinand VII's immediate entourage consisted of staunch defenders of the project. However, it was not until March 24, 1818, that further news was forthcoming about the Royal Painting Museum.

THE BUILDING

Back in the sixteenth century, El Prado de San Jerónimo was one of the favorite strolling areas for the people of Madrid. In 1861, Ramón de Mesonero Romanos, in his book *El antiguo Madrid*, included the following lines written around 1543 by Pedro de Medina and published in 1560 in his work *Grandezas y cosas memorables de España*:

Toward the eastern part [of Madrid], on leaving the houses behind, upon a rise there is a most sumptuous monastery of Hieronymite friars, with lodgings and rooms to welcome and accommodate monarchs, and with a fine and extensive vegetable garden. Between the house and the monastery, on the left-hand side on leaving the town, there is a beautiful, large poplar grove, the poplars being planted in three rows, creating two very wide and very long avenues, with four exquisite fountains of delicious water; at intervals, along the lengths of both avenues, there are many rose bushes winding around the bases of the trees. In this grove is a large pond which contributes much to its beauty and leisure possibilities.

On the right-hand side of the same monastery, on leaving the houses behind, there is another equally peaceful poplar grove, with two rows of trees creating a long avenue as far as the Atocha road; this grove has its streams and one side of it looks over the gardens. These groves are called the Prado de San Jerónimo, where in winter enjoying the sun and in summer the cool it is a wonderful sight to see the great number of people, finely dressed ladies and distinguished gentlemen and many noble men and women in carriages. Here great delight is taken in the coolness of the wind every summer evening and night and in the music, with no danger or dishonesty, thanks to the vigilance and diligence of the Court authorities.

In 1767, during the reign of Charles III and when the Count of Aranda was governor of the Royal Council, work to improve the urban conditions of the Prado de San Jerónimo was begun. José de Hermosilla y Saavedra,[29] captain in the engineering corps, was placed in charge. The land was leveled, by flattening hillocks and filling in gullies; the central avenue and the side streets were formed; and a great number of trees were planted, for the irrigation of which in the following years several fountains were placed at convenient intervals, outstanding among which are those of Cibeles, Apollo, and Neptune. Two years later the work was practically complete. The new avenue, with indications for the position of the future fountains, appears in the plan of Madrid drawn by Antonio Espinosa de los Monteros in 1769.

In the middle of the following decade, in 1776, the architect Ventura Rodríguez was commissioned to prepare the project for a porticoed avenue with a capacity for some three thousand people and with shops and booths where refreshments would be sold. Its location had to be halfway between the fountains of Cibeles and Neptune. However, the extremely high costs of Rodríguez's plan caused the project to be rejected.

A short time previously, in 1775, the preliminary plans for another of the great scientific projects of the Enlightenment began to take shape: those for the Royal Botanical Gardens. That year plots of land were purchased in the Prado de San Jerónimo, where an important collection of plant species would be cultivated. Under the direction of the engineer Tadeo López, the works were begun in 1776 and completed five years later.

It was also around this time, in about 1779, that Charles III and José Moñino, Count of Floridablanca, made the decision to found the Science Academy. This institution constituted the cohesive element in the vast plan put in motion by the monarch and his prime minister in an attempt to place Spanish science and industry on a par with those of the most advanced countries of Europe. In his desire to concentrate scientific entities, the monarch ordered the land to be bought next to the northern end of the Botanical Gardens, between the Monastery of San Jerónimo and the Paseo del Prado. His aim was to construct there not only the building that would house the academy but also associated institutions, which, in accordance with Floridablanca's proposals, were to include a museum of natural history, a chemical laboratory, an astronomical observatory, a museum of machines, and, if enough room were available, the Academy of Fine Arts.

Early in 1785 Juan de Villanueva was asked to draw up the corresponding plans. On May 30, 1785, the architect presented the king with two alternative projects. One of these combined the existence of the academy with the construction of a

Juan de Villanueva

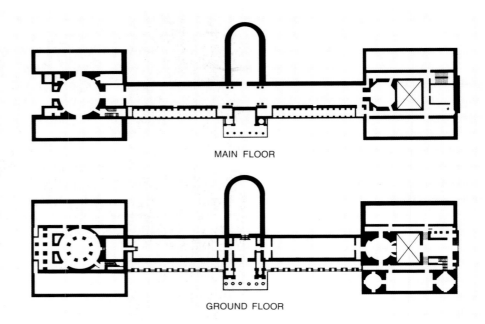

MAIN FLOOR

GROUND FLOOR

Plans for the main and ground floors as designed by Villanueva

peristyle, thus following to an extent the idea developed by Ventura Rodríguez. The second thoroughly rejected the idea of the porticoed avenue and devoted the whole building to its essential function. This latter solution being finally approved, its construction began almost immediately, at the end of the same year.

The work was financed from the funds confiscated from the Company of Jesus. The accounts and justifications corresponding to the construction of the Palace of El Prado have been lost, but it would seem that during the seven years from 1785 to 1792, an annual sum of two million *reales* was assigned to the project, that is, a total of some fourteen million *reales*. After Floridablanca's fall from power, in February 1792, he advised his successor, the Count of Aranda, to reduce the annual assignation for the renovation of the Palace of El Prado to 1.2 million *reales*.

Construction proceeded without serious setbacks, despite the fact that a few months later, in November 1792, the Count of Aranda was in his turn replaced by Manuel Godoy, the Duke of Alcudia. Godoy did everything he could to place obstacles in the way of the creation of the Science Academy, until finally, in 1796, he ordered work on its foundation stopped, adding in his own hand that "while I am head of government this establishment will not be finished." Nevertheless, he let work go ahead on the Palace of El Prado where, so it seems, it was thought to install the museum of natural history, the chemical laboratory, the museum of machines, and possibly the recently founded school of civil and canal engineers. Not so lucky was the astronomical observatory, for which Juan de Villanueva was commissioned in 1793 to erect a building in the Cerro de San Blas. The Palace of El Prado was virtually completed in 1808. Rumeu de Armas[30] reckons that the cost of the works so far would have reached the sum of approximately fifty million *reales*.

Yet another roadblock was placed in the way of the Palace of El Prado. During the war against the Napoleonic invaders the building was put into use as barracks for the forces of occupation. The palace suffered considerable damage, particularly the removal of the lead from its roof in order to make bullets. One of Villanueva's pupils, the architect Antonio López Aguado, in an article entitled "Madrid artístico; el museo," published in the *Semanario Pintoresco Ilustrado* of June 23, 1839, indicates that

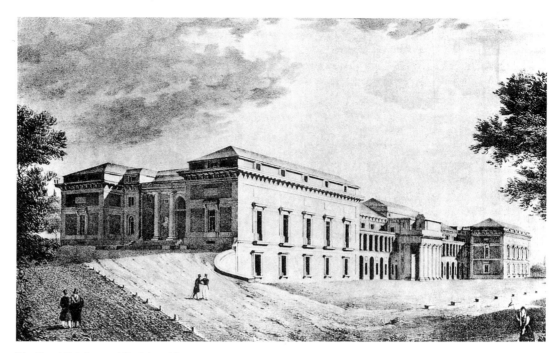

The Royal Painting and Sculpture Museum

architectural richness and sumptuousness . . . reigned in that building, covered with a double leaded and slated roof, placed and clinched with great mastery . . . until the ill-fated year of 1808, in which it shared the innumerable vexations suffered by Spain during the foreign invasion. . . . [The French] were responsible for a multitude of damages to its structure, concluding with the extraction of all its leading. . . . Left uncovered and abandoned to the inclemencies of the weather during the years of the French domination, all the rains that fell upon its vaults ruined most of them and prepared the way for a similar fate for the rest.

Pedro de Madrazo, in his prologue to the *Catálogo de los cuadros del Real Museo de Pintura y Escultura de S.M.*, published for the first time in 1843, also refers to the lamentable state of the noble building:

which was full of rubbish, as if it had been in ruins for many centuries, due to the extraction of all the leading when the foreign troops, both friend and foe, took possession of it during the War of Independence, fighting in Spain for an objective very different from that for which it was destined and in every way incompatible with its proper preservation.

PRELIMINARY PREPARATIONS (1818–19)

We have already seen how toward the end of 1814, on November 29 to be exact, the attorneys of the Supreme Royal Council of Castile found it was improper to create a museum using public funds and suggested that, in order to carry out the project, the Palace of Villanueva, built by Charles III to be the Science Academy, should be used as the seat of the institution. In this sense it is worth recalling the Royal Command of May 22, 1816, by which Ferdinand VII decreed the separation of the government and the interests of the Royal House from the administration of the State. One of the king's first decisions regarding the creation of the museum was the appointment of its director, designating for the post His Majesty's Chief Steward, that is the head administrator of the Royal House, as established in the Order of 1817 issued to develop the Royal Command of 1816. The position was held at the

time by José Gabriel de Silva-Bazán y Walstein, Marquis of Santa Cruz, who years later, in 1833, would receive further evidence of the trust that Ferdinand VII placed in him on being named executor of his will. The first action undertaken by the marquis as director of the museum of which we have any knowledge was on February 24, 1818, when he signed a decree requesting the inventories of the new palace (Oriente) and the royal houses. As from this moment events and news regarding the museum succeed each other regularly.

One week later, on March 3, 1818, there appeared in the Madrid *Gazette* an article dated the previous day which announced publicly that Ferdinand VII had decided to restore the building in the Paseo del Prado in order to house there the museum of fine arts (as the Royal Council had suggested). Special emphasis was placed on the point that it would be the king himself, with the collaboration of his wife, who would cover the costs of a project that could not be carried out with public funds.

> Madrid, March 2. — The state, as the result of an all-destructive war, into which has fallen the magnificent building of the Museum of Sciences, an enterprise worthy of the memory of H. M. Charles III, in whose reign it was begun, has constantly wounded the eye of our Lord King and kindled in his Royal soul the flame of the glorious idea to perfect a work which, beyond the greatness of the objective, concluded it will be one of the finest sights in Madrid. His Majesty being well convinced of this, and that the sciences and the arts will form a new whole when brought together in this exquisite work of architecture, and is no less aware that, since this idea cannot be realized using public funds destined to satisfy other, more pressing needs, the project would come to nothing unless his generous and protecting hand sustains it. To avoid such a tragic outcome and to erect in this *alcázar* the throne of Spanish Illustration, of the beauties of the arts and the miracles of nature, and to foment therein the germ and the power of industry and commerce, His Majesty has decided to take under his particular care the conclusion of such an important enterprise, and adds with pleasure that our Lady the Queen, faithful emulator of her parents' concern for the well-being of her vassals, has generously agreed to cooperate with him. In this sense, and in view of His Majesty's high appreciation of the tender homage of the love of his august wife . . . His Majesty has seen fit to order that to the scant funds lately granted to this building in order to prevent the rains from accelerating its ruin, and to which the generosity of our Lady the Queen has contributed, should be added a further contribution from his own Royal heritage so that his desires may be carried out, decreeing that preference be given to the part destined for gallery of the noble arts with the view, as H. M. has benevolently insinuated, to placing there many of the precious painting that adorn his royal palaces so that they may be preserved there for the study of scholars and for the delight of the public.[31]

It should be noted that this article is also a kind of manifesto of the objectives pursued by the new institution, objectives that essentially coincide with those defined today by the International Council of Museums (ICOM). According to ICOM, a museum is "a permanent institution preserving and exhibiting collections of objects of a cultural nature for the purposes of study, education and delight." These were undoubtedly the intentions of Ferdinand VII; whether or not they were fulfilled is another question.

Just one month after the announcement of the king's intentions, on April 5, 1818, the Marquis of Santa Cruz, having been informed of the inexistence of the inventories of the Palace of Orient and royal houses, which he had requested previously, ordered that they be drawn up by their respective keepers with the help of professors appointed by Vicente López.[32] The order was obeyed immediately and, five days later, on April 10, the painter presented the list of the paintings existing in the Palace of Aranjuez.[33] On April 14, the Marquis of Santa Cruz petitioned the king to turn over those paintings from the palace and the royal houses that Vicente López had requested, a petition to which Ferdinand VII agreed on April 18.

The paintings began to arrive at the museum on July 27. The first dispatch consisted of 32 canvases. In the remaining months of 1818 more paintings were delivered, until the figure of 850 was reached. This intense pace continued during the following year: 660 more paintings arrived between January 1 and November 19, the date of the opening of the museum. Thus the total number of works delivered by that time was 1,510, although of these only 311 were exhibited. In the following six weeks, 128 additional canvases were delivered, so that at the end of the year of its inauguration the Royal Painting Museum contained a total of 1,638 works.

The delivery notes were signed by the first steward of the palace, Luis de Weldorf, as ceder, and as receiver by the museum curator, Luis Eusebi. Eusebi, a painter of modest talent born in Rome on an unknown date, came to Spain around 1788 and was appointed court painter on February 25, 1816. Three years later, on April 21, 1819, upon the resignation of the engraver and lithographer Cárdano, he was appointed curator of the Royal Painting Museum.[34] With dignity and efficiency he carried out his functions, which, in addition to those inherent to the post, included the preparation of the first catalogues of the museum and advice to his superior, in which he was aided by his subdirectors.[35]

Meanwhile, the refurbishing of the venue continued at a steady pace, and questions about the organization, function, and economic structure of the entity were addressed. All this is reflected in a report to the king by the director of the museum, dated September 22, 1818:

> The Marquis of Santa Cruz, entrusted by Your Majesty with the task of forming the Gallery of Paintings in the Prado Museum with canvases pertaining to Y. M.; at the same time having the honor and satisfaction of informing Y. M. that I have already conditioned two halls to this end in the said building, transferring there the number of paintings for which there is sufficient room, it would be a breach of the trust which Y. M. has honored me if I did not submit to your august consideration whatever you consider fit to satisfy the benevolent desires of Y. M. with the best order and economy possible.
>
> It will not have escaped Your Majesty's superior perception that the formation and preservation of the painting gallery occasions expenses proportionate to the works carried out on the building, to the number and state of the canvases transferred there, and to the salaries paid to the employees of the Establishment. Your Majesty, thanks to your characteristically generous heart, had the kindness to assign to the Establishment the sum of 24,000 *reales* from your privy purse, which at the time of writing have been paid without the slightest delay. However, this amount, although in other circumstances more than enough to cover all the expenses of the Gallery, now covers only the slow repair of a small part of the great damage the building being reformed suffered in the past, devastating war. The ruinous state of the building makes it imperative that the damage be repaired as soon as possible, if it is not to increase and with it the corresponding expenses. Thus to destine for other objects any of the aforementioned sum would be a false economy. Thus Your Majesty understood the situation and by virtue of this ordered that the costs of transferring of the paintings be met by the Treasury of the Royal House. However, this resolution of Y. M. would indicate, it seems, the means whereby also to cover the costs of restoration of deteriorated paintings and of their preservation, as well as the salaries of the curator and two concierge-cleaners necessary for the normal maintenance of the Gallery; nevertheless, in order to avoid doubts and misunderstandings and to fix the order to be followed from now on, it would not be inopportune to make a number of observations concerning these two points. While the paintings remained in palaces and houses belonging to Y. M., their preservation was the responsibility of the First Court Painter and two assistants, whose salaries were paid by the treasury of the royal house, as well as the expenses incurred. There being therefore nothing new in this, by the mere fact of transferring the paintings to the Museum, the paintings there will be equally restored or preserved without extra cost to Y. M., without the diminishing of other funds or burdening your vassals. By adopting what is this simple measure, economical at the same time, nothing could be more coherent than to consider the gallery as depending upon the Royal Palace and the employees as servants of the Royal House, paid by your Treasury. In this way the establishment of the Painting Gallery in the Museum will be honored by depending

on Your Majesty's Royal Palace, will proceed at a steady pace that will facilitate its administration and government, and will require from the treasury of the Royal House the monthly sum of only 1,500 *reales* which the salaries may reach: the curator earning 800 ducats yearly and the two concierge-cleaners 400 ducats each, plus the wages of a few others when extraordinary work has to be carried out. Other than the means hereby proposed, it seems that there is no other to cover the costs or salaries than the funds of the Post Office, Royal Lottery or others; however, these branches, besides being somewhat overloaded, in practice present no little complication and the ensuing results would be neither advantageous nor satisfactory.

Given this supposition, it is thought preferable to

1. Continue investing in the repairs to the Museum the 24,000 monthly *reales* from Your Majesty's privy purse, paid in full.

2. Continue paying the costs of transferring the paintings from the Treasury of the Royal House.

3. Consider the Gallery as being dependent on the Royal Palace.

4. Not exonerate the First Court Painter from the obligation to restore and preserve the paintings.

5. Leave at his disposal the two assistants, paying them as hitherto, both salaries and restoration expenses, from the Treasury of the Royal House.

6. Finally consider as servants of the Royal House the curator and keepers of the Gallery, the Treasury paying these, when nominated, the annual sum of 800 ducats and 400 ducats respectively, as well as extraordinary costs that may be incurred, subject to Your Majesty's approval.

Thus, Sir, is the summary of what, after a painstaking study, it is deemed worthy for your sovereign consideration as most useful and advantageous for the most economical and least costly Establishment. Y. M. will decide through your prudence and wisdom the true advantages or drawbacks that might derive from its approval, and will resolve what most pleases Y. M., issuing the Royal Decree(s) you consider most opportune to this end.[36]

Observe how the Marquis of Santa Cruz defends the monthly assignation of 24,000 *reales* from the king's "privy purse" to be spent exclusively on the work of restoration of the building, arguing that the costs of transferring the canvases should be met by the General Treasury of the Royal House. As for the museum personnel, as can be seen this was reduced to the absolute minimum: the curator, two concierge-cleaners, and two assistant restorers, these latter under orders from the court painter. Their salaries, so the director claims, should also be paid from the General Treasury of the Royal House, as should the daily and extra expenses deriving from the functioning of the institution.

As usual, the reply was immediate; three days later, on September 25, 1818, His Majesty's chief steward informed the Marquis of Santa Cruz that the king had resolved to accept his suggestions regarding the museum:

Distinguished Sir. — I have informed His Majesty of Your Excellency's observations regarding the Painting Gallery established in the Royal Museum of El Prado, under your direction, and having studied the details expressed therein, H. M. has resolved to proceed according to your counsel. First: that the monthly sum of 24,000 *reales* shall continue to be invested from the privy purse in repairing the building. Second: that the General Treasury of the Royal House will continue to cover the costs of transferring the paintings from the Palaces and Country Houses to the Museum. Third: that the First Court Painter will continue to be responsible for restoring and preserving the canvases existing in the Gallery as if they were still in the Palace, remaining at his disposal his two assistants, the General Treasury of the Royal House as hitherto paying them their salaries and restoration expenses. Fourth and lastly: that the curator and two concierge-cleaners, whom Your Excellency considers indispensable for the Establishment, be considered servants of the Royal House, and paid from the same Treasury the salaries proposed by yourself, namely 800 ducats annually for the former and 400 each for the latter when appointed, in which case H. M. requires that Your Excellency choose members of the Royal service who do not form part of the permanent staff. Furthermore, any extra costs will be met in the same way after Royal approval has been granted. Signed, September 25, 1818.

The Count of Miranda.

The Marquis of Santa Cruz.[37]

Decision-making regarding the museum suffered no delays or obstacles arising from bureaucratic red tape. There was a clear will to proceed with the project at all speed. The application of the plan was also quite quick, and the activity surrounding the museum intensified as opening day approached. As soon as the king's approval of the plan proposed by the Marquis of Santa Cruz had been received, on September 28, 1818, the two restorers, Gómez and Bueno, began work. Between this date and November 6, 1819, that is, in the space of just over one year, they restored 297 works (better than one every three days per restorer).[38] Notice that this number is very close to that of the 311 canvases exhibited on the day the museum opened (November 19, 1819).

The death of María Isabel de Braganza, on December 26, 1818, less than one year before the official inauguration, produced no visible setbacks for the project. The king continued to be interested in the operation; evidence of this is the visit he paid on February 4, 1819, accompanied by his captain of the guard (Alagón), secretary of state (the Marquis of Casa Irujo), and the director of the museum (the Marquis of Santa Cruz), in order to inspect the work in progress on the restoration and the placing of the paintings to be exhibited in the gallery.[39]

There were also provisions made concerning the deadlines for the reconstruction. On September 14, 1819, the articles of marriage were signed between Ferdinand VII and María Amalia of Saxony. The possibility of coinciding the opening of the Royal Painting Museum with the royal nuptials arose, and on September 22, in view of the short time remaining, authorization was requested from the vicar general for work to be carried out on Sundays and religious festivals.

The information campaign through the press continued throughout the whole process. On September 27, 1819, the Madrid *Gazette* gave an account of the state of the reconstruction work on the building:

Madrid, September 27. — News concerning the works which at the expense of His Majesty and of this most heroic City are being carried out by the State Architect Antonio López Aguado and His Majesty's Architect Isidoro Velázquez:

It has been necessary to begin repairs on the fine Royal Museum building, whose roofs, as a result of events occurring during the last war, were left without either the lead or the slate which protected it, in order to prevent the collapse of its vaults, and to this end work has been carried out to cover the two halls situated to the left of the main entrance and which look onto the Paseo del Prado and the Paseo de San Jerónimo, both of which are now completely refurbished with their portico and entrance columns. Furthermore, construction work is in progress on the halls destined to house the painting gallery, the purpose of the building; at the same time the magnificent central hall is being covered, and the remaining roof sections being provisionally repaired in order to prevent damage and collapse as a result of rain. In these works 833,429 *reales* have been spent, provided by the munificence of our Lord the King.[40]

As for the source of the funds for the financing of the construction, there is not even the slightest mention of the participation of the late queen María Isabel de Braganza. The covering of all costs is attributed exclusively to Ferdinand VII.

It is also very interesting to calculate approximately what the 833,429 *reales* would be worth today; on the basis of the monthly income of 750 *reales* earned by the museum curator (see the report dated September 22, 1818, by the director of the museum), and considering that this would be the equivalent today of some 150,000 pesetas, the total amount would be some 166 million pesetas, or more than $1.5 million. Similarly, the monthly sum of 24,000 *reales* assigned by the king for the restoration of the building would today be almost five million pesetas, or nearly $50,000, per month. These are certainly impressive figures, although, when all is said and done, insufficient, since they enabled the exhibition of only one-fifth of all the paintings delivered to the museum; the budget should ideally have been five

times greater. The remaining canvases had to remain in the limbo of thoroughly inadequate storerooms until the time came for their redemption or, in more than one unfortunate case, their condemnation.

Despite all efforts, the museum was not ready to open in time for the marriage of the king, which took place on October 20, 1819. On October 23 the Marquis of Santa Cruz informed the chief steward that the halls were now ready and would be opened to the public on the day His Majesty saw fit. All that remained was to request from the secretary of state an order that the catalogue be published in the royal printing press.

Scarcely three weeks later, on November 12, the director of the museum received two thousand copies of the catalogue, as well as six bound exemplars for the monarchs and dignitaries. It was a booklet of twenty-one pages (a true bibliographical rarity nowadays), listing the paintings exhibited, the work of the curator Luis Eusebi. The following day, the Marquis of Santa Cruz sent the chief palace steward eighty-two fine gilt-bound copies of the publication, intended for figures of importance. He also sent him the text to be published in the *Gazette* informing the public of the opening of the museum. Finally he requested a detail consisting of a sergeant, a corporal, and twelve soldiers to guard the museum. Everything was finally in place, at least for the public opening, since, as stated before, 80 percent of the paintings delivered to the museum remained in storage under very dubious conditions.

FERDINAND VII: INAUGURATION AND EARLY DAYS OF THE ROYAL PAINTING MUSEUM (1819–33)

The Madrid *Gazette* of Thursday, November 18, 1819, included the following notice:

> One among other thoughts concerning the common good that have inspired in our Lord the King the ardent desire to work for the well-being of his subjects, and to propagate good taste as regards the Fine Arts, was that of forming and opening to the public a copious collection of paintings from home and abroad representing the different schools: an establishment that at the same time as embellishing the kingdom's capital and contributing to the luster and splendor of the nation provided art lovers with the opportunity to experience the most honest of pleasures and art students with the most efficient means to make rapid progress. To such dignified ends His Majesty donated a large number of the precious paintings distributed among his Royal Palaces and Country Houses and attributed funds to refurbish halls and galleries in the magnificent building of the Prado Museum, where the collection was to be housed. His august spouse, María Isabel de Braganza, whom God protect, was moved by the same desires as His Majesty and saw fit also to protect and provide stimulus for such an important project. One year and a half later much of the work has been completed, and after having been cleaned and restored the canvases of the Spanish school, still distinguished among those of other nations that have so gloriously cultivated the noble arts, have been duly hung. The work continues successively to refurbish the halls destined to house paintings from the Italian, Flemish, Dutch, German, and French schools; however, since it was His Majesty's wish to allow his beloved subjects to enjoy as soon as possible the pleasure and utility of seeing gathered together the most outstanding works of those painters who with them have honored the nation, he has decreed that the Museum be opened forthwith to the public, and to this end from the 19th of the current month of November it shall be open for eight consecutive days, except on those when there is heavy rain and mud, and that during the rest of the year it will be open on Wednesday of each week.[41]

Thus finally the opening day came; on November 19, 1819, the Royal Painting Museum opened its doors to the public. No official acts accompanied the event — Ferdinand VII did not even attend — and for most people in Madrid the occasion passed by completely unnoticed. For the following eight days it was possible to visit the museum daily from nine in the morning until midday, and subsequently the general public could gain admittance on Wednesdays during the same hours.

During the remainder of the week, except holidays, its doors remained closed to everyone except copiers and students.

The public part of the museum was limited to the first floor of the pavilion at the northern end of the building, access to which was by means of an embankment that reached up to the entrance door on this side. Inside, the circular gallery served as a kind of foyer for the two main halls, to the right and left respectively, and for the third hall, on the central axis, a kind of anteroom for the main gallery, which was still being refurbished. In these three halls were exhibited the 311 Spanish paintings that constituted the collection on view to the public. The remainder of the works, including all the canvases from the Italian, Flemish, Dutch, French, and German schools, still awaited their future home.

In the two main halls, on the left and right of the entrance, could be seen forty-three canvases by Velázquez (or at least attributed to his hand), the same number by Murillo, twenty-eight by Ribera, fifteen panels by Juan de Juanes, six compositions by Zurbarán, two by Carreño, several of the battle scenes from the Salón de Reinos of the Palace of Buen Retiro, works by Valdés Leal, Palomino, Mazo, Claudio Coello, Cano, Toledo, Núñez de Villavicencio, Carnicero, Espinós, Sánchez Coello, and forty-three still lifes by Meléndez. In the third hall, opposite the entrance door, were twenty-one canvases by recently deceased painters (Bayeu, Paret, Maella) and by others still living (Goya, Aparicio, José Madrazo, and Montalvo).

Some of the floors were made of flagstones, others of brick tiling, but there were still a few areas in which the floor was simply of beaten earth. During the summer months these floors were watered in order to cool the building and to prevent the dust from rising, while in the winter they were covered with matting. During the cold months the halls were heated by means of three braziers (one in each hall), supplied from the palace storerooms, which were lit only when the public was allowed to visit. For fuel, Luis Eusebi received twenty *arrobas* (just over two hundred kilos) of coal each month; if any was left over it was burned for the benefit of the long-suffering copiers.

The liberal-constitutional uprising of January 1, 1820, led by Riego, Arco Agüero, Quiroga, and Baños, also had repercussions, although these were not immediate, for the museum. Meanwhile activities continued as usual: at the beginning of the year fifteen new paintings were delivered, although not all the canvases came from the royal patrimony. From the museum's very conception, there was interest in completing the collections through the acquisition of works by the great masters and of paintings with which to fill in gaps. The first work purchased specifically for the Royal Painting Museum was a *Trinity* by José de Ribera (no. 1069), for which on April 5, 1820, Ferdinand VII paid the owner, Agustín Esteve, 20,000 *reales*.[42]

Before long, the first criticisms of the conditions in which the works were exhibited were heard, an indication of the extent of the arousal of the people's interest in the recently created institution. In the periodical *La crónica artística* of March 23, 1820, the following complaints were expressed:

> Upon entering the halls the first thing the visitor seeks is the chronological order of the paintings, in order to inform himself of the progress or decline of the painting of the Spanish School. However, he feels deceived on finding these works chaotically arranged as if they were in a private study or in a junk shop. Indeed, it seems that the organizers have taken pleasure in placing the paintings in a bizarre way, seeking only eurythmy or symmetry in order to please the ignorant, while intelligent people are left to guess the different periods of art in our country of Spain.[43]

A few days later, on April 2, in the *Miscelánea de comercio, arte y literatura*, the journalist Antonio García echoed the opinions published in *La crónica artística*, and moreover denounced the use of oil paint instead of varnishes for the restoration being carried out in the museum workshops.

As a result of the purges imposed by the liberals on Ferdinand VII, the Marquis of Santa Cruz was appointed ambassador to France on March 30, 1820. Nevertheless, before taking up his new post on April 8, he still had time to request from the royal stewards 20,000 *reales* to be invested in the restoration of paintings from the Italian school, since refurbishing work on the main gallery, where both these works and paintings from Aranjuez and San Ildefonso were to be exhibited, was on the point of completion. The money was assigned the following day.

THE PRINCE OF ANGLONA (1820–23)

On April 9, 1820, Pedro Téllez-Girón, Prince of Anglona, was appointed by Royal Command Director of the Royal Museum, replacing the Marquis of Santa Cruz. The comand specified that the prince, a staunch supporter of the liberal movement, would run the museum under the same conditions as his predecessor and confirmed the monthly allocation of 24,000 *reales* supplied by the treasury of the king's "privy purse," destined exclusively to the conditioning and restoration of the building. The remaining costs of running the establishment also continued to be met by the Royal House. As soon as he took up his duties, Anglona was forced to request new funds, since the 20,000 *reales* granted to his predecessor on April 9 had already been spent (presumably on back payments). On April 26 he was assigned a further 20,000 *reales*.

One month later, on May 20, 1820, a series of Italian paintings arrived from the Palace of Aranjuez, specifically those intended to complete the Italian gallery as promised on the opening of the museum. This new section was made ready during the summer and was opened to the public on August 6. In total 92 new canvases entered the museum during 1820. The new catalogue drawn up by Eusebi included the paintings in this new sector, with which the total number of works on exhibition reached 512; the book was put on the market in 1821.

With the inauguration of the new gallery came two new braziers and thirteen *arrobas* more of coal per month during the winter. As the heating remained insufficient, two stoves were purchased, each one consuming two *arrobas* of firewood. Nevertheless, visiting the museum during the winter was something of an act of heroism and devotion to the cause of the fine arts.

Attempts were continually made to correct the limitations of the building and the faulty distribution of the works. In order to improve the lighting conditions for the Italian paintings in the central gallery, four skylights were opened in the roof, with their corresponding curtains to filter the light during that part of the day when it entered directly from above. The paintings on exhibit were hung practically from the floor to the cornice, in order to take full advantage of the total wall surface, so that it was difficult to contemplate those highest up. To make their study easier, no better solution was found than that of purchasing, for sixty *reales*, a telescope placed at the disposal of visitors. More positive and sensible was the decision to renovate the ceilings of the storeroom where the paintings not on view were kept. (While not exposed to the public eye, they had been exposed, until that moment, to the dangers of inclement weather.)

It seemed that a promising period in the life of the museum was beginning; however, on April 7, 1823, all hopes were dashed. On this fateful day the Duke of Angoulême, at the head of the Hundred Thousand Sons of St. Louis, crossed the River Bidasoa to brutally repress the liberal movement. On May 23 the French troops entered Madrid. Eusebi, whether in obedience to orders from above or on his own initiative, drew up in three days a French version of the catalogue, of which one thousand copies were printed (four of these were specially bound for the king).

THE MARQUIS OF ARIZA AND ESTEPA and VICENTE LÓPEZ (1823–26)

On November 13 Ferdinand VII, who had been away from the capital since March 20, returned to Madrid. The Prince of Anglona went into exile in Italy. In order to replace him, on December 23, 1823, the king adopted an unprecedented solution: José Idiáquez Carvajal, Marquis of Ariza and Estepa, was appointed administrative

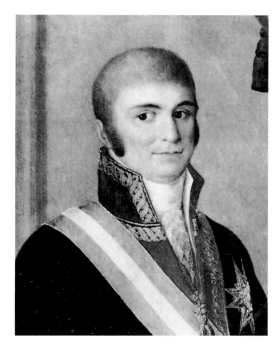

The Marquis of Ariza and Estepa

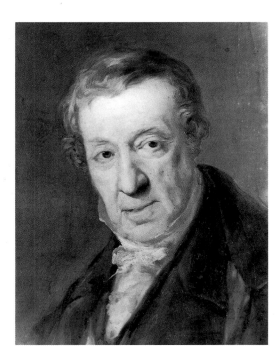

Vicente López

and financial director of the museum, while the artistic administration was entrusted to Vicente López, the court painter. This division of responsibilities did not produce the hoped-for results, largely on account of the marquis's frequent periods of absence.

In 1825 a new service was added to those already offered by the museum. On March 21 Ferdinand VII signed a Royal Command by which for a period of ten years the industrialist Ramón Castilla and the painter José Madrazo were granted the exclusive privilege of reproducing all the paintings in the royal sites and in the museum. Furthermore, they were authorized to install their lithography workshop in the building itself. While placing the reproduction room in the museum obviously responded to practical needs, it might also be considered as a precedent to the subsequent decision to allow the painter-directors of the museum to have their studios in the same building, with all the disorder and chaos this brought with it. Having visited Paris and Rome to engage lithographers to produce the plates, Castilla and Madrazo requested authorization to take the paintings to be reproduced to the lithographic workshop, and this was granted by the king on September 26. However, they were expressly forbidden to remove the canvases from the museum. On March 30, 1826, the first portfolio appeared of the *Colección litográfica de cuadros del Rey de España el señor Don Fernando VII*, containing sixty-two prints besides a portrait of the king and a general view of the museum. The sixteenth and final volume in the collection appeared in April 1829.

Restoration work on the building continued without interruption and without serious problems, until the remainder of the main gallery was completed. Work began also on the southernmost wing. The octagonal gallery immediately adjacent to the main one was the first to be attended; the two halls in this pavilion facing the same direction as the main gallery were left for the next phase. At the same time the works to be exhibited in the new halls were selected and approaches to their arrangement studied. Before the paintings in the storerooms could be inspected, porters had to be hired to move the stacked-up canvases — a fact that reveals the appalling conditions in which the works not on show were kept. More continued to arrive: on March 20, 1826, ninety-nine new paintings were received.

Given the situation caused by the considerable accumulation of works in the storerooms and the need to fill the new halls, it was considered prudent to close the museum, a decision announced in the *Diario de Madrid* on Friday, March 31, 1826: "Royal Painting Museum. — A Royal Command has decreed that certain alterations must be made to the arrangement of the paintings and some works carried out, and until these are completed the Museum will be closed to the public until further notice."

In view of a lack of interest on the part of the person whose responsibility it was to direct the installation of the new halls, Vicente López presented a project that was not limited to the distribution of the canvases destined to be hung in the visitable sections, but rather set out to totally reorganize the collections on show in the museum. According to his criteria, the Spanish paintings, instead of occupying the three salons around the rotunda in the building's northern wing, should be placed in the northern half of the main gallery, the Italians moved to the other half of the main gallery, and the works from the Flemish, Dutch, French, and German schools hung where the Spanish paintings had been. López gave no reasons for such a reordering of the canvases; perhaps he was motivated by the desire to see the Spanish works in a more prominent part of the building, instead of in the halls round the rotunda, which might have struck him as being less dignified.

From Seville the Marquis of Ariza sent a petition to the king, dated April 25, 1826, expressing his opposition to López's project. Ariza considered the drastic modifications suggested by the court painter to be both too costly and harmful.

Although there is no justification for the perpetual absenteeism of the administrative and financial director of the museum, neither is there any doubt that he was at least partially in the right: devoting even a portion of the scant funds available to the institution to reordering the paintings on show, while so many were still relegated to the precarious conditions of the storerooms, seems frankly imprudent. Ariza proposed that during his absence the king appoint someone to act as the painter's superior. As a candidate for the post he recommended José Rafael Fadrique Fernández de Híjar, Duke of Híjar and Count of Salvatierra, who was his nephew and held the position of Corps Chamberlain, that is, the head of the Royal Chamber, and therefore enjoyed the king's utmost confidence. Like the Marquis of Santa Cruz, Híjar was appointed executor of Ferdinand VII's will.

THE DUKE OF HÍJAR (1826–38)

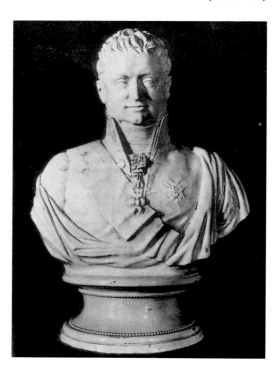

Ariza's proposal was accepted and the new appointment made on May 3, 1826. Notice was given that until the new director made his report, López's project was suspended. The Marquis of Ariza was never to return to his post at the museum and the Duke of Híjar remained at the head of the institution for over a decade. Initially he hardly seemed to be the ideal choice for the position, since he was not noted for his love of things artistic; nevertheless, he soon came to grips with the task and acted with such prudence, dedication, and common sense that he became one of the best directors the museum has ever had. And this is just as well, since it was his lot to govern in the midst of one of the most delicate moments in its history — the threat of the division of the royal patrimony after the death of Ferdinand VII in 1833.

On July 22, 1826, shortly after having taken over the position from his uncle, the Duke of Híjar addressed an order to the head steward of the palace in the following terms:

> Since in the Royal Palaces of Madrid and other Royal Sites, as well as in the Zarzuela, in the Quinta [del Arco] and others of His Majesty's possessions, there is an infinite number of paintings which, by virtue of their singular merit, should be housed in the Royal Painting Museum in order to form the excellent collections of the Spanish, Italian, and Flemish schools, as His Majesty has informed me, it is necessary that Your Honor should pass on the suitable orders to their curators or keepers so that they allow D. Juan Antonio Ribera, the court painter, and D. Luis Eusebi, curator of the aforementioned Royal Museum, engaged by me for this operation, to verify and choose those they consider most worthy of this objective, and arrange for the General Supervisors of the Royal House to provide necessary transport for the two commissioners and for the court sculptor D. José Alvarez, who should accompany them in order to examine the statues and other objects which by virtue of their beauty should be removed from the basements and other places where they are stored, and which I understand are some of the best and most delicate of their kind, although the true merit of such esteemed and appreciated works has yet to be known. . . .[44]

Some two weeks later, on August 8, the requested authorization was granted, and one month later, on September 4, 2,000 *reales* were supplied for the expenses of the journey. On October 7 the three commissioners addressed a report to the Duke of Híjar, in which they informed him that they had fulfilled their mission and were preparing lists of the 247 paintings and sculptures selected so that, once the king's approval had been secured, they might form part of the museum collection. Five days later, on October 12, Luis Eusebi sent the lists (except the one corresponding to the Royal Palace in Madrid) to his superior, adding a note requesting that no more works be sent to the museum until the hanging of paintings in the new halls had been completed. The report having been sent to the palace on November 13, five days later the Duke of Híjar was informed that Ferdinand VII had approved all the transfers except those from the Casita del Príncipe in El Escorial and from the Casita del Labrador in Aranjuez, expressly forbidding that anything be removed from these royal houses.

However, this was not a matter of simply enriching the museum at the expense of the royal sites, but part of what could be described as a genuine policy of purchase,

in which the attempt was made to create a first-class, well-rounded collection. Evidence of this is the incorporation of three works by the sixteenth-century painter Juan Vicente Masip (the father of Juan de Juanes). Two of these, a pair of exquisite canvases representing *The Martyrdom of Saint Agnes* (plate 18) and *The Visitation* (no. 851), were bought in 1826 for 5,000 and 4,000 *reales* respectively from the heirs of the Marquis of Jura-Real; the third, *Coronation of the Virgin* (no. 852) was purchased for 3,000 *reales* in 1828, with Vicente López serving as intermediary in the operation. One year previously the sculptor Valeriano Salvatierra had received no less than 15,000 *reales* (the equivalent of twenty months' salary for the curator Luis Eusebi) in exchange for a canvas depicting *The Holy Trinity* (plate 25) painted by El Greco for the attic of the altarpiece of Santo Domingo el Antiguo. Regarding this purchase, it must be kept in mind that El Greco was not to be truly valued as a painter until six or seven decades later, at the end of the nineteenth century.

The new director of the museum must have played a major role in this policy, as illustrated by the episode of the purchase of the magnificent *Christ Crucified* (no. 1167) by Velázquez, an episode which began with a letter dated August 11, 1826, written by the Duke of Villahermosa, Spanish ambassador in Paris, and addressed to the Duke of Híjar:

> Now that you are in charge of the Museum, news which gives me the utmost satisfaction, I must tell you that on sale here now are excellent Spanish canvases by Velázquez and Murillo, by the former the Christ of San Plácido; the others I believe to be of the Infante Don Luis, since it is the Countess of Chinchón who wants to sell them. I would be greatly pleased if the King were to make this purchase, for it would be a great pity if they did not return to Spain.[45]

Immediately upon receiving this letter, on August 29, 1826, the Duke of Híjar sent word of its contents to Don Francisco Blasco, head steward at the palace. Ferdinand VII was informed on September 11, 1826, and ordered that Villahermosa relate how many paintings were on sale in Paris, their price and subject matter, in order to determine if there were others of similar characteristics and merit in the museum. On October 7, the ambassador sent a report drawn up by the painter Francesco Lacoma, indicating that the paintings by Velázquez were the *Christ Crucified* of San Plácido and a *Shepherd and Fox*; those by Murillo a *Saint Francis at Prayer* and a *Saint Francis*; and by Ribera a *Saint Sebastian*.

On January 5, 1827, Lacoma's report reached Vicente López, who was entrusted with the mission of finding out through the painter in Paris the state of preservation and artistic quality of the works in question. About three weeks later, on January 28, Lacoma sent his second report, providing the details requested by López. On the basis of the report, the latter suggested that only the *Christ Crucified* of San Plácido be purchased.

The issue was shelved for a year and a half, until on July 11, 1828, Ferdinand VII approved the purchase of the Velázquez painting with the proviso that, considering the damage the canvas had suffered, it be bought for a price lower than the 20,000 francs at which it had been valued. Four months later, on November 12, Vicente López was able to inform the Duke of Híjar that the Countess of Chinchón had finally agreed to sell the work for 30,000 *reales*. Despite the fact that the countess died on November 24, negotiations continued until January 31, 1829, when Ferdinand VII accepted the sales conditions. The king sent Vicente López the order of payment on February 10, 1829, but then the countess's heirs put obstacles in the way of finalizing the operation. The solution was provided by the Duke of San Fernando de Quiroga, Don Joaquín José de Melgarejo, the husband of María Luisa de Borbón, elder sister of the deceased countess. The duke, taking advantage of his condition as legatee of whichever piece he desired from among the Countess of Chinchón's possessions, chose the painting in question and offered it to Ferdinand VII as a gift.

The gesture is worthy of praise not only by virtue of its generosity but also, and this distinguishes it even more, because it marked the first donation to be received by the museum.

Híjar had still not exhausted all the available resources to enrich the painting gallery. On November 14, 1826, he requested information from Vicente López regarding the paintings deposited by the king in the San Fernando Academy in 1816 as recognition of the entity's collaboration in the failed attempt to create the Ferdinandine Museum; it should be remembered that on this occasion López had been entrusted by the king with the task of selecting the works to be deposited. The painter, undoubtedly in an attempt to defend the academy's interests, suggested an exchange with paintings not on show in the museum. Híjar, in a document dated February 2, 1827, absolutely refused to accept such a proposal, alleging that

> since [the museum] is going through a period of alterations, it is not easy to determine whether the paintings are necessary or not to complete the collections; and if it transpires that they are not, they could be used as exchange pieces for those of other artists not represented in the Gallery.[46]

The king gave his support to the museum director and on February 19 ordered the academy to send to the gallery the nineteen paintings deposited in 1816.[47] At a meeting of the Academy Board on March 12, it was agreed to respect the royal wishes, although it was pointed out that one of the canvases claimed, Murillo's *Annunciation* (no. 969), had been in the museum since 1819. The observation served as a reminder that the said work had been replaced by one of Ribera's (*Jacob's Ladder*, no. 1117) and by a panel by Juan de Juanes (*The Savior*) and that in the academy there were five more paintings belonging to the royal family, deposited at different times.[48] As a consequence, on May 26, 1827, the Duke of Híjar sent an official letter to the secretary of the academy claiming these seven paintings for the museum. This time the dispatch was carried out promptly, and by June 7 the works were already in the gallery.

In the meantime Luis Eusebi, the ever-watchful curator, on reviewing the list of works contained in the Royal Command of February 19, 1827, recalled that in the so-called Casa de Rebeque, where the court painters had their studio, there was a series of works under the care of Francisco Bayeu that were later sent to a reserve hall in the Fine Arts Academy. In a letter dated March 3 he apprised the chamberlains' secretary, Pedro Grande, of this; Grande in turn informed the king. The Royal Command addressed to the academy, by which the order was given to deliver the paintings to the Duke of Híjar, was sent promptly (March 12) and accompanied by a note written in Ferdinand VII's own hand, warning that "it must be made clear to him [Híjar] that on no account are the indecent canvases in the reserve halls to be put on display to the public."[49]

The king here refers to an exquisite collection of nudes, among which there are masterpieces by Dürer, Titian, and Rubens, which were duly appreciated by some of the kings of Spain, including Charles I, Philip II, and Philip IV. Other Spanish monarchs were more shortsighted in this respect; outstanding among these was Charles III, who, because of his sanctimonious fanaticism, went to the extreme of ordering the works in question to be burned. Fortunately, Anton Raphael Mengs was able to dissuade him in time, and the Bohemian painter would be worthy of immortality for this alone. However, the king could not keep these works out of his mind, which were sinful in his eyes, and just before he died he entrusted his son Charles IV with the mission of destroying them. On this occasion also we have to thank José Joaquín de Silva Bazán, the Marquis of Santa Cruz, who was skillful enough to persuade his sovereign to deposit them in the Academy of San Fernando, in reserve halls, to which only people specially authorized had access. The first group of censored paintings reached the academy in 1792, and the second on January 4,

1796. On April 5, 1827, they were sent, thirty-five in all, to the Royal Painting Museum where, despite Ferdinand VII's categorical rejection of the idea, some were put on display in 1828. The remainder had to wait for the death of the king in order to come out of hiding.

Despite being so intensely involved in increasing the museum's collections, the Duke of Híjar did not wash his hands of the need to carry out the conditioning of the new halls (the southern half of the main gallery and the octagonal hall at its end, in the northern pavilion). On December 27, 1826, he presented his own project, thoroughly overriding the one conceived by Vicente López in April of that year. Híjar considered it more fitting to keep Spanish painting in the halls around the rotunda, in the northern wing of the building, and proceed with the installation of the Italian school in the central gallery. French and German painting, being scantily represented in the museum, would fit into the octagonal hall in the northern pavilion. Finally, the Flemish and Dutch works would occupy the two large halls in this very pavilion, both the same size as those housing the Spanish school, at the other end of the palace. The plan was approved by Ferdinand VII on January 5, 1827.

We have seen how Híjar not only increased the museum's funds but also devoted himself to controlling the works in storage. Throughout the year 1827 he carried out a systematic examination of the four thousand paintings contained in the deposits, a task for which he engaged personnel to clean, examine, and select the works with a view to displaying them in the new installations.

On January 3, 1828, the director of the museum informed the chief steward that a new catalogue was being printed and that as soon as it was ready the galleries could once again be opened to the public. Six days later Híjar received a communication informing him of the king's consent. On March 12 the *corregidor* Don Tadeo Ignacio Gil received the text to be published in the *Gazette*, which appeared in the March 17 issue:

> Having been concluded in the Royal Painting Museum the placing of the paintings corresponding to the Spanish, Italian, French, and German schools, our Lord the King has graced us with his royal permission to open the establishment to the public every week on Wednesdays and Saturdays: from May 1 until the end of August at eight in the morning, and from September 1 until the end of April at nine, and all year round until two in the afternoon. The plausible motive for this being that the 19th of this month being the day of Our Lady the Queen, on this same day the painting gallery will be opened to the public without interruption until Wednesday the 26th, at the times stipulated, and henceforth on the aforementioned days. Access will be allowed all people irrespective of class, although entry will be forbidden to those who are badly dressed or barefooted. Those on duty at the entrance will refuse admittance to anyone possessing poles or sticks, which will be confiscated, to be returned when the interested parties leave, exception being made for those who by virtue of their condition or station are required to carry walking sticks. The catalogue that has newly been prepared to explain the paintings will be on sale on the Royal Museum premises.[50]

Of similar interest, for the information it provides regarding the organization of the museum, is the text written by Luis Eusebi to introduce the catalogue, or *Noticia de los cuadros que se hallan colocados en la Galería del Museo del Rey Nuestro Señor, sito en el Prado de esta Corte*, published in Madrid in 1828.

FOREWORD

> It having come to the notice of Our Lord the King that the restoration of the precious paintings in his Royal Museum requires considerable time in order to be brought to conclusion, his magnanimous heart, wishing only the well-being and enlightenment of his beloved subjects and desirous that the public should as soon as possible be able to enjoy the admirable works bequeathed us by the most eminent masters of all the schools of painting, so that art lovers may form their opinions and that young artists devoted to such a noble art should have an eternal font of riches from which to drink, without the need to go in search of them in foreign countries, has commanded that all

the aforementioned canvases belonging to the Spanish, Italian, French, and German schools be displayed in whatever state they may be, without interrupting diligent work on their restoration, so necessary for the preservation of these precious monuments, and that the same be done with those belonging to the Flemish and Dutch schools, as soon as their designated venue is prepared to receive them, His Majesty (whom God preserve) also having decided the days upon which the public will be allowed to visit the Museum.

Permission to enter the Museum and contemplate and study this magnificent and precious collection is granted to Spaniards and foreigners alike and is not reserved for the potentates with time on their hands to admire talents, protect them and promote their advances, or for professors able to appreciate these paintings and delight in their sublime merits. Our benign Sovereign, whom God protect, being convinced that nature does not share out perspicacity and talent according to the situation and opulence of members of society, wishes that any individual of the kingdom, or the most humble citizen of the capital, be given an equal opportunity to excite his capacity to receive the impressions of beauty. The Most Honorable Director of the Museum grants permission to copy the precious works of art (with all due precautions) at the times stipulated for this activity.

All the paintings in the Museum are the property of Our Lord the King, being part of those that adorned the Palaces and Royal Houses in Madrid, Aranjuez, San Ildefonso, Pardo, Zarzuela, Quinta, etc.

The Museum of Our Lord the King is currently divided into four parts. In the two large halls to the right and left of the magnificent foyer are displayed paintings from the old Spanish school. The first section at the entrance to the main central Gallery provisionally contains works by members of the Spanish school still living or who have recently died. The second section of the main Gallery contains paintings from the different Italian schools and the third and last section of the same those from the French and German schools.

To some people it might seem unusual, since it is not common practice, that the French and German schools be together in the same hall; but it has been necessary to join them since the Museum contains few works from these two nations.

The Flemish and Dutch schools will occupy, once they are ready for the purpose, the two large halls looking onto the Botanical Gardens, companions of the other two in which paintings from the old Spanish school are housed.

The letters C.R. placed at the end of several articles indicate those paintings that are engraved and whose prints can be purchased at the Calcografía Real [Royal Printers'].

At the entrance there will be an employee to whom with every confidence can be given both walking sticks and umbrellas, and a voucher will be given so that they may be recovered upon leaving. From the same individual can be purchased the catalogue of the paintings in the Gallery in Spanish, French, and Italian, as well as the essay on the different painting schools by Don Luis Eusebi.

Visiting days are Wednesdays and Saturdays. During the winter season the Museum will be opened at nine in the morning, and during the summer at eight, remaining open until two o'clock in the afternoon all year round.

Travelers will be allowed admittance to the Museum on the remaining days of the week, provided they present a passport revised by the Superior Authority or a permission of temporary residence granted by the same Authority. Those artists with permits may enter for study purposes on the same days, except holidays.

Without a command from Our Lord the King communicated to the Rt. Hon. Director of the Museum, under no circumstances and under no pretext will it be allowed to take the paintings down from where they are hung.

On rainy days the public will not be admitted into the Museum.

Of the paintings in the Gallery removed to the restoration room and of those being copied for lithography, the frames shall remain as well as a note indicating this circumstance.

Under the charge of D. José Madrazo, court painter to Our Lord the King, lithographic copies of the paintings in the Gallery are being made: several portfolios of these are already on sale in the Establishment in Calle de Alcalá.

NOTE. The burning desire to open the Museum to the public as soon as possible, and the delicate state of health of the Editor, have been the reasons why the explanation of the paintings has been hurriedly prepared in Spanish, Italian, and French by D. Luis Eusebi, honorary Court Painter and Curator of the Painting Museum of Our Lord the King, adopting the method of transcribing faithfully the names of the Painters from

abroad and their countries of origin, with the same spelling used by Authors in their respective nations. This has seemed more fitting than adapting them to the Spanish, Italian, and French languages, since this would carry with it the obvious risk of distorting them to the point where they become unrecognizable, especially in the case of Flemish and Dutch artists, since very few are aware of the way to pronounce them, and finally so that the signatures and monograms the painters themselves put on their works may be recognized, as this is of great interest to discerning art lovers.

Don Luis Eusebi, Honorary Court Painter and Curator of the Painting Museum of Our Lord the King, resides in this same Establishment.

The number of paintings on display was increased by 245, the total number thus reaching 757.[51] Of these, 321 belonged to the Spanish school, 339 to the Italian, and the rest to the combined sector containing works by French and German artists. A major innovation was the extension of the visiting times to the museum to twice a week, Wednesdays and Saturdays. Along these same lines of consideration for the public can be interpreted the opportunity granted nonresidents in Madrid to gain access to the museum during the rest of the week — that is, on the days when authorized artists worked there — the only condition being that they provide evidence of their situation as "travelers" by presenting a passport or permit for temporary residence in the city. Similarly, in order to contribute to a greater knowledge and diffusion of the museum's treasures, it was now allowed, with prior permission, to copy the works or to purchase the prints produced at the royal printers'.

As a defense against potential criticisms, Eusebi justified some of the decisions he made regarding the new phase in the life of the museum. Acknowledging that the vast majority of the paintings needed restoring, he explained that given the impossibility of carrying out the work in a relatively short period of time, he preferred to exhibit them in their present state rather than postpone the opening date. And aware that presenting works from different national schools together was somewhat frowned upon, he offered his rationale for displaying French and German paintings in the same hall.

On August 19, 1828, Ferdinand VII visited the museum. He came accompanied by just one man at the early hour of six-thirty in the morning and was received at the entrance by the director, the Duke of Híjar, and an entourage including Vicente López; the architect Miguel Aguado de la Sierra, in charge of the restoration works; and the court painters Juan Antonio Ribera and José Madrazo. The faithful and dedicated curator Luis Eusebi was also present, despite his delicate state of health as a result of gallstones. The king first inspected the halls where the Spanish, Italian, French, and German schools were represented. He then went to the storerooms where the Flemish and Dutch works were kept awaiting the work to be completed on the halls that were to accommodate them. Next he visited the restoration room and the lithographic workshop, this latter directed by José Madrazo. The king did not overlook the reserve hall where the nude paintings from the academy were kept, expressing his pleasure at the beauties contained therein and their good state of preservation. Finally he inspected the sculpture gallery, where Valeriano Salvatierra was busy restoring the pieces. The visit ended at a quarter to nine.[52]

By the end of 1828 the restoration of the building would have been far advanced if not already completed. On November 4 the Duke of Híjar wrote to Agustín Ceán Bermúdez requesting from him a list of six painters, six sculptors, and four architects whose portraits should occupy the decorative medallions on the facade of the museum building. One month later, after several discussions concerning the matter, it was finally decided that there would be six painters (Murillo, Velázquez, Ribera, Juan de Juanes, Claudio Coello, and Zurbarán), five sculptors (Berruguete, Cano, Becerra, Hernández, and Álvarez) and five architects (Toledo, Machuca, Herrera, Pedro Pérez, and Ventura Rodríguez).

The Duke of Híjar also had to make use of his talents as a diplomat in order to resolve the dispute that arose around 1827–28 between Ramón Castilla and José

Madrazo in relation to the administration of the museum's lithographic workshop. Castilla complained of his partner's slovenliness; furthermore, the lithographers also complained about him, saying that while he was undoubtedly a good painter, he understood nothing of lithography. For his part, Madrazo refused to renounce his privileges. Híjar reported to the king, stating that while the two partners were incompatible, if Castilla left the workshop would come to a sorry end through Madrazo's incompetence, and if Madrazo left his reputation would suffer irreparable damage. As a result, he proposed that while the concession lasted a director be appointed who could deal with both. Ferdinand VII accepted the suggestion and, by a royal decree issued on March 8, 1829, he named the Duke of Híjar himself as director of the lithographic workshop.

Meanwhile Luis Eusebi's condition worsened. On hearing that an apparatus had been invented in Paris that triturated gallstones, he immediately requested permission for and traveling expenses toward a journey to the French capital where he would submit to treatment. He set off with his wife and son at the end of November 1828. It took them forty-two days to make the trip from Madrid to Bayonne where, on January 8, 1829, the 6,000 *reales* granted him having been spent, Eusebi once again asked for financial aid. On January 25 he received a further 8,000 *reales* and, so we assume, continued on his way. He would not have reached Paris until at least March, and in the meantime his illness gradually worsened and became critical. He died on August 16, 1829. Thus the museum lost one of its most fervent supporters.

On May 17, 1829, María Josefa Amalia of Saxony, Ferdinand VII's third wife, also died. As she had failed to provide the crown with its anxiously hoped-for heir, it should be no surprise that the king rapidly remarried, this time with María Cristina de Borbón, daughter of King Francis I of the Two Sicilies. The young princess (only twenty-three years old, compared to her ailing future husband's forty-five) reached Aranjuez on December 18, 1829, and the wedding took place three days later in Madrid. Upon learning that the queen was pregnant, in February 1830 Ferdinand VII signed the *Pragmática Sanción*, a resolution that had been taken by the Spanish *Cortes* in 1789 (but which Charles IV never published) by which no distinction was made between the sexes when it came to succeeding to the throne, and the Salic law was thus repealed. Logically enough, the royal decision caused indignation on the part of the supporters of the Infante Charles as heir to the throne. Eight months later, on October 10, 1830, the future Queen Isabella II was born.

Activity continued as normal in the museum: Híjar persevered in his determination to increase the collections and continued to request the transfer of works from the royal sites. Fruit of such determination was the arrival in September and October 1829 of several canvases from Aranjuez and San Ildefonso de la Granja. The acquisition of new works continued, and around this time the museum was graced with two *Apostles* (nos. 2202 and 2203) by Anton Raphael Mengs, both purchased from María Gueci in 1828; *The Assumption of the Magdalene* (plate 66) by José Antolínez, for which 2,500 pesetas were paid on June 15, 1829; and *The Mystical Nuptials of Saint Catherine* (plate 67) by Mateo Cerezo (although at the time attributed to Escalante), which was sold by the heirs of the Valencian merchant José Antonio Ruiz on June 15, 1829, for 12,000 *reales*.

There was also a need for sculptures to fill the anticipated statue hall. Back on July 5, 1814, on addressing the San Fernando academics during the solemn session referred to earlier, the king himself offered the museum, which at the time he intended to set up with the help of the academy, "the paintings, statues, busts, bas-reliefs, and other pieces of the noble arts that are not necessary for the decoration of the Royal Palaces."

I have also referred to the disposition by the Duke of Híjar, dated July 22, 1826, shortly after his appointment as director of the Royal Museum, in which he informed

the head steward of the imminent arrival of a commission composed of the painters Luis Eusebi and Juan Antonio Ribera and the sculptor José Álvarez, whose mission was to select paintings, statues, and other objects from royal sites to be acquired for the museum. It is in this context that one must consider the museum's request for half a dozen sculptures which, according to the inventories made on the death of Charles III, had been deposited by the monarch in the Fine Arts Academy of San Fernando. Despite protests from the scholarly institution, the pieces in question were collected on December 28, 1829. These consisted of two works by Pompeo Leoni (the busts of *Charles V* and of *The Empress*), a further two by Melchor Peres (the busts of the *Count-Duke of Olivares* and of *Don John of Austria*) and two bust portraits of *Charles V* and *Philip II*.

It was also at this time, after the first decade of the existence of the establishment, that the museum began to become recognized internationally. On July 13, 1829, the Soottish painter Sir David Wilkie published words of praise for it in the *Correo literario y mercantil*. Two years later (1831), the opinions of Prosper Merimée were published under the title of ''Le Musée de Madrid,'' in the Paris journal *L'Artiste*, in which he described the Prado Museum as one of the richest in Europe, superior to the Louvre not in the number of works but in their quality, since in the Spanish museum there were far fewer mediocre paintings than in the French one. In 1834 Louis Viardot, using the same title coined by Merimée, wrote about the Prado Museum in *La Revue Republicaine*.

Little by little the original project was being realized. On April 3, 1830, the new halls for the Flemish and Dutch schools were at last opened in the southern wing of the palace. Occupying part of the building's ground floor, the sculpture gallery was set up, with a selection of the works so far contained in the museum. Interest was not restricted solely to the pieces in the museum; there was also concern to ensure the comfort of the public during their visits. To this end, on May 27, 1830, eight mahogany benches that had been in the ''so-called *Cortes* of between 1820 and 23'' reached the museum.

After the death of Luis Eusebi, the museum director engaged José Musso y Valiente, a distinguished man of letters with a special interest in questions related to the plastic arts, to draw up the new catalogue. He commented upon this task in a letter to José Madrazo, dated November 1, 1830:

> I have concluded and brought entirely up to date the catalogues for the Flemish and Dutch schools as well as that for the reserve hall, which is all I can do without the notes for which I have been waiting for some time. Next post I shall send them to my brother with instructions that he deliver them to you so that you might do me the favor of correcting them and making all necessary amendments. Having done this, please be so good as to return them to me so that I might give them to the Duke of Híjar.[53]

In the summer of 1832 Ferdinand VII suffered an attack of paralysis. In the following weeks his condition worsened, so that by September there were fears for his life. The limitations imposed upon him by his illness and the intrigues of his brother, Charles, regarding the succession, sunk the king into a deep depression. Ferdinand's mental and physical health deteriorated to such an extent that he empowered his wife, María Cristina, to act on his behalf in matters of state.

Despite his precarious state of health the king continued to be interested in the painting museum. In 1832 he authorized the purchase, for 10,000 *reales*, of one of the most representative paintings of the post-Velázquez Madrid school, *The Triumph of Saint Hermenegildo* (plate 63) by Francisco de Herrera ''the Younger.'' On May 3, 1833, the Duke of Híjar informed the head palace steward, Francisco Blanco, that the king had requested him to purchase two paintings by José de Ribera, the property of the Marquis of Alcántara, namely an *Immaculate Virgin* (no. 1070) and a *Saint Augustine at Prayer* (no. 1094). In order to decide upon the purchase and destination of the canvases, Vicente López and Juan Antonio Ribera were consulted. Guided

by their "science and conscience," they considered the works as worthy to form part of the museum's collections, and valued them at 12,000 and 6,000 *reales* respectively, which was the price eventually paid for them.[54]

Queen María Cristina could have had little hope of her husband's recovery when on June 20 she called the *Cortes* together so that fealty would be sworn to Princess Isabella as the legitimate heir to the throne. Three months later, on September 29, 1833, Ferdinand VII died of fulminant apoplexy.

Ferdinand VII was a monarch who never aroused much sympathy; quite the contrary, as he himself had predicted, his death was lamented only by actors and players on the closing of the theaters. Historians have been unanimous in condemning him, heaping upon him a wealth of negative epithets. Less than thirty years after the monarch's death, in a work dedicated to his daughter, Queen Isabella II, Juan Rico y Amat described him as "vulgar in his gaze, miserable in his ideas, violent in his acts, affected more by grievances against him than offenses against the monarchy."[55] Nevertheless, it would be thoroughly unjust not to recognize him as truly responsible for the existence of the Prado Museum. His interest in the project remained constant throughout his life, as evidenced by his punctual monthly contribution of 24,000 *reales* from around 1818 until his death. In other words, for some sixteen years he gave an annual amount of 288,000 *reales*, coming to an overall total of more than 4.5 million *reales*, not counting extraordinary contributions. For example, on April 9, 1820, the monarch authorized the payment of an additional 20,000 *reales* for the restoration of Italian paintings; before the end of the month this sum had been spent and, on April 26, the king granted a further 20,000 *reales* for the same purpose. From 1821 until the death of Ferdinand VII, Vicente López presented accounts of around 20,000 *reales* annually for the restoration of paintings in the museum.[56] Pascual Madoz provides information that during those sixteen years Ferdinand VII assigned a total of some 7 million *reales* to the Royal Painting Museum.[57]

ISABELLA II (1833–68)

The Regency of María Cristina (1833–40)

The death of the King Ferdinand VII marked a period of uncertainty for the future of the museum. The king's will stipulated that with the exception of the jewels and precious stones listed in an inventory apart, signed by the king himself, all movable objects were to be free to be disposed of by his heirs, the Princess Isabella and her sister, the Infanta María Luisa Fernanda, and by their mother, Queen María Cristina. Indeed, something of this nature would have been expected, taking into account that in the Foreword preceding the 1828 catalogue of the Royal Painting Museum, it was expressly stated that "All the paintings in the Museum are the property of Our Lord the King."

With his testament, Ferdinand VII followed the same line as his grandfather, Charles III, and exempted himself from the criteria adopted by Philip IV and Charles II, who declared all paintings and other *objets d'art* inalienable property linked to the patrimony of the crown. As a result, the testamentary executor, Salvador Enrique de Calvet, invested with the wide powers granted him by the queen regent María Cristina, ordered an inventory and evaluation to be made of the Royal Painting Museum alongside the other royal palaces and sites.

By March 5, 1834, work had already begun on this; on that day Híjar requested from the head steward that "the sum of eight thousand *reales* be granted as aid to the curator [Carlos] Mariani to cover inevitable expenses, his being obliged to meet urgent costs in the preparation of the inventory ordered by Her Majesty."[58] This

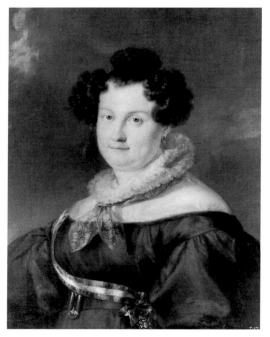

The queen regent María Cristina

news naturally caused deep concern among those people aware of the importance of the collection of paintings contained in the museum.

On April 6, 1834, José Musso y Valiente wrote to José Madrazo in the following terms:

> an inevitable result of the inventory you are preparing will be the removal of works from the Museum. What unease this causes me! How important it is to national glory that the Museum remain intact! I hope you will inform me of the final destiny of the precious collections and gems it contains.[59]

Some three months were needed to prepare the inventory for and evaluate all the paintings, sculptures, tables, vases and other objects in the Prado Museum. On May 28, 1834, the court painters Vicente López, José Madrazo, Bartolomé Montalbo, and Juan Gálvez, the sculptors Esteban de Agreda and José Elías, and other experts delivered the document, which was summarized as follows:

	Value of the paintings	Value of the frames
Spanish school	9,083,300 rs.	107,835 rs.
Italian, French, and German schools.	12,186,350 »	114,406 »
Flemish and Dutch schools.	5,262,200 »	107,406 »
H.M. study and reserve hall	2,430,200 »	64,296 »
In the storerooms.	1,523,941 »	103,580 »
	30,486,631 rs.	497,677 rs.

Value of the paintings with their frames	30,984,308 rs.
Sculptures (statues and busts).	6,531,075 »
Mosaic tables and hard stones, vases, porphyry, and Etruscans.	1,054,670 »
Bronze (lions, table legs, etc.).	63,000 »
Diverse tools.	34,448 »
Joinery, carpentry, glass, locksmithing, tapestries, and carpets.	173,738 »
Three paintings and six plates.	32,040 »
TOTAL	38,873,279 rs.[60]

Musso y Valiente learned directly from the Duke of Híjar of the completion of the inventories and of the valuation of the museum, which served only to increase his unease. On September 28 he wrote to his friend José Madrazo, expressing his fervent desire to find a solution toward maintaining the collection intact:

> Híjar has written to say that the paintings in the museum have been evaluated for the division. Since this must be carried out, could a way not be found for all to be assigned to the queen, that is, to Isabella II, so that we shall not witness the sorrowful sight of the breaking up of such a precious collection?[61]

Fortunately, common sense reigned among those with capacity for decision-making as regards the future of the museum. Once again it is José Musso y Valiente who, through his correspondence with José Madrazo, on October 15, 1834, informs us of this, though without going into details: "You cannot imagine how relieved I am to hear that the paintings from the Museum are to kept together, since otherwise the Museum would have been utterly destroyed, something that God would never forgive."[62]

The solution adopted was simply to assign to Isabella II all the works contained in the museum and to pay an indemnity to her sister, María Luisa Fernanda, for the part that would have corresponded to her. It remains unknown exactly who was responsible for such a wise decision (although perhaps it was not so wise as far as the personal interests of Isabella II were concerned). Be that as it may, it would be thoroughly logical to suppose that both the Marquis of Santa Cruz, who had been the first director of the museum, and the Duke of Híjar, who held the post at the

time, both having been executors of Ferdinand VII's will, would have had much to do with it, thus once again deserving our gratitude.

The execution of the king's will and the ensuing division of the royal patrimony was approved on November 21, 1834, by the Supreme Patrimonial Council. Nevertheless, it was agreed to suspend its execution and approval by the interested parties until Isabella II came of age.

In the meantime, the director of the museum continued to strive to improve the condition of the building and the paintings, sculptures, and other *objets d'art* for which he was responsible. On June 18, 1835, the Duke of Híjar sent the head palace steward a report concerning the work he considered necessary to carry out in the museum in order to ensure the safekeeping of the collections. Prominent in the document was an estimate for repairs, including the cost for replacing the lead on the roof, which alone came to 34,050 *reales*. Leandro Martínez rounded off the total budget figure at 59,860 *reales*, and it was approved on October 31, 1835. Other items included the furbishing of new halls and well-conditioned storerooms — "for stacked-up paintings may suffer damage through damp or mice, so they should be at least provisionally hung" and, the duke added, with considerable common sense, that it was necessary to hang them, "since only in this way are they safe and able to be preserved, there being almost one thousand in total."[63]

The head steward's reply reached the Duke of Híjar eight days later (June 26), notifying him that he had passed the report on to the queen governess, who had given orders that "propositions be put forward in order to realize the said works."[64]

Despite this exchange, however, on November 14, 1835, the problems had still not been solved. The director of the museum reiterated his warnings about the serious dangers arising from the existence of "a great plague of rats in the building, which might cause damage to the paintings, principally those stacked up in the storerooms."[65] In order to combat the plague he requested that two dozen traps be supplied. Furthermore, he suggested that it might be expedient to remedy the lack of glass in windows and on balconies.

Still not everyone was convinced of the importance of suitably refurbishing the Royal Painting Museum. In 1835, when the question of the museum budget was raised at the Plenary Session of the *Cortes*, several members considered it excessive in view of the country's precarious economic situation. Nevertheless, the committee entrusted with the study of the subject declared that they did not consider it possible to reduce the sum of money destined to maintain

> the building that adorns the capital and a Museum so rich in paintings that if any in Europe exceed it in the size of their collections, none so in the selection of paintings, since in it shine not only the best of the three most celebrated schools when their countries were subject to the Spanish crown, but also a rich collection of statues that ennoble its halls.[66]

These were difficult times. Besides the first Carlist War (October 4, 1833–August 31, 1839), there were fierce confrontations between liberals, progressives, anticlericals, moderates, absolutists, and so forth, which contributed greatly to a worsening of the country's economic situation. In this rarefied atmosphere decrees were issued to suppress and free from mortmain all religious orders, published on the earnest solicitation of Juan Alvarez Mendizábal, from the Ministry of Finance, between 1835 (July 25, September 3, and October 11) and 1836 (February 19 and March 8), in the attempt to replenish the state coffers. However, the repercussions that would ensue from such measures were not correctly foreseen, and besides failing miserably to achieve their main economic objective, they also introduced a factor of serious instability in the preservation of the country's artistic heritage.

The sale of monasteries and convents, including the contents of Cenobia and their corresponding churches, placed a considerable number of works of art in

circulation. Many private collectors took advantage of this situation. King Louis-Philippe of France, through his agent, Baron Taylor, acquired an extraordinary series of Spanish paintings of first-class quality. One of the gems in this collection was the set of six canvases by Zurbarán from the altarpiece in the Carthusian monastery, Jerez. José Madrazo and his son Federico assisted in its sale and export.[67]

By contrast, others attempted to recover such works in order to establish museums at different points on the Peninsula. José Musso y Valiente, for example, writes of this from Seville[68] in a letter dated August 12, 1835, and addressed, paradoxically enough, to José Madrazo: "Here I attempt to set up a museum with what I have managed to salvage from the suppressed monasteries and convents; I have already requested the Governor not to let even one painting leave the province. . . . If I had faculties and means at my disposal . . . no Nation could defeat me; patience."[69]

In Madrid there was a similar initiative, which culminated in 1836 in the creation of the Museo Nacional de la Trinidad, containing paintings from the suppressed monasteries and convents in the region. This entity had a checkered history throughout three and a half decades, until on March 22, 1872, it became part of the Prado Museum.

The radical spirit of reform with which Mendizábal attempted to cure the country's ailing economic situation also had its repercussions on the Royal House and, as a result, on the Painting and Sculpture Museum.[70] A general administrative restructuring of the Royal House was being planned, oriented toward the control of all expenses by the *Intendencia General de la Real Casa y Patrimonio*, a kind of Palace Finance Ministry. The first manifestation in this sense was made public on June 2, 1836, with the creation of a Board of Museum Directors that reduced the powers of the director of the establishment, although he had been appointed president of this new governing body. The secretary was the palace steward and the receiver the chief accountant of the Royal House; the board was completed by the first and second court painters.

Such administrative reorganization was no obstacle to the continued attempts to extend the exhibition areas for the works still stacked in the storerooms. On March 25, 1837, the queen regent gave her approval to the project by Martín López Aguado for the furbishing of a second sculpture hall. Toward the end of the year, on November 27, the president of the Board of Museum Directors, the Duke of Híjar, sent to the head steward the accounts corresponding to the 30,786 *reales* granted to the museum by Royal Command dated July 12, in order for the work to continue both on the exterior of the building and in the preparation of new halls. Of the aforementioned amount 27,421 *reales* had been spent to date. In the same document the president of the board requested a further budget contribution for the same purpose.[71]

The Board of Museum Directors was, however, short-lived. Two years after its constitution, on August 12, 1838, the Duke of Híjar, corps chamberlain and director of the Royal Painting Museum, received the following official communication signed by Sr. Piernas, General Administrator of the Royal House and Patrimony:

> The Museum of Painting and Sculpture, before August 12 the responsibility of the Corps Chamberlain, will henceforth come under the jurisdiction of the General Administrator of the Royal House and Patrimony and will be run under the title of Director by that person whom Her Majesty sees fit to appoint and who will respond directly to the Administrator. The Board of Museum Directors is henceforth dissolved, your honor's hard work and diligence being thoroughly recognized and approved.[72]

Híjar's reply was immediate:

> I acknowledge Her Majesty's decision to relieve me from my post and, in order to comply with her sovereign decision, expect your honor to appoint the person who on behalf of the General Administrator will become rigorously responsible for the inventory of artistic effects contained in the Establishment.[73]

In a letter dated August 18, 1838, José Madrazo allows us to glimpse the scope of the restructuring undertaken in the heart of the Royal House. The strong man in the new situation was Piernas, who, as well as general administrator, also took over the post of head palace steward. As we can see, he enjoyed the queen regent's full confidence:

> These days there have been notable events at the Palace as regards posts. I assume you already know Calvet . . . is no longer Secretary to the Head Steward Recently Piernas has been appointed Secretary, Administrator of the Royal House, in order to deal with all palace issues with Her Majesty; in name only, as an honorary position, the Marquis of Santa Cruz has been named Head Steward, but it is said that he has refused the post in dejection. As Queen's Equerry, the Duke of Abrantes, under the same terms, and the Duke of Híjar, Corps Chamberlain, again as an honorary title, his Secretariat having been removed. The Board of Directors of the Royal Museum has similarly been dissolved, and the Duke removed from his position as President. Henceforth the Museum comes under the jurisdiction of the Administrator, and Her Majesty will appoint a Director, immediately answerable to the former.[74]

Once again it is José Madrazo who, on August 24, 1838, informs us through his correspondence of the state of mind of the recently dismissed director:

> The Duke of Híjar has been greatly affected by his dismissal. As you well know, the Museum was recently governed by a Board of directors, of which the Duke was Director, a title which satisfied him, and this consideration I think should be enough to keep him in the post. It is said that he did not agree with the new forms of administration in the Palace, since in a way all depends on the *Intendente General* of the Royal House.[75]

JOSÉ MADRAZO (1838–57)

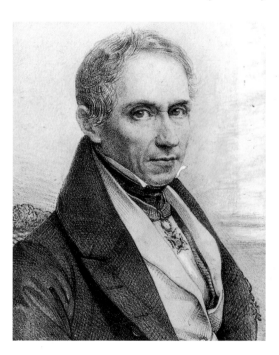

It was José Madrazo who, on August 20, 1838, was named by the queen regent María Cristina successor to the Duke of Híjar as director of the Painting and Sculpture Museum. This appointment marked the beginning of a tradition that would continue, with very few interruptions, throughout the whole of the next century: that of placing a painter in charge of the museum.

Before the official announcement, rumors abounded in Madrid about Madrazo's upcoming appointment. Nevertheless, the painter did not seem to be very enthusiastic about the idea (or at least did not wish to appear so), as he comments in a letter written a few days before his appointment:

> I assure you I would be most vexed about it, just when I am as full of enthusiasm as when I was a boy, and I would not change places with the greatest potentate in the world when I have my brushes in my hand. Moreover, I hate having to fight with underlings, for they are lazy and when one forces them to do their duty they come to hate their superiors. . . . If the post involved artistic matters only (different now from the activities of the previous Directors: Vicente López, Artistic Director only; Híjar, with the facility of obtaining funds from the privy purse, etc.) I would be most flattered, but with all the obligations and responsibilities the post entails, I should hate to be appointed.[76]

However, four days after the appointment, Madrazo proved to have a very clear, well thought-out idea of what his line of action would be:

> I confess to you once more that I find the appointment a somewhat irksome one, not because I do not consider myself capable of carrying it out to everyone's satisfaction, but because it takes time away from my painting just at the moment when I have taken up my brushes again with such enthusiasm that I think of nothing else day and night; but this I shall have to abandon for some time and occupy myself with furbishing the new painting halls and with the general catalogue, above all this latter, which will bring back to mind my late and lamented friend José Musso y Valiente, who worked so enthusiastically, promptly, and tastefully on it. Whom, then, can I count upon for help in a country in which there are so few of the good taste and knowledge of Musso?[77]

Furthermore, he launched himself fully and with great dynamism into his new responsibilities. Thus, among his first official communications was one addressed to the General Administrator of the Royal House and Patrimony, dated September 13, 1838:

In order to carry out the work necessary for the furbishing of the new halls to be opened in the Royal Museum, and since this cannot be done until the paintings hanging there have been removed and an inventory of them prepared . . . I beseech Your Honor to issue an Order telling the scribes employed in making copies of the original inventory, in the keeping of the Museum Curator, to do so as soon as possible, for otherwise Her Majesty's wishes will be difficult to satisfy.[78]

To judge from José Madrazo's correspondence, Ferdinand VII's widow had a special interest in the project for the museum and was a staunch supporter of the action its director proposed. Madrazo thus relates one of María Cristina's visits:

Yesterday, at three o'clock in the afternoon, Her Majesty the Queen Regent deigned to visit the Royal Museum [where she remained] until seven o'clock in the evening. Without sitting down to rest even for a minute, she inspected all the halls in which the paintings from the different schools hang, the storerooms and the restoration room, and those halls to be furbished for paintings; in brief, she visited each and every one of the rooms in the building, in order to be well informed as to what possibilities there are to ensure that all the paintings be displayed to their best advantage and in the best light possible. . . . This morning . . . Her Majesty . . . repeated to me her intention of stimulating the Museum to the utmost, being persuaded of the luster the increase and preservation of the precious store of paintings it possesses will give to her most excellent daughter's Throne . . . and if, as I have suggested to Her Majesty, the finest canvases from El Escorial are placed there, this reinforcement will prodigiously increase its interest with so many classical works, purging thus its galleries so that nothing mediocre remains there, although this can practically be done with what was lying abandoned in Museum storerooms and in the Palace of La Granja. . . . And if the grave circumstances in which the Nation finds itself do not block the way, and Her Majesty the Queen Regent carries out her promise to cover the essential costs, then it can be stated without the slightest immodesty that the Royal Museum of Madrid will be the first in Europe in terms of exquisite paintings, although we still lack canvases by a few painters of great merit.[79]

Madrazo was also concerned with the administrative structure of the institution in his charge and, despite the fact that regulations already existed governing the functions and responsibilities of the personnel employed in the museum, regulations the painter considered ''well thought-out,'' he nevertheless contacted the directors of the Musée du Louvre requesting a copy of their house rules, ''in case among its articles there are some that we might adopt, which would not be surprising since your Museum is older and you have greater experience.''[80]

Similarly, Madrazo had studied the personnel needs of the museum in order to ensure that it would function properly. On November 18 he submitted a proposal for personnel, which consisted of a director (with his corresponding salary as court painter), a secretary-administrator (with a salary of 6,600 *reales*), two restorers (12,000 and 10,000 *reales*), three assistant restorers (6,000, 5,000, and 5,000 *reales*) a reliner (3,650 *reales*), an assistant (2,920 *reales*), a keeper for the sculpture gallery (10,000 *reales*), a curator (8,000 *reales*), eleven porters (3,650 *reales* each), and three watchmen (2,920 *reales* each). The salaries, not including Madrazo's own, added up to a total of 118,080 *reales* per year. For the moment his proposal was rejected.

Even so, José Madrazo was quick to put his projects into practice. From a letter dated October 20, 1838, we learn that he had already begun to hang paintings in the rotunda and that his intention was to hang in corridors and up the stairs all the canvases still in the storerooms so that they could at least be seen and in order to ensure their preservation (in this he agreed with the Duke of Híjar). Also worthy of note is his decision that the so-called ''reserve hall,'' where the paintings were kept that had at one time been considered ''indecent,'' should cease to exist as such:

I am at present most busy with the hanging of paintings in the Royal Museum. Yesterday I placed eight large canvases in the rotunda to see how they looked and, satisfied with the result, I have decided that on Monday they shall be hung there permanently. . . .

Next I shall hang in the corridors that lead to the Flemish and Dutch schools other, second-rate, paintings, as well as in the lower corridors, where the reserve hall is, which shall cease to be so, and in those leading to the restoration room. I intend to hang paintings even in the wall panels lining the main staircase, for they will create an excellent effect and form a most sumptuous group, the Museum being somewhat bare with a portion of walls uncovered with room for this objective. As there are paintings enough for all, it would be a pity not to enrich these walls with them, removing them from the storerooms, where they are stacked up hidden from view, their merits ignored, and in danger of deteriorating. The mediocre canvases and those of least quality will be hung in a more dignified manner in these storerooms, since although they are not worthy to be shown in the galleries and corridors, they are nevertheless interesting either for the history of art or for the study of costume.[81]

Luckily for José Madrazo, Queen María Cristina gave her full support to his decisions, for which he congratulated himself on November 26, 1838: "So far good fortune has decreed that Her Majesty has denied me nothing of which I have had the honor to suggest concerning the Museum."[82] Royal backing was also fundamental to the success of two ambitious projects begun by Madrazo with a view to enriching the museum's treasures, incorporating on the one hand a selection of the paintings deposited in the Monastery of San Lorenzo de El Escorial and, on the other, the so-called *Tesoro del Delfín*, or Dauphin's Treasure, which was deposited in the Natural History Museum.

The first of these projects originated in 1838, with the temporary transfer of a series of the best paintings from the Monastery of San Lorenzo de El Escorial to the Royal Palace of Madrid, to prevent any possible damage they might suffer at the hands of the Carlist guerrillas who were marauding in the region. With the paintings in Madrid, Madrazo suggested to the queen regent during her visit there in October 1838 the possibility of incorporating them into the Royal Museum. His proposal accepted, the director reported on February 9 the following year the arrival "last Monday" of *The Visitation* (no. 300) by Raphael and several canvases by Titian and Veronese. At the same time he announced the forthcoming delivery of other paintings, outstanding among which were four by Raphael, *The Madonna of the Fish* (plate 143), *The Pearl* (no. 301), *The Holy Family with Sheep* (plate 141), and *The Virgin of the Rose* (no. 302); *Christ's Descent into Limbo* (no. 346) by Sebastiano del Piombo; *The Virgin of the Chair* (no. 210) by Guido Reni; and *The Entombment of Christ* (plate 155) and an *Ecce Homo* (no. 42) by Titian. The illustrious painter added that the canvases "will gain much, since they will be lined and retouched, most of them being arid and dry. And there is no doubt that if they had remained there longer they would have suffered incredible damage."[83] Consequently, in March 1839 Madrazo proposed that four new restorers be appointed at a salary of 3,000 *reales* each.[84]

With these works in the museum, the possibility must have occurred to Madrazo of obtaining other canvases from the monastery, and to this end he left on April 11 in a coach from the royal stables, on what he intended to be a two-day trip. Indeed, on April 13 a series of paintings arrived at the museum from El Escorial, outstanding among which are works by Bosch (*The Adoration of the Magi*, plate 194); Joachim Patinir (*Landscape with Saint Hieronymus*, plate 200); Mabuse (*Christ Between the Virgin Mary and Saint John the Baptist*, plate 203; and *The Virgin of Louvaine*, no. 1536); Giacomo Bassano (*Expulsion of the Merchants from the Temple*, no. 27); and Titian (*Christ with the Virgin*, no. 443).

In a letter written by José Madrazo dated April 20, 1839, he justifies the transfer fundamentally on the basis of their poor state of preservation, a condition that was to be corrected in the museum's restoration workshops.

I have examined all the paintings in the monastery . . . and I have brought to Madrid all those either ill treated through neglect or those the merits of which those good friars were unable to appreciate; among these are examples of the old German and Flemish

Construction at the Prado Museum in 1839

schools, exquisite works of the utmost interest, which once restored will be the admiration of all. . . .

In the proctor's office, on the floor beneath some baskets and pieces of wood, there was a painting I believe to be by Titian, an exquisite *Christ with the Virgin*. . . . Despite being in such a state, this painting is not among those which have suffered most, though it is covered with grease and grime; undoubtedly it was used to cover an oil jar. It is lucky for the fate of these paintings that I went to El Escorial, for in this museum they will be restored and looked after as if they had never suffered such neglect.[85]

The second initiative undertaken by José Madrazo as director of the museum was that of claiming the extraordinary renaissance and baroque vases known collectively as the Tesoro del Delfín, contained in the Natural History Museum since Charles III deposited then there on September 2, 1776. This collection consisted of a set of pieces in hard stone or rock crystal with rich gilt, silver, or cameo decoration, the inheritance Philip V received from his father, the dauphin of France, who died on February 8, 1712, when Louis XIV was still on the throne. The first formalities to achieve the transfer of the pieces were carried out on December 29, 1838.[86] On March 9, 1839, Madrazo already took it for granted that the collection of vases would go to the Royal Museum, and had assigned them their specific place: "The famous vases and other precious objects that were preserved in the Natural History Museum will also be housed in the museum, and I shall place them in those four niches in the octagonal room which served as Salvatierra's study, placing them in their respective glass cabinets so that they may be seen but not touched."[87]

The proposed move stirred intense political protest, as indicated by another of José Madrazo's detailed letters, this one dated March 23:

The Queen Regent has issued a Royal Command so that the famous rock crystal and agate vases and the cameo jewels from the Natural History Museum pass to the Royal Museum, since this setting is more appropriate for them. However, the Board of Study Directors, of which Quintana is President, oppose this and, what is worse, have published several libellous articles in the *Eco del Comercio*, giving to understand in the most malicious and picaresque fashion that the intention was to remove the jewels from the Natural History Museum in order to sell them, on the supposition that they were the property of the Nation, when this is not the case, since they belong to the Royal Heritage, being the legacy Philip V received from his father, the Dauphin of France.[88]

The controversy arising from the transfer lasted for almost two months. There were ministerial interventions, press campaigns in which José Madrazo himself took part, and even resignations from the Board of Study Directors. The issue was finally settled with the Royal Command of May 11, 1839, by which the permanent transfer of the objects to the Royal Museum was ordered.[89]

When José Madrazo was appointed director of the Royal Museum, prominent among the program of activities he planned to carry out (see the letter dated August 24, 1838) was the furbishing of new halls in which to exhibit both those paintings newly added to the museum's treasures and those formerly contained in the storerooms. On March 9, 1839, with the remodeling already underway, Madrazo wrote about his plans:

My intention is to have all the paintings hanging by the birthday of the Queen Regent, which falls on April 27 next, although I still have much to do in the museum. The famous vases and other precious objects in the Natural History Museum will also come to the Prado, and I shall place them in those four niches in the octagonal hall that was Salvatierra's studio, in glass display cabinets so that they may be seen and not touched, since the said gems belong to the Royal Heritage, and it is the Queen's wish to house in the museum all those *objets d'art* that pertain to her daughter, Queen Isabella. Besides those paintings we already have here from El Escorial there are others, among them *The Madonna of the Fish*. As you can see, with such treasures our Royal Museum of Madrid will be a veritable king of museums and the admiration of all.[90]

The paintings, vases, and jewels of the dauphin were not the only *objets d'art* to be put on display; also to be included were the hard stone tables given by Pope

Pius V to Philip II and Don John of Austria. Furthermore, a new sculpture hall was being furbished, a project apparently begun by the now abolished Governing Board,[91] which had been presided over by the Duke of Híjar, and now brought to fruition by Madrazo.

On April 12, a few days before the inauguration of the new installations, it was decreed that all works in Vicente López's studio belonging to the Royal Family should be recovered and added to the treasures of the Royal Painting Museum. This collection consisted mainly of drawings by painters from the generation immediately preceding that of López: the most numerous group was of works by Francisco Bayeu, although there were also series by Anton Raphael Mengs, Tiepolo, Luis Paret y Alcázar, Luca Giordano, Alonso Cano, and Gaspar Becerra. There were also a good number of prints and a small number of oil paintings, outstanding among which were three sketches by Bayeu (which figure in the 1843 catalogue as nos. 355, 500, and 562). Surprisingly enough, there were also a couple of portraits by El Greco.[92]

Just as planned, the six new painting halls and the sculpture gallery were opened on April 27. We do not know exactly how many paintings were hung at the time, but in the catalogue published four years later, 1,833 are listed. This represents a spectacular increase of 1,076 over the 757 that existed in 1828; in other words, the number more than doubled. Furthermore, to these figures must be added the statues and reliefs and, later on, the vases and jewels from the Dauphin's Treasure. However, the interest did not lie only in increasing the number of works on display; to judge from the long article that the *Gazette* devoted to the event on May 2, formal aspects concerning the presentation of the works were also the subject of careful study. Particularly impressive was the sculpture gallery,

> that delightful venue which is surely the object of the most fervent imagination of everyone who crosses its threshold. Wonderful to observe is the perfectly harmonious order of the numerous works it contains, as well as the surprising and magnificent effect caused by the mysterious light that, reflected against the walls of exquisite jaspers, perfectly figured, causes the statues to stand out against a marvelous background. The observer imagines himself transported as if by a spell to centuries far in the past, wishing to participate in the several scenes represented there; all this endows that august corner with a certain air of sanctity, which fills the curious visitor with veneration and respect.[93]

In addition to providing details about the new halls, the article in the *Gazette* is of particular interest in that it confirms on the one hand the commitment of the widow of Ferdinand VII to continue the task begun by her husband, and on the other reveals the close relationship existing between the queen regent and the director of the museum:

> So many examples of so many periods have been accumulated, in order to show that the arts need Kings and Kings need the arts . . . and herein lies the reason why the august Queen Regent has chosen not to abandon the beautiful path followed by the most sovereign monarchs of all times and Nations.
>
> Since the moment the Spanish became blessed enough to call themselves the children of such a good mother, she has constantly offered her generous protection to the arts and artists. . . . As a true artist, she harbored desires only she could bring to fruition: it was necessary that she should provide them with the means to study fruitfully and advance, even at the cost of great sacrifice; she settled her gaze on the temple of the arts, a genuine breeding ground of masters and a tree of delicious fruit with which to nourish their spirit, because talent and genius evolved with the help of those who in the past cultivated the vast field of Nature, along whose rough and spiny paths it is necessary to walk in search of perfection. However, the smoother the path the better and surer is the journey. And this is the main advantage museums offer. . . .
>
> Just approval is similarly deserved by the act of having adorned with such good order both the walls of the building and its corridors and stairways, especially the rotunda at the entrance . . . necessary in order to display over two thousand paintings, a

prodigious figure that surely no other museum in Europe can boast. And the exhibition of a third part is thanks to Her Majesty, who has put into practice her praiseworthy desire to favor artists and ennoble and extend the glory of Spain. To realize this task she has chosen people of uncommon knowledge and undisputed diligence and energy. For who would believe that all these halls have been furbished and all these improvements made in the space of under one year? Señor Madrazo therefore deserves a tribute of gratitude, since he has carried out to the letter the wishes and intentions of our august Sovereign and caused the admiration of the public at large. . . .

Her Majesty deigned to visit the establishment days past in order to see and examine the improvements carried out in such a short space of time, and we do not doubt that she was entirely satisfied with her wise decision to place Señor Madrazo as Director of the Museum, since he has managed perfectly to interpret her wishes and bring her intentions to fruition.[94]

The queen regent's determined will to assist and favor the training of young artists also had its negative side. To enable the students who went every day to the museum to copy works in peace and uninterrupted, it was agreed to reduce the general public's visiting times exclusively to Sundays and holidays.

Madrazo was not satisfied by the notable increase in the number of works exhibited after alteration work; he aspired to add to the museum's treasures still further. On August 22, 1840, he sent an official letter to the general administrator of the palace, indicating "the expediency of visiting all the Royal Palaces and Possessions, in order to give greater importance to the museum and to have closer at hand canvases and panels in order to restore them and preserve them with surer guarantees."[95] This project would not be realized, however. On October 10 that very year María Cristina, the queen regent, was forced to abdicate and go into exile. She was succeeded in the regency by General Espartero, while the tutorage of Isabella II was entrusted to Agustín Argüelles, a distinguished liberal statesman and one of the fathers of the Constitutions of 1812 and 1837.

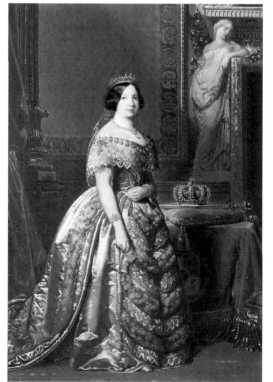

Isabella II

The Majority of Isabella II (1843–68)

On November 8, 1843, having just turned thirteen, Isabella II was declared to have reached the age of majority. Shortly afterward, on March 29 of the following year, the young queen, guided by her mother, appointed a committee to examine the execution of the will of Ferdinand VII. The committee was composed of six members — two representatives of each of the parties involved: Isabella II; her sister, María Luisa Fernanda; and their mother, María Cristina — and was presided over by the Duke of Híjar, the sole surviving executor of the late king's will (the Marquis of Santa Cruz had died in 1839).

The members of the committee agreed that "no inventory should be made of the monuments to our glory and former greatness, which from the remote past have mostly belonged to our monarchs, and any idea of dividing them is highly repugnant."[96] This led them to the conclusion that the will had not been correctly executed, since the value of the legacy to be shared out had been increased by the addition of certain assets, such as the Royal Museum, that could not be divided and by their very nature could not be assigned to anyone other than the heiress to the crown. The only person this affected negatively was Isabella II, who had no choice but to accept this part of the legacy and to pay her sister an indemnity for the portion that otherwise would have fallen to her. Despite the inequity of the solution, the commissioners, taking into account the time that had passed since the reading of Ferdinand VII's will and the circumstances of the moment, did not consider it expedient to repeat the inventories and evaluations of the holdings to determine their corresponding division. Instead, in the findings they published on March 17, 1845, they again proposed that the queen should accept as her own all the *objets*

d'art and precious possessions of the different palaces and royal sites and pay her sister an indemnity for what should have been her share, although they reduced the compensation to three-quarters of the assessment of 1834. In their report, the commissioners strongly opposed any possible division of goods:

> The splendor of the Throne would fade if Spain were to lose such an artistic treasure that since ancient times has been in the possession of Your Majesty's august predecessors, a treasure fit only for a monarch, which if it ceased to be the legacy of the crown would undoubtedly disappear, thus depriving the Fine Arts of one of their richest heritages.[97]

In other words, technically speaking, Isabella II could consider not only the Royal Museum but also all the treasures contained in the different palaces strictly as her own private property, and was at liberty to dispose of them as she saw fit. Aware of the legal ambiguity of such a situation, the committee presided over by the Duke of Híjar issued another report in November 1845. The document included a draft law declaring "the Royal Palaces, Museums, etc., and the paintings, statues, and other artistic and natural treasures of the same provenance" linked to the Crown.[98] It would be necessary to wait another twenty years, until 1865, by virtue of the Law of May 12, for the Crown's institutional heritage to acquire its essential legal definition.

In the meantime, life at the museum proceded as usual, although not without the occasional sudden alarm concerning its physical safety. For example, on October 10, 1841, the Artillery Division, which had recently moved to the former monastery of Saint Hieronymus, fired a salvo in honor of Isabella II on the occasion of her birthday. The cannons were so close to the museum that the blast from the explosions shattered several window panes and caused a number of paintings to fall. José Madrazo made a formal protest about the incident, fearing that if the building were severely shaken some of the vaults might collapse, with the remainder following suit as a result of the forces from the very weight of the building. In June 1843 the director was forced to send a letter to the Captain General of Madrid to express his concern on learning that the artillery barracks, on Buen Retiro Avenue, had six thousand *arrobas* (that is, over sixty tons) of gunpowder in its stores. The military did not share Madrazo's concern and promised simply that every precaution would be taken; fortunately no mishap took place.[99]

Luckily not everyone was so indifferent as far as the museum was concerned. On February 24, 1843, permission was requested from the general administrator to protect the building by means of a new invention, the lightning rod, a report on which had been prepared by the physicist Santiago Vicente Masarnau. The project having been approved, Masarnau was engaged to supervise its installation, and on November 10 there arrived from Paris an entire set, consisting of a point of platinum, the conductor itself, and six additional points. The following week a locksmith was engaged to make the six remaining conductors so that the protective system could be installed.

Between 1845 and 1847 the question about the employment of museum personnel once again arose. The great number of paintings needing lining, cleaning, or consolidating was too much for the restorers to cope with; the problem was further exacerbated by the resignation of some of these specialists, who were understandably attracted by the incentives offered by the private sector. The number of guards employed in the museum was also insufficient to fill the needs of surveillance of the works on display. The opening of new halls and the hanging of paintings in corridors and on staircases complicated questions of security to such an extent that, for example, on March 8, 1842, a painting was slashed.[100] Having been consulted with regard to the matter, Madrazo once again presented the same project (with a few slight modifications) he had submitted in November 1838, adding that the question of salaries was due for revision. His proposal was rejected on this occasion

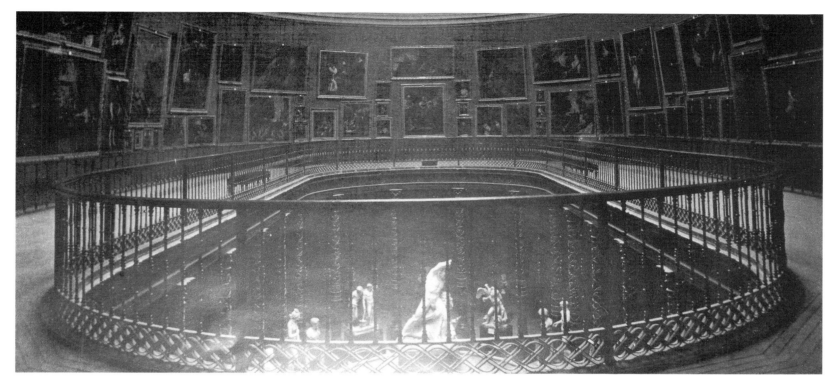

Hall of Queen Isabella de Braganza and sculpture room

as well, and museum personnel was increased by just one restorer, two watchmen, and one scribe.

On the morning of September 17, 1849, Isabella II made a thorough inspection of the Royal Museum. As a result of her tour, it was agreed four days later to prepare budgets for a series of initiatives to be submitted for royal approval. Outstanding among these initiatives were the project to tile the halls with stone from the quarries near the Granja de San Ildefonso; that of attempting to acquire, through purchase, exchange or leasing, a plot of cultivated land adjacent to the museum building, belonging to the Invalids Barracks, in Atocha; and that of constructing a new picture gallery, one story high, along the eastern facade of the museum.[101]

These projects, however, were not to be carried out in the nineteenth century; thay were shelved until 1914–18. Completion work was undertaken, however, on the only part of the original building still unfinished. Villanueva had conceived the headquarters of the Science Academy as a construction with two bodies at the ends of a long gallery. Inserted perpendicularly into the center of this gallery was a third block that defined the main axis of the building, something like the Temple of the Sciences. This block was divided into three clearly differentiated areas: the large square portico that presides over the Paseo del Prado facade; the circular vestibule which divides the gallery in two; and a wide nave with a basilical plan that terminates in an exedra originally intended to have formed a hall for solemn acts, the height of the first two floors of the building.

Only the foundation of the walls of the nave existed when the architect Narciso Pascual Colomer was engaged to complete it. Instead of keeping to the original plan for a hall of double height, however, Colomer decided to split it horizontally into two floors. The upper of the two was destined for the exhibition of paintings, and possibly because of this, to take maximum advantage of the wall surface, there are no windows; lighting was achieved by means of a skylight. In this hall was displayed a selection of what was considered the best paintings of all those in the museum's storerooms, and it was dedicated to Queen Isabella de Braganza. Due to the slope of the land, the hall below was a kind of half-basement, which, having no windows,

had to be lit from the floor above through a hole in the ceiling. Given these circumstances, only sculptures could be shown in the lower hall.

The inauguration of these new halls took place in 1853. With this ceremony the number of paintings rose to 2,001, while the sculpture figure was 118. Thanks to the pen of Mesonero Romanos, who in 1854 published his *Nuevo Manual Histórico y Tipográfico y Estadístico de la Villa de Madrid*, we have a contemporary description of these halls:

> This gallery, which, as I said, is on both floors, ground and first, where the sculpture and painting halls are, is a fine elliptical room open in the center, and running around it above is a balcony or balustrade from which both floors can simultaneously be seen, illuminated by the crystal roof and the first floor sustained by elegant columns, the whole offering an amazing perspective. As regards the paintings hanging in the top part, what can be said except that they are the finest in this admirable museum.[102]

However, the gallery was not to everyone's taste, as can be seen in Araujo Sánchez's acute criticism, which appeared more than twenty-five years later:

> The plan was so original that it will be remembered for years to come. From the floor rose up iron columns of horrendous bad taste to support a gallery with banisters that ran around the first floor, forming a kind of well in the center. The paintings were on the first floor, but the width of the gallery allowed the observers to see them only from very close up or very far away. On the ground floor there were sculptures that received a distant light, dimmed by the shade of the gallery. The motive for these defects was undoubtedly the desire to provide light for the lower level, which would have remained in darkness if the first floor had been completely paved; but it would have been better to leave one part totally useless than leave two in poor condition.[103]

Although the palace approved the idea of extending the installations in the Royal Museum, the same approval was not forthcoming when it came to increasing the personnel to look after this rich heritage. Quite the contrary; in March 1857 a reduction of the museum staff was proposed, which caused the director to express his protest in writing on March 6. Seeing that he could not make sense prevail, on March 30, José Madrazo tendered his resignation.

JUAN ANTONIO RIBERA (1857–60)

The palace tried to persuade Madrazo to revoke his decision; however, given the firmness of Madrazo's will, the attempt was to no avail, and Juan Antonio Ribera was designated to succeed him. Court painter since Ferdinand VII's return to Spain, Ribera had already collaborated in the Royal Museum tasks during the time of the Duke of Híjar when, on July 22, 1826, he, together with the curator Luis Eusebi and the court sculptor José Álvarez, was commissioned to make a selection of *objets d'art* from the different palaces and royal houses worthy of incorporation into the establishment. His appointment caused the displeasure of Federico de Madrazo, son of the former director, who considered the post to be nothing less than hereditary.

Juan Antonio Ribera's term of office was very short; he died on June 15, 1860. He therefore did not have the opportunity to define and execute a line of action in all its extension. Nevertheless, he did make clear that his main concern was the proper preservation of the rich heritage under his care. We have already seen that in the so-called Hall of Queen Isabella the most outstanding works in the collection were displayed. Paradoxically, since they were housed in a section of the building constructed after the installation of the lightning conductor, in 1842, these works were precisely the most exposed to accident during an electrical storm. One of the first measures adopted by the new director was to remedy this situation, calling once again on the services of the physicist Santiago Vicente Masarnau.

During Ribera's term of office restoration on the paintings continued; more than fifty works were cleaned and consolidated, and a number of others were recanvased. He also made sure that the restoration workshop was equipped with the team, materials, and chemical products necessary for the correct progress of its mission.

His concern was not limited to remedying the damage already suffered by the works of art, however; he also attempted to eliminate the possible causes of such harm. It is in this regard that he sent a report to his superiors advising that "the terrain before the main facade of this Royal Museum, between this and the Paseo del Prado, must be properly sanded and given the slope necessary so that the waters flow away from the building, and little touched so that they do not filter through and damage the foundations."[104]

FEDERICO DE MADRAZO (1860–68)

In July 19, 1860, Federico de Madrazo was appointed to the post made vacant by the death of Juan Antonio Ribera. At the age of forty-five, Madrazo had achieved great prestige as a painter and was well established in court circles. Yet despite his professional success and the numerous commissions given him on the strength of this, he assumed with great enthusiasm the responsibilities involved in the position.

Among the first measures he adopted was to transfer several busts, reliefs, and marble sculpture fragments that were in grave danger of decomposing due to the damp his predecessor had warned about. His zeal was not enough, however, to prevent the theft, in June 1861, of a small painting, the first theft occurring in the museum. Luckily, the work stolen was of absolutely no artistic significance. By contrast, of great import was the acquisition, on July 16 of that same year, due to negotiations carried out personally by Federico de Madrazo, of the extraordinary panel by Fra Angelico depicting *The Annunciation* (plate 137). This work came to fill one of the largest holes in the museum's collections, the Italian Renaissance period. Madrazo, who had seen the painting in the convent of the Descalzas Reales, managed to persuade the nuns to cede it to the museum in exchange for his painting them another canvas on the same subject. It was as simple as that. The first donation ever to be directly received by the museum also dates from this time (Velázquez's *Christ Crucified*, no. 1167, was in fact a gift to Ferdinand VII, who in turn gave it to the museum [see p. 37]). This was Jan van Kessel's composition consisting of forty small paintings of animals (no. 1554), which had formerly been the property of Charles IV. They were ceded in 1865 by Count Hugo, who indicated that the group had belonged to Joseph Bonaparte.

The museum staff had been gradually increasing, and in 1863 it corresponded to the scheme José Madrazo had wanted twenty-five years previously. The personnel consisted of the director, an auditor, a secretary, three restorers, two liners, a restoration assistant, a sculptor, a stonecutter, a carpenter, a concierge, seven watchmen, three porters, an ordinary hand, and four guards.[105]

Everyday activities in the Royal Painting and Sculpture Museum carried on as normal as far as possible given the difficult circumstances of the time. However, one question remained unresolved: the legal position regarding ownership of the museum. The debate was opened in November 1845 when the committee presided over by the Duke of Híjar entrusted with the revision of Ferdinand VII's will presented a bill that proposed linking the *objets d'art* in the royal palaces, including the museum, to the Crown's inalienable patrimony. Political unrest in the country, complicated further by the claims of the dowager queen María Cristina as regards the inheritance from her late husband, impeded the rapid resolution of the matter. Finally, however, common sense prevailed, and on May 12, 1865, the law was passed by virtue of which the museum was made definitively safe from personal whims.[106]

In the meantime, the economic situation in Spain was worsening, and the galloping recession naturally also affected the museum. On November 17, 1866, a Royal Decree was approved by which the museum staff was reduced. The department most affected was the restoration workshop, two of whose employees were relieved of their posts; also dismissed were the auditor, the stonecutter, the carpenter, and one of the seven watchmen. Besides the staff reduction, restrictive measures also

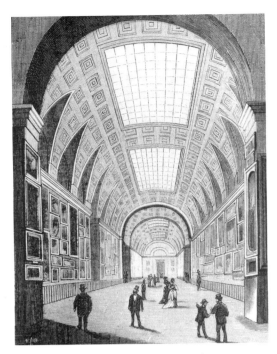

The large gallery on the main floor around 1870

affected the employees' salaries, which were reduced by 1,000 *reales*, except in the case of the porters, whose wages were cut 500 *reales*. The pay of the "hand" and the guards was not affected, since it could not possibly have been lower.[107] A further symptom of the gravity of the situation was the July 1868 request presented by two of the humblest of the museum employees, asking for permission to reside on the premises. This would become normal practice in the future and would eventually cause considerable problems in the administration of the establishment.

Apart from the financial difficulties of the moment, the crisis through which the country was going would have more important and lasting consequences for the museum. In September 1868 the liberal revolution broke out, led by generals Serrano and Prim. On the 26th of that same month Isabella II was dethroned and expelled from Spain. During the period when the conflict directly affected Madrid, the museum was closed as a cautionary measure.

THE LIBERAL PERIOD (1868–74)

On September 29, 1868, when news spread of the defeat of the troops loyal to Isabella II, a people's revolt broke out in the streets of Madrid. After the first days of confusion, the provisional Revolutionary Junta began to prepare the creation of an organism that would assume responsibility for the administration and control of the Crown's patrimony, included in which was of course what had hitherto been called the Royal Painting and Sculpture Museum. On October 15 the *Gazette* published a document presented the day before by Francisco Serrano, president of the provisional government, to the chancellor of the exchequer, in which he informed him of the appointment of the ten members of the "Committee entrusted with the preservation, custody, and administration of the assets constituting the Patrimony of the Spanish Crown." Pascual Madoz was made president of the committee and Manuel Ortiz de Pinedo secretary; the board members were the Marquis of the Vega de Armijo, the Marquis of Perales, José María Fernández de la Hoz, Cristino Martos, Manuel Silvela, José Cristóbal Sorni, Camilo Labrador, and Vicente Rodríguez.

Before the creation of this committee, on October 11 Federico de Madrazo and Pascual Madoz had met to analyze the situation of the museum after recent events. Madrazo pointed out to Madoz the need to unblock certain functions of an administrative nature, such as the payment of salaries, which had been frozen as a result of the revolution. Federico de Madrazo appears to have had no intention of resigning, despite the facts that his appointment was made by the deposed queen and he totally disagreed with the new rulers of the nation. Consequently, the new government was forced to make the decision of dismissing him.

ANTONIO GISBERT (1868–73)

On November 19, 1868, the committee appointed in Madrazo's place Antonio Gisbert, a painter committed to the liberal cause and a friend of two of the main revolutionary leaders: Francisco Serrano, who at the time was president of the constituent *Cortes* and would later be made regent of the kingdom, and Juan Prim, president of the Council of Ministers. Three days later, Gisbert informed his superior that he had taken possession of the post.[108]

One of the first consequences of the new order of things was the decision to open the museum to the public five days a week instead of only on Sundays and holidays.[109] Another important event for the museum was the acquisition, in January and February 1870, of cartoons for tapestries by Goya, Bayeu, and Castillo. After the death of Ferdinand VII these large canvases had been transferred from the Royal Tapestry Manufactory of Santa Bárbara to the Royal Palace of Madrid. There, removed from their frames and rolled up, they were stored in the Oficio de Tapicería. Before 1867 Federico de Madrazo had unsuccessfully claimed those by Goya for the Royal Museum, complaining that "they are going to ruin in the Palace

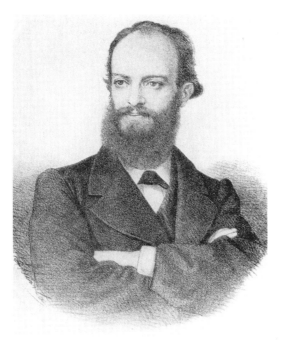

Antonio Gisbert

basements."[110] Also Gregorio Cruzada Villamil, from the recently created Tapestry Museum of El Escorial, had again attempted to recover them in 1869.[111] It was the theft of six of the cartoons that finally led to the decision to transfer them to the Prado Museum.[112] There, however, they were displayed in rooms on the top floor in conditions unworthy of the quality of the works. Once again Ceferino Araujo gives us his impressions regarding this: "The ceilings are low; the first room has a bad staircase and the others a worse entrance, which once again shows that the building is hardly suitable for the purpose it is intended to fulfill. Further evidence of this is the fact that it has proven impossible to find a way to gain space other than dividing up four rooms with partitions."[113]

The definition of the new legal situation of the museum, adapted to the country's new political structure, and its position within the administrative scheme of the State, was not a quick, punctual operation; on the contrary, it was a gradual process that lasted several years. From the very moment of its inception, on October 14, 1868, the "Committee Entrusted with the Preservation, Custody, and Administration of the Assets Constituting the Patrimony of the Spanish Crown" came to depend on the Ministry of Finance. The legal apparatus necessary to consolidate the new situation of the museum was not created until late in 1869, with the law of December 9–18, by which the Royal Patrimony was declared null and all its assets acquired by the State. Stated simply, the museum was nationalized. Two months later, on February 22, 1870, the Development Ministry claimed the transfer of the museum from the Ministry of Finance; the operation was subsequently carried out by virtue of a decree issued by the regent of the kingdom, the Duke of La Torre.[114]

When the transfer had taken place, the Development Ministry was faced with the responsibility of administering two national painting museums, both in Madrid: El Prado and La Trinidad. Given the economic situation of the country, the heads of this department must have considered that such duplicity was unjustifiable, and

Staircase in the La Trinidad Museum

on November 25, 1870, the regent of the kingdom, Francisco Serrano, by agreement with the Council of Ministers and on the basis of a proposal by the Development Minister, José Echegaray, signed a decree by which a committee was appointed to study the fusion of the two museums. Having reached this stage, this would perhaps be the opportune moment to go back to the origins of the Trinidad Museum, in order to follow its evolution up to the point when the two accounts converge.[115]

The Museo Nacional de la Trinidad (1835–72)

With the confiscation of the assets of the religious orders decreed by the finance minister, Juan Alvarez Mendizábal, in 1835, a great number of works of art from convents and monasteries were left defenseless. A number of initiatives at different points on the Iberian Peninsula (we have already seen the concern of José Musso y Valiente in Seville) came together to save such a rich heritage. Also public administration collaborated in this task and, on January 13, 1836, the *Junta de Profesores* was appointed exclusively to fulfill this objective.[116]

Two years later the work carried out by this junta was consolidated by a Royal Command dated December 31, 1837, taking the form of a national museum incorporating some nine hundred paintings and sculptures already recovered and to which would be added those that were to be collected in the future from the provinces of Madrid, Toledo, Avila, and Segovia. The administration of the museum was entrusted to a commission of professors, one member of which was Valentín Carderera, a painter and art historian who personally attended to matters related to the restoration, classification, and placing of the works. Chosen to house a great number of pieces was the convent of La Trinidad, which had its main entrance in Calle de Atocha and two side entrances, one in Calle Relatores and the other in the Plazuela del Progreso. At first the idea had been to use San Francisco el Grande, the largest of Madrid monasteries, but the idea was quashed when the *Cortes* chose it to house the *Panteón de los Hombres Ilustres* (Gallery of Illustrious Men).[117]

After the secularization of the trinitarian convent, the church was divided in two; the transept was transformed into a chapel for the congregation of Ave María, while the nave, subdivided horizontally, became the institute theater. When paintings began to arrive from former religious houses, several rooms were furbished to house them. Then,

> with the objective of extending in the aforementioned church the National Painting Museum housed in the building, the chapel was closed and the venue given to the Institute, the flooring having been demolished that that corporation had laid, and new flooring was made, thus creating a magnificent salon whose ceiling was the vault that covered the former church.[118]

In addition to those works formerly contained in monasteries and convents, the museum also temporarily acquired the magnificent collection of the Infante Sebastián Gabriel de Borbón y de Braganza, Ferdinand VII's brother, confiscated as punishment for his support of the Carlist cause. The collection contained outstanding examples of the work of such Spanish artists as Juan de Juanes, El Greco, Ribera, Mazo, Mateos, Carreño, Arellano, Escalante, Sánchez Cotán, Sebastián Muñoz, Tobar, Meléndez, and Goya, as well as a fine series of Italian and Flemish paintings. In 1854, when the infante became reconciled with his niece, Queen Isabella II, the collection was returned to him.

On July 24, 1838, the museum was considered essentially ready and its doors were opened to the public. It did not remain open for long, however, as work soon began on extending the exhibition halls:

Transept of the church of the convent of La Trinidad

The establishment subsequently underwent many alterations, having been closed for a considerable time, during which several projects were carried out, among which was providing the high cloister with light by opening skylights in the vaults in order to use the walls looking onto the sumptuous courtyard. Several halls were furbished and the museum was opened to the public on a weekly basis.[119]

The Museo Nacional de la Trinidad was reopened on May 2, 1842, during the regency of General Espartero. His government supported the museum project, that same year obtaining from the *Cortes* approval of a budget that included fundamentally ordinary, extraordinary, and personnel expenses totaling 92,500 *reales*. There was also a reordering of the center's administrative structure, and on April 18, 1843, the commission of professors in charge of the museum was dismissed. In its place appeared the figure of director, an essentially honorary post since it was unpaid, and that of subdirector, which was more effective.

This state of affairs was also short-lived. In 1847 Juan Bravo Murillo ordered the transfer of the Ministry of Commerce, Instruction, and Public Works to the La Trinidad convent, despite opposition from the Director General of Public Instruction, Antonio Gil y Zárate. Alternative premises in which to house the museum's paintings were sought, but the prospects were far from encouraging. So bad was the situation that when the tenth volume of the *Diccionario Geográfico–Estadístico–Histórico de España* was published by Pascual Madoz in 1850, Eguren, who was responsible for the chapter on Madrid, wrote the following:

> Short-lived indeed was this notable museum that is now without premises, since the building that formerly housed it has been occupied by the Ministry of Commerce, Instruction and Public Works. Attempts to transfer it to the Prado Museum have met with unsurpassable obstacles (one of these being lack of space) so that now if there is no beneficent hand to take care of the exquisite works it contains, the National Museum will be of no further use to the general public.[120]

The solution finally adopted was a compromise and, as such, unsatisfactory. The ministry and the museum lived side-by-side in the same building. The exhibition area was reduced to the high cloister and the former transept; a few paintings were

hung in the ministry offices and the rest, quantitatively the most important part, were stored in unsuitable conditions in what had hitherto been the restoration workshop.

This was essentially the state in which Gregorio Cruzada Villamil found the museum when he became subdirector on December 22, 1862. The eminent essayist's link with the museum was also to be short-lived, for in October 1864 he resigned. Still, he was able in this short period, on the basis of an inventory drawn up in 1854, to write the *Catálogo provisional historial y razonado del Museo de Pinturas*, which was published in 1865. The author states that of the 1,739 paintings in the museum's collections he catalogued only 599, since the remainder "lack artistic merit"; on the other hand, he included in his publication the 760 canvases by nineteenth-century painters who had been awarded prizes in the successive National Exhibitions of the Fine Arts. Regarding the cataloguing criteria, it should be pointed out that this was the first book of its kind published in Spain with a minimum of scientific rigor; instead of following the usual topographical pattern, according to the arrangement of the works in the museum's halls, Cruzada grouped them by artists, whom he ordered alphabetically. Furthermore he added references to the provenance of the works.[121]

The unstable situation in which the Museo Nacional de la Trinidad found itself meant that continued efforts were made to find solutions to the problem. In 1868 José Caveda and Gregorio Cruzada Villamil thought about the possibility of transferring the collection to the Libraries and Museums building that was being erected in the Paseo de Recoletos. A few months later, in October 1868, Vicente Poleró published a booklet in which he proposed the gathering together in one "great National Museum" not only the collections of the Museo del Prado and the Museo de la Trinidad, but also those of the San Fernando Academy of Fine Arts, those of the Royal Sites, and a selection of the best pieces to be found in the country's churches and cathedrals.[122]

Possibly influenced by Poleró's text (although not necessarily so since, as we saw earlier, the idea had also occurred to Pascual Madoz twenty years earlier), on November 27, 1870, the Madrid *Gazette* published the following decree sanctioned by Francisco Serrano, regent of the kingdom, after the proposal by José Echegaray, development minister, expressed in his preamble:

EXPOSITION

Sir: As a result of the general law confiscating the assets that constituted the Patrimony of the Crown, these became the property of the Nation, and the Painting and Sculpture Museum of El Prado came to depend on the Ministry of Development. The Government already possessed another National Museum containing the works of art that had belonged to the former religious communities and others either acquired by the State with the funds assigned annually to this purpose or from the National Fine Arts Exhibitions.

The first of these museums is housed in a monumental building, while the second is installed provisionally in the halls of this Ministry, the artistic gems it contains being hidden in offices where they are in daily peril of deterioration and where no access is permitted to those people who would wish to appreciate or copy them. As both museums now belong to the Nation, there is nothing to justify the fact that they are separated, when they should undoubtedly be brought together so that the celebrated panels by Van Eyck and Rincón and the canvases by Rivera, Morales, and Murillo can be admired by all, both from home and abroad.

It is true that the Prado building does not have sufficient capacity to contain all the works it possesses; however, the Constituent *Cortes* have ceded the Government in this year's budget a permanent credit of 200,000 *pesetas* with which to extend the palace; and although this is not enough to house well and with sufficient room all the works of both museums, the best of both could be exhibited with dignity while the means

are studied in the meantime decorously to display the rest as soon as possible so that their recognized merits can be appreciated. Together they could all form priceless collections in which would be represented the different periods of art, the different schools forming the pages of its history; and using the modern works acquired as a base, soon a contemporary museum might be set up in which would figure paintings and statues signed by artists awarded prizes in the foremost exhibitions held abroad.

Furthermore, there are first-class works which, as they belong to the State, should correspond to the museum. These are in the National Archaeological Museum, deposited in provincial museums, in the possession of churches and corporations, and even in the Academy of San Fernando there are paintings by Goya and Murillo which if ceded together with others to the Museum, would considerably increase its riches. In order to carry out this project, and in accordance with the Council of Ministers, the undersigned proposes that a committee be appointed of people well-versed in the subject to indicate the means to fuse the museums of El Prado and La Trinidad into one single entity and the works of painting, sculpture and engraving acquired that belong to neither. The committee should also classify them, establish the rules for the preparation of an inventory-catalogue and the regulations for the museum's administration, and propose the type and condition of the employees. In short, given the importance of the service the establishment offers to the State, the Government should be informed of whatever is necessary to be done so that our museum not only preserves its great reputation but also that its fame be exalted to the level deserved by the many and valuable works it contains. This Committee should be the center where everything concerning the Museum is decided, and be responsible for the extension work on the El Prado building, to which end shall be answerable to them the Architect of this ministry and those which the San Fernando Academy appointed to study the project for the new constructions.

On these bases, the undersigned minister has the honor to propose the following decree project.

Madrid, November 25, 1870. The Development Minister
 José Echegaray.

In accordance wth the proposal by the Minister of Development and in agreement with the Council of Ministers, I hereby decree the following:

Article 1. A Committee will be appointed presided over by Sr. D. Manuel Silvela and composed of Messrs D. Eduardo Fernández Pescador, of the Academy of San Fernando, D. Juan Facundo Riaño, Professor at the Escuela Especial de Pintura and of the Escuela de Historia, D. Gabriel Rodríguez, D. Rafael Prieto and D. Francisco Pi i Maragall, *Cortes* Deputies, D. Antonio Gisbert, Director of the El Prado Museum, D. Cosme Algarra, Director of the Museo de la Trinidad, D. Simeón Alvalos, Director of the Escuela Superior de Arquitectura, D. Carlos Luis de Rivera, Director of the Escuela Superior de Pintura, Escultura y Grabado, and D. José Gregera, Subdirector of the El Prado Museum, who will act as secretary, with the purpose of proposing to the Government the bases upon which to fuse into one entity the National Museums of Painting and Sculpture of El Prado and La Trinidad, assigning the objects to be contained in the same which, being the property of the Nation, are in the power of official or private corporations and establishments.

Article 2. The Committee will also propose the historial and artistic classification of the paintings, statues, and engravings contained in both museums, the bases for an inventory–catalogue raisonné of the said works, the academic and administrative staff and their responsibilities and the set of regulations by which the Museum is henceforth to be governed.

Article 3. The President of the Committee will request from the Development Ministry whatever reports and data necessary for the said committee to carry out its mission as well as possible.

Article 4. The Secretary will be paid a salary of 1,000 *pesetas* and expenses incurred in the transfer of works, new constructions, repairs, and materials of all kinds will be met according to the stipulations established in chapter 31, article 1 of section 7 of the general state budget, the Development Minister being authorized to administer the said credit and dictate whatever measures he considers necessary to the execution of this decree.

Madrid, November 25, 1870 FRANCISCO SERRANO

 The Development Minister
 José Echegaray.[123]

One and a half years later the Regency of the Kingdom issued a decree, dated March 22, 1872, by which the Museo Nacional de la Trinidad was officially closed and the works contained there ordered to be transferred to the Museum of El Prado. However, since extension work had not been carried out on this occasion either, it was impossible for the Prado Museum to house the almost two thousand works involved. The walls in the public areas of the museum had already been covered by José Madrazo, and in the storerooms there was insufficient space. It is hardly surprising, therefore, that only one hundred or so works were actually transferred to the country's first painting museum. Most of the remainder were dispersed all over the peninsula in provincial museums, county councils, city halls, education centers, private societies, churches, and episcopal palaces. To make matters worse, deposits were made without even the slightest administrative control, and the absence of follow-up operations in subsequent years led to the destruction and loss of a considerable number of works which, while perhaps not of first-class quality, were nevertheless essential to a reconstruction of the general panorama of Spanish painting.

THE FIRST REPUBLIC (1873–74)

**FRANCISCO SANS I CABOT
(1873–81)**

As the consequence of the proclamation of the First Republic in February 1873, on July 16 Antonio Gisbert, a staunch supporter of King Amadeus I, tendered his resignation as director of the Prado Museum. The person first considered to replace him was Eduardo Rosales, and on August 7, 1873, the republican government offered him the post. However, from the Panticosa spa where he was staying, the painter refused the offer on account of his delicate state of health. Indeed, less than a month later one of the great nineteenth-century Spanish artists prematurely passed away. The position was finally occupied by Francisco Sans i Cabot, a painter of moderate talent who managed to survive the transition from the Republic to the Restoration.

Coinciding with the beginning of the republian period, a new "extensive" edition of the painting catalogue was published, the work of Pedro de Madrazo. Possibly influenced by the catalogue of the Museo de la Trinidad prepared by Cruzada Villamil in 1865, Madrazo arranged the work alphabetically by artist and included critical and biographical notes and erudite descriptions of and references to the provenance of the artworks.

THE MONARCHY RESTORED (1875–1931)

On June 25, 1870, from her exile in Paris, Isabella II abdicated her throne in favor of her son, Alphonso XII. The attempt at a Republic having failed, the young prince was declared king of Spain on December 28, 1874. Twelve days later, on January 9 of the following year, Alphonso XII arrived in Barcelona. The monarchy thus having been restored, the Royal Patrimony returned to the Crown. It would have been natural to suppose that the Prado Museum would have been included, but this was not the case, and the museum remained separate from the Royal House and under the auspices of the state, a situation which has lasted to this day. The nature of the museum as a national asset undoubtedly had a major part to play in this decision, as did the recent consolidation with the Museo Nacional de la Trinidad, as a consequence of which works belonging to the state were added to a collection which had hitherto been strictly of royal provenance.

A short time afterward, in 1876, a new set of museum regulations was published. This document established public visiting times as working days from nine in the morning until four in the afternoon, with the exception of Monday, when the museum opened at one in the afternoon, the mornings being reserved for cleaning. Entry cost

fifty centimes, and on Sundays when the weather was fine entry was free. The director had to be both a painter and a member of the San Fernando Academy; the subdirector a sculptor and either a member of the academy or a prizewinner. As a provisional measure a curator was to take charge of the paintings from the former Museo de la Trinidad while these remained elsewhere.[124]

On October 10, 1878, an incident occurred that first signaled a grave danger threatening the museum. At eleven o'clock in the morning a small fire broke out in the Italian hall, in the end section to the left of the main room. The museum watchmen hurried to the scene and managed to put out the fire, but three of them suffered injuries of varying degree: Frutos Hernández, José Gintián, and Mariano del Real, who lost his sight. Several paintings were scorched by the flames, the most affected being a canvas by Sassoferrato.[125]

Francisco Sans i Cabot died on May 5, 1881. As director he had not been especially brilliant, but he must have been deeply convinced of the importance of the museum since, in his will, in which he figures as *pintor de historia y Director del Museo Nacional de Pintura y Escultura, natural de Barcelona*, drawn up in Madrid on June 11, 1879, before the notary Miguel Diaz Arévalo,[126] the artist left "to his wife Adelaida del Moral y de Cruzado all his possessions in Madrid except the painting by Mariano Fortuny entitled *The Moroccan Farrier*, which he bequeaths to the National Painting and Sculpture Museum." The painting was reproduced in the form of an engraving, the preparatory drawing for which was by Sans i Cabot himself, in the journal *La Ilustración Española y Americana*[127] with the caption: "*Moroccan Farriers* (copy of the painting by Fortuny made by Sr. D. Francisco Sans, to whom the work belongs)."

However, the painting did not reach his chosen destination, or, if it did, it left the museum on an unknown date, since at the beginning of this century Moreno photographed it in the Bauer collection in Madrid[128] and, years later, it came to form part of the collection of the Bilbao shipbuilder Félix Valdés.

FEDERICO DE MADRAZO (1881–94)

The death of Francisco Sans i Cabot left the post of director of the museum vacant. On May 14, 1881, Federico de Madrazo was named as his successor and thus began a second and longer term of office. This was not to be an easy period in the life of the Prado. Since permission had been granted for the museum staff to live on the premises, the general situation had deteriorated progressively. Within the organization itself were elements who disturbed the good order and security essential to the correct function of the institution. Rodrigo de Soriano, a journalist and son of the museum's subdirector, the painter Soriano Murillo, described the situation thus:

> At that time the Painting Museum was a pit of *Tócame Roque*. . . . Garrets and corners were the scene of family gatherings. . . . There were kitchens, fires and bunk beds, studios and offices, piles of firewood, and I think even the odd powder magazine. The minister simply shrugged his shoulders at the complaints of the subdirector. Even today, now that the museum has been altered, thefts continue.[129]

One of the first initiatives undertaken by Madrazo during this period was the preliminary negotiations to secure one of the most significant donations in the entire history of the Prado. The operation was concluded on December 20, 1881, when Alphonso XII signed the Royal Command by which Baron Emile d'Erlanger's donation of Goya's Black Paintings (plates 101 and 102) was formally accepted.[129] Painted by the brilliant Aragonese artist around 1821–22 on the walls of the living and dining rooms of his house on the outskirts of Madrid, the works were still there when the property was sold by his grandson to the Frenchman Rudolph Caumont in 1860. In 1873 the so-called Quinta del Sordo (Deaf Man's Villa) became the property of the German banker Baron Emile d'Erlanger, who in fact was interested only in the paintings. He immediately entrusted the task of removal, transfer to canvas, and

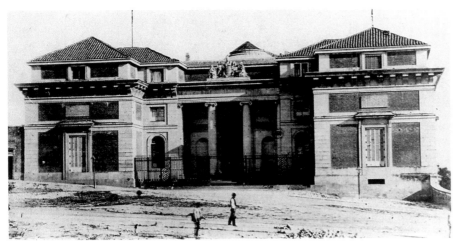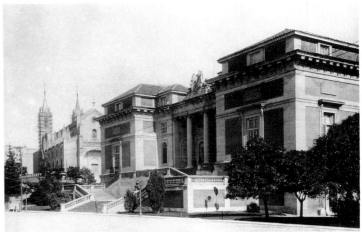

North facade of the Prado Museum before and after the construction of the first staircase

restoration of the compositions to Salvador Martínez-Cubells, a painter and chief restorer at the Prado Museum since 1869,[131] who was assisted in this task by his sons Enrique and Francisco. Exhibited at the Trocadero Palace in Paris during the Universal Exhibition of 1878, the paintings did not arouse the interest their owner had expected, and so, having rejected a number of offers of purchase, he decided finally to donate them to the Prado Museum.

Although not of the same momentous significance, the museum received a few donations more at the beginning of the 1880s, outstanding among which are gifts by Francisco de Palafox, Duke of Saragossa, and by Ana María González Velázquez. The former donated Goya's equestrian portrait of his father, General Palafox (no. 725), which the museum acquired on February 23, 1884; the latter gave that same year a portrait painted by her father, Zacarías González Velázquez, of her grandfather, the painter Antonio González Velázquez (no. 2495). Of greater importance, if only for the number of works, was the legacy left by the Duchess of Pastrana in 1889. It consisted of more than two hundred paintings, including Rubens's sketches for his Parada Tower compositions (nos. 2038–44), a painting by Drouais (no. 2467), a *Hunting Scene* by Charles de la Traverse (no. 2496), a Canaletto (no. 2478), and a balloon scene by John-Francis Rigaud (no. 2598).

During this period a number of improvements were made to the general condition of the building. Still, the repeatedly announced extension works were unforthcoming. Between 1882 and 1885, the architect Jareño directed the lowering of the embankment that affected part of the eastern facade and permitted direct access to the first floor on the northern side. It became therefore necessary to build a monumental staircase in order to maintain access through the door on this facade. Simultaneously, on clearing the ground floor on the eastern side, it became possible to open windows in the bottom section of the central body. This provided direct lighting for the sculpture gallery beneath the oval hall named after Queen Isabella II. An indirect consequence of this operation was the possibility of blocking the central eye-window that had formerly been the only light source for the lower hall, and thus was eliminated the absurd gallery that had impeded the correct appreciation of the paintings hanging there, the best in the whole museum. Remodeling work on the northern facade was completed in 1833 and crowned with the sculpture group by Geroni Suñol representing the *Allegory of the Three Major Arts*.

Work was carried out to improve the exhibition condition of the collections, seemingly without even the slightest concern on the part of the museum administrators to follow the most elementary logic in ordering the works on display, and even less to apply scientific criteria. Ceferino Araujo denounced the situation in 1887:

I have already pointed out the advantages of having all the paintings by the same artist displayed together, but today not only is this not the case but, collections referring to the same subject matter, which complement each other, are scattered, and triptychs which should be together are divided between three rooms. If the paintings were placed in order, the visitor would not have to tolerate the irritating experience of finding changes every time he comes to the museum and not knowing whether the canvases have simply been moved elsewhere, taken to the storeroom, or donated to another establishment. Disorder serves only to confuse. . . .

Serious and definitive steps must be taken. The paintings are constantly moved around merely to fulfil that condition of symmetry described by the critic in *La Crónica Artística* which had served as the basis in 1820.[132]

This was not the museum's most serious problem. We have already noted the chaotic situation that reigned inside the premises when Madrazo began his second term of office as director; ten years later nothing had changed. Given the general indifference to this state of affairs and with the intention of pricking the conscience of those in a position to take effective decisions to remedy the situation, on Wednesday November 25, 1891, Mariano de Cavia, a journalist sensitive to artistic matters, published the following fake report in the newspaper *El Liberal*:

LAST NIGHT'S CATASTROPHE.
SPAIN IN MOURNING
FIRE IN THE PAINTING MUSEUM.

The first news

Night, oh mournful night, we could say with D. Juan Nicasio Gallego, if the occasion were opportune for flowery rhetoric and if the idea of mournfulness could be associated with that of the terrible bonfire that at this very moment holds the whole of Madrid in the grip of fear and grief.

At two o'clock in the morning, when in order to close this edition all that was needed was the last minute news normally supplied by the Civil Governor's Office, we received from this official center a telephone call communicating this sinister and terrible news:

— The Prado Museum is burning!

The Prado Museum, burning! . . .

At that very moment the bells of the parish churches began their gloomy tolls. We rushed out into the street and on reaching the Puerta del Sol we saw the movement of a highly unusual number of people. In Cuatro Calles an imposing mass moved down the Carrera. . . . From the cafés, from the circles, from the casino, from the Veloz, from the Peña emerged the night owls in a disordered throng, and such was the hubbub of voices that at practically every window and balcony people looked out, their sleep disturbed by the row in the street.

— What a disgrace! What a catastrophe! Poor Spain! We have lost our only presentable possession! . . .

Thus did the people shout and rushed desolate to the Prado, avid to see in order to believe such a misfortune, hoping against hope that the reality would be less terrible than the fear.

But it was not so, the glare of the blaze illuminating the clouds gathering over Madrid seemed to say:

— Give up all hope!

The "Jettatura"

It is the evil shadow of Cánovas! Thus was the opinion of many. Two weeks had passed without any national catastrophe and, of course, matters could not go on this way. . . . No, Providence cannot forget us, and this reminder is far from gentle!

A conservative deputy, a friend of Messrs Silvela and Villaverde, a man with a sharp, witty tongue, exclaimed to a colleague of his from the newer generation:

— Friend, this is indeed a true *jettatura*. You do it better than us. A fine debut for Romero Robledo and Elduayen!

— And what about Linares Rivas? interjected an embittered *lopezdominguista*.

The truth is that without giving credit to superstitions, events seem to prove the superstitious right.

Even the most unconcerned citizen is forced to conclude that Spain is gripped by a cruel, evil and implacable destiny under the domination of the conservatives.

Mariano de Cavia

The fire

A cry of anguish, followed by violent imprecations, shouts of woe and even blasphemies poured from everyone's lips when the curious — and forgive the impropriety of the term — reached the Prado and saw the monumental building designed by D. Ventura Rodríguez [read Juan de Villanueva] crowned in flames, sending up columns of smoke towards the clouds and, from time to time, bundles of sparks like dazzling residues of the spirits of Velázquez, Murillo, Raphael, Rubens, Titian, and Goya. . . .

No, it was not only the eastern wing or just the western wing or the center of the building. What was burning was the whole museum, the entire museum, all four sides of the museum.

We heard an observer say: The whole of Europe will be saying tomorrow that Spain has lost one of the few jewels remaining on her crown. This is like the dismemberment of the homeland.

Some people wept. . . . Others rushed toward the building, following the soldiers who had arrived from the nearby Docks barracks.

From the central door emerged men carrying canvases — perhaps those of least value, the least interesting — which they had managed to cut from their frames with knives.

The water pumps worked with a difficulty we would call extraordinary if this were not normal in the case of this particular service. What can a handful of hose pipes do in the face of the proportions of the disaster? The jets of water directed toward the museum from the Explanada de los Jerónimos seemed to enliven the blaze rather than extinguish it.

Confusion was rife. Everyone gave orders; nobody obeyed. The authorities ran hither and thither when they were not immersed, like many people, in a kind of stupor as dumbstruck they watched the fire increase in magnitude.

—My God, what is this? we heard from Sr. San Pedro, Mayor of Madrid.

And the Marquis of Viana, civil governor, ignoring form and decorum, simply replied:

— The end!

Origin of the disaster

Pressure of time and the gravity of the circumstances do not permit us now to enter into details about the founding of the Painting Museum or to describe its splendid halls or its rich treasures.

Time will remain to us — if the *jettatura* of Sr. Cánovas does not do away once and for all with every Spaniard — to tell the country what at this very moment she is losing, what Humanity and Art is losing, due to the lack of official foresight.

Yes, the cursed and eternal lack of foresight on the part of our governors is the cause of this grievous catastrophe.

It seems that the fire broke out in one of the building's garrets occupied, as known by everyone, including those in a position to impede it, by a swarm of museum staff and employees.

There they cooked, there they lit fires for all kinds of household needs, there it was forgotten, when all is said and done, that a single spark was enough to destroy incalculable riches. . . . Furthermore, the floors and ceiling were the perfect agents of the destructive element, thanks to the weakness and flammability of their boards and webs of reeds, practically bare in all cases.

A still smoldering brazier or fire, a stew made at midnight, a cigarette end . . . and farewell *Wonder of Sicily*, farewell *The Lances*, farewell *Holy Family with Little Bird*, farewell *Testament of Isabella the Catholic*, farewell Virgins and Christs, Apollos and Venuses, heroes and drunkards, kings and jesters, goddesses by Titian and hermits by Ribera, visions by Fra Angelico and respites by Teniers!

Immense must be the responsibility of those who have not seen fit to stop such abuses in time and prevent dangers at the opportune moment; but what is responsibility in Spain? A hollow word.

The development minister, injured

Among the people we saw in the front line of the catastrophe was Sr. Linares Rivas.

— What a debut, as we heard someone say moments before.

The development minister was highly indignant on learning of the probable cause of the disaster.

He shouted: But what were my predecessors thinking? This was in a state of most scandalous neglect, in the most ignominious abandon. . . . Who could possibly tolerate

that in the museum's garrets lives a multitude with women, children, cats and dogs? How could the directors of public instruction consent to this? How could the ministers of development allow it?. . .

Sr. Linares Rivas, on seeing how little attention was being paid to his eloquent outburst, realized that this was not the moment for discourse but for action.

He therefore rushed with a determination worthy of utmost praise to the very scene of the danger. . . . Lost among the crowd of artillerymen, workers, and three of four of our press colleagues, he entered the museum through the front door.

Moments later we saw him being carried back out in the arms of several people who had snatched him from the jaws of certain death. On attempting to enter the main gallery, Señor Linares Rivas was hit on the shoulder by a blazing board as the ceiling collapsed.

It seems that the injury is not serious, not that this detracts in any way from the courageous and generous act of the minister of development.

A laudable but sterile sacrifice!

Last minute news

The misfortune suffered by Sr. Linares Rivas has increased the confusion and disorder among the authorities and their subordinates. The fire is at its most terrible height and the Prado Museum, the glory of Spain and the envy of Europe, is as good as lost.

With tears in our eyes we hurriedly close this edition, reproducing the following letter that has just arrived from the scene of the catastrophe:

"Dear friend and editor: As this is the first time I have ever acted as a reporter, I believe the result is not at all bad. Here you have a brief account of the sad events *that might possibly occur when they are least expected.*

Yours,

Mariano de Cavia"[133]

Not surprisingly, the article had tremendous impact. Just as Orson Welles's 1938 broadcast of his radio adaptation of *The War of the Worlds* by H. G. Wells spread panic all over the United States, many of the people who read Cavia's text in 1891 without noticing the final sentence believed that the chronicle related an absolutely real event.

Cavia's joke, if this is the appropriate word, was well received by the authorities. Aureliano Linares Rivas, recently appointed development minister and naturally flattered by the heroic role he had been assigned to play, found in the article the perfect justification for a set of immediate and drastic measures. To begin with, he announced that he would personally inspect the museum the following Saturday, alluding to a possible expulsion of the functionaries who lived with their families on the premises. For his part, Antonio Cánovas del Castillo, head of government, declared himself to be delighted by the journalist's invention, declaring that he had been preaching the same thing for fourteen years (although as a preacher he must have been thoroughly ineffective if during such a long period he achieved nothing positive!).

The following day, Thursday, November 26, *El Liberal* published a front-page article by Mariano de Cavia entitled "Why I set fire to the Prado Museum,"[134] in which he justified his text of the previous day. In his defense the journalist referred to fires that had broken out in the Monastery of San Lorenzo de El Escorial and in the Alcazares of Segovia and Toledo, as well as the theft of Murillo's *St. Anthony* from the Cathedral of Seville. He also presented as a precedent the alarm raised by the lord provost of London, saying that the British Museum was burning, in order to verify the efficacy of the city's fire service. Parallel to this, the newspaper carried out an investigation by which it discovered news of three arson attempts on the Prado Museum in the last fifteen years, one on October 10, 1878, and the other two just a few months before the article's publication, and within a short time of each other, on July 18 and 21, 1891. *El Liberal* published the information on Saturday, November 28, 1891.

That same day the development minister, Linares Rivas, accompanied by the inspecting architect, Señor Avalos, Señores Arbós and Samsó from the *Junta Inspectora*, and the head of the fine arts department, Señor Castro, inspected the Prado Museum from eleven in the morning until two in the afternoon. Their host was the museum secretary, since Federico de Madrazo was indisposed. During the visit the basements were inspected, and the minister "was horrified at what he saw; pile upon pile of timber and firewood." To make matters worse, in order to inspect the basements candles were necessary, since there was no other form of lighting. It is hardly surprising therefore that Linares immediately ordered all that inflammable material to be removed by the following Monday. Another point of conflict was the room where the copiers kept their easels, canvases, and work utensils, among which was paint, oils, and solvents such as turpentine — in other words a set of highly inflammable materials. When the ministerial committee entered the room, they found an unattended brazier that was alight! Elsewhere it was observed that the stove chimneys passed among large piles of wood.

Linares had announced his forthcoming visit on the day Cavia's article was published, yet despite the interval of three days those responsible for the museum had been incapable of lifting even a finger to alleviate the dangers, as if they were sunk in a depressive lethargy. As one might expect, *El Liberal* gave an account of the minister's visit in its edition no. 4546, dated Sunday, November 29, 1891.

Needless to say, all the museum personnel living on the premises were evicted and the materials that presented potential causes of fire removed. Nevertheless, nothing was done to eliminate another aspect of the museum's organization that represented a major threat to the security of the establishment: the concession granted to the director (Federico de Madrazo) and to the subdirector (Luis Alvarez Català) that allowed them to have their own private studios in the building. This carried with it an unnecessary stream of customers, models, and visitors that upset the correct application of the opening and closing times of the museum.

The question of how to treat works by contemporary artists in the context of the Prado Museum was present from the very foundation of the establishment. When its doors were opened to the public for the first time, on November 19, 1819, a hall already existed for works by either recently deceased artists (such as Maella or Bayeu) or those still living (such as Goya, Aparicio, or José Madrazo himself). We have already seen that in the Museo Nacional de la Trinidad when Gregorio Cruzada Villamil published his catalogue in 1865, he included the 760 paintings acquired by the state from the National Fine Arts Exhibitions. Five years later, on November 25, 1870, José Echegaray, the development minister, in his preamble to the decree by which a committee was set up to study the fusion of the Prado Museum and the Museo de la Trinidad, took the separation of contemporary works a step further: "using the modern works acquired as a base, soon a contemporary museum might be set up in which would figure paintings and statues signed by artists awarded prizes in the foremost exhibitions held abroad."

In other words, the idea gradually began to take shape that the Prado Museum should be devoted to artists of the past, already consecrated by history, while the work of living or recently deceased artists should be grouped together in a separate museum contemporary art. In 1894 it seems that the decision had finally been taken, and some of the paintings from the museum's Contemporary Painting Hall were removed, to be housed in what four years later would be opened as the Museum of Modern Art.

VICENTE PALMAROLI (1894–96)

Federico de Madrazo died on June 11, 1894. To replace him Vicente Palmaroli was appointed director of the museum, maintaining the long-standing tradition of a painter-director. Luis Alvarez Català continued as subdirector. Palmaroli was able to achieve little, since he died just one and a half years after having taken up his

post, on January 25, 1896. The only events of note that took place during his tenure were three donations.

The first was made in 1894 by Ricardo Blanco Asenjo and consisted of a sixteenth-century Flemish panel (no. 2224). At the end of this year, on November 27, the Marchioness of Cabriñana ceded four panels from the fifteenth and sixteenth centuries. Two of these contributed to the scantily represented Dutch school; one was by Paulus Potter, *Landscape with Two Cows and a Goat* (plate 250), and the other, the *Young Draftsman* (no. 2127), was signed by Gérard van Palthe. The remaining two were a *Saint Hieronymus* (no. 2185) by the German Israhel van Meckenen and an exquisite composition of *The Virgin and Child Between Two Angels* (no. 2543) by the Flemish painter Hans Memling.

The third donation, made in 1895 by one of the sons of the late Federico de Madrazo, the painter Raymundo de Madrazo y Garreta, was of special significance. It consisted of two of the tapestry cartoons by Goya taken from the Royal Palace in 1869, belonging to the first period when the Aragonese painter collaborated with the Royal Tapestry Manufactory of Santa Bárbara: *Hunting Dogs and Utensils* (no. 753) and *Majo with Guitar* (no. 743) painted in 1775 and 1779, respectively.

FRANCISCO PRADILLA ORTIZ (1896–98)

The period during which Francisco Pradilla Ortiz was director of the museum was neither very long nor very brilliant. Indeed, the celebrated painter of such canvases as *Doña Juana la Loca* and *The Surrender of Granada* did not show any particular liking for a post of undoubted prestige which he occupied as from February 3, 1896.

Only a few months after Pradilla's appointment, an excellent opportunity arose to acquire a series of first-class paintings. Unfortunately that opportunity was missed. In 1896 the Osuna Collection was sold after the noble family was ruined due to the irresponsible handling of their finances. Among the works put up for auction were two series by Goya, which were sold at very reasonable prices. One of them consisted of seven canvases painted in 1787, commissioned by the Duchess for the Alameda de Osuna, which were acquired by the Duke of Montellano, the counts of Romanones and of Yebes, and by the Hungarian Marzel von Nemes. The second series was of six small witchery paintings that were purchased from the artist by the Duke and Duchess of Osuna in June 1798, of which two were acquired by José Lázaro Galdiano and another two by the National Gallery of London. Of the whole lot, the Prado Museum managed to acquire only the magnificent *The Duke of Pastrana* (plate 65) by Juan Carreño de Miranda, for the then-considerable sum of 15,000 pesetas.

Fortunately for the museum, private individuals continued to make donations. In 1896 it acquired the portraits of *Tadea Arias de Enríquez* (no. 740) by Goya, donated by Luisa and Gabriel Enríquez, the subject's grandchildren, and of *San Juan de Ribera* (no. 947) by Luis de Morales, ceded by María Enríquez de Valdés. The following year the family portrait of the *Duke and Duchess of Osuna and Their Children* (no. 739), also by Goya, was acquired, thanks to the generosity of the subjects' descendants.

The fact that the museum received major donations does not mean that its administrators were concerned with showing the new acquisitions to the public. Evidence of this neglect was a complaint made to the museum authorities in 1897 by one of Baron d'Erlanger's sons that the Black Paintings, almost a quarter century since they had been donated, were still not exhibited and that the name of his father as their donator did not figure anywhere.

Another negative event occurred in 1897. The slack security facilitated the theft of a canvas by Murillo representing *Saint Anne Teaching the Infant Virgin Mary to Read* (no. 873), a sketch for the painting of the same subject (no. 968).

Nevertheless, among the many people linked to the museum there were some concerned with modernizing it and giving it a more scientific orientation. This was

the departure point for a new concept of what a museum should be. Thanks to these people, in 1897 a new set of inner regulations was published, which stipulated the director's obligation to

> maintain correspondence with the directors of national and foreign museums in order continually to perfect of the catalogue as regards the classification of the works and the biographical notes concerning their authors . . . [and] create inside the museum a specialized library in which it is possible to study the history of art . . . with the catalogues of all the museums and art galleries in Spain and abroad, for which donations will be sought from private individuals and from public establishments.

In other words, the museum was not assigned its corresponding budget or, if it was, this was not very generous. The subdirector, who must have spoken French, was obliged to "carry out correspondence concerning artistic and administrative matters and to be in charge of the library and archive."[135]

Francisco Pradilla cannot have been very enthusiastic about these new regulations, since on July 29, 1898 he resigned as Director of the Museum.

LUIS ÁLVAREZ CATALÁ (1898–1901)

Appointed in Pradilla's place was Luis Álvarez Catalá, museum subdirector since the time of Federico de Madrazo, who on two occasions had seen colleagues of his from the outside be granted the post ahead of him. His appointment coincided essentially with the inauguration, on August 1, 1898, of the Museo de Arte Moderno, to which were taken the works from the Prado's so-called Contemporary Painting Room.

The year 1898 was also the ill-fated year of the Spanish-American War. From the very beginning it was clear that this venture could only bring disaster for Spain. An enigmatic article by Rodrigo Soriano entitled "Arte, millones . . .," published in the December 18, 1923, edition of *La Libertad*, refers in retrospect to the evaluation of work in the Prado Museum during the Spanish-American War. Apparently the evaluation was carried out with a view to either use the museum as a possible guarantee for a loan or even to sell it in order to obtain money with which to finance the war or face the costly reparations it was anticipated the United States would demand. The works of Velázquez were valued at 18,600,000 francs, those of Rubens at 4,000,000, and those of Goya at 3,000,000.

Fortunately the matter went no further than this, although if such an intention really did exist, it is clear evidence of the imprudence and incompetence of those in control of Spain's destiny. This ominous episode ended on December 10, 1898, with the signing in Paris of the peace treaty between Spain and the United States. As a final reference to the repercussions the war might have had on the country's foremost painting museum, suffice it to say that the American collector Henry O. Havemeyer lamented the fact that as compensation to the United States his government had demanded the Philippines instead of the Prado Museum.[136]

After Spain's humiliating defeat at the hands of the United States, the country became thoroughly demoralized, but life went on, and in 1899 the third centenary of the birth of Velázquez was celebrated. There were none of the great demonstrations that might have been expected under happier circumstances, but there was an official desire to commemorate the event. On June 6 a solemn act, presided over by the queen regent, was held to inaugurate the new installation of the works by the master from Seville in the great oval room, formerly known as the Room of Queen Isabella, where they still are today. The organizing committee was headed by the eminent art historian Aureliano de Beruete, the future director of the museum, who on this occasion also reviewed the catalogue of paintings by the artist. Subsequently Beruete published a monograph on Velázquez, which is considered one of the classics in the artist's bibliography. One week later, on June 14, a monument to Velázquez, the work of

Inauguration of the Velázquez Hall on June 6, 1899. Drawing by Comba

the sculptor Aniceto Marinas, was unveiled opposite the entrance to the museum. Carolus Durán and Jean Paul Laurens, representing French painters, attended the ceremony and placed a floral wreath before the monument.

Luis Álvarez Catalá passed away some four months later, on October 4, 1901.

**JOSÉ VILLEGAS
(1901–18)**

The successor of Álvarez Catalá was another painter who, following the new regulations, introduced changes in the administration of the museum and carried out major reforms. Such inner chaos resulted that the figure of Villegas as a museum director is surrounded by controversy. Outstanding among the innovative measures he introduced was the organization of one-artist exhibitions, the first of which was devoted to the work of Doménikos Theotocópoulos, better known as "El Greco," in 1902. Then came that of Zurbarán, in 1905, and later, in 1915, that of Luis Morales, called "El Divino."

Villegas also concerned himself with the publication of the museum's treasures. He entrusted the preparation of the sculpture catalogue to Eduardo Barrón, a sculptor himself, the first time that such an essential task was commissioned. The catalogue was completed in 1909. Perhaps its commission is one of the reasons why the result was so modest in comparison to the magnificent painting catalogue produced by the director Pedro de Madrazo in 1872. Despite this, however, the work was a useful one and the only one of its kind until 1969.

From the ministry, still in the spirit of the 1897 regulations, the activities of the museum were oriented in a more scientific manner. A clear will to properly care for and conserve the works and to improve the efficiency of the administration of the establishment was evident. Magnificent proof of this is the 1910 appointment of Pedro Beroqui as secretary of the museum. Beroqui was one of the best-versed persons in the museum's history and the author of a capital monograph on this subject.

On June 7, 1912, following a proposal by Santiago Alba y Bonifaz, Minister of Public Instruction and Fine Arts, Alphonso XII sanctioned a Royal Command creating the Board of Trustees of the Prado Museum.[137] This board was set up with a view to revitalizing the museum, endowing it with a new capacity for the administration and control of the collections, and raising the scientific level of its activities, at the same time potentiating its role as an organism to diffuse the world of art. The minister's text makes these points clear:

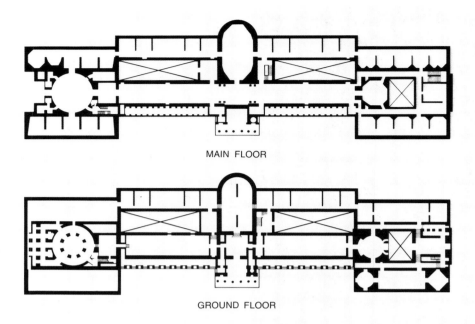

MAIN FLOOR

GROUND FLOOR

Plans for the main and ground floors of the museum after the extension of 1914–18

New bases for the transformation and extension of the building; communication with the leading museums worldwide and with others in Spain, where a considerable artistic and historical wealth lies ignored and, in many cases, in danger of disappearing; preparation of special exhibitions and organization of lectures, the first for high-level critical purposes, the second to provide information about the art world; review and contrast of the old inventories of works contained in the deposits of corporations and institutions of all kinds; stimulation and guidance of donations on the part of private individuals, hitherto highly limited by the notorious lack of contact between citizens and centers of the State.[138]

According to this decree, the board of trustees was to be composed of nine members, including three members of the board of directors: the inspector general of fine arts, the director of the museum, and the secretary of the same institution. However, a few months later, on March 14, 1912, it was considered advisable to increase the number to twelve, plus the three directors. The Duke of Alba was named president, Jacinto Octavio Picón, vice-president. Membership consisted of Gustavo Bauer, José Lázaro Galdiano, Pablo Bosch, Aureliano de Beruete, Alejandro Saint-Aubin, Elias Tormo, the Marquis of Casa-Torres, the Marquis of Vega-Inclán, Manuel Bartolomé Cossio, and Luis de Errazu, in addition to the three museum board of directors members, José Joaquín Herrero, José Villegas, and Pedro Beroqui. Notable is the presence of art historians (Aureliano de Beruete, Elias Tormo, and Pedro Beroqui) and collectors, some of whom became donors of works to the museum (José Lázaro Galdiano, Pablo Bosch, and Luis de Errazu).

The incorporation of suitably qualified art historians continued in October 1913 when Francisco Sánchez Cantón was commissioned to update the museum's painting catalogue. In 1914 the new museum board of governors, fulfilling the stipulations in the preamble of the founding decree, finally undertook the project of expanding the museum. That year saw the beginnings of the addition of new halls along the eastern facade of the building. Highly respectful of the work of Villanueva, the new constructions did not affect the old ones, and a courtyard was built to separate them. The work lasted several years, until the new sections were inaugurated in 1920.

These first years of the twentieth century were also rich in donations. The first was by Ramón de Errazu, which arrived in 1904 and was composed of twenty-five paintings by several first-class nineteenth-century artists, including Fortuny (*Fantasy*

Ramon de Errazu

Pablo Bosch

of *Faust*, no. 2605, and *Moroccans*, plate 116), Raymundo de Madrazo (*Portrait of Ramón de Errazu*, no. 2614), Martín Rico, Meissonier, and Baudry. The following year the Duchess of Villahermosa offered the museum two portraits by Velázquez, one of *Antonia Ipeñarrieta y Galdós with Her Son Luis* (no. 1196), and the other of her husband, *Diego de Corral y Arellano* (no. 1195).

In 1912 the Prado received two legacies. Thanks to one of them, from Cristóbal Ferriz, the museum was enriched with the *Portrait of Feliciano Bayeu* (no. 740h) by the subject's father, Francisco Bayeu, and with two magnificent works by Goya of terrifying iconography: *The Beheading* (no. 740i) and *The Bonfire* (no. 740j). The second donation that year was even more important, thanks to the munificence of the donor, the Hungarian collector Marzel von Nemes. His contribution was the large canvas depicting the *Relief of Genoa by the Second Marquis of Santa Cruz* (plate 60) by Antonio de Pereda. This was the only one of the series of battle paintings that had originally decorated the Salón de Reinos of the Palace of Buen Retiro which was not already in the Prado, since it had been stolen by the French general Sébastiani during the Napoleonic invasion.

This series of legacies is closed by the most spectacular of them all and one of the most outstanding in the whole history of the museum: the one given in 1915 by Pablo Bosch, a member of the board of trustees. It consisted of 89 paintings, 946 medallions, and 825 coins, plus 25,000 pesetas destined for the installation of the donation. Among the paintings were works by Bosch, Alonso Cano, Antonio Carnicero, Gerard David, Fernando Gallegos (*The Saviour*, no. 2467), Corrado Giaquinto, Goya, El Greco, Jaime Huguet, Jorge Inglés, Adriaen Isenbrandt, Vicente López, Luis de Morales (*Madonna and Child*, plate 20), Peter Neefs, Van Orley, Marinus van Reymerswaele (*Saint Hieronymus*, plate 206), Hyacinthe Rigaud, Francesco Solimena, and Antoni Viladomat.

These were not the only additions to the number of catalogued works by great masters in the museum. The painstaking exploration of the unclassified painting storerooms allowed the recently appointed subdirector, José Garnelo, to recover in 1915 the magnificent painting of *The Stigmatization of Saint Francis* (no. 365a), signed by Giovanni Battista Tiepolo. The large canvas was found rolled up and in a bad state of repair, but fortunately the skill of the restorer, F. Amutio, returned it to its original splendor.

Garnelo's efforts notwithstanding, the museum was dealt a serious blow when, on September 20, 1918, José Villegas reported the theft of several of the pieces forming the so-called Dauphin's Treasure. As related in the press the following day, Garnelo had warned that the central showcase of the three housing this collection was open, and that several pieces were missing. The thief had apparently been able to act with absolute tranquillity, since the removed stem of one of the goblets was found in the open case, and the objects had been rearranged to disguise the robbery. Furthermore, the thefts were not the result of a single action, but had been carried out over an extended period of time. Two months previously Anselmo Arribas, a museum watchman, had told the concierge, José García, that it seemed to him that pieces were missing from the case. Indeed, later (on October 15) it was discovered that one of the stolen pieces had been pawned for 150 pesetas at least one year previously.

On September 22, 1918, José Villegas justified the concierge's having paid little heed to his subordinate's warnings by indicating that several objects from the Dauphin's Treasure had been in the hands of the restorer and that consequently, he had assumed that these were the items the watchman had found missing. At that time the photographers Campúa and Zegri checked the contents of another display case and discovered that other pieces were gone. News of this was brought to the subdirector, but instead of thanking the two photographers for their assistance, he threw them out of the museum. When an inventory of the objects remaining in the cases was made, it was discovered that eighteen pieces, all of them of agate with

gilt decoration and cameos and precious stones, were either missing or seriously damaged.

A week after the discovery of the theft, on September 27 and 28, José Lázaro Galdiano, a member of the museum's board of trustees, gave two lectures in which, besides attempting to justify the conduct of José Villegas, he expressed his disagreement with four specific aspects of the organization and functioning of the museum. First he denounced the dispersal of the paintings from the Museo de la Trinidad, adding that he had set up a committee to inspect these five hundred canvases. Then he criticized the rule that stipulated that the director of the museum had to be not only an artist but also a first-prize winner. He also faulted the criteria for restoration applied in the museum, which he considered to be excessive (he gave as examples the cases of *The View of Saragossa* (plate 58) by Mazo, and the *Offering to the Goddess of Love* by Titian). Finally Galdiano expressed his opposition to the existence in the museum of the private studios of the director and subdirector, for the following reasons:

> The director and his two subalterns, and this is something that will amaze all those versed in this subject, set up in the Prado their painting and sculpture studios, where they spent hour after hour receiving and dismissing their models and purchasers of their works while the public was visiting the halls. And who knows if they did not also work there after hours! If one bears in mind that the museum closes at one o'clock in the afternoon in summer, it would not be unreasonable to suppose that after that time they would want to work and, as a result, permit the entrance of their collaborators.[139]

Police investigations, which continued until the middle of October 1918, led to the arrest of those alleged to have been responsible for the theft: Rafael Coba, a museum functionary from early 1917 until April 1918 and the main suspect; Darío Fernández, Félix Velloso, and Alejandro Varela, three museum watchmen suspected of complicity; and an expert silversmith, Isidro Agruña, suspected of having acquired part of the booty. The trial took place a considerable time later, from November 15 to 20, 1919.

In the meantime José Villegas refused to acknowledge his indirect responsibility in the affair, so that Mariano Benlliure, the director general of fine arts, had to force him to resign as director of the museum. For his part, José Garnelo, the subdirector, fell gravely ill to the point of being close to death.

AURELIANO DE BERUETE Y MORET (1918–22)

Lázaro Galdiano's opinions regarding the professional profile desirable for the director of the museum were shared by a considerable number of the members of the board of trustees. In early December of 1918 it was proposed that Aureliano de Beruete y Moret be named the new director of the museum and that Fernando Alvarez de Sotomayor be appointed subdirector. The proposal was heartily approved by people of intellectual caliber and common sense, such as Mariano de Cavia, for example.[140] The appointments took effect on December 31. For the first time the director of the museum was neither a painter nor a member of the court nobility, but rather a prestigious art historian with a long list of publications to his credit (*Velázquez*, 1898; *The School of Madrid*, 1909; *Valdés Leal*, 1911; *Goya* (three volumes) 1917–18, and the *Catalogue of the Exhibition of Portraits of Spanish Women*, 1918).

One of the first decisions taken by Beruete when he became director of the Prado was to appoint a commission entrusted with the task of reviewing the archives with a view to publishing a new painting catalogue to appear in 1920. Pedro Beroqui was placed at the head of the project, and so that the high scientific level of the work would be guaranteed, in January 1919 the board of trustees sent eminent art historians abroad invitations to study and catalogue the museum's paintings. Among those who responded favorably were Bernard Berenson (Italian painting), George Hulin de Loo and Max Friedlander (Flemish primitives), Hermann Voss (Mannerists and the Baroque), and Marcel Nicolle (the French School).[141]

Taking advantage of Berenson's presence in Madrid, Beruete asked his impression of a panel that was currently for sale: *The Virgin of the Knight of Montesa* (plate 13), attributed to Paolo de San Leocadia. The positive opinion expressed by the Italian painting specialist convinced Beruete of the need to acquire the work for the museum. The panel was the property of the Valencian antique dealer Albarrán, who had fixed its price at 100,000 pesetas. On July 10, 1919, the board of trustees of the Prado Museum learned that the Bilbao shipbuilder Horacio de Echevarrieta was prepared to put forward the necessary sum for the acquisition of the panel and, if the work came to form part of the museum's collections, would accept only 90,000 pesetas in return. As a result of this generous proposition, a public subscription was convoked. However, opinions were divided as to the sense of acquiring the piece; from October 1919 the press echoed the controversy, articles by Angel Sánchez Rivero appearing in the weekly *España* opposing to the purchase, while Margarita Nelken, in *Le Figaro*, and Angel Vegué y Goldini, in *El Imparcial*, supported the operation. Despite this, the sum of 75,490 pesetas was collected; the board of trustees supplied the remaining 14,510, and the panel entered the museum in June 1920, registered as no. 1355. This was the first work the museum acquired by public subscription.

November 19, 1919, marked the first centenary of the Prado Museum, although the occasion passed by practically unnoticed. One of the few events that took place was a lecture delivered by Elias Tromo in the central gallery of the museum. The lack of festivities commemorating the occasion was hardly surprising, since legal proceedings had begun to clarify the affair of the theft of the Dauphin's Treasures just four days earlier. This was hardly the most propitious moment for celebrations, especially in view of how the proceedings were developing.

The jury's verdict was given on November 20, and despite the weight of evidence presented, Rafael Coba was declared guilty only of being an accessory after the fact and sentenced to six months and one day of imprisonment (which he had already more than served in preventive detention). The other accused, the watchmen Darío Fernández, Félix Velloso, and Alejandro Varela, and the silversmith Isidro Agruña, were absolved.

Given the lenience of the jury and the passiveness of the state, which did not even appeal the sentence, a people's movement came into being in rejection of the attitude of "Justice." The daily *El Sol* published a note of protest, requesting the public's support. Outstanding among the many signatories of the petition were Valle-Inclán, Jacinto Benavente, Azorín, Pío Baroja, Quintiliano Saldaña, Manuel Azaña, and Constancio Bernaldo Quirós. The names of painters and sculptors were notable for their absence. This note of protest never went beyond having a purely symbolic character: delivered to the Minister of Justice, he simply passed it on to the Minister of Public Instruction.

When Beruete became director of the museum the last stages of the construction of the new halls, along the eastern facade of the building, were being completed. Immediately he began to study the remodeling of the rooms, according to more scientific criteria regarding the arrangement of the works. Evidence of the meticulousness with which the remodeling was performed is the series of watercolors the new director commissioned from Fernando Alvarez de Sotomayor, subdirector of the museum, as preparatory sketches for the final installation of paintings on the different walls. In 1920 the remodeling of three old halls was begun; two being devoted to Velázquez and one to Goya, very well accepted by public and specialists alike. Soon afterward the twenty-three new rooms were opened. Despite the space gained, as the result of new exhibition criteria that avoided the stacking of previous periods, it was still impossible to eliminate the storerooms. Works that while not of extraordinary quality could nevertheless be considered of interest to historians continued to be kept there.

At this time the museum library also enjoyed the beginning of a new period of prosperity. Unfortunately that prosperity was soon interrupted by the Spanish Civil War and not resumed until much later.

Coinciding more or less with these events, on May 14, 1920, Alphonso XIII sanctioned a Royal Decree by which the official name of the museum ceased to be the Museo Nacional de Pintura y Escultura to become simply Museo Nacional del Prado. The same decree approved the administrative and function regulations, which remained in force until 1985.

During Beruete's short term as director of the Prado, the museum's collections were also enriched with the acquisition of a number of works. The extraordinary panel entitled *Saint Domingo de Silos Enthroned as Abbot* (plate 11) by Bartolomé Bermejo was acquired from the National Archaeological Museum; so were the compartments of an altarpiece depicting the *Legend of Saint Michael* (no. 1332) by the so-called Master of Arguís and a *Saint Vincent* (no. 1334) by the so-called maestro of the Archbishop Mur, who has been identified as Tomás Giner. Moreover, in 1921 Dr. César Cabañas donated a splendid *Saint John the Evangelist* (no. 2444) by El Greco.

Unfortunately the first art historian to become director of the Prado was not allowed to fully develop a program that though scarcely initiated, already offered excellent prospects for the museum. After a long illness, on June 22, 1922, Aureliano de Beruete y Moret died at the age of forty-six.

FERNANDO ÁLVAREZ DE SOTOMAYOR
(1922–31)

Despite the fact that placing a scholar in charge of the museum had proven a positive step, the board of trustees and the government agreed to appointing the former subdirector, Fernando Álvarez de Sotomayor, as Beruete's successor, thus returning to the tradition of placing a painter in the position. Still, they were determined to balance the situation, and thus appointed as subdirector an art historian who had been linked to the museum since 1913 and who would be one of the Prado's solidest stanchions for almost half a century: Francisco Javier Sánchez Cantón.

In order finally to complete the definition of the legal structure of the Prado Museum, determined by the royal decrees of June 7, 1912 (creation of the board of trustees) and May 14, 1920 (new denomination and regulations), on April 4, 1927, Alphonso XIII sanctioned a third disposition by which the National Museum of El Prado was granted its own juridical status and functional autonomy.[142]

The policy of stimulating donations to the Prado Museum, recognized by the minister Santiago Alba on creating the board of trustees, continued to gather fruit during the years prior to the Spanish Civil War. Private individuals ceded works to the museum almost every year. To these canvases were added those purchased directly by the board, so that the increase in the collections was considerable.

In 1922 the *Portrait of Josefa de Manzanedo* (no. 2603) by Raymundo de Madrazo was donated, and the following year Andrea del Sarto's *Saint John the Baptist with a Sheep* (no. 579) was bought in Paris. In 1924 the Board of Trustees bought from Zafra *The Archangel Saint Michael* (no. 1326), the work of an anonymous fifteenth-century painter; in its turn, the magnificent work by Tiepolo depicting *Abraham and the Three Angels* (plate 182) was generously donated by the Sainz family, while the large canvas with the composition of *Saint Buenaventura Taking the Franciscan Habit* (no. 2411a) by Francisco Herrera "the Elder" was ceded by Dr. Carvallo in 1925. That same year saw donations from Luis de Castro y Solís (among which was a panel by Isenbrandt) and from Fernando de los Villares y Amor, as well as the purchase of Van der Weyden's *Piety* (no. 2540).

In 1926 Luis de Errazu, one of the museum board members, ceded several works, notable among which are a fragment of *Saint Pascual Bailón* (no. 364a) by Tiepolo, of which work the Prado already possessed another fragment (no. 364); the effigy of *Julián Romero Wearing the Habit of the Order of Santiago* (no. 2445) by El Greco,

and several portraits by Pietro Martire Neri, Angelica Kauffmann, and Hoppner. For his part, the Count of Niebla presented three portraits by Goya, those of *María Antonia Gonzaga, Marchioness of Villafranca* (no. 2447), of her son and husband of Cayetana de Silva, *José Álvarez de Toledo, Marquis of Villafranca and Duke Consort of Alba* (no. 2449) and of *María Tomasa Palafox, Marchioness of Villafranca* (no. 2448), sister-in-law to the previous subject. In the same year a possible *Self-Portrait* (no. 2511) by Alonso Sánchez Coello was acquired, and the following year a fifteenth-century panel signed by Maestro Bartolomeus representing the *Virgin of the Milk* (no. 1322), a copy of a *Self-Portrait* (no. 2912) by Murillo, and a panel with *The Visitation of the Virgin to Saint Isabella* (no. 2541) by a student of Juan de Flandes.

The series of donations continued with one from General Mille's widow in 1928 (*Saint Teresa de Jesús in Glory*, no. 2531, by Bayeu) and one from Enrique Puncel in 1929 (*Vision of Saint Sebastián de Aparicio*, no. 2484, by Maella, and the *Festivity in a Garden*, no. 2477, attributed at the time to Amigoni). Purchases were *The Rich Man Epulon and the Poor Man Lazarus* (no. 2509) by Juan de Sevilla; a *Family Portrait* (no. 2525) by Jan van Kessel; the *Retable of Don Sancho de Rojas* (no. 1321) by Rodríguez de Toledo; what is assumed to be a *Self-Portrait* (no. 2476) by Bernini; and the exquisite *Saint Damian* (no. 1339) by Fernando Yáñez de la Almedina.

The most intense year as far as the acquisition of works is concerned was without any doubt 1930. The legacy of Pedro Fernández Durán, for example, consisted of almost one hundred paintings, among them the exquisite *Virgin and Child* (plate 190) by Van der Weyden and and five magnificent canvases by Goya: *The Colossus* (plate 98), a portrait of *General Antonio Ricardos* (no. 2784), and sketches of the cartoons for tapestries entitled *The Blind Hen* (no. 2781), *The Drunken Bricklayer* (no. 2782), and *The Hermitage of Saint Isidore on the Day of the Festivities* (no. 2783). He also gave the museum a series of tapestries, embroideries, armor, and other objects, as well as a major collection of 2,785 drawings (raising the total of drawings in the Prado to 4,000).

The same year Xavier Lafitte presented the museum with sixteen paintings, including the *Old Usurer* (no. 2506) by Ribera, two Neapolitan landscapes (nos. 2462 and 2463) by Luigi Vanvitelli, a couple of *Vases* (nos. 2507 and 2508) by Juan de Arellano, and an *Annunciation* (no. 2512) by Luis de Morales. Purchases were a *Retable of Saint John the Baptist and Saint Catherine* (no. 1336, by Juan de Sevilla, also called Juan de Peralta), a predella (no. 2519) signed by Miguel Ximenez, six panels by the Maestro of Sisla (*Annunciation*, no. 1254; *Visitation*, no. 1255; *Adoration of the Wise Men*, no. 1256; *Presentation in the Temple*, no. 1257; *Circumcision*, no. 1258; and *Passage of the Virgin*, no. 1259), a *Saint Hieronymus* (no. 2503) by Antonio del Castillo, and the *Epiphany* (no. 2470) by Brueghel "the Elder."

Furthermore, that year the Count of Cartagena presented the museum with a gift of 300,000 pesetas with which to purchase paintings. With this sum, excellently administered by the board and by Sánchez Cantón (some money was even left over), fifteen works were acquired in the following years, among them paintings by Maino, Paret, Tiepolo, Valdés Leal, and Zurbarán.

During these years efforts continued to improve the overall conditions of the building. Juan de Villanueva's original plan centered the exhibition halls mainly on the first floor, access to which was gained directly from the embankment by the north facade. For this reason, the staircase connecting this floor with the ground floor was purely functional and rather narrow. In order to take maximum advantage of the building, with accesses also from the ground floor, a large staircase connecting the two floors was necessary. Entrusted with the design of the staircase was the architect Pedro Muguruza, who placed it in the section adjacent to the oval room, between the new rooms along the eastern facade and the central gallery, on the right as one enters the main door. The new staircase was inaugurated on September 20,

1925, and by way of praise suffice it to say that it seems as if it had always been there.[143]

Work was next carried out to improve the structure of the vault covering the central gallery, replacing the false reed and plaster with for a real one in concrete, capable of withstanding a possible collapse of the roof. This work, essential for the protection of the collections, was inaugurated on December 12, 1927. Finally, in 1929 and 1930 the top floor of the northern wing was remodeled in order to house the donation from Fernández Durán.

A number of exhibitions were also organized in the 1920s, of which the most important was one held in April–May 1928 to commemorate the first centenary of the death of Goya. To the museum's own paintings were added over ninety loaned by private collectors and other institutions, making it very difficult for a show of this magnitude ever to be repeated. For the occasion a number of new rooms were opened on the ground floor to display the tapestry cartoons. Less spectacular, perhaps, but of great dignity and art-historial interest, was the exhibition commemorating the 150th anniversary of the death of Anton Raphael Mengs, held in 1929.

THE SECOND REPUBLIC (1931–36)

RAMÓN PÉREZ DE AYALA (1931–36)

On April 14, 1931, the Second Republic of Spain was proclaimed. Fernando Álvarez de Sotomayor, a staunch monarchist, resigned as director of the museum in order to avoid serving the new regime. He was succeeded by Ramón Pérez de Ayala, a novelist who had no particular predilection for ancient painting or art. In fact, he was never really active in his position, since he was also appointed Spanish ambassador to London, and the museum was actually run by its subdirector, Francisco Javier Sánchez Cantón.

The change in the political regime caused no upsets to the inner organization of the institution. The board of trustees retained its attributions, under the presidency of the Duke of Alba. Picón, Bauer, Bosch, Saint-Aubin, and Errazu had all died by this time, and they were succeeded at different times by Boix, Gómez-Moreno, the Count of Casal, the Count of Peña Ramiro, the Count of Romanones, Mariano Benlliure, Allendesalazar, Beistegui, Marañón, Ovejero, and Sánchez Cantón.

The board was determined that the Prado Museum attain increased international recognition, not only in terms of its collections but also owing to its potential for academic contributions. Thus in 1934 a meeting of the International Museum Council (dependant upon the League of Nations), was organized in Madrid in which the Prado played a major role. The following year a joint exhibition was held in Madrid with works provided by the National Chalcographies of Rome, Paris, and Madrid.[144]

These cautious attempts to open out to the world were not enough for the local community of art historians. Enrique Lafuente Ferrari captured the general feeling in a series of articles published in 1935 in the periodicals *La Epoca* and *Ya*, in which he called for a more open relationship with museums abroad, especially in regards to the loan of works for major exhibitions. He bemoaned, for example, the absence of Spain in the Brussels Exhibition and in the one on Italian Art, held in Paris, both in 1935. His exact words were these:

One of the most formidable exhibitions to have been held for many years was the astonishing collection of Italian masterpieces brought together in the Petit Palais. In this field Spain can also hold her head up high. Spain, the country of the "amateur" kings, the country that protected Titian, bought priceless paintings and commissioned sculptures from Michaelangelo, was absent from this kind of international "record" to which contributions have been made from the United States to Russia, from Portugal to Turkey. A few months ago a "fortunate" decree forbade Spanish museums from contributing to exhibitions of this kind: congratulations to those who believe that this

is the road to follow. In any case it represents one more lock on the barrier of isolation behind which we happily imprison ourselves to spend our energies on cafe conversations, narrow-minded ambitions, and that bilious passion we call politics.

In Paris, capital of culture, while the success of the Italian exhibition was still resounding, the idea was born of holding a similar one on Spanish art next year. We should logically be flattered by this French project to place our art after that of Italy and provide it with the never-to-be-scorned opportunity to gain international recognition. We Spaniards have so few chances to win battles, either bloody ones or not, that it seems that this one is not to be missed. However, it is to be feared that official spheres will reply evasively to such an honorable suggestion. I have already commented on our administration's attitude when, in the belief that prevention is better than cure, they issued this year a wise decree forbidding Spanish museums from participating in this kind of exhibition.[145]

However, it was not only a question of opening outwards. The problem was a far more serious and deeper one. Blas Taracena referring to works carried out in the Prado, called for a more coherent museum policy in January 1935:

> If this initiative is compared to the sweet slumber in which Spanish museums have been immersed for the first quarter of this century, then we must acknowledge the good will of the State. However, this plausible rejuvenating action is still far from being a true museum policy. What is lacking is an essentially political quality, an overall vision, orientation, guidelines which, if followed, will mean that each individual work carried out will be part of a carefully drawn-up general plan. What has been done in Spain to date in this sphere are efforts worthy of every merit, isolated efforts that exalt the name of some of our museums, but as a whole they still remain faithful to the heterogeneous standards which in the more or less distant past originated each of them, which in many cases maintain the collective character of their initial nucleus or the arbitrary administrative base upon which they were created.[146]

Independent from these discussions on a theoretical level, the life of the museum continued as usual. The incorporation of new works, either through purchase or donation, was maintained at the normal rhythm, although there was an increase in the acquisition of medieval painting, coinciding with Manuel Gómez-Moreno's becoming a museum board member in 1931. That same year two panels were purchased of *Scenes from the Life of Saint Lucy* (nos. 2535 and 2536) by the Maestro of Estimariu. The following year saw the acquisition of the magnifcent *Retable of the Life of the Virgin and of Saint Francis* (no. 2545) from La Bañeza (León), the work of Nicolás Francés, and in 1933 two Flemish triptychs, one by the Master of the Half Figures (depicting the *Annunciation*, the *Purification*, and the *Birth*, no. 2552) and the other by the Master of the Holy Blood (with the *Annunciation*, *Saint Hieronymus* and *Saint John the Baptist*, no. 2494), as well as an altarpiece compartment with the representation of the *Miracle of Saints Cosme and Damian* (no. 2549), attributed to Fernando del Rincón. Finally, before the outbreak of war two more medieval panels were acquired for the Prado Museum: a *Saint Anthony of Padua* (no. 2574) by the Berruguete circle and a *Supper in the House of the Pharisee* (no. 2596) by Maestro Robredo.

These were obviously not the only paintings acquired during this period; the list is considerable and it would be impossible to list each work. Still, some of them deserve special mention: *The Liberation of Saint Peter by an Angel* (plate 61) by Antonio Pereda and the *Portrait of Don Manuel Silvela* (no. 2450) by Goya, both purchased in 1931; the three allegories of *Commerce* (no. 2546), *Agriculture* (no. 2547), and *Industry* (no. 2548), painted by Goya for the Godoy Palace, and the *Saint Diego of Alcalá* by Zurbarán, which entered the museum in 1932. The following year saw the acquisition of a fragment (an angel with a crown of Madonna Lilies, no. 583) from the *Saint Joseph* painted by Tiepolo for the Church of San Pascual in Aranjuez and the small panel depicting *Charles III Eating before His Court* (plate 85), the work of Luis Paret y Alcázar. A canvas on which Francisco Bayeu painted thirteen sketches for tapestry cartoons (plate 83) was acquired in 1934; in

1935 the *Virgin and Souls in Purgatory* (no. 2579) by Pedro Machuca entered the museum, and in 1936, Zurbarán's *Saint Luke before Christ Crucified* (no. 2594) was acquired.

A number of major donations were also made during this period, outstanding among which were those from the Count of Pradere in 1933, which included an *Annunciation* (no. 2555) by Antonio Pereda; from the Duke of El Arco, in 1935, with the *Portrait of an English Knight* (no. 2584) by George Romney; and especially from the Duke of Tarifa, who gave two portraits, by Pantoja de la Cruz, one of *Philip III* (no. 2562) and the other of *Queen Margarita* (no. 2563), as well as the exquisite composition of *The Moneychanger and His Wife* (plate 205), by Marinus van Reymerswaele. One last donation was made to the Prado before the rebellion of July 18, 1936, but given the circumstances it did not enter the museum until 1940. This was given by Mariano Lanuza, who donated the panel of *Christ Presented to the People* (plate 201), one of the most outstanding works in the oeuvre of the Flemish painter Quentin Massys.

The gradual increase in the size of the collections through both purchase and donation, in conjunction with the new museographical criteria applied since the 1920s, allowing greater space between each work on show, caused the museum storerooms to become even more crowded. This overcrowding had two major consequences. In 1935 work began to remodel the reserve rooms, with the installation of "combs" for the paintings. A more unfortunate result occured when, surrendering to the impulse to exhibit as many paintings as possible, the republican government initiated a new campaign to lend works from the Prado to other institutions — luckily these were essentially recently remodeled provincial museums: Castellón, Málaga, La Coruña, Vigo, Vitoria, and Saragossa, among them. The 1942 catalogue lists some seven hundred fewer paintings than the one from 1920, of which three hundred were in the storerooms and the remaining four hundred had been ceded to other institutions, some during the time of the dictatorship of Primo de Rivera, but most between 1931 and 1936.

In June 1936 Ramón Pérez de Ayala left his post as Spanish ambassador in London to assume personally, at least in theory, the running of the Prado Museum. However, this situation was to be very short-lived, since as soon as the Spanish Civil War started, before the end of July, Pérez de Ayala simply abandoned Madrid, leaving the museum once again in the hands of its subdirector, Francisco Javier Sánchez Cantón.

THE CIVIL WAR (1936–39)[147]

The outbreak of the civil war caused an abrupt change in the life of the country, which logically also affected the Prado museum. On July 21, that is, three days after the military uprising, Sánchez Cantón delivered to the museum concierge a list of the 250 works to be placed in safekeeping as soon as the alert sounded.[148]

On August 28, 1936, the first bombs fell on Madrid. Two days later the Prado Museum was closed to the public. The press demanded protective measures for the picture gallery, to which the Minister of Public Instruction replied that these measures were being taken. Francisco Javier Sánchez Cantón and Pedro Muguruza, the museum's architect, were responsible for directing the operation. On the very afternoon of August 30, the main paintings on the first floor (among them all those hanging in the *Sala Velázquez*) were removed to the ground floor of the building. One week later only about thirty of the least important paintings still hung, and those were in the safest rooms. The sculptures, the hard stone tables, and the decorative objects of the central hall were protected with bags of sand. The works were gathered together in the northern wing, the most important canvases being placed around the low rotunda (the safest area in the building), leaving the central

Sculptures, stone tables, and decorative elements in the museum's central hall protected by sandbags

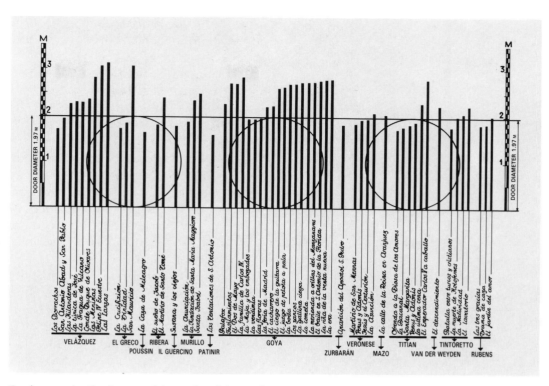

Graph comparing the diameter of the reinforced door to the security chambers of the Banco de España with the smaller dimensions of some paintings from the Prado Museum and other public collections

Access to the basement of the Banco de España, October 1937

space free. Windows and access doors to the galleries were covered with sandbags and sheets of fiber cement. On the first floor a protective layer of wood and bags of earth were placed on the floor of the rotunda, while in the large gallery piles of sand and metal fireguards were installed. On the top floor a layer of sand was spread as a preventive measure against fire. The skylight in the dome of the rotunda was also protected.[149]

These measures were not sufficient to ensure the safety of the works in the event of a bomb falling directly on the building. Consequently the Dirección General de Bellas Artes began to seek alternative refuges for the works. It was first thought that they could be stored in the ironclad chambers of the Banco de España, thirty-five meters underground, but this idea was rejected due to the many logistical problems encountered. Access was difficult, as it was necessary to carry the cumbersome paintings through a series of galleries and down sets of stairs. Assuming these obstacles could be overcome, a new barrier would emerge — the span of the reinforced door (seventy-seven inches in diameter) did not allow access to any work whose minimum dimension was greater than this.[150] Of course, the paintings on canvas could have been removed from their frames and rolled up, but only a few were in a fit state to withstand such an operation without undergoing preparatory treatment, and this was impossible to carry out in the time available.[151] Another factor taken very much into account when it came to rejecting the idea of the ironclad chambers of the Banco de España was the impossibility of ensuring, given the electricity restrictions caused by the war, maintenance of the correct temperature and humidity conditions.

The possibility of refurbishing one of the galleries adjacent to the ironclad chambers, closing off its ends with masonry, was considered but soon rejected, since as there was no air conditioning, the recently built work would cause the level of relative humidity to increase. Without artificial environmental control, these practically nonventilated premises were thoroughly unsuitable. Five of the canvases by El Greco for Illescas that had been deposited there had to be removed after a few

days due to the thick layer of mold that had formed on their surfaces; fortunately, this layer was removed without difficulty.[152]

Meanwhile, Giral's government had fallen, and, on September 4, Azaña entrusted Largo Caballero with the formation of a new one. Largo offered the post of minister of public instruction to Jesús Hernández, who in turn appointed Wenceslao Roces subsecretary of the ministry and José Renau director general of fine arts. That same day Ramón Pérez de Ayala fled the country, thus definitively abandoning his post as director of the museum, and on September 12 a ministerial order was signed removing him from the position. One week later, on September 19, Pablo Ruiz Picasso was appointed to replace him.[153]

PABLO RUIZ PICASSO (1936–39)

The idea behind Picasso's appointment was to use the artist's international prestige to call attention to the dangers threatening the works in the Prado Museum. However, as Pérez Sánchez very adroitly pointed out, it was a "thorough mistake, which can be justified only by the exceptional nature of the circumstances. It was a return to the idea of the director-artist, and furthermore now at the antipodes of the requirements of knowledge which for other concepts the republican government stipulated for the museum director."[154]

Indeed Picasso, who never actually occupied his post, undoubtedly poured all his energies and creative forces into the defense of the republican cause (proof of this is his *Guernica* [plate 134], painted for the Spanish pavilion at the International Exhibition of 1937). There is no evidence that he ever sincerely attempted to offset the difficulties besetting the museum. It was Sánchez Cantón, who continued as acting director as well as subdirector of the Prado, who had to assume responsibility for the establishment in such difficult times.[155]

On October 29 there was another change in the museum staff. José Lino Vaamonde replaced Pedro Muguruza as the architect curator.[156] One of his first acts was to reinforce the exterior of Villanueva's building. At that time the rebel forces had managed to advance to the very gates of Madrid and were being contained at the university campus. The nationalist generals then decided to launch an air attack in order to demoralize the population. The bombardments of civilian areas became intensified from the end of October.

In view of the growing risk these indiscriminate attacks represented for the works housed in the Prado and other Madrid museums, the republican government decided immediately to transfer the most outstanding works of this rich heritage to Valencia, far from the battle front. On the morning of November 5, 1936, Sánchez Cantón was summoned by José Renau, director general of fine arts, and Wenceslao Roces, subsecretary of the Ministry of Public Instruction, who informed him of the government's decision. That very afternoon the ministerial order reached the museum, indicating which paintings were to be prepared for transfer. The list was composed of forty-two works: four by Titian (*The Emperor Charles V on Horseback*, plate 151; *Danaë and the Shower of Gold*, plate 153; *The Bacchanal*, plate 152; and a *Self-Portrait*, plate 156), four by Tintoretto (*Midianite Virgins; The Woman Who Discovers the Bosom*, plate 161; *The Baptism of Christ*, plate 162; and *Battle Between Turks and Christians*), thirteen by Velázquez (*Saint Anthony Abbot and Saint Paul the Hermit*, plate 52; *Mercury and Argos*; *The Infanta Margarita of Austria*; *Las Hilanderas*, plate 57; *Prince Baltasar Carlos on Horseback*; *Queen Mariana of Austria*; *The Count-Duke of Olivares*; *The Lances*, plate 53; *Doña Juana Pacheco*; *Philip IV on Horseback*; *Las Meninas*, plate 56; and two views of the *Villa Médici*), twelve by El Greco (*The Pentacost*; *The Holy Family*; *Portrait of an Unknown Gentleman*; *The Knight with His Hand on His Breast*, plate 26; *The Resurrection*; *The Crucifixion*; *Saint John the Evangelist*; *The Purification*; *Saint Maurice and the Theban Legions*; *Philip II's Dream*; *Saint Peter, Saint Bartholomew, and Saint James*), and nine by Goya (*The Maja Clothed*, plate 96; *The Maja Nude*, plate 97; *The Family*

Paintings being prepared for their transfer to Valencia

Truck used for transporting the works

of Charles IV, plate 95; *The Meadow of Saint Isidore*, plate 90; *The Second of May, 1808, at Madrid*, plate 99; *The Moncloa Executions*; *Una Manola*; *A Fight with Cudgels*; and *The Witches' Sabbath*, plate 101). Of these thirty-seven were from the Prado, while the remaining five were El Greco's that had been in the museum for some time but belonged to the collections of El Escorial, the Church of San Ginés, and the Monastery of La Encarnación.[157]

In Valencia the ground floor of the Torres de Serranos had been furbished for the resting place of the transferred works. The features of this medieval structure — one of the gates of the city walls — were perfect: granite walls ten feet thick; two floors above separated by solid vaults, the two lower floors a yard thick at the key, and the top one five feet; ground-floor pavement some five feet above street level; a basement sixteen feet underground and almost twenty feet wide (which absorbed the tremors caused by bombs falling in the immediate vicinity); and very stable temperature and humidity conditions. To all this was added a series of additional measures, planned by a team of architects directed by José Lino Vaamonde: reinforcement of the ground-floor vault faced with a yard-thick layer of rice cork (a highly elastic material able to absorb the shock from the fall of material from above in the case of a direct hit); facing of the intermediate vault with a yard-thick layer of clay; facing of the top vault with five layers of earth bags; covering the windows with a "sandwich" of two reinforced concrete plaques with sand in between; doors reinforced with iron; the total absence of electric or telephone wiring inside in order to avoid the possibility of short circuits; fire extinguishers with nonacid liquid, and environmental control by means of air conditioning. In this way the artworks to be stored would be protected from explosions caused by direct hits, from the effect of shock waves, from incendiary bombs, and from environmental changes. The republican government was therefore justly proud of having created refuge installations where the paintings were kept in better storage conditions than when in the Prado Museum itself.[158]

The transfer of the paintings, in individual crates lined with wadding and treated with fire-resistant materials, began in early November 1936 on board a convoy of trucks. On the seventh of that month the board of governors of fine arts put the communist deputy Florencio Sosa in charge of the operation. It was Sosa who organized the two first expeditions, on November 10 and 15, composed of eighteen and eleven paintings respectively. In the meantime the ministry ordered sixty-seven more works to be prepared for transfer, although there would be no more movement of canvases for the rest of the month. On December 3 Sosa was replaced by María Teresa León, who, endowed with wide powers, managed in just over six weeks to evacuate 180 paintings and as many drawings. However, the lack of criteria in the

selection of works and the improvised way in which the transfers were carried out[159] (in some cases the paintings were not even wrapped) finally led to the dismissal of María Teresa León from her post.[160]

From then on, the Junta del Tesoro Artístico was entrusted with coordinating the evacuation of the works. Aware of the fact that all the good intentions in the world could not replace the lack of clear criteria and material means, and echoing the misgivings of Sánchez Cantón and the museum's restorers concerning the conditions of the transfer (environmental changes, shaking, etc.) of works in a delicate state, the members of the junta sent the following report to José Renau, director general of fine arts:

> This board considers it essential, given the importance of the mission with which we have been entrusted, that the government efficiently and promptly redress the imbalance currently existing between the need immediately to safeguard works of incalculable value and the lack of the suitable means with which to do so.
>
> To date a number of works from our museums have been put in safekeeping, thanks to active collaboration on the part of the Alliance of Antifascist Intellectuals and the Fifth Regiment, but since this board has been officially entrusted with this delicate mission, we consider it essential that the task be undertaken with the means, guarantees, and authority that only the government can provide; in other words, the orders from the government, the decisions of the board, and the organization of the expeditions should not depend either upon services in which goodwill is not sufficient to offset the lack of the proper elements, or upon the obtaining of cars and trucks, supply of fuel, and issuing of indispensable safe-conducts in which delays and obstacles obstruct an operation whose urgency requires absolute regularity.
>
> Therefore, in order to carry out our mission with utmost efficacy, we of the board request from the government:
>
> 1. That the indispensable means of transport be assigned to us permanently.
> 2. That the safe-conducts for these vehicles and their drivers as well as those for the members of the board be of a permanent nature that ensures freedom of movement at the opportune moment and the organization of the technical services of safekeeping of the works being transported, and that the supply of fuel and accessories be carried out with all necessary safeguards.
> 3. That the board be supplied with the most efficient means of protection of the expeditions, not only the armed guard service but also the materials for wrapping, timber, shavings, blankets, canvas, and fire extinguishers.
> 4. That the government fix a criterion as regards the order of prelacy with which the works are to be transferred, or the limit to be fixed for a selection to be made among thousands of works, as well as for those others which because of their state of preservation or alterations to their surfaces or frames the Board considers unwise to transfer due to the damage that may be caused to them in transit.[161]

Indeed, the conditions of transfer improved, from the points of view not only of the selection of works and administrative control, but also of the means available. During the month of April forty-four canvases left the museum bound for Valencia, among them *Los Borrachos (The Drunkards)* (plate 50) and *Las Hilanderas (The Spinners)* (plate 57) by Velázquez and *The Three Graces* (plate 214) by Rubens, as well as the vessels forming the so-called Dauphin's Treasure. Following a period in which no works were sent, the expeditions resumed in the summer of 1937. Between the end of June and beginning of August, more paintings were transferred, including *The Family of Charles IV*, three of the "Black Paintings," and fourteen cartoons for tapestries by Goya, eighteen sketches by Rubens, the two canvases by Murillo depicting *The Founding of Santa Maria Maggiore*, and the last work by Velázquez still remaining in the Prado, *Prince Baltasar Carlos in Hunting Attire*. Three final expeditions to Valencia on February 5, March 17, and April 4, 1938, brought the total number of paintings from the Prado Museum to find shelter in the Torres de Serranos to 361, together with 184 drawings and the Dauphin's Treasure.[162]

Before the last three expeditions took place, Sánchez Cantón was dismissed as subdirector due to his growing reluctance to authorize the removal of paintings.

He was succeeded temporarily on the same day, January 11, 1938, by Roberto Fernández Balbuena, the former president of the Junta del Tesoro Artístico de Madrid and the delegate of the Ministry of Public Instruction.[163]

The nationalist forces, meanwhile, had launched a propaganda campaign avowing that the paintings in the Prado Museum were under no risk in Madrid. From their point of view, the transfer was simply an excuse to remove the paintings from the country and sell them abroad. It is undeniable, however, that the safety of these artistic treasures was far from assured in a city that had become a battle front. The Prado Museum did not, in fact, run a great risk of a premeditated attack, but it could have been the object of an accidental bombardment. Indeed, on November 16, 1936, that is, shortly after the evacuation operation had begun, a bomb went off some sixty-five yards from the museum's rotunda, as a result of which the wall support of an alabaster high relief attributed to Agostino Busti was broken, and the work fell to the floor, smashing into pieces.[164] As the result of this same act, the remains of flaming torches and a number of incendiary bombs were found on the roofs of the building; fortunately, the latter never exploded. A number of buildings of cultural interest as well as several churches and monasteries were actually hit by bombs, among them the National Library, the Museum of Modern Art, the Academy of San Fernando, the Liria Palace, the Church of San Sebastián, the Convent of the Discalced Sisters, the monasteries of La Encarnación and the Trinitarians, a fountain in the Paseo del Prado, and the Royal Palace itself.[165]

The evacuation and the propaganda campaign launched by the national forces naturally caused considerable alarm in European cultural circles. Echoing these sentiments was an article published in *The Times* on June 20, 1937, by Sir Frederick Kenyon, former director of the British Museum, who demanded more information regarding the issue. Pablo de Azcárate, Spanish ambassador in London, immediately sent him a formal invitation to visit the country and inspect for himself the circumstances of the historical-artistic patrimony under the care of the republican government.

In Valencia, Sir Frederick Kenyon and his associate, F. G. Mann, director of the Wallace Collection in London, were able to verify that the measures adopted in the Torres de Serranos were the correct ones. By unwrapping a number of works at random, they found that they were in a perfect state of preservation. They did, however, express a certain reticence regarding the installation in the Colegio del Patriarca.

One of the consequences of this visit was a special issue of the journal *Mouseion*, the organ of the International Museum Council, with articles by Kenyon himself,[166] by the director general of fine arts, José Renau,[167] and by Francisco Javier Sánchez Cantón.[168] In his article, Sir Frederick Kenyon clearly manifested his appreciation of the work carried out: ''It is wonderful that in such difficult times they have been capable of so much in such a short time. . . . Those who carried out the evacuation and the conditioning deserve the gratitude of all those who desire the treasures of Spain, which are the treasures of the entire world, to be saved from the horrors of war.''

Meanwhile, in Madrid the Junta del Tesoro Artístico was intensely involved with attempting to save as many as possible of those works of art exposed to acts of vandalism in the multitude of churches, convents, and private residences whose owners had fled in fear of indiscriminate reprisals on the part of fanatics. San Francisco el Grande, the Archaeological Museum, and the Prado were the main centers of shelter for the orphaned works.[169] At the end of 1938 in the Prado Museum alone there were more than sixteen thousand paintings deposited by the Junta del Tesoro Artístico; there were no more simply because they did not fit.[170] Some of these works, such as the large canvas of *The Last Supper* by Luis Tristán from the Church of Cuerva; the *Martyrdom of Saint John the Evangelist* painted by

Unexploded bomb on the roof of the museum building

Claudio Coello for the Church of Torrejón; and the *Virgin with Saint Francis and Saint Philip*, a work by Francisco Rizi from the Capuchin Convent of El Pardo, were later dramatically rescued from among the bombs. Others arrived in a truly awful condition, such as some of the compositions included in the altarpiece of the Church of Yepes, by Tristán, which were delivered by soldiers to the Prado restorers.

The works gathered in the Prado were duly registered in the inventory, their provenance noted, and minimally classified. If their state of preservation was considered deficient, the conservation department of the museum, under the charge of the prestigious Jerónimo Seisdedos, carried out whatever service was deemed necessary. Among the works that received such attention was Bosch's *Garden of Delights* (plate 198), which came to the museum from the Monastery of El Escorial, suffering serious problems of pigment consolidation. The restoration completed, it remains in the Prado to this day.

The rebel army's Aragon offensive toward the Mediterranean in March 1938 threatened to isolate Catalonia from the remainder of the territory under the control of the republic. Fearing that this nationalist advance might impede the evacuation of the artistic patrimony stored in Valencia to a neutral country, the government ordered the immediate removal of these works to Catalonia. Under extremely difficult circumstances, attacked by aircraft and having to make wide detours in order to avoid enemy troops, with roads blocked, insufficient fuel, and risky, improvised solutions (such as hanging the boxes containing the larger paintings on the side of the trucks so that the vehicles would be shorter than the seventeen feet of the lowest bridges under which they had to pass), Ceferino Colina Quiroz managed to get the thirty-six trucks, split up into several convoys, to their destination.

In addition to the 361 paintings, 184 drawings, and Dauphin's Treasure from the Prado Museum, 52 paintings were transported from the Modern Art Museum; 122 from the Duke and Duchess of Alba Collection; and several hundred from El Escorial, the Royal Palace, the San Fernando Academy, and private collections. Also included in the convoys were objects from the Palace of Liria and a multitude of codices, books, and documents from the Academy of History, the National Library, and the Historical Archives. The only mishap that occurred was when the box containing Goya's *Second of May* hit a balcony when the convoy was passing through Benicarló. The impact caused the box to break and the top left-hand corner of the painting to tear. This was left unrepaired, as a visible record of the exodus of the works from the Prado Museum during the Civil War and as a homage to all those who, by dint of dedication and effort, managed to carry out the miracle by which this was the only damage caused during such a long and treacherous operation.[171]

In Catalonia a number of temporary shelters were improvised. We know very little about their conditions, in terms both of security and environmental control. It can be assumed, however, that as the end of the war approached, with the increasing difficulties of the republican government, the forced pilgrimage, and the rising need to supplement with ingenuity and willpower the ever-decreasing means, the state of the set of works not only did not improve but, quite the contrary, reached quite horrifying levels of deterioration.

First the works were deposited in the Monastery of Pedralbes in Barcelona, in Sant Hilari Sacalm and in Viladrau (both west of Girona). At the end of April 1938 a considerable number were transferred to the Castle of Figueres, some fifteen miles from the French border. Meanwhile reinforcement work was carried out on the castle in the nearby town of Perelada, where in May and June the most important paintings were taken, among which were those of the Prado Museum, El Escorial, the San Fernando Academy, and the collection of the Duke and Duchess of Alba, as well as tapestries, books, jewelry, and other objects. In August a third refuge was prepared in the talcum mines of La Vajol, two miles from the border. Owing to the shelter's

exceptional safety conditions and its closeness to France, the works of greatest importance were deposited there.[172]

On December 23, 1938, the nationalist army's general offensive against Catalonia was launched on the Segre front. After ten days all organized resistance on the part of the republicans had been quashed. On January 15, 1939, Tarragona fell, and the population fled in panic from the air attacks and the uncheckable advance of Franco's troops. Control of the situation having been lost, the republican side attempted an orderly retreat northward, but they were overwhelmed by the enemy impetus, and the retreat turned into chaotic flight to the French border. On January 26, Barcelona was occupied by the *nacionales*. Given its inability to ensure the safety of the artistic treasures in its care, Negrin's government had no alternative but to accept the intervention of the International Committee for the Preservation of Art Treasures in Spain, dependent upon the League of Nations.

This committee had been created thanks to the effort of the painter José María Sert, a personal friend of Avenol, secretary general of the League of Nations, whom he had met in 1936 when he had painted murals for the institution's conference room at its headquarters in Geneva. Sert had obtained from the Burgos government's Minister of Foreign Affairs, General Jordana, powers to set up an international committee entrusted with the task of negotiating the transfer of the artistic heritage evacuated by the Republic to Geneva, where it would remain under the protection of the League of Nations as long as the war lasted. Membership in this committee consisted of representatives of the Louvre; the Rijksmuseum; England's National Gallery, Tate Gallery, and the British Museum; The Metropolitan Museum of Art in New York; and of Belgian and Swiss museums. It was presided over by Pierre David-Weill.[173]

On February 2, 1939, contact was established in Figueres between Julio Alvarez del Vayo, representing the Republic, and the delegates of the International Committee for the Preservation of Art Treasures in Spain, among whom were Jacques Jaujard, subdirector of the Louvre, and Neil McLaren, curator of the National Gallery. The negotiations, which took place in an atmosphere of tension due to the constant advance of the nationalist troops, lasted until the afternoon of the next day. According to the terms of the agreement, the works of art in the shelters of Figueres, Perelada and La Vajol, belonging as they did to the Spanish nation, would be sent to Geneva, where they would remain under the protection of the secretary general of the League of Nations until the end of the war, at which point they would be returned to the Spanish government. That very night, the eve of the fall of Girona, preparations began for the new transfer, which was also to be fraught with difficulties. The first of these was the unavailability of the seventy-five trucks promised by the French government; the drivers refused to enter a war zone. Vehicles were procured from here and there, and the journey continued amid complete chaos and the melée of refugees fleeing from the nationalist troops. Franco's forces had cut off the road into France; still, more than 2,000 boxes containing the masterpieces of Spain's artistic treasure, managed to cross the border. Among these were the 136 paintings and 184 drawings that left Valencia in March 1938. But a great many other pieces remained behind, exposed to all possible dangers.

Once in France the works were kept provisionally in a warehouse in Le Boulou and in a castle in Saint-Jean-Pla-de-Cors. On February 10 a special twenty-two–wagon train was prepared in Céret station to take the works of art to Geneva, where they arrived on the night of the thirteenth: During the journey across French territory the convoy was guarded by a dozen *gendarmes* who were relieved by Swiss guards when the train crossed the Swiss border. Traveling with the works were two republican representatives, Timoteo Pérez Rubio and José María Giner Pantoja, who had taken care of them practically since they left the Prado Museum. In a letter to Angel Osorio, the republican president, Manuel Azaña, pays tribute to the selflessness of these two faithful custodians of the art collections:

They reached Geneva with the expedition and took care of the works until the Burgos delegates received them. The two functionaries had only two Swiss francs between them, and they might have died of starvation if the Mexican Minister, Señor Fabela, had not taken them in. . . . They have been staying in Fabela's residence for four months. All they managed to achieve with their relations was that Señor Méndez Aspe sent them from Paris one thousand French francs. And nobody has given the credit they deserve. According to the press, the canvases were saved thanks to the painter Sert and Señor Avenol![174]

In Geneva the Spanish art heritage was deposited in the halls of the library of the League of Nations. There an inventory was drawn up by a committee consisting of Pérez Rubio and Giner, representing the Republic, Eugeni d'Ors and José María Sert, representing the nationalists, and Eric McLagan, director of the Victoria and Albert Museum; Neil McLaren from the National Gallery; Jaujard, Dreyfus, Huyghe, and Verget from the Louvre; Deonna and Gielly from the History Museum of Geneva; and Vallery-Radot, delegated by the Secretary General of the League of Nations. In making this inventory the members of the committee verified that the Junta General del Tesoro Artístico had wrapped the works correctly, a fact that figured in their report. A short time later a delegation from the nationalist Servicio de Recuperación reached Geneva. Among the members of this delegation were Pedro Muguruza and the new director of the Prado Museum, Fernando Álvarez de Sotomayor, who thus began his second term at the head of the picture gallery. Having painstakingly confirmed the contents of the inventory, these two gentlemen signed the receipt by which Pérez Rubio and Giner were relieved of their responsibilities.

DICTATORSHIP (1939–75)

FERNANDO ÁLVAREZ DE SOTOMAYOR (1939–60)

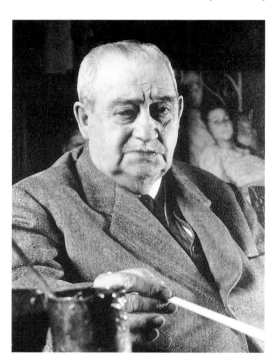

The presence of such an extraordinary collection in Geneva inspired the members of the International Committee for the Preservation of Art Treasures in Spain to create an exhibition in the Swiss capital of the best works in the collection. The idea was accepted by the Franco government, and the exhibition of 173 pieces was opened on June 1, 1939, in the Geneva Museum of History. It was a resounding success; some 400,000 people visited the show in the three months it was open to the public.

On August 31 the exhibition closed, and all that apparently remained to be done was wrap the works up and transport them back to Spain. However, the following day dawned with dramatic news that once again placed the Spanish art heritage in jeopardy: that very morning Germany had invaded Poland. On September 3 France and Great Britain declared war on Germany. A quick decision had to be taken: if the treasure remained in Geneva it might be trapped there for a long period, with the additional threat that Switzerland might become involved in the conflict; on the other hand, if the transport option was taken, apart from difficulties in finding adequate means with France occupied in preparing for war, there was also the risk of an attack by German aircraft. Apparently Eugeni d'Ors chose to adopt the latter option.

Cristóbal del Castillo, a diplomat friend of José María Sert who had already been involved with the evacuation of the works to Geneva, describes the events thus:

Months later, in August 1939, another cataclysm was approaching with giant steps. The mobilization of France had begun. It was impossible to obtain trains, and our masterpieces from the Prado were isolated in Geneva, far from the homeland and threatened by the fact that Switzerland might become involved in the war.

Once again it was José María Sert, that unrivaled patriot and lover of his country's art, who went into action. He put us in touch with Anatole de Monzie, Minister of Public Works in Paris. Four goods trains were specially conditioned, left Geneva, and crossed France with our collections from the Prado, the military trains which practically monopolized the tracks being held up to let them through. Thus the paintings reached the Spanish border and returned home. Hours later hostilities began, and it would have been impossible to recover such esteemed treasures.[175]

At last, on September 9, 1939, after almost two years of pilgrimage, 361 paintings, 184 drawings, and the Dauphin's Treasure once again crossed the threshold of the Prado Museum.

Meanwhile, after Franco had proclaimed victory in his last war communiqué on April 1, 1939, the new directors of the Prado were attempting to return to the situation that had existed before the proclamation of the Second Republic in 1931. The board of trustees was re-established, with the Count of Romanones at its head, and, as already noted, Sotomayor was once again appointed director of the museum. In his turn, Sánchez Cantón recovered his position as subdirector. The building's protective elements were removed and the insignificant damage it had suffered during the Civil War repaired.[176] While they were waiting for the return of the paintings deposited in Geneva, the museum governors organized an exhibition of a selection of the most outstanding paintings collected by the Junta del Tesoro Artístico de Madrid during the war years and housed provisionally in the Prado. Opened on July 7 under the title of "De Barnaba de Módena a Goya," it was a temporary version of the "great National Museum" that Vicente Poleró proposed in 1868.

As soon as the Geneva expedition reached the Prado, the paintings were reinstated in the museum's halls. Every effort was made to repeat as faithfully as possible the layout that had existed in the summer of 1936. It was as if people wanted everything to be the same, as if the painful episode of the exodus had been nothing but a nightmare. Unfortunately, outside the sheltered environment of the picture gallery, there was too much evidence to show that the nightmare had in fact been a reality.

In view of the international echo of the transfer of the paintings and the success of the Geneva exhibition, the government attempted to elevate the image of the museum. As a consequence, by order of the head of government in 1941, some of the most outstanding works from El Escorial that had been housed in the Prado during the war came to form a permanent part of the museum's collections: *The Garden of Delights* (plate 198), *The Hay Wain* (plate 196), and *The Table of the Capital Sins* (no. 2822), all by Bosch; *The Descent from the Cross* (plate 189) by Van der Weyden; and *The Maundy* (plates 159 and 160) by Tintoretto.

On June 27, 1941, one of the works most claimed by Spain, Murillo's so-called *Immaculate Virgin "of Soult"* (plate 76) was officially returned. In 1813, during the Napoleonic invasion, the painting had been taken from the Hospital de los Venerables in Seville by Marshal Nicolas-Jean de Dieu Soult. Auctioned in May 1852 after the death of the marshal, it was acquired for 615,000 francs by the Louvre and came to be considered one of the gems of the Parisian museum. The return was made as part of the exchange agreement of works of art and documents signed with General Pétain's collaborationist government in Vichy. By virtue of this pact France also returned the *Lady of Elche*, which, given its nationalist connotations, entered the Prado, and the Visigothic votive crowns of Guarrazar and the remains of the Iberian sculptures of Osuna, which went to the National Archaeological Museum. In exchange Spain donated one of Velázquez's works in the Prado Museum, a replica of the *Portrait of Mariana of Austria* (no. 1190), in order to enrich the collection of Spanish painting in the Louvre.

In what might be interpreted as a parallel gesture, in 1941 the Prado Museum returned Murillo's *Saint Isabella Curing the Mangy* to the Hospital de la Caridad in Seville, from whence it had been taken during the War of Independence. Fears that this might create a precedent and that an avalanche of return petitions might ensue proved to be unfounded.

During these years there was also a decided interest in filling the gaps in the museum's collections and giving them a certain coherence as a reflection of the history of painting in general and of the Spanish school in particular. However, this interest was basically on the part of the board of trustees and was not shared by the director.

His narrow vision was clearly revealed when he installed mural paintings that in their day had decorated the Hermitage of the Santa Cruz in Maderuelo (Segovia). These were the first Romanesque works to enter the Prado,[177] and when they were installed in 1949, Alvarez de Sotomayor commented in disgust (and paradoxically he was right) that "to exhibit these paintings is tantamount to justifying the presence of Picasso in the Prado Museum."[178] Despite Sotomayor's opposition, the board of trustees knew very well their criteria, and later, in 1957, when the occasion arose, they fostered an exchange between the Spanish government and The Metropolitan Museum of Art in New York, through which the latter ceded to the Prado Museum for an indefinite period the *Hunt of the Hare* (plate 1), one of the compositions from the twelfth-century mural decorations of San Baudel de Berlanga. In return, and under identical conditions, the ruined apse of the Church of San Martín de Fuentidueña (Segovia) was ceded to be reconstructed in The Cloisters, the branch of the Metropolitan Museum devoted to art of the Middle Ages.

As to the purchase of works, there was determined action on two fronts: the board of trustees and the Ministry of National Education. Although given the organization in force at the time the latter had greater possibilities, the board of trustees, with the remnants of the 300,000 pesetas given in 1930 by the Count of Cartagena (administered very prudently), managed to acquire some very interesting works. Most of these acquisitions were paintings of the Spanish school from the fifteenth to the nineteenth centuries. Apart from the aforementioned Romanesque murals, the oldest works bought during this period were two panels by Fernando Gallegos, acquired in 1959 by the Ministry of National Education: *The Calvary* (no. 2997) and *Piety* (no. 2998), the latter with the master's signature. From the sixteenth century were acquired several works by Juan de Flandes (in 1952), two by León Picardo (in 1947), and two extraordinary panels by Fernando Yáñez de la Almedina: *Saint Anne, the Virgin, and the Child with Saint John the Baptist as a Boy* (no. 2805) and the splendid and well-known *Saint Catherine* (plate 14).

The so-called "Golden Age of Spanish Art" was logically a period to be very well represented. Several paintings by El Greco were purchased: the magnificent *Saint Andrew and Saint Francis* (no. 2819) from the Monastery of La Encarnación in Madrid; a *Holy Countenance* (no. 2874); four figures of the apostles from Almadrones (*Salvador*, no. 2889; *Saint Philip*, no 2891; *Santiago*, no. 2980; and *Saint Paul*, no. 2892); and *The Adoration of the Shepherds* (plate 27), which was in the artist's own sepulchral chapel in the Monastery of Santo Domingo el Antiguo, Toledo, when it was acquired in 1954 by the State for the then astronomical sum of 1.6 million pesetas. By El Greco's pupil Luis Tristán were acquired in 1942 two feminine heads (*Saint Monica*, plate 28; and *Weeping Saint*, no. 2837) that originally formed part of the altarpiece of Yepes. Francisco Ribalta's *Christ Embracing Saint Bernard* (no. 2804); Alonso Cano's *The Miracle at the Well* (plate 48); and Zurbarán's *The Immaculate Conception* (plate 43, from the Convent of the Esclavas Concepcionistas in Seville) and *Saint Anthony of Padua* (no. 3010) also increased their respective catalogues in the Prado. Two canvases by Velázquez were also acquired at this time: one was the portrait of *Sister Jerónima de la Fuente* (no. 2873), dated 1620, that is, from the young master's Sevillian period; the other was the exquisite *Christ Crucified* (no. 2903), signed and dated 1631, from the Convent of the Bernardine nuns in Calle Sacramento. In 1940 the splendid *Still Life* (plate 30), signed and dated by Felipe Ramírez, was purchased; six years later came *The Flower Vase* (plate 69), originally attributed to Zurbarán before being recognized as the work of the excellent and somewhat enigmatic painter Juan Fernández "the Peasant." Also acquired was the portrait of a *Gentleman in Magistrate's Collar* (no. 2845) by Murillo.

Works from the eighteenth and nineteenth centuries purchased for the museum were few but of excellent quality: two exquisite compositions by Luis Paret y Alcázar (the *Masked Ball*, no. 2875; and *Play Rehearsal*, no. 2991); a good portrait by Goya,

that of the Archbishop of Valencia, *Don Joaquín Company* (no. 2995); and a portrait by Vicente López Portaña of *Doña Salvadora Jara de Camarón*.

Purchases of the remaining painting schools during the 1940s and 1950s were in general less numerous and of poorer quality than those of the Spanish school. Also in these cases it was the Ministry of National Education that assumed responsibility for the acquisitions; the board of trustees did what it could within its limited possibilities.

The Italian school was enriched by a *Portrait of the Marquis of La Ensenada* (no. 2939) by Amiconi; a *Saint Carlos Borromeo* (no. 2993) by Luca Giordano; and another of the great canvases painted by Giovanni Battista Tiepolo for the Church of San Pascual de Aranjuez between 1767 and 1769 — the *Saint Anthony of Padua with the Boy Jesus* (no. 3007). Few also were the new purchases of the Flemish school: an *Adult Christ of Sorrows* (no. 2818) by Adriaen Isenbrandt; a *Snowy Landscape* (no. 2816) by Pieter Brueghel; and the *Young Man and Philosopher* (no. 2974) attributed to Abraham van der Hecken. Outstanding among the acquisitions from the Dutch school is an excellent copy of a *Self-Portrait* (no. 2808) by Rembrandt. Interesting also are two landscapes, one an anonymous seventeenth-century work (no. 2860) and the other (no. 2978) a copy by Jan Joseph van Goyen; portraits of *William of Bavaria* (no. 2977) and his wife *Elisabeth van Bronckhorst* (no. 2976) by Mierevelt; and an *Adoration of the Shepherds* (no. 2984) by Abraham Gerritsz Cuyp. The French school was enhanced by a major acquisition — the canvas depicting *Time Defeated by Hope, Love, and Beauty* (plate 254) by Simon Vouet — and by two canvases of *Cupids* (nos. 2854 and 2855), copies by François Boucher.

Purchases were also made of canvases from the British school, which was not previously represented in the Prado Museum. Fernando Alvarez de Sotomayor, who in his capacity as professional painter devoted his time essentially to the portrait genre, focused his efforts to enrich the collections of the museum he directed exclusively on this area of his own professional interest (which reveals the error of appointing as director of a museum a painter instead of an art historian). Thus, owing to his efforts the museum obtained, either through purchase or donation, almost a dozen works representative of British portrait painting from the eighteenth and nineteenth centuries. Among these were two by Sir Joshua Reynolds, the *Portrait of an Ecclesiastic* (no. 2858) and the portrait of *Mr. James Bourdieu* (plate 271, donated by the antiquarian Bertram Newhouse). Two portraits by Thomas Gainsborough were acquired in a short space of time: one of the doctor *Isaac Henrique Sequeira* (plate 272), ceded in 1953 by Bertram Newhouse, and one of *Robert Butchert of Walthamstow* (no. 2990), acquired by the board of trustees in 1955.

Between 1958 and 1959 the board bought three works by Thomas Lawrence: *John Fane, Tenth Count of Westmorland* (plate 273), *Portrait of a Lady from the Storer Family* (no. 3011), and *Portrait of Miss Marthe Carr* (no. 3012). Other British portraitists represented in the Prado were George Romney, Martin Archer Shee, John Watson Gordon, and John Hoppner. To these portraits were added two interesting Spanish landscapes by the Scottish Romantic David Roberts: *The Castle of Alcalá de Guadaira* (plate 275) and *Torre de Oro in Seville* (no. 2853).

During the years following the Spanish Civil War, a series of donations contributed a considerable number of works to the museum, among them some which can be considered of capital importance. In September 1939 the first donation was made, a canvas that had formed part of the royal collections until Ferdinand VII gave it to the painter Juan Gálvez. Notable for its iconography, *The Nude "Monster"* (no. 2800) by Juan Carreño de Miranda forms a pair with another portrait of the same girl, this time dressed (no. 646), which was sent to the museum directly from the Palace of La Zarzuela in 1827. The works were reunited thanks to the generosity of the Baron of Fornas. On December 8, 1941, the financier, politician, and collector Francesc Cambó ceded to the museum an exceptional series of panels from the Italian

Francesc Cambó

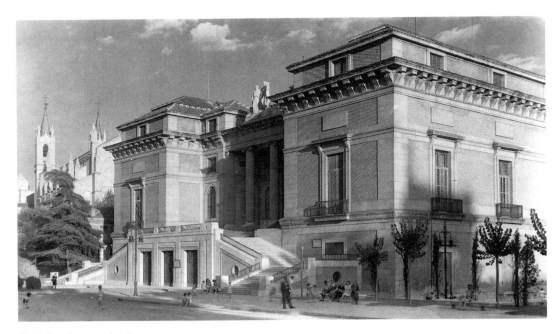

North facade, second staircase

quattrocento, which to a large extent closed one of the biggest gaps in the picture gallery's collections. This donation consisted of three compositions of *The History of Nastaglio degli Onesti* (plate 138 and nos. 2838 and 2840) by Sandro Botticelli; two small panels dedicated to *Saint Eloisius* (nos. 2841 and 2842) attributed to Taddeo di Gaddi; an *Angel Musician* (no. 2843) by Melozzo da Forli; and a canvas depicting the *Liberal Arts* (no. 2844) by Giovanni da Ponte. In order to complete the donation, Cambó included a *Still Life with Pottery Jars* (plates 41 and 42) by Francisco de Zurbarán, one of the few still lifes definitely attributed to him. Thus the name of Francesc Cambó deserves to figure in the short list of great donators to the Prado, alongside the Baron of Erlanger (1881), the Duchess of Pastrana (1889), Pablo Bosch (1915), and Pedro Fernández Durán (1930).

Without a doubt, Francisco Goya y Lucientes is one of the best represented painters in the Prado. Even so, works from Goya's Bordeaux period — that is, his last — were notably missing. Two donations filled this very conspicuous gap: in 1946, on the death of Fermín Muguiro, the museum acquired the portrait of an ancestor of the deceased, *Don Juan Bautista Muguiro* (no. 2898), painted in May 1827, and the famous *Milkmaid of Bordeaux* (plate 103). In 1962 Thomas Harris, an eminent English Hispanist and author of an excellent catalogue of Goya's engravings and lithographs, gave the museum a *Bullfight* (no. 3047) painted between 1825 and 1826.

In 1962 another major donation was received: the pair of polychrome wood sculptures representing *Ephimeteus* and *Pandora* carved by El Greco and ceded by the Countess of Las Infantas in memory of her husband, Joaquín Pérez del Pulgar y Campos. Also by El Greco is a *Saint Sebastian* (no. 3002), donated in 1959 by Blanca de Mora y Carrillo de Albornoz, the Marchioness of Casa Riera, in memory of her father the Marquis of Casa Torres. Finally, to close this chapter on legacies, a donation was made in 1959 by Frederick Mont of a work tentatively attributed to Antonio Puga depicting an *Old Woman Seated* (plate 62), thought to be a portrait of the artist's mother.

Despite the obvious interest on the part of those capable of making decisions in enriching the collections of the museum, there was not even the remotest interest in verifying the state in which, after the tempestuous years of the Civil War, the many paintings from the Prado Museum spread all over Spain were preserved. Quite

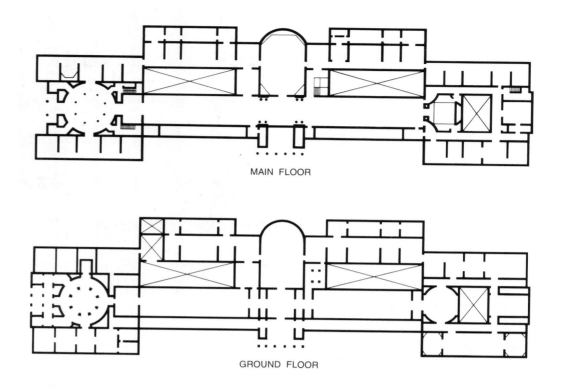

MAIN FLOOR

GROUND FLOOR

Plans of the main and ground floors after the extension of 1955

the contrary, once again a policy of deposits was applied; this time the works ended up in military government headquarters, captaincy generals, ministries, civil government headquarters, embassies, and other government entities in which the paintings could barely be seen by art historians and other scholars, not to mention the general public. The situation was further aggravated by the fact that in general, not even the most elementary formalities of administrative control were carried out when it came to ceding works. Logically, the museum offered passive resistance to such government abuses, to the extent that paintings were sometimes hidden in storerooms difficult to enter.[179]

A growing awareness of the ability of the collections of *objets d'art* to attract a great number of people led to a reconsideration of the circulation of visitors to the Prado Museum. The absence of a door on ground floor level on the northern facade of the building was an obstacle to the free movement of the public. Consequently, in 1943 the decision was made to modify the staircase built by Jareño in 1880, when the original embankment was flattened, that gave access to the door on the first floor of the north facade. The remodeling was entrusted to the architect José María Muguruza, by whose design a triple door was opened on this facade, making the movement of the public easier. Similarly, improvements were made to the fire safety of the building: all the timber elements of the ceilings and floors were replaced.[180] These were but simple efforts to improve the existing spaces to prevent possible accidents. What the museum needed was work of another kind. It was by now evident that the building was too small to house its collections properly, due not only to the massive acquisitions of new pieces but also to the new museographical criteria, which no longer permitted the vertical stacking of canvases common previously. Around 1950 the idea was born of extending the Prado Museum beyond the building designed by Villanueva. A suggestion was made to use the building opposite Villanueva's, on the other side of the Paseo del Prado, in order to create

a symmetrical building, connected underground to the original one, and to distribute the collections in a logical and coherent way between both. However, there was no decisive action in this direction from the museum authorities, and the available space was occupied finally by the Casa de Sindicatos; thus the opportunity for an attractive solution was missed.

In 1952 the architect Azpiroz presented another extension project, this time to the south, occupying part of the botanical gardens. Fortunately opposition to such a plan was absolute on the part of those who, aware of the importance of the gardens, considered such an act barbaric. This clear and decisive position, linked to the astronomical budget the plan needed, led to the rejection of Azpiroz's proposal. Finally, in 1955, a solution was adopted that was by no means new: the construction of two additional galleries on the building's rear facade, backing onto those added in 1914–18. Plans for the addition were drawn up by the architects Fernando Chueca Goitia and Manuel Lorente, under the direction of José María Muguruza. The civil engineer Rodolfo Lama was responsible for carrying out the work.[181]

Little more can be said about the activities of the museum and its board of trustees during this phase. No exhibitions were organized, and apart from the periodical updating of the *Catalogue of Paintings*, the only publications to appear were a catalogue on the Dauphin's Treasure, written by Diego Angulo and published in 1944, and a catalogue of classical sculpture commissioned by the Board from Antonio Blanco and published in 1957. Art history experts on the staff were also few in number at this time, consisting of the subdirector Francisco Javier Sánchez Cantón, Diego Angulo Iñiguez, assistant curator between 1941 and 1946, and Manuel Lorente, architect, who occupied his position until he retired in 1970.

The year 1950 saw the death of the Count of Romanones, who had been president of the board of trustees since the end of World War II. He was succeeded by Rafael Sánchez Mazas, a former minister without the slightest connection to the world of museums or art. On the positive side it is worth emphasizing the gradual incorporation into the board of eminent art historians such as Diego Angulo Iñiguez, who became its vice-president; José Ramón Aznar, the Marquis of Lozoya; and María Luísa Caturla, whose presence guaranteed the organization's scientific rigor and endowed it with a certain independence and authority.[182]

**FRANCISCO JAVIER SÁNCHEZ CANTÓN
(1960–68)**

On the death of Fernando Alvarez de Sotomayor, the board of trustees presented Francisco Javier Sánchez Cantón as candidate for the presidency of the Prado Museum. The proposal was accepted by the ministry and the official appointment was made on April 1, 1960. In order to occupy the post of subdirector vacated by Sánchez Cantón, the board proposed Xavier de Salas Bosch, who took up his position on February 27, 1961. This marked the first time in the entire history of the museum that both the director and subdirector were art historians.

In this new phase of its history, the works of the Prado Museum began to be present in exhibitions held in other European centers, such as those of Mantegna in Mantua, Poussin in Paris, Il Guercino in Bologna, and Tiepolo in Udine. Times were changing, and the museum began to collaborate in international research projects into the history of art. Little by little, thanks mostly to efforts on the part of Diego Angulo, the technical staff at the service of the museum gradually increased in size. In 1961 Alfonso E. Pérez Sánchez became responsible for the review of works ceded in deposit, although his task unfortunately was purely to inform, not remedy.[183]

The situation remained far from ideal, however, since the government continued to consider the museum its own possession to be used at will. The Ministry of National Education raised absolutely no objections to the lending of paintings from the Prado to serve as cultural attractions in the framework of a badly understood touristic and folkloric policy. On the occasion of World's Fairs, such as those of New York,

San Antonio (Mexico), and Tokyo, the masterpieces of Spanish art were forced to coexist with agricultural products, typical cuisine, and Flamenco, and were subjected to uncontrolled environmental conditions after having been exposed to the dangers of intercontinental travel without the slightest scientific justification. The government, despite boasting of the international significance of the museum, continued to deny it the infrastructure it needed.[184] Soon even the press began to urge for reforms: there were protests about the increase in the entrance fee, when admission to the museum, it was felt, should ideally have been free; complaints about the poor lighting in some of the rooms; and objections to the disorder and constant moving of the paintings on display and the unsuitable treatment of the paintings when being moved.[185]

Three organizations were responsible for operations to increase the museum's collections, although they acted independently from one another: the board of trustees, the Ministry of Education, and the board of export of works of art. The paintings were purchased not only in Spain but often on international markets, principally those of London and Paris. As in the previous period, the works acquired were mostly Spanish from between the thirteenth and eighteenth centuries, and there was a certain balance to the volume of purchases. The *Altar Frontal of Guils* (plate 3) from the Church of San Esteban in Baixa Cerdanya, a small population nucleus near Puigcerdà, is the work of an anonymous thirteenth-century Catalan artist. Also Catalan are the two sections from twin altarpieces donated by the future King Henry II of Castile to the Sanctuary of Nuestra Señora de Tobed, in the middle of the fourteenth century. Each of these has three compartments with the *Histories of Saint John the Baptist* (no. 3107) and *Histories of the Magdalene* (no. 3106) and recently has been attributed to Ramón Destorrents. The fifteenth-century acquisitions are completed by a *Saint Dominick* (no. 3111) by an anonymous Valencian painter; a panel with the *Martyrdom of Saint Catherine* (no. 3039) by Fernando Gallegos; and a *Resurrection of Christ* (no. 3109) by Pedro Berruguete. Outstanding among the sixteenth-century works acquired during these years are *Magdalene and Three Dominican Saints: Saint Peter the Martyr, Saint Catherine, and Margaret of Hungary* (no. 3110) by Juan de Borgoña; a *Saint Gregory, Saint Sebastian, and Saint Tirso* (no. 3112) by his son, Juan de Borgoña "the Younger"; a new panel by the Valencian Fernando Yáñez de la Almedina representing the *Virgin and Child* (no. 3081); and the magnificent *Descent from the Cross* (plate 16) by Pedro Machuca.

Although perhaps not equaling the spectacular purchases of sixteenth-century painting made in the previous two decades, interesting additions were made to the museum's treasures in the 1960s. Of the Valencian school are a *Saint John the Evangelist* (plate 34) by Juan Ribalta and a *Saint Ramón Unborn* (no. 3087) by Jerónimo Jacinto Espinosa. The Andalusian school is represented by a *Head of a Saint with Throat Cut* (no. 3058) by Francisco de Herrera "the Elder" and two works by Alonso Cano, a *Saint Anthony of Padua* (no. 3041) and what is possibly his most spectacular composition in the Prado, *Apparition of the Virgin to Saint Bernard* (no. 3131). As regards the Madrid school, worthy of mention are works by F. Juan Rizi (*Saint Benedict and Saint Mauro*, no. 3108) and by Juan Antonio Escalante (*The Communion of Saint Rose of Viterbo*, no. 3046), as well as an anonymous *Saint Roque* (no. 3105). The most outstanding piece acquired was the impressive portrait of *Nicolás Omazur* (plate 77) by Murillo; with this acquisition the Prado obtained a magnificent example of a facet of the work of the great Andalusian painter heretofore scantily represented in the museum.

Eighteenth-century purchases during this period were limited to three: two small but highly interesting works by Goya — one of the compositions executed on tin-plate while he was convalescing from his grave illness in 1792, *The Strolling Players* (plate 93), and a sketch of the *Apprehension of Christ* (no. 3113) for the large painting for the Sacristy of Toledo Cathedral, dated 1788 — and an *Immaculate Conception* (no. 3070) by an anonymous painter of the Madrid school.

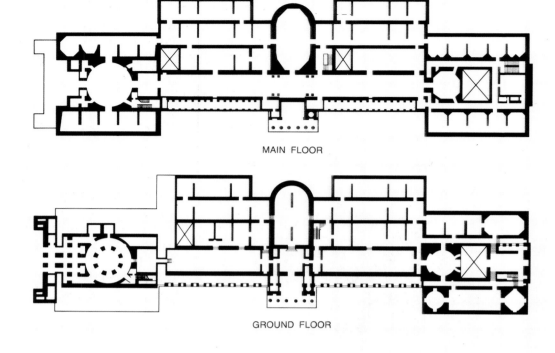

MAIN FLOOR

GROUND FLOOR

Plans of the main and ground floors after the extension of 1964–67

As regards foreign schools, although the number of works acquired was not very large, among them there were pieces of first-class quality. Shining brilliantly above all the others is *The Dead Christ Supported by an Angel* (plate 139) by Antonello de Messina. Bought by the board of trustees as an anonymous Valencian work, not only was its perfect state of preservation revealed once it had been cleaned, but it also became possible to verify its author. Notable also is the composition of *Christ Served by the Angels* (plate 184) by Alessandro Magnasco. From the Flemish school were acquired an *Old Woman Pulling out Her Hair* (no. 3074) by Quentin Metsys and a *Children's Bacchanal* (no. 3127) by Keil Eberhard, while both the French and the British schools were enriched by only one painting each: a *Vanitas* (no. 3049) by Jacques Linard and the *Portrait of Mrs McLean of Kinlochaline* (no. 3116) by Henry Raeburn, respectively. Donations were not particularly spectacular during these years, being limited to a *Portrait of the Duchess of Castro Enríquez* (no. 3089) by Federico de Madrazo, ceded by María Paz García de la Loma y Alvarez in 1964; 124 engravings by Goya, given by the English erudite Thomas Harris; a panel of the *Temptations of Saint Anthony* (no. 3085), very possibly by Hieronymus Bosch, donated by Mme. D. M. van Buuren in February 1965; and finally a *Fragment of the Altarpiece of the Virgin* (no. 3211) attributed to Jaime Huguet and donated by Adolfo Arenaza in 1968.

In an attempt to further increase the capacity of the building, around 1967 the patios that had been between the rear facade of Villanueva's original building and the first galleries constructed along this facade were covered. These works, built directly on the walls of the facade, blocked the windows designed by Villanueva, and therefore not only the new rooms on the ground floor but also those of the 1914–18 galleries became completely dark and condemned to the permanent use of artificial lighting.

The end of 1967 also saw the modification of the legal statutes of the Prado Museum. By decree no. 2764 of November 27, 1967, the administrations of the museums depending on the Dirección General de Bellas Artes became grouped together in a single organism. Subsequently, in accordance with decree no. 83, dated

January 18, 1968, relative to the reorganization of the Ministry of Education and Science, that organism came under the jurisdiction of the ministry.[186] The function of the museum administration, dependent on the Dirección General de Bellas Artes, was regulated on March 4, 1968, by virtue of decree no. 522. Under its second article the museums that had previously functioned autonomously were integrated into the Patronato Nacional de Museos, under the direction of the Dirección General. On August 31, 1968, a command was issued declaring the integration of the Prado Museum into the Patronato Nacional de Museos de la Dirección General de Bellas Artes; that is, it was effectively deprived of any possibility of functioning autonomously.[187]

DIEGO ANGULO IÑÍGUEZ
(1968–71)

Given the government's attitude it need not surprise us that in August 1968 a ministerial decision was taken without the prerequisite of consulting the board of trustees. Francisco Javier Sánchez Cantón was peremptorily removed from his post as director of the museum due to his advanced years. Two months later, on October 13, 1968, the government decided to drastically renew the Prado Museum board simply by arbitrarily dismissing all members over seventy years old, as if they were functionaries who had reached retirement age. It was precisely these people — Francisco de Cossío, Fernando Labrada, Manuel Gómez Moreno, Antonio Marichalar, María Luísa Caturla, the Marquis of Lozoya, and Enrique Lafuente Ferrari — who knew most about the center's problems. Most of their replacements had not even the remotest link with the museum world; the only exceptions were Joan Ainaud de Lasarte, director of the Catalunya Art Museum; Antonio García Bellido, specialist in Roman sculpture; and Enrique Marco Dorta, well known for his studies of Spanish-American art. In protest against this action, and revealing a most praiseworthy integrity on publicly expressing his disagreement with the interventionist attempts on the part of the government, the president of the board of trustees of the Prado Museum, Jesús Rubio, resigned from his post.[188]

Appointed to succeed Sánchez Cantón as director of the Prado Museum was Diego Angulo Iñíguez, who was named to the position on August 15, 1968, again without any consultation with the board of trustees. Xavier de Salas Bosch continued as subdirector. While Angulo was director, he had constantly to face ministerial interference in the administration of the museum. One such occasion was in 1969, the celebration of the 150th anniversary of the museum, which unfolded amid official self-congratulation and bureaucratic difficulties. The situation led him to request that he be relieved, after only three years at the head of the institution, diplomatically alleging ill-health as his motive.[189]

In the short space of Angulo's tenure a series of extremely positive tasks was carried out: the recovery of the works scattered over the country in different museums; the programming of the conditioning and diffusion of the major fund of drawings; and the beginnings of the publication of the systematic catalogue of the works in the Prado. The volume on Flemish painting was entrusted to Matías Díaz Padrón and published in 1975; three volumes of Spanish drawing from the fifteenth to the eighteenth centuries were prepared by Alfonso Pérez Sánchez and Rocío Arnáez and published in 1972, 1975, and 1977. In 1969 a new catalogue was also published on sculpture in the Prado Museum in which, besides the revised version of the classical section prepared by Antonio Blanco, was also included a section on medieval and modern sculpture, the work of Manuel Lorente. Pedagogical itinerant exhibitions were prepared, based on series of paintings from deposits (recovered or still to be so) with the objective of divulging the general history of painting on different university campuses. The reorganization of works on display was planned in accordance with criteria of historical logic and chronology, revaluing formerly scorned series such as the Flemish painting from the Torre de la Parada and those of sculpture. On Saturdays and Sundays public lectures were given. In addition, the first official guide to the museum was published.[190]

During these three years several exhibitions of varying importance were held. The objective of one of them was to present the museum's main acquisitions (through purchase, donation, or legacy) between 1958 and 1968. Another was an exhibition to commemorate the four-hundredth anniversary of Pieter Brueghel's death; in order to achieve this, works from his studio, by his followers, and in his style, as well as engravings and photographs were gathered around the only work in the gallery definitely attributed to him, *The Triumph of Death* (no. 1393). There were also two eminently scholarly exhibitons, one of Goya's preparatory sketches for engravings together with the series of prints presented to the museum by Thomas Harris (a collector and author of the best and most exhaustive catalogue of Goya's graphic work), the other, held in 1970 in the Casón del Buen Retiro, devoted to seventeenth-century Italian painting in Spain.

Despite the short duration of Diego Angulo's term at the head of the Prado Museum, the board of trustees made at the time a series of interesting acquisitions for the painting gallery. The most outstanding of these was Rubens's large *Equestrian Portrait of the Duke of Lerma* (no. 3137), whose departure from Spain was avoided thanks to a law enacted by the Republic that declared that no work that had at some time or another belonged to the Patrimony of the Crown could ever be exported. Two canvases from the Spanish school were purchased at this time, both of them still lifes: one (no. 3203) is signed by Tomás Yepes, an artist hitherto unrepresented in the museum; the other (no. 3159) is attributed to Mateo Cerezo. Three Italian paintings were acquired: a large canvas by Matia Preti depicting *Glory* (no. 3146) and two compositions by Bernardo Cavallino, *The Curing of Tobias* (no. 3151) and *The Wedding of Tobias* (no. 3152). Flemish works acquired were a panel of *The Trinity* (no. 3210) by Pieter Coecke van Aelst and a *Portrait of a Man* (no. 3209) by Jan Mostaert. For its part, the Dirección General de Bellas Artes supplied two suggestive creations by the Frenchman Jean-Baptiste Pierre of a genre previously unrepresented in the Prado Museum, namely a pair of canvases devoted to the loves of *Diana and Calixtus* (no. 3217) and *Jupiter and Antiope* (no. 3218).

This period also saw an interesting series of donations and legacies. The first of these, from the widow of Carlos Jiménez Díaz, consisted of three Spanish paintings, a *Holy Family* (no. 3147) by Luis de Morales; an *Archangel Saint Michael* (no. 3149) by Juan de Valdés Leal; and a *Saint Euphemia* (no. 3148) by Zurbarán. The most substantial of all was the legacy from the dowager Countess of Los Moriles, which included an exquisite pair of *Vases* (nos. 3138 and 3139) by Juan de Arellano; two sketches that might be by Mariano S. Maella: the *Doubt of Saint Joseph* (no. 3140) and the *Liberation of Saint Peter* (no. 3141); a *Portrait of a Lady* (no. 3142), an anonymous French work from the early eighteenth century; an anonymous sixteenth-century *Saint Jerome in Penitence* (no. 3143); and a fragment of a copy made by an artist of the Bruges school of the well-known composition by Robert Campin: *The Virgin and Child "of the Milk"* (no. 3144). In 1969 Adolfo Arenaza presented the museum with a small canvas depicting *Saint Anne, the Virgin, and the Child* (no. 3145), signed by the almost unknown Juan Ramírez de Arellano. In his turn, José Luis Várez Fisa provided a *Retable of Saint Christopher* (no. 3150), an anonymous fourteenth-century Spanish work that filled a wide gap in the collections. The series of donations came to an end with an interesting composition of the *Nuptials of the Virgin* (no. 3153) by Francesco Mazzuchelli, a representative of the last period of Lombard Mannerism, given in 1970 by José Milicua, and with the *Portrait of Consuelo Rocamora Menéndez* by Fernando Alberti, donated by the subject herself.

It was also at this time that the effects of atmospheric pollution on the works became evident. The fumes from the traffic outside the museum — even the breath of the museum visitors — proved harmful to the art. For several years debates were held concerning environmental control inside the museum, a question that further complicated the issue of the expansion of the institution.[191]

Bearing in mind that the painting entered the museum just two weeks before the publication, on November 25, 1891, of the explosive article by Mariano Cavia telling of the "fire" in the painting museum that shocked the whole city, it would not be impossible, in view of the agitation caused by the article, that the recently acquired painting had been simply overlooked and relegated to some corner. The dejection into which Madrazo had fallen during the last two and a half years of his term and the short-lived careers of his three immediate successors (Vicente Palmaroli, 1894–96; Francisco Pradilla, 1896–98; and Luis Álvarez Català, 1898–1901) might also have contributed to the fact that the existence of the painting was simply forgotten.

Finding this lost gem was the final touch to a brilliant career at the head of the Prado Museum. In 1977, at the age of seventy, Xavier de Salas retired from his post as director of the gallery.

JOSÉ MANUEL PITA ANDRADE
(1978–81)

Xavier de Salas was replaced as director of the Prado Museum by José Manuel Pita Andrade, professor of art history at the University of Granada, who had revealed his great ability as an administrator when he organized the Twenty-third International Congress of Art History in 1973.

The country's new political regime gave rise to a remodeling of the structures of government. On July 4, 1977, Royal Decree no. 1558 created the Ministry of Culture, under whose jurisdiction and within the framework of the Dirección General de Patrimonio Artístico, Archivos y Museos, came the Patronato Nacional de Museos, including all the entities belonging to this organization, among them the Prado Museum. The board of museum trustees began to meet once again, and during their first meeting Xavier de Salas Bosch was elected president. Beginning on July 9, 1979, these meetings came to be held on a monthly basis.

Royal Decree no. 3001, dated November 23, 1979,[200] marked a further step toward the gradual attainment of autonomy of the museum. The first article of the new provision redefined the structure of the board. It would now consist of a minimum of six inherent members: the director of the Prado Museum, the director general of the Patrimony, the subdirector of museums, two representatives from the Professional Association of Museum Curators, and the comptroller delegate of the Intervención General de la Administración del Estado. Also on the board would be the honorary directors of the Prado Museum, a representative of the Board of Evaluation and Export of works of historical or artistic importance, and another of the Consultative Council of Museums. Ten additional members would also be appointed by ministerial order, on the proposal of the director general of the Patrimony, and chosen from among fine arts academics, university professors, painters, sculptors, or other individuals either well-known for their competence or interest in the art heritage of Spain or who had distinguished themselves in their services rendered to the museum. This membership was renewable every three years, and the same member could be designated anew.

In Article Two, sections one and two, the decree defines the functions of the board of trustees in the following terms:

> One. Besides the functions conferred upon it by decrees nos. 383 and 3970, dated February 12, the Royal Board of Trustees of the Prado Museum will have that of submitting reports and preparing proposals concerning any matter affecting the National Museum of El Prado, especially the following:
> a) Regulations that must govern the functioning and internal regime of the National Museum of El Prado.
> b) Measures necessary for the safekeeping, preservation, and proper exhibition of the paintings and works of art contained in the museum.
> c) The organization of cultural activities and research plans to promote the museum, and the planning of its publications.
> d) Acquisition of works of art for the museum.

e) By request of the Director General of the Patrimonio Artístico, Archivos y Museos, express their opinion on any question referring to the life of the Museum, including the appointment of members of the Royal Board of Trustees.

Two. The report of the Royal Board of Trustees will be binding in the case of requests for loans of works from the National Museum of El Prado to be included in exhibitions in Spain or abroad.[201]

In short, the Prado Museum continued without its own juridical personality and still depended entirely on the Patronato Nacional de Museos. In its turn, the board of trustees itself became an essentially consultative body without capacity for action. The only real, effective faculty conceded to the board was the right of veto when it came to the question of the loan of works; at last neither the government nor politicians could dispose freely of paintings for senseless exhibitions or place in jeopardy paintings in a delicate state of preservation. This was certainly an improvement over the previous condition.

On May 29, 1980, in fulfillment of this decree, the Ministry of Culture signed the Order of Appointment of the members of the board of trustees of the Prado Museum.[202] Representing the Association of Museum Curators were Martín Almagro Basch, director of the National Archaeological Museum, and Consuelo Sanz Pastor, director of the Cerralbo Museum. The ten members appointed directly were José Luis Alvarez Alvarez, Justino Azcárate Flórez, the Marquis of Casa Torres, Alfonso Pérez Sánchez, Luis Díez del Corral, José Luis Várez Fisa, Jaime Carvajal y Urquijo, Luis Coronel de Palma, Douglas Cooper, and the Mayor of Madrid. Subsequently, the board of trustees was increased with the incorporation of María Luisa Caturla, Enrique Lafuente Ferrari, José María de Azcárate, Plácido Arango, and Fernando Chueca Goitia as Honorary Patrons.[203]

Among the first measures adopted by the new director of the museum was the creation of the Center of Studies of the Prado Museum. This initiative, aimed toward scientific training in museum techniques of art history graduates, was designed to awaken in them a professional vocation toward fine arts museums in general and the Prado Museum in particular. During the second term of the 1978–79 course a cycle of seventy classes was given, during which it became clear that there was a need for courses with practical sessions and seminars. Unfortunately, this experiment had absolutely no support from the government, and the 1979–80 session had to be suspended through lack of funds. At the beginning of 1981 José Manuel Pita still harbored the hope that classes could be resumed in the last term of the year. Nevertheless, some months later he had practically thrown in the towel. The curt reference made to this in the *Bulletin of the Prado Museum* could not possibly be more eloquent: "There is nothing to be said concerning the possibility of resuming activities in this Center."[204]

The government's stance toward hiring professionals was somewhat more positive. In 1980 state examinations were held for the posts of two curators, one for French, German, and British painting and the other for the department of drawing. The first position was secured by Juan José Luna, who had already revealed his interest in the subject in his doctoral thesis on seventeenth- and eighteenth-century French painting in Spain. The second post was assigned to Manuela Mena Marqués, a specialist in seventeenth- and eighteenth-century Italian drawing.[205]

Unfortunately, the same diligence did not apply to another department of vital importance for a museum of the stature of the Prado: the restoration workshop. When José Manuel Pita Andrade took charge of the museum, he found that the formerly prestigious restoration department had been condemned to a slow death through starvation. Several of the restoration posts had been declared "dispensable," even though this section, by virtue of its very nature and of the enormous number of works in its charge, was always overwhelmed with work. By insisting constantly on the

need for more specialized personnel, the director of the museum finally managed in mid-1980 to make the Ministry of Culture accede to the appointment of four additional restorers, destined fundamentally to the task of cleaning works by Velázquez.[206]

In turn, the equipment for the laboratory of analysis of works of art continued to increase. In 1978, thanks to institutional aid, the purchase was made of elementary microanalysis equipment of fluorescence of X-rays through energy dispersal (Kevex). The first project to utilize this apparatus was a systematic analysis of the works of El Greco, thanks to which highly interesting data was obtained concerning the composition of the master's paintings.[207]

Meanwhile, remodeling work on Villanueva's building followed its course, beset with inevitable delays. At the end of 1979 the eastern section of the underground chamber where the air-conditioning system was to be installed was completed. Work has also begun on the southern half of the building. On February 4, 1980, the first ten rooms in this section, those on the first floor added in the successive extensions, were opened by King Juan Carlos I and Doña Sofia. At the same time the rooms' systems of environmental control and illumination were set in motion. By mid-February 1981 the part corresponding to the southern half of the main second-floor gallery was ready, and, one year later, on February 1, 1982, the thirteen rooms on the ground floor of this same sector of the building were opened to the public. At the same time, the restoration room, painting storeroom, and changing rooms began to function.[208]

By the end of 1980 a project had been prepared to build a new cafeteria, which would be constructed underground outside the perimeter of the building, linked to it by means of a corridor. A few months later the project had been completed for the building's southern wing, which contained exhibition rooms on the ground and second floors. Offices for the board of trustees and the administration and curators, the library, and the laboratory of analysis of works of art would be on the top floor. By mid-1981 plans had become perfected concerning the central section: the large Velázquez Hall, on the second floor, and the conference room and concert hall on the ground floor, directly opposite the so-called Velázquez door.[209]

Once the Casón del Buen Retiro had come to form part of the Prado Museum, plans were prepared to remodel it. On July 23, 1980, work began on the exhibition rooms (including restoration of the large Luca Giordano Hall), the drawing gallery, the museum's photographic laboratory, and the offices of the department of nineteenth-century art. By the beginning of 1981 the work was virtually completed and the collections of nineteenth-century painting and sculpture were reinstalled; they finally reopened to the public on June 24 of that year.[210]

Simultaneously, the decision was made to revise systematically the works deposited in institutions scattered all over the country and in Spanish diplomatic premises abroad. In June 1978 the Consulting Committee of Scientific and Technical Research had promised assistance to carry out the task, which involved the examination and photographing of all the works located and arduous investigation to find those whose traces had disappeared. This assistance was subsequently approved and granted by the new Ministry of Universities and Research. Also of great importance was the legal assistance offered by the Attorney General's Office, which supplied invaluable documentation concerning the works held in trust.[211]

The revision of the so-called scattered Prado also affected the conditions of exhibition, environment, and security in which the works in question found themselves. In view of all this and also of the importance of the works in relation to the collections as a whole, the museum authorities reconsidered the suitability of their being held in trust. A theft that had taken place in 1981 in the Museo Balaguer, in Vilanova i la Geltrú, where a good many paintings from the Prado were housed (including the exquisite *Annunciation*, no. 3888, by El Greco and two of the canvases

by Maíno for the altarpiece of the Church of San Pedro Mártir in Toledo, nos. 3018 and 5080), alerted authorities to serious danger, and as a result the works held in trust were removed until the unfortunate museum had been reconditioned.[212]

During Pita Andrade's term of office, purchases of new works for the Prado Museum were carried out by the Junta de Calificación de Obras de Arte. Outstanding among the acquisitions of Spanish painting are the *Savior Blessing* (no. 6074) by Zurbarán and the magnificent portrait in miniature of *Juana Galarza de Goicoechea* (no. 4194), painted in 1805 by Goya, who would shortly afterward become the subject's son-in-law. An artist hitherto unrepresented in the Prado was the Valencian painter Vicente Salvador Gómez, whose canvas depicting *The Expulsion of the Merchants from the Temple* (no. 2661) was acquired in Paris. Acquisitions from this period were completed with a *Piety with Magdalene* (no. 6394) by Pedro Núñez de Villavicencio and two paintings alluding to the *Celebration of the Festival of San Fernando in Aranjuez* (nos. 4180 and 4181) by the Italian Francesco Battaglioli, who lived in Spain between 1754 and 1760.

The Flemish school was enriched by two paintings, one from the sixteenth century — *Couple of Villagers in the Market* (no. 6393) by Pieter Aersten — and *Piety* (no. 6392) by the seventeenth-century artist Jacob Jordaens. Novelties of Italian painting were *Boys Gathering Fruit* (no. 6077) by the Baroque artist Michelangelo Cerquozzi and four works by three eighteenth-century artists, *Sweet and Pastry Seller* (no. 3263) and *Mora Players* (no. 6076) by Giacomo Francesco Cipper, a canvas by the Venetian Francesco Fontebasso depicting *The Husband and the Unwise Virgins* (no. 6079), and *Virgin and Child with Saints* (no. 6078) by Giovanni Battista Pittoni. The department of French painting received an anonymous work from the eighteenth century in the style of Girodet with the story of *Venus Curing Aeneas* (no. 6075), acquired at auction, and *The Death of Calanus* (no. 6073) by Jacques-Antoine Beaufort, one of the precursors of Neoclassicism. A final purchase was one of the paintings executed by David Roberts during his visit to Spain: *Interior of the Mezquita in Cordoba* (no. 6160).

Donations and legacies received by the museum between 1978 and 1981 were few but significant. Thanks to the generosity of José Saldaña, who in 1978 presented a canvas depicting *Saint Clara Driving Away the Unfaithful with the Eucharist* (no. 3264), the museum received a magnificent example (signed and dated in 1693) of the work of Isidoro Arredondo, a Madrid painter of the late seventeenth century, whose name had yet to figure in the Prado. The canvas depicting *The Metal Snake* (plate 260), one of Sébastien Bourdon's masterpieces, was bequeathed to the museum by Katy Brunov on her death in 1979. April 8, 1979, saw the death of José María Giner Pantoja, whom we have already seen as keeper of the works from the Prado Museum when they were being transferred to Valencia, Catalonia, and Geneva during the Spanish Civil War. As if his contribution had not already been more than enough, in his will he bequeathed to the museum the receipts from the sale of his house in Paris, which the board of trustees destined to the acquisition of paintings.[213]

Opening a totally new field in the Prado Museum, on October 11, 1979, Douglas Cooper presented the *Portrait of Josette* (plate 131) by the Madrid painter Juan Gris. Painted in 1916, this Cubist canvas was a kind of anticipation of the arrival of one of the paradigmatic works of contemporary painting, Pablo Picasso's *Guernica* (plate 134).

Picasso's huge painting — more than twenty-five feet wide — had been created as a commission from the republican government to decorate the Spanish pavilion at the Paris International Exhibition of 1937. After the exhibition closed, Picasso kept the painting himself for a while. In 1939 he deposited it in the Museum of Modern Art, New York, on behalf of the democratic government of Spain and in his own name as fideicommissary. On several occasions Picasso publicly expressed his wish that *Guernica* hang in the Prado, but not until democracy had been

restored in Spain. On the artist's death in 1973 responsibility for the custody of the painting was entrusted to his seven heirs, who in turn delegated the task to the lawyer Roland Dumas.

Once parliamentary democracy had been restored in Spain, the government elected by the people began negotiations to recover the great work. These negotiations were long and complicated, since it was a *sine qua non* condition that all seven heirs and their lawyer had to give their unanimous consent that the painting be handed over by the Museum of Modern Art. The location in 1980 of the documentation of Luis Araquistain, Spanish ambassador in Paris, and that of his cultural advisor, Max Aub, which revealed that the republican government had bought *Guernica* for the sum, then considered symbolic, of 150,000 French francs paid to Picasso on May 28, 1937, greatly facilitated the reaching of an agreement. At last, on September 10, 1981, the painting, having been removed from its canvas, rolled, and strongly guarded, arrived at Madrid-Barajas Airport from New York.[214]

The activities of the Prado Museum were considerably intensified as of 1978. The increase in the number of exhibitions there could not have been more radical. In the three years during which José Manuel Pita was director, at least seven were held. Unfortunately, since the institution contained no room for temporary exhibitions, some of the halls of the gallery had to be used, so that the number of the museum's works visible became considerably reduced.

Exhibitions changed not only in their number, but in their character as well. There was a series of exhibitions intended essentially to put on display those works from collections normally inaccessible to the public or to show the kind of work that went on in the museum's restoration room. Examples of this are the commemorative exhibition of the "Bicentenary of the Death of Mengs" (1728–1779), held in the Prado from June 12 to July 27, 1980, and the "Panels by Pedro Berruguete for Paredes de Nava" (1980), after the theft. In this section can also be included the exhibition of twenty-one paintings, "New Acquisitions of Works, Corresponding to the Years 1978–1981."

Other exhibitions, the fruit of collaboration between the Prado and other museums, mostly abroad, sought to examine concrete topics of joint interest. These exhibitions often traveled to the different centers. Through these activities, the Prado Museum revealed its determination to become thoroughly integrated into the international scientific community devoted to the study of art. Outstanding among these exhibitions was "European Art in the Spanish Court in the Eighteenth Century" (Bordeaux and Paris, May–December 1979; Prado Museum, February–April 1980).

To a certain extent we can even distinguish a third kind of exhibition, oriented simply toward the temporary exchange of more or less monographic groups of works responding to the particular interests of the respective centers. It is here that we would situate "Seventeenth-Century Spanish Painting from French Provincial Museums" (Madrid, March–April 1981), which had previously been shown in Tokyo and Osaka, complemented by sixteen canvases from the Prado. In return, the Japanese put on the "Namban Art" exhibition (Madrid, February 12 to March 15, 1981). Also belonging to this section was "Treasures from The Hermitage," consisting of ten Spanish and fifteen Dutch paintings (Madrid, April 29 to July 29, 1981), loaned in exchange for thirty-two Spanish canvases from El Greco to Goya sent to Moscow and Leningrad from September to December. For its part, the loan of fifty Spanish paintings from the sixteenth and seventeenth centuries to the National Museum of Belgrade, during September and October 1981, meant that it became possible to see at the same time in the Prado the interesting show of medieval Serbian art of the twelfth through fourteenth centuries.

Among the tasks undertaken with enthusiasm by the new museum team was a series of educational activities (lectures, cycles, short courses, seminars, teacher

The hanging of Guernica *in the Casón del Buen Retiro*

training). Included at first within the "Art Missions," they have continued until the present day without a generic title to define them.

Also of capital importance was the appearance of *The Bulletin of the Prado Museum*, which provides a large number of news items concerning the institution. The bulletin contains monographic articles, not only by the curators and technical staff of the museum but also by professionals not linked to the institution, on topics related to the Prado's collections. Of great importance are the permanent sections in each issue, such as the one devoted to the "scattered Prado," in which little by little an inventory is being published of the huge number of canvases, sculptures, and other objects administered by the museum. Extraordinarily useful in order to follow the history of the institution are the "Preliminary Words" by the director and the "Prado News" sections.

It is important to mention here as well the foundation in 1980 of the Friends of the Prado Museum, an entity that in future years would make major contributions to the activities and the collections of the museum.

Although in general the activities carried out by the Prado from 1978 on can be seen as extraordinarily positive, the museum authorities were still engaged in a bitter struggle with the government, and particularly with the Dirección General del Patrimonio, Archivos y Museos, in order to achieve effective autonomy and juridical status for the museum. Untenable situations continued to exist, such as the inability to pay for the diesel fuel necessary to work the recently installed system of environmental control. Faced with the imperative of having to shut down such costly equipment due to bureaucratic red tape, Pita Andrade opted to commit the administrative sacrilege of diverting the revenue obtained from the sale of entrance tickets to the purchase of fuel for the air-conditioning system. Another absurdity generated by the museum's lack of autonomy was the impossibility of formalizing an annual donation of one million pesetas to finance a small part of the activities of the restoration workshop, because the check could not be made out directly to the Prado Museum. The last straw was the attitude of the government regarding the transfer and installation of *Guernica*. The Dirección General del Patrimonio

monopolized the operation and pushed the Prado completely aside, to the extent that the only document that exists in the museum archives relative to the transaction is a copy of the receipt acknowledging the arrival of the painting, signed by the museum director. Pita Andrade felt even greater indignation at the prepotency shown by the Dirección General when it came to the installation of the work. The suggestions of the museum technicians were totally ignored, and not even a minimum of respect was shown for the recent remodeling of the Casón, completed scarcely six months earlier, which was used as a ballroom. As a result of all this, in mid-October 1981 José Manuel Pita Andrade submitted his irrevocable resignation, shortly before the first public showing in Madrid of *Guernica* on October 24.

FEDERICO SOPEÑA
(1981–83)

The new director chosen was Federico Sopeña, a scholar from the San Fernando Academy of Fine Arts and a brilliant musicologist. In disagreement with the ministerial decision, Alfonso E. Pérez Sánchez resigned as subdirector. His place was taken by Manuela Mena, linked to the museum since 1978 and chief curator of the drawings department since 1980. Alongside her, Manuel Jorge Aragoneses was appointed subdirector responsible for the remodeling of the museum.

Construction on the building followed its course; on October 8, 1982, the new subterranean cafeteria was opened. The following month the library and the offices of the board, directors, and curators began moving to their new locations on the third floor of the southern wing.[215]

As regards the restoration workshop, on July 9, 1982, the Executive Council of the Banco de España agreed to grant financial assistance requested by the museum in order to restore thirty-five paintings and set up a series of scholarships for study abroad.[216]

During the short period of Sopeña's term, the State's policy of purchasing pieces for the Prado Museum lost none of its relative intensity. They were not always works of first-class quality, perhaps, but they were by painters poorly represented in the museum's collections. To the Spanish school belong three panels by Miguel Ximénez, representing *The Trinity* (no. 6893), *Saint Catherine* (no. 6894), and *Saint Michael* (no. 6895); six altarpiece compartments with scenes from the Passion (nos. 6897–6902) by Rodrigo de Osona "the Younger"; a triptych of the *Holy Family* (no. 6777) by Gabriel de Cárdenas; two canvases by the Madrid artist Diego Polo, *The Gathering of Manna* (no. 6775) and *Saint Jerome* (no. 6776); *Christ on the Way to Calvary and the Veronica* (no. 6782) by Valdés Leal; and two gallant scenes (nos. 6732 and 6733) by José Camarón y Boronat. Also acquired during this period were *Birth of the Virgin* (no. 6778) by the Italian Jacopo Ligozzi; five French paintings, two by Jean-Louis-François Lagrenée (*The Sense of Smell*, no. 6770, and *The Sense of Touch*, no. 6771) and three by Jean-Antoine Julien, better known as Julien de Parme (*The Kidnapping of Ganymede*, no. 6772; *The Dawn Kidnapping Cephalus*, no. 6773; and *The Leave-Taking of Hector and Andromache*, no. 6774); and four paintings from the Netherlands: *Crucifixion* (no. 6779) by Louis de Caulery; *Set of Domestic Utensils* (no. 6780) by Frans Ryckhals; *Portrait of Petronella de Waert* (no. 6892) by Gérard ter Borch; and *Cavalry Charge* (no. 6891) by Pieter Meulener.[217]

The list of donations could not be shorter: there was one only. Its quality is exceptional, however, since it is the delicate *Portrait of the Countess of Santovenia* (no. 6711) by Eduardo Rosales. This gift is of special significance, since it marks the first contribution to the museum collections by the Association of Friends of the Prado Museum, with the collaboration of the Banco de España and the Caja de Ahorros (Savings Bank) of Madrid.[218]

During the period of just over a year that Sopeña was director of the museum, the policy of exhibitions in the Prado continued with the same intensity. A collaboration among the Ministry of Culture, the Haus der Kunst and Alte Pinakothek of Munich, and the Kunsthistorisches Museum of Vienna bore a major exhibition

of Spanish painting from the sixteenth to eighteenth centuries in Central European collections, which was held first in Madrid, from December 1, 1981, until January 31, 1982, and subsequently shown in Munich and Vienna. Also held were the first three in a series of large-scale one-artist exhibitions devoted to the great Spanish masters represented in the museum: El Greco, Murillo, and Meléndez; future years would see shows on the Ribaltas, Zurbarán, Goya, Sánchez Coello, Velázquez, and Valdés Leal.

The exhibition "El Greco of Toledo" was organized jointly with the Toledo Museum of Art (Ohio); the National Gallery of Art, Washington, D.C.; and the Dallas Museum of Fine Arts. Curated in Spain by José Manuel de Pita Andrade, with Alfonso Pérez Sánchez as his assistant, it was open in Madrid from April 1 to June 6, 1982, and was complemented by another exhibition organized by the Ministry of Culture entitled "The Toledo of El Greco," held in the city where the Cretan genius lived and worked. This exhibition was sponsored by the American Express Foundation and the Fundación Banco Urquijo, beginning a line of economic collaboration that would intensify over coming years.

The exhibition commemorating the four-hundredth anniversary of the death of Murillo was organized exclusively by the Prado. Manuela Mena, subdirector of the museum, was the curator, and the event enjoyed the special collaboration of Enrique Valdivieso. Opened in Madrid on October 8, 1982, it was closed on December 12 that same year to be shown in London during the first third of 1983. An exhibition devoted to the still lifes of Luis Meléndez, organized by Juan José Luna, curator of French, British, and German painting, was the first show created by the Prado that subsequently traveled to other Spanish cities (Barcelona, February–March 1983; Valencia, February–March 1984), thus initiating the new policy to spread information about the activities and collections of the museum.

During the last period of Federico Sopeña's term as director examinations were held to designate a curator of seventeenth-century Flemish and Dutch painting. By a resolution passed on February 23, 1983,[219] the post was awarded to Matías Díaz Padrón, a former pupil of Diego Angulo, internationally recognized as a specialist in the field and author of the Prado Museum's Flemish painting catalogue, published in 1975.

ALFONSO E. PÉREZ SÁNCHEZ (1983–91)

On December 3, 1982, after the triumph of the Spanish Socialist Workers Party in the elections held in October, the first socialist cabinet of the democracy was formed, with Javier Solana as Minister of Culture. Two and a half months later, on February 16, 1983, the minister signed an order dismissing Federico Sopeña as director of the Prado Museum and appointing Alfonso E. Pérez Sánchez in his place.[220] In his address at the official act of appointment, held in the museum on February 22, 1983, and presided over by Solana, the new director made it clear that he had undertaken a deep analysis of the condition of the Prado Museum and that he had very sharply defined objectives:

> If once I called the Prado "the great invalid of our culture," that has managed to survive so many adverse situations with its shine practically undimmed and its patrimony virtually unscathed — thanks to the very quality of its collections and the selflessness of the people who have served it — I believe the time has come to attend to it properly, to endow it with a new stature, a personnel and economic infrastructure, and to provide it with the extension that has been claimed for so long.
> While convinced that this attention will be forthcoming, I feel duty-bound to point out those areas where specific attention is needed, returning anew to the essential premises posed by any museum, and taking it for granted in the first place that legal autonomy is needed to carry out these premises without the obstacles of every kind that today stand in their way.
> Preservation of these collections, which are always — and perhaps more so in the Prado than elsewhere — living history, direct and clear evidence of our past and our

Alfonso E. Pérez Sánchez

very condition. With all its limitations and all its glories, the Prado is the history of Spain, and as such must be preserved, from the masterpieces that are mentioned and recalled daily, permanently adorning the museum's walls, to the last of the canvases scattered over the country, often in remote parts, neglected and sometimes even in a deplorable state. Such preservation requires suitably and rigorously trained staff, selected according to demanding criteria, devoted to their work, and well paid.

Exhibition of these collections. Of course, it is inconceivable that today's Prado exhibit on its walls the entirety of its rich heritage, but limiting ourselves to what we might call the gems of the collections, its fabulous richness calls for immediate extension of the museum. The Prado needs nearby premises of quality and prestige that will house with dignity important sectors of the collections and the services necessary for a modern museum. Furthermore, there is a need to reconsider very seriously the accessibility to the public of all the remaining collections, which by virtue either of their quality or historical interest are worthy of this, in periodical or itinerant exhibitions, so that in both Madrid and in the rest of Spain people will be able to contemplate what today is vegetating, often in great peril, in storerooms or offices of so many official or semipublic buildings.

Research. The Prado must also be a center of rigorous research, bringing to bear on its collections — that is, on a patrimony that belongs to everyone — all the means of modern scientific research. I believe that developing efficient formulas of collaboration in this field with Spanish universities and different institutions is an essential task that, in the not too distant future, will provide us with rigorous, modern scientific catalogues and new analyses of the techniques and resources of the masters of the past, possibilities enjoyed by other museums the world over of less objective wealth than ours.

Here too there is an obvious need for adequate means and sufficient personnel, but here too, and to no lesser extent than in other areas, a stringent selection is also essential. If the Prado sets out to be the foremost painting gallery in the world, having so many masterpieces is not enough; necessary also is a quality scientific staff, well trained and highly dedicated. Possibly the issue is not one of the number of people involved, but rather of the preparation and efficiency of a sufficient number of true professionals. And it must be pointed out that it already possesses a number of these, whose activities are severely limited by lack of means.

Finally, after having made reference to the museum's task as an educational establishment, Pérez Sánchez summed up in the following terms:

This is, then, a complete program, an ambitious one as I am aware, and in order to carry it out the collaboration and enthusiasm are needed of all those whom I acknowledged earlier, the minister principally now. To his decisions, to his ability to listen and to understand, we shall owe the solving of so many structural problems from the so longed for administrative autonomy to the increase in budgets, completion of works, and the granting of premises that will permit the necessary extension. And also to the help of all those who from the museum in their daily work in fulfilling their individual missions reveal their love for an institution that belongs and must belong to all Spaniards.[221]

After allowing a prudent period of time to elapse, in issue number 12 of the *Bulletin of the Prado Museum*, the last one corresponding to 1983 (but written early in 1984),[222] Pérez Sánchez once again requested what he had already asked for on taking possession of his post:

the legal structure that will endow the museum with its own legal status and also allow it, among other important functions, to receive subsidies, aid, legacies, and donations without the administrative obstacles with which it is beset today, placing its initiatives and projects in grave jeopardy.[223]

With the slowness that the Spanish government is apparently incapable of overcoming, but with the unquestionable desire to offer effective solutions, the minister of culture held a press conference in the museum's meeting rooms on October 14, 1984. During this conference Solana announced the government's decision to restore the Prado Museum's administrative autonomy as of January 1, 1985. To that end, Law no. 50, dated December 30, 1984, of the General State Budgets for 1985, determined in Article 87.2 that the Prado Museum was an

administratively autonomous organism assigned to the Ministry of Culture and directly responsible to the head of the ministry.

During the first four months of 1985, the Ministry of Culture, the board of trustees, and the directors of the Prado Museum prepared the draft of the statute that would make effective the autonomy granted by the Budget Law. Finally, on August 1, 1985, the king sanctioned Royal Decree no. 1432, by which the "National Museum of El Prado" was constituted as an autonomous organism and its statutory regulations were established (see the Appendix, page 437, for the complete text of the Royal Decree).[224] The preamble to this decree declared that:

> in view of the experience acquired since the aforementioned regulations were established and of the results of the comparative analysis of the legal and organizational regime of great museums in other countries, it has been deemed advisable to grant the National Museum of El Prado, in its renewed condition as autonomous organism, a set of updated statutory regulations that, in accordance with its specific tradition and respecting its singular character, will promote a new period of modernization and efficacy in the museum's scientific and economic administration.

To this end, this present Royal Decree defines and limits the functions of the governing bodies of the museum; the basic structure of assessment and museum management is established through the Subdepartment of Preservation and Research and the departments of Conservation and of Restoration; lastly, an Administrative Department is created whose functions, among others, are to coordinate the economics and management of the museum and the administration of the funds assigned to it.

> These measures are designed to endow the National Museum of El Prado with a new juridical and administrative regime, which, while it may subsequently be developed and modified, will allow the institution to carry out the exalted mission of preserving, exhibiting, and enriching the collections of works of art that form its patrimony and, closely linked to the history of Spain, constitute one of the most sublime manifestations of universally recognized artistic expression.

The decree first establishes the nature, classification, and juridical regime of the entity, and goes on to define its objectives and functions (preserve, exhibit, and provide information concerning the works that constitute the patrimony; provide assessment in terms of its domain; contribute to the training of specialized staff; carry out research; cooperate with other centers of a similar nature; etc.). It then indicates that the governing body consists of the president, the royal board of trustees, and the director of the museum; additionally, provisions are made for a scientific committee.

Regarding the board of trustees, the decree defines its composition — ex-officio members and others who are appointed personally — and lists its functions (establish general guidelines, mark out the internal regulations of the museum, accept subsidies and donations, propose and approve acquisitions, control deposits, authorize exceptional works of restoration, request the addition of other premises to the museum, approve the work to be carried out on them, authorize temporary loans, provide information about candidates for director and subdirector, propose honorary directors, determine procedures of selection and engagement of staff, etc.). The director, appointed by Royal Decree agreed upon by the Council of Ministers on the proposal of the minister of culture, has the rank of director general and is essentially responsible for executing the decisions of the board, coordinating the different services of the museum, and supervising the staff. Dependent upon him are the general subdepartments of Conservation and Research (subdivided in turn into several preservation departments and one of restoration) and of economic and administrative matters.

On October 10, 1985, the board of trustees was appointed. Besides the ex-officio members, the board consisted of Diego Angulo, José Manuel Pita, Antonio Blanco Freijeiro, José María Azcárate Ristori, Felipe Garín, Manuel Casamar, Gonzalo Anes,

Justino Azcárate Flórez, Jaime Carvajal, Julio González Campos, and José Luis Yuste. During the board's first meeting, held on October 30, Justino Azcárate Flórez was elected president, although soon afterward he resigned due to his age. On April 2, 1986, he was succeeded by Gonzalo Anes.

In December 1985 Alfonso E. Pérez Sánchez was appointed director general of the newly autonomous museum, while Manuela Mena was named subdirector of conservation and research. The management team was appointed early in 1986; it consisted of one manager and five service heads for security, works and maintenance, planning and control, finances, and personnel. In August that same year Matías Días Padrón was appointed head of the Department of Flemish and Dutch Painting, Juan José Luna Fernández head of the Department of French, British, and German Painting, and Joaquín de la Puente Pérez head of the Department of Nineteenth-Century Painting. On June 1, 1987, Juan Miguel Serrera and Jesús Urrea were appointed heads of the departments of Spanish and Italian painting, respectively.[225]

The state of the Prado Museum's restoration workshop when Alfonso Pérez Sánchez took over as director could not have been more discouraging. His own description in the last 1983 issue of *The Bulletin of the Prado Museum*, echoed the feelings of the board of trustees:

> It is well known . . . that many of the museum's paintings are in a deplorable state after many years of maltreatment and neglect. It is also well known that the museum is normally in a state of penury. The lack of a permanent, well-remunerated staff of restorers, selected according to stringent criteria, means that the workshop is condemned to live a precarious existence, which sometimes leads to situations of mistrust and accusations as violent as they are unfounded.
>
> The Prado has informed the government on numerous occasions of the need to suitably equip the workshop and to establish a set of objective norms of selection that would allow the permanent engagement of those who have already proven their worth, and give an opportunity to those who have not yet managed to do so in a thoroughly convincing manner.
>
> We the governors of the museum consider it our duty once again to make this request, to which the government has yet to reply, and to leave a written record of the highly serious problem represented by obstacles to the renewal of the few contracts issued since 1983, and legal difficulties in the way of freely disposing of private financial donations intended precisely to attend to problems of restoration.[226]

Indeed, Pérez Sánchez made gargantuan efforts to secure this assistance despite bureaucratic obstacles. Before the first year of his term had come to an end, he managed to obtain enough economic support from the firm of Productos Roche, S.A., to enable him to organize, from November 25 to 28, 1983, an international symposium of the highest possible scientific level, on the serious problems posed by the delicate state of preservation of some of the most outstanding works in the museum: Velázquez's *The Spinners* (plate 57) and the "Black Paintings" (plates 101 and 102) by Goya. Fruit of this meeting, attended by many well-respected and recognized specialists, was a series of recommendations published in the *Bulletin* that would be seriously considered when the paintings in question were finally restored.[227]

On May 14, 1984, cleaning work began on one of the Prado Museum's most famous canvases, *Las Meninas* by Velázquez (plate 56). The operation, which was the object of some controversy, was carried out by John Brealey, director of the Department of Painting Conservation at The Metropolitan Museum of Art, New York. The eminent restorer, one of the most highly regarded in the world, donated his services in homage to the great work of art. His travel and accommodation expenses were met by Mrs. Hilly Mendelssohn, who contributed one million pesetas through the H. M. Foundation. Two and a half months later, the restoration work was completed, and the painting was exhibited in its new, pristine state on July 31, 1985, in the so-called Rotonda de Ariadna.[228]

This was but one example of several donations the Prado Museum received toward restoration work in 1984. The Banco de Bilbao also provided one million pesetas and the Caja de Ahorros de Madrid five million to this end.[229] In 1985 Mrs. Hilly Mendelssohn offered a further million pesetas to the Prado restoration workshop, and the International Journalists Federation donated 550,000 pesetas to the restoration of Goya's magnificent portrait of *Don Gaspar Melchor de Jovellanos* (plate 94).[230] Furthermore, a donation of three million pesetas from the firm INITECSA enabled the restoration of *The Spinners* and the subsequent documentation and exhibition of the work and its restoration process.[231]

Obviously the restoration workshop of a museum as important as the Prado could not depend entirely on the generosity of people who made voluntary contributions, just as it could not function properly with a considerable number of operations entrusted to people with temporary contracts. Finally the claims on the part of the different museum departments were satisfied, on April 1, 1986, when on the basis of the results of the corresponding examinations, five new painting restorers and an official gilder were appointed; with this the permanent restoration staff was almost doubled, from seven to thirteen.[232]

Another important step toward improving the restoration workshop was taken with the agreement signed in 1987 between the Prado Museum and The Metropolitan Museum of Art. By this pact John Brealey spent a year in Madrid beginning on October 15, 1987. His mission was to act as consultant to the technical team in the Prado and to establish the essential guidelines for the definitive installation of the restoration workshop. This project was supported by Plácido Arango, a longstanding collector and patron of the arts and a member of the Prado's board of trustees from May 20, 1986.

The Department of Technical Documentation (formerly the Laboratory of Analysis of Works of Art), directed by María del Carmen Garrido, has worked closely with the restoration workshop. The documentation prepared by this department on all the works subject to inspection (radiography, reflectography, infrared treatment, ultraviolet fluorescence, stratigraphy, spectometry by energy dispersed by X-rays, etc.) has been extraordinarily useful, not only for restorers but also for curators and art historians in general.

Particularly spectacular is information revealed about the "Black Paintings," data collected in preparation for the symposium held at the end of November 1983 on the state of this series of works.[233] Equally fundamental was the systematic study of twenty-one canvases by Velázquez carried out in 1985 and funded by a grant from the Hispanic–North American Joint Committee for Cultural and Educational Cooperation. An extension of seven months, approved in October 1985, allowed the study of seven more paintings by the master.[234]

In April 1985 the Department of Technical Documentation received a grant from the Hispanic-North American Joint Committee for Cultural and Educational Cooperation enabling the purchase of a cryostat detector system and a compatible computer. This completed the equipment necessary for analysis through energy dispersal by X-rays.[235]

Midway through 1983 the museum's Didactic-Pedagogical Department was set up. Directed from October 1 of that year by Alicia Quintana, institute professor and doctor in history, the project was firmly backed by the Friends of the Prado Museum Foundation.[236]

Remodeling continued at its usual pace, and between February and April of 1983 provisional refurbishing was carried out on the ground-floor temporary exhibition halls in the northern wing, where the offices and library had formerly been. The following July halls 34–38 were inaugurated at the other end of the building, on the second floor of the southern wing, with some of Goya's paintings. Almost a year later, on May 30, 1984, the conference and concert hall was completed,

opposite the so-called Velázquez Door. Remodeling of the southern half of the building was at last completed on March 29, 1985, the date on which the Velázquez halls (11 and 12–15A) and those of Goya containing his tapestry cartoons (halls 19–23 and 39), the "Black Paintings" (hall 67), and the drawings (hall 66, with low lighting, below 50 lux, to ensure the preservation of the works) were opened to the public.

In subsequent years work began on the rooms adjacent to the northern half of the large gallery, on both the ground and second floors. The first section to be made ready was the ground floor, where on February 22, 1988, the eleven halls housing Flemish and German painting of the fifteenth and sixteenth centuries and Spanish painting of the sixteenth century were opened. Very shortly afterward, on May 3, eleven more rooms were opened on the second floor, coinciding with the exhibition of the works of Zurbarán whose paintings, once the show was over on September 30, were replaced by sixteenth-century Venetian painting and the works of El Greco. Among the latest improvements have been the cleaning and restoration of the facade and ground floor of the northern wing (begun in 1988 and completed in 1990), after which access to the museum through the Goya Door once more became possible. In 1991 work was completed on the second floor in the rooms around the rotunda and the northern half of the central gallery. Finally, the complete restoration of Villanueva's building is in sight.

Once the main building is in its optimum condition, it will be the *casón*'s turn to be the object of extensive remodeling and renovation of the environmental control, lighting, and security systems. Coinciding with these works, a study will be made of the reordering and ways to present the collections it houses; a key problem here will be the placing of *Guernica*, the preparatory drawings for the work, and the paintings of Juan Gris and Joan Miró.

The new installations resulting from remodeling work are designed to provide greater dignity to the conditions of presentation of the works permanently on display, with the consequent decrease in the density of occupation of available surfaces. The recourse of hanging paintings in corridors and staircases has by now been rejected since, because it is impossible to set up a comprehensive surveillance system, these paintings would run a greater risk of acts of vandalism. In recent years there has also been a continual increase in the technical and administrative staff, with a view to providing the increasing number of services that society demands from a museum. This has led to the "occupation" of eighteen of the rooms formerly given over to exhibiting works. For this reason, the number of works that will be on show once remodeling work has been completed is likely to be much smaller than it was in 1976.[237] In fact, the museum storerooms have become so crammed once again that three public rooms have had to be taken over for this purpose. In consequence, the expansion of the Prado Museum has again become a matter of prime importance.

The question of extending the museum's display space was addressed throughout the 1980s. In October 1984 the minister of culture, Javier Solana, announced that the Palace of Villahermosa, in the Plaza de Cánovas del Castillo and directly opposite Villanueva's building, had been purchased in order to act as an annex to the Prado Museum. The minister added (thus satisfying a claim made by Pérez Sánchez during the historic set of lectures he gave about the Prado Museum in 1976) that the Salón de Reinos, together with the *casón* the only part still surviving of the Palacio del Buen Retiro and then occupied by the Army Museum, had also been given over to the painting gallery.

Almost at once, in the first months of 1985, studies began to find ways to adapt the Palace of Villahermosa to its proposed new function as the site of the installation of eighteenth-century works centering around the figure of Goya. While the refurbishing works were still incomplete, the idea emerged to use the rooms on the

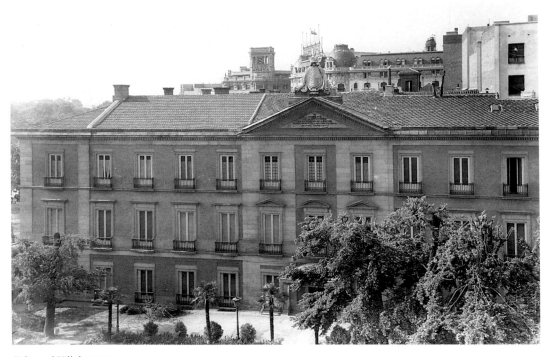

Palace of Villahermosa

ground floor of the palace as temporary exhibition halls. One year after the minister's announcement, on October 1, 1985, an exhibition was opened devoted to seventeenth-century Neapolitan painting. This was the first in a series of important exhibitions in the Palace of Villahermosa organized by the Prado over the next three years.

Just as everything seemed finally to be moving in the right direction, an unforeseen factor radically changed the situation. Baron Hans-Heinrich von Thyssen-Bornemisza decided to move his family's art collection, consisting of some fifteen hundred pieces, of which a small selection of some three hundred works was at the time on show in the so-called "Villa Favorita" in Lugano. He based his decision on the refusal of the cantonal government of the Ticino to cover the costs of remodeling and extending "Villa Favorita" so that the public might be able to see a more substantial part of the collection. The Ministry of Culture made contact with the baron in April 1987 regarding the possibility of bringing a considerable part of his collection to Spain. After a year of negotiations, during which a number of alternative candidates from around the world emerged, in mid-March 1988 Baron Thyssen-Bornemisza formally proposed to the Spanish government the temporary transfer to Spain of some seven hundred works from his collection.[238]

The possibility of allocating the Palace of Villahermosa to house these works was discussed. Quite naturally, this proposal met with opposition on the part of the Prado, for if this agreement were signed, the museum would miss a unique opportunity to solve its overwhelming problems of lack of space.[239] On April 7 Javier Solana and Baron Thyssen-Bornemisza signed an agreement regarding the points to be developed, among which figured the loan for a minimum of ten years of over seven hundred works from the collection, the creation of a foundation with public capital but private rights, which would assume responsibility for the works ceded and would pay an annual sum to their owners, and the cession, free of charge, of the Palace of Villahermosa to the foundation.[240] The definitive agreement, signed on December 20, 1988, by the new minister of culture, Jorge Semprún, and Baron Thyssen-Bornemisza, meant for the Prado Museum the irrevocable loss of the palace.[241]

From his section in *The Bulletin of the Prado Museum*, the director of the institution expressed his sorrow and disappointment, pointing out the problems that such a decision carried with it for the country's foremost painting gallery:

> The ministerial decision to give over the Palace of Villahermosa to house the Thyssen collection has deprived the Prado of a building whose assignment to the museum was celebrated by all as a milestone in its history, since it met in a particularly fortunate way the needs of extension so often repeated and so unanimously expressed by the successive directors and patrons.
>
> All that has been written in successive volumes of the *Bulletin* since the last four-month period of 1984 has thus remained without effect. During the three years in which the Palace of Villahermosa has been ascribed to the Prado it has more than demonstrated its ability to meet the museum's demands even though — awaiting sufficient funds — it has proven impossible to refurbish it totally to house the Goya collections and those of the eighteenth century, so that it has been used only for memorable temporary exhibitions.
>
> The works carried out in Villanueva's building during this time, since it was assumed that the Villahermosa Palace would be available, have meant that the exhibition areas have been reduced still further, so that when construction is completed in 1990 the number of canvases on display will be much smaller than when it began in 1976. Entire series of our rich collections will not be seen, and it will not be possible to exhibit even the best known, except in anthology form.
>
> The expansion of the Prado has therefore once again become the prime concern of the museum governors and the Board of Trustees.
>
> We hope that the Minister of Culture will be sufficiently sensitive to manage to find the way to solve our problem, assigning to our venerable and symbolic institution a building that fullfils those conditions that have been repeated so often and which the Palace of Villahermosa met so perfectly: architectural dignity and nobility, physical proximity to the mother building, and comfort and inner flexibility to receive — not forcing them but rather adapting to them — the collections to be housed there. Along the Paseo de la Castellana, to which so much cultural and symbolic significance has recently been attached as part of our country's projection to the rest of Europe, there are a number of significant buildings that would admirably fulfill these conditions.
>
> Given the anxiety with which we view the precarious conditions of space the museum will have to tolerate over the next years, we once again raise our voices to demand the solutions and attention that the importance of the Prado has always merited and which, believing them to have been granted, has once again seen vanish into thin air.[242]

In other words, in order temporarily to exhibit in Spain a private collection, extraordinary though it may be, public accessibility to the fabulous Spanish royal collection, complemented with the major collections from the by-now extinct Museo de la Trinidad and Museo de Arte Moderno, and constantly enriched by intelligent acquisitions and generous legacies and donations, was compromised.

In the years that have passed since the ministry made such an unfortunate decision as far as the Prado Museum is concerned, the board of trustees has been unable to find a solution to the problem. The Salón de Reinos was ceded to the Prado Museum in 1984, but an alternative solution for the Army Museum has still to be found. The board has discussed other possible premises for the extension of the Prado, among them the present headquarters of the Ministry of Agriculture and, once again, the Palace of Buenavista, but none of the proposed buildings is as yet available. It is imperative to find a way out of this deadlock, since both the indispensable restructuring of the Casón and the final installation of Villanueva's building once remodeling work has been completed depend on the solution adopted.

The number of works acquired since 1983 has been considerable. The Prado has managed to purchase a number of works by Spanish Renaissance painters, such as the small oratory panel with the image of *Christ of the Sorrows* (no. 7289) by the Sevillian artist Juan Sánchez de San Román; three panels depicting the *Flagellation of Christ* (no. 7400), the *Healing of the Paralytic* (no. 7399), and the

Veronica (no. 7401) attributed to Juan de Borgoña, and *Descent* (no. 6996) by Juan Correa de Vivar.

In comparison with other periods, acquisitions of Spanish painting from the Golden Age have been relatively few: *Martyrdom of Santiago* (no. 7421) by Francisco de Zurbarán; the *Triumph of David* (no. 7159) by Pedro Atanasio Bocanegra; *Christ on the Way to Calvary* (no. 7080) by Valdés Leal; *Fantastic Landscape with Lake and Waterfall* (no. 7044) by Ignacio Iriarte, and a *Saint Andrew* (no. 7051) by Francisco Rizi.

By contrast, a large number of eighteenth-century paintings was received. Outstanding among these are a *Self-Portrait* (no. 7460) by Antonio González Velázquez; a good example of Mariano Salvador Maella's prowess as a portrait painter, the effigy of *Don Froilán de Berganza* (no. 7042); and three works by Goya: a small canvas depicting *The Duchess of Alba and Her Duenna* (no. 7020), a portrait in miniature of *Manuela Goicoechea y Galarza* (no. 7461), and the famous painting of the *Marchioness of Santa Cruz* (no. 7070) recovered after its illegal export thanks to the tenacity of the Ministry of Culture.[243]

Straddling the eighteenth and nineteenth centuries are the figures of Zacarías González Velázquez, who painted the portrait of his mother, *Manuela Tolosa y Abylio* (no. 7459), and Vicente López Portaña, whose gifts as a portrait painter are well represented in *Doña María Francisca de la Gándara* (no. 7041). An outstanding "acquisition" from this period was the contribution of Mercedes Agueda, an eminent disciple of Xavier de Salas who has followed in the footsteps of her master as "discoverer" of Goyas in the museum's storerooms. Agueda recognized as being by the Aragonese painter a tapestry cartoon which was thought to have been lost: *Fighting Cats* (no. 6323), which entered the museum as an anonymous work in 1870.[244]

The number of paintings by nineteenth-century artists purchased is also substantial. By the son of Vicente López Portaña, Luis López Piquer, the Prado Museum obtained the sketch for a ceiling depicting *The Goddess Juno in the Mansion of Dreams* (no. 7042). Good examples of the realist tendencies of the late nineteenth century are two *Landscapes* (nos. 6973 and 7053) by Ramón Martí Alsina. Madrid "neo-Goyism" is represented by Eugenio Lucas's *Condemned by the Inquisition* (no. 6974) and Genaro Pérez Villamil's *Herd of Bulls* (no. 6996). Other purchases of works from the last third of the century include the *Portrait of Maximina Martínez de la Pedraza* (no. 6993) by Eduardo Rosales; *Queen Juana la Loca in the Castle of La Mota* (no. 7018) by Francisco Pradilla; *Trip down the Tiber* (no. 7291) by Salvador Sánchez Barbudo; a *Portrait* (no. 6975) by Antonio Caba; the anecdotal composition of *Birthday Greetings* (no. 6995) by Raymundo de Madrazo; and the sober *Portrait of Sarah Bernhardt* (plate 125) by Santiago Rusiñol. Acquisitions from this period were completed with with forty-five academic drawings (nos. 5477–5521) by Carlos Luis de Ribera and a further six, among which there are several reproductions of scenes from the burial ceremony of Mariano Fortuny (nos. F.A. 1113–17, 1120), by Alejandro Ferrant.

The Prado's collections of non-Spanish works have been enriched in an essentially homogenous way. The Flemish painting section was increased with an anonymous fifteenth-century panel representing the *Annunciation* and the *Visitation* (no. 7023); two works by the sixteenth-century painter Joachim Bueckelaer, *Christ in the House of Mary and Martha* (no. 6972) and *Market* (no. 7024); and an eighteenth-century work, *School Teacher* (no. 6402), by Jan Josef Horemans. Since 1983, the Italian painting section has been increased with *Saint Francis Receiving the Stigmata* (no. 6997) by Orazio Borgianni; *Flagellation of Christ* (no. 6998) by Pier Francesco Mazzuchelli; and *Spinner* (no. 7474) by Giacomo Francesco Cipper. The eighteenth-century French school was increased with a work by François Boucher classical in theme: *Pan and Siringa* (no. 7066), the first of its kind to enter the Prado with absolutely no doubts as to the identity of its author. The collection of works by his

contemporary Jean Pillement, already represented in the Prado, was increased by the acquisition of a composition characteristic of his style: *Shipwrecked Sailors Coming Ashore* (plate 269). A poorly represented section, that of the French Pre-Impressionists, was increased by a *Seascape* (no. 7002) by Eugène-Louis Boudin. German painting was increased by one work only: *The Virgin with the Boy Jesus and Saint Johnette* (no. 7440) by none other than Lucas Cranach. Finally, the British school collection was extended with a *Portrait of Mrs. Sawbridge* (no. 6992) by Francis Cotes and a *Landscape with Figures* (no. 7048) by James Bertrand.

The list of legacies and donations received by the Prado Museum since 1983 is also a long one. That year, thanks to the generosity of Vicente Lledó, two works by Paolo de Matheis were acquired: *Solomon and the Queen of Sheba* (no. 6944) and *Saint John Showing Christ His Disciples* (no. 6943). The year 1984 was a particularly rich one in terms of contributions from private individuals: Lady Foley donated a *Landscape* (no. 6982) by Nicholas Pocock, the antiquarian Manuel González presented the museum with *Leda and the Swan* (no. 6999) by Georg Pencz, *Portrait of a Little Girl* (no. 7001) by Valeriano Domínguez Bécquer was bequeathed by Sonia Fenykovy, and a canvas of uncertain iconography depicting *Tethis Imploring to Jupiter* or *Magdalene at the Feet of Christ* (no. 7185) by Eduardo Rosales was donated by Eugenia Soriano and accepted by the board of trustees on December 4, 1984. The most important contribution of 1984 was made by Douglas Cooper, who died on April 1, 1984. In his will the great connoisseur of contemporary French painting left the museum two more works by Juan Gris, *Violin and Guitar* (plate 130) and a preparatory sketch for *Portrait of Josette* (plate 131); a *Still Life with Dead Birds* (no. 7078) by Picasso; the palette used by Picasso in 1961 for the painting *Les Déjeuners*; and a copy of the book of the same title written by Cooper himself, with a drawing and dedication by Picasso.[245]

In 1985 José Saldaña Suances, who in 1978 had donated a painting by Isidoro Arredondo representing *Saint Clara Driving away the Unfaithful with the Eucharist* (no. 3264), presented the museum with its partner, *Saint Louis* (no. 7038). The following year Pilar Juncosa, the widow of Joan Miró, gave the museum two paintings by her late husband — *Snail, Woman, Flower, Star* (plate 135) and *Dragonfly with Red-Tipped Wings in Pursuit of a Snake Spiraling Toward a Comet* (plate 136) — by which the Prado's collection of contemporary Spanish painting began to acquire coherence. Also in 1986 the museum acquired the works bequeathed by the Duke of Pinohermoso on his death on December 31, 1984: *Concert of Birds* (no. 7160) by Frans Snyders, *Deer Attacked by a Dog* (no. 7161) by Paul de Vos, and *The Count of Pinohermoso and the Marquis of Molins in Seville* (no. 7162) by José Roldán. Another contribution, notable for its uncommon place in the oeuvre of Juan van der Hamen, a painter known rather for his still lifes, was the *Portrait of a Dwarf* (no. 7065), presented by the Fundación Bertrán — by way of the Friends of the Prado Museum — in 1986. Particularly curious was the donation made by Pedro María Orts of a false El Greco, *Adoration of the Shepherds* (no. 7077), which has proven to be of great use to the museum since it has been possible to analyze it with a view to identifying other possible forgeries of similar characteristics.

In 1987 a *View of Paris* (no. 7163) by Martín Rico was bequeathed to the museum by the Marchioness of Manzanedo, while the portrait of *Dolores de Pedroso Sturdza, Countess of San Esteban de Cañongo, on the Beach of Biarritz* (no. 7303) by Paul Chabas was presented by Mercedes and Margarita de Pedroso, sisters of the subject. For his part, José Luis Várez Fisa, one of the museum's patrons since May 20, 1986, and a benefactor of the institution for twenty years previously, offered in 1988 *Saint Christopher* (no. 7402) by Orazio Borgianni. Enrique García Herraiz that same year presented the Prado Museum with *Mass of Saint Gregory* (no. 7403) by Jerónimo Jacinto Espinosa, coinciding with the end of the major exhibition devoted to the Ribaltas and their times. Finally, in 1990 the Friends of the Prado Museum

foundation managed to acquire for the museum the *Martyrdom of Saint Steven* (no. 7466) by Bernardo Cavallino.

In order to bring this chapter on donations to a close it is essential to mention several drawings given to the museum. Outstanding among these is a magnificent *Baptism of Saint Hermenegildo* (F.A. 1062) by Vicente López Portaña, given by Manuel Casamar Pérez in January 1983, and two that came to the museum thanks to the Friends of the Prado Museum foundation, one by Goya (1983) and the other by Murillo (November 2, 1984, with the collaboration of Coca-Cola).

The increased activity of the Prado Museum in the field of exhibitions first seen in the 1970s persisted in the 1980s. The impossibility of providing the public with access to the great majority of the museum's paintings has led to the need to organize temporary monographic exhibitions based on its own collections,[246] some of which have traveled to several other Spanish cities.[247] Similarly there have been special exhibitions featuring individual works after their restoration in which information is given about the process involved, as was the case with *Las Meninas* and *The Spinners*, for example. In addition, the lack of space in the museum has caused the board of trustees to be better disposed toward the idea of lending works for exhibitions organized by other entities. The Prado authorities have also taken pains to display creations by artists or schools poorly represented in the museum by having one-artist shows from private collections or museums around the world.[248]

Without any doubt the most spectacular phenomenon of the 1980s was the increase in the degree of participation of private sponsors, especially from the worlds of the press and banking. The firm commitment of these new sponsors to the tasks of the picture gallery is clearly revealed in the appointment, on July 17, 1990, as president of the board of trustees of the Prado Museum of José Ángel Sánchez Asiain, president also of the Banco Bilbao–Vizcaya Foundation.[249] This collaboration has made it possible to organize large-scale exhibitions that would otherwise have been unaffordable. The prime example of this is the "Velázquez" show, which was visited by over 500,000 people and for which the catalogue, reprinted on several occasions, sold some 250,000 copies (the norm for other comparable exhibitions is between 50,000 and 150,000 visitors and between 5,000 and 15,000 copies). The unexpected profits have been assigned to the museum by the Fundación Banco Hispano Americano, the sponsors of the event, for the acquisition of new works.

There is, however, a negative aspect to this situation. Such so-called mega-exhibitions are sometimes seen to reduce art to a mass consumer and media event. This has led to a general reflection concerning what the social function of a museum should be in our times. As we have seen, the Royal Painting Museum was conceived originally both as a center in which to preserve works and as a place where future artists could complete their professional training by studying the works of the past. Students and artists were allowed daily access, while the public in general was restricted to one day a week only. After the liberal revolution of 1868 the museum became accessible to all practically every day. Certain recent events, however, make some people think that things may have gone too far. Avidity for cultural consumption on the part of society in general exposes the works to certain dangers that might compromise their correct conservation. The emblematic character of certain masterpieces (Michelangelo's *Pietà,* the *Mona Lisa,* etc.) makes them especially vulnerable to acts of vandalism, obliging those responsible for museum security to place them behind solid barriers that preclude a full appreciation of those very values that made them into axiomatic works. And not only these extraordinary artworks receive stringent protection; it is now almost impossible to contemplate a picture close up without being startled by the alarms that go off automatically when one approaches a painting.

Exhibition fever, with the ensuing transfer of works, increases the threat to their preservation; besides the danger of accidents while they are being transported, the

very vibrations produced during movement, handling, and environmental changes are all factors of risk. Furthermore, there is always the possibility that decisions are made for motives of political propaganda — when the first priority should always be to ensure the proper preservation of the works — or that these exhibitions are organized on the basis of popularity rather than merit, when in fact the museum's mandate is to "make available knowledge to those alien to the field to which this knowledge corresponds."[250] It is certainly difficult to spread such knowledge if it does not exist in the first place. To reach a balance between preservation, accessibility, research, and popularization must be the prime objective of all museum policies, especially when the establishment in question is of the stature and significance of the Prado Museum.

POSTSCRIPT

On February 12, 1991, Alfonso Pérez Sánchez, director of the Prado Museum, and Manuela Mena, subdirector, placed their signatures on a manifesto signed by a total of eighteen prominent figures in the Ministry of Culture in protest against the war begun on January 17 between the combined forces of the United States, Britain, France, Saudi Arabia, and other European and Arab nations and the Iraqi armed forces after the latter's invasion of Kuwait.[251]

Three days later, in response, the Council of Ministers, by request of Jorge Semprún, Minister of Culture, dismissed the Director General of the Book and the Director General of Fine Arts, who had promoted the idea. In solidarity with his colleagues, Alfonso Pérez Sánchez tendered his resignation to the minister, who accepted, and the museum was thus left without a director. The remodeling of the government, which took place on March 11, 1991, and from which Jordi Solé Tura emerged as the new minister of culture, and the minister's prudent decision not to act precipitously, meant that the uncertainty as to the new director of the Prado lasted some months more.

FELIPE VICENTE GARÍN LLOMBART
(1991–present)

Finally, on April 19, 1991, the Council of Ministers, on the suggestion of Solé Tura, appointed Felipe Vicente Garín Llombart as director of the National Museum of El Prado. The news caused some surprise, since the name of the new director had not figured among those the mass media had discussed as possible candidates. Nevertheless, the general opinion was that the council had acted wisely by proposing someone with wide experience in museum administration, given above all that he had to continue the major task begun by his predecessor. Director of the Fine Arts Museum of San Pio V, Valencia, from 1967 to 1990, Garín is also familiar with the other side of public administration: for a year from December 1976 he was in charge of the National Commissariat of Museums and Exhibitions of the Ministry of Education, and then of the General Subdepartment of Museums between January 1978 and June 1979, after the governmental reorganization that gave rise to the creation of the Ministry of Culture. Furthermore, his membership of the Junta de Calificación del Patrimonio Histórico Español (of which he is vice president) and of the board of trustees of the Prado Museum (since 1985) are also two factors firmly in his favor. Thanks to these Garín is perfectly qualified to deal with the current situation and needs of Spain's foremost art museum. When taking possession of his post, Garín outlined what his main objectives were: the expansion of the areas occupied by the museum with the intention of adopting a decision before the end of 1991, reforms of the museum's legal situation in order to give it greater agility, improvements to the center's scientific capacities, fostering teamwork, attending to new social demands, and finally making the "national" character of the Prado a reality.[252]

COLORPLATES

PAINTING COLLECTIONS

Since its foundation the Prado Museum has figured among the limited number of great institutions where the best European works from medieval times to the present day can be admired. A study analyzing the origin and development of each of these institutions would be extraordinarily beneficial, first because it would permit the inclusion of a great number of first-class paintings into a general hypothetical scheme and, second, because it would enable the appreciation of the great European families who collected paintings and who, quite recently, as a practical derivation of the Age of Enlightenment, have brought such cultural institutions into full function. An analysis of the contents of each of these institutions would also lead us to interesting conclusions, but such a study must be based on many factors: the economic stimuli that brought them to life; the reasons for prestige or authority that have complemented their aesthetic values; and what different criteria during a given period have oriented the growth of their collections, especially those of painting. Therefore, with so many variables, this analysis, for the moment, must remain simply suggested in its multiple possibilities.

There is no doubt, for example, that a detailed observation of the museums of Florence and Rome lets us appreciate the variations introduced by the civil or religious authorities who were the driving force behind them since the sixteenth century. Also evident is the westernization of the present-day Hermitage Museum, whose collections were initiated by Peter the Great and raised to an extremely high standard by the determination of the empress Catherine II, who in her reign of little more than thirty years (1762–96) and with a careful program of acquisition, managed to situate them among the best of her epoch; it would be necessary subsequently to follow the circumstances that permitted the extension of the basic contents until the museum was opened to the public in 1852 and, lastly, go on to the new political situation in Russia after the revolution of 1917. Likewise the Louvre has characteristics of its own; during the time of its revolutionary foundation, the collections of the aristocracy and of the French crown were gathered together, these last for the most part of François I (1515–1547) and Louis XIV (1643–1715); later the museum was greatly enriched by the incorporation of important private collections. The great German picture galleries (Dresden Gemäldegalerie, Kaiser Friedrich Museum) reflect the personality of the Saxon-Prussian monarchies of the eighteenth century. The National Gallery in London, founded in 1823, responded to the desire of the British government to endow the country with a painting gallery in keeping with the glory of the empire. Facets characteristic of the Dutch bourgeoisie of the seventeenth century are notable in the museums of the Netherlands (Frans Hals in Haarlem, Rijksmuseum in Amsterdam, and the Mauritshuis in The Hague). In the United States donations of private collectors were largely responsible for the rise of such important institutions as The Metropolitan Museum of Art in New York and the Museum of Fine Arts, Boston. Such private initiatives were later complemented by federal ones, thanks to which the National Gallery of Art, in Washington, the most modern of great public museums since it was inaugurated in 1941, now exists.

The Prado Museum has its own special characteristics, since it reflects the specific circumstances of the Spanish monarchy, who looked after and endeavored to increase its collections from the fifteenth until the middle of the nineteenth centuries, and of state patronage, which has permitted a considerable increase of its collections. Of particular interest here are the series corresponding to the different schools of pictorial creativity that have developed since Romanesque times in the different Spanish kingdoms and after the subsequent unification carried out by the Catholic monarchs. But what also stand out are other groups that recall the important links that the Spanish monarchy maintained with other active European centers of art throughout the sixteenth, seventeenth, and eighteenth centuries.

Representatives of the Prado took it upon themselves to stimulate, collect, and carefully preserve the best work not only of painters living in its domains but also of artists attached to the court in territories depending upon the Spanish crown. Major commissions were given also to Italian artists, even those who were not Spanish subjects, such as the Venetians, who are well represented in the museum. Ambassadors and other high dignitaries who were sent to countries across Europe made a point of presenting high-quality gifts of an artistic nature, especially paintings. Acquisitions were also frequent, and, once the royal collections became public museums in the early nine-

teenth century, they were supplemented by the purchase of specific works as well as donations and bequests. During that time the basic lines of action of the Prado Museum were established, and they have been followed with little modification since. The extremely high prices of first-class works make it very difficult to do more than fill a small space in the front lines. Sometimes, such as in the case of the Spanish and Italian schools, the museum has been able to reach this objective, but it has been impossible to fill in all the gaps that exist in the other great European schools, such as the French, German, Dutch, or British. Even so, it is possible to admire many fine examples of all of these in the Prado Museum.

SPANISH SCHOOL

The prologue corresponding to the Romanesque period of Spanish painting during the twelfth and thirteenth centuries is remembered with dignity in its two modalities. Mural painting is magnificently represented in some of the compositions from the twelfth century that adorn the walls of the eleventh-century Mozarab church dedicated to St. Baudelio and situated near Casillas de Berlanga (Soria); its themes of a profane character (plate 1) make it of extraordinary interest. The paintings that decorate the vault and walls of the hermitage of Santa Cruz de Maderuelo (Segovia) are also exceptional; their bright coloring and varied iconography of Christ blessing, angels, biblical scenes (plate 2), and saints have been linked to the Catalan paintings of Taüll. Painting on board is also represented in the frontal from Guils (plate 3) in the Catalan Pyrenees, presided over by the *Pantocrátor* in accordance with the habitual layout.

Broader and more varied is the representation of paintings from the fourteenth and fifteenth centuries preserved in the Prado, where there are excellent examples of the successive styles and artistic activity on the Iberian Peninsula. Most of these are single panels, but there are also examples of the diverse typologies represented by Hispanic altarpieces, as occurs with those dedicated to Saint Cristopher (plate 4) of a Franco-Gothic style in its Castilian version, or to the Archbishop Sancho de Rojas, which is thought to have been painted in Toledo in the style related to the Italian Gothic. Even more outstanding is Nicolas Frances (1434–1468), who gives his personal interpretation of the so-called international style with a beautiful altarpiece depicting the life of the Virgin and Saint Francis, of complex structure and varied iconography. Juan de Peralta, also known as Juan Hispalense, devoted himself completely to vivacity of color and movement, while Juan de Levi, Maestro de Arguis, and the occasional anonymous artist show the rich variations that make the Aragonese version of the style unique.

Toward the end of the Gothic period quantity and quality join together in the development of a style known as Hispano-Flemish, determined by its expressionist vigor, richness of its observation of realist details, the progressive use of oil painting techniques, and a greater concern for the creation of space, as much in interiors as in open landscapes. It is also easy to appreciate the growing strength of the centers of creation in Castile and Andalusia, in the face of those from the east coast of the peninsula, which, despite everything, maintain a dignified level. These are represented here by one of the lesser works by the Catalan Jaime Huguet (1414/15–1492) and by works that demonstrate the potent artistic skill of Bartolomé Bermejo from Córdoba (. . . 1474–1495), active in Aragon, Valencia, and Catalonia in the last quarter of the fifteenth century and whose art was also appreciated in Castile, as shown by the magnificent *Saint Domingo* (plate 11) from the Monastery of Silos. Artists such as Jorge Inglés, related to the Marquis of Santillana, and especially Fernando Gallegos (. . . 1466–1507. . .) opened the way to much wider horizons. Gallegos reveals his potent expressiveness in several panels, including *Christ Giving the Blessing* (plate 6), *Piety*, and *Calvary*. In this same spirit are a series of works by anonymous painters such as the maestros of Los Luna, of La Sisla, and of the Eleven Thousand Virgins and the artist of *The Virgin of the Catholic Monarchs* (plate 5), all of them highly personal interpretations of great contemporary Flemish painting, widely known and appreciated in Castile. This proclivity was intensified with the arrival of the exquisite art of Juan de Flandes (. . . 1496–1519), who in 1496 entered the service of Queen Isabella the Catholic; excellent examples of his work have come down to us (*The Resurrection of Lazarus*, plate 12; *Prayer in the Garden*). Finally, clearly oriented toward the start of the Renaissance are works attributed to the Italian Paolo de San Leocadio (. . . 1472–1514 . . .), such as *The Virgin of the Knight of Montesa* (plate 13); by the Osonas, both father and son named Rodrigo, who show direct contact with northern Italy; and by Fernando del Rincón, the possible painter of the portrait of *Francisco Fernández de Córdoba*.

Among all these stands out the figure of Pedro Berruguete (c. 1450–c. 1504), who, as a consequence of his stay in Italy, perfectly illustrates the penetration into Spain of the new Renaissance developments. Berruguete was there around 1477, working in the ducal court of Urbino with Justo de Gante, and returned to Castile around 1483, to paint in the province of Palencia (Paredes de Nava, Becerril) and in Avila. From there come several tapestries (see plates 9 and 10) and the panels from the Monastery of Santo Tomás (plates 7 and 8), where memories of Italy, superimposed on the local tradition, are

appreciable. Immersed in the new tendencies, works that reflect Leonardo, by such representative painters as Fernando Yáñez de la Almedina (. . . 1505–1536 . . .) or Fernando de Llanos (active in Valencia), and especially in the *Saint Catherine* (plate 14) by Yáñez, also are represented in the museum. Contemporary with Yáñez was Juan de Borgoña, active in Toledo, and the German who took the name of Alejo Fernández when working in Córdoba, the author of an exquisite *Flagellation* (plate 15).

Characterized by the influx of Raphaelesque tastes, the next phase in our Renaissance painting corresponds to the second third of the sixteenth century and is represented in Valencia by works such as *The Martyrdom of Saint Agnes* (plate 18), by Juan Vicente Masip (1475–1545/50), and by his son, the popular Juan de Juanes (1523?–1579) with his *Savior*, *The Last Supper* (plate 19), compositions for the altarpiece of San Esteban, and the excellent portrait of Luis Castellà de Vilanova. From the Toledo area we find Juan Correa de Vivar (c. 1500–1566) and his *Transit of the Virgin*, and moving toward Granada, Pedro Machuca (end of fifteenth century–1550), whose strong Mannerist tendencies are evident in *The Virgin and Souls in Purgatory* (plate 17) and especially in *The Descent from the Cross* (plate 16). Meanwhile, in Burgos, we have León Picardo (d. 1547), who reveals a lesser innovative capacity in his *Annunciation*. Particularly outstanding during this period is Luis de Morales (c. 1500–1586), from Extremadura, who was known as ''the Divine'' by virtue of the unique expressiveness of his stylized personages. He created highly esteemed prototypes such as *Madonna and Child* (plate 20), the *Ecce Homo* or *Our Lady of Sorrows* with Mannerist touches, tendencies which can also be found in Blas del Prado (c. 1546/47–c. 1599).

The painters who worked directly for the court in the second half of the sixteenth century acquired special prestige. Several of the aforementioned artists had sporadically done so, but from this period on, artists such as Juan Fernández Navarrete (c. 1526–1579), already linked to El Escorial and author of *The Baptism of Christ* (plate 23), devoted themselves especially to attending to the needs of the king. Painters such as Alonso Sánchez Coello (1531/32–1588), in addition to creating works of a religious character such as the large canvas of *Saint Sebastian Between Saint Bernard and Saint Francis* (plate 21), devoted themselves to portrait painting; thanks to Sánchez Coello we are now familiar with the figures of Philip II, Isabel Clara Eugenia, Catalina Micaela, and the unfortunate Prince Charles (plate 22). His undeniable qualities are eclipsed, however, by the genius of Domenikos Theotokopoulos, better known as El Greco (1540–1614), a Cretan who,

after residing in Venice and Rome, arrived in Spain around 1576, attracted by the possibility of working in El Escorial. He took up residence in Toledo where, away from rules, he was able to develop independently his own personal art style, giving a strong spiritual expressiveness to his portraits and religious works; in both genres he is well represented in this museum. Outstanding among the first are the effigies of *The Knight with His Hand on His Breast* (plate 26), *Doctor Rodrigo de la Fuente*, *Rodrigo Vázquez*, *Julián Romero*, and *Jerónimo de Cevallos*, as well as other personages who have not been identified. In the second the artist develops an extensive iconography, notable among which are the interpretations of *The Annunciation* (plate 24), *Saint Francis*, *Saint John the Evangelist*, *Saint Benedict*, *Saint Andrew*, *The Holy Trinity* (plate 25), *Christ Embracing the Cross*, *The Holy Family*, and *The Adoration of the Shepherds* (plate 27). Together the examples of the two different genres allow us to study the many varied qualities of this unique artist.

With El Greco we enter the seventeenth century, the most brilliant for Spanish painting, which at the same time stood with dignity alongside the best work being produced in the rest of Europe. Great individual figures and solid groups are found in centers like Madrid or Seville, perfectly defined and of a standard that was maintained throughout the century. From both cities were collected works that became essential to the royal collections, forming the foundation of the Prado Museum, and being selected for the planned Museo de la Trinidad. These circumstances, combined with the enthusiasm for art of the Spanish monarchs from the *Reyes Católicos* to Charles IV, have resulted in the series of works collected here.

No less fundamental to their respective countries than to Spain, and giving a fruitful approximation to their high aesthetic values, are the important contributions by Italian and French painters. The representations of the Dutch, German, and British schools, on the other hand, despite their undoubted importance, remain in a secondary position. Historical circumstances help us to understand this difference.

Within this suggestive concurrence of schools we must concede preeminence to the one that developed in court circles established in Madrid as of 1561. Here there was a confluence of derivations from the Toledan school and the one that developed for a time in El Escorial, which represented a direct link with some of the active Italian tendencies. Some of the artists were even born in Italy or had Italian parents. As examples we might recall Vicente Carducho (1576/78–1638), for the series of works dedicated to the Carthusians and his collaboration with three paintings in the decorative program

of the Salón de Reinos in the Palace of El Buen Retiro, and Eugenio Caxés (1574–1642), who participated in this same program. As another extension of what characterized the previous century, we must also consider the portraits of Bartolomé González (1564–1627) and Rodrigo de Villandrando (d. 1621), and with incipient elements of naturalism, the still lifes and fruit bowls by Juan van der Hamen (1596–1631).

Deriving from the creative force represented by El Greco in Toledo, we find Luis Tristán (c. 1585–1624), author of important portraits and religious paintings such as *Saint Monica* (plate 28), on the Yepes altarpiece. Contemporary with him are the still-life artists Van der Hamen (plate 29) and Felipe Ramírez (. . . 1628–1631; plate 30) and in a certain way, Pedro de Orrente (1580–1645), well known for his biblical and pastoral scenes. As a link between this group and that of the court we must place Juan Bautista Maíno (1578–1649), who, familiar with Caravaggio, stands out for his realism, easily perceptible in the works he painted for the altarpiece of San Pedro Mártir in Toledo (plates 31 and 32), and for the Salón de Reinos.

Coming to the end of the first quarter of the century and coinciding with Philip IV's ascent to the throne in 1621, a new and fundamental stage in Spanish painting was initiated. Court painting enabled the artists to go beyond the limits marked by religious themes. Here portraits were necessary and themes of historical or mythological character perfectly justifiable; also the existence of very important collections permitted the contemplation and assimilation of solutions by great masters, particularly from the Italian or Flemish schools. A series of positive elements became consolidated and developed with the incorporation into this group in 1623 of a young painter from Seville, Diego Rodríguez de Silva y Velázquez (1599–1660), who would raise Spanish art to the highest of levels. But for a few exceptions, the most important part of Velázquez's not very prolific output is preserved in the Prado. There are examples of his younger years in Seville, such as *The Adoration of the Magi* (plate 49) and several portraits (*Jerónima de la Fuente, Francisco Pacheco, Luis de Góngora*), sure in execution, precise, and with sober coloring, in a style that, in part, can still be seen in his first portraits at court, such as those of the infante Don Carlos or of King Philip IV. A definite change appears in *Los Borrachos (The Drunkards)* (plate 50); perhaps the influence of Peter Paul Rubens had something to do with this, as he was in Madrid at that time. The theme, the range, the protagonists, and the open-air setting mark a big step forward in his art, which is confirmed by *The Forge of Vulcan* (plate 51), with its personal interpretation of fable and the arrangement of the protagonists, correctly drawn, in realist lighting, and perfectly situated in an environment whose aerial perspective is supremely well achieved. It is only logical to assume that this painting reflects what he was able to assimilate on his first trip to Italy.

During the eighteen years between his return to Spain in 1631 and his second trip to Italy in 1649, Velázquez painted numerous works and would have painted more if he had not had to occupy himself with the demands of his obligations to the palace. These works vary greatly in theme and quality. Some, such as *Saint Anthony Abbot and Saint Paul the Hermit* (plate 52), are of religious iconography, but portraits prevail. Several are of ordinary people, such as Diego del Corral and Antonia de Ipeñarrieta, but the majority are of members of the royal family, such as the equestrian portraits of Philip III and Philip IV and of their respective wives, Margarita of Austria and Isabella of Bourbon, which decorated the Salón de Reinos, for which he also painted his very popular *The Lances*, or *The Surrender of Breda* (plate 53), a perfect evocation of that historical event. Other equestrian portraits are of Prince Baltasar Carlos, the center of the country's hopes, and of the Count-Duke of Olivares at the height of his political career. Very personal are the portraits of Philip IV, the infante Cardinal Fernando, and Prince Baltasar Carlos, all depicted outdoors in hunting attire and accompanied by dogs.

In the latter part of the 1630s Velázquez developed his ability to capture and interpret the physical and psychological, when he painted portraits of personages who were complex in all senses, such as the court jesters, and countenances which may have appeared ludicrous, such as Pablo de Valladolid, Barbarroja, Cristobal de Castañeda, el Niño de Vallecas, Calabacillas, Diego Acedo, Sebastián de Mora, and Antonio el Inglés. In strong contrast to these stands the portrait of the sculptor *Juan Martínez Montañés* (plate 54), with its concentration strictly on the essential. Some years later, around 1642, we find two religious paintings of different character. In one, the *Crowning of the Virgin*, his sober humanity stands out, while in his portrayal of *Saint Anthony Abbot and Saint Paul the Hermit* the subjects are notable for their archaisms.

On his second trip to Italy, where he remained until 1651, Velázquez painted and resolved aspects of the decoration of the Alcázar of Madrid. From this stay we have two small landscapes of the Villa Médicis (see plate 55), clearly precursors of the tendencies of the classical realist works of the eighteenth century. On his return and parallel with his position in court as head steward, he resumed his dedication to painting and reached sublime heights with *Las Hilanderas (The Spinners)*

(plate 57), with its mythological setting and masterful technique. The important part in Velázquez's art played by light reaches its culmination in *Las Meninas (Maids of Honor)* (plate 56), where he manages to transcribe the simple atmosphere in which he positions the members of the royal family. As a complement, he produced more portraits of the king, his new wife, Mariana of Austria, and the infanta Margarita, over which he spreads a delicate chromatic harmony.

It was only logical that the sway of Velázquez's art, still within the court environment, would influence other painters. This can be clearly appreciated in the work of his son-in-law and collaborator, Juan Bautista Martínez del Mazo (1610/15–1667). His name is linked with landscapes (*View of Saragossa*, plate 58; *Landscape with a Temple, Calle de la Reina in Aranjuez*) and with portraits such as those of Prince Baltasar Carlos and of the empress Margarita of Austria.

Other of Velázquez's contemporaries who revealed a great prowess were Benito Manuel de Agüero and Francisco Collantes (c. 1599–c. 1656), both of whom cultivated the landscape; the latter often used it as a frame for biblical scenes, such as in *The Vision of Ezekiel* (plate 59). Antonio Puga (1602–1648) created popular scenes, and attributed to him is the portrait *Old Woman Seated* (plate 62), painted in such a direct way that it brings to mind certain of today's realist compositions. Others worked to meet the demand for compositions of an especially religious nature, among whom are to be found Jusepe Leonardo (1605–1656) and Juan Ricci (c. 1600–1681), in whose works there is a progressive penetration of the dynamism and characteristic of the Baroque at its height. Antonio de Pereda (1611–1678) also devoted himself to religious painting (*The Liberation of Saint Peter by an Angel*, plate 61), but after a promising start at court (evidenced by his magnificent painting of the *Relief of Genoa*, plate 60, painted for the Salón de Reinos), he had to renounce his brilliant future on the death of his protector, Juan Bautista Crescenzi, Marquis of La Torre.

In the second half of the seventeenth century richness of color and freedom of theme dominate and provide an optimistic component related to Rubens and Van Dyck. These characteristics can be appreciated in *The Triumph of Saint Hermenegildo* (plate 63) by Francisco de Herrera "the Younger" (1622–1685), in the religious works such as *The Annunciation* (plate 64) by Francisco Rizi (1614–1685), and especially in the work of Juan Carreño de Miranda (1614–1685), who in his royal portraits manages to convey to us the stifling atmosphere of the court of Charles II, and in those of the ambassador P. I. Potemkin or the Duke of Pastrana (plate 65),

reveals his splendid sense of color. He also painted excellent religious paintings (*The Immaculate Virgin*), a genre in which he was joined by other outstanding artists, such as José Antolínez (*The Assumption of the Magdalene*, plate 66), Juan Antonio de Frías y Escalante (1630–1670), and Mateo Cerezo (*The Mystical Nuptials of Saint Catherine*, plate 67). Bringing the series to a brilliant close is Claudio Coello (1642–1693), whose portraits (*Padre Cabanillas*) and religious paintings (such as the *Triumph of Saint Augustin* and *The Virgin and Child Adored by Saint Louis, King of France*, plate 68) are conceived with typical Baroque opulence.

Although at the time they were considered a secondary genre, today the still lifes and flower pieces of the several Spanish artists who specialized in this are highly esteemed. This genre was also sporadically cultivated by other painters. Outstanding here are Juan Fernández "the Peasant" (*The Flower Vase*, plate 69), Juan Bautista Espinosa (*Apples, Plums, Grapes, and Pears*, plate 70), and Tomás Yepes (d. 1674), with a very personal and varied style. But perhaps the best-known still life artists of this period are Juan de Arellano (1614–1676), who painted numerous flower pieces (see plate 71), and his son-in-law Bartolomé Pérez (d. 1693), whose free and agreeable technique is evident in his flower vases and in his garlands with saints in the center, in the Flemish style.

While the courtly nucleus drew in many artists from the outskirts, several other centers acquired singular vigor, although their life span varied considerably. There was, for instance, a very active group in Valencia, who since the previous century had maintained a good relationship with Italy. The Catalan Francisco Ribalta (1565–1628) stands out for his contributions; trained in Madrid and in El Escorial and established in Valencia since 1595, he imposed his realist style related to that of Caravaggio on various works (*Saint Francis Comforted by an Angel Musician*, plate 33; *Christ Embracing Saint Bernard*). His son Juan, who died prematurely in 1628, followed with grandeur in his father's footsteps (*Saint John the Evangelist*, plate 34). From Francisco Ribalta's studio came Jerónimo Jacinto Espinosa (1600–1667), whose style became somewhat archaic in his religious paintings. The anecdotal prevailed in the work of Esteban March (1610–1669), and in Mateo Gilarte (c. 1620–1675) was evident a solidity and somewhat rigid quality of structures. A case apart is José de Ribera, who, from 1616 until his death in 1652, worked in Naples, which then depended on the Spanish crown; this explains this artist's close links with Spanish art and his strong influence there. Works of this artist in the museum's collections permit his evolution to be appreciated, from a strict

caravaggismo through to a light and luminous toning and his creative capacity in compositional types and schemes. Figures of saints and apostles (*Saint Andrew*, plate 36) or historical personages (*Archimedes*, plate 35), from the waist up or full length; compositions of a mythological character (*Ixion*, plate 37; *Ticius*); religious works (*Trinity*, *The Martyrdom of Saint Philip*, plate 38) or biblical scenes (*Isaac and Jacob*, *Jacob's Dream*); and figures of hermit saints closely linked with the landscape in which they are situated (*Saint Paul*, *Magdalene*, *Saint John the Baptist in the Desert*, plate 39) all show the quality of his art and why he was so esteemed at court.

The Sevillian school was even more fortunate and widely favored, since this Andalusian city had become a point of arrival and departure for those journeying to and from the recently colonized America. Throughout the seventeenth century great masters came to this fecund school, endowing it with its notable personality. As well as the patriarchal Francisco Pacheco, there also stand out the strong expression of Francisco de Herrera "the Elder" (*Saint Buenaventura*) and the intensely religious works of Francisco de Zurbarán (1598–1664), the monastic painter par excellence, as demonstrated by the series for the Convent of La Merced Calzada (*Vision of Saint Pedro Nolasco*, *Apparition of Saint Peter to Saint Pedro Nolasco*). Among his copious productions stand out the religious works (*The Savior Blessing*, plate 40; *The Immaculate Conception*, plate 43; *Saint Luke as a Painter before Christ on the Cross*, plate 44; *Saint Casilda*, plate 45; *Saint Jacobo de la Marca*, plate 46); his still lifes (plates 41, 42), very intense in their simplicity; and his participation in the Salón de Reinos, with ten compositions alluding to the feats of Hercules and the painting of the *Defense of Cadiz Against the English*. His contemporary Alonso Cano (1601–1667) is remembered mainly for his anecdotal portraits of Spanish monarchs and his religious paintings of a high standard (*The Miracle at the Well*, plate 48; *Christ and the Angel*; *Saint Bernard and the Virgin*, plate 47).

The next period of Sevillian painting is represented by Bartolomé Esteban Murillo (1618–1682), who lived an intense professional life and exercised prolonged influence by virtue of his religious works, gentle and reposed, expressed with solid outlines and increasingly flowing and expressive brushstrokes. A fine interpreter of the popular (*The Holy Family with Little Bird*, plate 73), he developed a wide repertoire of themes that are easy to assimilate, such as the *Adoration of the Shepherds*, *The Virgin of the Rosary* (plate 72), *The Annunciation*, *Child Virgin with Saint Anne*, *Virgin with Saint Ildefonso*, and *Saint Bernard*, with full celestial accompaniment; single figures such as Saint Hieronymus or Saint James the Apostle; the couple,

so frequent in Andalusia, of busts with the *Ecce Homo* and the Virgin of Sorrows; and the paintings of Jesus and John the Baptist as children (see plate 75). Of special interest are the sketches for a series dedicated to the Prodigal Son (see plate 74) and three large canvases for which the artist was commissioned to decorate the Sevillian church of Santa María la Blanca. In the development of the themes *The Dream of the Patrician John and His Wife* and *The Patrician Tells the Pope His Dream* it is easy to appreciate such sensitive details as the snow-covered landscape of the first or the solutions of space in the second. The series of Immaculate Conceptions, of which he painted more than thirty versions, is worthy of special attention; a clear ancestry is recognizable in the interpretations by Murillo. Known by the names of El Escorial, Half Moon, Aranjuez, or "de Soult" (plate 76), each with its own peculiarities, unique grace, richness of detail, and delicate colors, all justify the fame and the high regard they enjoy today. If in some of these paintings conventionalism can be observed, the objectivity of the artist is clearly visible in two portraits, those of *Nicolás Omazur* (plate 77), half length, and of the anonymous full-length *Gentleman with Ruff*.

Leaving aside the immediate derivations from the Murillo style in the works of Pedro Nuñez (*Children's Games*), the great Andalusian contribution is seen in the works of the Cordobese Antonio del Castillo (1616–1668), a magnificent draftsman who reveals his skills in a series on the life of Joseph (see plate 78), and especially in those of Juan de Valdés Leal (1622–1690), who developed a passionate oeuvre, vibrant and completely Baroque, represented in the Prado by several paintings in a series of Saint Hieronymus, *Jesus among the Doctors*, and *Fall on the Road to Calvary*. Completing the panorama are the landscape paintings by the Sevillian Ignacio de Iriarte (1621–1685; see plate 79) and the devout paintings of the Granada artists Pedro Anastasio Bocanegra (1638–1689) and Juan de Sevilla (1643–1695).

The activity of the great painters in the court and the Sevillian schools ended almost simultaneously with the death of the last representative of the Austrian dynasty in 1700. At the same time a new epoch dawned in Spanish history. The political reality became situated within the context of a general panorama, that of Europe, and the results of these fundamental events can be appreciated in all spheres of artistic creation throughout the eighteenth century. The intense activity of foreign painters — French and Italian, by birth or in spirit — made up for national deficiencies and helped in the artistic consolidation of a generation who would recover the prestige of Spanish painting and, in the figure of Francisco Goya, carry it to universal heights.

Clear evidence of decline can be seen in the works of Antonio Acisclo Palomino y Velasco (1655–1726), essentially a fresco painter and a competent author of treatises on art — the museum contains several of his religious paintings and works of an allegorical character (*Air, Fire*) — and in those of Miguel Jacinto Meléndez and Bernardo Germán Llorente (c. 1680–1759). Evidence of the beginning of the recovery period are the numerous still-life paintings (see plates 80 and 81) by Luis Eugenio Meléndez (1716–1780), noted for their solid outline, ordered composition, and intense realism. Similar comments can be made about the work of Luis Paret y Alcázar (1746–1799), who shows his exquisite finesse in paintings such as *Charles III Eating before His Court* (plate 85), *The Royal Couples*, and *Ferdinand VII Takes the Oath as Prince of Asturias*; in portraits such as that of his wife, *María de Las Nieves Micaela Fourdinier* (plate 86); and in sharp references to the contemporary scene (*Masked Ball, Play Rehearsal*).

The general recovery of the country, manifested on the one hand by the construction of the new royal palace in Madrid, the modernizing of other royal buildings, and the organization of the Royal Tapestry Factory of Santa Bárbara, and on the other by the creation of the Royal Fine Arts Academy of San Fernando, favored the spectacular emergence of a generation of painters who filled the second half of the eighteenth century. Foremost among these was Francisco Bayeu (1734–1795), closely linked to Anton Raphael Mengs; he is represented in the Prado by a wide-ranging and interesting series of sketches (see plates 82 and 83) for frescos for royal palaces and churches and for tapestry cartoons destined for the Santa Bárbara factory, a task in which his brother Ramon Bayeu (1746–1793) also participated, as did José del Castillo (1737–1793) with his own, less popular style. As an epilogue to this group we must remember Zacarías González Velázquez (1763–1834), who painted several good portraits (*Antonio González Velázquez*). Working in another style, closer to that of Mengs, was Mariano Salvador Maella (1739–1819), author of many frescoes and oil paintings preserved in the museum, including the allegory of the *Seasons*, sketches for tapestry cartoons (*Seascape*, plate 84), religious paintings, and portraits. More attracted to contemporary reality was Antonio Carnicero (1714–1814), as can be seen in his *Montgolfier Balloon* (plate 87), landscapes, and portraits.

If to the aforementioned are added artists such as Mariano Sánchez (1740–1822), painter of documented landscapes, or Joaquin Inza (1736–1811), a painter of stiff portraits, we will have a more complete panorama of the Spanish contemporaries of Goya and will better understand the distance that separated them. However, even if we widen the circle to include other important European artists, the conclusion would still be the same. Francisco Goya y Lucientes (1746–1828) was born on the periphery and moved to the court to stretch his talents. From Saragossa he went to Madrid, where, helped by his brother-in-law Francisco Bayeu, he worked on cartoons for the tapestry factory. This he did from 1775 to 1792, depicting bright, colorful, popular themes, evoking the Madrid of the time (*The Parasol*, plate 88; *The Crockery Seller*, plate 89; *Playing at Giants*, plate 92). Several sketches for these, such as that of *The Meadow of Saint Isidore* (plates 90 and 91), are true antecedents to what would be innovation a century later.

Other early works, highly varied in theme, show the progressive development of the artist's impetuous personality. This is seen in his religious paintings (*Immaculate Conception, Crucifix, Holy Family, The Capture*), but is much more evident in other genres, such as his portraits, copiously represented in the museum. Some correspond to his position as court painter, for instance the different versions of the new king Charles IV and his wife, María Luísa, with their progressive evocation of psychological qualities and varied apparel that reflects the change in feminine fashion, and several of both on horseback, culminating in the group portrait of *The Family of Charles IV* (plate 95), which clearly exposes the character and human quality of the models, lined up before the observer. Preparatory studies, with busts of several of the protagonists, heighten the interest of the painting. After the war years Goya had the opportunity to paint the portrait, with similar results, of Ferdinand VII, then king. To this group of palace portraits must be related those of Cardinal Luis María de Borbón, which permit us to establish the parameters of official portraits and thus compare them with those that govern private portraits, which Goya freely painted of his family, friends, and clients of diverse social standing. There are in the museum numerous works of this type, ranging from his wife and brother-in-law (Josefa Bayeu and Francisco Bayeu) to the members of the military (General Ricardos, General Urrutia, General José de Palafox on horseback) or of the church (the Archbishop of Saragossa and Valencia); the aristocracy (the Count of Floridablanca, the Duke and Duchess of Osuna and their children, Tadea Arias de Enríquez, the Marchioness of Villafranca, the Duke of Alba); and other diverse personages (Cornelio van der Gotten, Gaspar Melchor de Jovellanos, plate 94; Isidoro Márquez, Manuel Silvela). All of these are oil paintings on canvas, and all contain multiple pictorial values. The same is true even in the portrait of Juana Galarza de Goicoechea, which provides a sample of the artist's enormous talent for miniature paintings.

Goya also painted subjects uncommon in Spanish painting at that time. Outstanding for their high aesthetic and representative values are *The Maja Clothed* (plate 96) and *The Maja Nude* (plate 97). Also exceptional are those works of highly diverse characteristics painted on tin-plate, which include several tragic scenes (*The Beheading, The Bonfire*); still lifes (*Dead Turkey, Dead Fowl*); works of anecdotal themes (*Strolling Players*, plate 93; *Picador on Horseback*); and others that are allegorical (*Commerce, Agriculture, Industry*), as well as three canvases that express the artist's reaction to the tragedy through which his people lived between 1808 and 1813: *The Colossus* (plate 98), *The Second of May, 1808, at Madrid* (plate 99), and *The Third of May, 1808, at Madrid* (plate 100). In these, in addition to the pictorial values, easy to appreciate, there is a richness of content that penetrates the causes and development of that tragedy. Completely apart, due to their absolute freedom of artistic expression and the complexity of the ideas developed in them, are the works known as the "Black Paintings" (see plates 101 and 102), painted around 1819–23 to decorate what was at the time Goya's country house. Painted on a variety of themes, their common denominator is harsh fantasy, and they are open to multiple interpretations. Their color range, with chestnut, green, and red tones helping to relieve the dominant black and white, emphasizes the mysterious attractiveness they awaken.

Finally, the Prado has in its collections several paintings that are perfectly representative of Goya's years spent in exile in Bordeaux, between 1824 and 1828. One of these is the *Bullfight*, another *The Milkmaid of Bordeaux* (plate 103), an expression of the pictorial vitality of the future, and still another the portrait of *Juan B. Muguiro*, which demonstrate the long road traveled by Goya in over sixty years of activity and which place him in the forefront of the most active vanguard movements in nineteenth-century European painting.

As a link with the preceding situations Vicente López Portaña (1772–1850) is highly representative. From López Portaña we have an extensive gallery of portraits of personages from the court of Ferdinand VII. These are of impeccable outline and sure technique but are far removed from the life with which, using essential brushstrokes, Goya managed to infuse them. Here the effigies of Fernando VII and his different wives combine with those of military men such as Colonel Juan de Zengotita Bengoa, of the Mercedarian Gascó Tomás, of the councilor Antonio Ugarte and his wife, all of great significance during that epoch. Faithful followers of his style were his sons Bernardo (1801–1874) and Luis (d. 1865), as can be seen in their respective works, a portrait of *Queen María Isabel de Braganza* (plate 105) and a sketch for a ceiling with the goddess Juno in the mansion of dreams.

Of the three most important sectors of romantic currents in Spanish painting, only that of Catalonia is poorly represented in the museum. The Sevillian Antonio María Esquivel (1806–1857) has left us a major gallery of portraits including his *Meeting of Poets* (plate 106), in which some forty effigies can be seen around the painter in his studio. Seven more portraits broaden our knowledge of this artist's talents when it comes to depicting his contemporaries. Manuel Cabral (Bejarano) y Aguado (1827–1891) proves himself a true Sevillian in *The Corpus Christi Procession in Seville* (plate 109), while José Gutiérrez de la Vega (1790/91–1865) shows himself to be totally linked with the tradition of Murillo in his *Saint Catherine*, although in his *Maja Sevillana* he reflects great Venetian painting.

A link between the Sevillian circle and that of Madrid can be appreciated in the work of Valeriano Bécquer (1834–1870), who in this museum is represented by a *Portrait of a Little Girl* and by paintings in which he recalls his stay in Soria with his brother, the poet. True-to-life scenes are reflected in *The Dance, The Present, The Spinner*, and *The Woodcutter*, while in his *Family Scene* the environment of his time is perfectly captured. Manuel Rodríguez de Guzmán (1818–1867) also attempts to evoke his era with his visions of *The Fair of Santiponce*, of the *Washerwomen of the Manzanares*, and the *Water Carriers*. Outstanding in the field of interpreting themes extracted from everyday life in the court (in several cases with traces of Goya) are the small paintings by Leonardo Alenza (1807–1845), lively transcriptions of such everyday scenes as *A Veteran, The Viaticum, The Spanking, A Madrid Girl, Revenge, Drunkard*, and *The Brash Galician*, as well as several portraits. Such Goyesque antecendents can be appreciated with greater intensity in the work of Eugenio Lucas Velázquez (1817–1870) in his paintings with *majos* and *majas*, bullfights, witches' Sabbaths, prisoners, religious subjects, and themes related to the Inquisition, as well as several portraits. The works of Genaro Pérez Villamil (1807–1854), a free interpreter of reality in his *Interior of Toledo Cathedral* and in several landscapes, are less abundant in the Prado but no less significant. Any discussion of portrait painting must also consider the work of Rafael Tejeo (1798–1856); several of his canvases are of the aristocracy, but his usual models are members of the bourgeoisie who characterized the era. The art of Carlos Luis de Ribera (1815–1891) can also be included in the romantic current. Ribera was a prolific portrait painter of the contemporary elite society, represented here by *Portrait of a Little*

Girl, Lady with Child, and *Magdalena Parrella with Her Daughter*, all of high quality. The same can be said of the paintings of Manuel Castellano (1826–1880) and also of the objectives of the painting of those years. If *The Horse Corral in the Old Madrid Bullring* (plate 107) is just a pretext to offer an iconographical gallery of the figures of the bull-fighting world of the middle of the century, we should also remember the poetic way in which Esquivel offered us a similar collection of writers in 1846, all perfectly identifiable.

It is unnecessary here to insist on the strength and the scope reached by great paintings on historic themes, which demanded complex preparation and laborious execution. Naturally enough, they absorbed the initiative of many Spanish painters. This orientation was not exclusively theirs but was widespread in European spheres, where there was a profusion of complex compositions alluding to the historical episodes of any country. Great energy was expended to document the apparel, household furniture, customs, and homes of those who altered the course of the past, all faithfully reproduced in what was usually a simple setting. It is easy to see the evolution of this genre from the conventional *Death of Viriatus* by José de Madrazo (1781–1859) to the succesive interpretations of the same theme by José Casado del Alisal (1832–1886), to the *Surrender of Bethlehem* by Lorenzo Vallés (1831–1910) and Dióscoro de la Puebla's (1831–1901) dynamic attempt in *The Daughters of El Cid* to situate several nude figures in the light among the shadows of the forest. Other aspects of professional knowledge can be appreciated in *The Burial of Saint Sebastian* by Alejandro Ferrant (1843–1917) and in *Doña Juana la Loca* (plate 122) by Francisco Pradilla (1848–1921). In *The Lovers of Teruel* Antonio Muñoz Degrain (1840?–1924) shows a certain tendency toward melodrama, while a definite sobriety prevails in *The Execution of Torrijos and His Companions* by Antonio Gisbert (1834–1901).

Of even greater interest is the development of landscape painting and here, at the early stages of a genre with its own personality, stand out Carlos de Haes (1826–1898) from Castile and Ramon Martí Alsina (1826–1894) from Catalonia. The latter has only one landscape in the museum, while Haes is much more fully represented, with his *Picos de Europa* (plate 110) and paintings of the Cantabrian mountains and coastline; of Aragon, in the outskirts of Calatayud; of the coast of Valencia and Mallorca; and of the lands around Madrid, each with its own particular problems of light. Not to be forgotten here are works deriving from Haes's stay in Holland and Normandy. This group of works, many of small dimensions,

abounds with positive suggestions for future development. From his immediate successor, Jaime Morera (1854–1933), we have a view of *Lake Trasimeno*, and from his follower Juan Espina (1848–1933) several landscapes. Derivations of Haes's style can be seen in the *View of Toledo* by Ricardo Arredondo (1835–1908) and in the *Procession in a Town* by Serafín Avendaño (1838–1916). At a remove from these, with the adoption of other points of view, we find figures such as Mariano Barbasán (1864–1924); Antonio Muñoz Degrain, with his views of Granada (see plate 123) and his *Sunset over the Sea*; and Fernando de Amárica (1866–1956), with his luminous landscape of the *Banks of the Zadorra*.

Special mention must be made of two artists who were considered among Spain's greatest, but whose careers were truncated by their early deaths: Eduardo Rosales (1836–1873) and Mariano Fortuny (1838–1874). Each demonstrated during his short life a marked capacity to renovate the pictorial panorama with regard to light and color, in tune with European avant-garde movements, but their contributions were reduced to masterful flashes of inspiration. Rosales demonstrates this in *The Testament of Isabella the Catholic* (plate 111), *The Presentation of Don John of Austria to Charles V* (plate 112), and *The Death of Lucretia*, as well as in his portraits, such as that of the young *Conchita Serrano y Domínguez, Countess of Santovenia* (plate 114) and the *Female Nude* (plate 113), superb in its simplicity. The unlimited potential of Fortuny is evident in his study for the *Battle of Wad-Ras*, in his *Queen María Cristina Reviewing the Troops*, in his Moroccan themes (see plate 116), in the avant-garde concepts developed in *The Painter's Children in the Japanese Salon* (plate 118), in his approach to light revealed in his watercolors *Idyll* (plate 119) and *Landscape* (plate 121), in the *Nude on Portici Beach* (plate 120) and *Old Man Naked in the Sun* (plate 117), and in *Bullfight* (plate 115). The strong impact of Fortuny on his fellow artists can be appreciated in several works by Francisco Lameyer (1825–1877) and in some aspects of the versatile Martín Rico y Ortega (1833–1908), whose landscapes of Aragon, of the banks of the Seine, and of the Guadarrama mountains, as well as several highly personal views of Venice and Granada are exhibited in the Prado.

The multiform facets, often full of anecdotal elements, of realist painting from the last third of the century are given special expression in the copious work of Federico de Madrazo (1815–1894), the author of excellent portraits (*Federico Flórez; Carolina Coronado; Countess of Vilches*, plate 108; *Evaristo San Miguel; Marchioness of Montelo; The Gironas*), and in that of his son Raymundo Madrazo (1841–1920). Other

realist painters of note from this period include José Jiménez Aranda (1837–1903), represented here by his *A Procession in the Month of May* (plate 124), Francisco Masriera (1842–1902), and Francisco Domingo (1842–1920).

Even greater creativity can be seen in a series of painters who, since around 1900, developed ideas echoing several of the great European contemporary currents and endowed them with full personality. This is evidenced by the Castilian Aureliano de Beruete y Moret (1845–1912) in his luminous landscapes (see plate 127) of the banks of the Manzanares, of Torrelodones, of the outskirts of Madrid and Toledo, and of the Guadarrama. It is also demonstrated by a number of artists from the periphery who enriched the world with new ways of seeing and relating to the landscape of Spain, figures such as the Asturian Darío de Regoyos (1857–1913), who lyrically depicted the beaches of San Sebastián and the Basque country, the simple reality of a *Henroost* or the pure image of a *Town*. The Basque contribution is minimally represented with a *Portrait*, as a simple reference to the art of Ignacio Zuloaga (1870–1945). The representation of the fertile Catalan group is more abundant and varied, with two works by Francisco Gimeno (1858–1927), *The Game Reserve* and *Aigua Blava*, as representative of their pictorial vision as those of Santiago Rusiñol i Prats (1861–1931) in his *Garden of Aranjuez*, the portrait of *Sarah Bernhardt* (plate 125), and *The Old Faun*; the unique color sense of Joaquim Mir Trinxet (1873–1940) is perfectly expressed in *The Hermitage Garden* (plate 126), *The Oak Tree and the Cow*, and *Waters of Moguda*. Finally the great works from the area of Valencia include several paintings by Ignacio Pinazo (1849–1916), some of which show him to be an antecedent to a great figure during this period, Joaquín Sorolla y Bastida (1863–1923), who is represented by a wide range of portraits and by two canvases characteristic of his style, one from his early days, *They Still Say That Fish Is Expensive!* (plate 128), and another from his later, the daylight vision of *Children on the Beach* (plate 129).

With the incorporation of very representative works corresponding to our rich and multiform twentieth century, diverse circumstances have permitted the exhibition of various paintings in the halls of the Prado Museum. Two of these demonstrate the personality of Juan Gris (1887–1927) in the period between 1913 and 1918, fundamental to his evolution. *Violin and Guitar* (plate 130), from 1913, with its rich polychrome, is of accentuated verticalism interrupted by the forms of the musical instruments. *Portrait of Josette* (plate 131) is of even greater interest. Gris cultivated the portrait to an exceptional degree, and in this case he paints his wife with an extreme chromatic asceticism and a refined Cubist synthesis. It was executed between September and November, 1916, when the family was living in La Turena.

One of the most popular sections in the museum is the one housing the pieces by Pablo Ruiz Picasso (1881–1973). Gathered here are some of his most fundamental works. Essential to a knowledge of one aspect of this versatile artist is his *Still Life with Dead Birds* (plate 132). Painted in 1912, it corresponds to the period in which his Cubism referred to a perfectly determined object, which brings to mind the process of creation and crystallization of the idea for *Guernica* (plate 134), without doubt the most representative painting of our century. Its large dimensions and the elements integrated into it endow the canvas with a monumental character that surpasses any anecdotal quality. On April 26, 1937, the town of Guernica was bombed and destroyed. This episode of the Spanish Civil War provided the emotional stimulus for Picasso. He painted the canvas, after a period of feverish activity that began on the following May 1, so that it could be integrated into the Pavilion of the Spanish Republic in the International Exhibition inaugurated in Paris on May 25, 1937. The complexity of this exceptional creative process can be followed in the series of more than seventy preparatory sketches and a study in oils (plate 133) created day by day and also preserved here and in a series of photographs in which Dora Maar, who at the time was living with the painter, captured the different phases through which the realization of the astonishing work passed during the month. From the very beginning the work is a perfectly defined allegory of universal pain caused by gratuitous violence. After having been kept at various venues, especially in the Museum of Modern Art, New York, the canvas returned to Spain in September 1981 for installation in the Prado Museum.

The panorama of contemporary Spanish painting in the Prado has also been enriched in recent years with two examples of the extraordinarily lyrical and personal art of Joan Miró (1893–1983). One of these, which according to its inscription is entitled *Snail, Woman, Flower, Star* (plate 135), is a preparatory study for a tapestry produced in the winter of 1933-34; its subjects stand out against a very elaborate background of gentle color tones. The other, from 1951, has a title descriptive of its contents: *Dragonfly with Red-Tipped Wings in Pursuit of a Snake Spiraling Toward a Comet* (plate 136). On a setting created by a cloudy background, the artist situates elements of pure color that allude to people, animals, and heavenly bodies, with the inclusion of a checkerboard effect.

1. **Anonymous** (12th century)
Hunt of the Hare
Mural painting transposed to canvas, 72 ⅞ × 141 ¾″ (185 × 360 cm)

2. **Master of Maderuelo** (12th century)
Creation of Adam and the Original Sin
Mural painting transposed to canvas, width 14′ 9 ⅛″ (450 cm)

3. **Anonymous Catalan** (13th century)
Altar Frontal of Guils [no. 3055]
Paint on board, 36 ¼ × 68 ⅞" (92 × 175 cm)

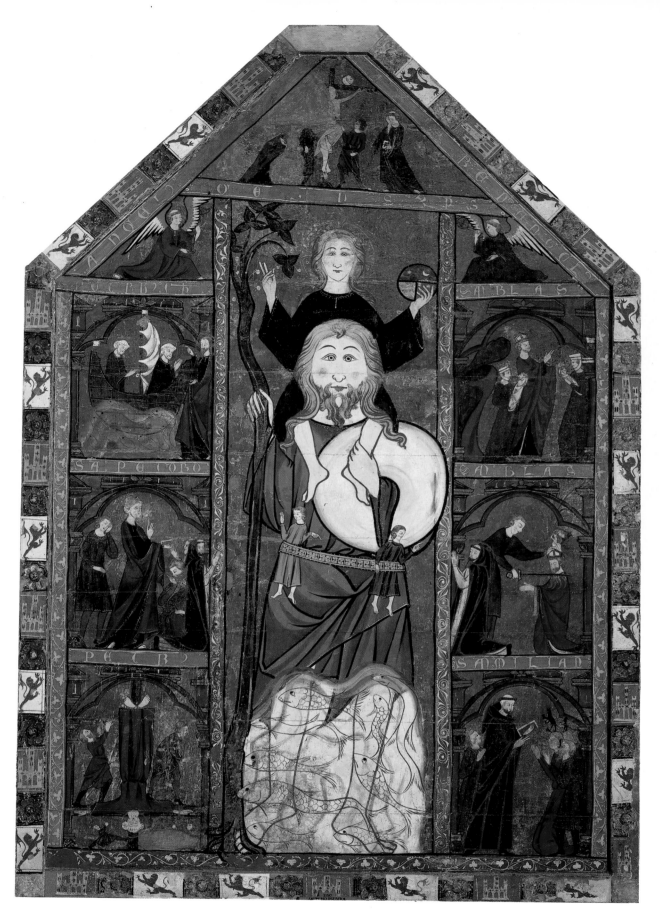

4. **Anonymous** (14th century)
Retable of Saint Christopher [no. 3150]
Paint on board, 104 ¾ × 72 ½″ (266 × 184 cm)

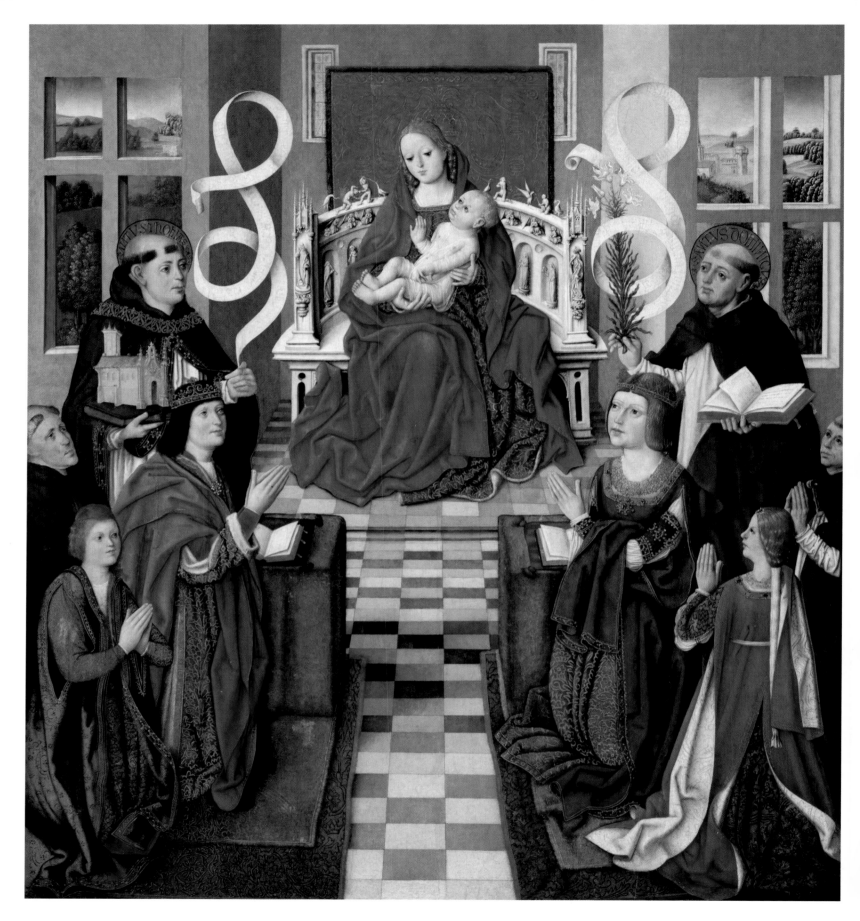

5. **Anonymous Castilian** (15th century)
The Virgin of the Catholic Monarchs [no. 1260]
Paint on board, 48 ⅜ × 44 ⅛″ (123 × 112 cm)

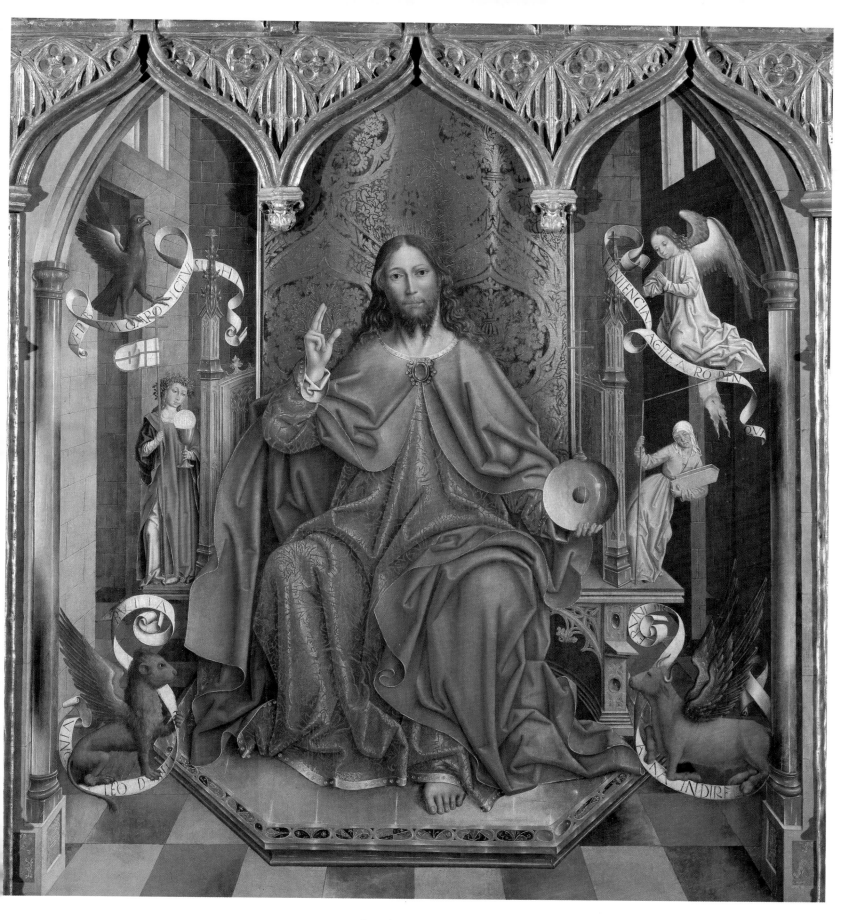

6. **Fernando Gallegos** (...1466–1507...)
Christ Giving the Blessing [no. 2647]
Oil on board, 66½ × 52″ (169 × 132 cm)

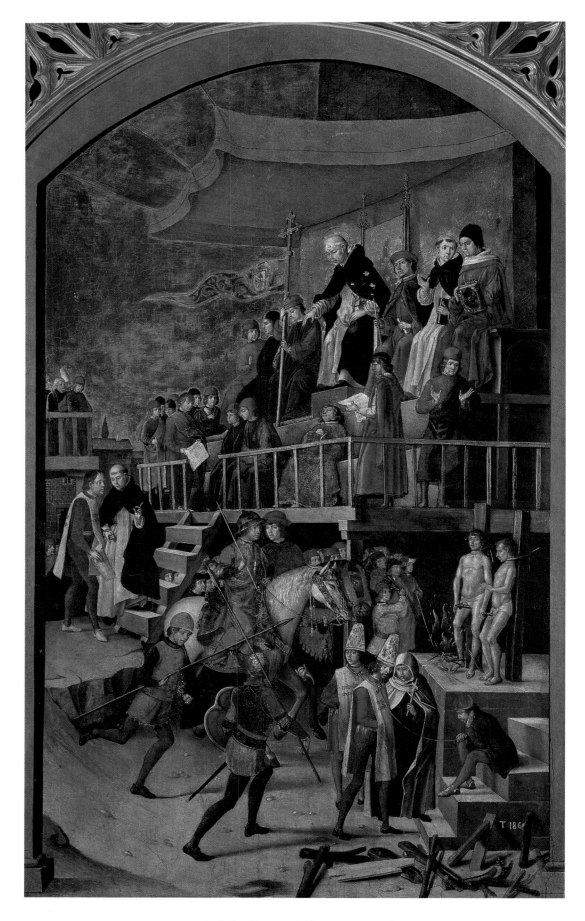

7. **Pedro Berruguete** (c. 1450–c. 1504)
Saint Dominick Presiding over an Auto da Fé [no. 618]
Oil on board, 60 ⅝ × 36 ¼″ (154 × 92 cm)

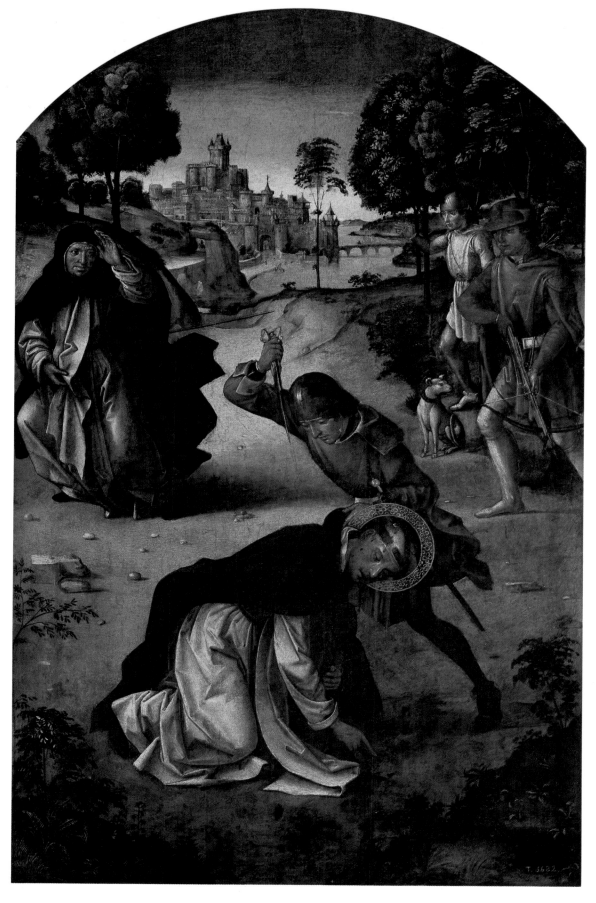

8. **Pedro Berruguete** (c. 1450–c. 1504)
Death of Saint Peter the Martyr [no. 613]
Oil on board, 50⅜ × 32¼″ (128 × 82 cm)

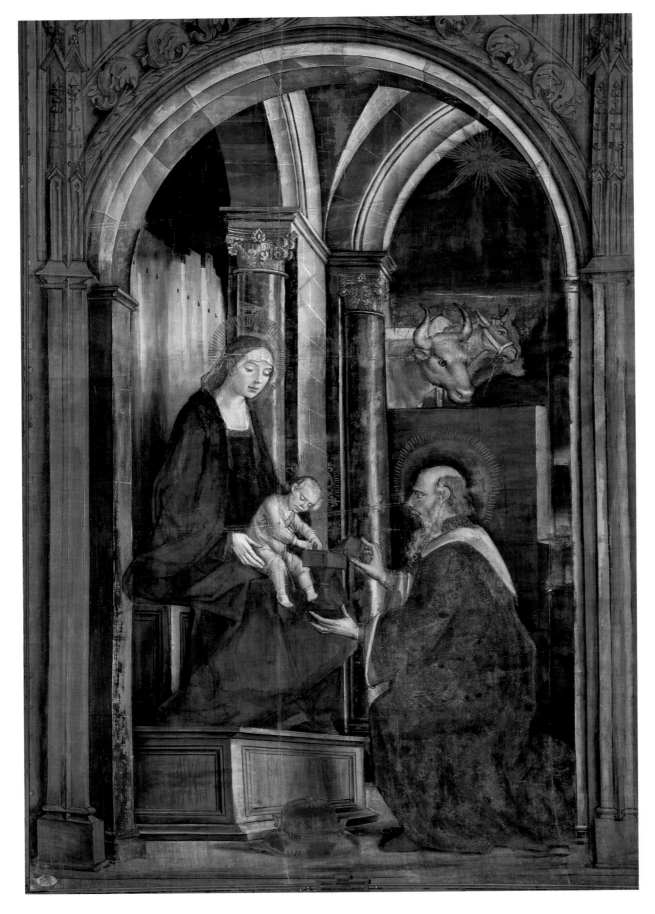

9. **Pedro Berruguete** (c. 1450–c. 1504)
The Adoration of the Three Wise Men [no. 125]
Oil on board, 137 ¾ × 81 ⅛″ (350 × 206 cm)

148

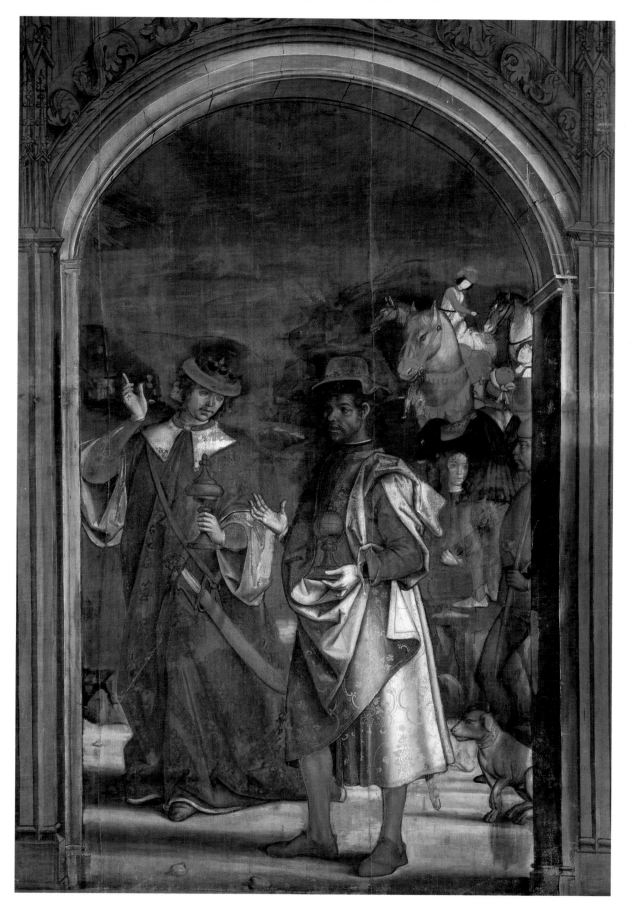

10. **Pedro Berruguete** (c. 1450–c. 1504)
Two Wise Men [no. 126]
Oil on board, 137 ¾ × 81 ⅛″ (350 × 206 cm)

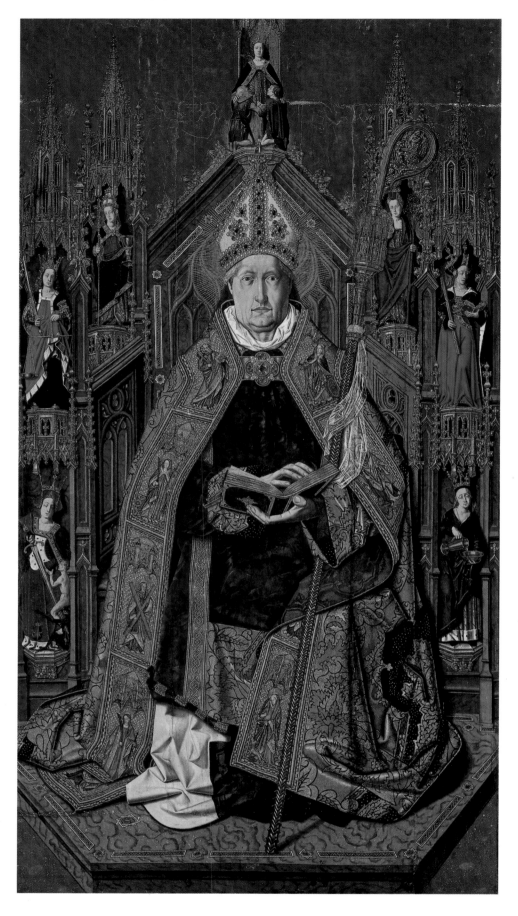

11. **Bartolomé Bermejo** (. . . 1474 – 1495)
Saint Domingo de Silos Enthroned as Abbot [no. 1323]
Oil on board, 95 ¼ × 51 ⅛″ (242 × 130 cm)

150

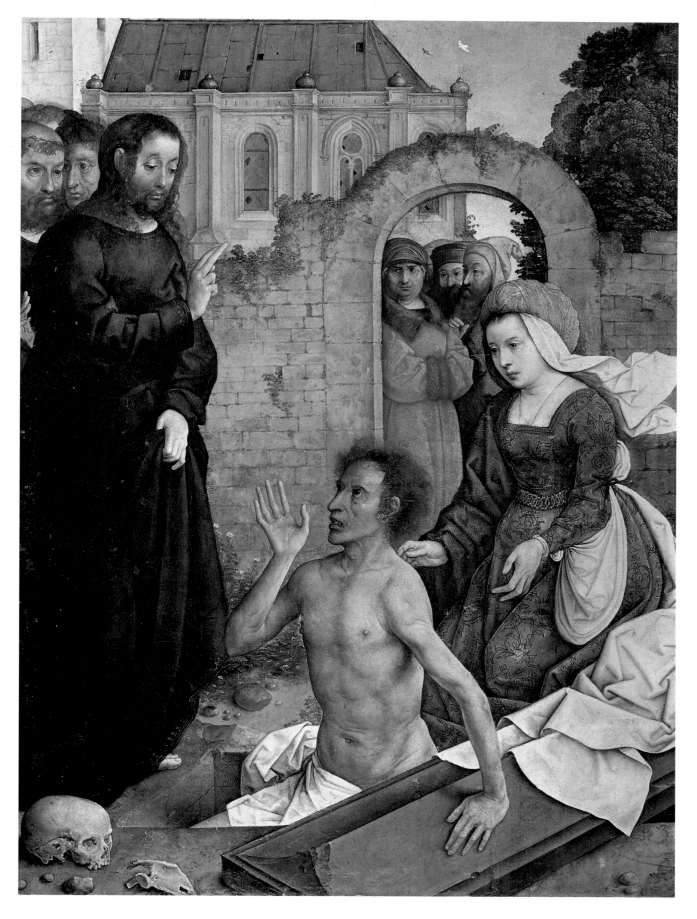

12. **Juan de Flandes** (...1496–1519)
The Resurrection of Lazarus [no. 2935]
Oil on board, 43 1/4 × 33 1/8″ (110 × 84 cm)

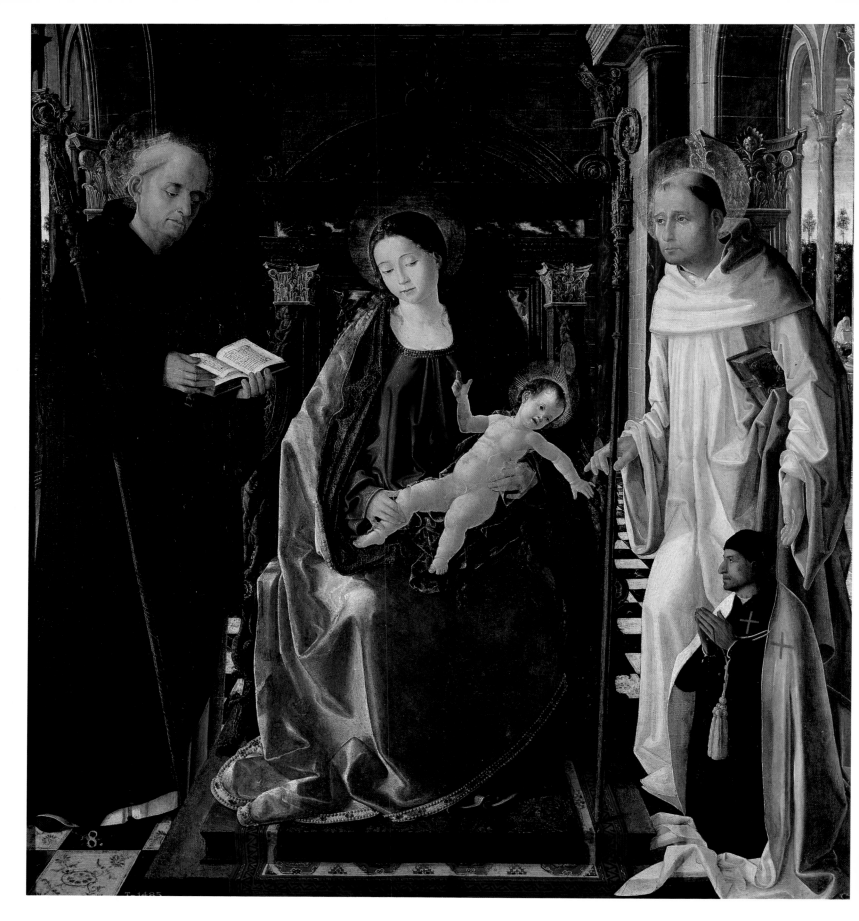

13. **Paolo de San Leocadio ?** (. . . 1472–1514 . . .)
The Virgin of the Knight of Montesa [no. 1335]
Oil on board, 40 ⅛ × 37 ¾″ (102 × 96 cm)

152

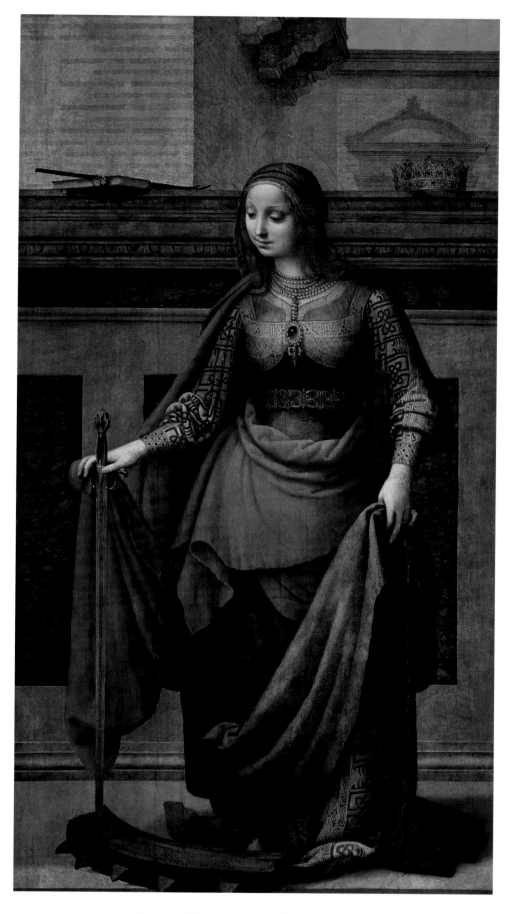

14. **Fernando Yáñez de la Almedina** (...1505–1536...)
Saint Catherine [no. 2902]
Oil on board, 83 ½ × 44 ⅛″ (212 × 112 cm)

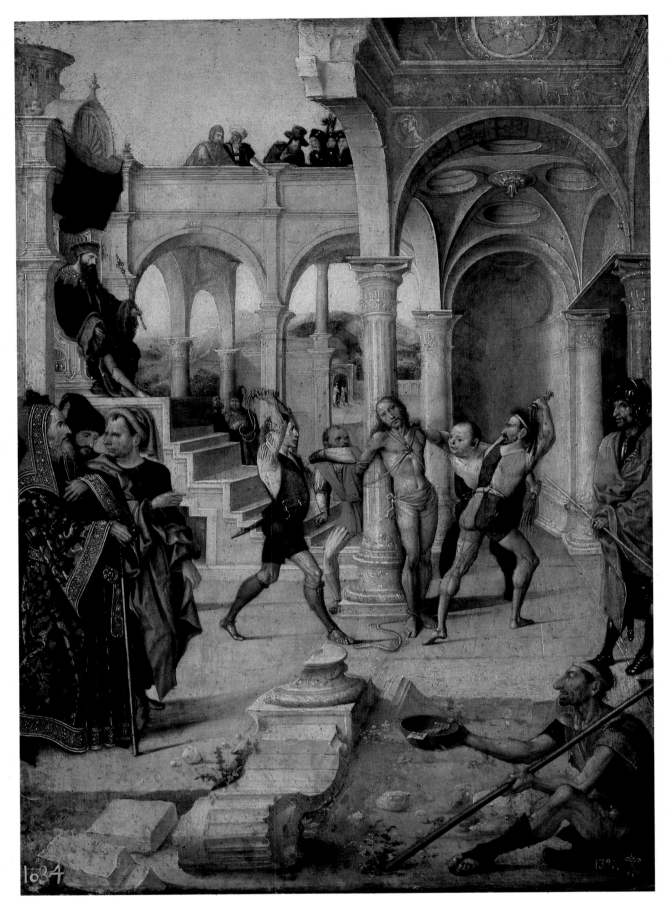

15. **Alejo Fernández** (c. 1474–1545/46)
The Flagellation [no. 1925]
Oil on board, 18⁷⁄₈ × 13³⁄₄″ (48 × 35 cm)

154

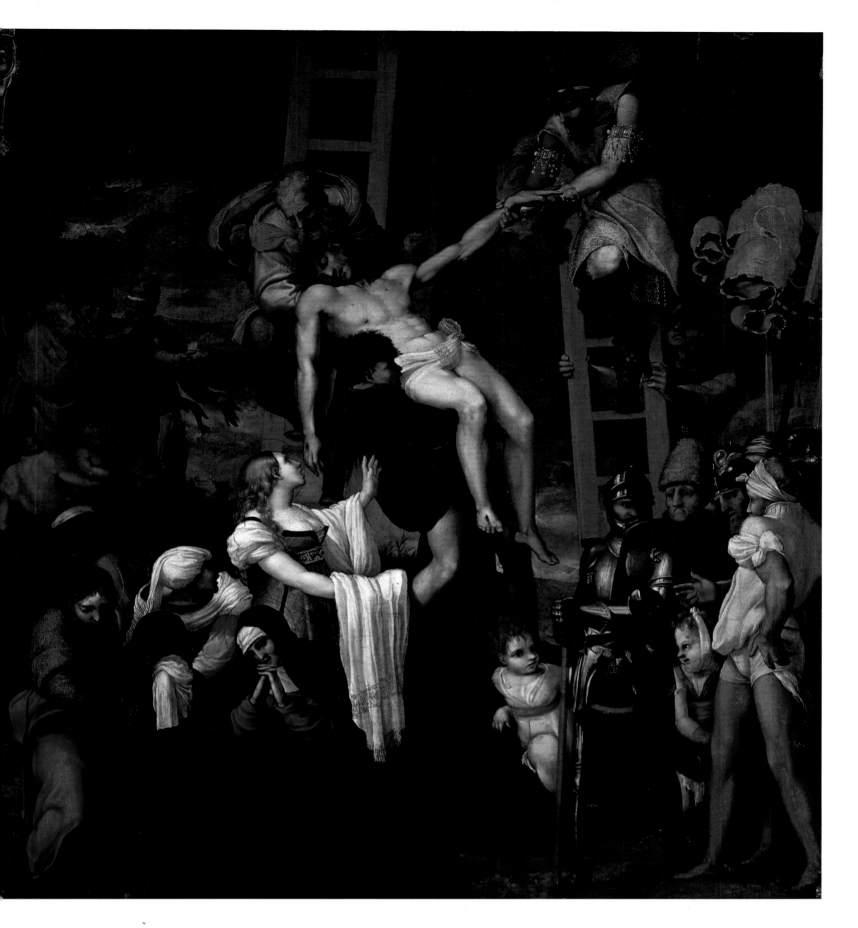

16. **Pedro Machuca** (end of 15th century–1550)
The Descent from the Cross [no. 3017]
Oil on board, 55 ½ × 50 ⅜″ (141 × 128 cm)

155

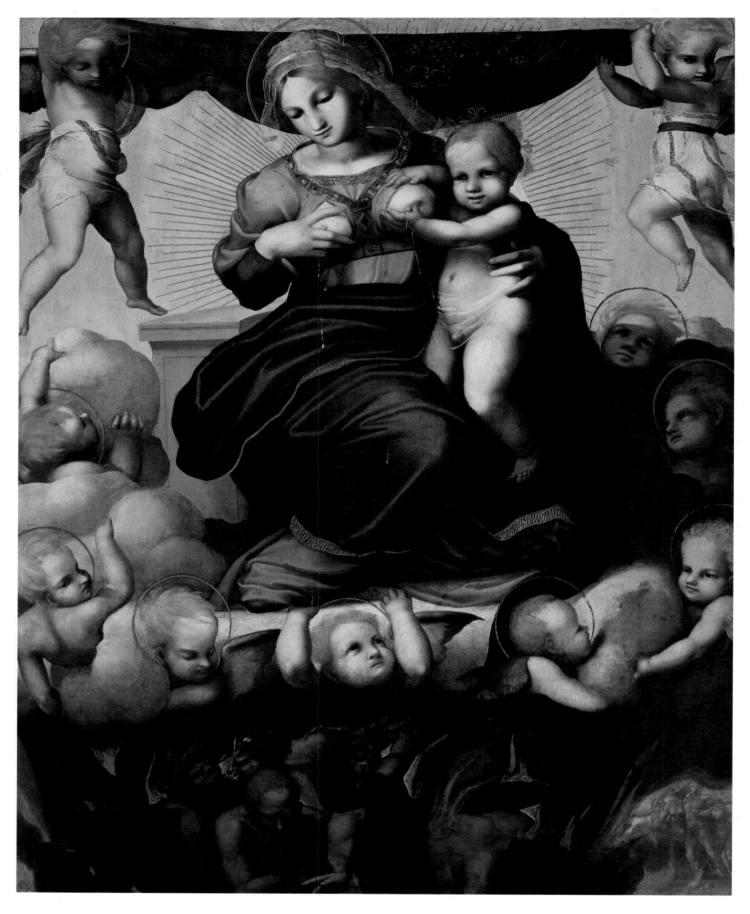

17. **Pedro Machuca** (end of 15th century–1550)
The Virgin and Souls in Purgatory. 1517 [no. 2579]
Oil on board, 65 ¾ × 53 ⅛″ (167 × 135 cm)

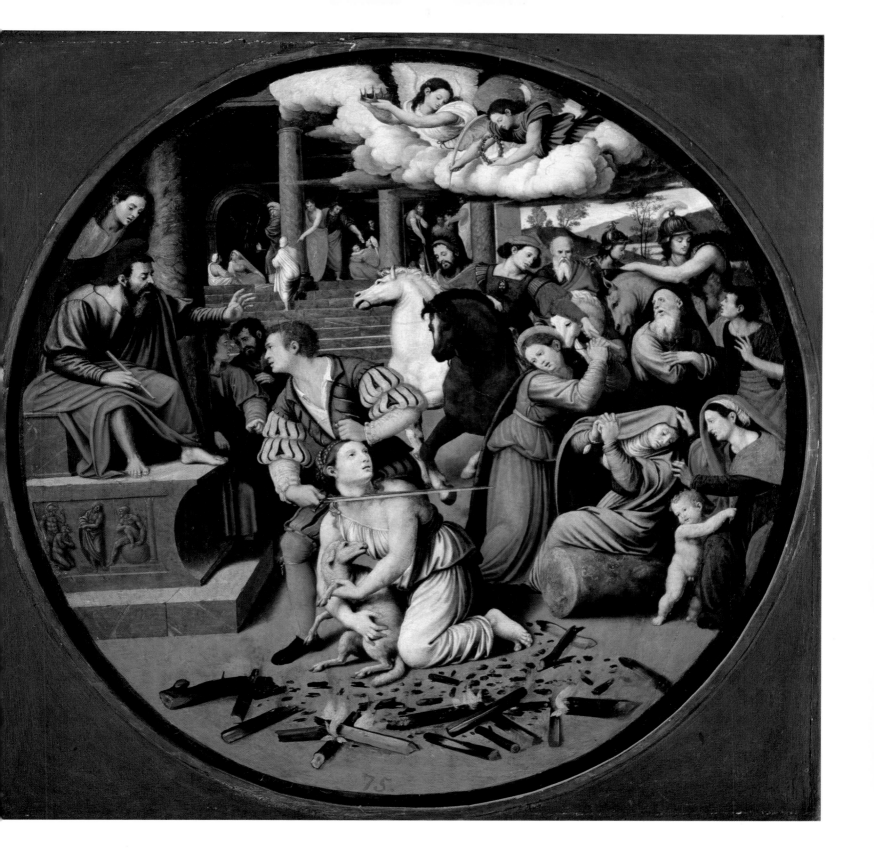

18. **Juan Vicente Masip** (c. 1475–1545/50)
The Martyrdom of Saint Agnes [no. 843]
Oil on board, diameter 22⅞″ (58 cm)

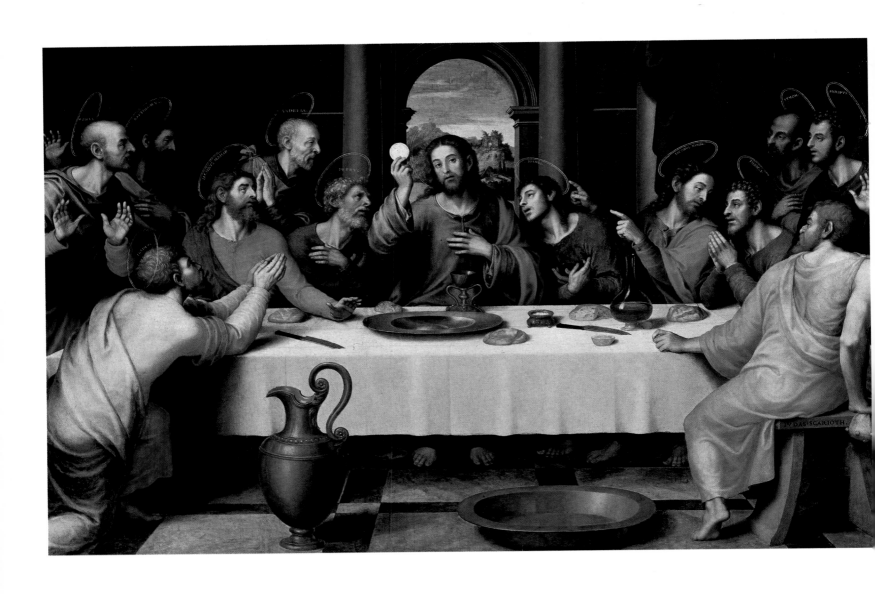

19. **Vicente Juan Masip,** called **Juan de Juanes** (1523?–1579)
The Last Supper [no. 846]
Oil on board, 45 ⅝ × 75 ¼″ (116 × 191 cm)

158

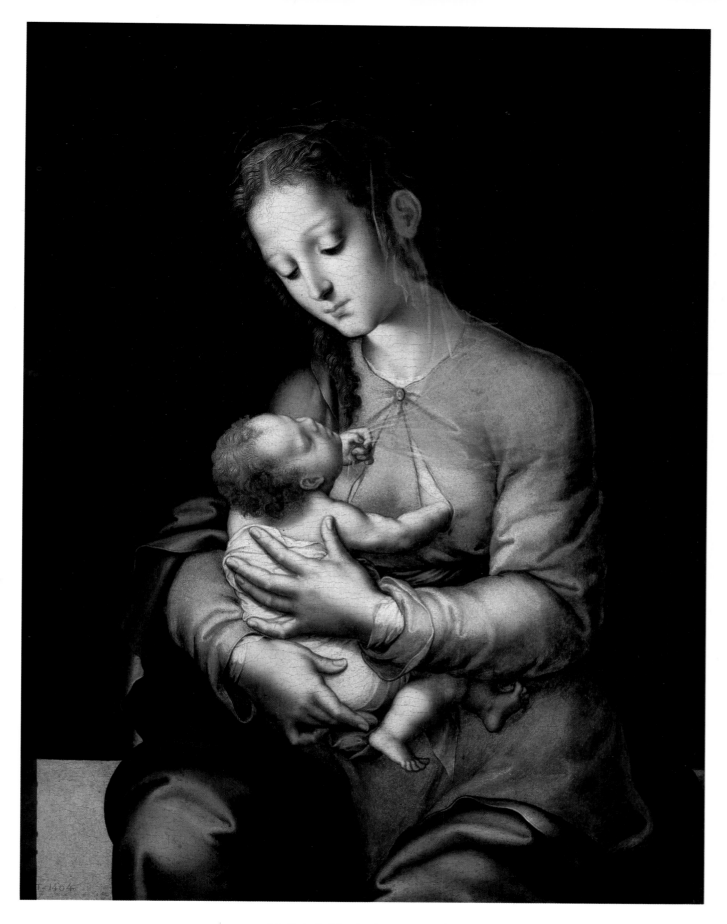

20. **Luis de Morales** (c. 1500–1586)
Madonna and Child [no. 2656]
Oil on board, 33 ⅛ × 25 ¼″ (84 × 64 cm)

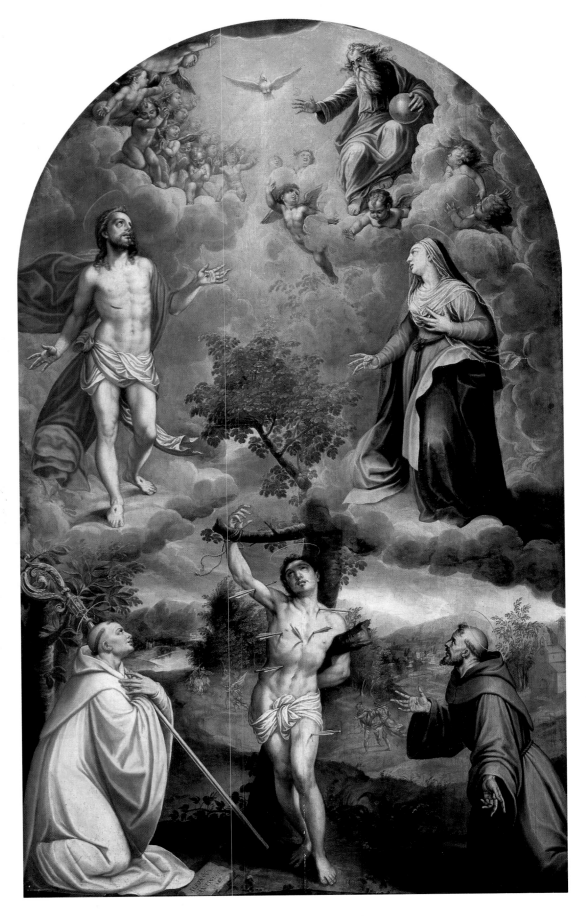

21. **Alonso Sánchez Coello** (1531/32–1588)
Saint Sebastian Between Saint Bernard and Saint Francis. 1582 [no. 2861]
Oil on board, 116 ⅛ × 77 ⅛″ (295 × 196 cm)

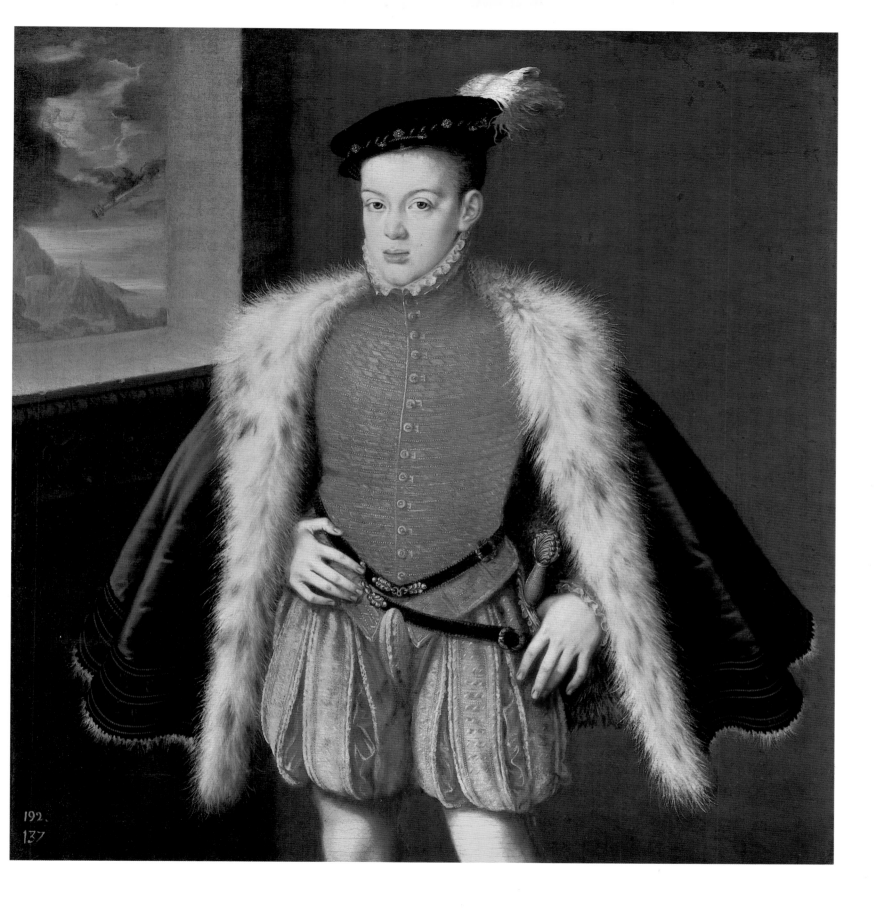

22. **Alonso Sánchez Coello** (1531/32–1588)
Prince Charles [no. 1136]
Oil on canvas, 42 7/8 × 37 3/8″ (109 × 95 cm)

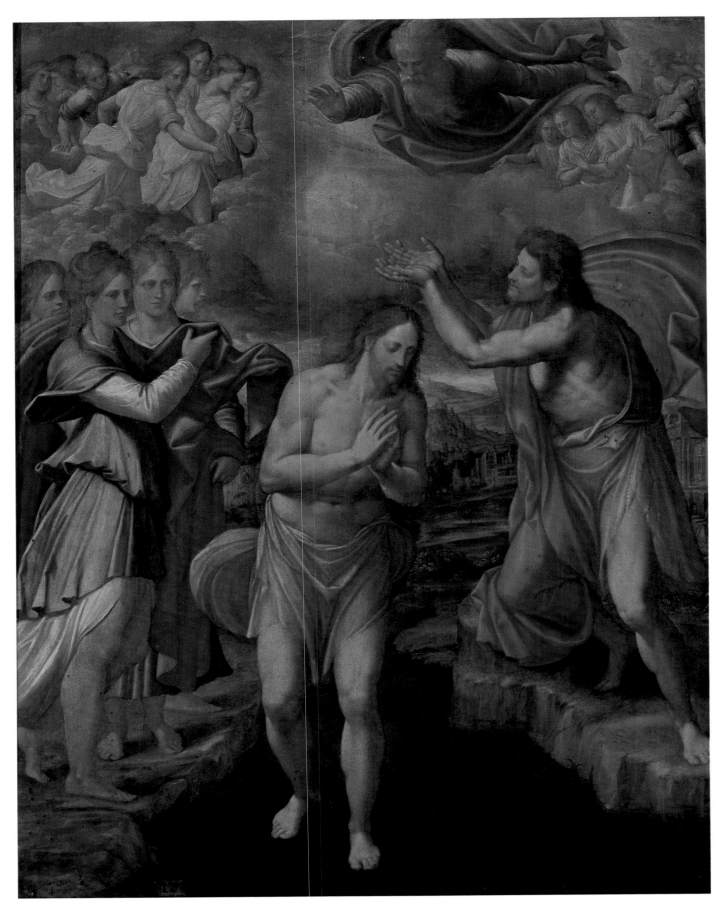

23. **Juan Fernández Navarrete, ''The Dumb Man''** (c. 1526–1579)
The Baptism of Christ [no. 1012]
Oil on board, 19 ¼ × 14 ⅝" (49 × 37 cm)

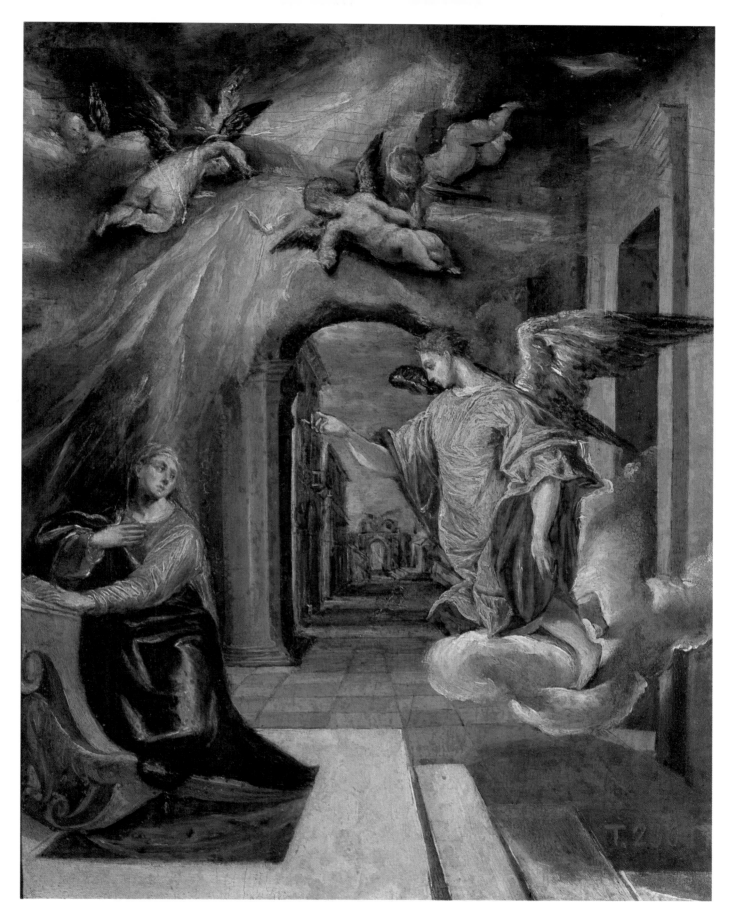

24. **Domenikos Theotokopoulos,** called **El Greco** (1540–1614)
The Annunciation [no. 827]
Paint on board, 19 ¼ × 14 ⅝″ (49 × 37 cm)

163

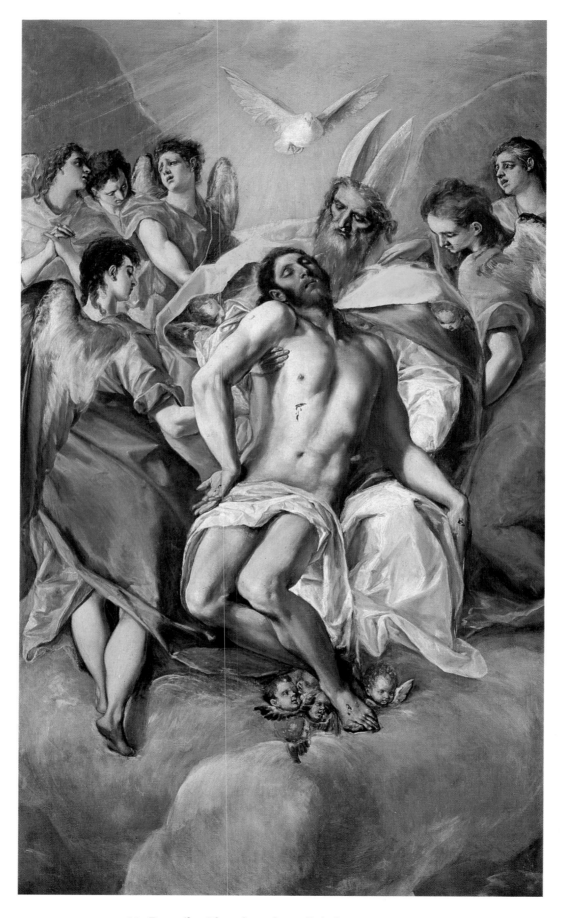

25. **Domenikos Theotokopoulos,** called **El Greco** (1540–1614)
The Holy Trinity. 1577 [no. 824]
Paint on canvas, 118 ⅛ × 70 ½″ (300 × 179 cm)

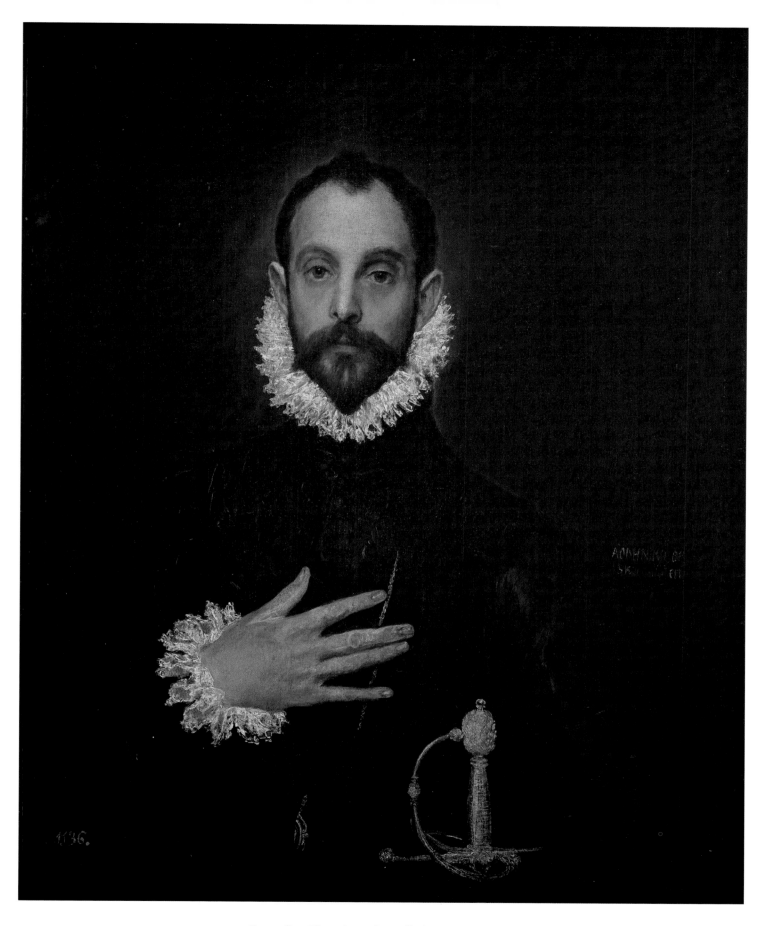

26. **Domenikos Theotokopoulos,** called **El Greco** (1540–1614)
The Knight with His Hand on His Breast [no. 809]
Paint on canvas, 31⅞ × 26″ (81 × 66 cm)

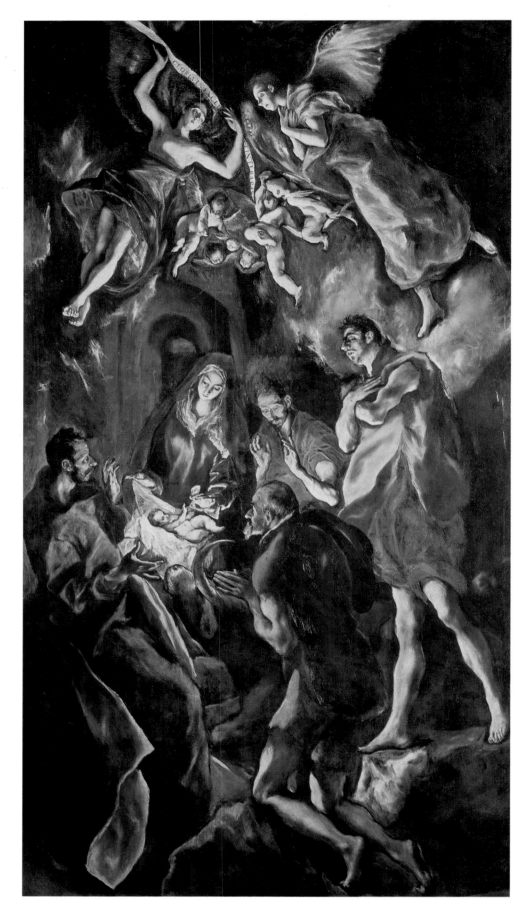

27. **Domenikos Theotokopoulos,** called **El Greco** (1540–1614)
The Adoration of the Shepherds [no. 2988]
Paint on canvas, 125⅝ × 70⅞″ (319 × 180 cm)

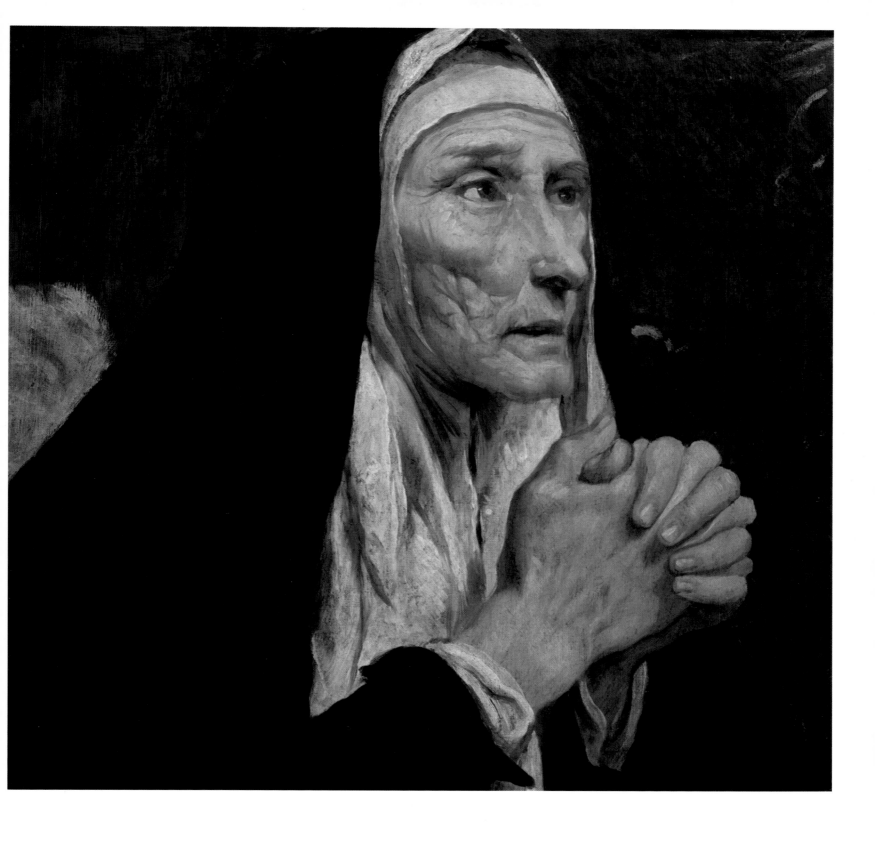

28. **Luis Tristán** (c. 1585–1624)
Saint Monica. 1616 [no. 2836]
Oil on canvas, 15 ¾ × 16 ½″ (40 × 42 cm)

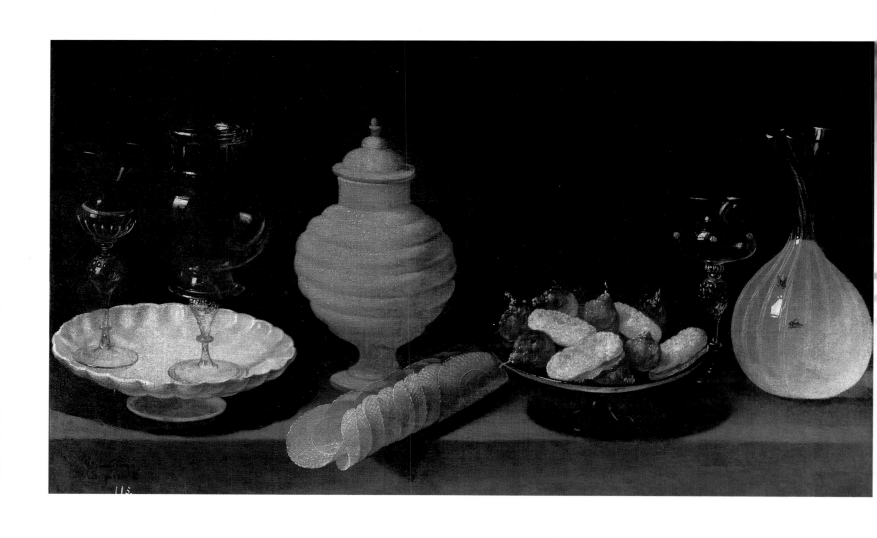

29. **Juan van der Hamen y León** (1596–1631)
Still Life (Glass, Pottery, and Sweets). 1622 [no. 1164]
Oil on canvas, 20 ½ × 34 ⅝″ (52 × 88 cm)

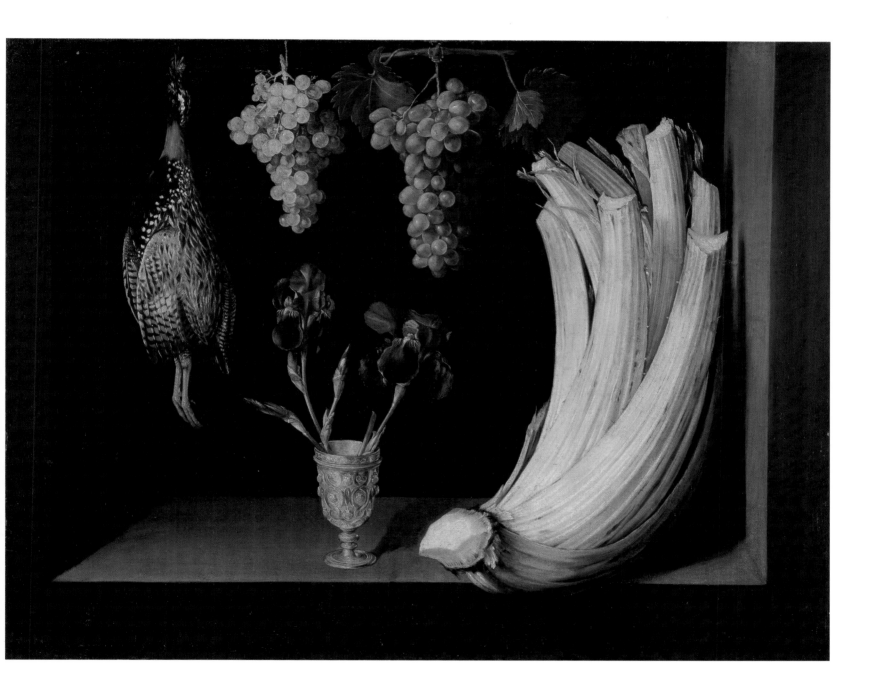

30. **Felipe Ramírez** (. . . 1628–1631 . . .)
Still Life (Thistle, Grapes, Partridge, and Irises). 1628 [no. 2802]
Oil on canvas, 28 × 36 ¼″ (71 × 92 cm)

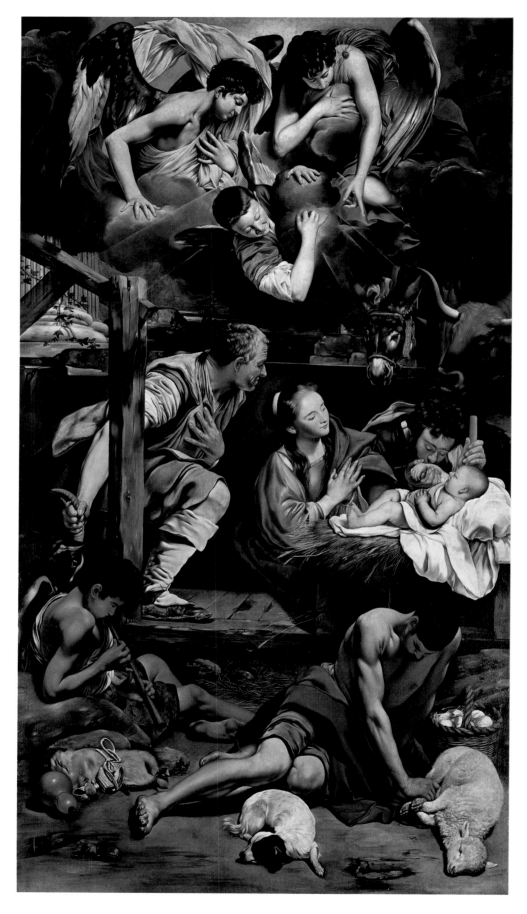

31. **Juan Bautista Maíno** (1578–1649)
Adoration of the Shepherds. 1611–13 [no. 886]
Oil on canvas, 124 × 68 ½″ (315 × 174 cm)

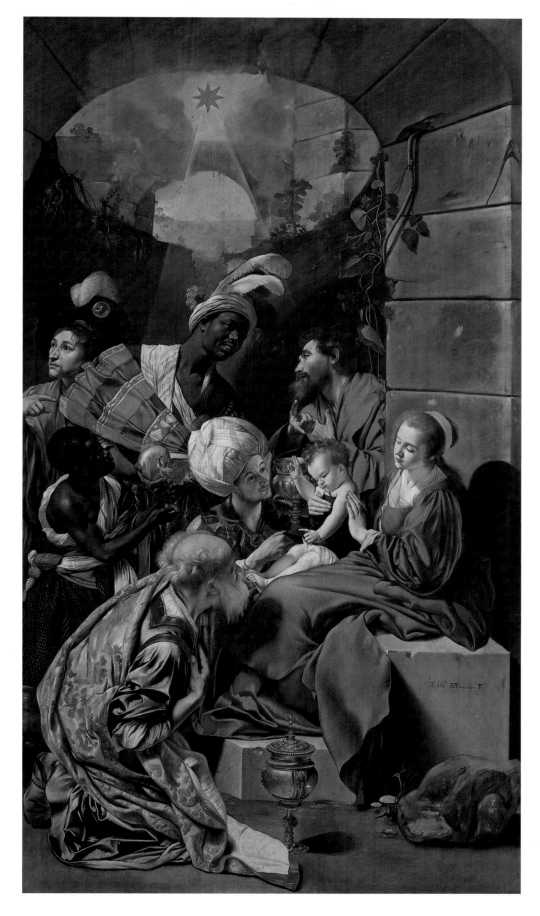

32. **Juan Bautista Maíno** (1578–1649)
The Adoration of the Magi. 1611–13 [no. 3227]
Oil on canvas, 124 × 68 ½″ (315 × 174 cm)

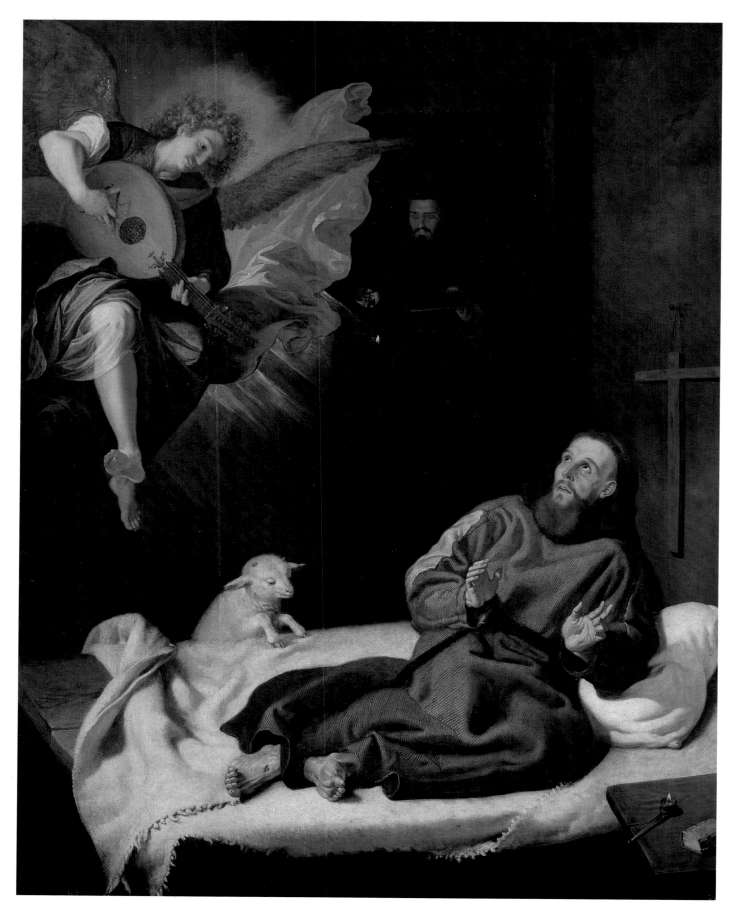

33. **Francisco Ribalta** (1565–1628)
Saint Francis Comforted by an Angel Musician. 1620 [no. 1062]
Oil on canvas, 80 3/8 × 62 1/4″ (204 × 158 cm)

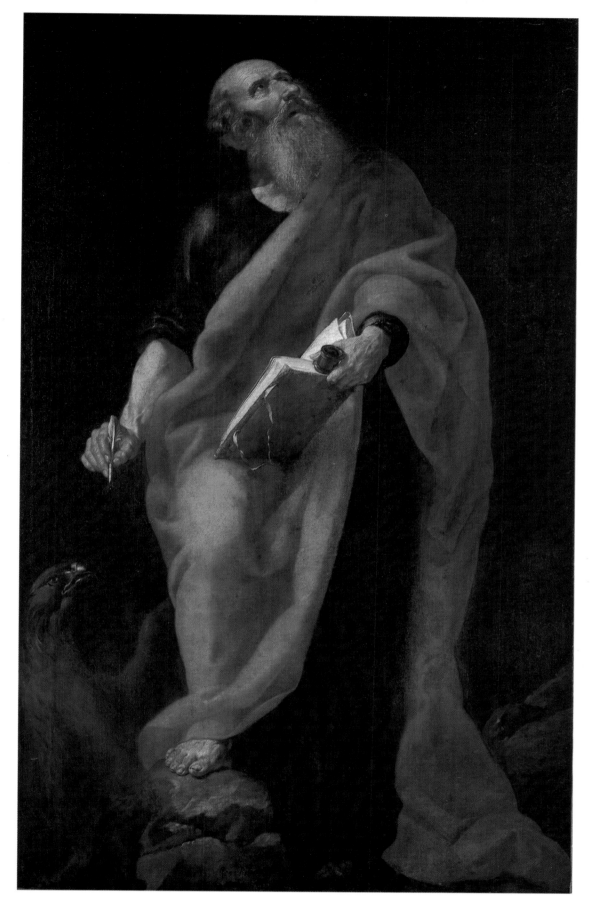

34. **Juan Ribalta** (1596/97–1628)
Saint John the Evangelist [no. 3044]
Oil on canvas, 71 5/8 × 44 1/2″ (182 × 113 cm)

173

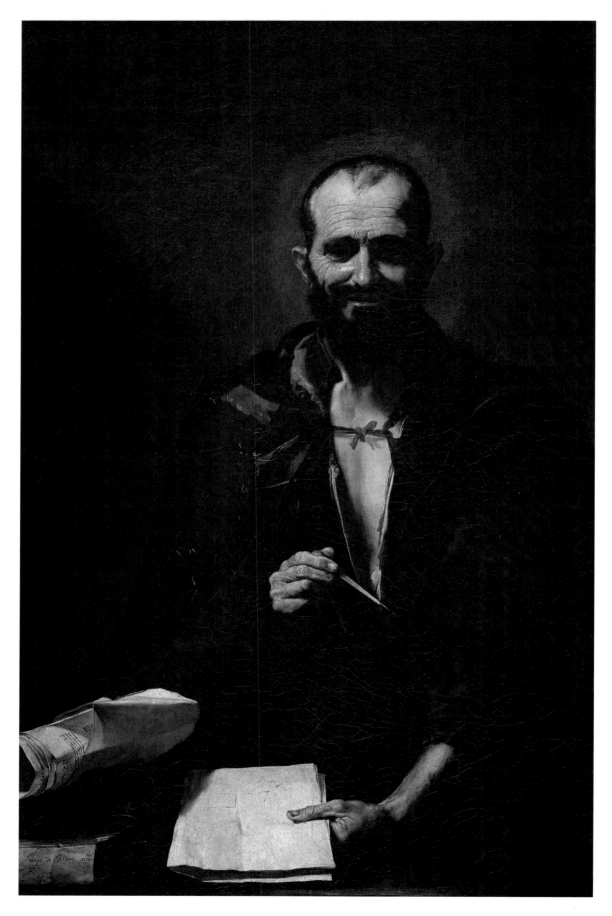

35. **José de Ribera** (1591–1652)
Archimedes. 1630 [no. 1121]
Oil on canvas, 49 ¼ × 31 ⅞″ (125 × 81 cm)

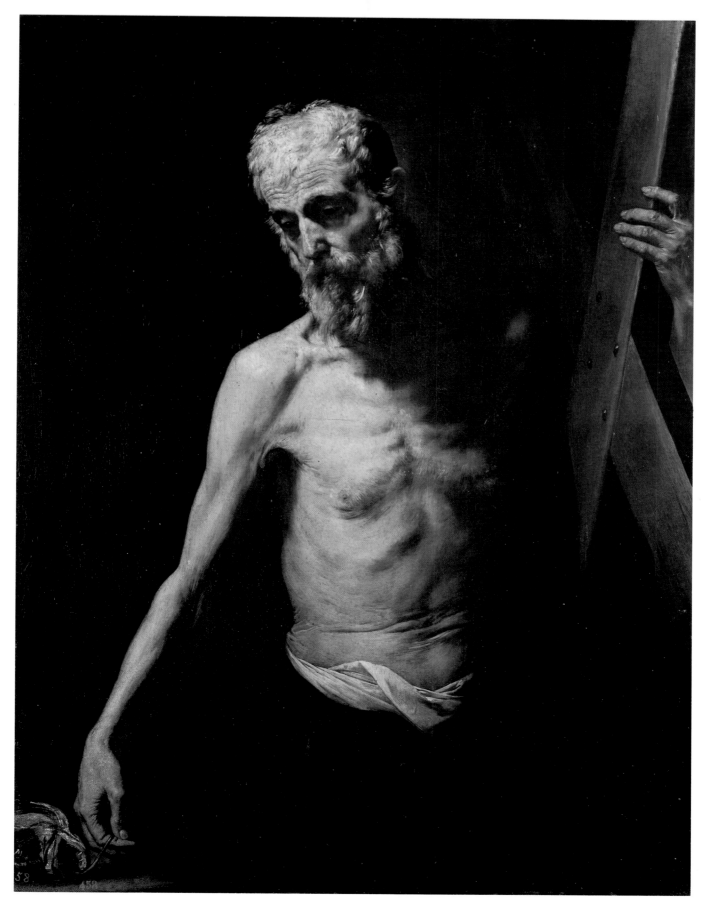

36. **José de Ribera** (1591–1652)
Saint Andrew [no. 1078]
Oil on canvas, 48 ⅜ × 37 ⅜″ (123 × 95 cm)

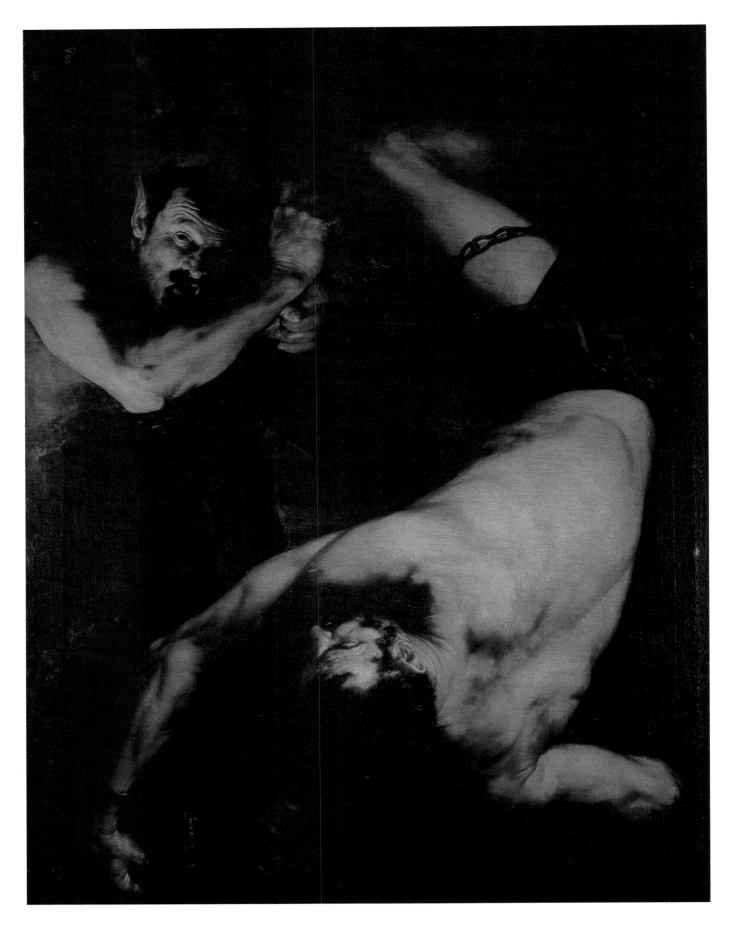

37. **José de Ribera** (1591–1652)
Ixion. 1632 [no. 1114]
Oil on canvas, 118 ½ × 89 ⅜″ (301 × 227 cm)

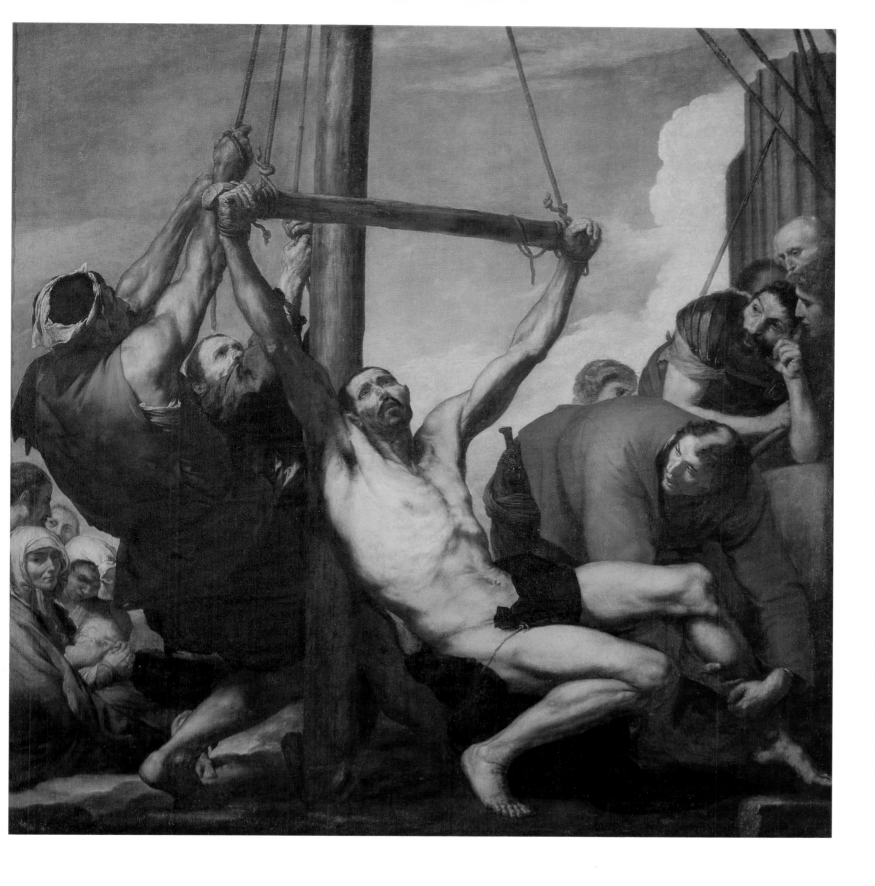

38. **José de Ribera** (1591–1652)
The Martyrdom of Saint Philip. 1639 [no. 1101]
Oil on canvas, 92 1/8 × 92 1/8″ (234 × 234 cm)

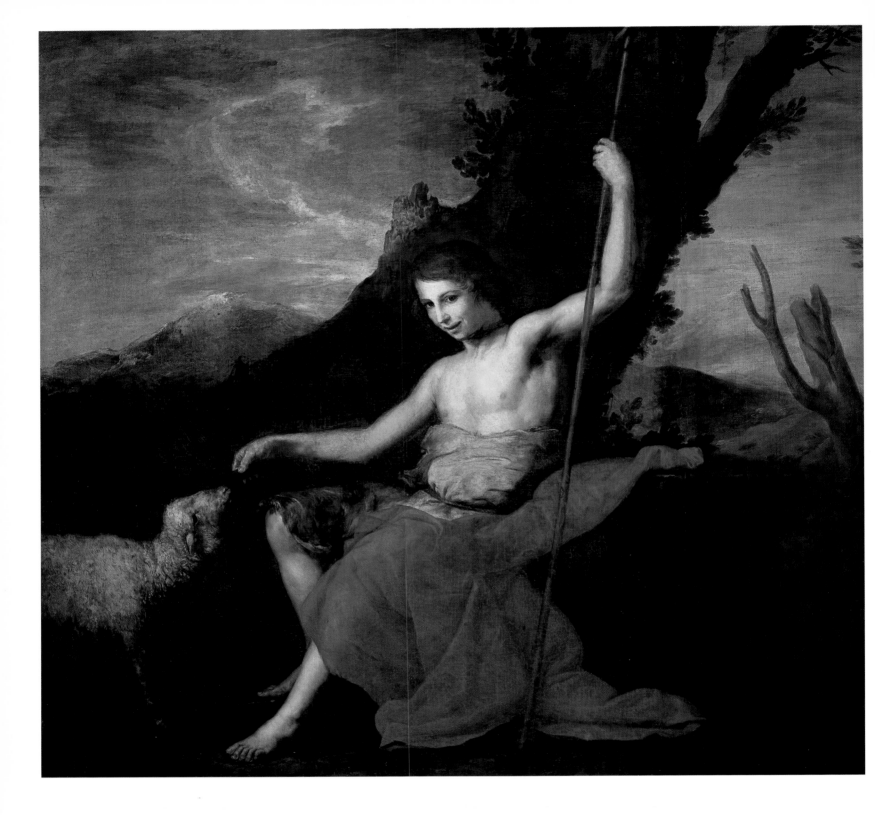

39. **José de Ribera** (1591–1652)
Saint John the Baptist in the Desert [no. 1108]
Oil on canvas, 72 ½ × 78″ (184 × 198 cm)

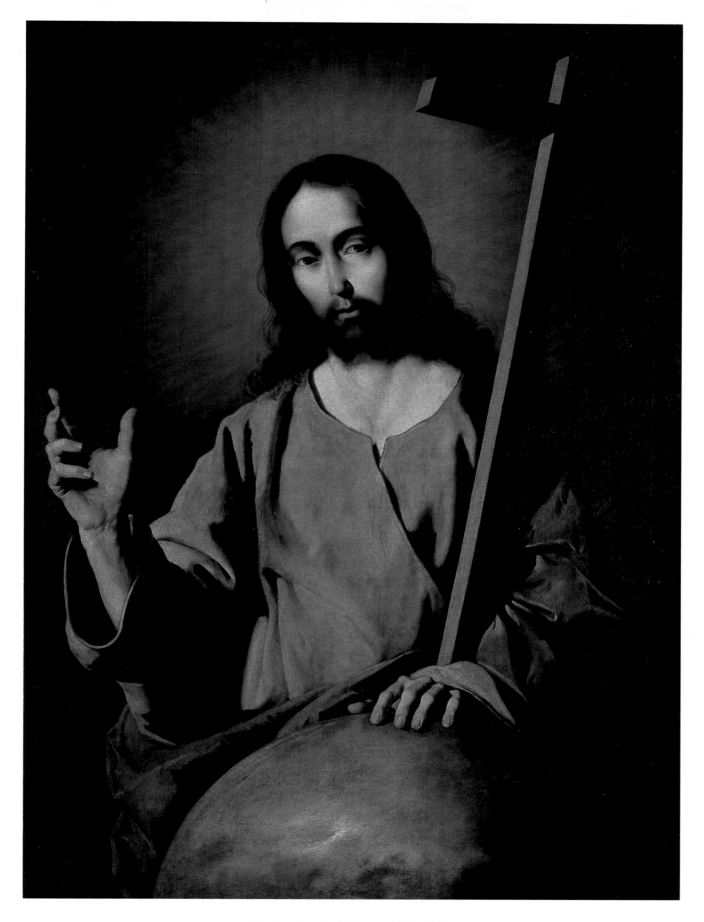

40. **Francisco de Zurbarán** (1598–1664)
The Savior Blessing. 1638 [no. 6074]
Oil on canvas, 39 × 28″ (99 × 71 cm)

179

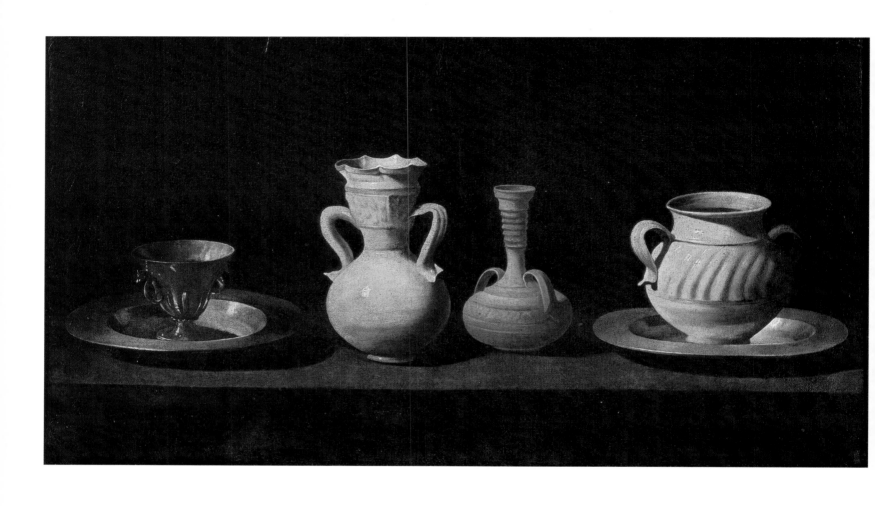

41 & 42. **Francisco de Zurbarán** (1598–1664)
Still Life with Pottery Jars [no. 2803]
Oil on canvas, 18 ⅛ × 33 ⅛″ (46 × 84 cm)

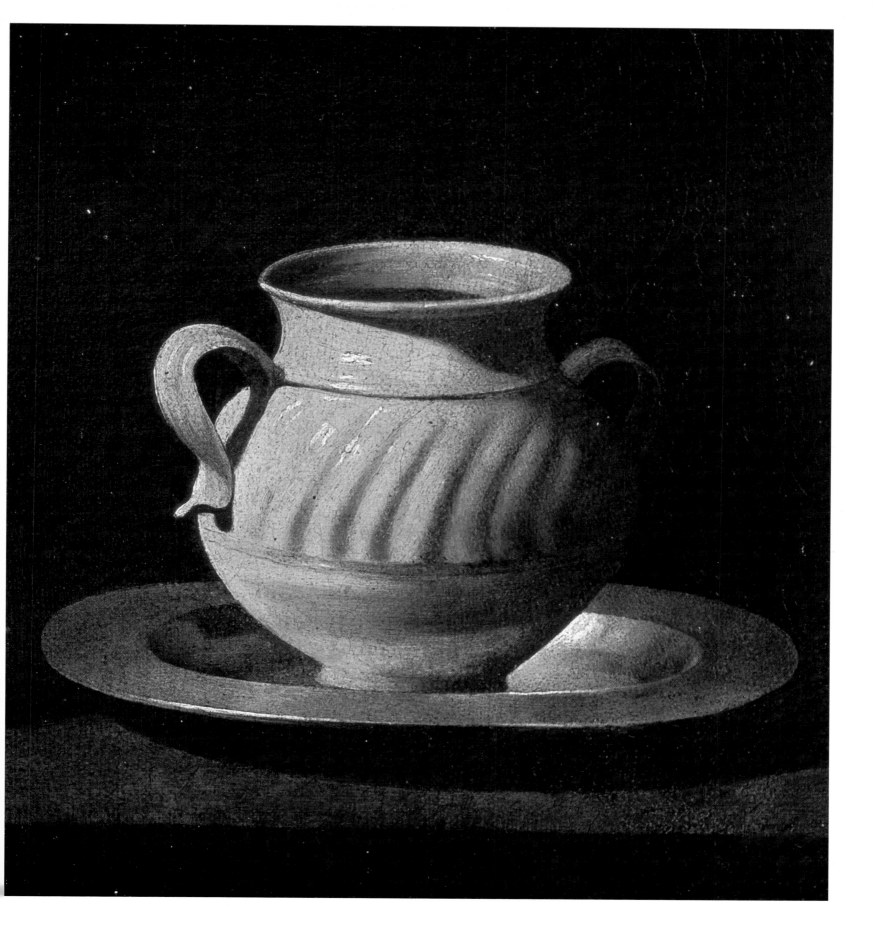

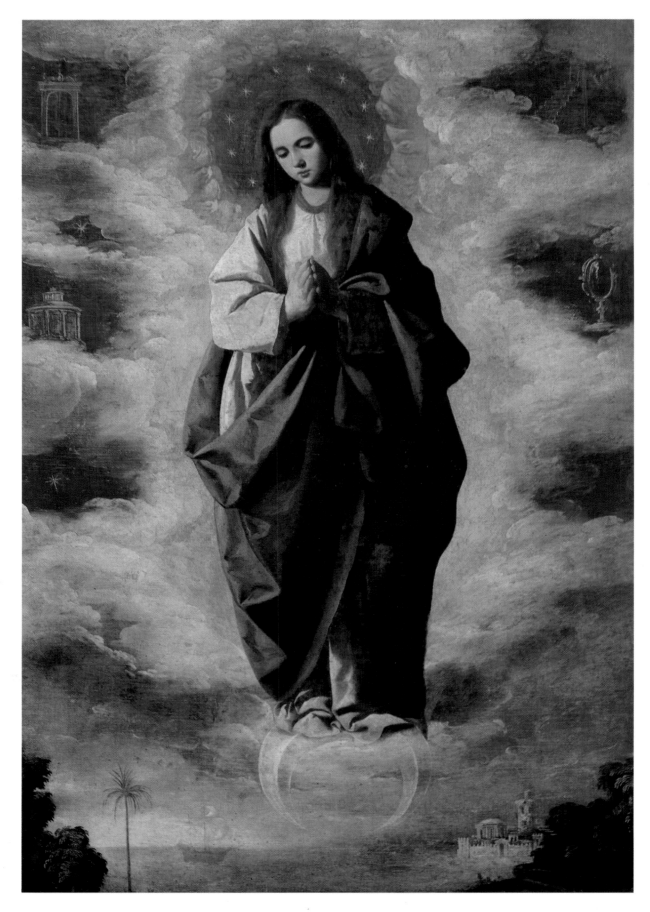

43. **Francisco de Zurbarán** (1598–1664)
The Immaculate Conception [no. 2992]
Oil on canvas, 54¾ × 41″ (139 × 104 cm)

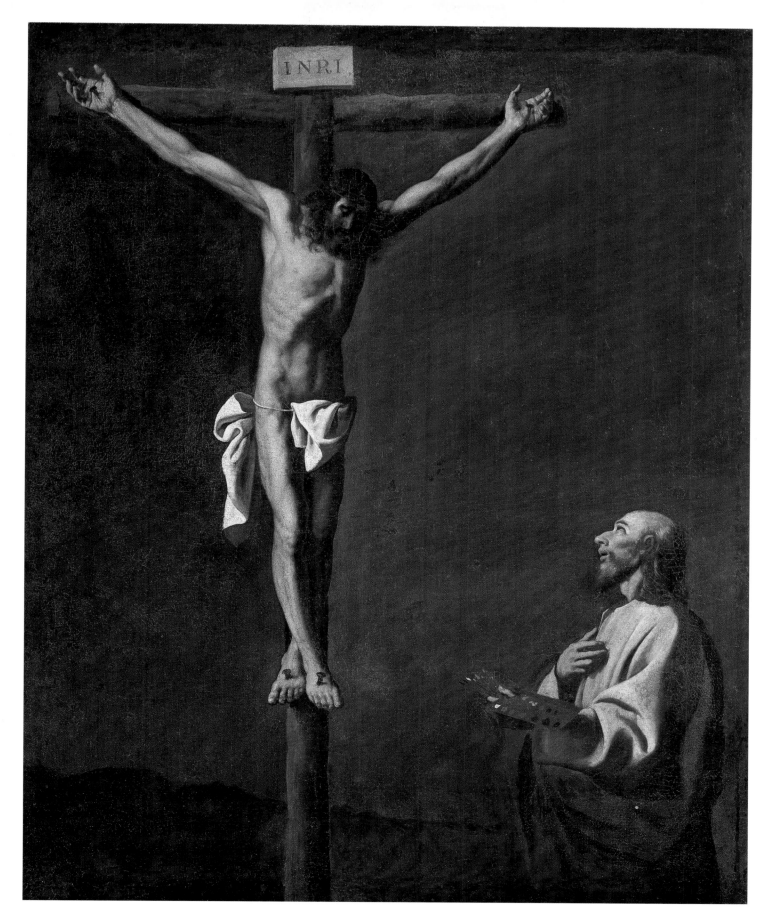

44. **Francisco de Zurbarán** (1598–1664)
Saint Luke as a Painter before Christ on the Cross [no. 2594]
Oil on canvas, 41 ³⁄₈ × 33 ¹⁄₈″ (105 × 84 cm)

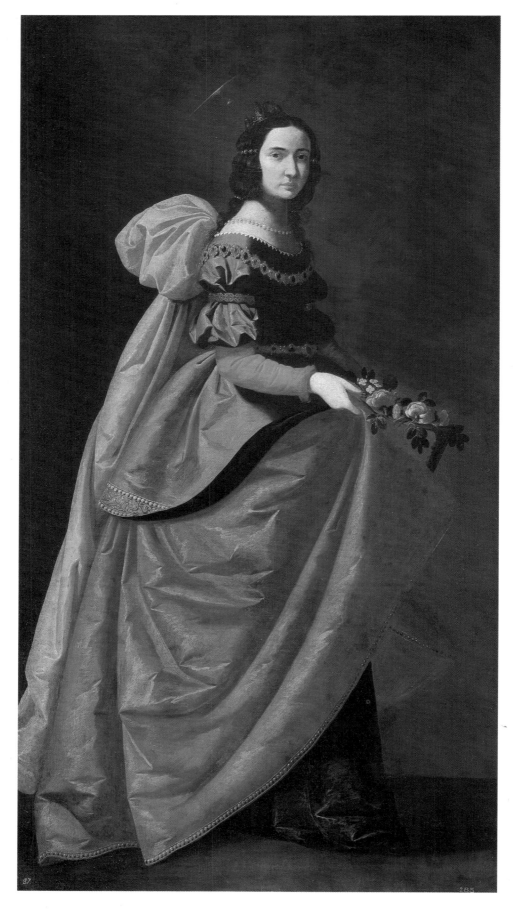

45. Francisco de Zurbarán (1598–1664)
Saint Casilda [no. 1239]
Oil on canvas, 72 ½ × 35 ⅜″ (184 × 90 cm)

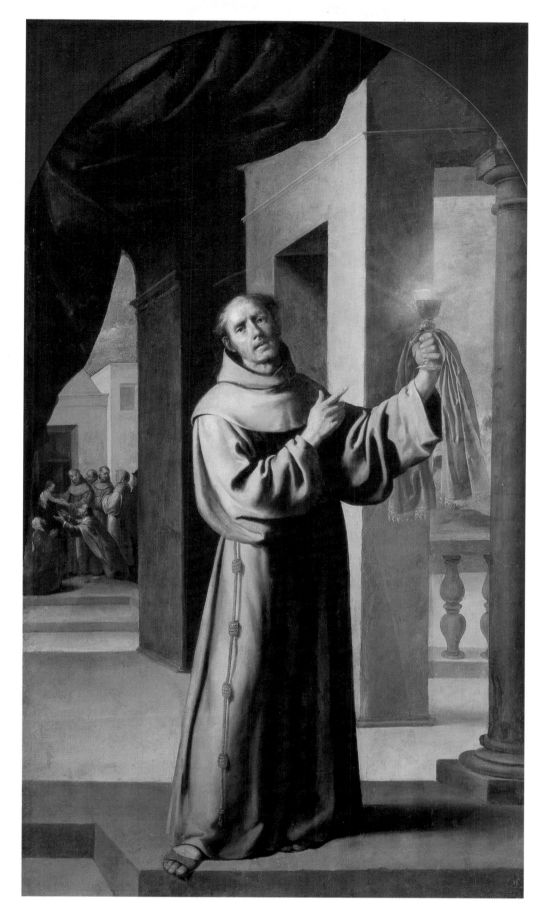

46. **Francisco de Zurbarán** (1598–1664)
Saint Jacobo de la Marca [no. 2472]
Oil on canvas, 114 ⅝ × 65″ (291 × 165 cm)

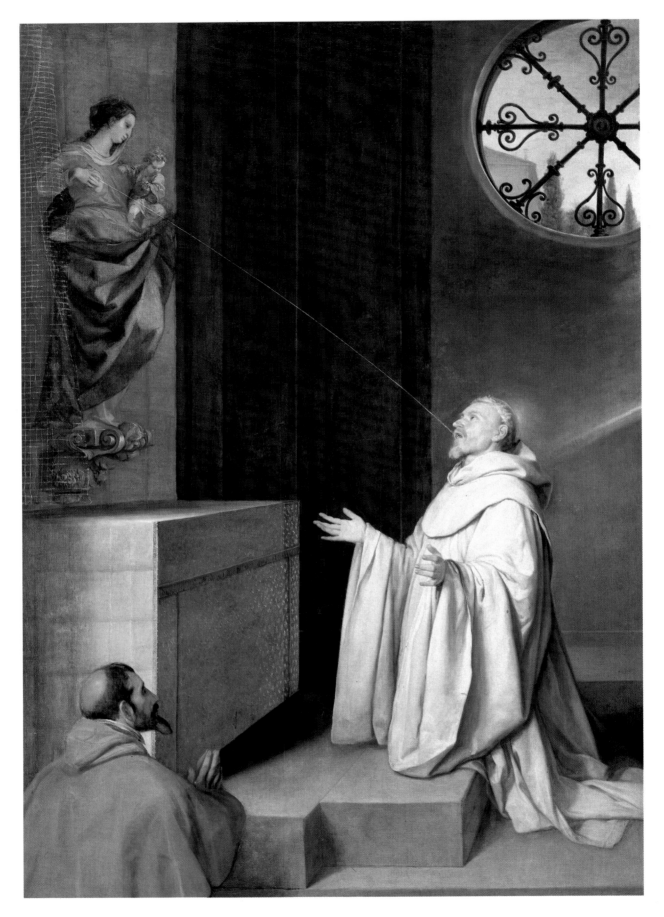

47. **Alonso Cano** (1601–1667)
Saint Bernard and the Virgin [no. 3134]
Oil on canvas, 105 ⅛ × 72 ⅞″ (267 × 185 cm)

186

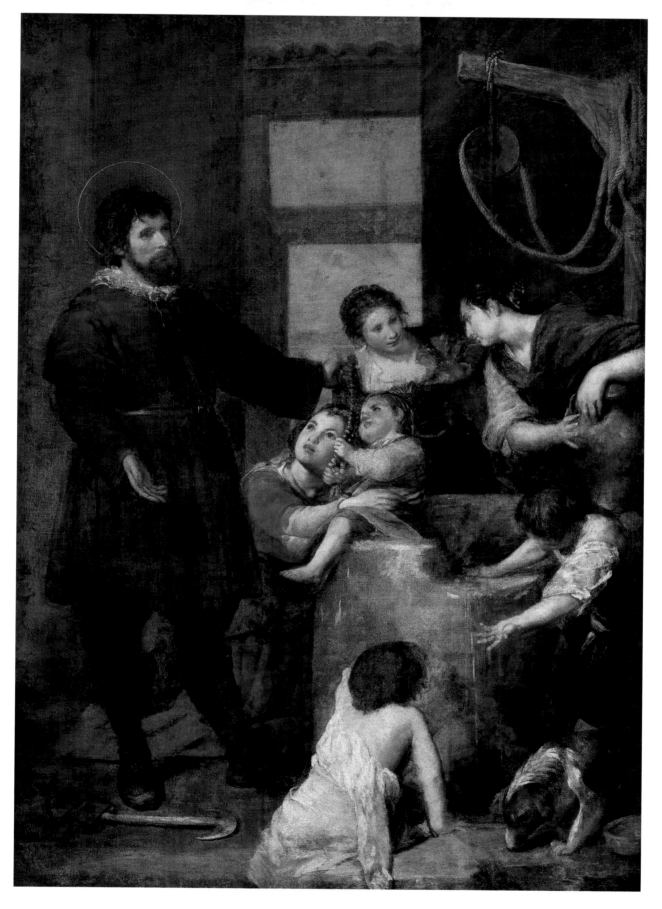

48. **Alonso Cano** (1601–1667)
The Miracle at the Well [no. 2806]
Oil on canvas, 85 × 58 5/8″ (216 × 149 cm)

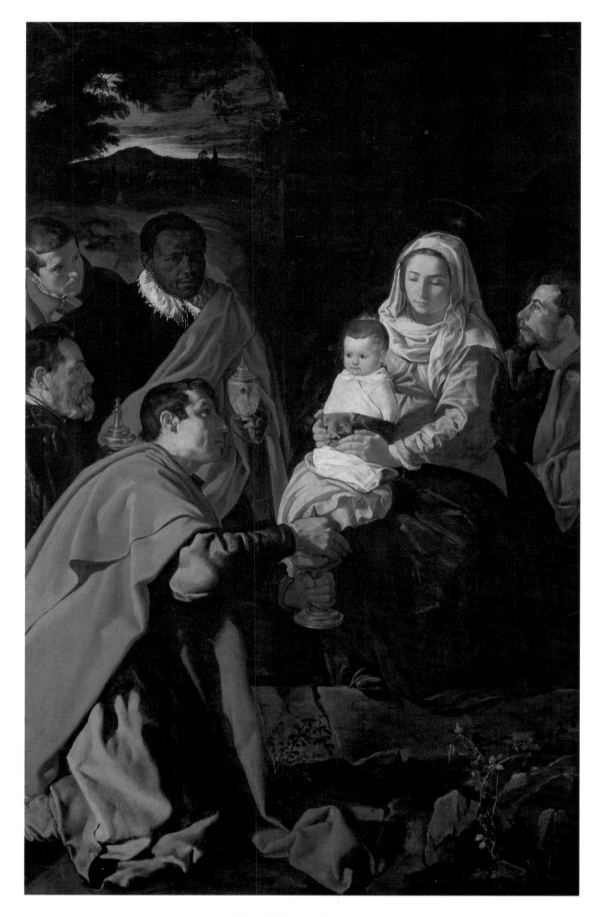

49. Diego Velázquez (1599–1660)
The Adoration of the Magi. 1619 [no. 1166]
Oil on canvas, 79 ⅞ × 49 ¼″ (203 × 125 cm)

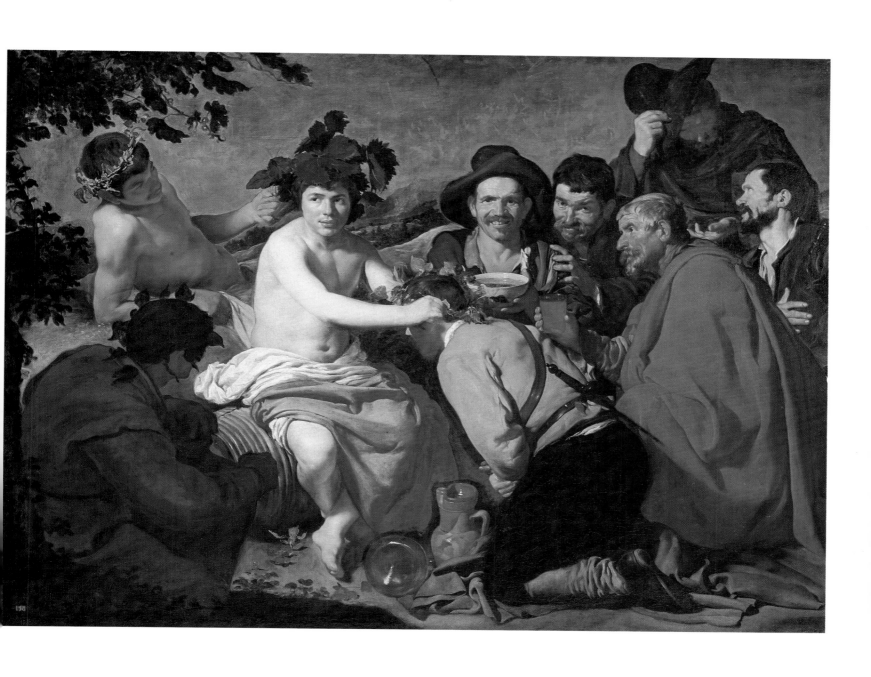

50. **Diego Velázquez** (1599–1660)
Los Borrachos (The Drunkards) or *The Feast of Bacchus*. Before 1629 [no. 1170]
Oil on canvas, 65 × 88 ⅝″ (165 × 225 cm)

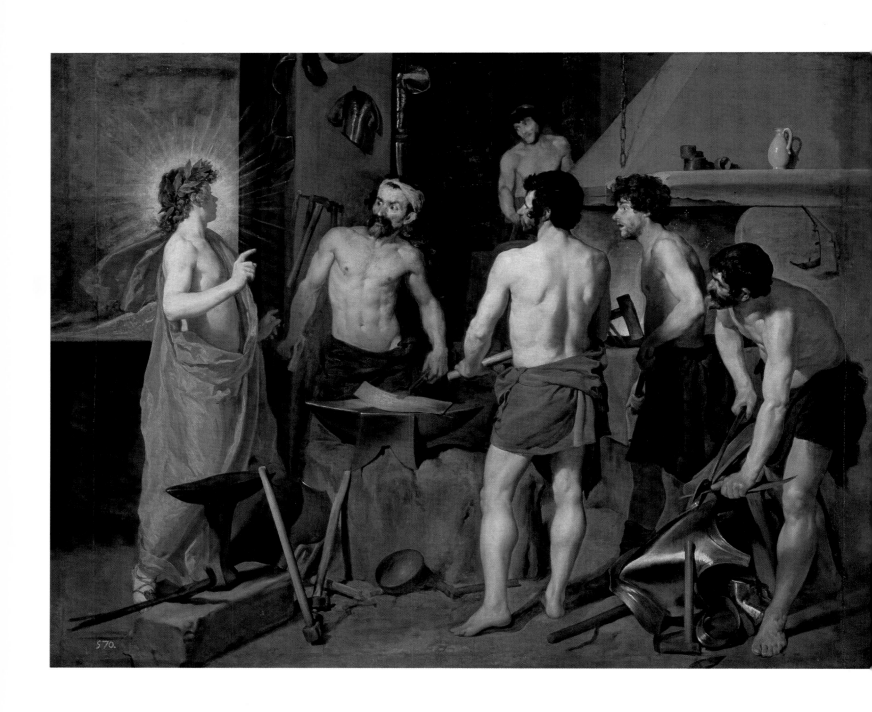

51. **Diego Velázquez** (1599–1660)
The Forge of Vulcan. 1630 [no. 1171]
Oil on canvas, 87 ¾ × 114 ⅛″ (223 × 290 cm)

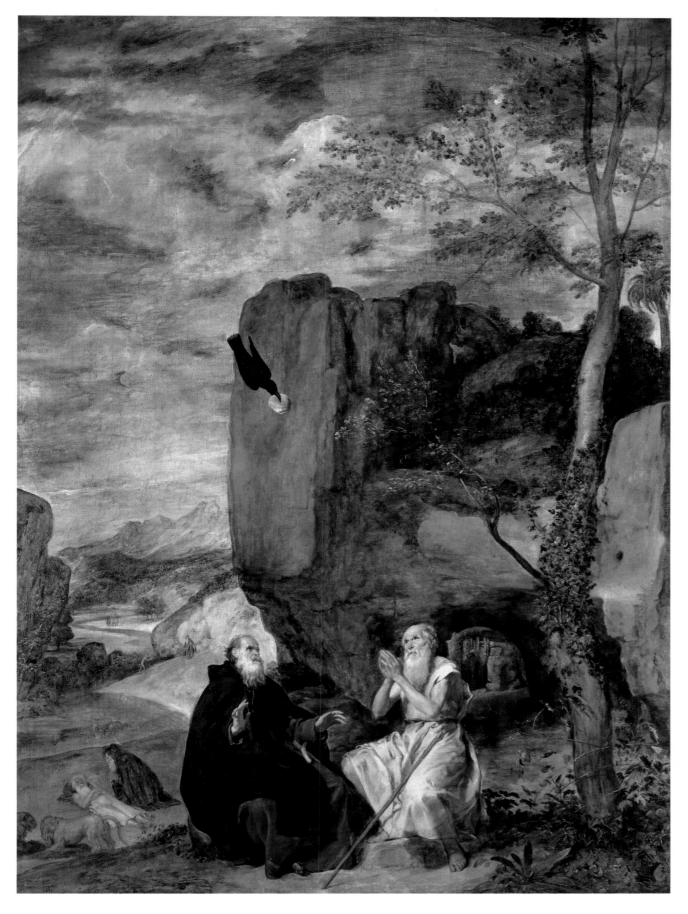

52. Diego Velázquez (1599–1660)
Saint Anthony Abbot and Saint Paul the Hermit. c. 1634 [no. 1169]
Oil on canvas, 101 ⅛ × 74″ (257 × 188 cm)

191

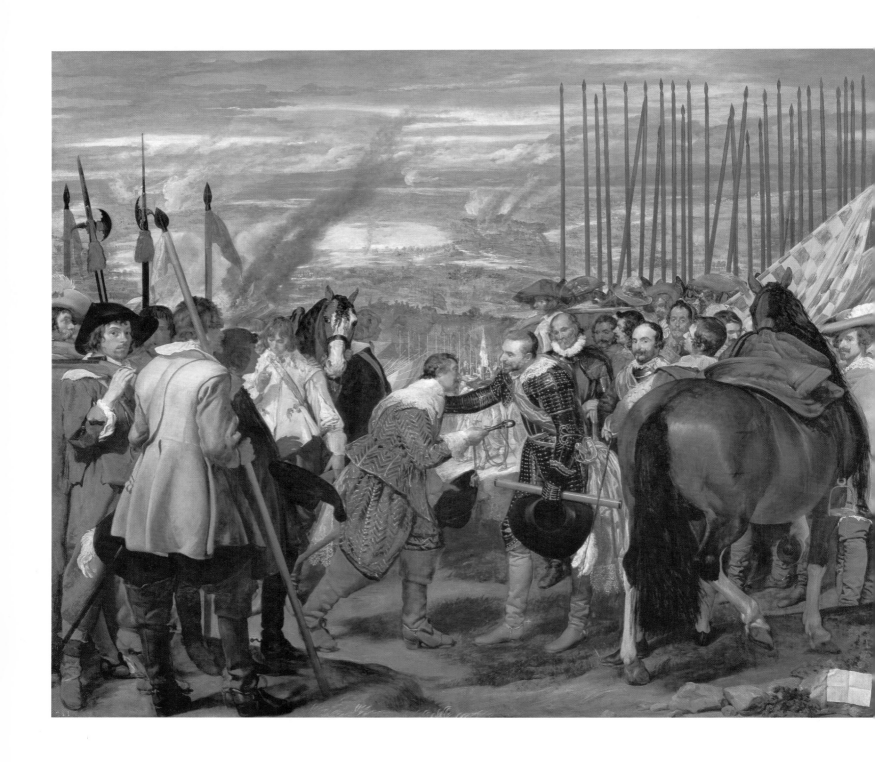

53. **Diego Velázquez** (1599–1660)
The Lances or *The Surrender of Breda*. Before 1635 [no. 1172]
Oil on canvas, 10′ ⅞″ × 12′ ½″ (307 × 367 cm)

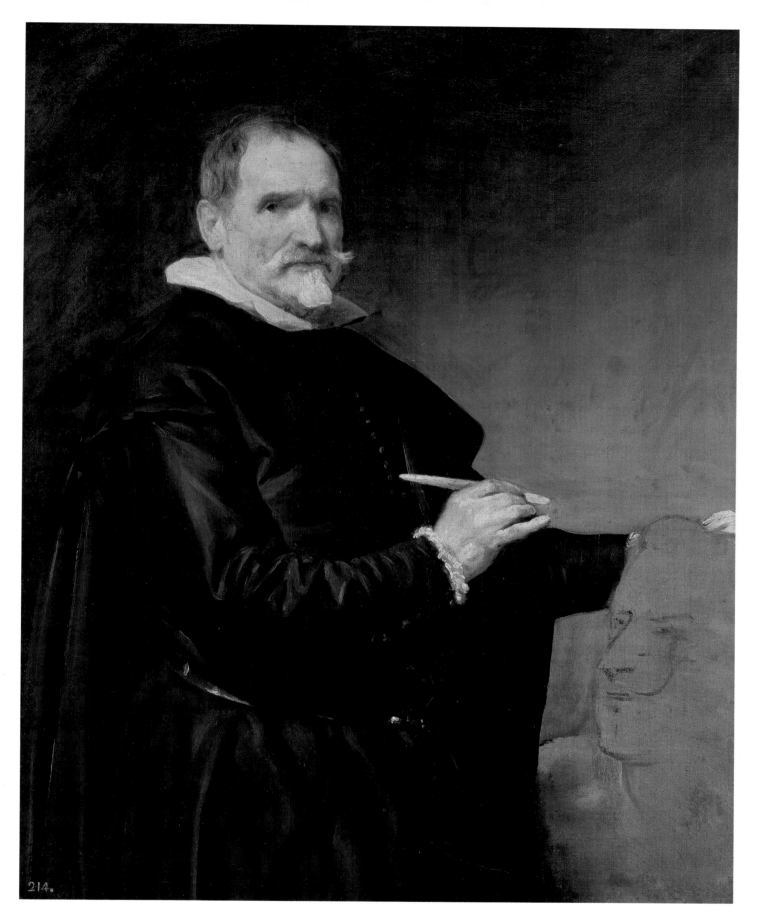

54. **Diego Velázquez** (1599–1660)
Juan Martínez Montañés. 1635/36 [no. 1194]
Oil on canvas, 42 ⅞ × 42 ⅛″ (109 × 107 cm)

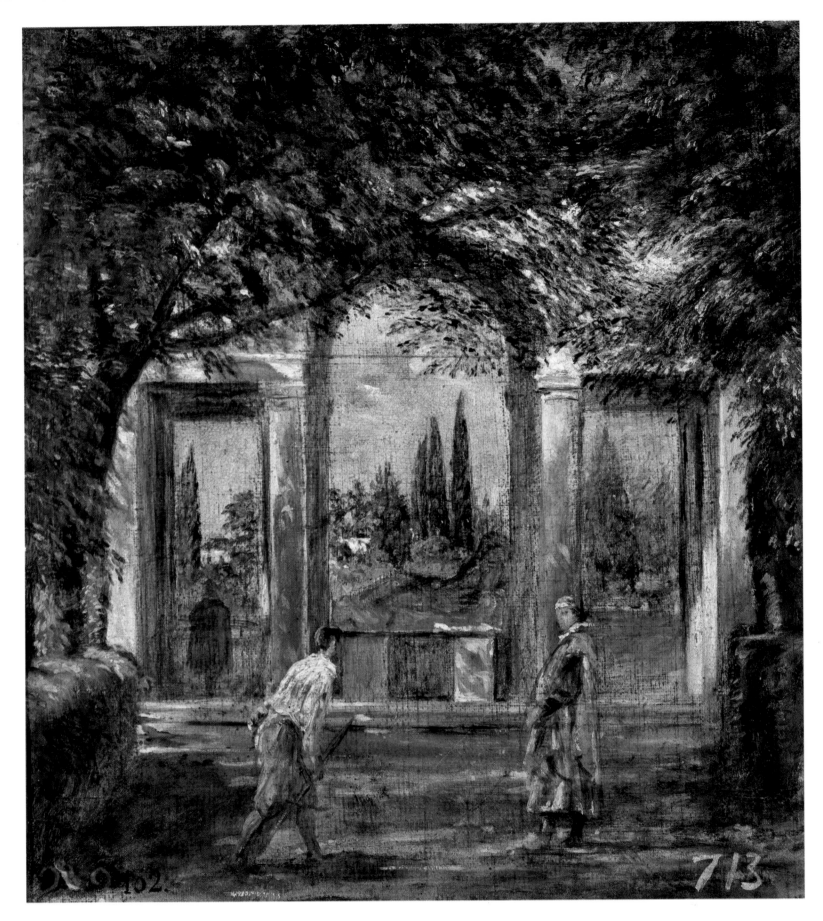

55. **Diego Velázquez** (1599–1660)
View of the Garden of the "Villa Médici" in Rome [no. 1211]
Oil on canvas, 17 3/8 × 15″ (44 × 38 cm)

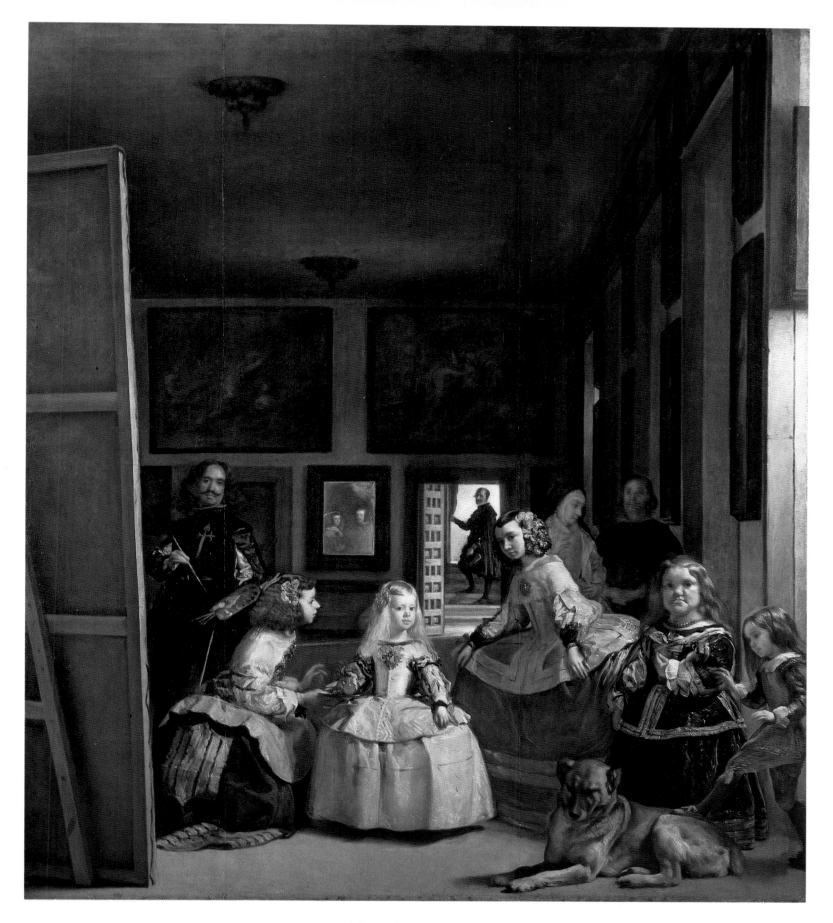

56. **Diego Velázquez** (1599–1660)
Las Meninas (Maids of Honor) or *The Family of Philip IV.* c. 1656 [no. 1174]
Oil on canvas, 10′ 5¼″ × 9′ ⅝″ (318 × 276 cm)

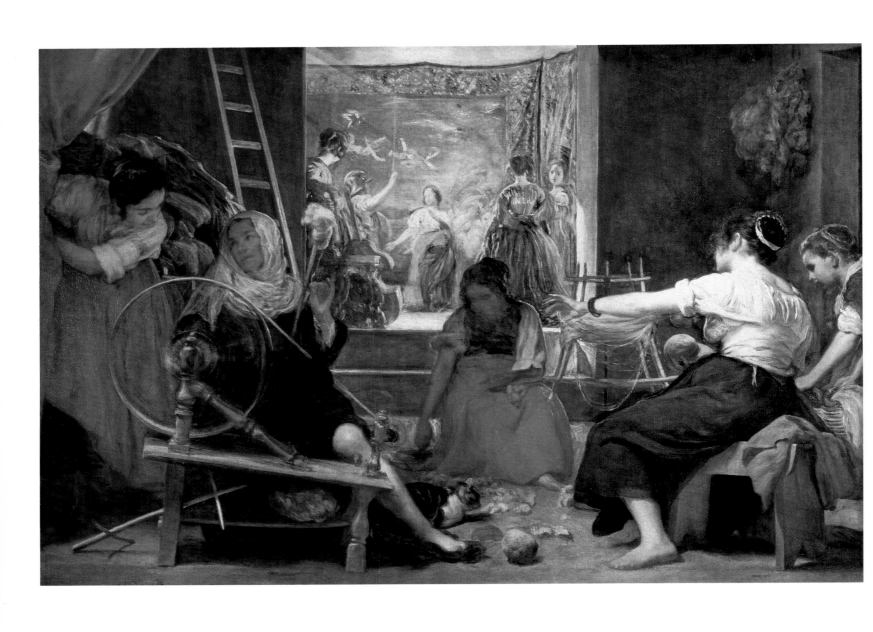

57. **Diego Velázquez** (1599–1660)
Las Hilanderas (The Spinners) or *The Fable of Arachne.* c. 1657 [no. 1173]
Oil on canvas, 86 ⅝ × 113 ¾″ (220 × 289 cm)

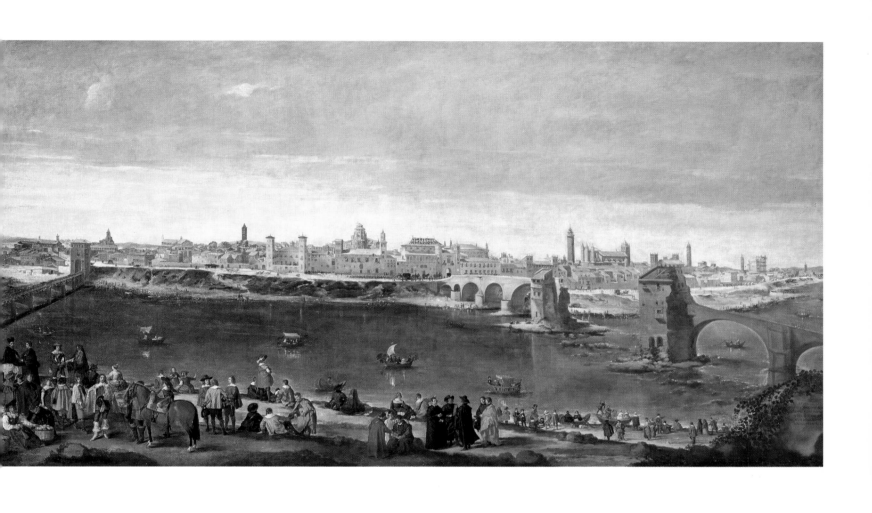

58. **Juan Bautista Martínez del Mazo** (1610/15–1667)
The View of Saragossa. 1647 [no. 889]
Oil on canvas, 71 1/4 × 130 3/8″ (181 × 331 cm)

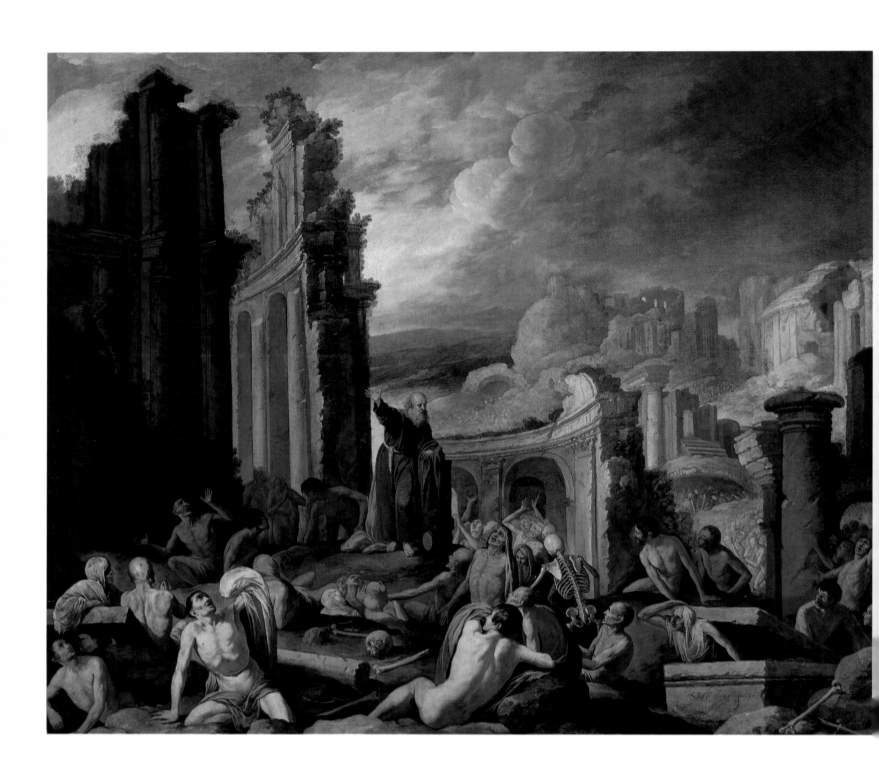

59. **Francisco Collantes** (c. 1599–c. 1656)
The Vision of Ezekiel: The Resurrection of the Flesh. 1630 [no. 666]
Oil on canvas, 69 5/8 × 80 3/4″ (177 × 205 cm)

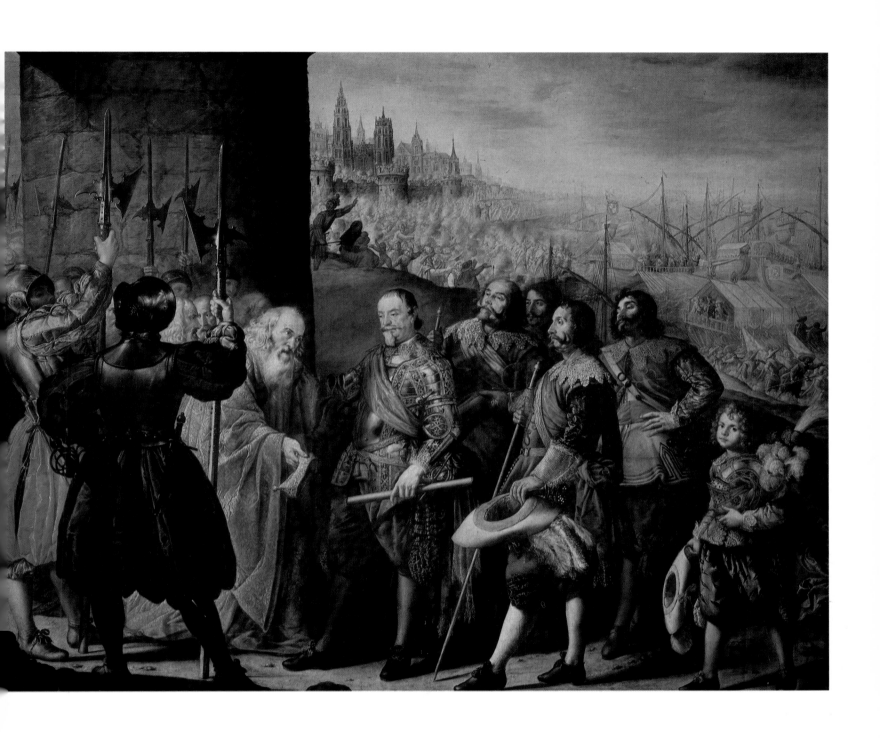

60. **Antonio de Pereda** (1611–1678)
Relief of Genoa by the Second Marquis of Santa Cruz. 1634 [no. 1317a]
Oil on canvas, 9′ 6⅛ × 12′ 1⅝″ (290 × 370 cm)

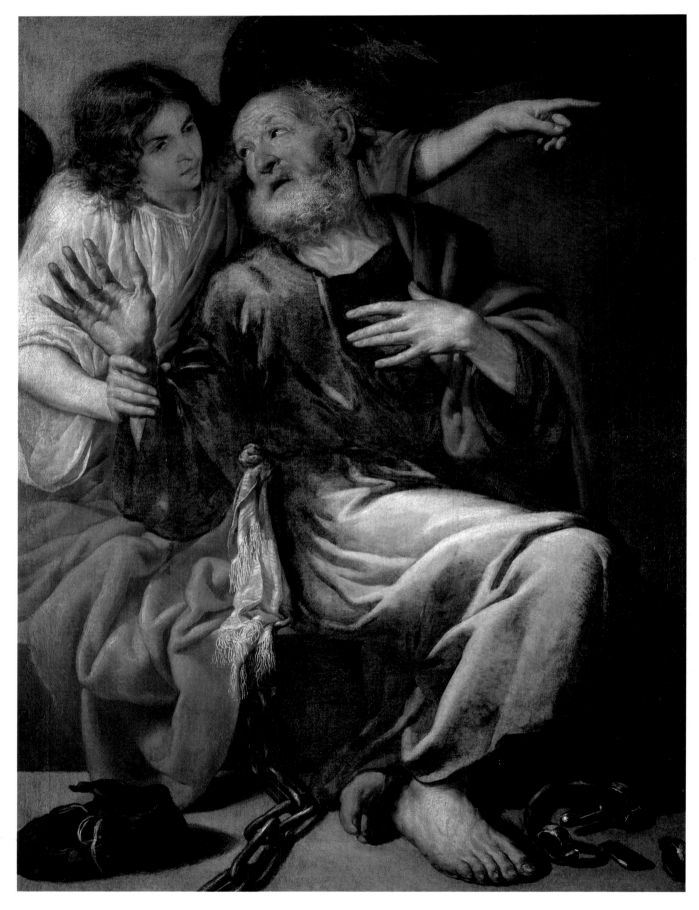

61. **Antonio de Pereda** (1611–1678)
The Liberation of Saint Peter by an Angel. 1643 [no. 1340]
Oil on canvas, 57 ⅛ × 43 ¼″ (145 × 110 cm)

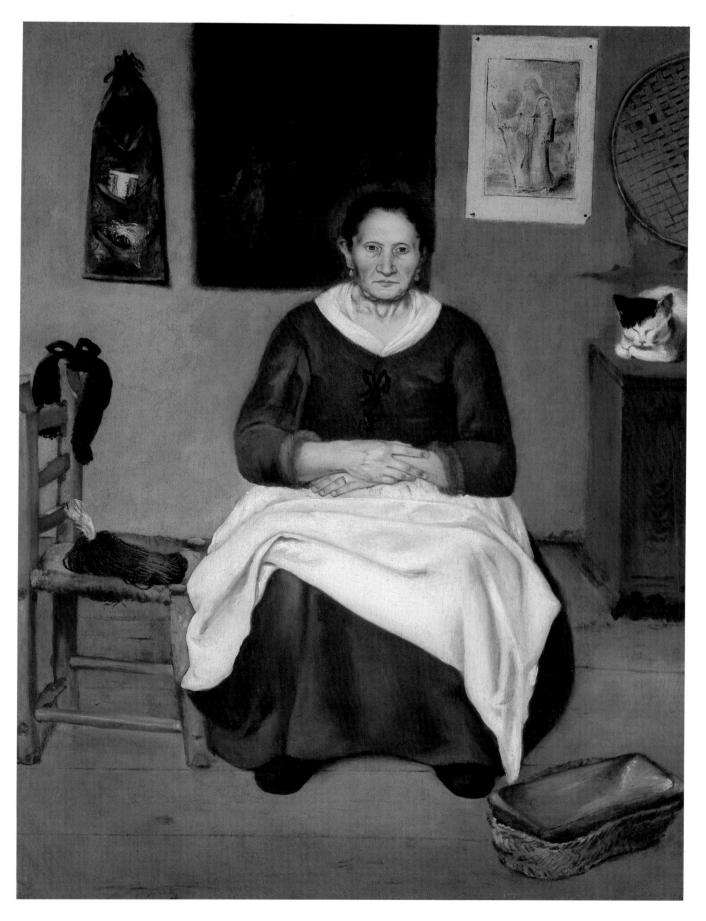

62. **Antonio Puga ?** (1602–1648)
Old Woman Seated [no. 3004]
Oil on canvas, 57⅞ × 42⅞″ (147 × 109 cm)

201

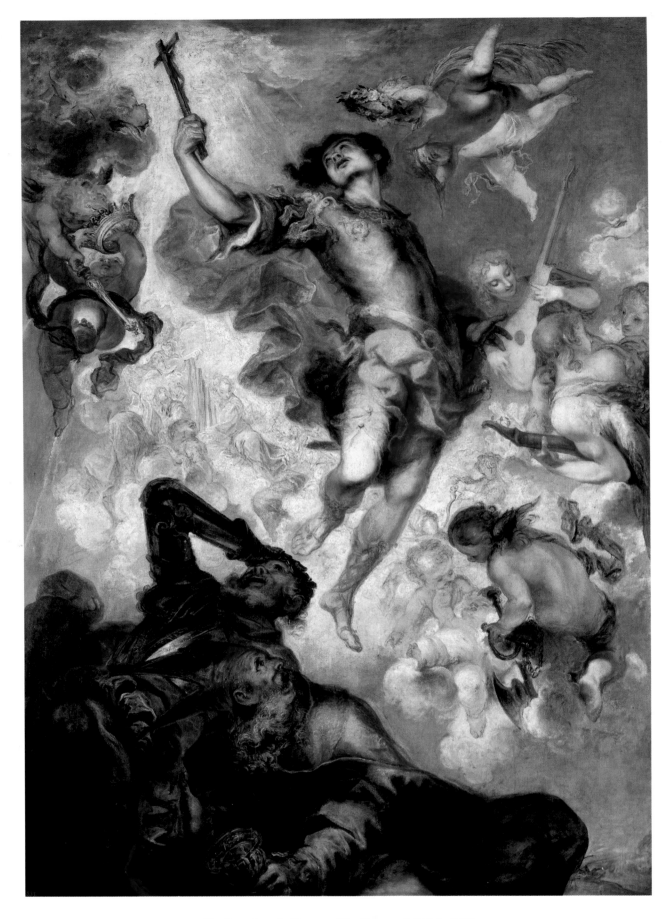

63. **Francisco de Herrera ''the Younger''** (1622–1685)
The Triumph of Saint Hermenegildo. 1654 [no. 833]
Oil on canvas, 129 ⅛ × 90 ⅛″ (328 × 229 cm)

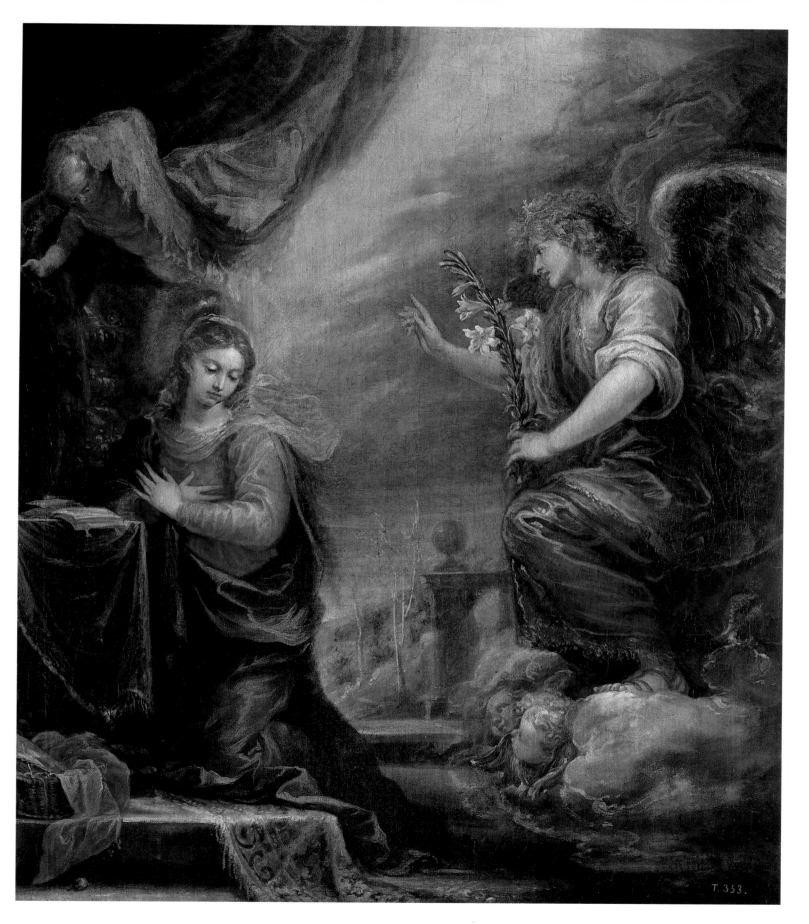

64. **Francisco Rizi** (1614–1685)
The Annunciation [no. 1128]
Oil on canvas, 48 × 37¾″ (122 × 96 cm)

203

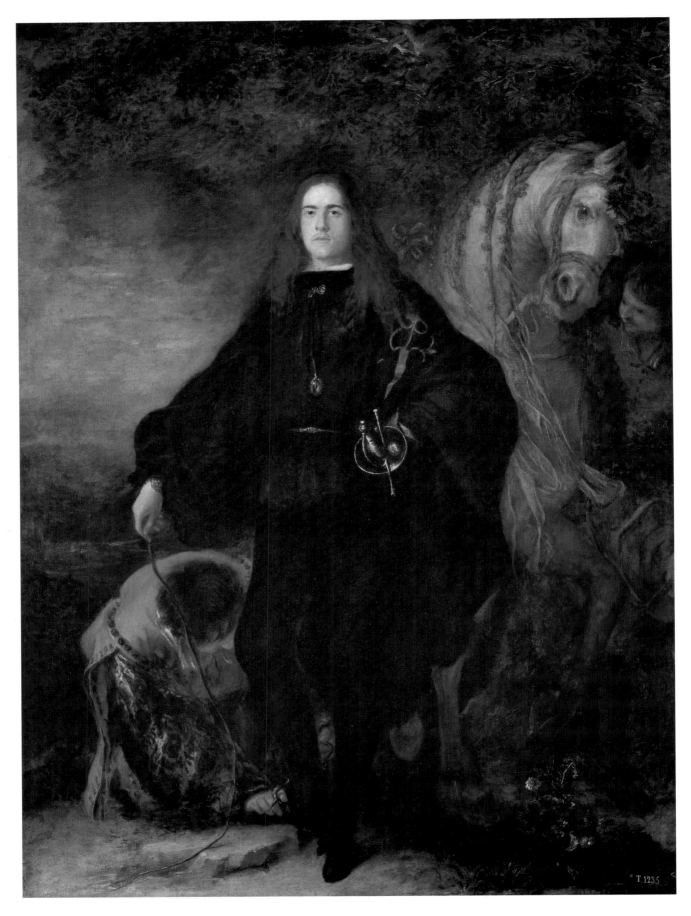

65. **Juan Carreño de Miranda** (1614–1685)
The Duke of Pastrana [no. 650]
Oil on canvas, 85⅞ × 61″ (217 × 155 cm)

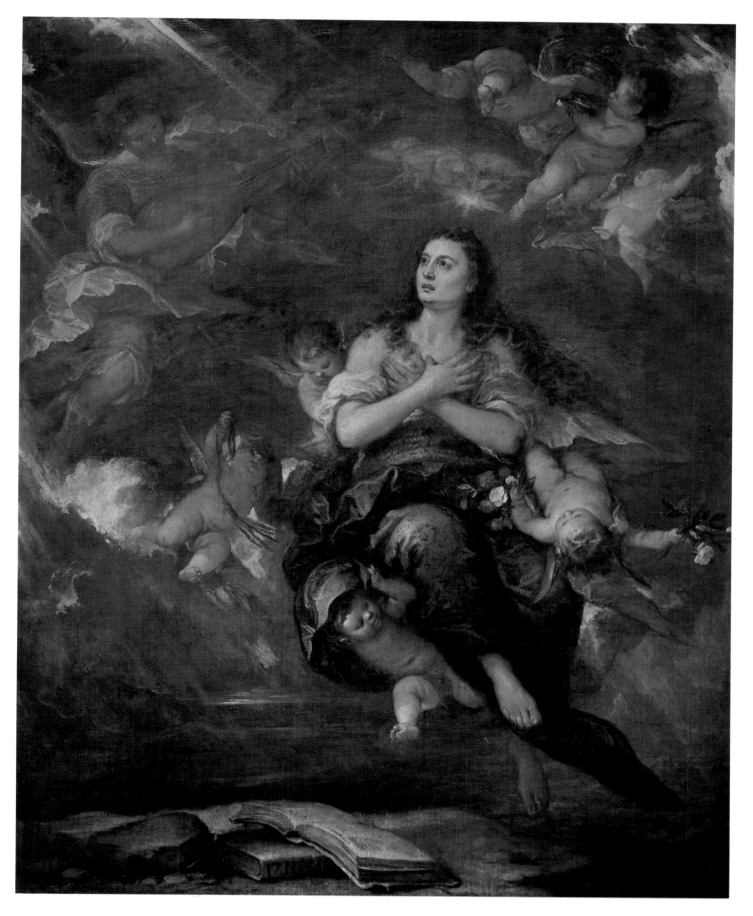

66. **José Antolínez** (1635–1675)
The Assumption of the Magdalene [no. 591]
Oil on canvas, 80¾ × 64⅛″ (205 × 163 cm)

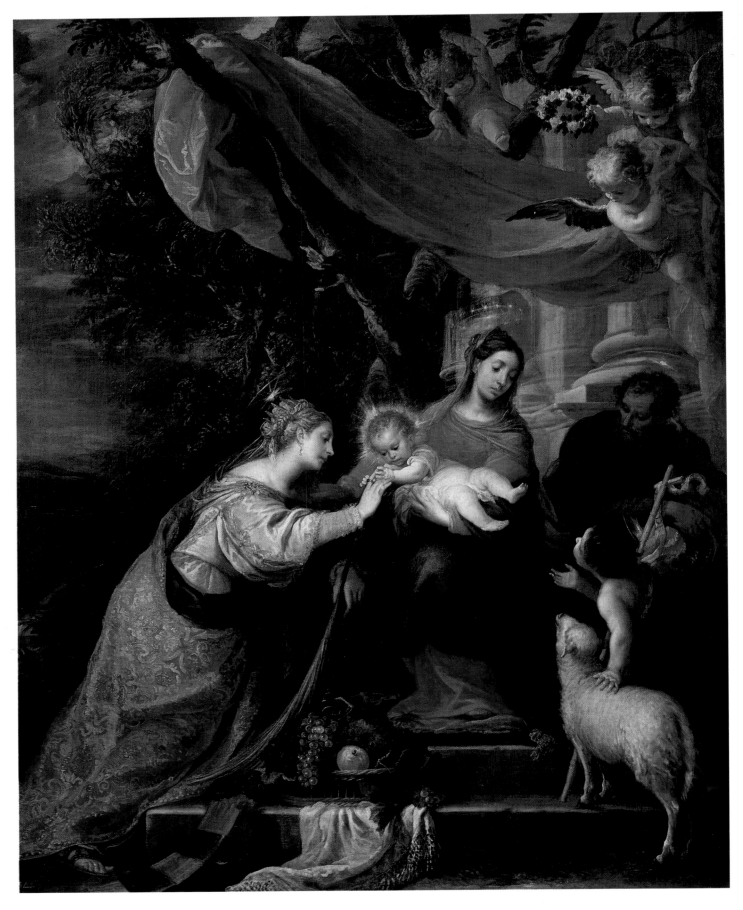

67. **Mateo Cerezo** (1626–1666)
The Mystical Nuptials of Saint Catherine. 1660 [no. 659]
Oil on canvas, 81 ½ × 64 ⅛″ (207 × 163 cm)

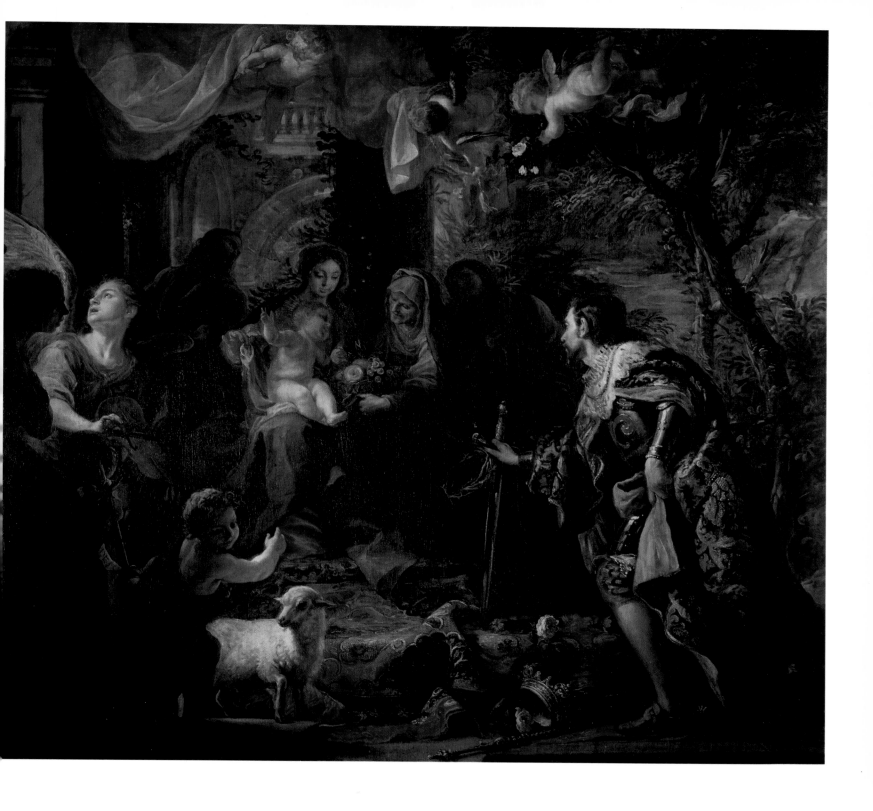

68. **Claudio Coello** (1642–1693)
The Virgin and Child Adored by Saint Louis, King of France [no. 661]
Oil on canvas, 90 1/8 × 98″ (229 × 249 cm)

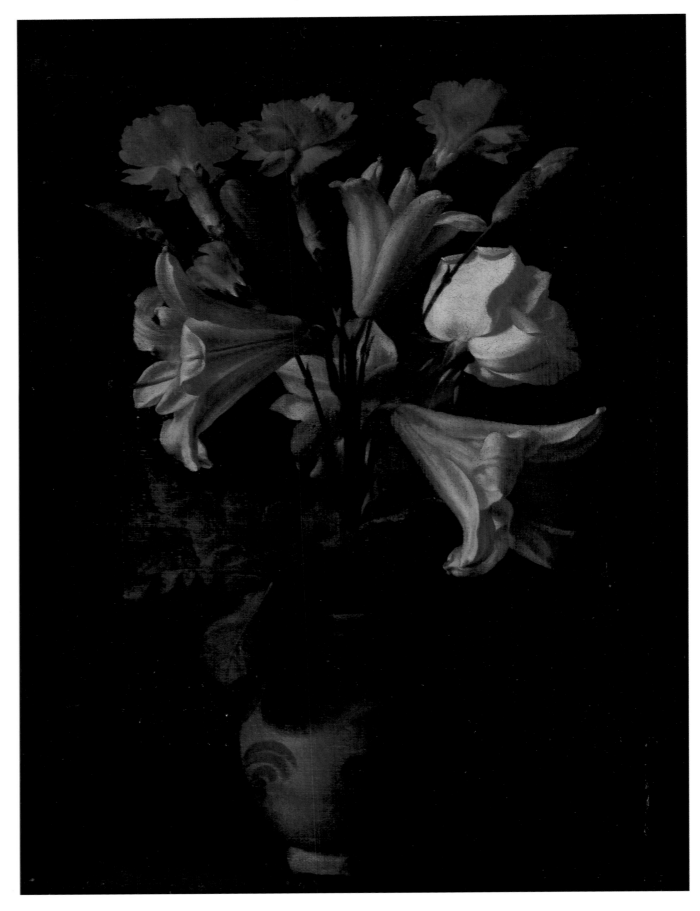

69. **Juan Fernández "the Peasant"** (...1629–1657)
The Flower Vase [no. 2888]
Oil on canvas, 17 3/8 × 13 3/8" (44 × 34 cm)

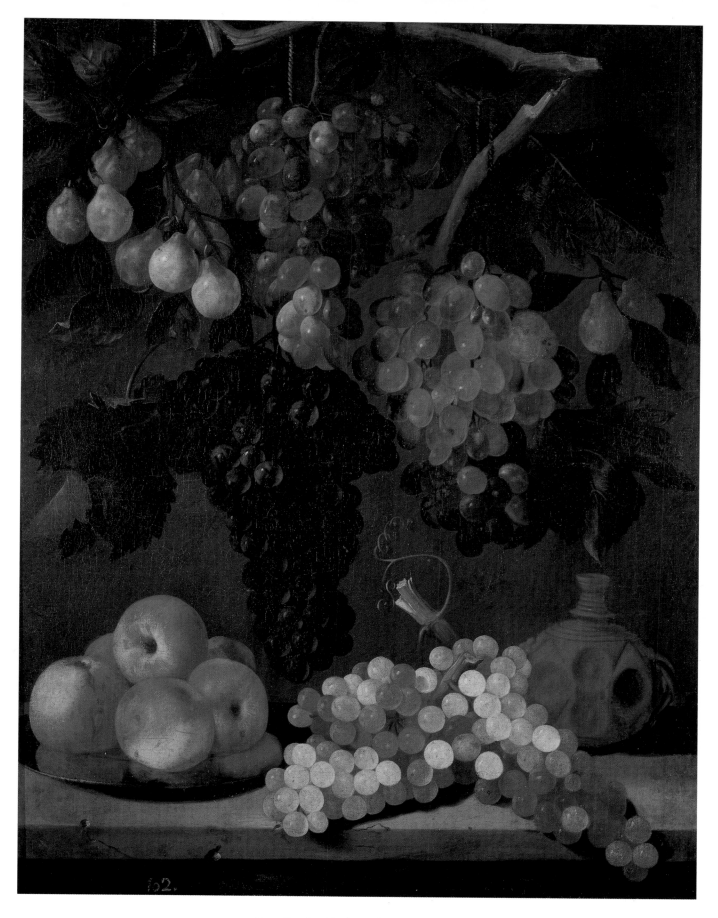

70. **Juan Bautista Espinosa** (. . . 1624 – 1651 . . .)
Apples, Plums, Grapes, and Pears [no. 702]
Oil on canvas, 29 ⅞ × 23 ¼″ (76 × 59 cm)

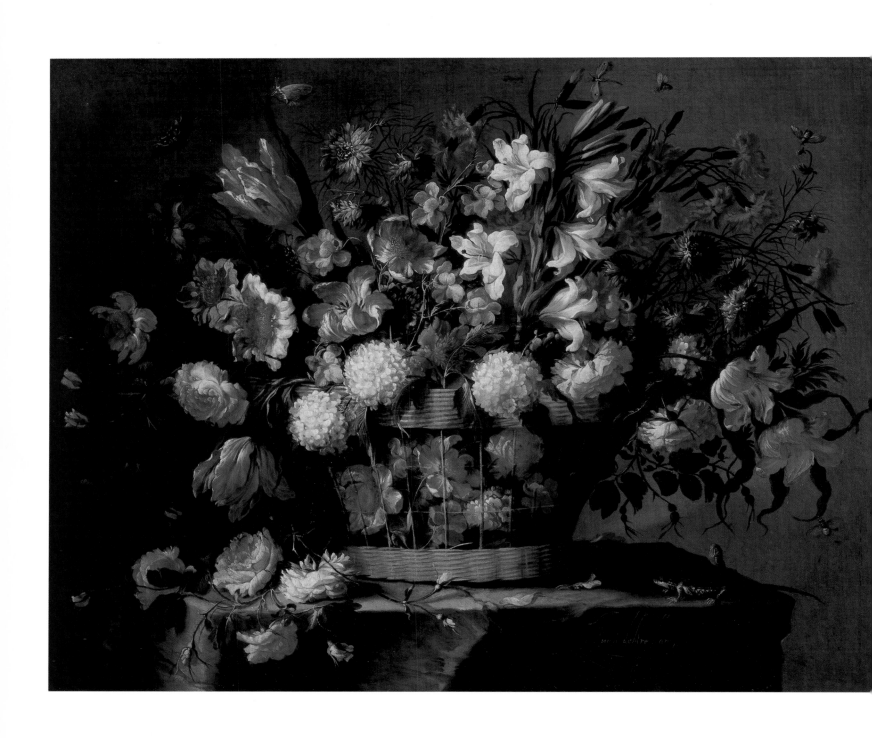

71. **Juan de Arellano** (1614–1676)
The Flower Vase [no. 3138]
Oil on canvas, 33 ⅛ × 41 ⅜″ (84 × 105 cm)

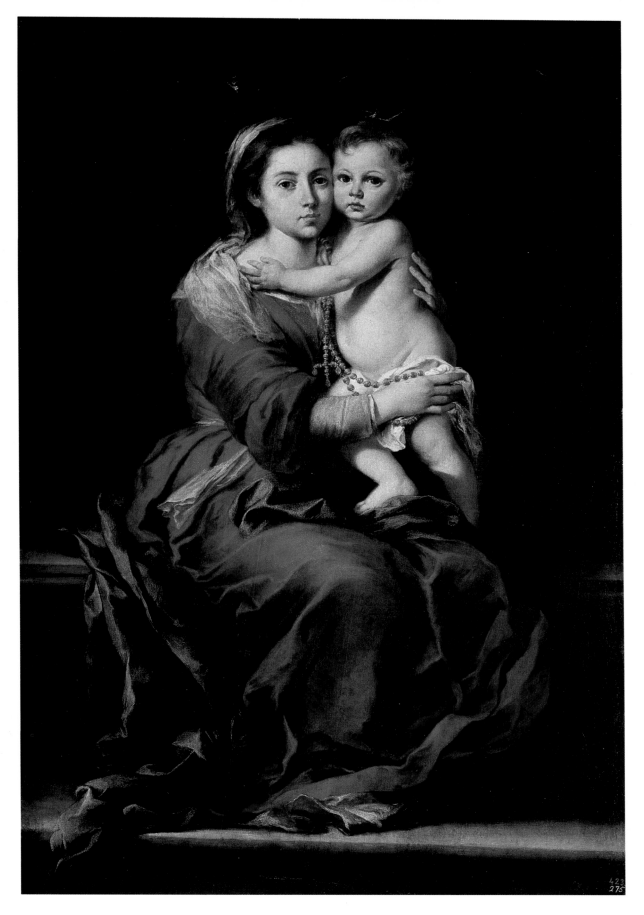

72. **Bartolomé Esteban Murillo** (1618–1682)
The Virgin of the Rosary [no. 975]
Oil on canvas, 64 ⅝ × 43 ¼″ (164 × 110 cm)

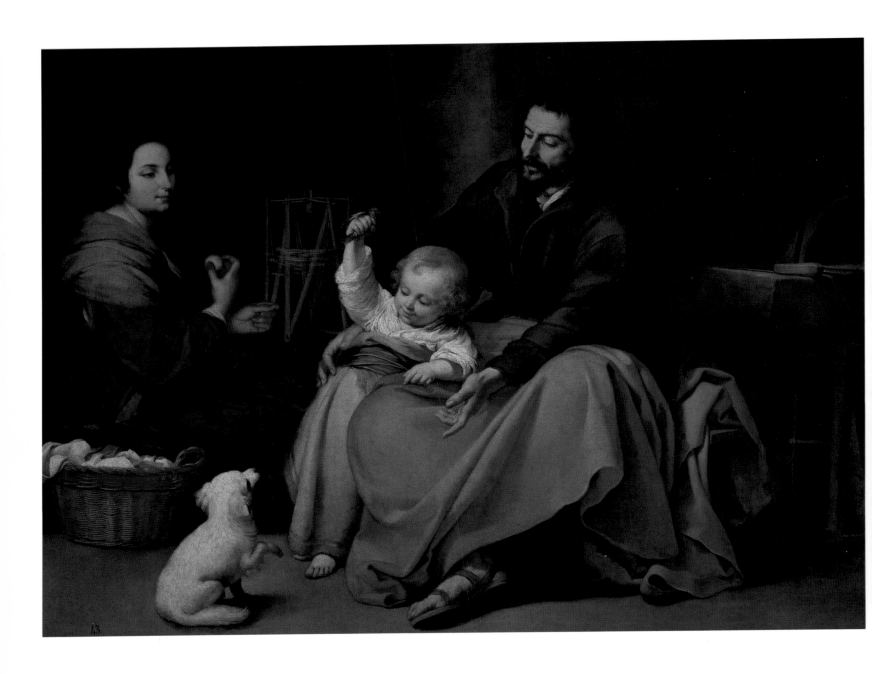

73. **Bartolomé Esteban Murillo** (1618–1682)
The Holy Family with Little Bird [no. 960]
Oil on canvas, 56 ¾ × 74" (144 × 188 cm)

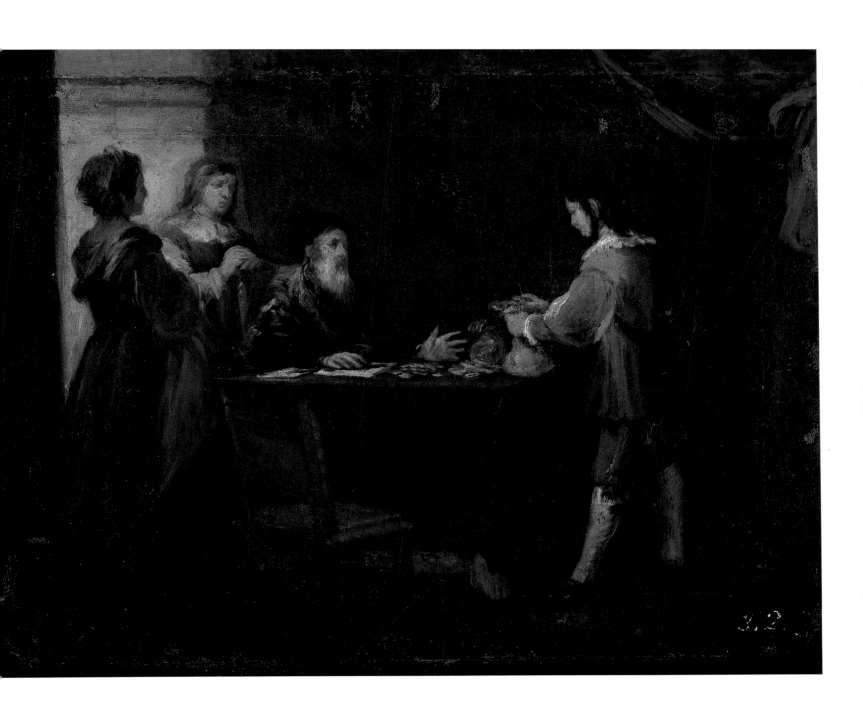

74. **Bartolomé Esteban Murillo** (1618–1682)
The Prodigal Son Receives His Rightful Inheritance [no. 997]
Oil on canvas, 10 ⅝ × 13 ⅜″ (27 × 34 cm)

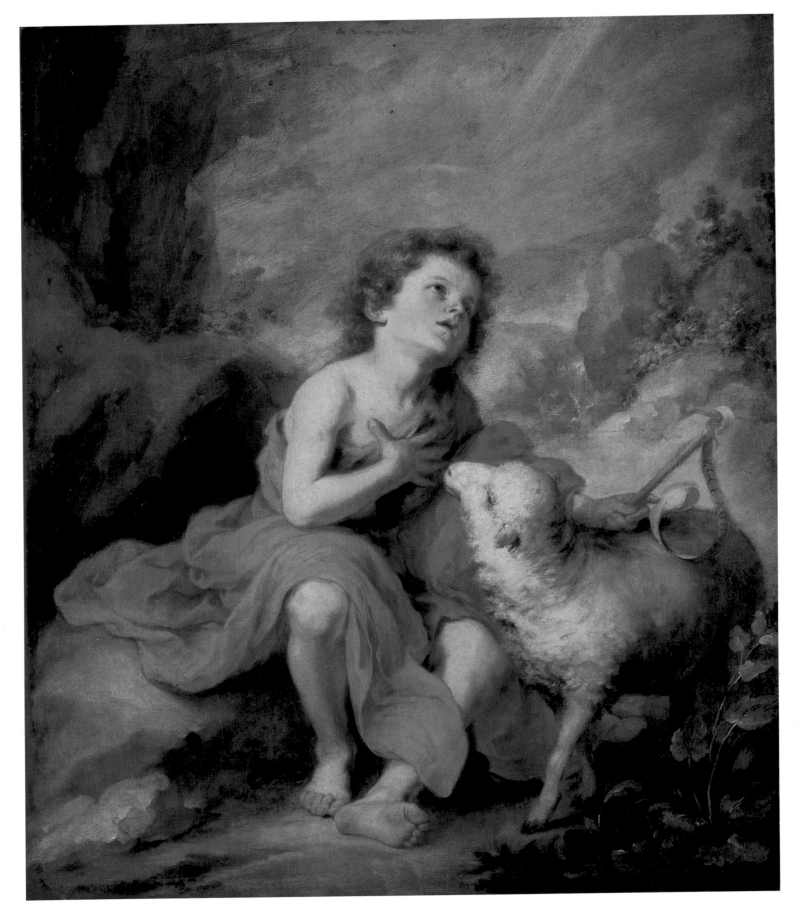

75. **Bartolomé Esteban Murillo** (1618–1682)
Saint John the Baptist as a Boy [no. 963]
Oil on canvas, 47 5/8 × 39″ (121 × 99 cm)

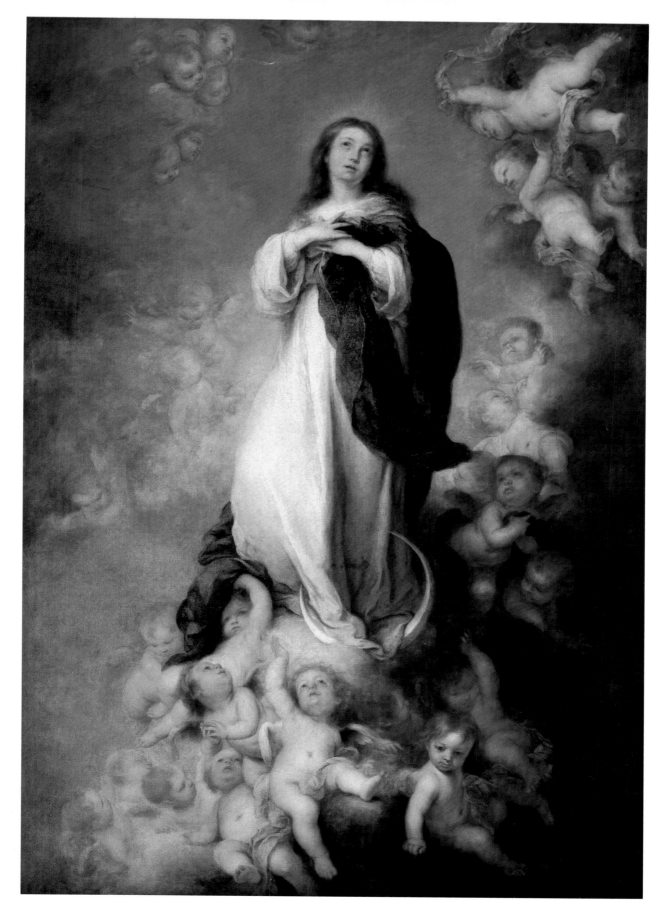

76. **Bartolomé Esteban Murillo** (1618–1682)
The Immaculate Virgin ''of Soult.'' c. 1678 [no. 2809]
Oil on canvas, 107 ⅞ × 74 ¾" (274 × 190 cm)

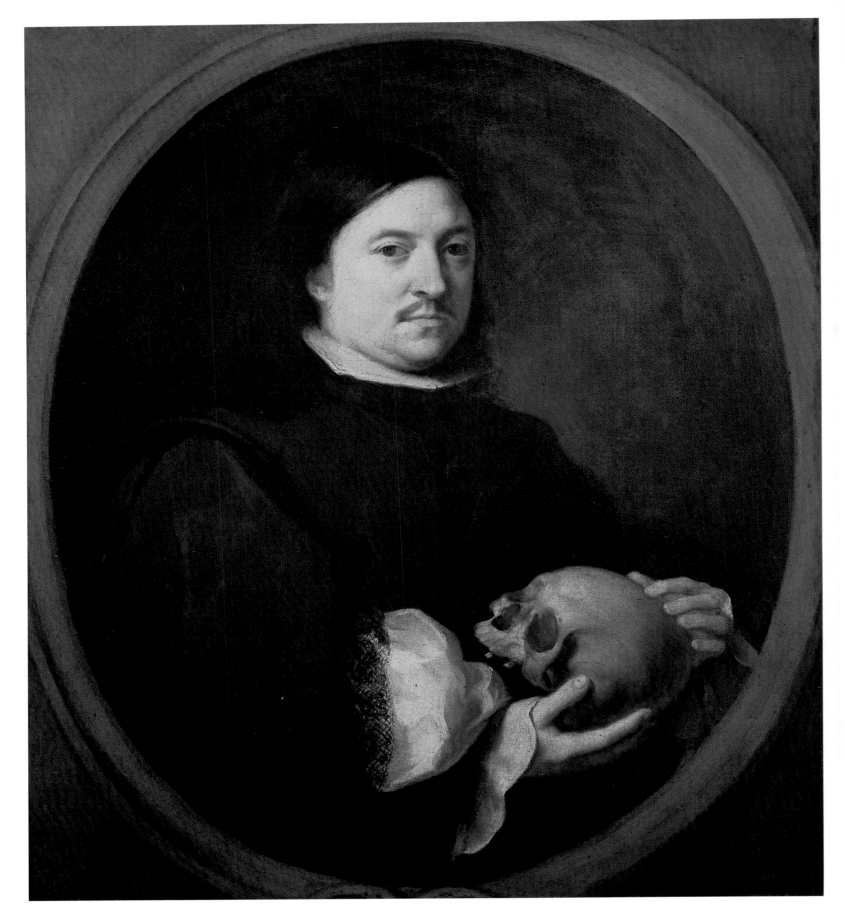

77. **Bartolomé Esteban Murillo** (1618–1682)
Nicolás Omazur [no. 3060]
Oil on canvas, 32 ⁵⁄₈ × 28 ³⁄₄″ (83 × 73 cm)

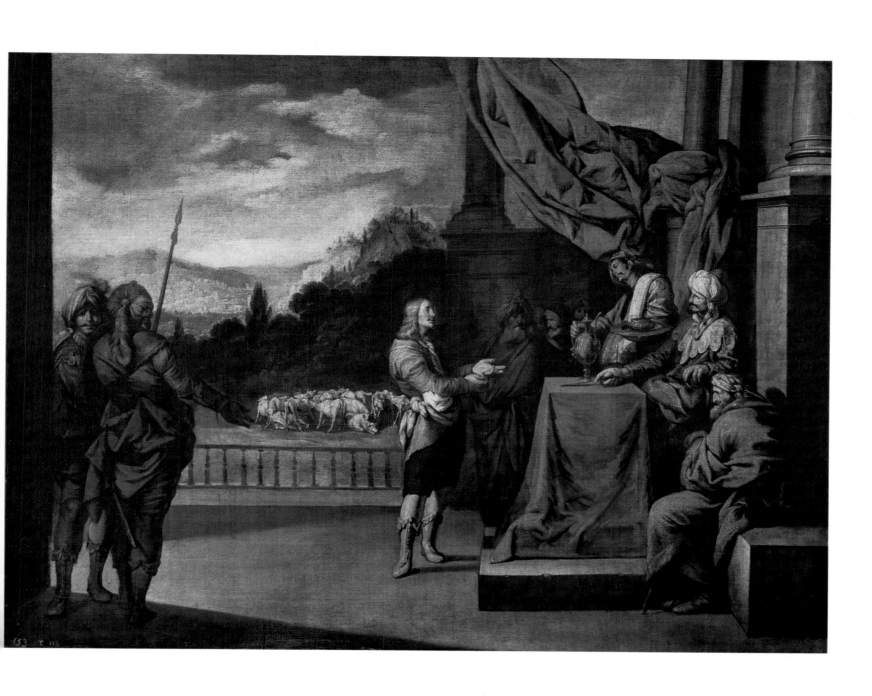

78. **Antonio del Castillo Saavedra** (1616–1668)
Joseph Explains the Dreams of the Pharaoh [no. 954]
Oil on canvas, 42 7/8 × 57 1/8″ (109 × 145 cm)

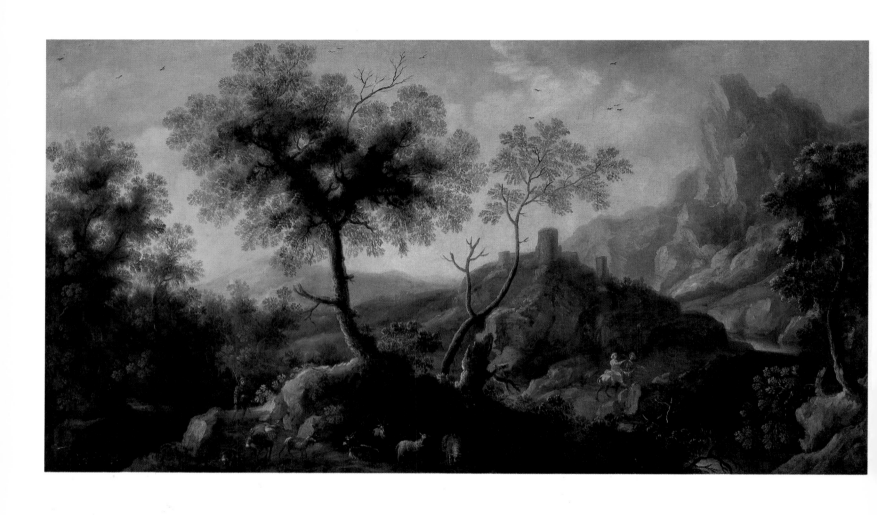

79. **Ignacio de Iriarte** (1621–1685)
Landscape with Shepherds. 1665 [no. 2970]
Oil on canvas, 41 ³⁄₄ × 76 ³⁄₈″ (106 × 194 cm)

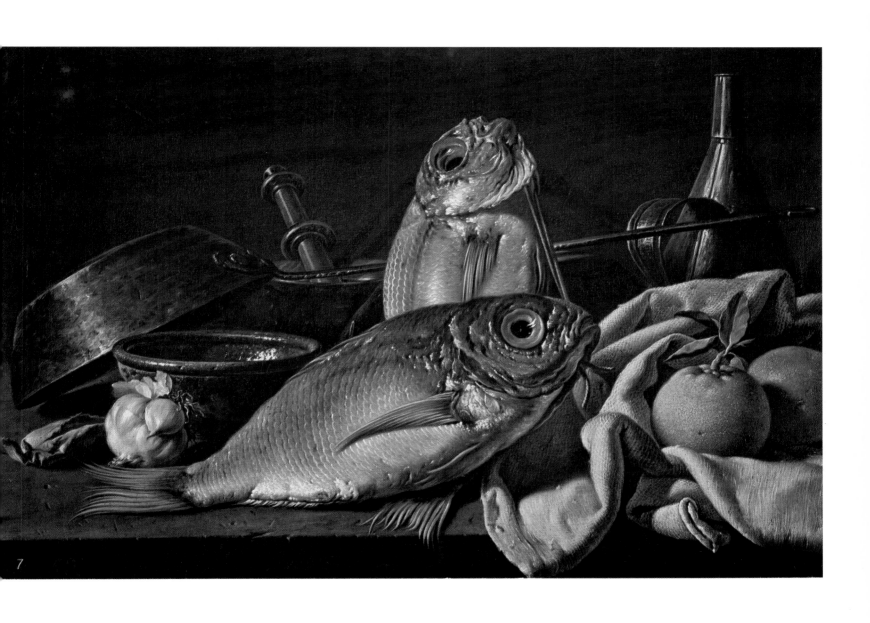

80. **Luis Eugenio Meléndez** (1716–1780)
Still Life (Sea Bream and Oranges). 1772 [no. 903]
Oil on canvas, 16 ½ × 24 ³/₈″ (42 × 62 cm)

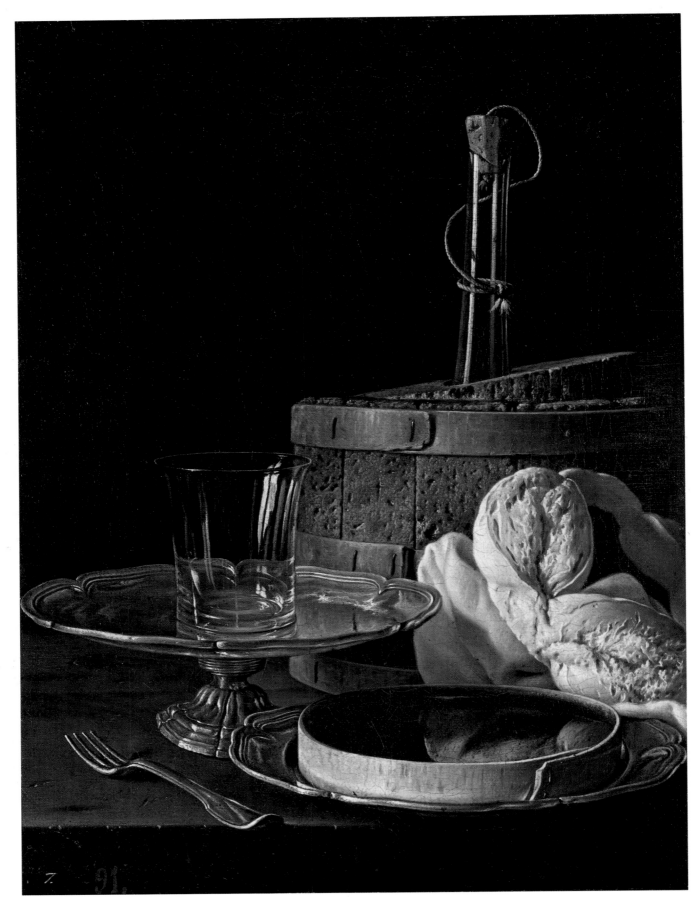

81. **Luis Eugenio Meléndez** (1716–1780)
Still Life (Box of Sweets, Pastry, and Other Objects). 1770 [no. 906]
Oil on canvas, 19 ¼ × 14 ⅝″ (49 × 37 cm)

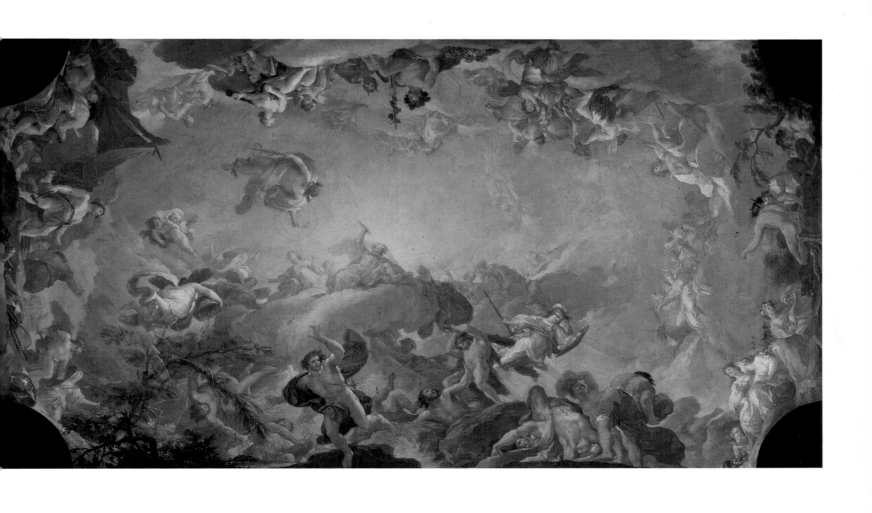

82. **Francisco Bayeu y Subías** (1734–1795)
Olympus: Battle with the Giants. 1764 [no. 604]
Oil on canvas, 26 3/4 × 48 3/8″ (68 × 123 cm)

83. Francisco Bayeu y Subías (1734–1795)
Painting with Thirteen Sketches for Tapestry Cartoons [no. 2599]
Oil on canvas, 17 3/4 × 37 3/4″ (45 × 96 cm)

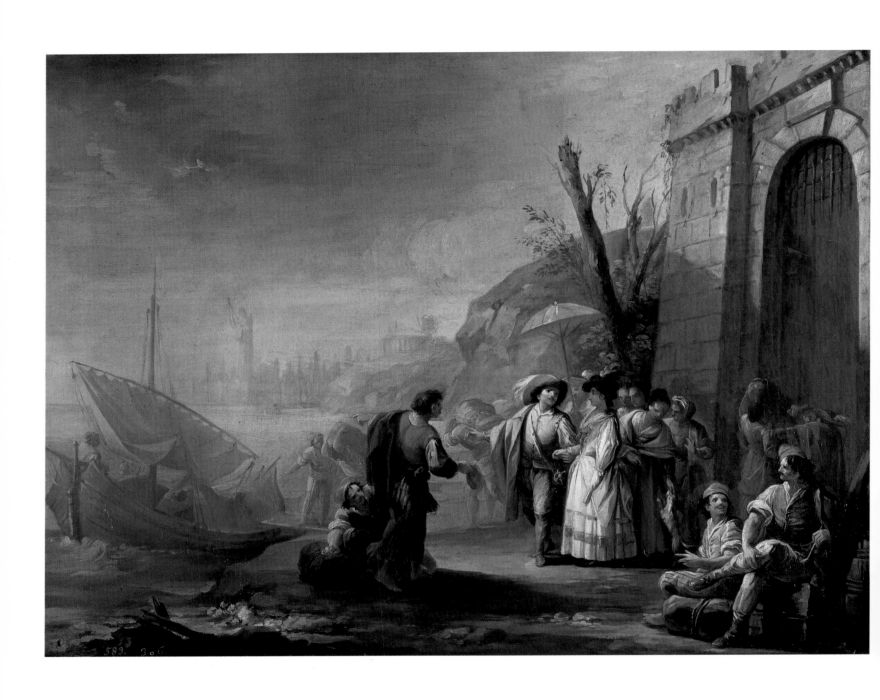

84. **Mariano Salvador Maella** (1739–1819)
Seascape [no. 874]
Oil on canvas, 22 × 29 1/8″ (56 × 74 cm)

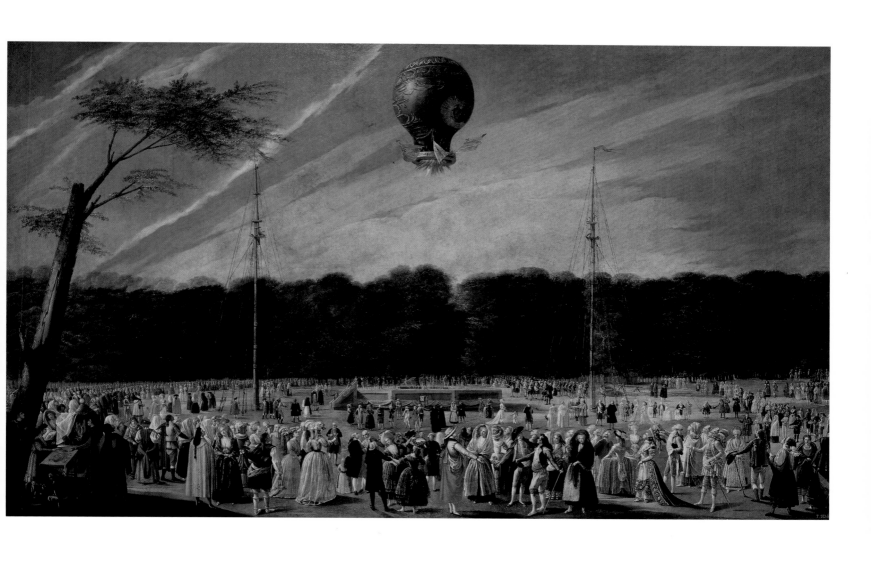

87. **Antonio Carnicero** (1748–1814)
The Ascent of Monsieur Bouclé's Montgolfier Balloon in the Gardens of Aranjuez,
Madrid, June 5, 1784 [no. 641]
Oil on canvas, 66⅞ × 111¾″ (170 × 284 cm)

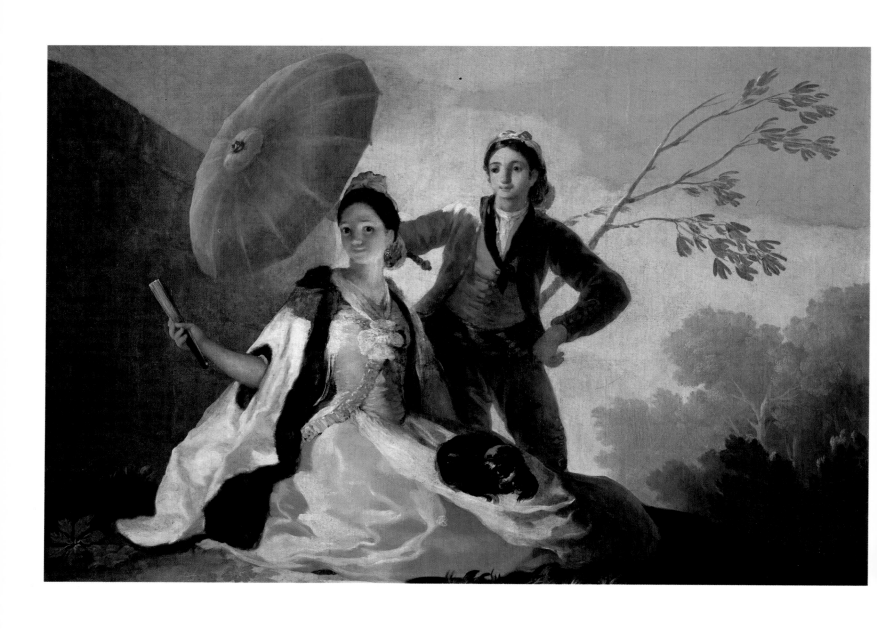

88. **Francisco Goya y Lucientes** (1746–1828)
The Parasol. 1777 [no. 773]
Oil on canvas, 41 × 59 ⅞″ (104 × 152 cm)

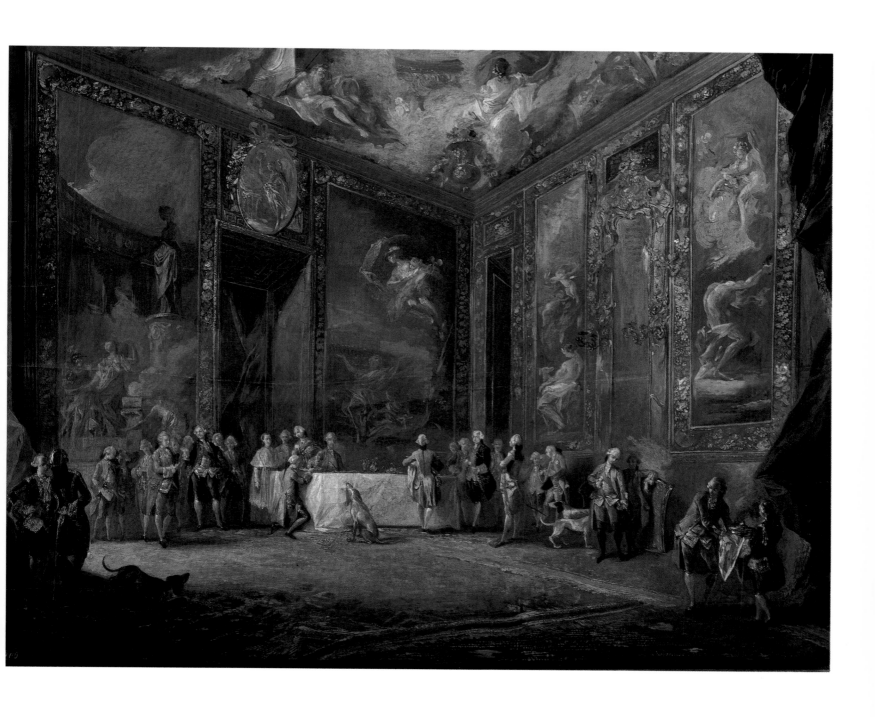

85. **Luis Paret y Alcázar** (1746–1799)
Charles III Eating before His Court [no. 2422]
Oil on board, 19⅝ × 25¼″ (50 × 64 cm)

225

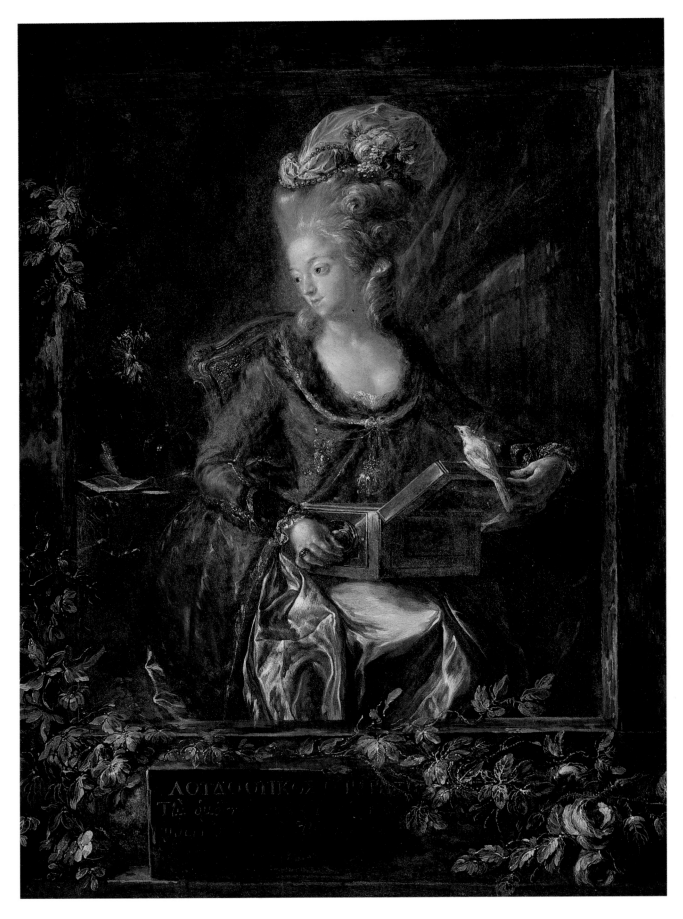

86. **Luis Paret y Alcázar** (1746–1799)
María de las Nieves Michaela Fourdinier [no. 3250]
Oil on copper, 14 5/8 × 11″ (37 × 28 cm)

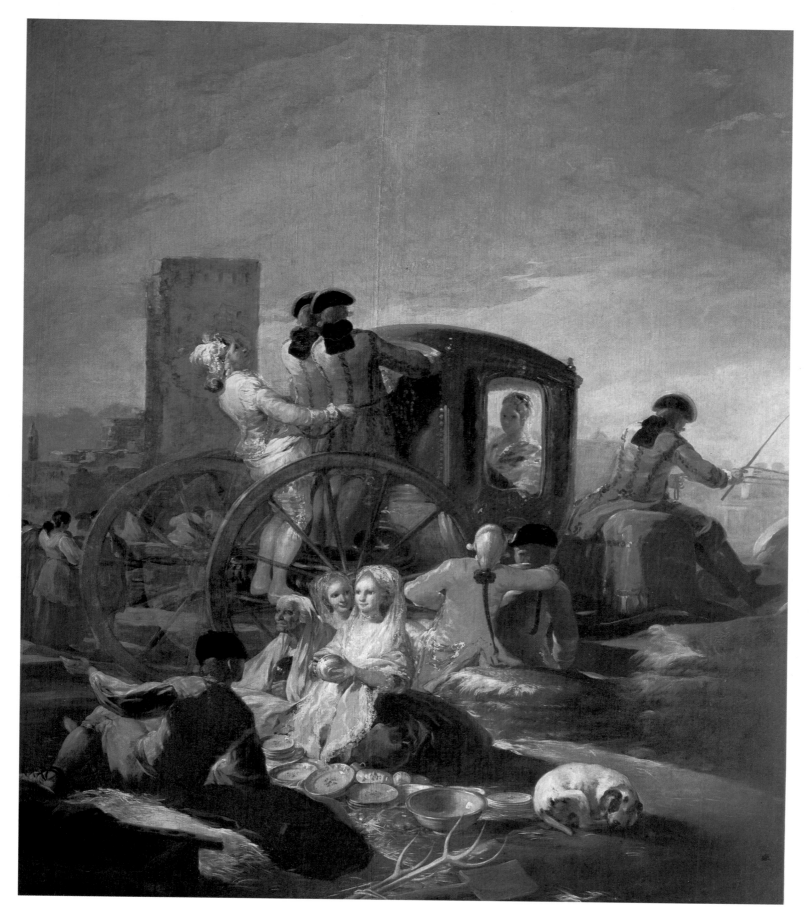

89. **Francisco Goya y Lucientes** (1746–1828)
The Crockery Seller. 1778 [no. 780]
Oil on canvas, 102 × 86 ⅝″ (259 × 220 cm)

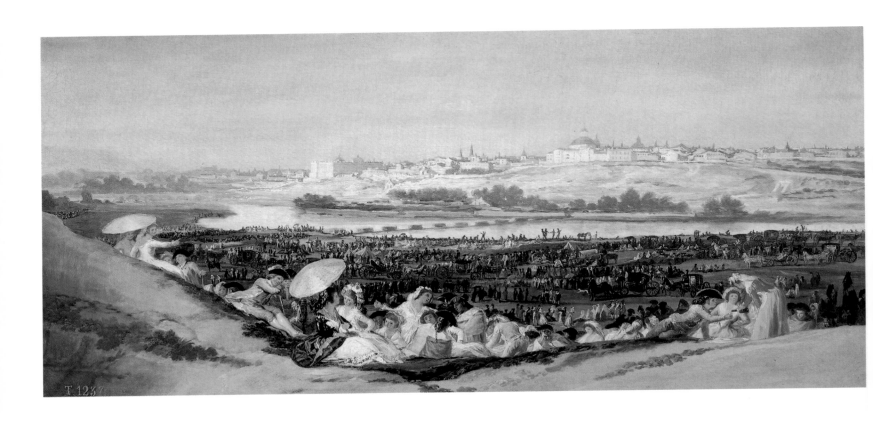

90 & 91. Francisco Goya y Lucientes (1746–1828)
The Meadow of Saint Isidore. 1788 [no. 750]
Oil on canvas, 16 ½ × 35 ⅜″ (42 × 90 cm)

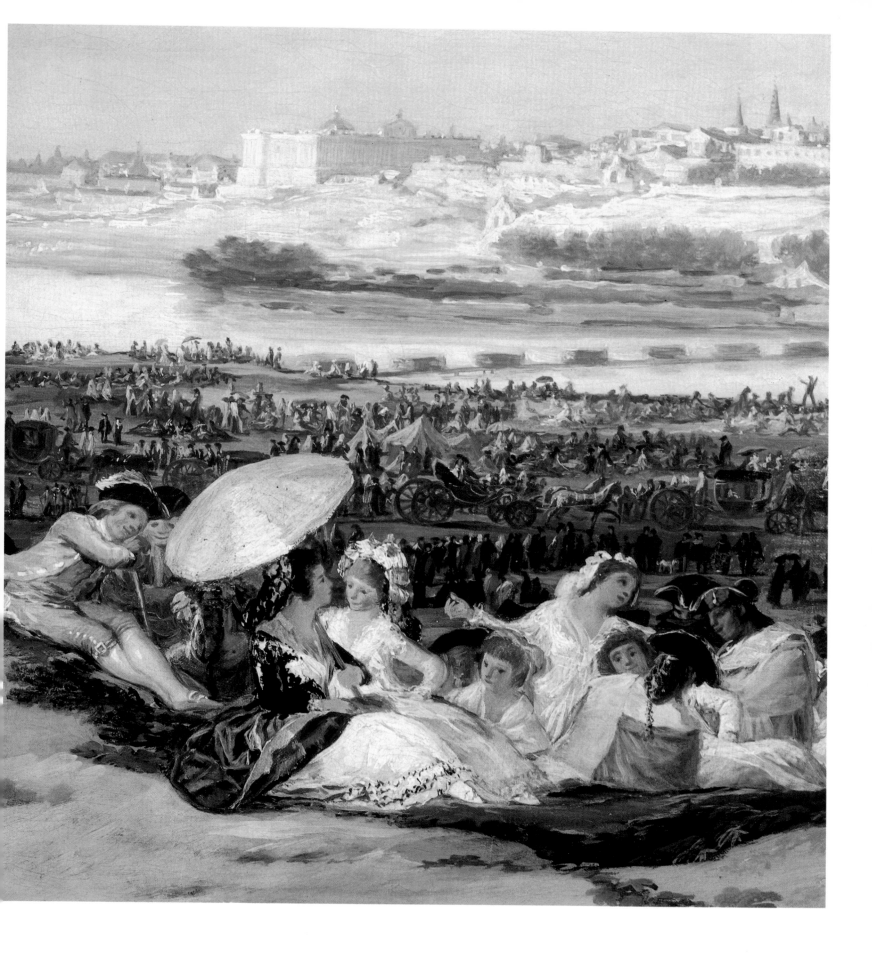

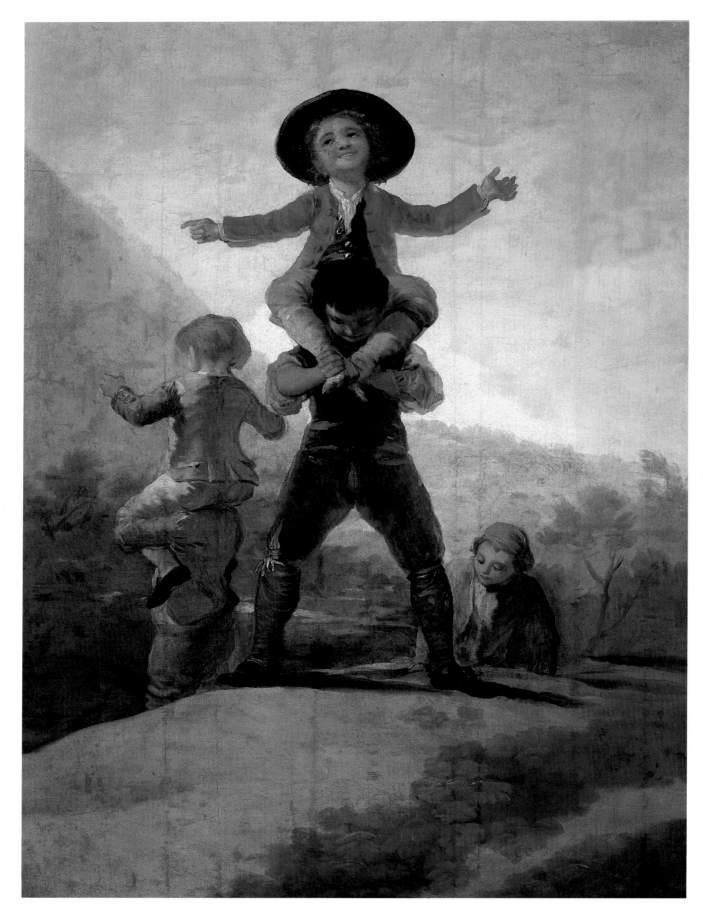

92. **Francisco Goya y Lucientes** (1746–1828)
Playing at Giants. 1791–92 [no. 800a]
Oil on canvas, 53 7/8 × 41″ (137 × 104 cm)

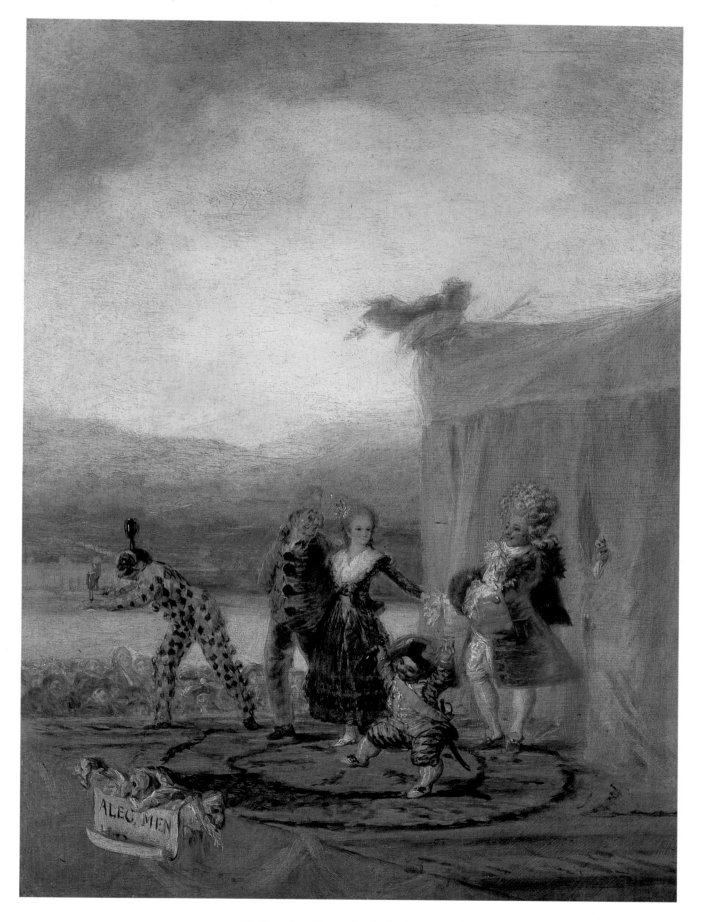

93. **Francisco Goya y Lucientes** (1746–1828)
The Strolling Players [no. 3045]
Oil on tin plate, 16 7/8 × 12 5/8″ (43 × 32 cm)

233

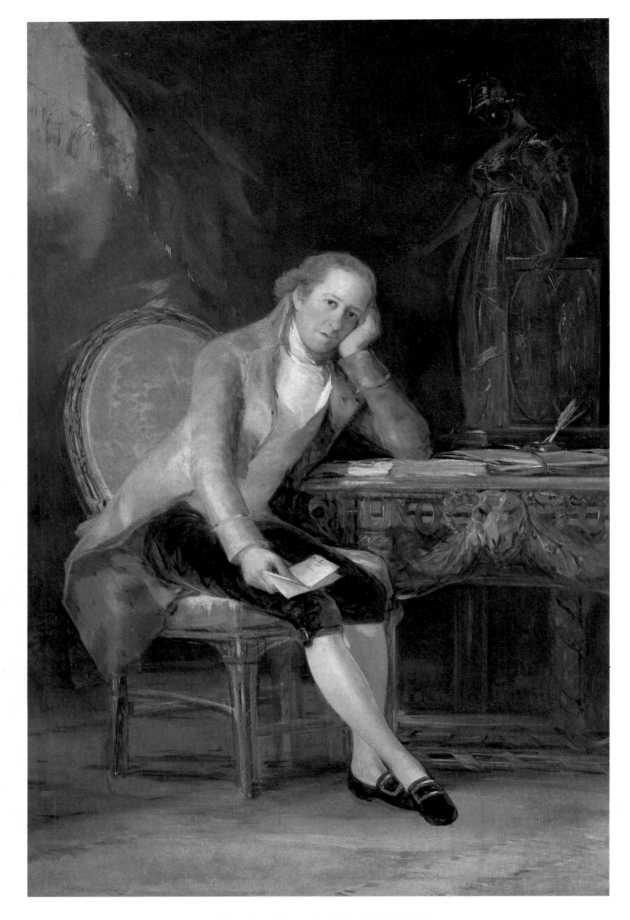

94. Francisco Goya y Lucientes (1746–1828)
Don Gaspar Melchor de Jovellanos. 1797 [no. 3236]
Oil on canvas, 80¾ × 48⅜" (205 × 123 cm)

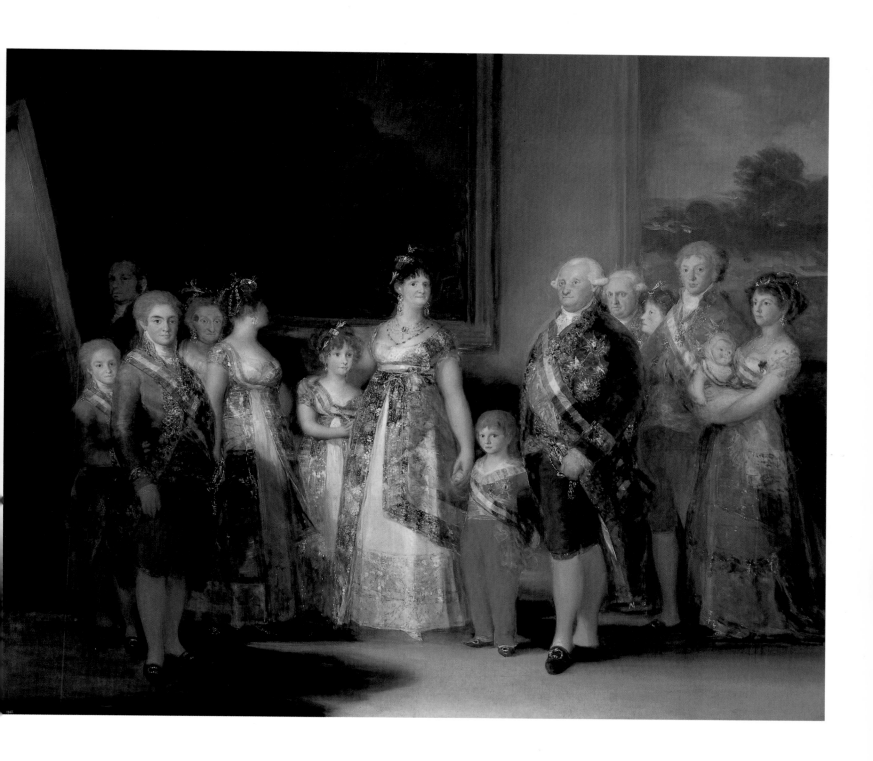

95. **Francisco Goya y Lucientes** (1746–1828)
The Family of Charles IV. 1800 [no. 726]
Oil on canvas, 110 ¼ × 132 ¼″ (280 × 336 cm)

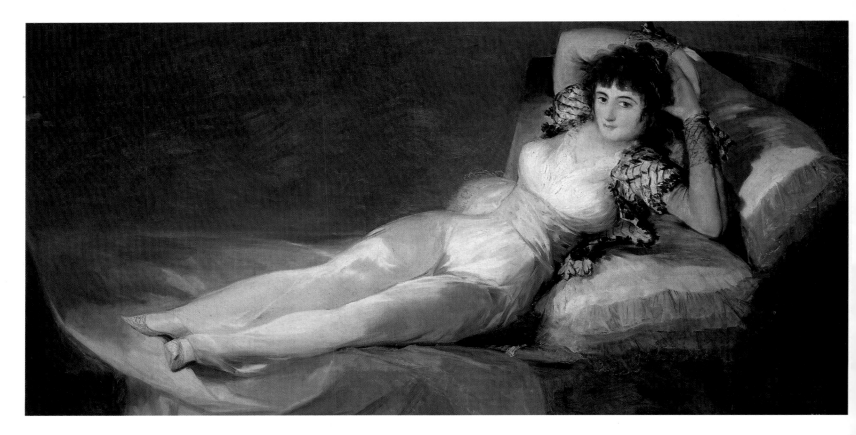

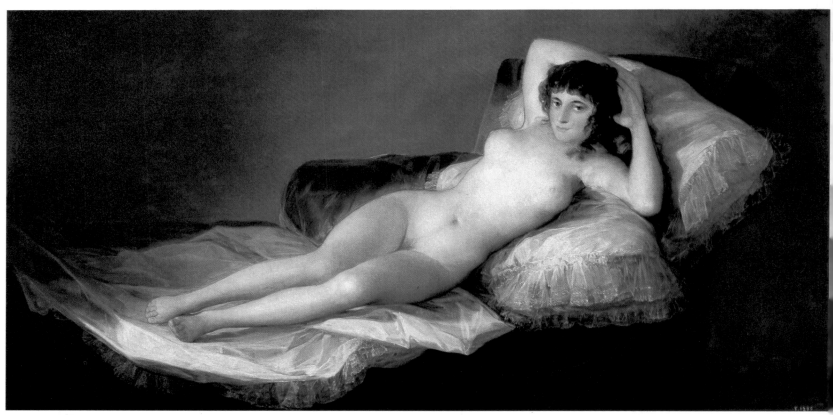

96. **Francisco Goya y Lucientes** (1746–1828)
The Maja Clothed. c. 1800 [no. 741]
Oil on canvas, 37 3/8 × 74″ (95 × 188 cm)

97. **Francisco Goya y Lucientes** (1746–1828)
The Maja Nude. c. 1800 [no. 742]
Oil on canvas, 38 5/8 × 75 1/4″ (98 × 191 cm)

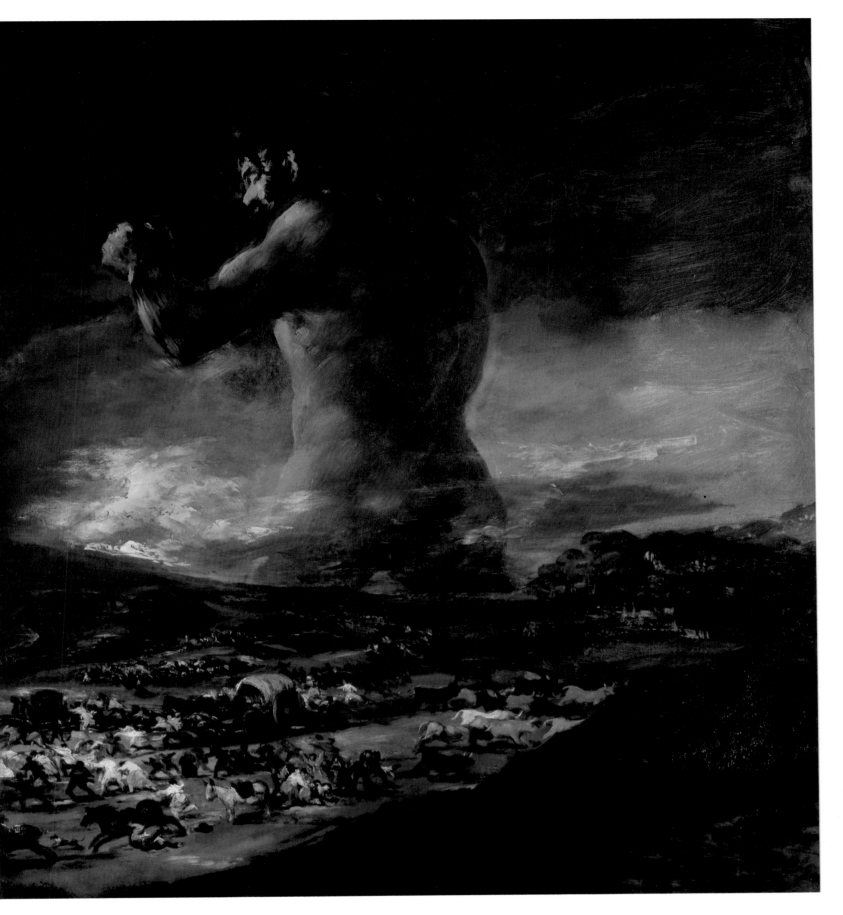

98. **Francisco Goya y Lucientes** (1746–1828)
The Colossus or *The Giant*. c. 1808 [no. 2785]
Oil on canvas, 45⅝ × 41⅜″ (116 × 105 cm)

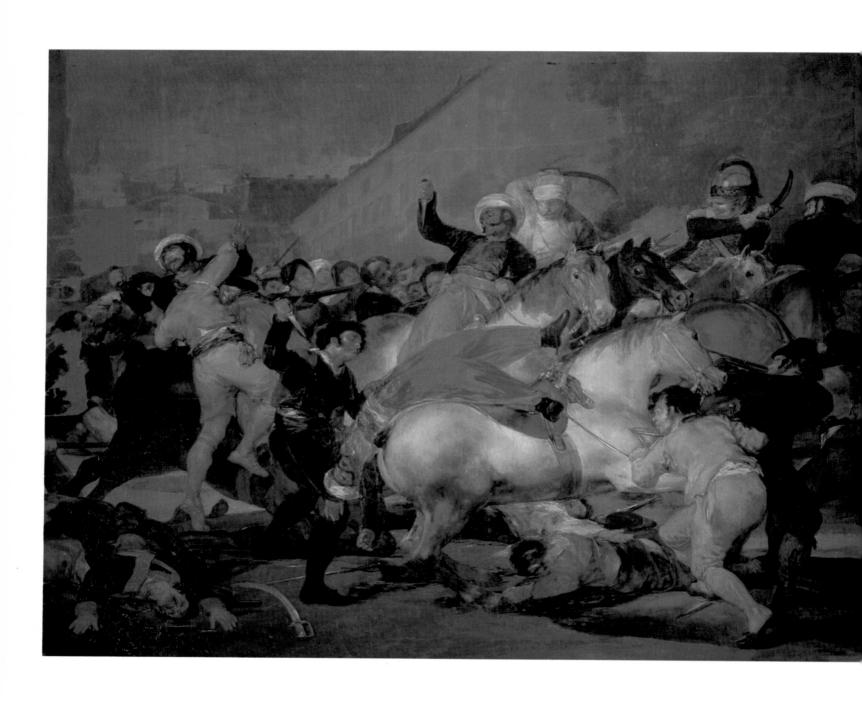

99. **Francisco Goya y Lucientes** (1746–1828)
The Second of May, 1808, at Madrid: The Fight Against the Mamelukes. 1814 [no. 748]
Oil on canvas, 104 ³/₄ × 135 ⁷/₈″ (266 × 345 cm)

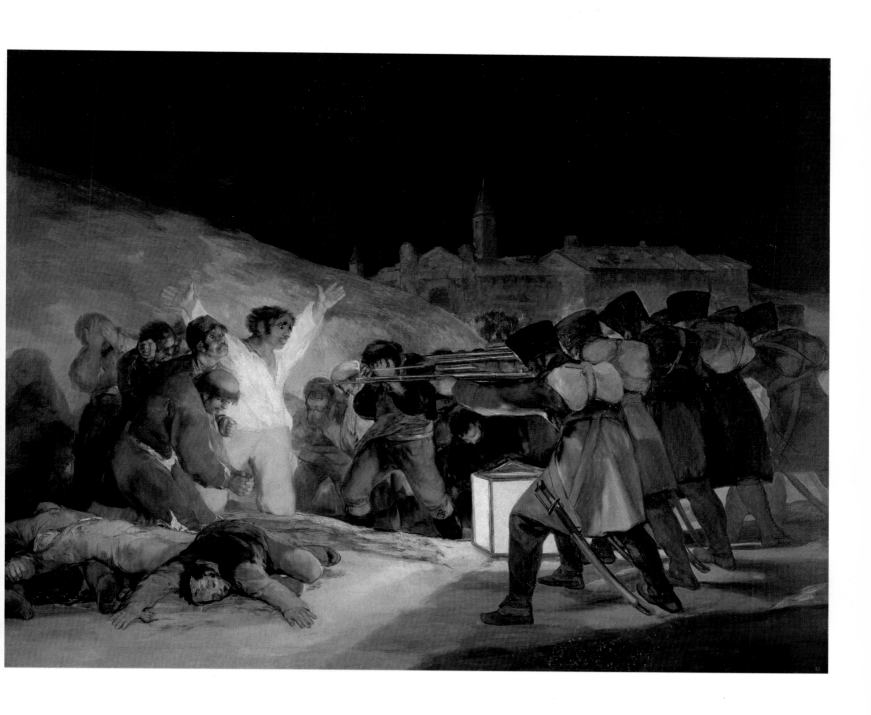

100. **Francisco Goya y Lucientes** (1746–1828)
The Third of May, 1808, at Madrid: The Shootings on Príncipe Pío Mountain. 1814 [no. 749]
Oil on canvas, 104 ¾ × 135 ⅞″ (266 × 345 cm)

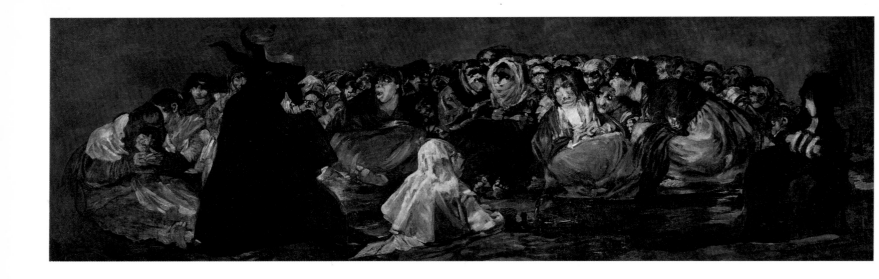

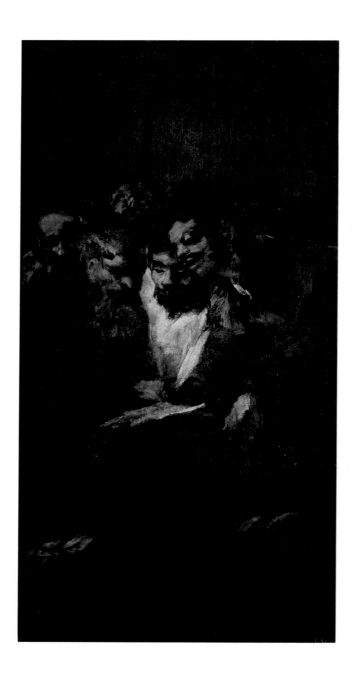

101. **Francisco Goya y Lucientes** (1746–1828)
The Witches' Sabbath or *The Great Goat*. 1819–23 [no. 761]
Mural painting, transposed to canvas, 55 1/8 × 172 1/2″ (140 × 438 cm)

102. **Francisco Goya y Lucientes** (1746–1828)
The Reading or *The Politicians*. 1819–23 [no. 766]
Mural painting, transposed to canvas, 49 5/8 × 26″ (126 × 66 cm)

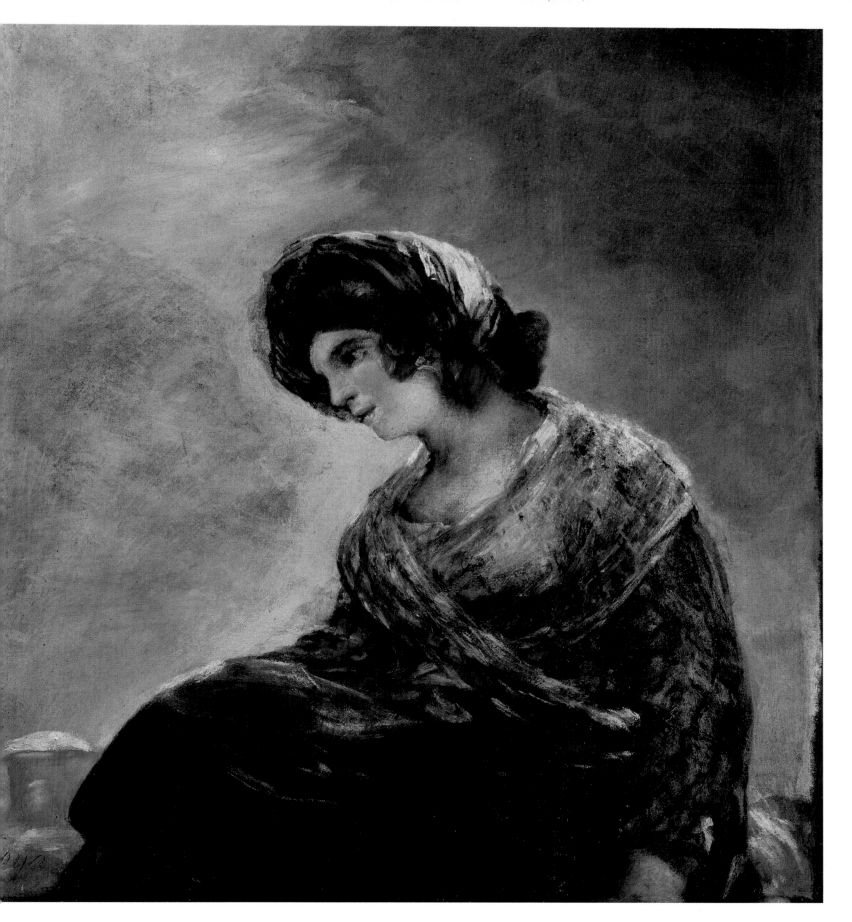

103. **Francisco Goya y Lucientes** (1746–1828)
The Milkmaid of Bordeaux. c. 1824 [no. 2899]
Oil on canvas, 29 1/8 × 26 3/4″ (74 × 68 cm)

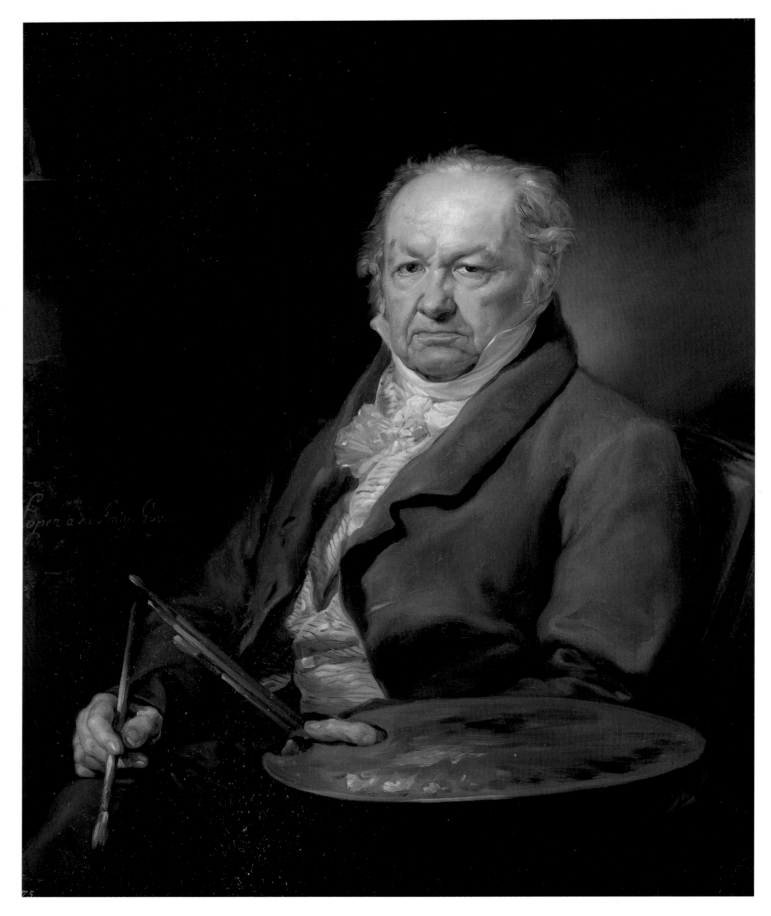

104. **Vicente López Portaña** (1772–1850)
The Painter Francisco Goya. 1826 [no. 864]
Oil on canvas, 36 5/8 × 29 1/2″ (93 × 75 cm)

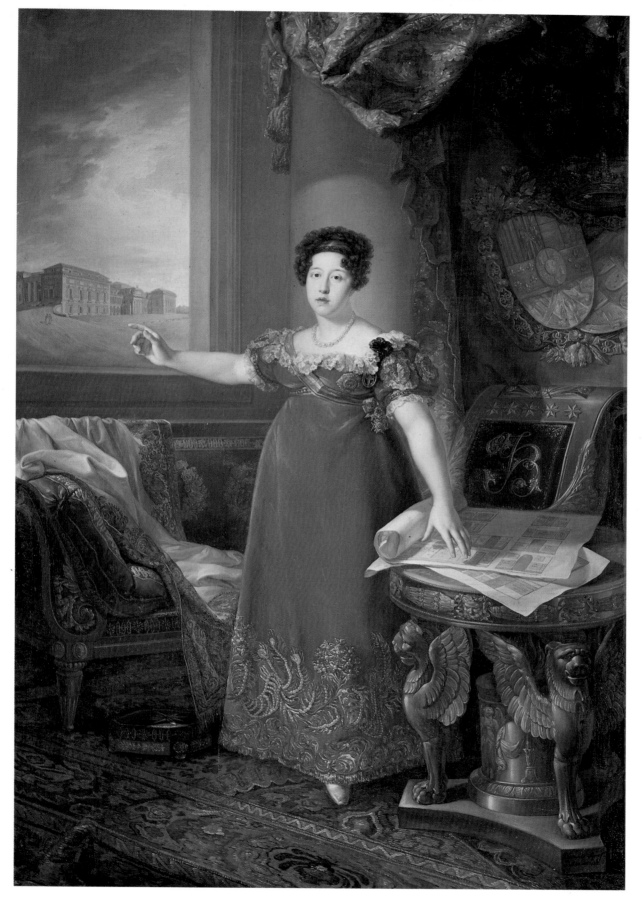

105. **Bernardo López Piquer** (1801–1874)
Queen María Isabel de Braganza. 1829 [no. 863]
Oil on canvas, 100 × 67 ¾″ (254 × 172 cm)

106. **Antonio María Esquivel y Suárez de Urbina** (1806–1857)
Meeting of Poets in Antonio María Esquivel's Studio. 1846 [no. 4299]
Oil on canvas, 56¾ × 84¼″ (144 × 214 cm)

107. **Manuel Castellano** (1826–1880)
The Horse Corral in the Old Madrid Bullring, Before a Fight. 1853 [no. 4272]
Oil on canvas, 66 ⅛ × 96 ½″ (168 × 245 cm)

108. Federico de Madrazo y Kuntz (1815–1894)
Amalia de Llano y Dotres, Countess of Vilches [no. 2878]
Oil on canvas, 49 ⅝ × 35″ (126 × 89 cm)

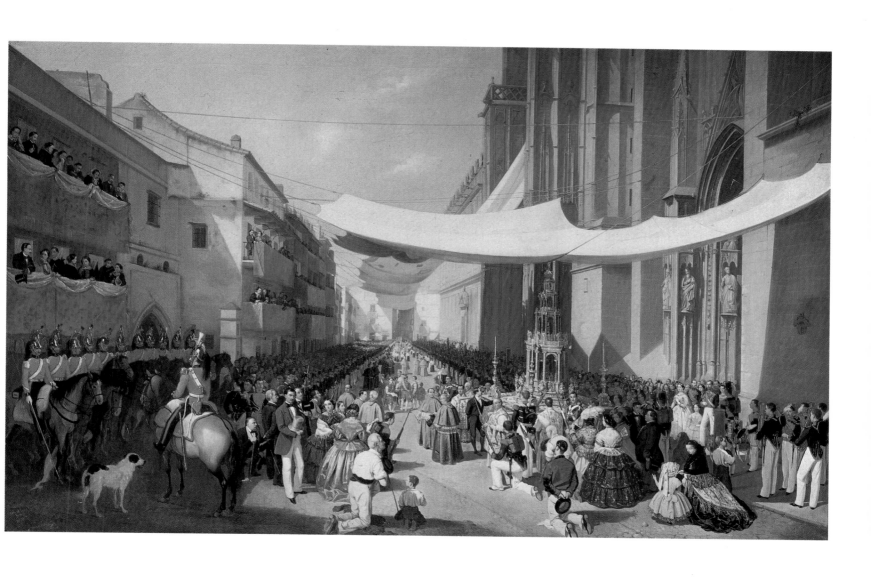

109. **Manuel Cabral (Bejarano) y Aguado** (1827–1891)
The Corpus Christi Procession in Seville. 1857 [no. 4259]
Oil on canvas, 59 7/8 × 95 5/8″ (152 × 243 cm)

110. **Carlos de Haes** (1826–1898)
The Picos de Europa (The Mancorbo Channel). 1876 [no. 4390]
Oil on canvas, 66 ⅛ × 48 ⅜″ (168 × 123 cm)

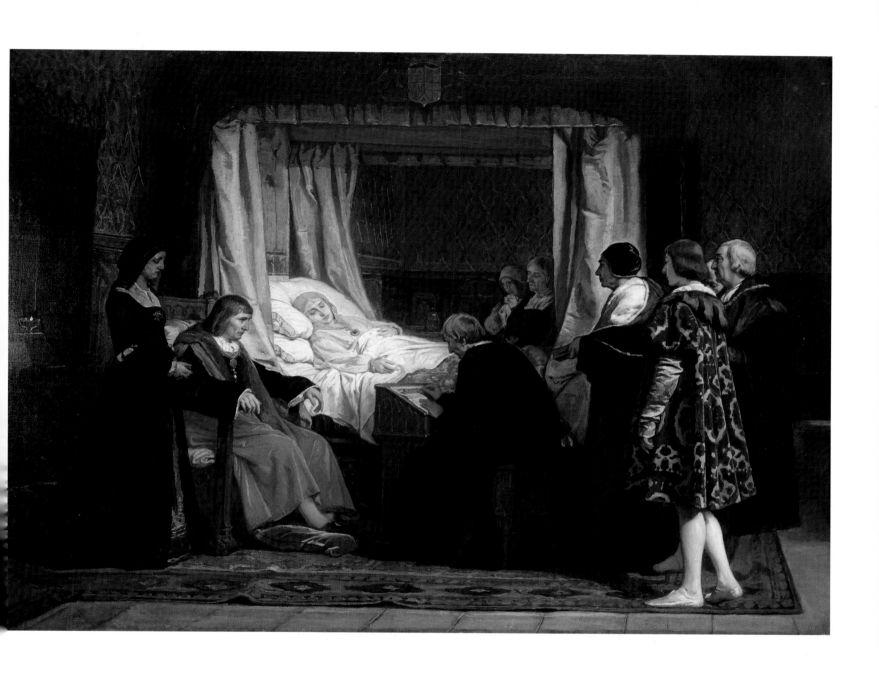

111. **Eduardo Rosales Gallina** (1836–1873)
The Testament of Isabella the Catholic. 1864 [no. 4625]
Oil on canvas, 9′ 5 ⅛ × 13′ 1 ⅜″ (290 × 400 cm)

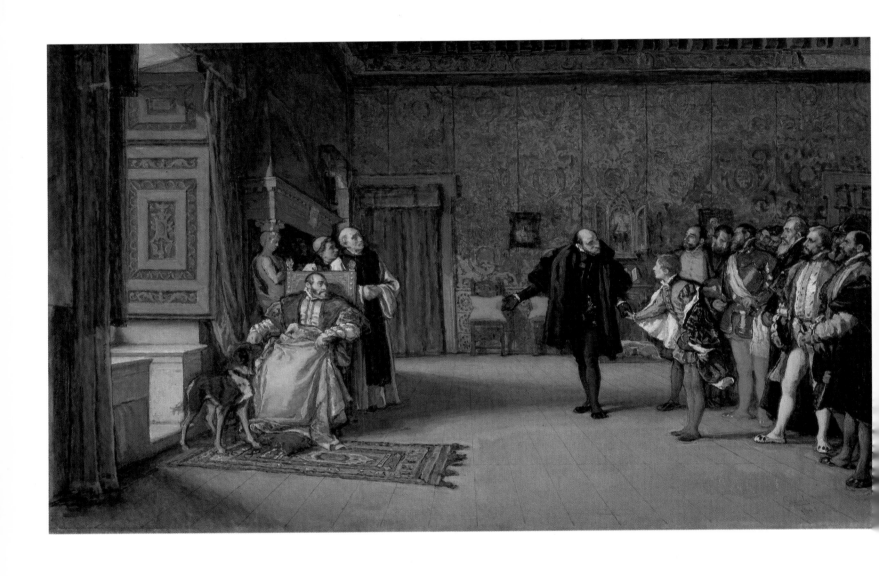

112. **Eduardo Rosales Gallina** (1836–1873)
The Presentation of Don John of Austria to Charles V. 1869 [no. 4610]
Oil on canvas, 29⅞ × 48⅜″ (76 × 123 cm)

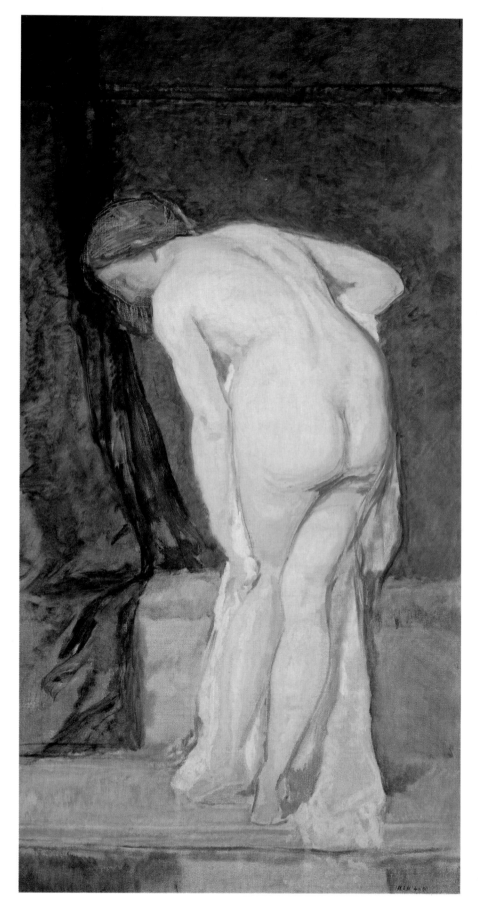

113. **Eduardo Rosales Gallina** (1836–1873)
Female Nude or *Getting out of the Bath* [no. 4616]
Oil on canvas, 72 ⅞ × 35 ⅜″ (185 × 90 cm)

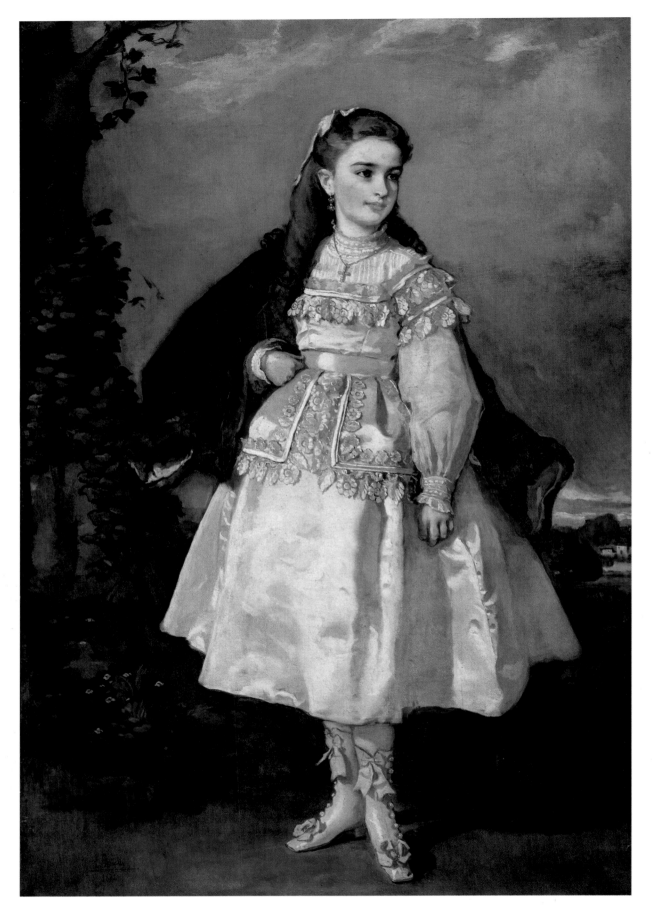

114. **Eduardo Rosales Gallina** (1836–1873)
Conchita Serrano y Domínguez, Countess of Santovenia. 1871 [no. 6711]
Oil on canvas, 64 ⅛ × 41 ¾″ (163 × 106 cm)

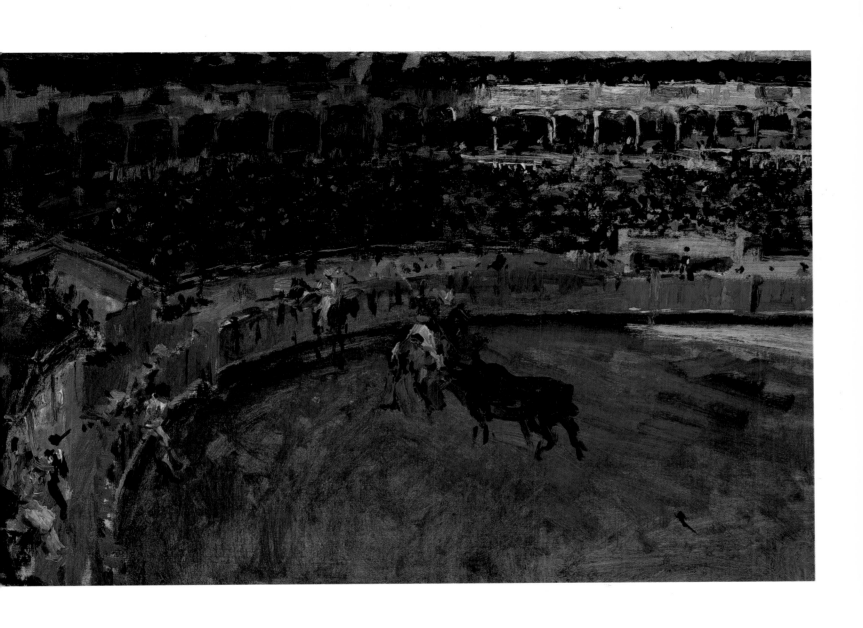

115. **Mariano Fortuny i Marsal** (1838–1874)
Bullfight [no. 4328]
Oil on canvas, 11 ³/₄ × 18 ⅛″ (30 × 46 cm)

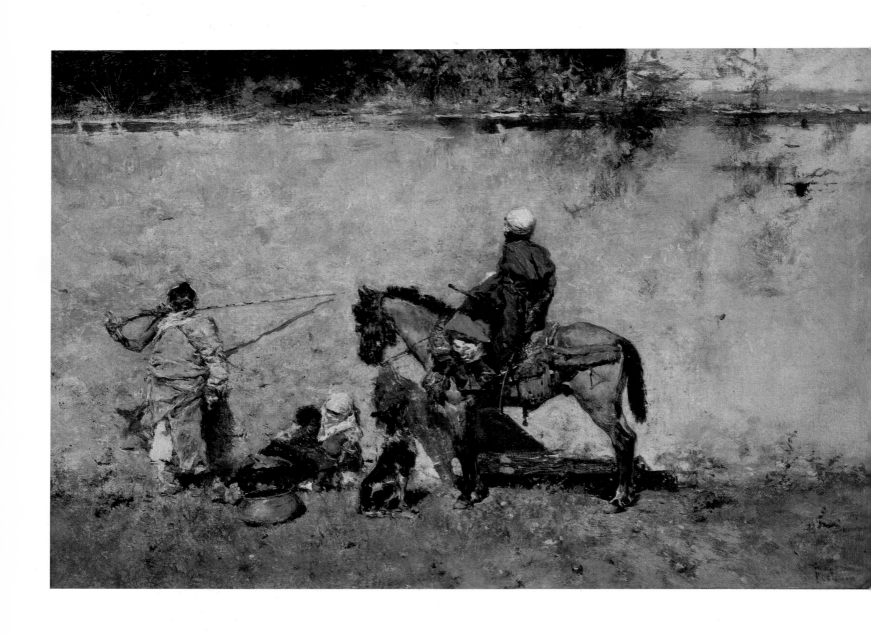

116. **Mariano Fortuny i Marsal** (1838–1874)
Moroccans [no. 2607]
Oil on board, 5 ⅛ × 7 ½″ (13 × 19 cm)

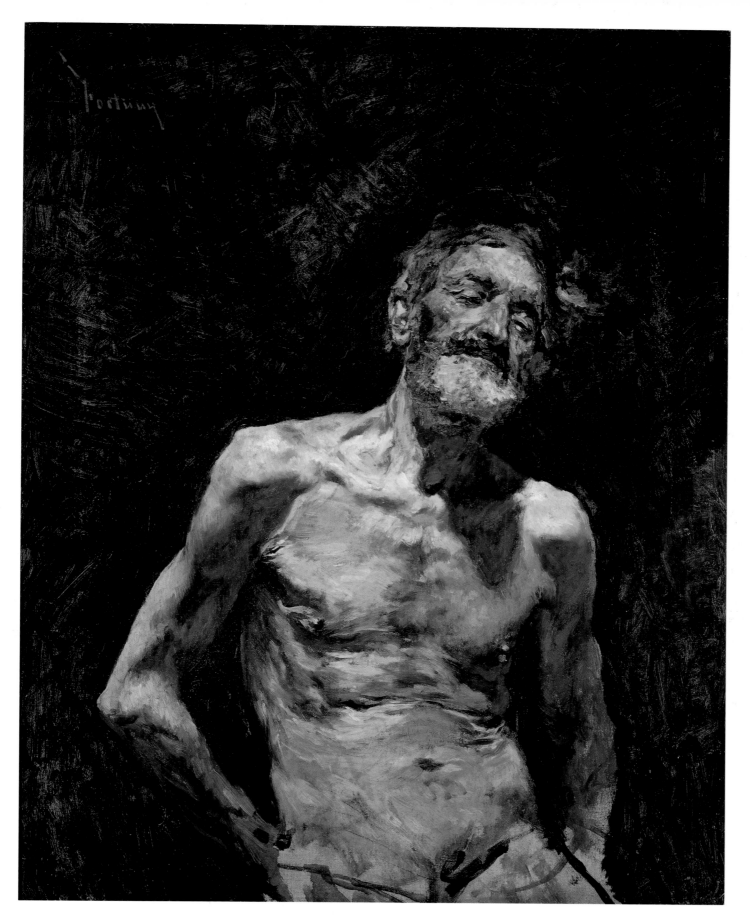

117. **Mariano Fortuny i Marsal** (1838–1874)
Old Man Naked in the Sun [no. 2612]
Oil on canvas, 29 1/8 × 22 7/8″ (74 × 58 cm)

118. **Mariano Fortuny i Marsal** (1838–1874)
The Painter's Children in the Japanese Salon [no. 2931]
Oil on canvas, 17 3/8 × 36 5/8″ (44 × 93 cm)

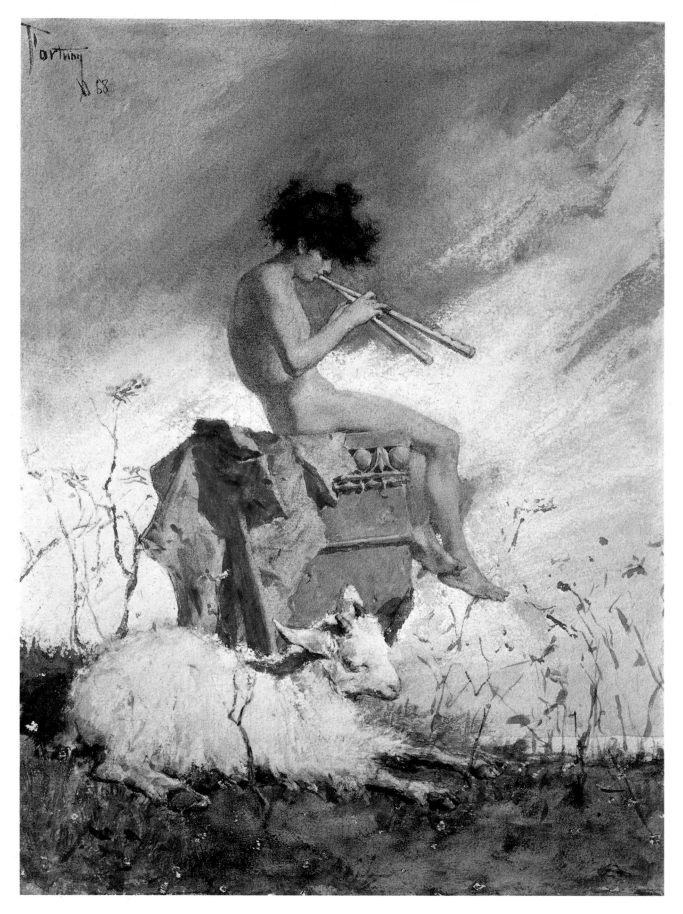

119. **Mariano Fortuny i Marsal** (1838–1874)
Idyll. 1868 [no. 2609]
Watercolor on paper, 12 ¼ × 8 ⅝″ (31 × 22 cm)

257

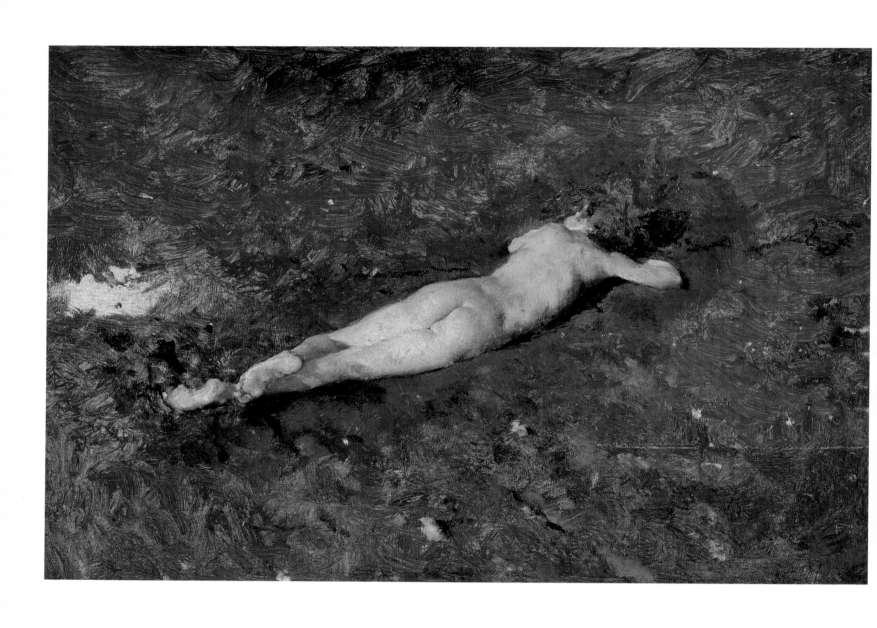

120. **Mariano Fortuny i Marsal** (1838–1874)
Nude on Portici Beach [no. 2606]
Oil on board, 5 1/8 × 7 1/2″ (13 × 19 cm)

121. **Mariano Fortuny i Marsal** (1838–1874)
Landscape [no. 2627]
Watercolor on paper, 15 ¾ × 12 ¼″ (40 × 31 cm)

122. **Francisco Pradilla Ortiz** (1848–1921)
Doña Juana la Loca. 1877 [no. 4584]
Oil on canvas, 11′ 1⅜″ × 16′ 4⅞″ (340 × 500 cm)

123. **Antonio Muñoz Degrain** (1840?–1924)
A Rain Shower in Granada [no. 4520]
Oil on canvas, 37 ⅜ × 56 ¾" (95 × 144 cm)

124. **José Jiménez Aranda** (1837–1903)
A Procession in the Month of May. 1897 [no. 6763]
Oil on canvas, 18 ½ × 25 ⅝″ (47 × 65 cm)

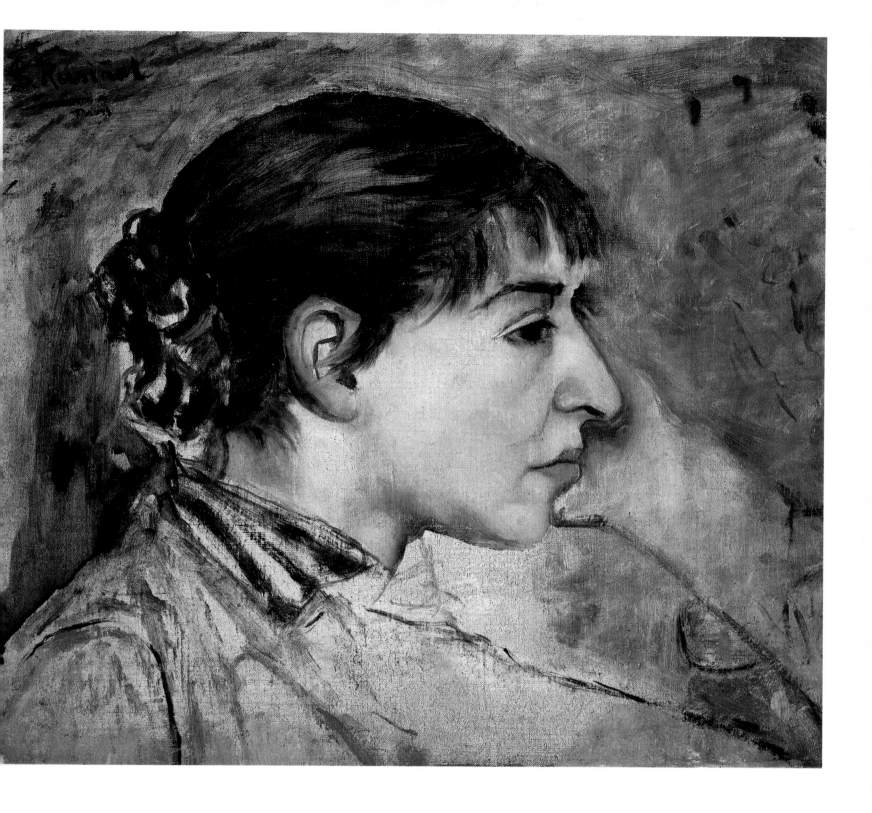

125. **Santiago Rusiñol i Prats** (1861–1931)
Sarah Bernhardt [no. 7019]
Oil on canvas, 13 ³/₈ × 15″ (34 × 38 cm)

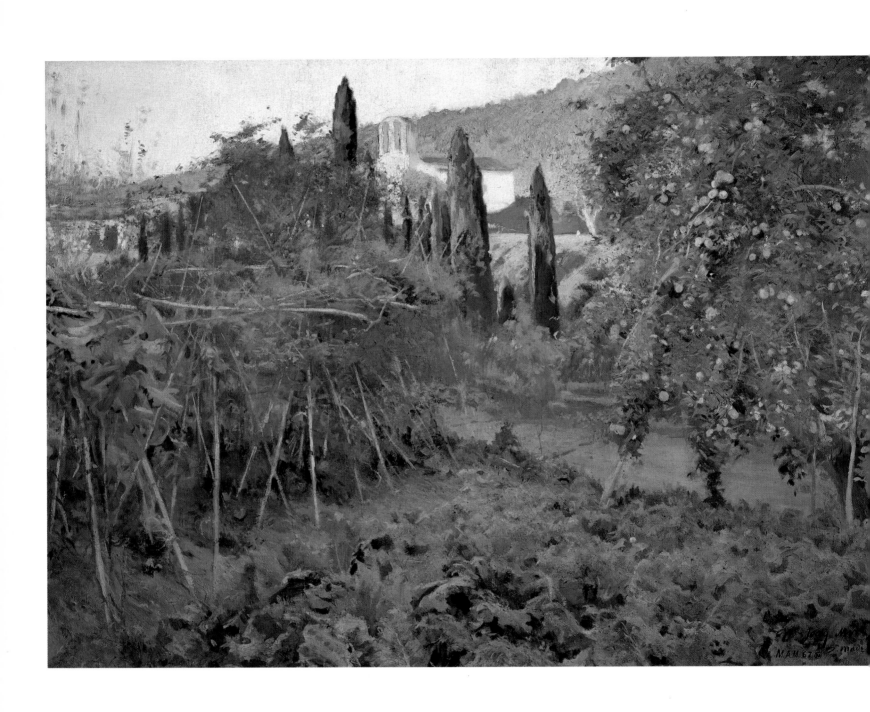

126. **Joaquim Mir Trinxet** (1873–1940)
The Hermitage Garden [no. 4514]
Oil on canvas, 45 ¼ × 59 ½" (115 × 151 cm)

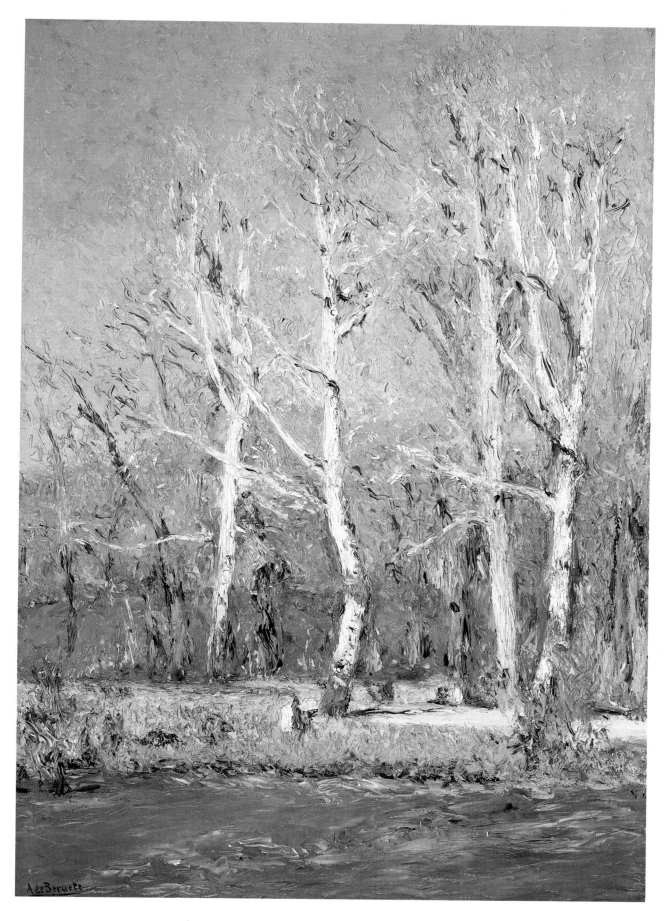

127. **Aureliano de Beruete y Moret** (1845–1912)
A Winter Landscape: Group of Infantes. 1911 [no. 4057]
Oil on canvas, 37 ³⁄₈ × 26 ³⁄₈″ (95 × 67 cm)

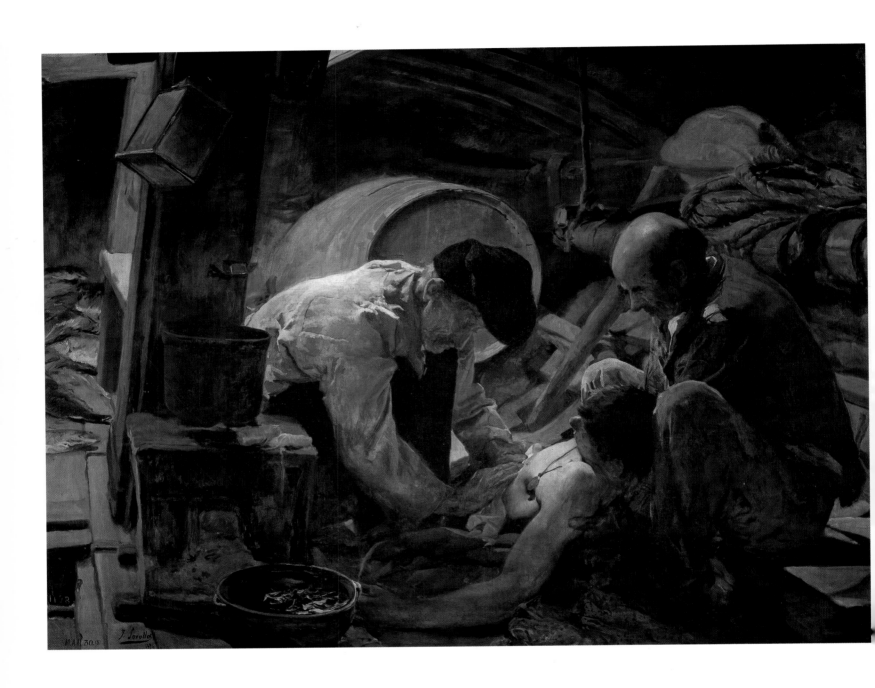

128. **Joaquín Sorolla y Bastida** (1863–1923)
They Still Say That Fish Is Expensive! 1894 [no. 4649]
Oil on canvas, 60 ¼ × 80 ⅜″ (153 × 204 cm)

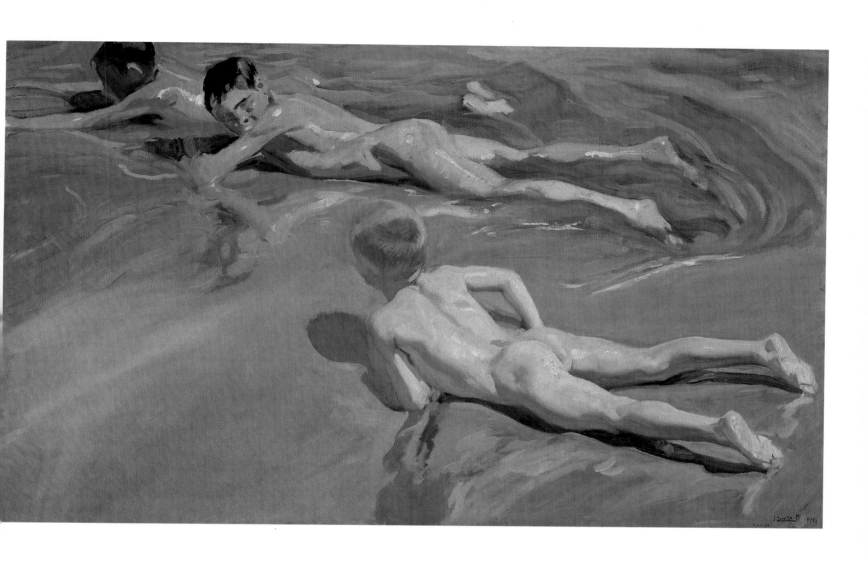

129. **Joaquín Sorolla y Bastida** (1863–1923)
Children on the Beach. 1910 [no. 4648]
Oil on canvas, 46 ½ × 72 ⅞″ (118 × 185 cm)

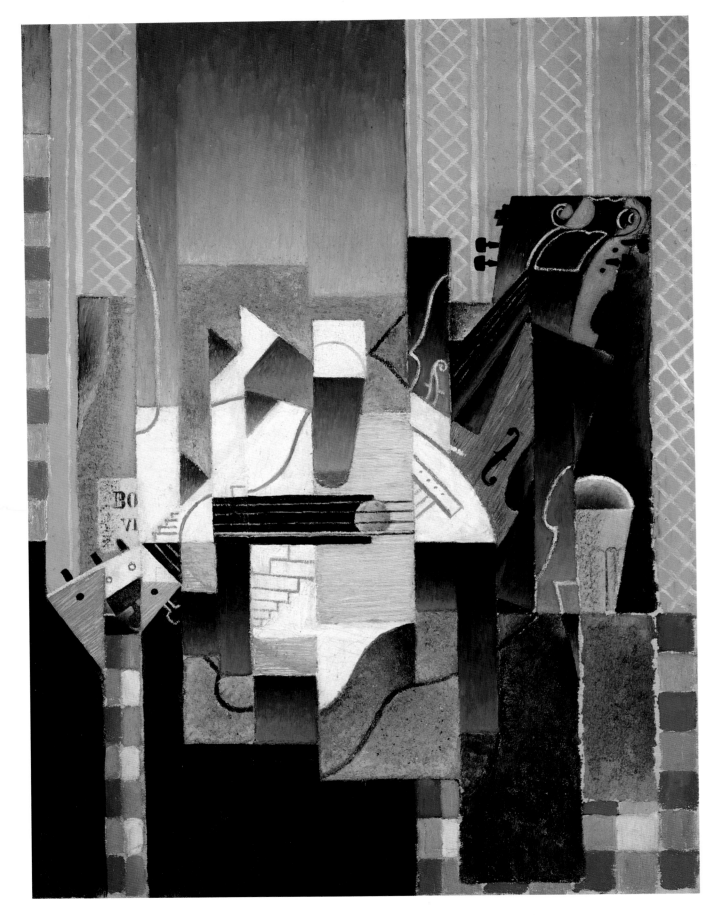

130. **José Victoriano González, Juan Gris** (1887–1927)
Violin and Guitar. 1913 [no. 7079]
Oil on canvas, 31⅞ × 23⅝″ (81 × 60 cm)

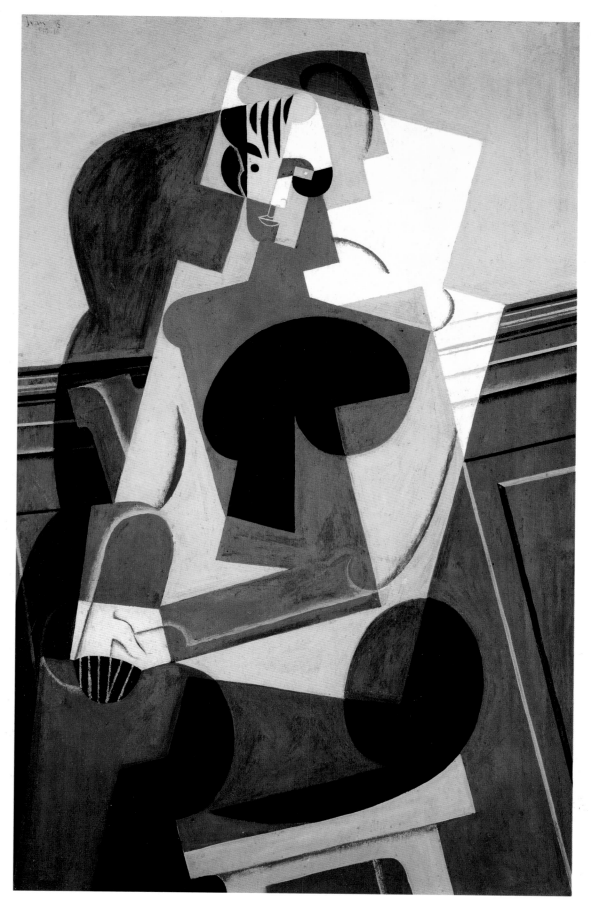

131. **José Victoriano González, Juan Gris** (1887–1927)
Portrait of Josette. 1916 [no. 4389]
Oil on board, 45 ⅝ × 28 ¾″ (116 × 73 cm)

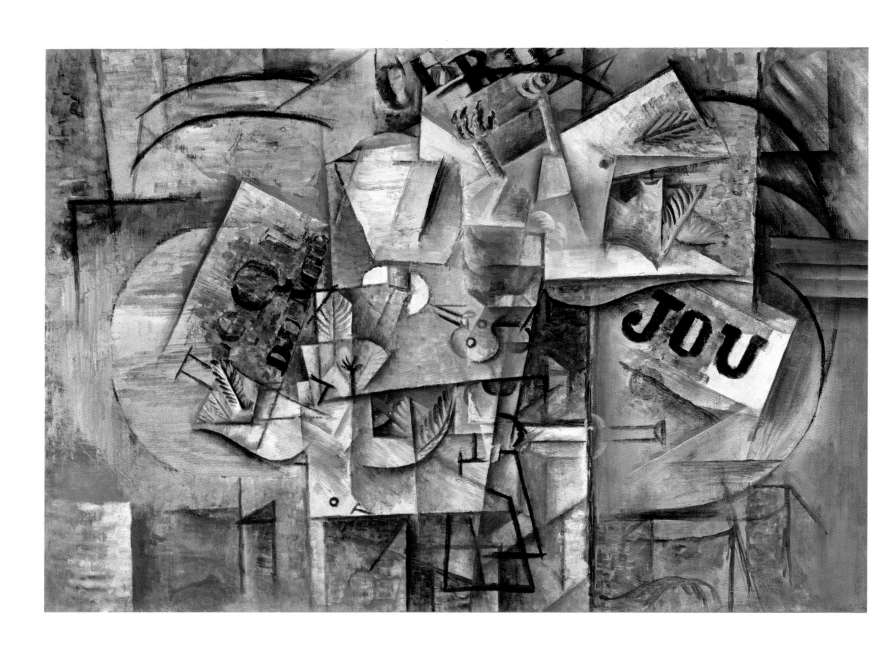

132. **Pablo Ruiz Picasso** (1881–1973)
Still Life with Dead Birds. 1912 [no. 7078]
Oil on canvas, 18 ⅛ × 25 ⅝" (46 × 65 cm)

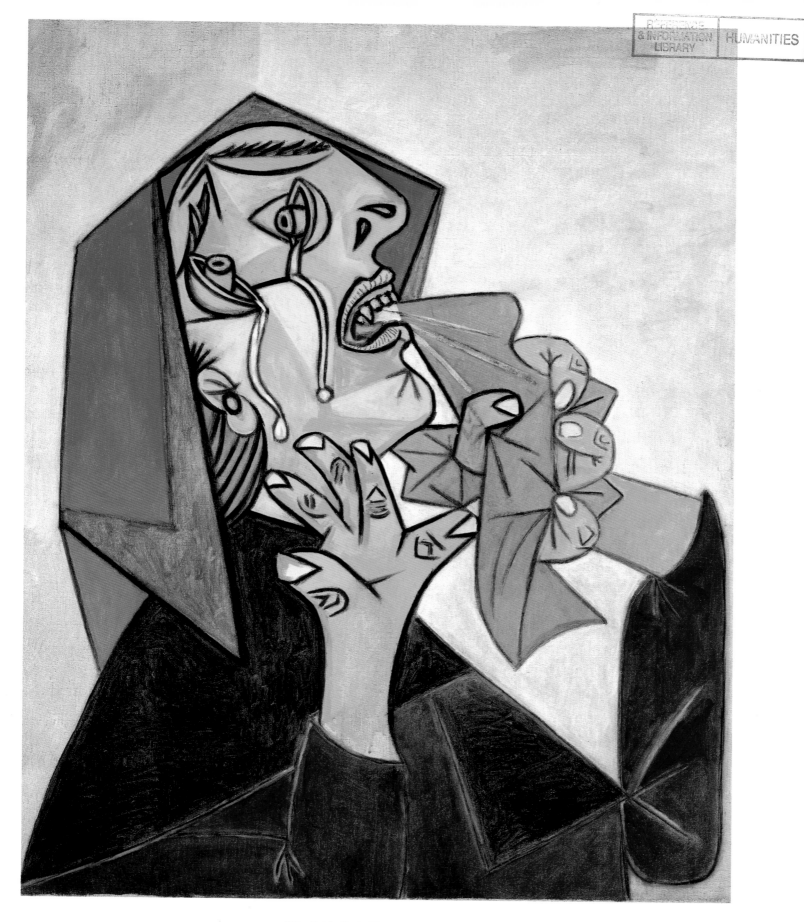

133. **Pablo Ruiz Picasso** (1881–1973)
Woman Crying, with a Handkerchief. 1937 [no. 6945]
Oil on canvas, 36 ¼ × 27 ½″ (92 × 70 cm)

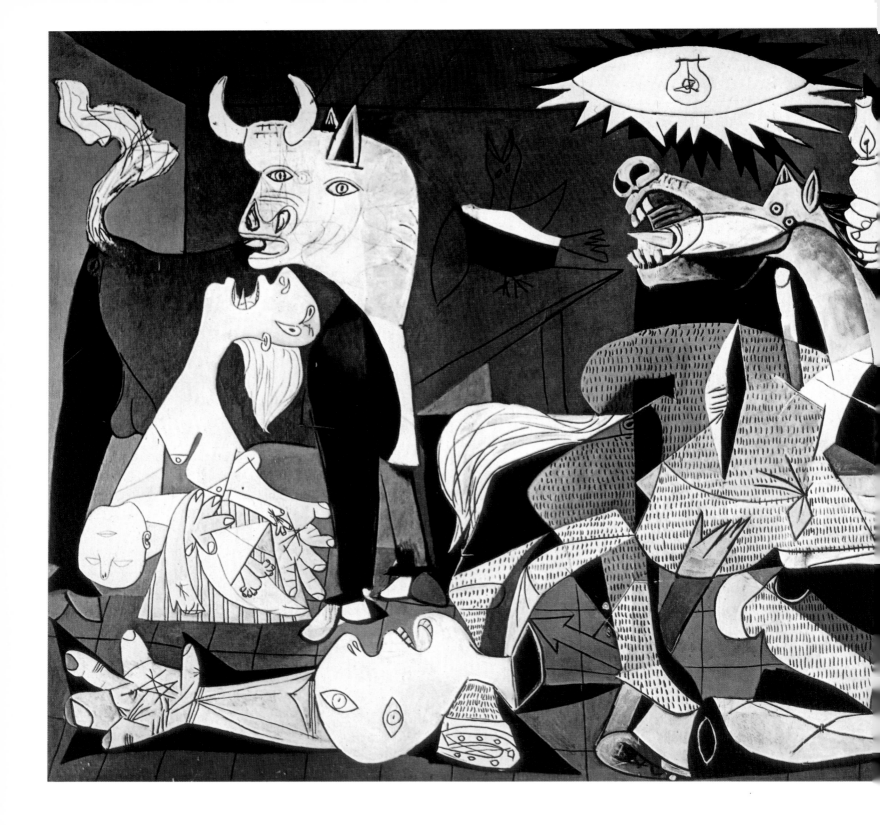

134. **Pablo Ruiz Picasso** (1881–1973)
Guernica. 1937 [no. 6479]
Oil on canvas, 11′ 5 3/8″ × 25′ 5 1/2″ (349 × 776 cm)

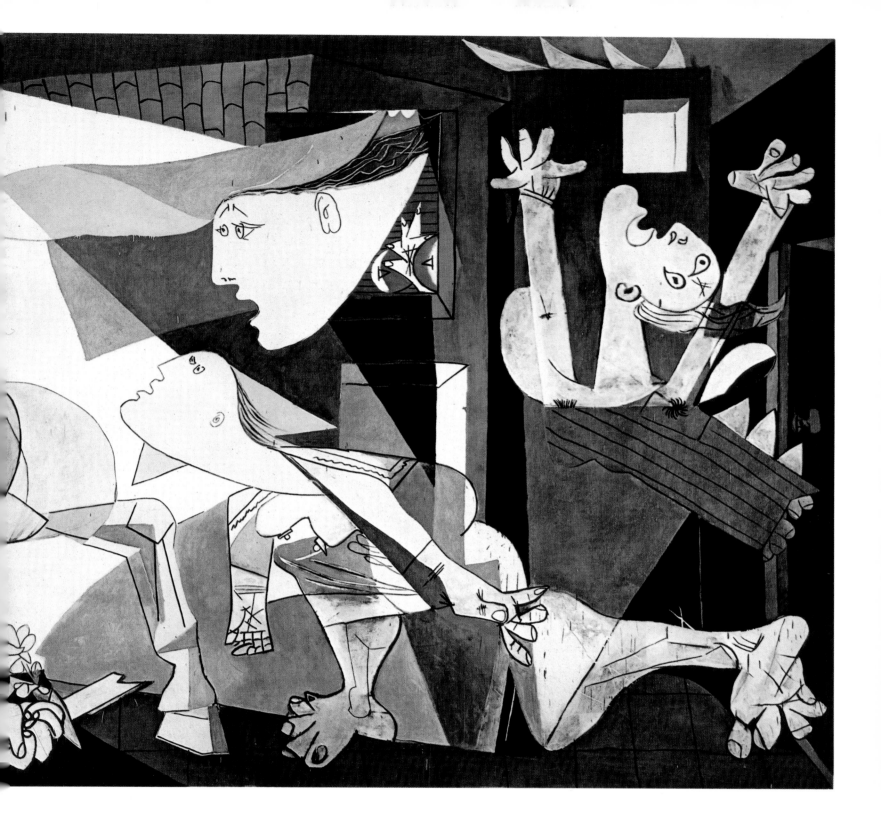

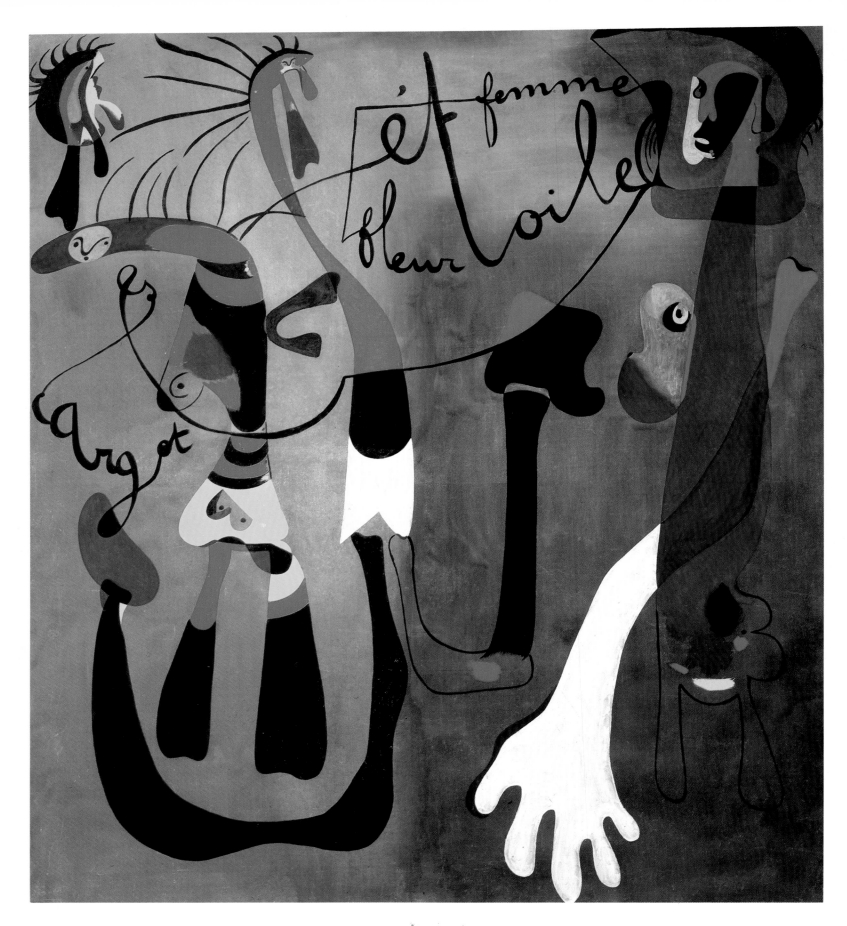

135. **Joan Miró** (1893–1983)
Snail, Woman, Flower, Star. 1934 [no. 7144]
Oil on canvas, 76 ¾ × 67 ¾″ (195 × 172 cm)

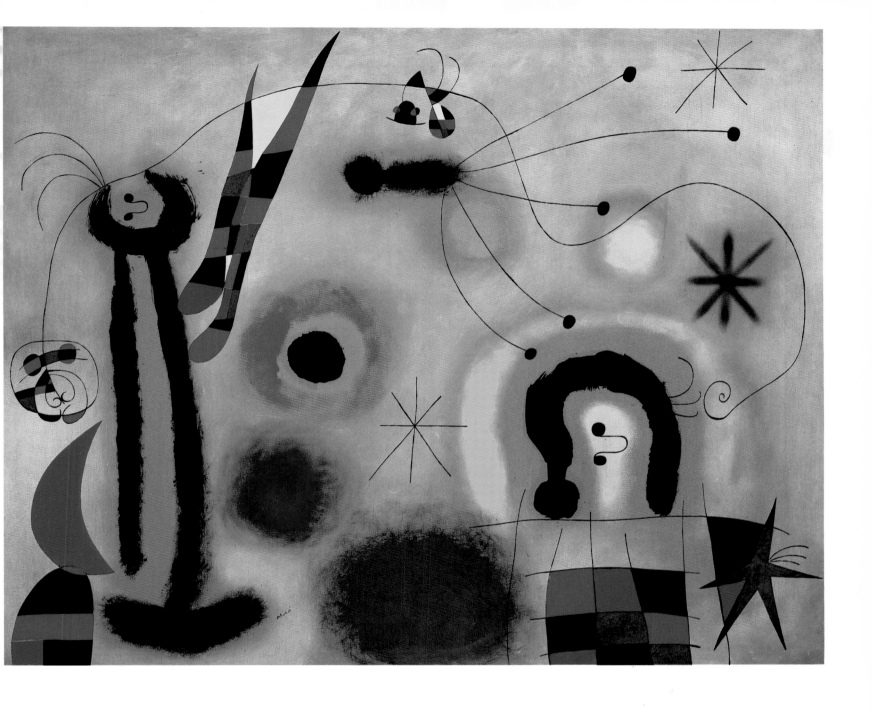

136. **Joan Miró** (1893–1983)
*Dragonfly with Red-Tipped Wings in Pursuit of a Snake
Spiraling Toward a Comet.* 1951 [no. 7145]
Oil on canvas, 31 7/8 × 39 3/8″ (81 × 100 cm)

ITALIAN SCHOOL

The Prado Museum is essential for the study and knowledge of the pictorial evolution of the different schools highly representative of the Italian scene. From the end of the fifteenth century until well into the eighteenth, Spain exercised intense political influence in Italian lands, while at the same time Italian art enjoyed considerable prestige in the Spanish halls of power. Works by Italian artists figured highly in the collections of Spanish monarchs, who acquired numerous greatly esteemed paintings of diverse character and origin.

Italian art in the Prado begins with the works of two followers of Giotto: Tadeo di Gaddi (c. 1300–1366), whose two compositions alluding to Saint Eloy hang in the museum, and Francesco Traini (c. 1345), who is represented by a *Virgin and Child*. Of a much higher standard are the reminiscences of the fifteenth-century Florentine school: the works of Fra Angelico (c. 1400–1455) and Alessandro Filipepi Botticelli (1444/45–1510) are among those characteristic of the different aspects of such a fundamental school. *The Annunciation* (plate 137) by Fra Angelico is greatly admired for its delicate harmony of color and strength of outline in an idealized atmosphere, while the sensitive and passionate temperament of Botticelli is cleary revealed in the three panels with episodes from *The History of Nastagio degli Onesti* (plate 138). Accompanying these are works by Melozzo da Forli (1438–1494) and by Antoniazzo Romano (d. c. 1512). From the Padua school we find Andrea Mantegna (1431–1506) and his *Death of the Virgin* (plate 140), a balanced composition with precise outline, and the creatively restless Antonello de Messina (c. 1430–1479), whose *Dead Christ Supported by an Angel* (plate 139) marked the introduction into Italian art of oil painting, the country's painters having hitherto preferred the technique of tempera.

The representation of the three great painters who mark the definite beginning of the sixteenth century is certainly deficient, as neither Leonardo nor Michelangelo can be studied in the museum. A fundamental group of works by Raphael (1483–1520), however, can be admired here. Though varied in content and styles, the paintings of Raphael in the Prado Museum's collections are consistently of high quality. His sensitivity can be appreciated in *The Holy Family with Sheep* (plate 141), *The Holy Family with Oak Tree* (plate 145), and

The Holy Family (The Pearl); in compositions such as *The Madonna of the Fish* (plate 143) and *The Fall on the Road to Calvary* (plate 144); and in portraits such as *Portrait of a Cardinal* (plate 142). The collaboration of Giulio Romano (1499–1546) is evident in *The Holy Family with Oak Tree* (plate 145), while derivations from this are also clearly appreciable in works by Pierino del Vaga (1547), such as *"Noli Me Tangere."* Echoes of Leonardo are clear in the *Holy Family with Saint John* and *Salome*, of Bernardino Luini (1480/90–1532), and the influence of Michelangelo is perceptible in the work of Daniele da Volterra (1509–1566).

Aspects of Mannerism are prefigured in the work of Andrea del Sarto (1486–1530). Hanging in the Prado are examples of his very personal portraits (*Lucrecia di Baccio del Fede, Wife of the Painter*, plate 146), and his religious compositions, such as the *Mystical Matter*, including some with his habitual triangular scheme, *Holy Family* and the *Sacrifice of Isaac*. Immersed in this current is Bronzino (1503–1572), the official portrait painter of the Medicis of Florence, as is shown in his effigy of *García de Medicis*. The Parmesan, Antonio Allegri da Correggio (1493–1534), can be admired for his *Virgin with the Child and Saint John* and especially for the *"Noli Me Tangere"* (plate 147), of concentrated passion. Francesco Mazzola, Il Parmigianino (1503–1540) was fully immersed in Mannerism, as can be seen in several paintings of rhythmic outline and unique chromatic range, such as *Saint Barbara*, the *Holy Family with an Angel*, and a number of his portraits. Other Italian Mannerist painters represented in the museum include Jacopino del Conte and Francisco Salviati. Aspects of what was to be known as the Baroque style can be seen in such paintings by Federico Barocci, called Fiori da Urbino (c. 1535–1612), as *The Birth* (plate 148) and *Christ on the Cross*. Other painters were to be protagonists of a beneficial dispersion to France, namely Nicolo dell'Abate (c. 1509/12–1571?), represented here with a *Lady in a Green Turban*, and to Spain, such as Luca Cambiaso (1527–1585) and Bartolomeo Carduccio (1554–1608), who contributed to the decoration of El Escorial.

The Prado does not hold many canvases from Venetian artists of the fifteenth century. Only Giovanni Bellini (c. 1430–1516) stands out in this period, with *The Virgin and*

Child Between Two Saints (plate 149). The importance increases as we move into the sixteenth century with Giorgione (1478–1510) and *The Virgin with the Babe in Arms Between Saint Antonio de Padua and Saint Roque*, with Palma the Elder (1480–1528) and his *Adoration of the Shepherds*, and, more particularly, with the quantity and quality of the output of the brilliant Titian (c. 1490–1576), preserved in the museum.

Almost forty paintings show the diversity of Titian's creative capacities, the extent of his knowledge, and the strength of his artistic sensibility. In his true-to-life portraits of the aristocracy of his epoch, such as those of *Federico Gonzaga, Duke of Mantua*, of the anonymous *Gentleman Showing His Watch*, and of *Daniele Barbaro*, the severity of the pictorial treatment does not exclude the quality of the cloths and the jewels or the psychological penetration into each of the subjects. Even more complex are the presentations of the *Marquis of El Vasto* as he is haranguing his soldiers and of *The Emperor Charles V, on Horseback, in Mühlberg* (plate 151). Logically inferior is the portrait of the Empress Isabel, sitting and in three-quarter profile, due to the fact that Titian did not know her in person, while that of the prince who was to become Philip II reflects an acute awareness of his personality, just as the artist demonstrates in his *Self-Portrait* (plate 156) painted in 1567 at the age of eighty.

Freely interpreted mythological fables can be seen in Titian's *The Bacchanal* (plate 152) and *Offering to Venus*, painted in 1518–19 for the Duke of Ferrara; in the two paintings, with slight variations, of *Venus Delighting Herself with Love and Music* (plate 154); the singular *Danaë and the Shower of Gold* (plate 153), from 1553; and *Venus and Adonis* from the same year, whose theme was extracted from Ovid's *Metamorphoses*, an inexhaustible source for the mythological. Titian's repertoire of biblical and religious themes demonstrates the profound knowledge of the artist in all aspects. The canvas depicting *Adam and Eve* (c. 1570) offers more evidence of his mastery of nude painting in the open air, while the rest denote a wide variety of solutions, with expressive half-length figures (two versions of *The Virgin of Sorrows*, the *Ecce Homo*, a bust of *Christ*, and *Salome*). The full-length *Saint Margaret* stands out against an expressive landscape, while *Christ with the Cyreneum* is of a pronounced dramatic quality. Outstanding for its superb foreshortening and fitting surroundings is *The Entombment of Christ* (plate 155), and for the complexity of a perfectly expressed idea the *Glory*, warm in atmosphere, allusive to the triumph of Lepanto over the Turks in 1571. To appreciate Titian's change of style it would be useful to compare these paintings with that of the *Virgin and Child with a Masculine and a Feminine Saint*, painted around 1516 and also preserved in the museum. The Prado also contains an outstanding set of canvases to which the maestro participated to a greater or lesser extent.

Parallel to Titian, other artists added qualities to this Venetian school: for example, Lorenzo Lotto (c. 1480–1556), skillful interpreter of the gentle group of *Micer Marsilio and His Wife*, and Sebastiano del Piombo (1485–1547), painter of *Jesus Bearing the Cross* and *Christ's Descent into Limbo*, outstanding for their vigorous foreshortening of the protagonist. The works of Paolo Caliari, known as Veronese (1528–1588), are endowed with a sense of decorative monumentality revealed in great fresco compositions, in Venetian palaces and sumptuous villas on the outskirts, and in canvases of brilliant conception, where the rich and magnificent are especially prevalent, even though many of them are religious in theme. This characteristic is perfectly noticeable in *Jesus Among the Doctors* and *Jesus and the Centurion*, whose sumptuous architectonic backgrounds are in part continued in *Susanna and the Elders* and are substituted by a no less attractive landscape in *Venus and Adonis* (plate 158) and in *The Finding of Moses* (plate 157). Other aspects of his personality are shown in the *Martyrdom of Saint Mena*, with the dynamic dramatism of its personages and the usual chromatic richness. Of a different character are the presumed portrait of *Livia Colonna* and the *Magdalene in Penitence*, as are the pathetic scene of *The Wandering Family of Cain* and the dynamic space arrangement developed in the *Sacrifice of Abraham*. Given Veronese's spectacular and prolific output, it is only to be expected that he had followers and some of them, such as his brother Benedetto and his son Carlo, have works in this museum; canvases produced by his studio are in the collections as well.

All that represents happiness, optimistic coloring, or spectacle in these great Venetian painters was displaced by the dramatic tension and passionate agitation prevalent in the painting of Jacopo Robusti, Tintoretto (1518–1594). Despite the large group of works which Velázquez brought back with him from his second trip to Italy, Tintoretto is insufficiently represented in the Prado. Outstanding are *The Maundy* (plates 159 and 160), by virtue of the important part played by the space in which the protagonists move, and, by virtue of its special viewpoint, a series of six canvases biblical in theme, suitable for the decoration of a ceiling. Also uniquely attractive are the portraits by this artist, such as his *Bust of a Gentleman* and *Young Gentleman*, from around 1546–48, and the *Knight with a Golden Chain*, highly economic in its

resources, from around 1560. The attraction is maintained in his *Portrait of a Prelate, Venetian General*, and *Senator*, from a somewhat later period, and in the singular *Woman Who Discovers the Bosom* (plate 161). Other facets can be seen in canvases such as the versions of *Judith and Holofernes, The Baptism of Christ* (plate 162), *The Violence of Tarquin*, and *Battle Between Turks and Christians*. There is no lack here of paintings that show the wide influence of this painter, logical in the production of his children Marietta and Doménico, notable in the Dutchman Lambert Sustris, and rather less so in the work of Giovanni Battista Moroni, a portrait painter of sensitivity.

The Bassanos, who cultivated a different facet of the brilliant Venetian school, form a group apart. The family was headed by the father Jacopo (1510/15–1592) and continued by his sons Francesco, Gerolamo, Leandro, and Gian Battista, who established an active studio specializing in genre painting that is a clear predecessor of Baroque naturalism. It is difficult to accurately pinpoint the individual contributions of each of them in the numerous biblical series, the mythological paintings, and pastoral scenes, all with a multitude of persons and animals in both interiors and landscapes. *The Animals Entering Noah's Ark* (plate 163), *Expulsion of the Merchants from the Temple, Adoration of the Shepherds, Adoration of the Wise Men*, and several parables are among the most outstanding examples of their work, but there is no lack of portrait paintings in the Bassanos' oeuvre.

The beginning of the seventeenth century saw no pause in the contributions of the painters active in Italian cities. Representing basically two tendencies, naturalist and classicist, they mirrored the trend that was spreading throughout Europe, adapted to each environment. The naturalist reaction against the Mannerist spirit was headed by Michelangelo Merisi, known as Caravaggio (1573–1610), active in Rome, Naples, Malta, and Sicily, who is represented here by a young *David Victorious over Goliath* (plate 164). The immediate influence of Caravaggio can be detected in the *Self-Portrait* by Orazio Borgianni (1575–1616); in *Holy Family and Saint Catherine* by Bartolomeo Cavarozzi (c. 1590–1625); in the *Saint Catherine* by Antiveduto Grammatica (1571–1626); and in several paintings by Orazio Lomi de Gentileschi (1563–1639), whose *Moses Rescued from the Waters of the Nile* (plate 165) demonstrates the refinements typical of his later phase.

A similar opposition to Mannerism in its initial stages can be observed in the Carraccis, brothers Agostino (1557–1602) and Annibale (1560–1609) and cousin Ludovico (1555–1619). The last was the eldest and therefore possibly the maestro, active in Bologna, and his works are of an idealized realism, in the style of the Counter-Reformation, as can be seen in his *Saint Francis and the Angel* and *Prayer in the Garden*. Agostino was the most intellectual and Annibale the most outstanding and had the greatest influence abroad. The quality of Annibale Carracci's work can be appreciated in his *Assumption of the Virgin, Venus, Adonis, and Cupid*, his methodically idealized *Landscape with Bathers*, and in the sections of his fresco paintings for the Herrera Chapel in the Roman church of Santiago de los Españoles, which are preserved in the Prado. His followers were many, among them Guido Reni (1575–1642), whose very refined and sensitive personality is discernible in his many paintings in the museum. Most of his works fall into three categories: religious, such as *Saint Sebastian* (plate 167), *Magdalene*, and *Saint James the Elder*; mythological, like *Hippomenes and Atlanta* (plate 166) and *Lucretia*; or genre, such as *Girl with a Rose*. Other members of the group were Francesco Albani (1578–1660), with his *Paris Trial*; Domenico Zampieri, Il Domenichino, who was delicately correct in his *Martyrdom of Saint Andrew*, his *Funeral Rites of a Roman Emperor*, and an exquisite *Landscape*; and Giovanni Francesco Barbieri, called Il Guercino (1591–1666), whose overflowing personality can be seen in *Susanna and the Elders* (plate 168) and in *Saint Peter Liberated by an Angel*.

Parallel to this group from Bologna and its followers, another important nucleus developed in Rome around the middle of the century that arrived at completely Baroque solutions in painting on canvas and, more especially, on vaults and walls. The different phases are represented by painters like Giuseppe Cesari, the Gentleman of Arpino (1568–1640), whose style is archaic; by Giovanni Lanfranco (1582–1647), represented in the museum by paintings with Roman history themes (*Auspices in Rome, Naumaquia, Gladiators, Funeral Rites of an Emperor*); by Andrea Sacchi (1599–1661), imbued with classicism; and by Pietro da Cortona (1596–1669), somewhat poorly represented and of less interest. The Neapolitan center was equally rich and interesting for its close relationship with Spain, on whose crown it depended and in which José de Ribera occupied an outstanding position. Worthy of note here is Massimo Stanzione (1585–1656) and his *Preaching of Saint John the Baptist in the Desert* (plate 169), *Beheading*, and the dynamic *Sacrifice to Bacchus*; Aniello Falcone (1607–1656), highly esteemed for his canvases of battles (*Turks and Christians, Gladiators*) and his realist scenes (*Concert*); Andrea Vaccaro (1605–1670), who in some cases is reminiscent of Ribera; and Bernardo Cavallino (1616–c. 1656), noted for the exquisitely delicate form of his figures in *The Curing of Tobias* (plate 170). Still-life paintings also reached great heights with

the works of Giuseppe Recco (1634–1695), Giovanni Battista Ruoppolo (1629–1693), Paolo Porpora (1617–1670/80), and Andrea Belvedere (c. 1652–1732), while Salvator Rosa (1615–1673) was noted for his landscapes.

The culmination of the Bolognese school was reached with the multiform and rich works of Luca Giordano (1632–1705), who painted with creative ease and speed of execution. Giordano's paintings in the Prado embrace all stages of his production, from the Riberesque juvenile period (*Saint Anthony of Padua*) to his admiration for Rubens and the sketches for Neapolitan decoration (*The Defeat of Sisara*, plate 171; *The Victory of the Israelites*; and *Deborah's Canticle*). In 1692 he arrived in Spain, where he made sketches for his frescoes for the staircase of El Escorial (*Battle of Saint Quentin, Prison of the Constable of Montmorency*) and for his portraits of Charles II and of Mariana of Neoburg, in the style of Velázquez. A great number of canvases with biblical and religious themes, with dynamic battles and mythological episodes reveal the portentous skill of the artist and his capacity to adopt a wide variety of styles.

The drop in the level of the several schools active in Italy is clearly revealed in the works of the Florentine painters Cristófano Allori (1577–1621, *Cristina de Lorena*), Francesco Furini (1600–1630, *Piety*), and Giulio Cenare Procaccini (1574–1625), by the Venetian Palma ''the Younger'' (c. 1548–1628), outstanding in decoration, and by Bernardo Strozzi from Genoa (1581–1644), whose roots are to be found in Caravaggio and Rubens (*The Veronica*). With them the splendid Italian series of the seventeenth century is brought to a close.

With the coming of the new dynasty of the Bourbons, waves of transformation mark the beginning of the eighteenth century in Spain. Even so, the close link with Italy, especially with Rome, Naples, and Venice, continued and was even increased with the incorporation of some of those cities' painters into the Spanish court, as happened to the Roman Andrea Procaccini (1671–1734, *Cardinal Carlos de Borja*). Around 1735–36 Sebastiano Conca (1680–1764) received commissions for the palace of La Granja (*Alexander the Great in the Temple of Jerusalem*, plate 173), while Giovanni Paolo Panini (1691/92–1765) revived classical antiquity in a proto-romantic way (*Pyramid of Caius Cestius, Ruins with Saint Paul (?) Preaching*, plate 174). On the other hand, Pompeo Girolamo Batoni (1708–1787) leaned toward Neoclassicism and stands out for his portraits (*William Hamilton, Charles Cecil Roberts,*

plate 172), some of which were given atmosphere by the insertion of unmistakably Roman buildings in their backgrounds. In Naples portrait painting, landscapes and decorative works acquired a particular vitality, as is shown by Francesco Solimena (1657–1747) in his *Self-Portrait* and *Saint John the Baptist* (plate 175) and especially by Corrado Giaquinto (1700–1766), who lived in Madrid (1753–62) and is represented in the Prado by his religious canvases for the Palace of Buen Retiro, allegorical compositions (*Justice and Peace*, plate 177), and sketches for the vaults in the Royal Palace of Madrid (*Battle of Clavijo, Spain Pays Homage to Religion and the Church*, and *The Birth of the Sun and the Triumph of Bacchus*, plate 176). Completing the panorama are portraits by Giuseppe Bonito (1707–1789), author of *Turkish Embassy* and *Maria Amalia of Saxony*, and Mariano Nani (c. 1725–1804), with his still-life paintings of cinegetic themes.

Greater prominence was enjoyed by Venice, the scene of a brilliant aesthetic evolution that had positive repercussions on Spanish painting. Luigi Vanvitelli (1653–1736) initiated the urban landscape genre with *Venice Seen from the Isle of San Giorgio* (plate 178) and *Outskirts of Naples*, while Jacopo Amiconi (c. 1680–1752) traveled Europe and finally settled in Spain, where he died after painting biblical works (*Joseph in the Pharaoh's Palace*, plate 179) and portraits (*Marquis of La Ensenada, Infanta Maria Antonia*). The culmination of eighteenth-century Venetian art was reached with Giovanni Battista Tiepolo (1696–1770), whose portentous frescoes open up ceilings to infinite perspectives. In the museum are works from his first period, such as *Queen Zenobia before Emperor Aurelianus* (plate 181), sketches (see plate 180) for works to be carried out in Venice and Saint Petersburg, and canvases with religious themes (*The Immaculate Conception*, plate 183; *The Angel of the Eucharist*; *Saint Pascual Bailón*; *The Stigmatization of Saint Francis*; *Saint Antonio de Padua*; and *Abraham and the Three Angels*, plate 182), with abundant derivations.

The most immediate influence of Tiepolo is seen in several paintings by his son, Gian Domenico Tiepolo (1727–1804), with themes of the *Passion*, and in the pastel portraits by Lorenzo Tiepolo (1736–1776). In addition to the Venetian painters, Alessandro Magnasco from Genoa (1677–1749) should also be remembered, for his *Christ Served by the Angels* (plate 184), immersed in a disquieting atmosphere. These works bring to a close the discussion of the Italian contributions to the Prado, one of the world's best collections of Italian art.

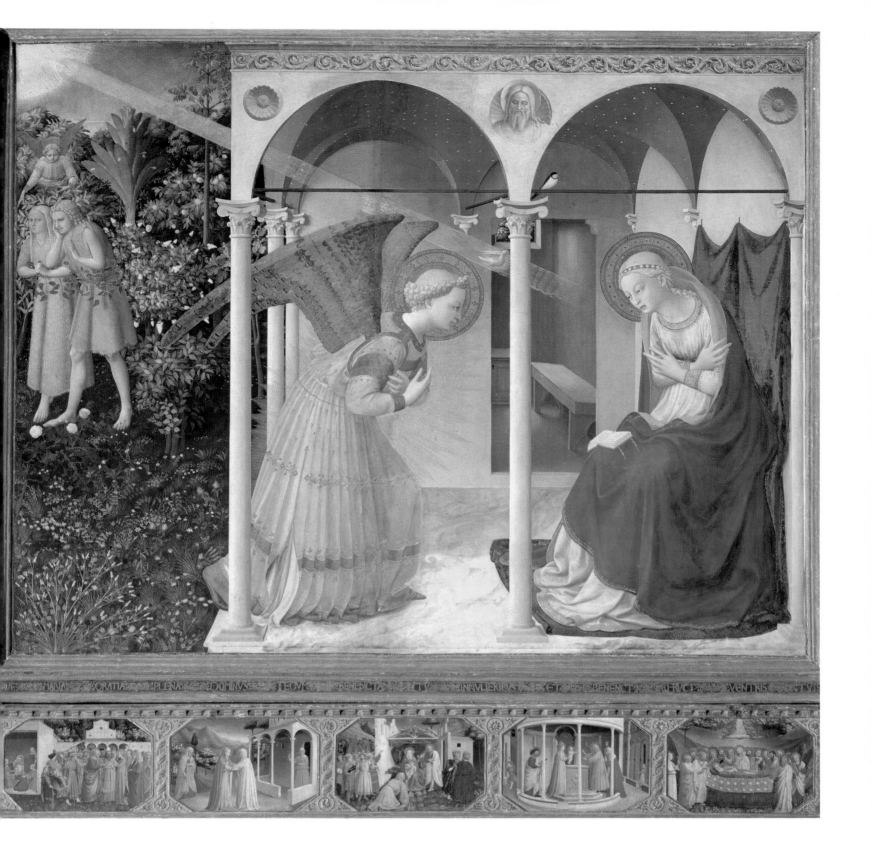

137. **Guido di Pietro da Mugello, Fra Angelico** (c. 1400–1455)
The Annunciation. 1435–45 [no. 15]
Tempera on board, 76-3/8 × 76-3/8″ (194 × 194 cm)

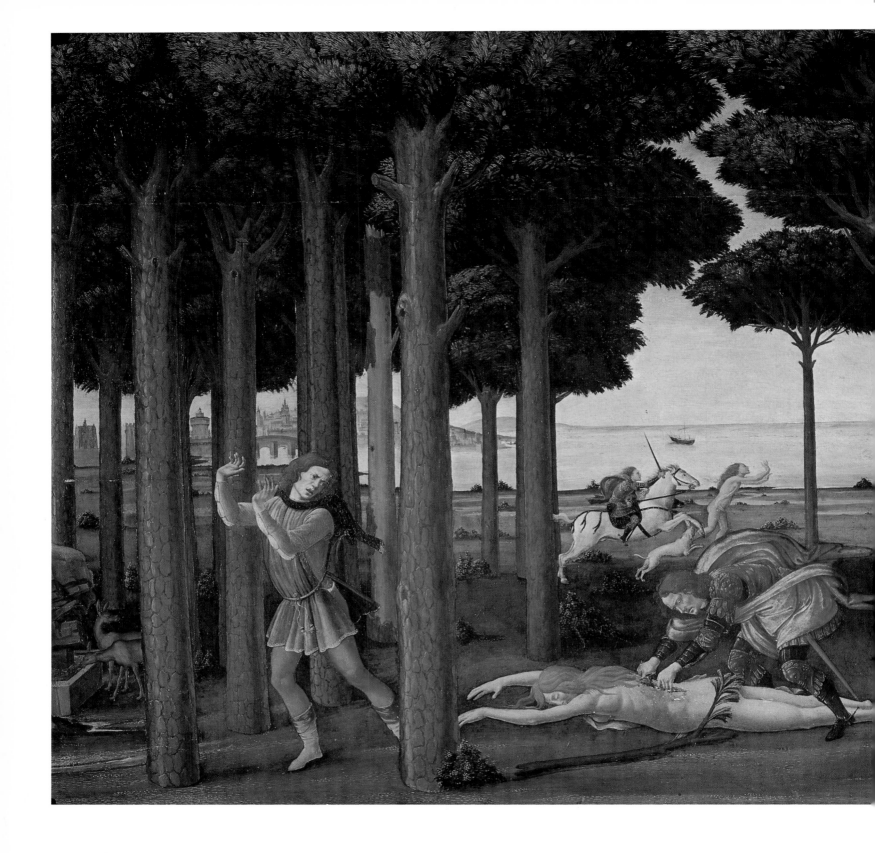

138. **Alessandro Filipepi del Botticelli**, called **Sandro Botticelli** (1444/45–1510)
The History of Nastagio degli Onesti (painting II) [no. 2839]
Paint on board, 32 ¼ × 54 ⅜″ (82 × 138 cm)

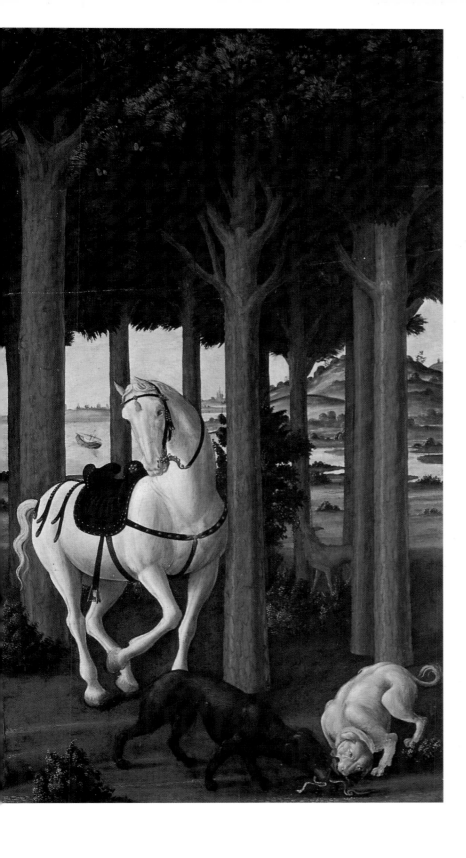

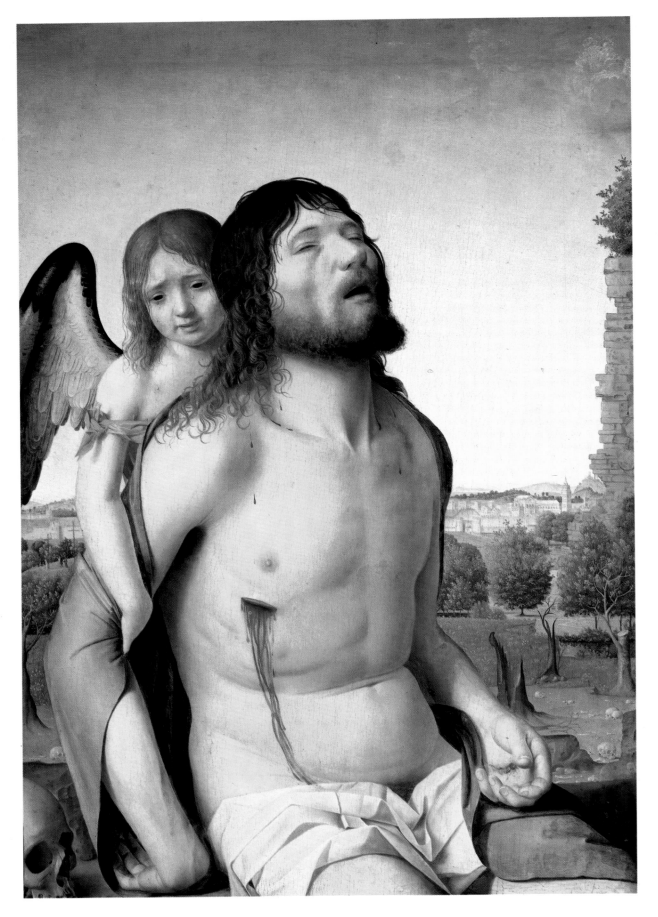

139. **Antonello de Messina** (c. 1430–1479)
The Dead Christ Supported by an Angel [no. 3092]
Paint on board, 29 ⅛ × 20 ⅛″ (74 × 51 cm)

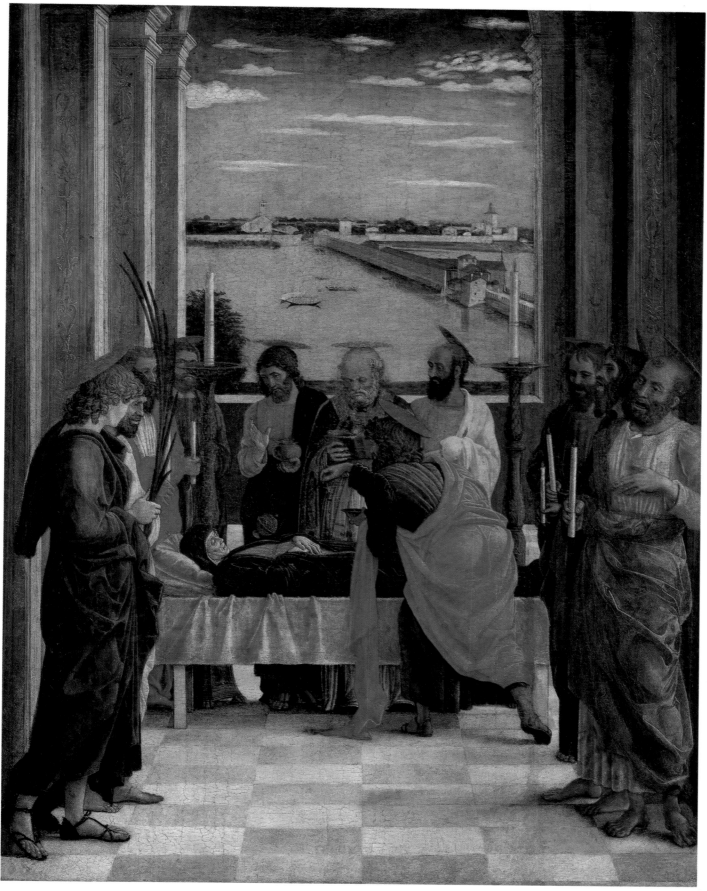

140. **Andrea Mantegna** (1431–1506)
The Death of the Virgin [no. 248]
Paint on board, 21 ¼ × 16 ½″ (54 × 42 cm)

285

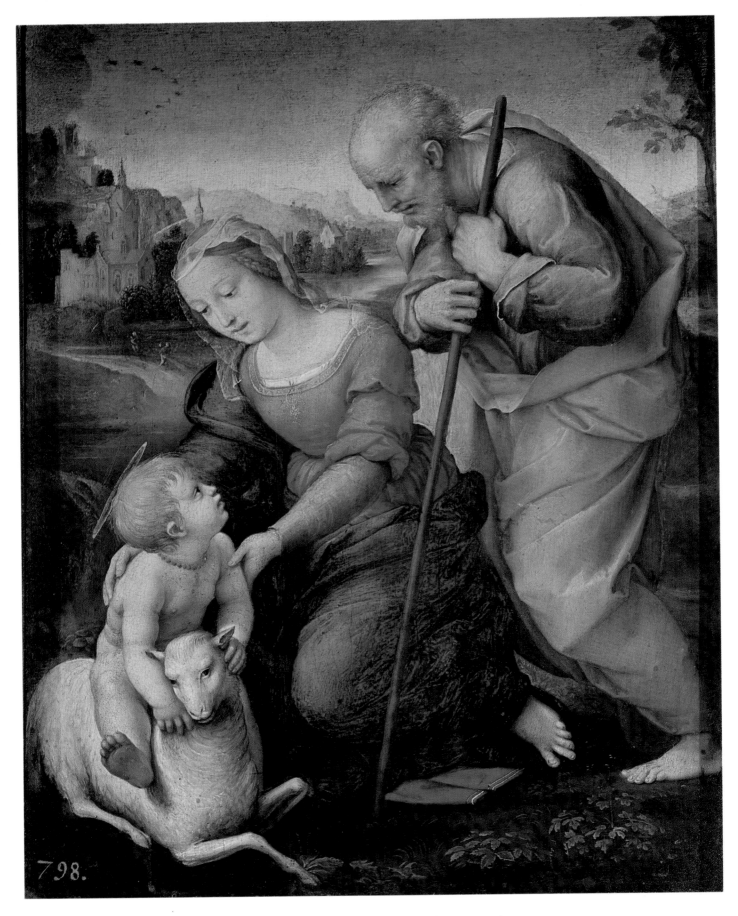

141. **Rafaello Sanzio,** called **Raphael** (1483–1520)
The Holy Family with Sheep. 1507 [no. 296]
Paint on board, 11 ³/₈ × 8 ¼″ (29 × 21 cm)

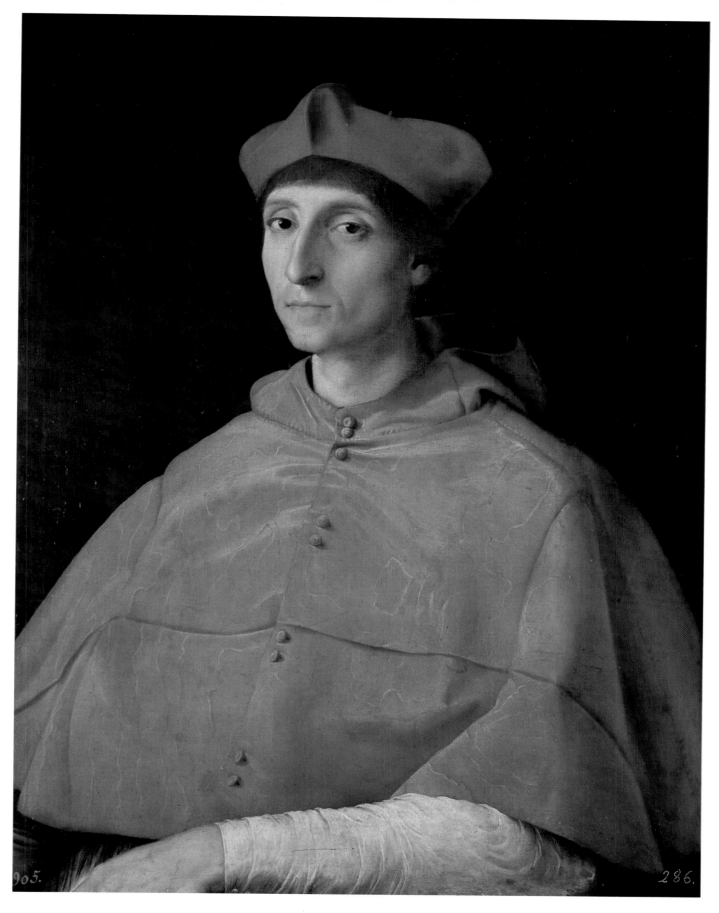

142. **Rafaello Sanzio,** called **Raphael** (1483–1520)
Portrait of a Cardinal. c. 1517 [no. 299]
Paint on board, 27 ½ × 24″ (70 × 61 cm)

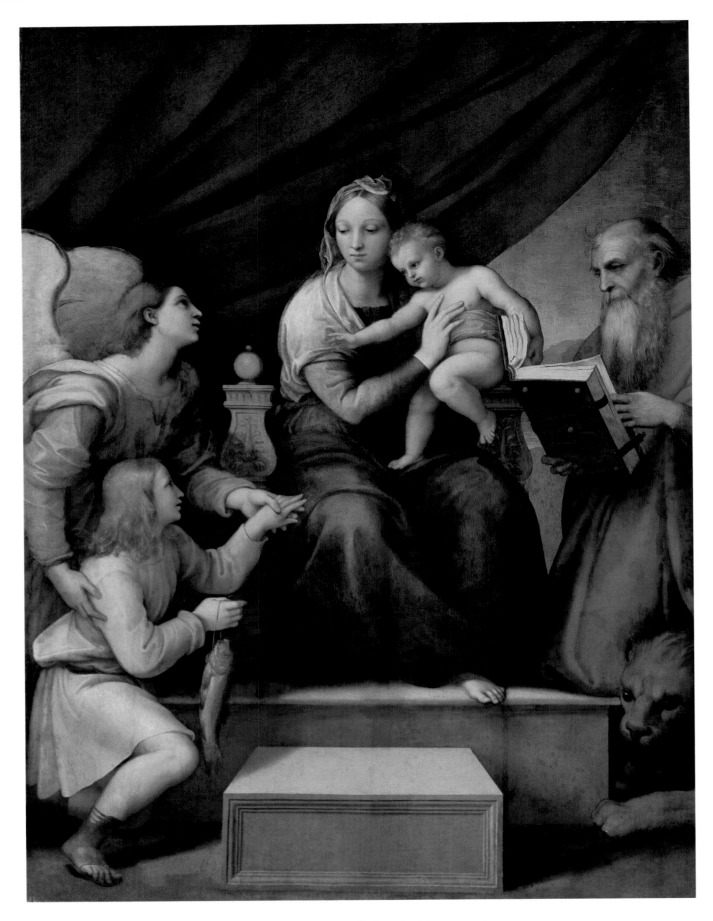

143. **Rafaello Sanzio,** called **Raphael** (1483–1520)
The Madonna of the Fish [no. 297]
Paint on board, transposed to canvas, 84⅝ × 62¼″ (215 × 158 cm)

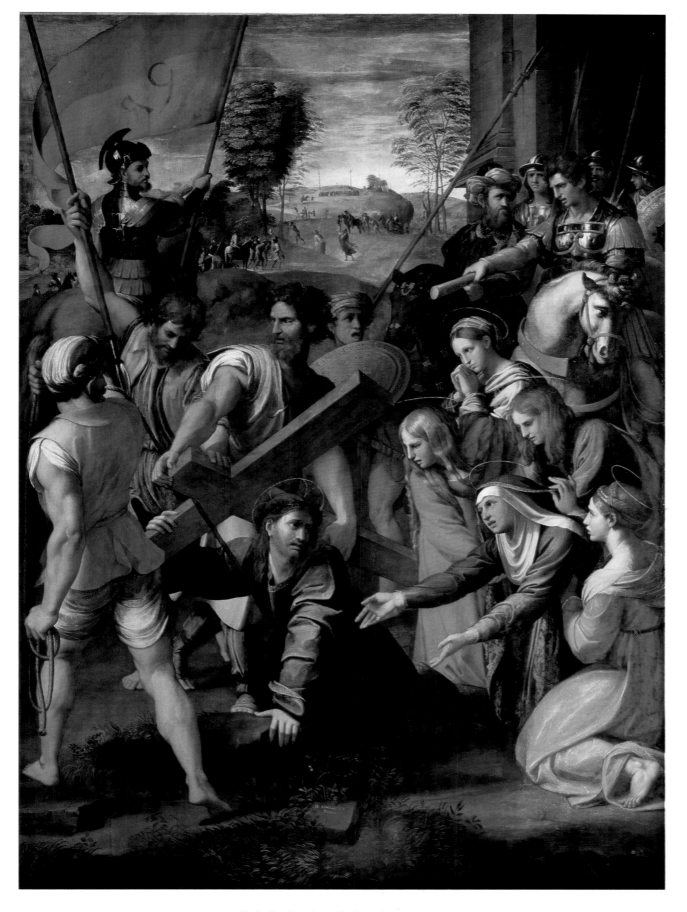

144. **Rafaello Sanzio**, called **Raphael** (1483–1520)
The Fall on the Road to Calvary. c. 1517 [no. 298]
Paint on board, transposed to canvas, 125 ¼ × 90 ⅛″ (318 × 229 cm)

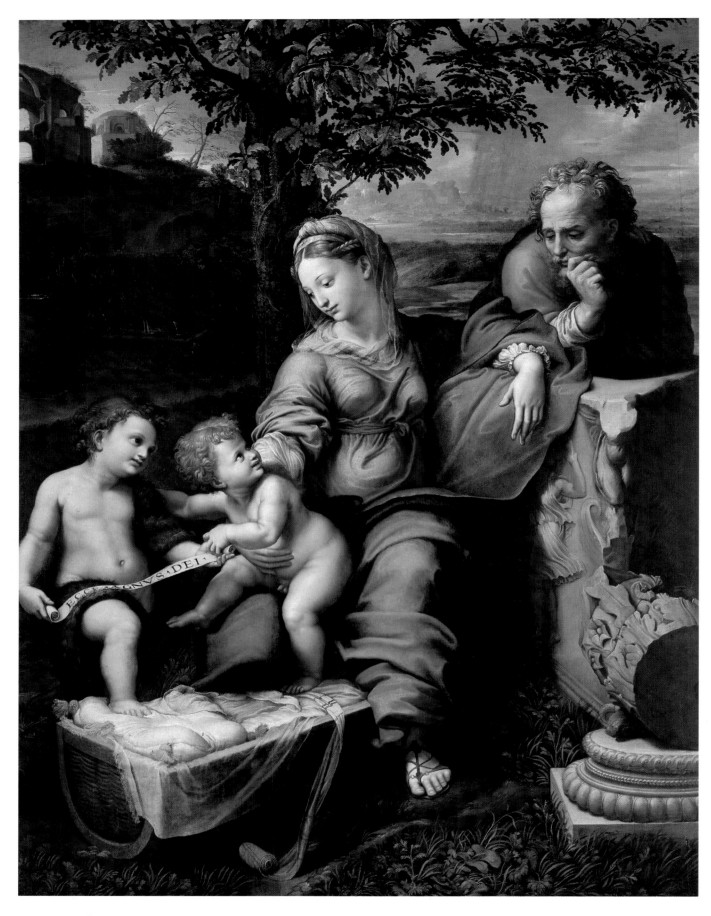

145. **Rafaello Sanzio**, called **Raphael** (1483–1520), and **Giulio Romano** (1499–1546)
The Holy Family with Oak Tree [no. 303]
Paint on board, 56¾ × 43¼" (144 × 110 cm)

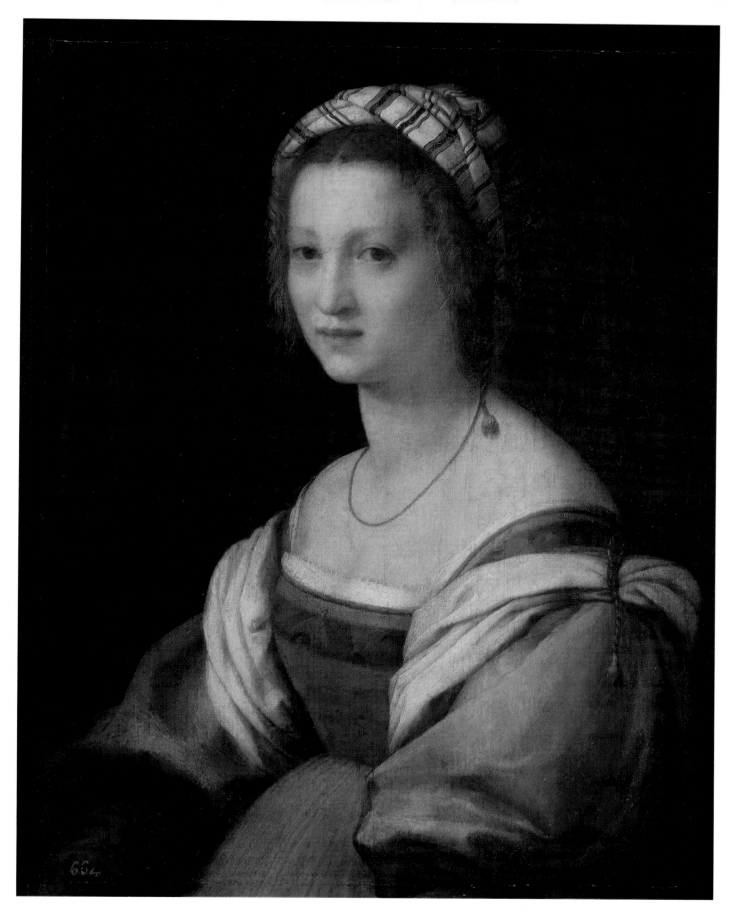

146. **Andrea da Angiolo,** called **Andrea del Sarto** (1486–1530)
Lucrecia di Baccio del Fede, Wife of the Painter [no. 332]
Paint on board, 28¾ × 22″ (73 × 56 cm)

291

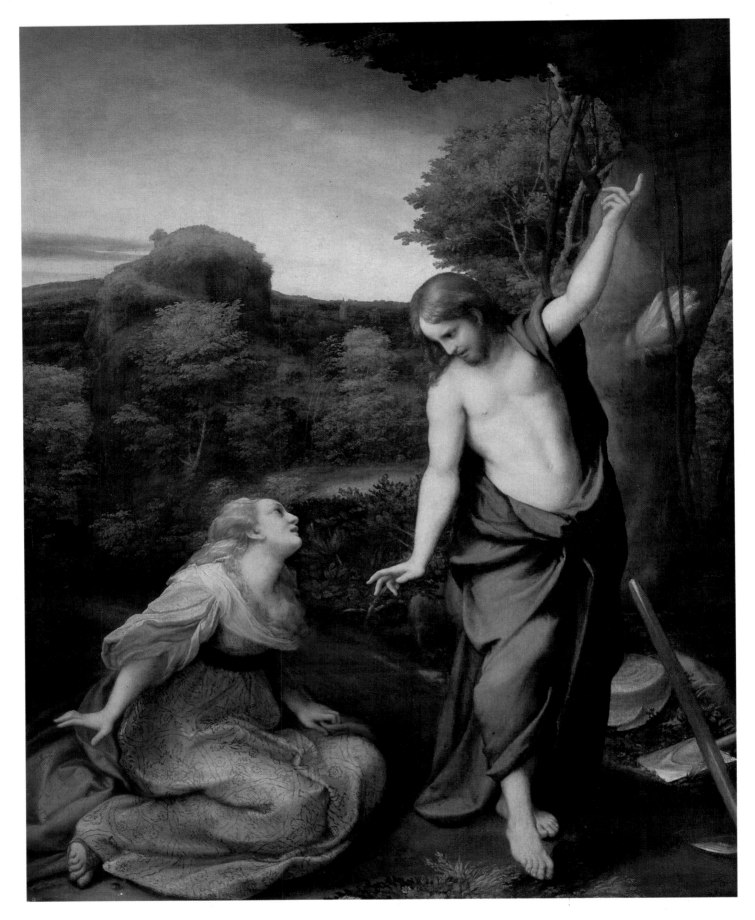

147. **Antonio Allegri da Correggio** (1493–1534)
"Noli Me Tangere" [no. 111]
Paint on board, transposed to canvas, 51 ⅛ × 40 ½" (130 × 103 cm)

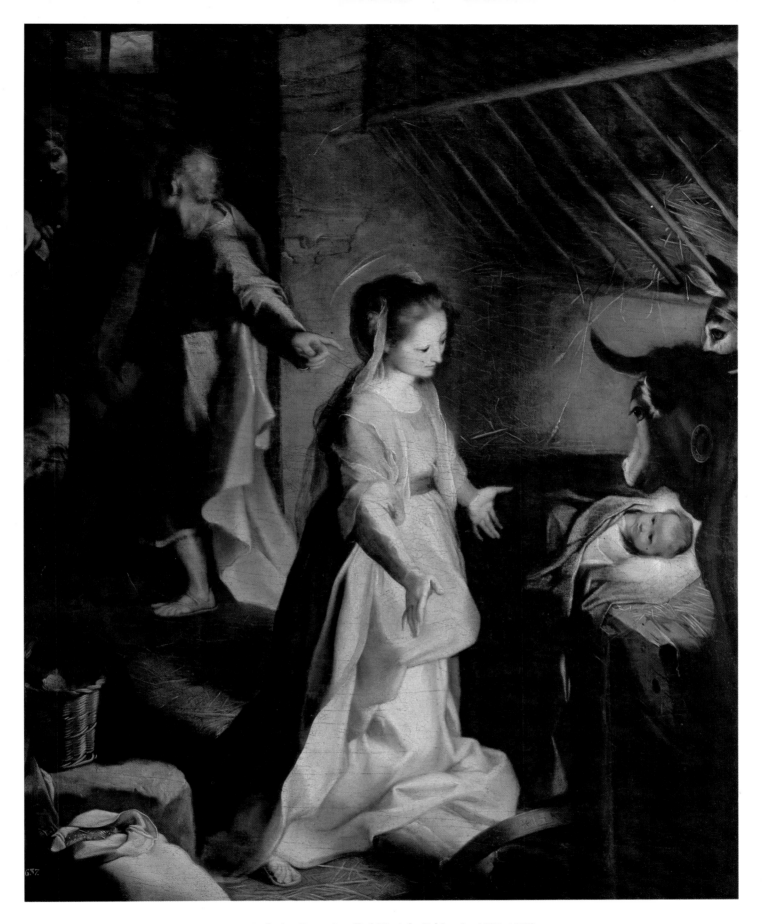

148. **Federico Barocci,** called **Fiori da Urbino** (c. 1535–1612)
The Birth [no. 18]
Oil on canvas, 52 ¾ × 41 ⅜″ (134 × 105 cm)

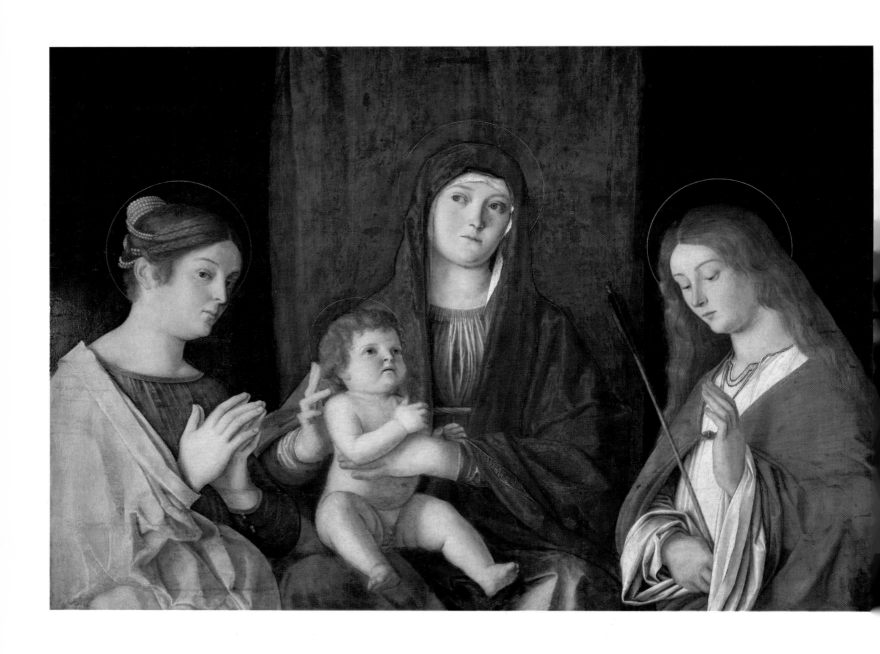

149. **Giovanni Bellini** (after 1429–1516)
The Virgin and Child Between Two Saints [no. 50]
Paint on board, 30⅛ × 41″ (77 × 104 cm)

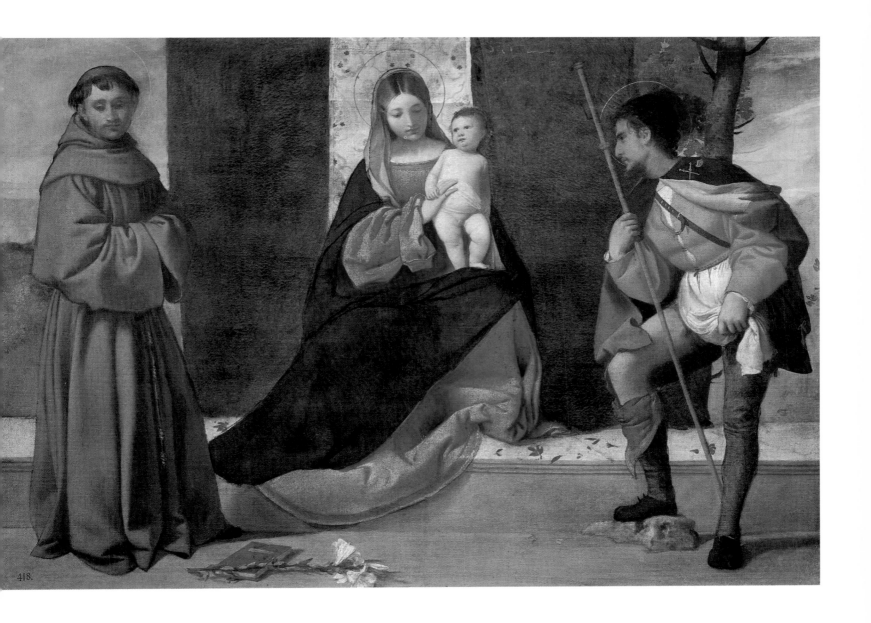

418.

150. Giorgio da Castelfranco Giorgione (1478–1510)
The Virgin with the Babe in Arms Between Saint Antonio de Padua and Saint Roque [no. 288]
Oil on canvas, 36 ¼ × 52 ⅜″ (92 × 133 cm)

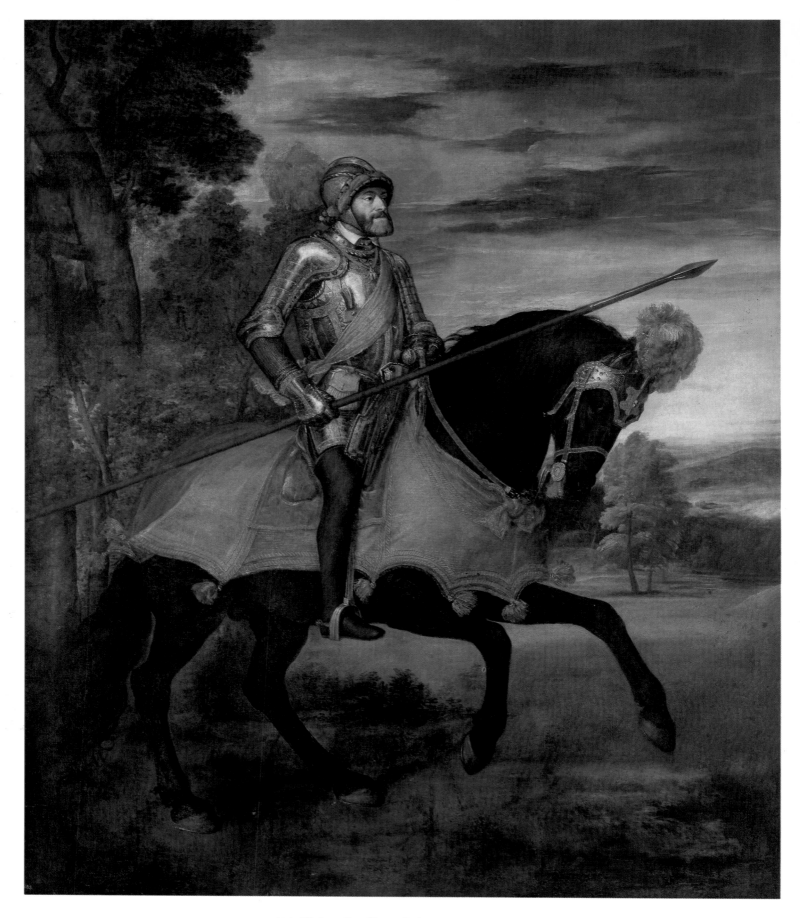

151. **Tiziano Vecellio,** called **Titian** (c. 1490–1576)
The Emperor Charles V on Horseback, in Mühlberg. 1548 [no. 410]
Oil on canvas, 130¾ × 109⅞" (332 × 279 cm)

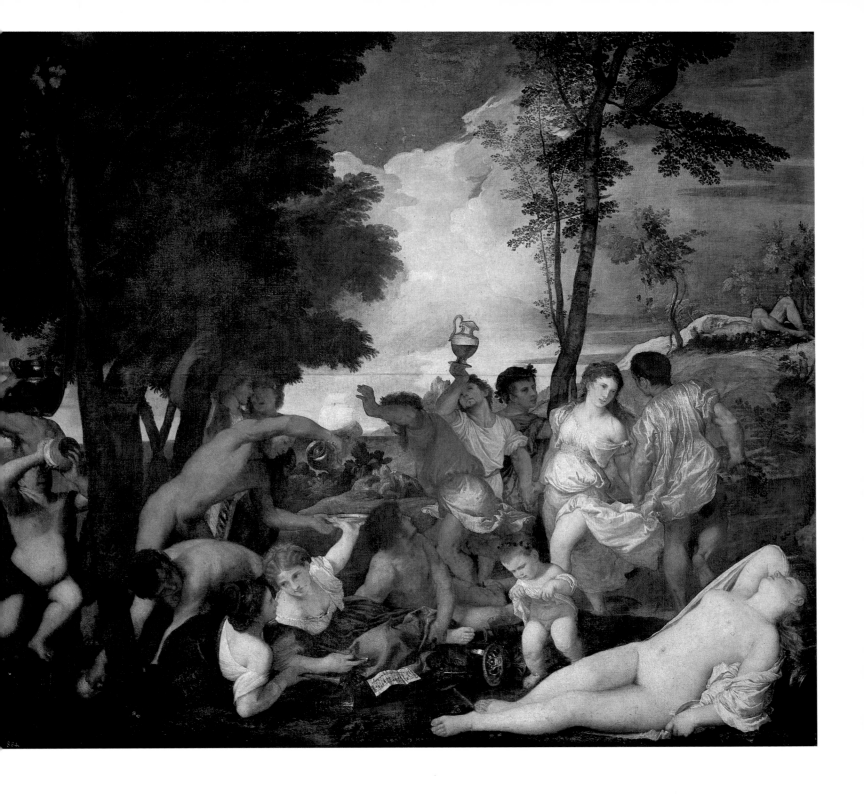

152. **Tiziano Vecellio,** called **Titian** (c. 1490–1576)
The Bacchanal. c. 1520 [no. 418]
Oil on canvas, 68 ⅞ × 76″ (175 × 193 cm)

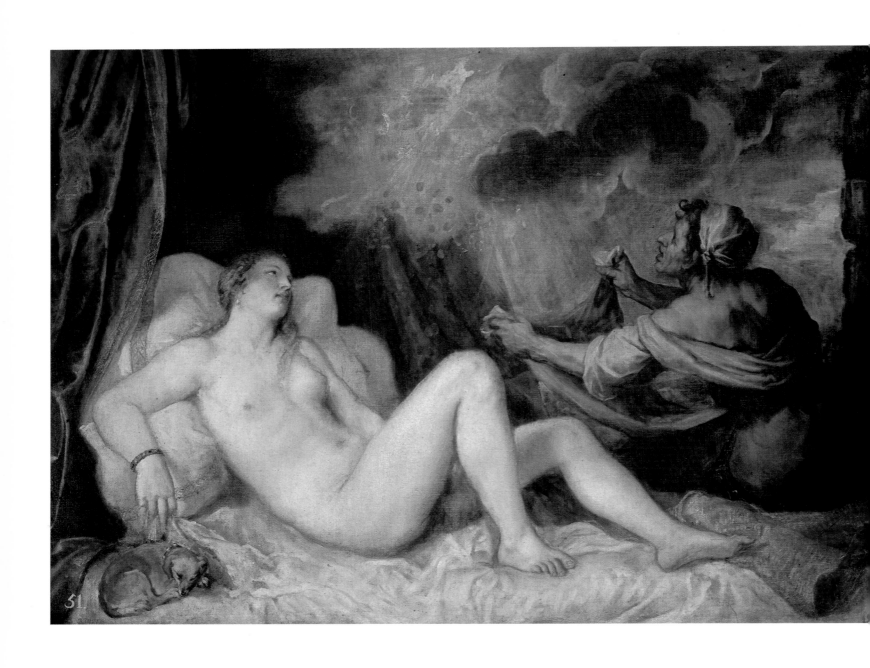

153. **Tiziano Vecellio,** called **Titian** (c. 1490–1576)
Danaë and the Shower of Gold. 1553 [no. 425]
Oil on canvas, 50 ¾ × 70 ⅞″ (129 × 180 cm)

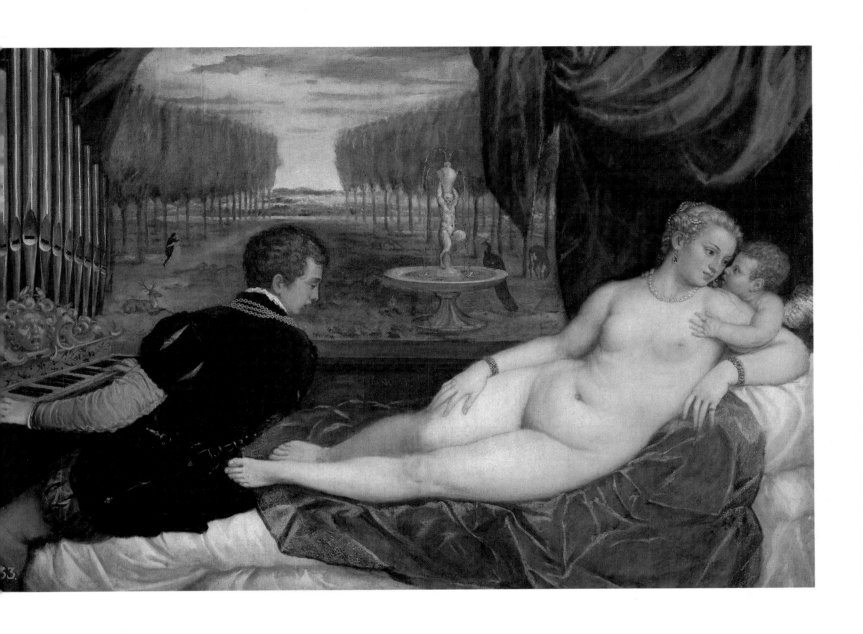

154. **Tiziano Vecellio,** called **Titian** (c. 1490–1576)
Venus Delighting Herself with Love and Music [no. 421]
Oil on canvas, 58 ¼ × 85 ⅜″ (148 × 217 cm)

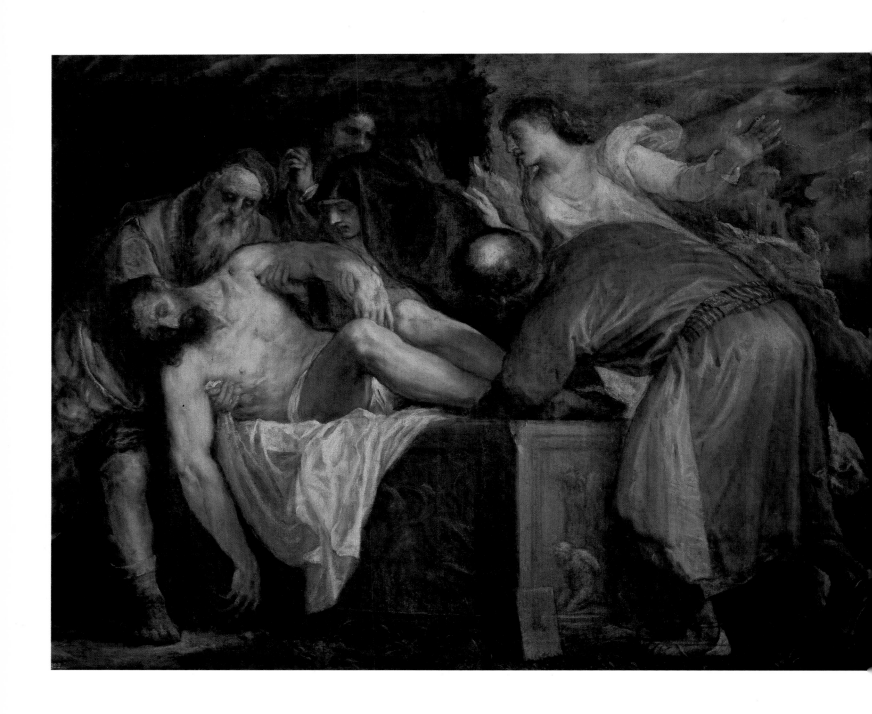

155. **Tiziano Vecellio,** called **Titian** (c. 1490–1576)
The Entombment of Christ. 1559 [no. 440]
Oil on canvas, 53 ⁷/₈ × 68 ⁷/₈″ (137 × 175 cm)

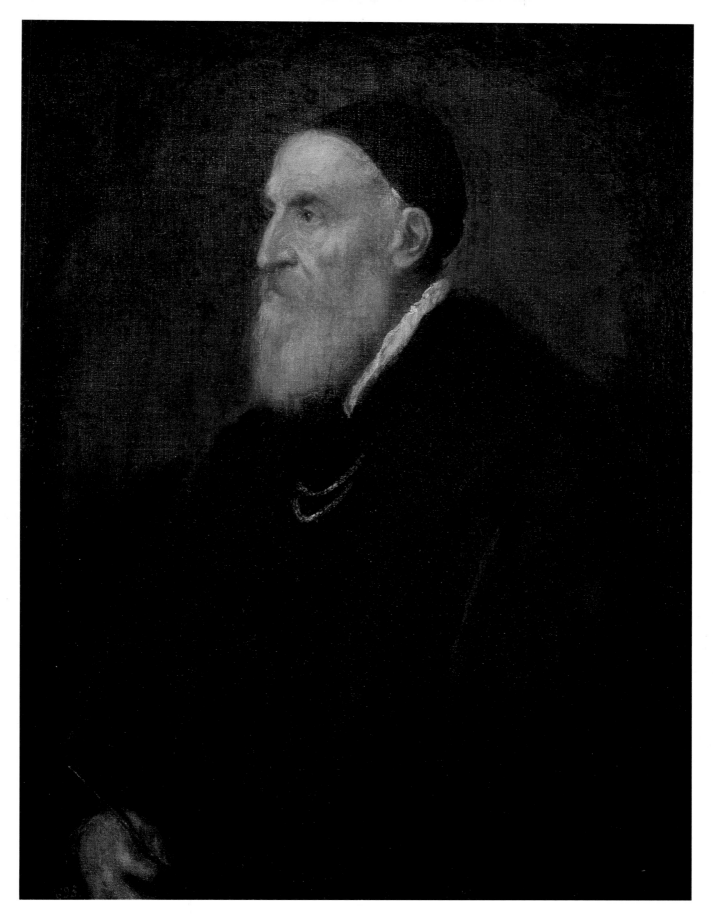

156. **Tiziano Vecellio,** called **Titian** (c. 1490–1576)
Self-Portrait. 1657 [no. 407]
Oil on canvas, 33 7/8 × 25 5/8″ (86 × 65 cm)

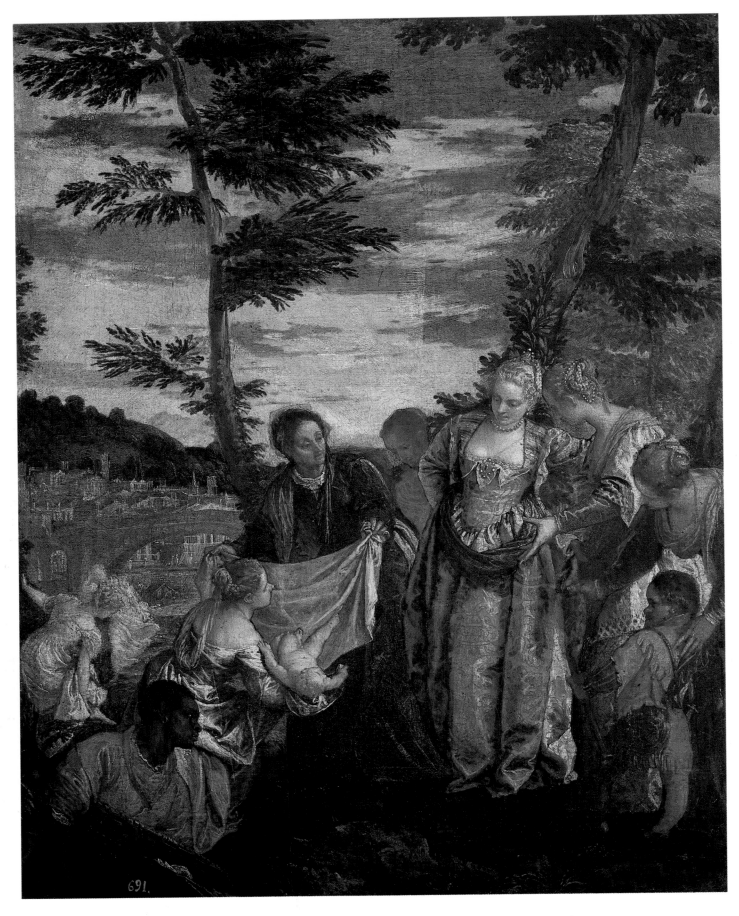

157. **Paolo Caliari**, called **Paolo Veronese** (1528?–1588)
The Finding of Moses [no. 502]
Oil on canvas, 19⅝ × 16⅞″ (50 × 43 cm)

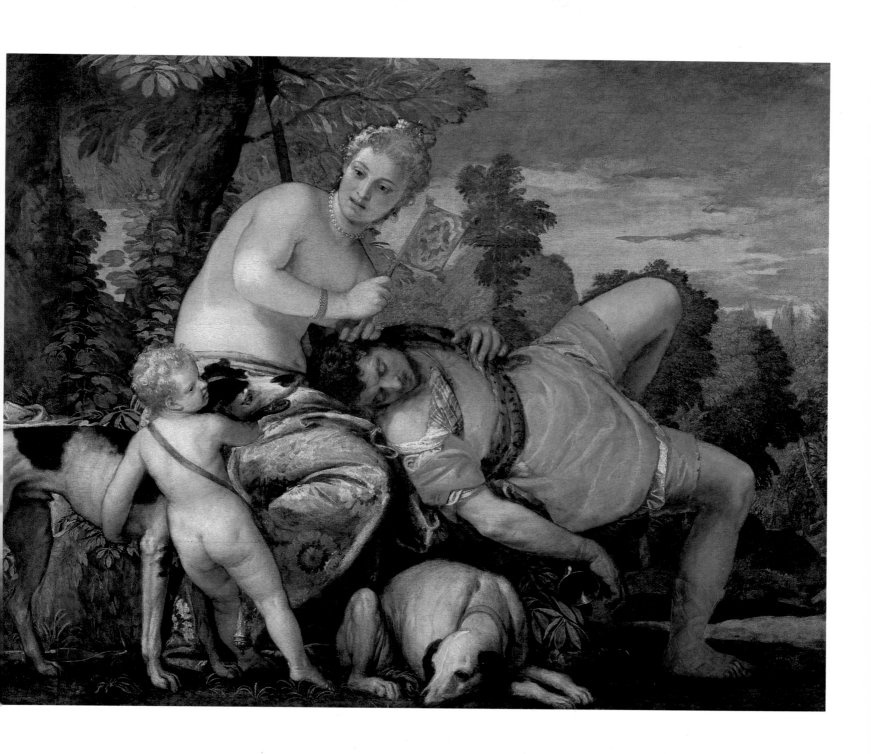

158. **Paolo Caliari,** called **Paolo Veronese** (1528?–1588)
Venus and Adonis [no. 482]
Oil on canvas, 61 × 75 ¼″ (155 × 191 cm)

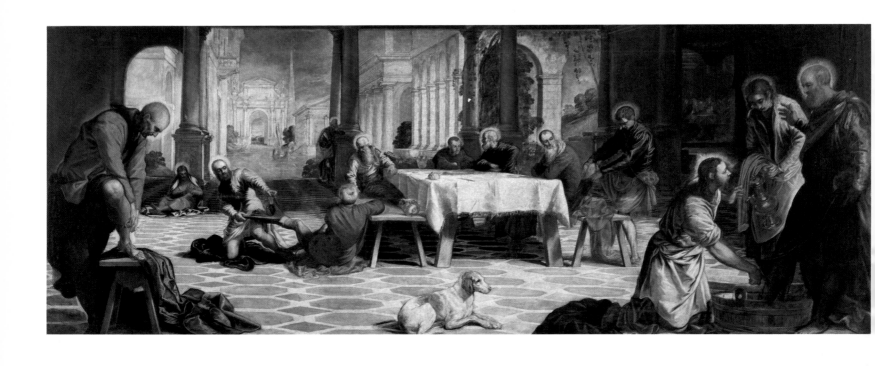

159 & 160. **Jacopo Robusti**, called **Tintoretto** (1518–1594)
The Maundy. 1547 [no. 2824]
Oil on canvas, 82 ⁵⁄₈ × 209 ⁷⁄₈″ (210 × 533 cm)

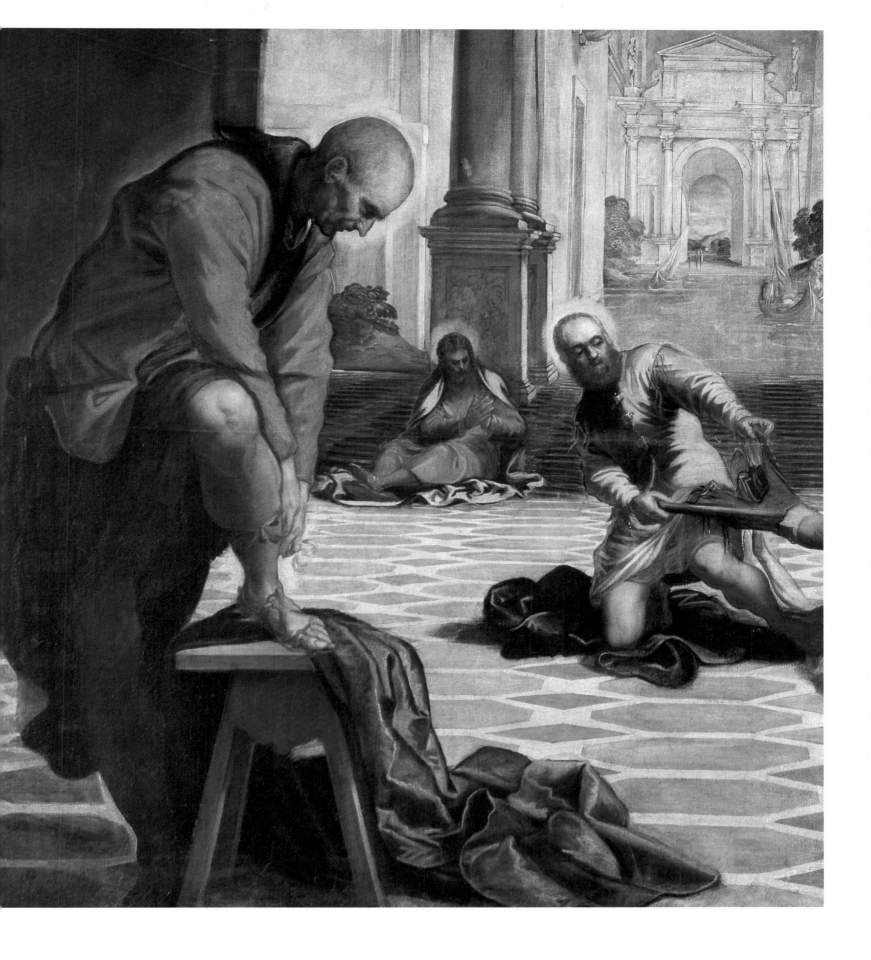

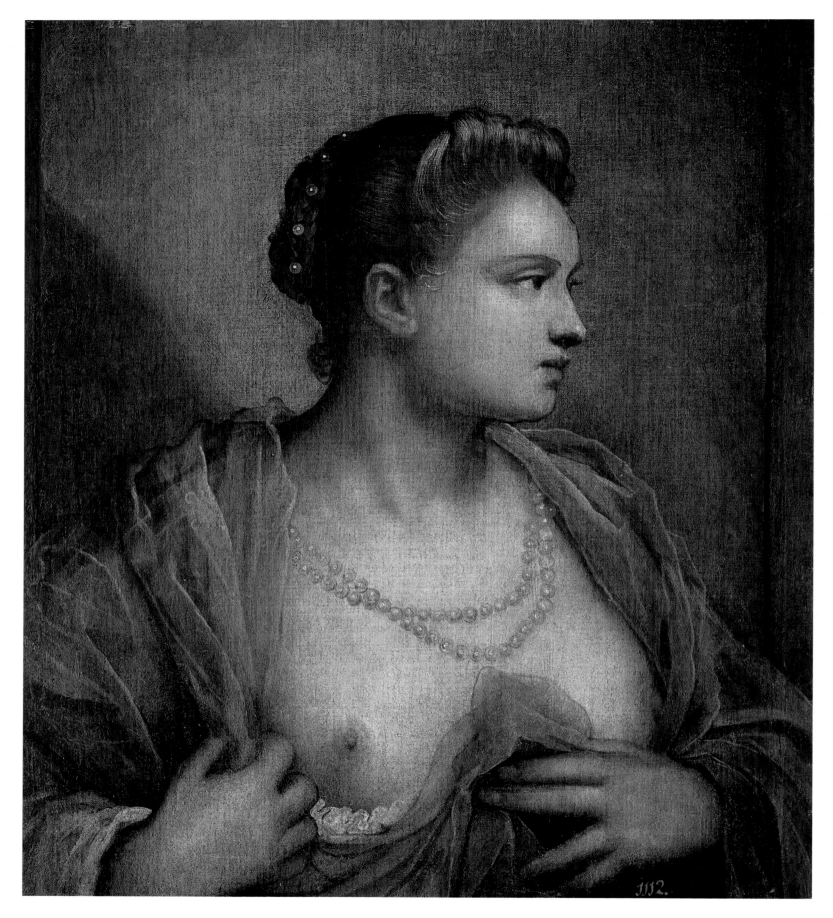

161. **Jocopo Robusti,** called **Tintoretto** (1518–1594)
The Woman Who Discovers the Bosom [no. 382]
Oil on canvas, 24 × 21⅝″ (61 × 55 cm)

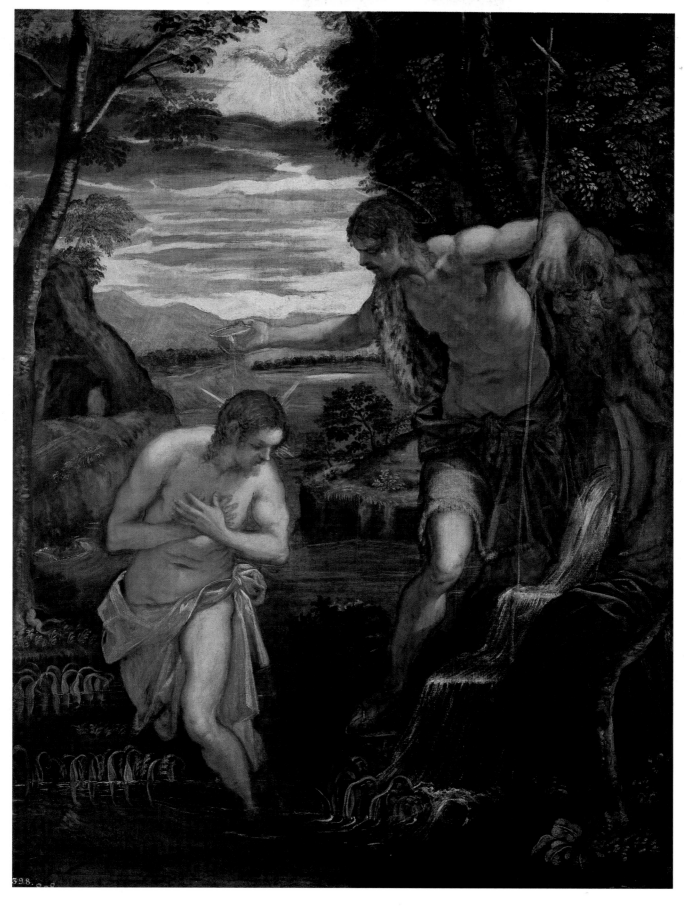

162. **Jocopo Robusti,** called **Tintoretto** (1518–1594)
The Baptism of Christ [no. 397]
Oil on canvas, 53 ⅞ × 41 ⅜″ (137 × 105 cm)

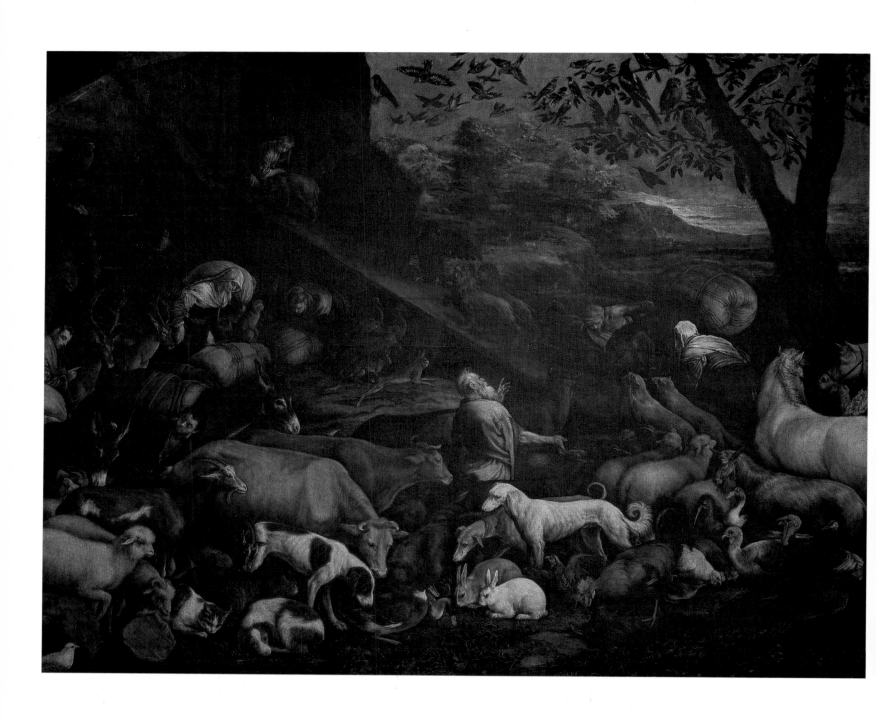

163. **Jacopo da Ponte Bassano** (1510/15–1592)
The Animals Entering Noah's Ark [no. 22]
Oil on canvas, 81 ½ × 104 ⅜" (207 × 265 cm)

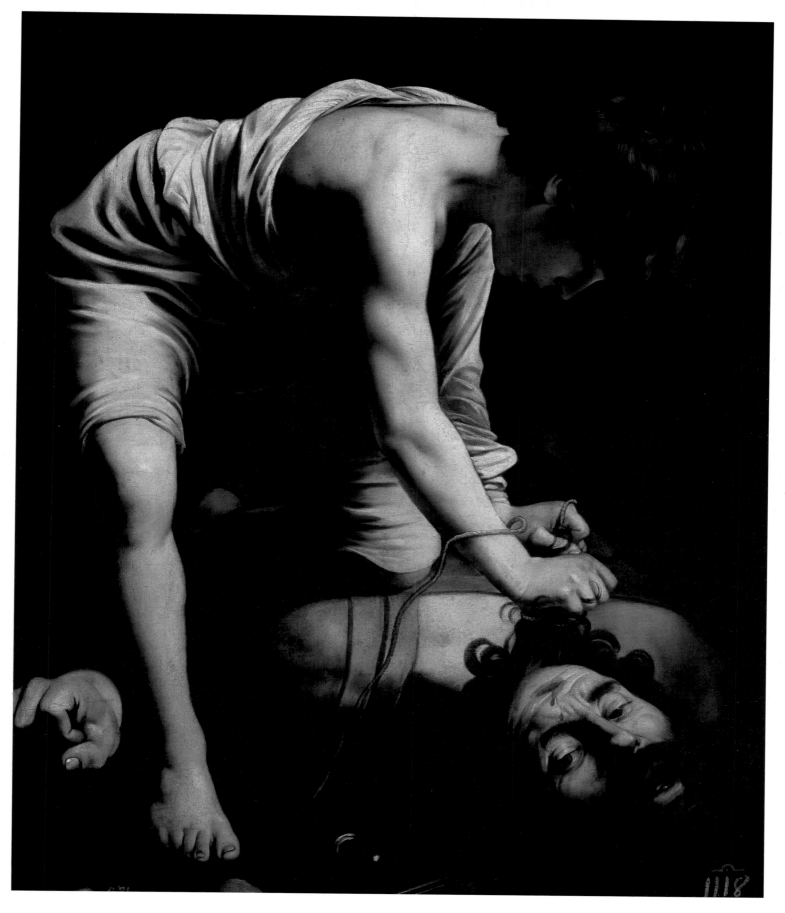

164. **Michelangelo Merisi,** called **Caravaggio** (1573–1610)
David, Victorious over Goliath [no. 65]
Oil on canvas, 43 1/4 × 35 7/8″ (110 × 91 cm)

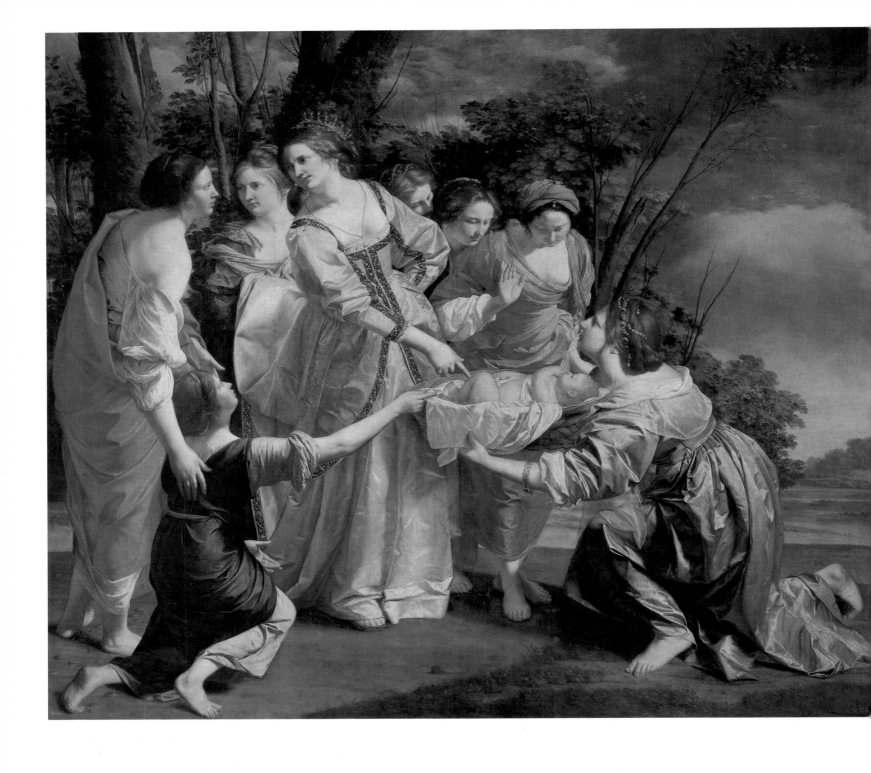

165. **Orazio Lomi de Gentileschi** (1563–1639)
Moses Rescued from the Waters of the Nile [no. 147]
Oil on canvas, 95 ¼ × 110 ⅝″ (242 × 281 cm)

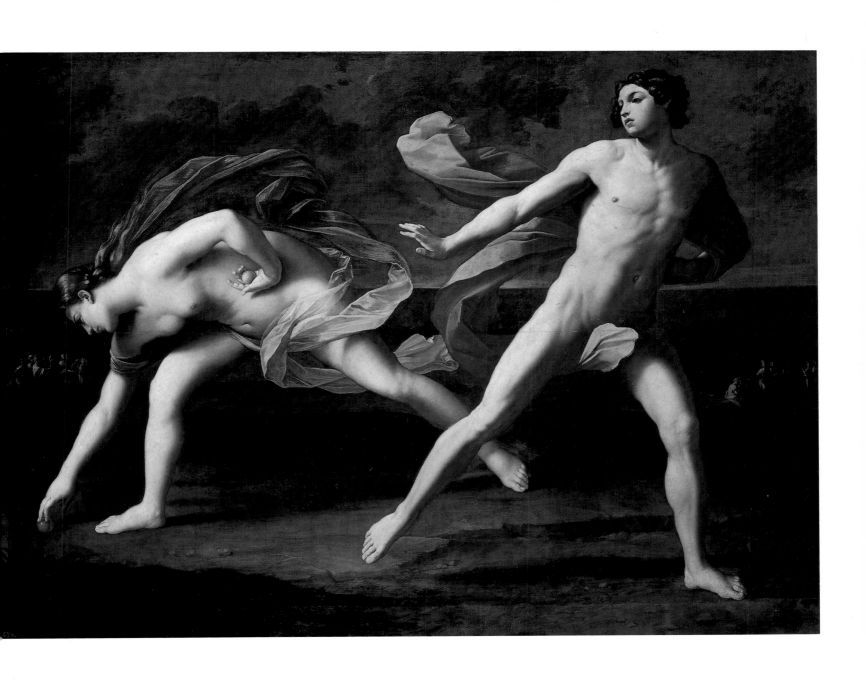

166. **Guido Reni** (1575–1642)
Hippomenes and Atlanta [no. 3090]
Oil on canvas, 81⅛ × 116⅞″ (206 × 297 cm)

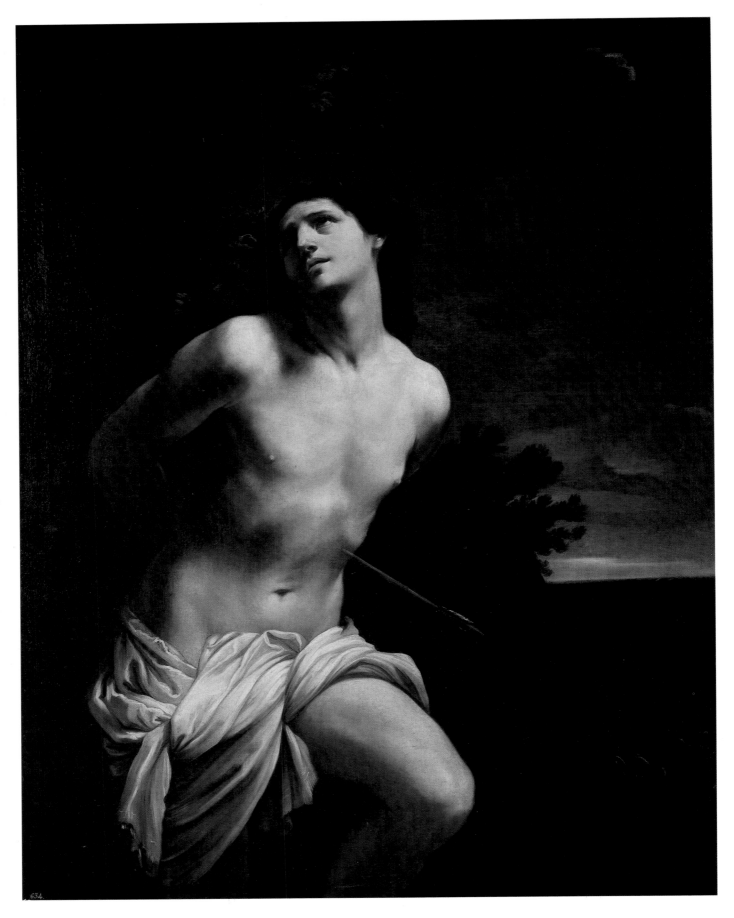

167. **Guido Reni** (1575–1642)
Saint Sebastian [no. 211]
Oil on canvas, 66⅞ × 52⅜″ (170 × 133 cm)

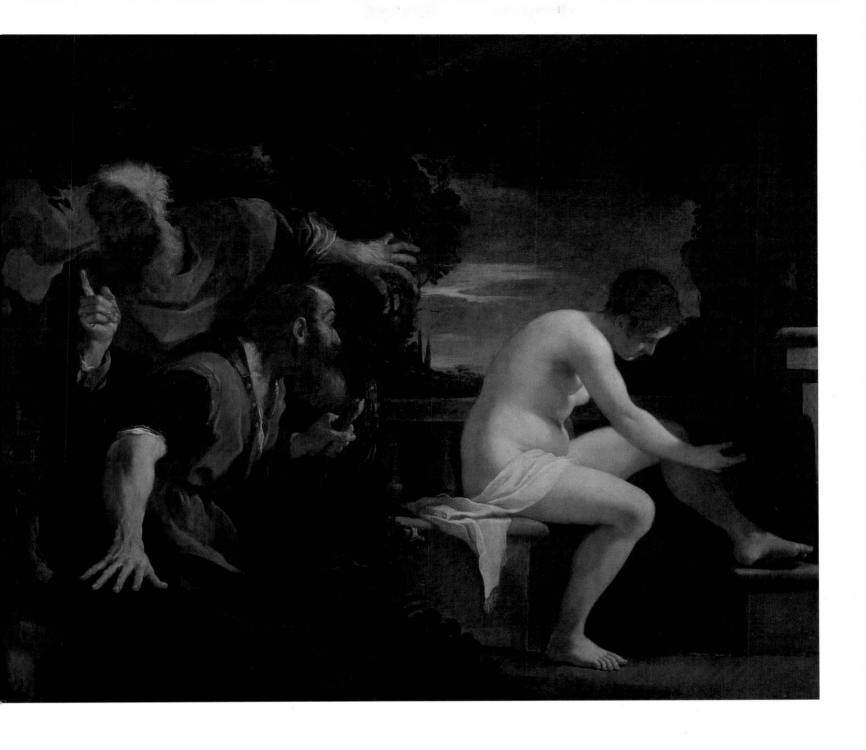

168. **Giovanni Francesco Barbieri,** called **Il Guercino** (1591–1666)
Susanna and the Elders [no. 201]
Oil on canvas, 68 7/8 × 81 1/2″ (175 × 207 cm)

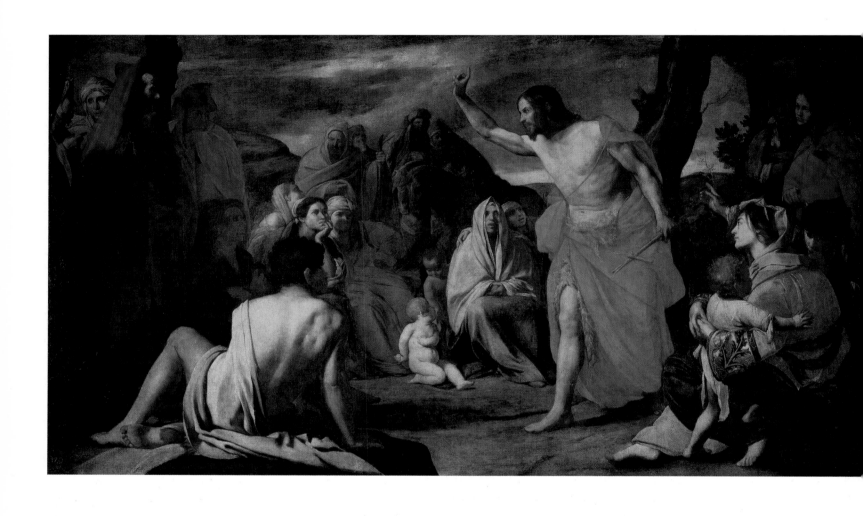

169. **Massimo Stanzione** (1585–1656)
Preaching of Saint John the Baptist in the Desert [no. 257]
Oil on canvas, 73 ⅜ × 131 ⅞″ (187 × 335 cm)

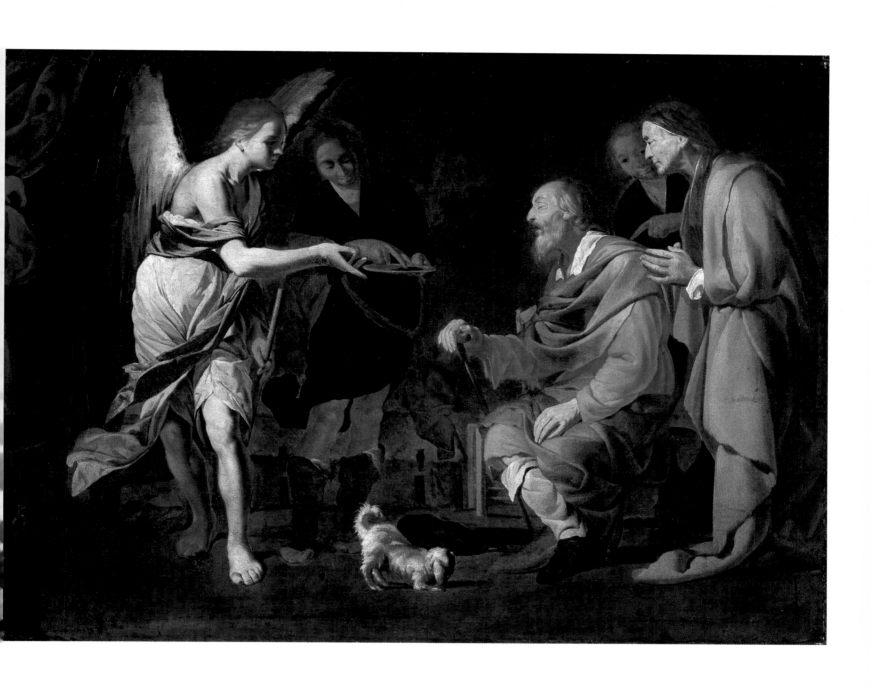

170. **Bernardo Cavallino** (1616– c. 1656)
The Curing of Tobias [no. 3151]
Oil on canvas, 29⅞ × 40½″ (76 × 103 cm)

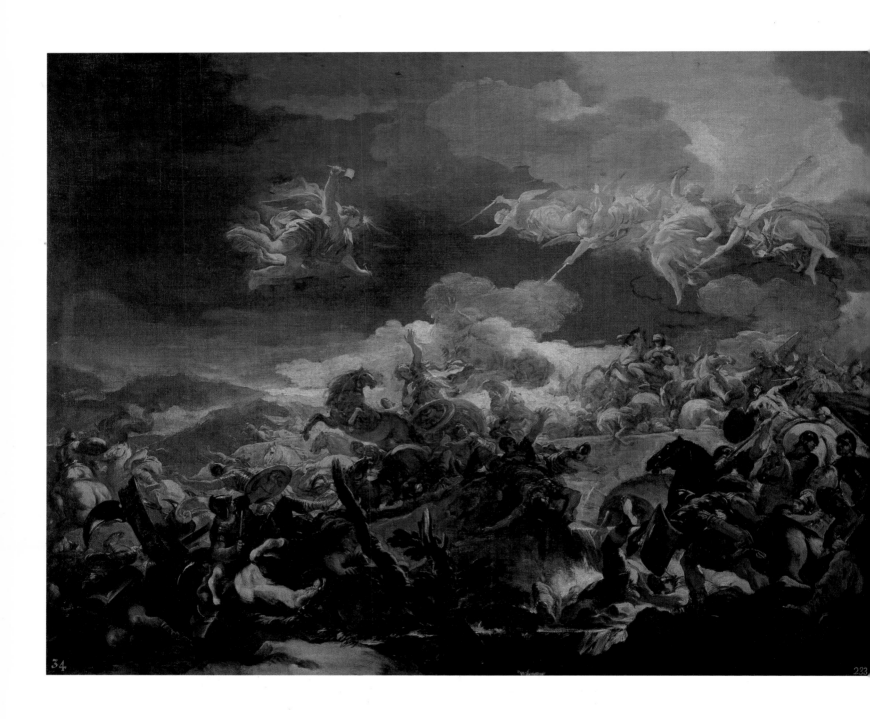

171. **Luca Giordano** (1632–1705)
The Defeat of Sisara [no. 160]
Oil on canvas, 40 ⅛ × 51 ⅛″ (102 × 130 cm)

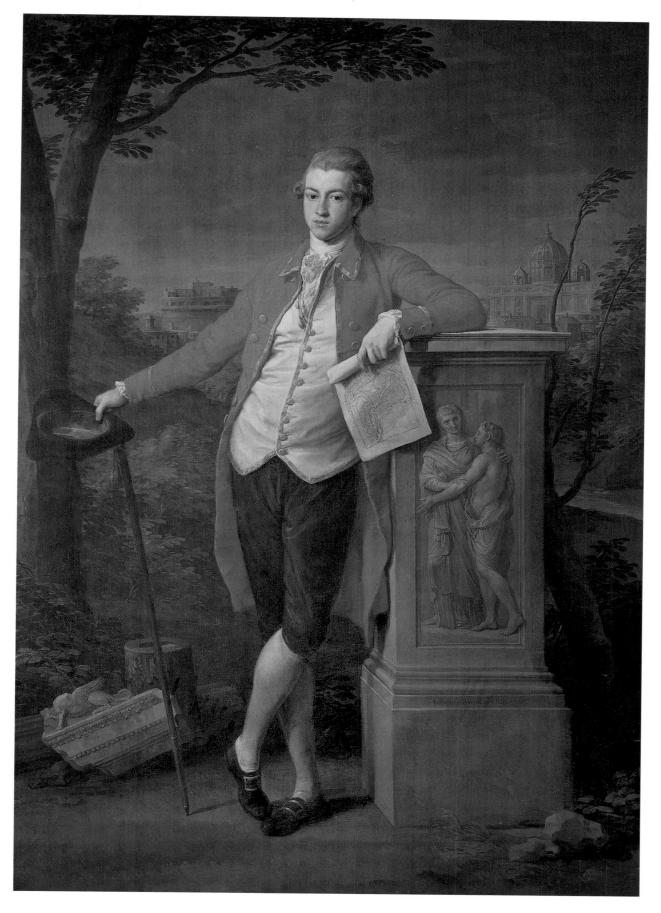

172. **Pompeo Girolamo Batoni** (1708–1787)
A Knight in Rome: Charles Cecil Roberts. 1778 [no. 49]
Oil on canvas, 87 × 61 ¾″ (221 × 157 cm)

317

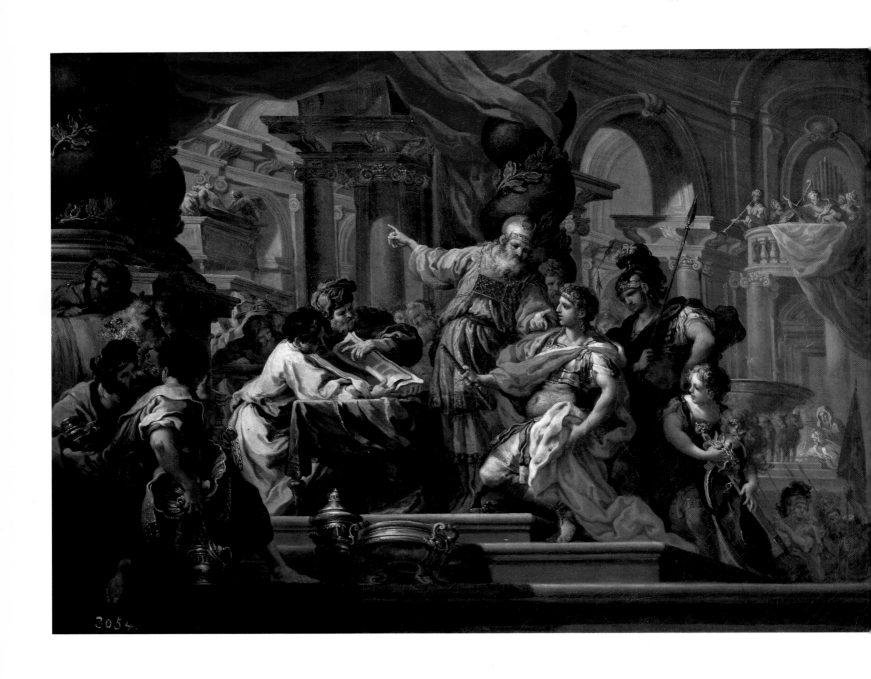

173. **Sebastiano Conca** (1680–1764)
Alexander the Great in the Temple of Jerusalem. 1735/37 [no. 101]
Oil on canvas, 20 ½ × 27 ½″ (52 × 70 cm)

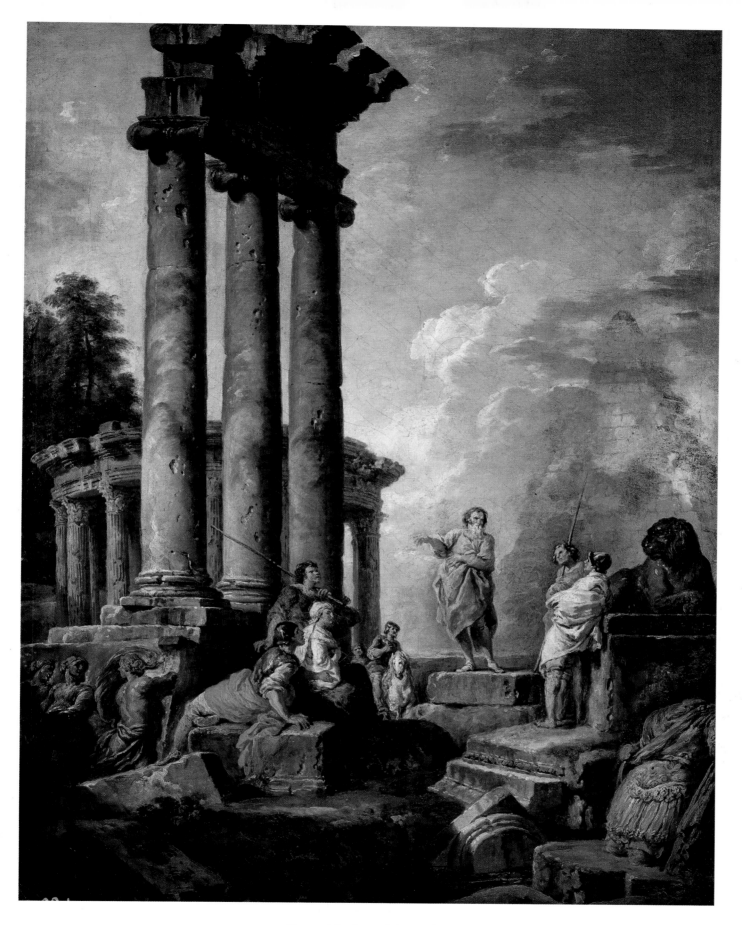

174. Giovanni Paolo Panini (1691/92–1765)
Ruins with Saint Paul (?) Preaching. 1735 [no. 275]
Oil on canvas, 24¾ × 18⅞″ (63 × 48 cm)

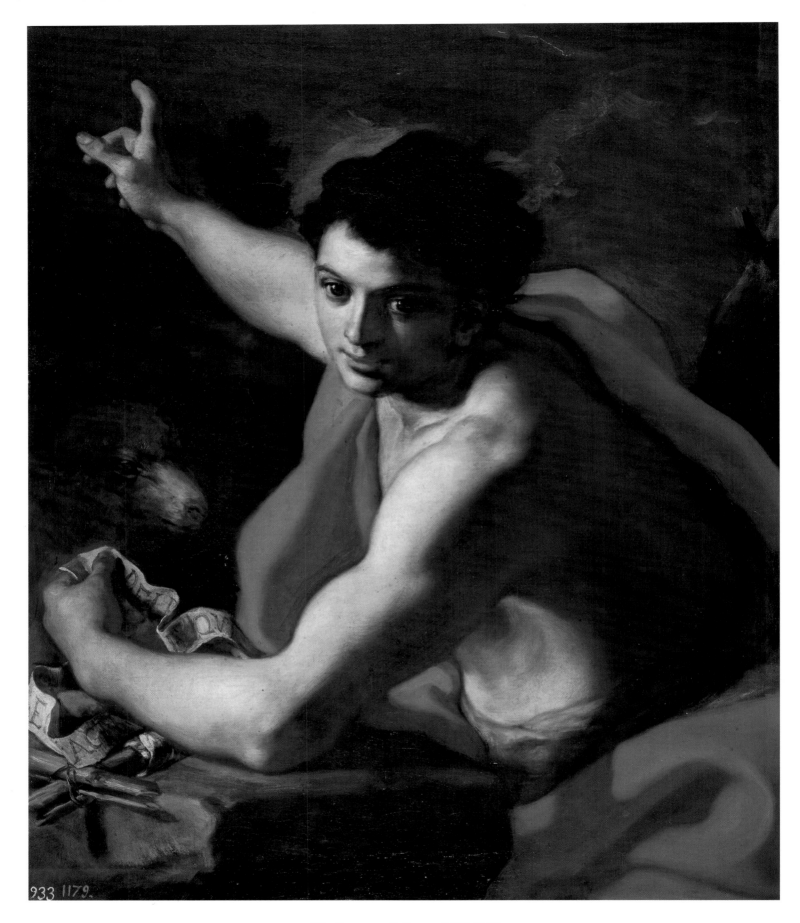

933 1179.

175. **Francesco Solimena** (1657–1747)
Saint John the Baptist [no. 351]
Oil on canvas, 32 ⅝ × 27 ½″ (83 × 70 cm)

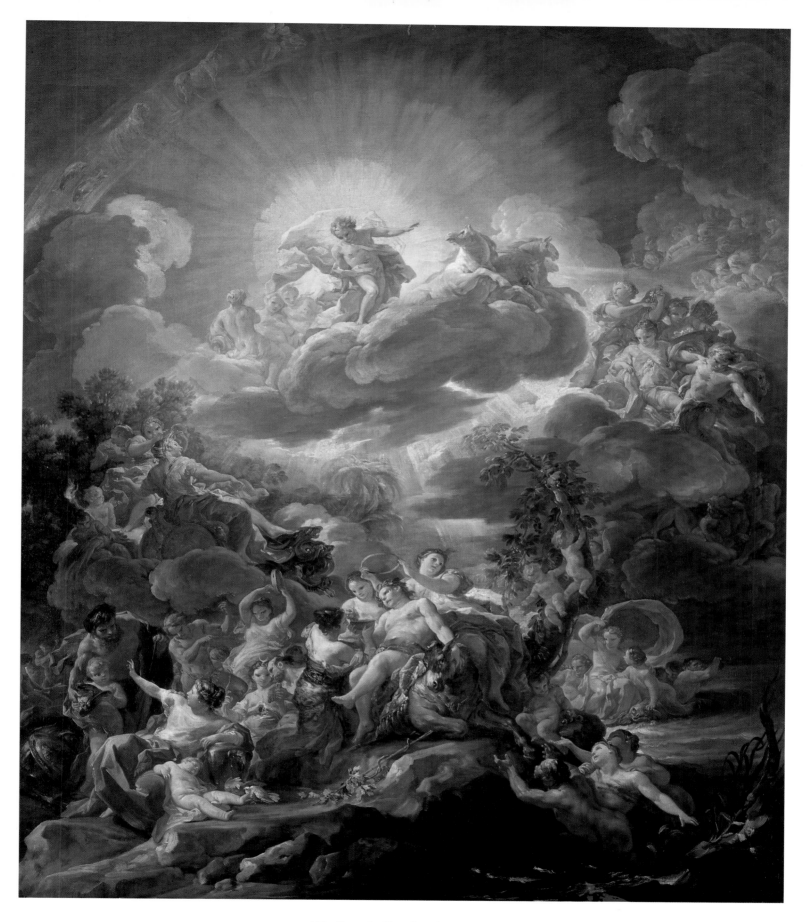

176. **Corrado Giaquinto** (1700–1765)
The Birth of the Sun and the Triumph of Bacchus. 1762 [no. 103]
Oil on canvas, 66 ⅛ × 55 ⅛″ (168 × 140 cm)

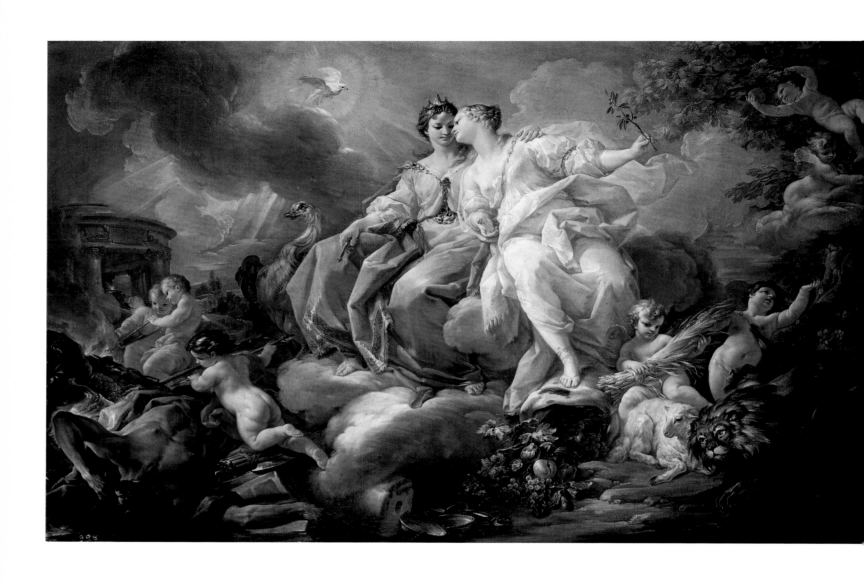

177. **Corrado Giaquinto** (1700–1765)
Justice and Peace [no. 104]
Oil on canvas, 85 × 128″ (216 × 325 cm)

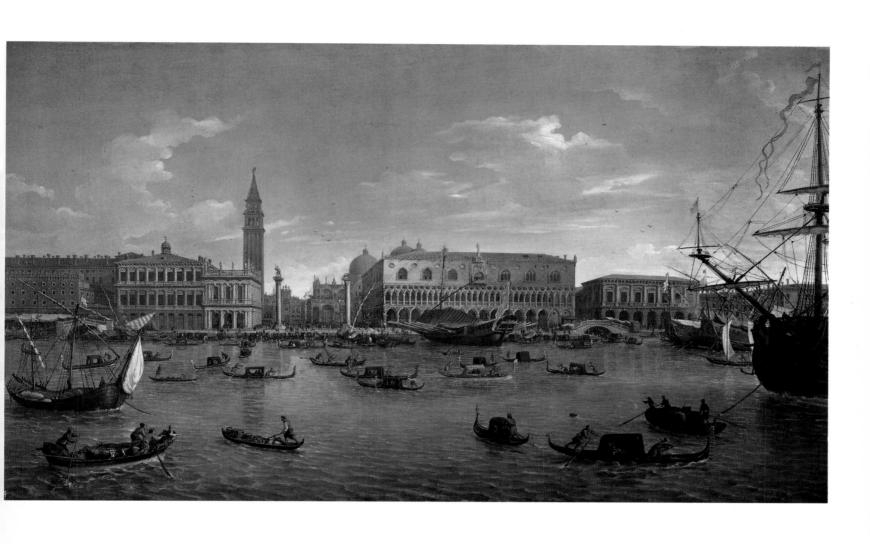

178. **Luigi Vanvitelli** (1655–1736)
Venice Seen from the Isle of San Giorgio. 1697 [no. 475]
Oil on canvas, 38 ⅝ × 67 ⅜″ (98 × 171 cm)

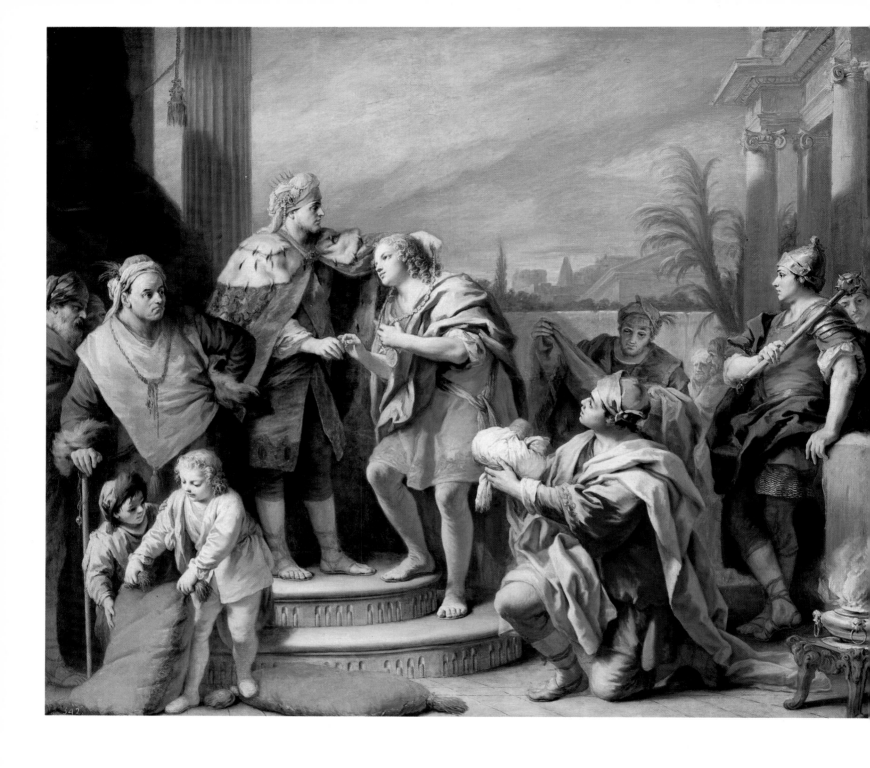

179. **Jacopo Amiconi** (c. 1680–1752)
Joseph in the Pharaoh's Palace [no. 5261]
Oil on canvas, 111 3/8 × 128″ (283 × 325 cm)

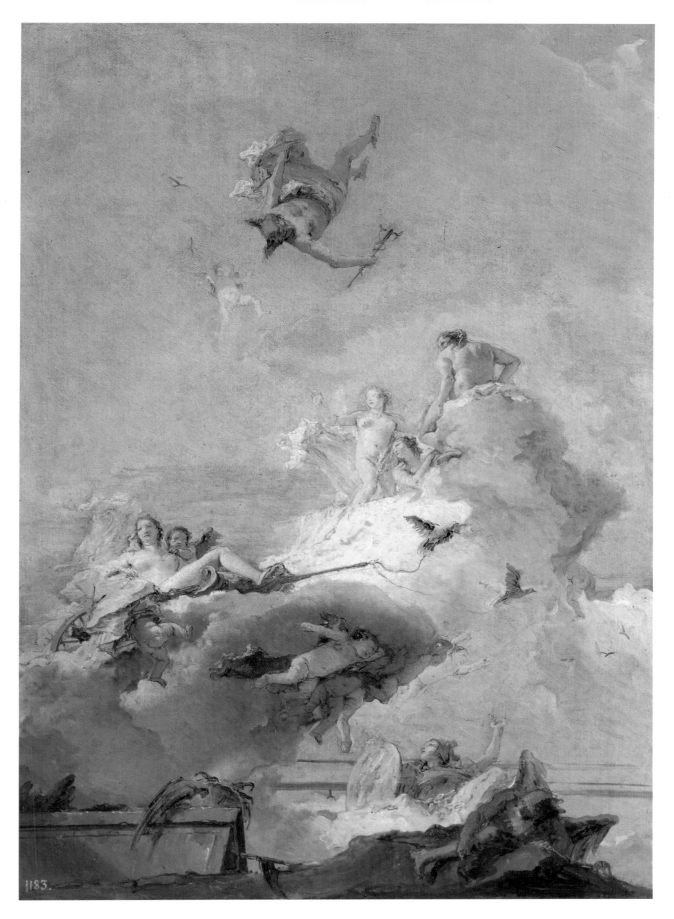

180. Giovanni Battista Tiepolo (1696–1770)
The Olympus [no. 365]
Oil on canvas, 33 ⅞ × 24 ⅜″ (86 × 62 cm)

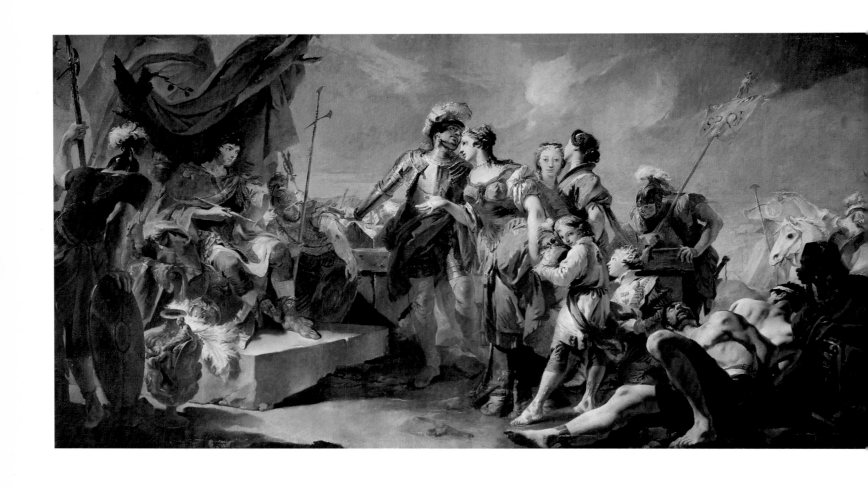

181. **Giovanni Battista Tiepolo** (1696–1770)
Queen Zenobia before Emperor Aurelianus [no. 3243]
Oil on canvas, 98 3/8 × 196 7/8″ (250 × 500 cm)

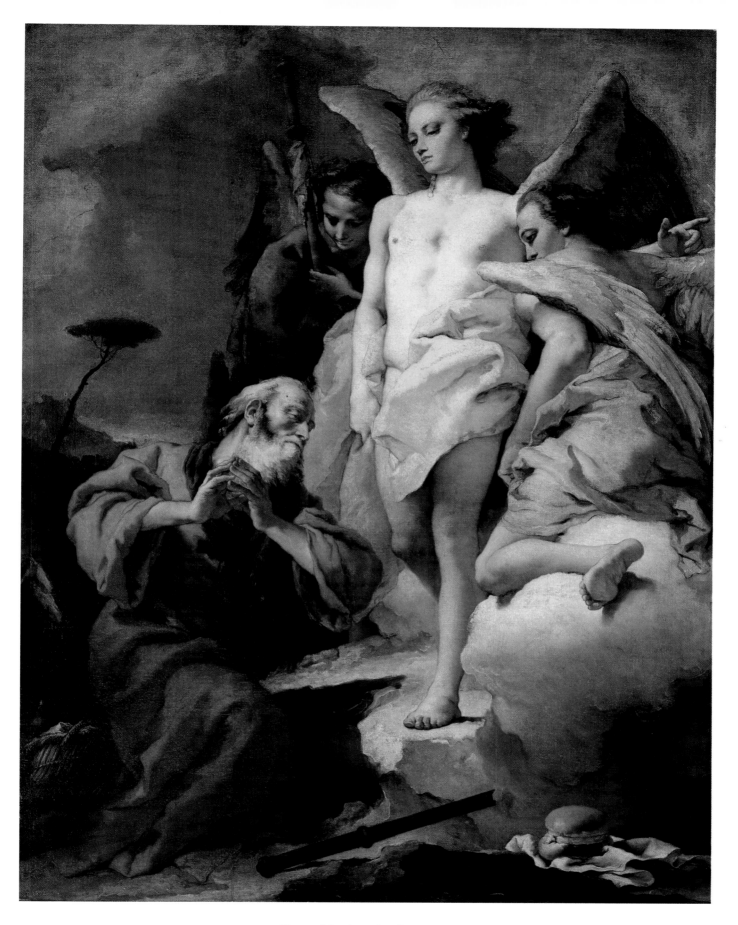

182. Giovanni Battista Tiepolo (1696–1770)
Abraham and the Three Angels [no. 2464]
Oil on canvas, 77 1/2 × 59 1/2″ (197 × 151 cm)

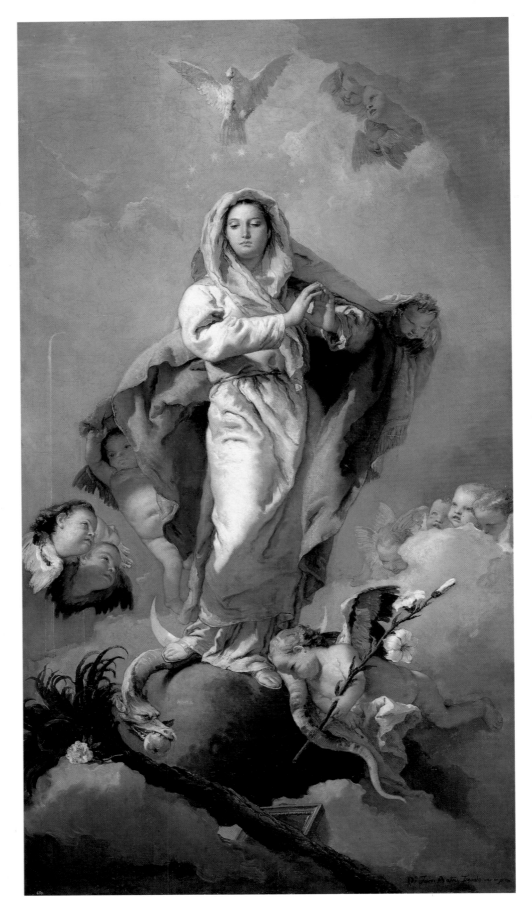

183. Giovanni Battista Tiepolo (1696–1770)
The Immaculate Conception [no. 363]
Oil on canvas, 109⅞ × 59⅞″ (279 × 152 cm)

328

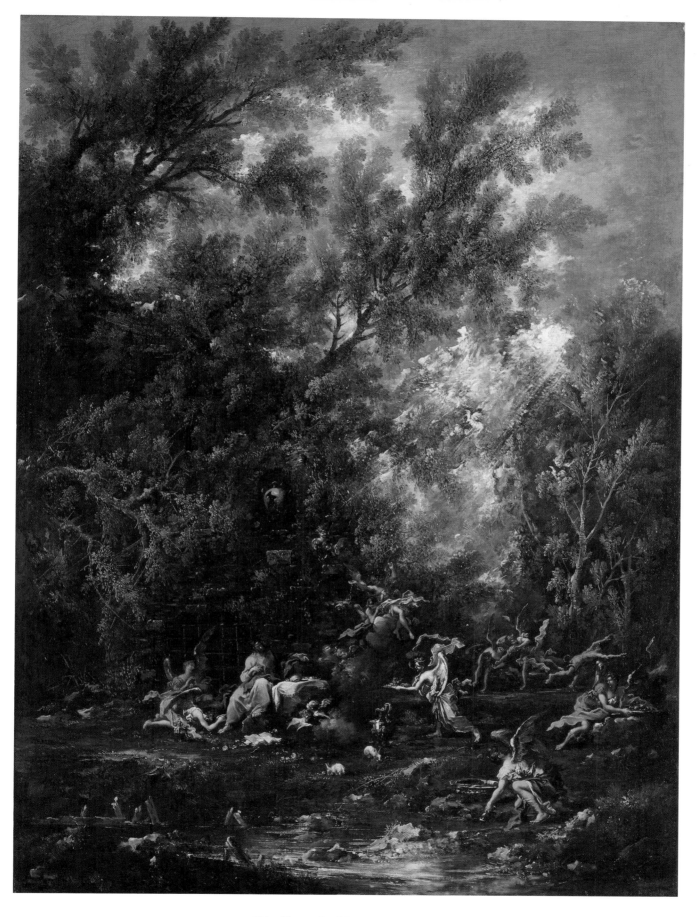

184. **Alessandro Magnasco** (1677–1749)
Christ Served by the Angels [no. 3124]
Oil on canvas, 76 × 55 ⅞" (193 × 142 cm)

FLEMISH SCHOOL

The comments made with reference to the Italian groups, so fundamental to the high artistic level of the Prado Museum collections, could be repeated with reference to the schools developed in the Flemish cities. Like those of Italy, these too were closely linked to the Spanish court, although in the case of Flanders this relationship ended with the signing of two treaties, that of Westphalia, by which Holland achieved her independence in 1644, and the Treaty of Utrecht, which in 1714 separated from Spain the southern, Catholic area, which came to form part of the Austrian Empire in 1715.

The style of the Flemish painters, who brought with them the new technique of transparent oil painting (the tempera used by the Italians was opaque), was adopted by the Court of Castile in the second third of the fifteenth century. Among the pioneers of this style was the painter of *The Fountain of Grace*, who had considerable affinities with the Van Eycks. To this circle also belonged Petrus Christus and Louis Alincbrot (. . . 1432–c. 1463), who painted a complex composition depicting *Scenes from the Life of Christ* (plate 185). Somewhat vague is the figure of Robert Campin (c. 1375–1444), formerly referred to as the Master of Flemalle, who painted *The Nuptials of the Virgin* (plate 186) with grisailles on the back; he was also responsible for the diptych with *Saint John the Baptist and the Franciscan Maestro Henricus Werl* (plate 187), in which he reveals his mastery of interiors, and *Saint Barbara* (plate 188), which confirms his equally masterful treatment of light and color. The style of Rogier van der Weyden (1399/1400–1464), concerned essentially with narrative, is characterized by balanced, elegant, and highly expressive figures. The quality of his work can be appreciated in *The Descent from the Cross* (plate 189), *Piety*, and *The Virgin and Child* (plate 190), popular subjects at the time. Van der Weyden had considerable influence on Dirk Bouts (c. 1420–1475), whose poliptych depicting *The Annunciation — The Visitation — The Adoration of the Angels— The Adoration of the Wise Men* (plate 191) is notable for its delicious environmental qualities, both in landscapes and interiors.

The last decades of the fifteenth century saw the figure of Hans Memling (c. 1433/35–1494), who continued to develop the forms of Van der Weyden interpreted in an exquisitely decorative way, as can be appreciated in his triptych with the *Nativity, Epiphany*, and *Purification*. Shortly thereafter Gerard David (c. 1450/60–1523) interpreted with great originality *A Rest During the Flight to Egypt* (plate 192); the lyricism of the landscape also gives character to his *Virgin and Child*. Thus we come to the work of Hieronymus van Aeken Bosch (c. 1450–1516), singular not only in his own period but in all others and highly esteemed by Philip II, who managed to gather together a considerable number of his canvases. Alongside works we might be tempted to describe as "conventional," such as the triptych *The Adoration of the Magi* (plate 194), are others in which this artist managed to condense popular wisdom in highly complex compositions, charged with allusions to legends and superstitions, to fantasies bordering on insanity. For this reason the content is more important than the form in *The Extraction of the Stone of Madness* (plate 193), *The Table of the Capital Sins*, and *The Temptations of Saint Anthony* (plate 199). Capital works in this context are his two great triptychs; in one of these he combines *The Path of Life* (plate 195) on the doors with the crude struggle to mount *The Hay Wain* (plate 196) inside. In the second triptych *The Creation of the World* (plate 197) and *The Garden of Delights* (plate 198) are combined. These are samples of the insatiable powers of contemplation and extraordinary imagination of Bosch, who had no followers of quality. One of his contemporaries was Joachim Patinir (c. 1480–1524), from whom landscape as a genre acquired strength, accentuated by the high viewpoint he adopted in his *Rest During the Flight to Egypt*, *Landscape with Saint Hieronymus* (plate 200), and *Step on the Stygian Lake*, while his *Temptations of Saint Anthony Abbot* is an example of his collaboration with Quentin Massys (1465–1530). Denoting the intrusion of Italian elements deriving from Raphael and Leonardo da Vinci are Massys's *Christ Presented to the People* (plate 201) and *Old Woman Pulling out Her Hair*. Belonging to Massys's circle were the Master of Frankfurt (*Saint Catherine and Saint Barbara*); Adriaen Isenbrandt (. . . 1510–1551), represented here by his *Mass of Saint Gregory* (plate 202); and Ambrosius Benson (d. 1550), who enjoyed great esteem in Castile (*Saint Anne, the Child, and the Virgin* and *Embrace before the Golden Gate*).

With the dawn of the sixteenth century came the new developments of the Renaissance. Jan Gossaert, called Mabuse

(c. 1478–1533/36), can be appreciated in his paintings of *Christ Between the Virgin Mary and Saint John the Baptist* (plate 203) and *The Virgin and Child* (plate 204), a subject that inspired other excellent works, such as *The Holy Family* (plate 207) by Bernaerdt van Orley (c. 1492–1542) and canvases by other sixteenth-century painters. A few novelties were introduced by Marinus Claeszon van Reymerswaele (end of fifteenth century–1567) with *The Moneychanger and His Wife* (plate 205) and *Saint Hieronymus* and by Jan Sanders van Hemessen (c. 1500–c. 1565) with *The Surgeon*. Jan van Scorel (1495–1562) reached great heights with his portrait of *A Humanist*, as did Michael van Coxcie (1499–1592) with his religious themes. Standing out above all is the figure of Pieter Brueghel "the Elder" (c. 1525/30–1569), who returned to the pure tradition of the Netherlands. Brueghel observed the popular aspects of his own environment, with their animation and color, and extracted from them satirical and moralistic conclusions. An example of his art is *The Triumph of Death* (plates 209 and 210). A fusion between Flemish traditions and Italian innovations can be seen in the Italianate Martin de Vos (1532–1603), who reveals the quality of his style in two allegorical compositions: *Aeolus, the Air* and *Ceres, the Earth*. The best example of such a fusion can be appreciated in the transcendent series of portraits by Anton Mor van Dashorst (1517–1576), better known as Antonio Moro, a highly refined and objective observer of kings and aristocrats. The figures of the Emperor Maximilian; his wife, Mary of Austria; Catherine of Austria; Joan of Austria; and Mary Tudor (plate 208); and the portrait, exceptional in so many ways, of the jester Pejerón, are fine examples of his work, and copies of his canvases made by anonymous pupils confirm the extent of his influence.

With the turn of the seventeenth century a new period began which, after the Twelve-Year Truce (1609–21), divided the country into two areas: the southern, Catholic zone, which would give life to the school that would continue to be called Flemish, and the northern, Protestant zone, which for all intents and purposes must be called Dutch. Each had distinct characteristics, and each had the good fortune to have a major artistic figure represent it: Rubens of Flanders and Rembrandt of the Netherlands. In the aristocratic Flemish sector religious themes abounded, mythological subjects were cultivated with overwhelmingly sensual joy, and portraits, genre painting, and still lifes reached great artistic heights. Prominent on the Dutch side, in which the *haute bourgeoisie* predominated, were the intimacies of genre painting, landscapes, portraits (both individual and collective), and still lifes. Historical circumstances more than justify the difference of levels to be observed between the two in the Prado Museum.

In the Flemish zone artists to a large extent continued the previous tradition. Pieter Brueghel "the Younger" (1564–1638) imitated his father in one sector of his work, while another son, Jan Brueghel de Velours (1568–1625) treated landscapes, mythological themes, flower painting, and allegories with considerable originality. He was employed in the service of the Spanish Archduke Alberto and Duchess Isabel Clara Eugenia, a fact that explains the many paintings of his in the Prado, such as the series of the *Bodily Senses*, a multitude of bouquets and garlands, rural and popular scenes, and religious canvases. A disciple of his in the popular genre was Jan de Momper.

From this nucleus emerged the impetuous art of Peter Paul Rubens (1577–1640), a highly versatile figure who identified thoroughly with the Baroque. He lived and worked in Italy between 1600 and 1608 (*The Paris Trials*, *Saint George's Fight with the Dragon*, plate 211), but it was in his homeland that he was most prolific. *Epiphany* (1610), *Apostolate* (1612–13), the models of cartoons for *The Victory of Eucharistic Truth over Heresy* (plate 212) in the Royal Convent of the Discalced Sisters; mythological themes such as *Ceres and Two Nymphs*, the Achilles series, *Nymphs and Satyrs, Atlanta and Meleagrus, Diana and Her Nymphs, The Three Graces* (plate 214), *The Paris Trials* painted for the Parada Tower; religious paintings, in several of which the Madonna or the Child are the protagonists, the *Supper in Emmaus, Rest During the Flight to Egypt*; popular scenes (*Dance of the Villagers*, plate 215) or mundane themes (*The Garden of Love*, plate 213); and a number of portraits (*The Duke of Lerma; Archduke Alberto; Isabel Clara Eugenia; Maria de Medici*, plate 216; *Anne of Austria; The Infante Cardinal*) all attest to the genius and versatility of this great Baroque master.

The Prado also contains many works in which Rubens collaborated with his studio assistants. Worthy of special mention also is the series of small, exquisite works that are the fruit of a collaboration between Rubens and Jan Brueghel de Velours; the former was responsible for the figures and the latter for the floral borders or the landscapes. In the Prado these are represented by *The Vision of Saint Humbert* (plate 217) and *The Virgin and Child in a Manger Surrounded by Flowers and Fruit* (plate 218). Jan Brueghel was also a fine painter in his own right, as he demonstrated magnificently in creations such as the series of the *Allegories of the Senses* (see plate 219) or the constantly imitated theme of *The Earthly Paradise* (plate 220). Anthony van Dyck (1599–1641) also began his

career in Rubens's studio, and after a highly fecund period in Italy (1621–27), where he produced his elegant views of Genoa, he returned first to Flanders and then settled finally in England in 1631 in order to place himself at a remove from the area dominated by Rubens. To his Italian period belong many religious paintings (*The Crowning with Thorns*, plate 222; *The Capture*, plate 224; *The Mystical Nuptials of Saint Catherine; The Metal Snake*, plate 221; and *Saint Rosalie*) and a number of portraits (*Polixema Spínola*). The painter worked very intensely upon his return to his homeland, particularly in the field of the portrait (*F. E. de Nassau, Amalia de Solms Braunfels, E. de Bergh, The Engraver Paul de Pont, Martin Ryckaert, E. Liberti, The Infante Cardinal*), and there are some outstanding works from his English period, in particular the portraits of *The Artist with Sir Endimion Porter* (plate 223), Jacobo Gaultier, Diana Cecil, and Maria Ruthwen.

The contributions of the Flemish painting school were extended by the work of Jacob Jordaens (1593–1678), an artist very much in the wake of Rubens (he studied under the Baroque master) but who accentuated the popular and everyday, even in subjects of a classical nature (*Offerings to Ceres*, plate 225; *Meleagrus and Atlanta*). For Philip IV's Parada Tower he painted *Marriage of Tethis and Peleus* and *Cadmus and Minerva*. Much more personal are *The Artists and His Family in a Garden* (plate 226) and *Three Strolling Musicians*. Other artists, such as Cornelis de Vos (c. 1584–1651) and Erasmus Quellinus (1607–1678), also contributed to the decoration of that tower, and many more supplied the demand for portraits, including Gaspar de Crayer (1584–1669) and Justus Sustermans (1597–1681); for seascapes (plate 227), such as Gaspard van Eyck (1613–1673); for landscapes, realized by Jacques d'Arthois (1613–1686); for battles or hunting scenes, a genre in which Peeter Snayers (1592–1666) shone; and for interiors of palaces or churches (see plate 228), in which Pieter Neefs ''the Elder'' was able to demonstrate his mastery of perspective.

Genre painting constituted a chapter apart, thanks to artists such as David Teniers (1610–1690), who also painted landscapes, religious scenes, allegories, and portraits. Teniers is represented profusely in the Prado by canvases of drinkers and smokers; of country scenes replete with suggestive details (*Village Fête*, plate 229; *Villagers Conversing*); of military subjects leaning toward genre painting; of social satires (*The Old Man and the Maid*, plate 230); and by canvases alluding to the medical profession. Of particular interest is *The Archduke Leopold Wilhelm in His Gallery of Paintings in Brussels* (plate 231), in that it constitutes a graphic catalogue of a collection of which the artist was curator.

The contributions of painters of animals and still lifes reveal the breadth of the Flemish art market at the time. Outstanding among those artists who chose as their subjects hunting, farmyards, and kitchen scenes was Frans Snyders (1579–1657) with canvases such as *The Fruit Bowl* (plate 232), *A Pantry, Fruit Dish, Concerto of Fowl, Wild Boar Cornered*, and *Deer Hunt*. In this genre he collaborated with Rubens, as did a painter of greater dynamism, Paul de Vos (c. 1596–1678), who favored hunting scenes such as *The Roe Deer Hunt, Deer Cornered by a Pack of Hounds* (plate 233), and *Cat Fight*. An even greater innovator was Jan Fyt (1611–1661), who painted delicately nuanced flowers and captured the subtle qualities of animal skins and bird plumage. These values can be clearly appreciated in his *Hunting Still Life, Concerto of Fowl, Ducks and Water Hens Surprised by Dogs* (plate 234), and *Hen Coop*. The formula of framing compositions with garlands of flowers was enriched by Daniel Seghers (1590–1661); indeed, *Garland with the Virgin and Child, Garland of Roses*, and *Jesus and Saint Teresa in a Garland of Flowers* (plate 236) explain the enormous prestige he enjoyed. Finally, still lifes were considerably developed by the efforts of such artists as Osias Beet (1580–1624; plate 235), Clara Peeters (1594–1659), and Joris van Son (1623–1667).

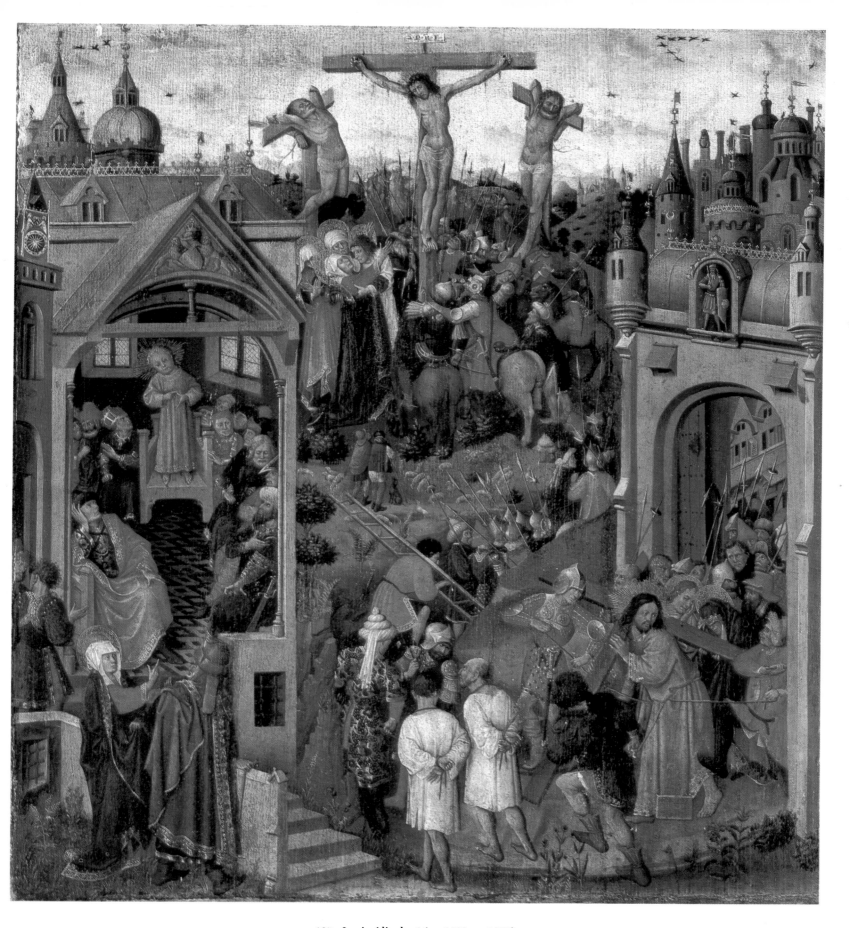

185. **Louis Alincbrot** (. . . 1432–c. 1463)
Scenes from the Life of Christ [no. 2538]
Paint on board, 30¾ × 26⅜″ (78 × 67 cm)

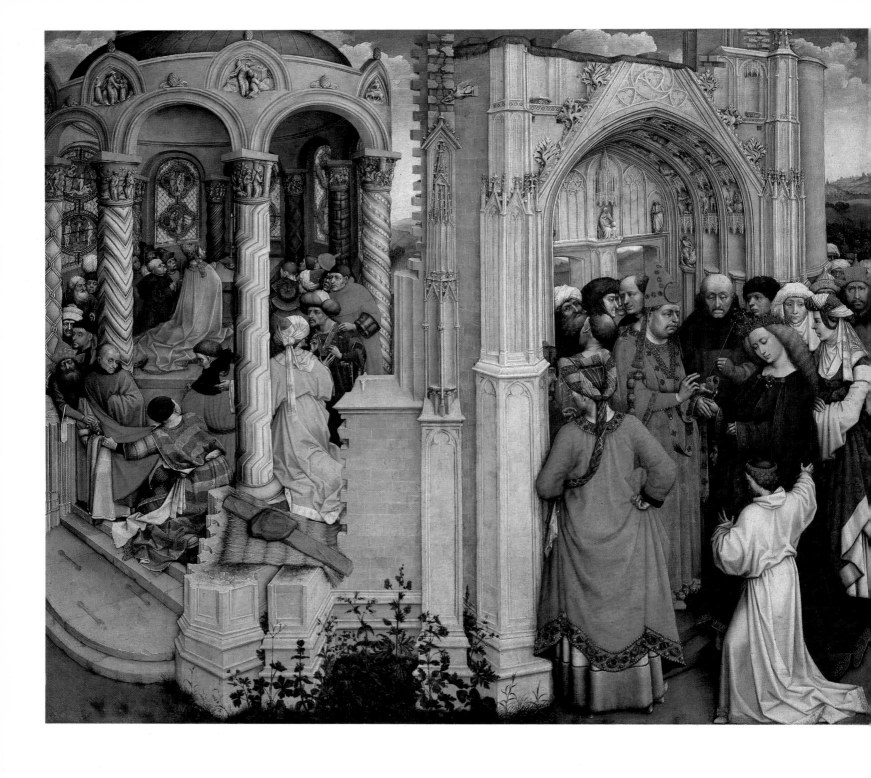

186. **Robert Campin** (c. 1375–1444)
The Nuptials of the Virgin [no. 1887]
Oil on board, 30 3/8 × 34 5/8″ (77 × 88 cm)

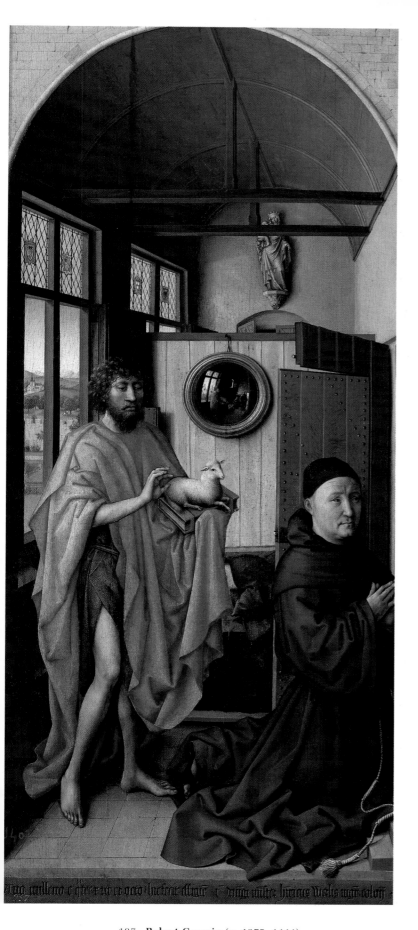

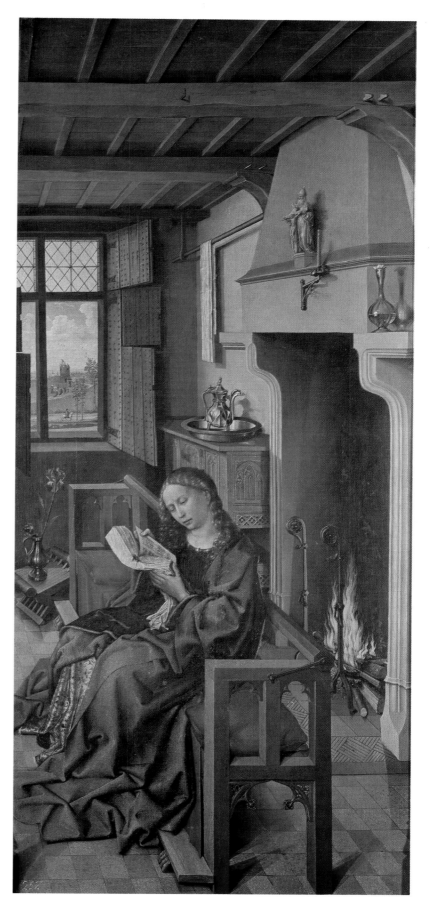

187. **Robert Campin** (c. 1375–1444)
Saint John the Baptist and the Franciscan Maestro Henricus Werl. 1438 [no. 1513]
Oil on board, 39¾ × 18½″ (101 × 47 cm)

188. **Robert Campin** (c. 1375–1444)
Saint Barbara. 1438 [no. 1514]
Oil on board, 39¾ × 18½″ (101 × 47 cm)

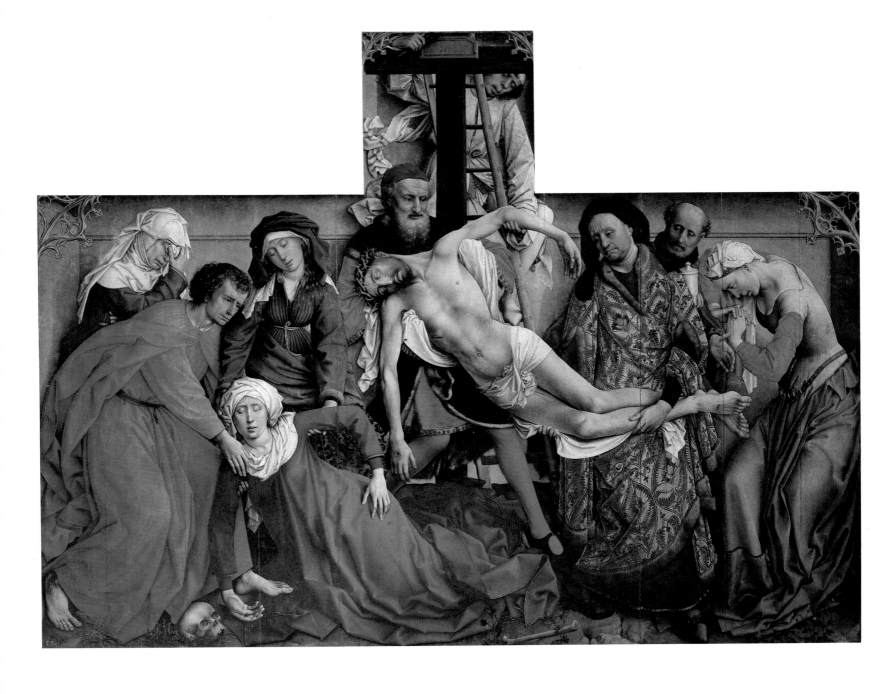

189. **Rogier van der Weyden** (1399/1400–1464)
The Descent from the Cross. c. 1435 [no. 2825]
Oil on board, 86⅝ × 103⅛″ (220 × 262 cm)

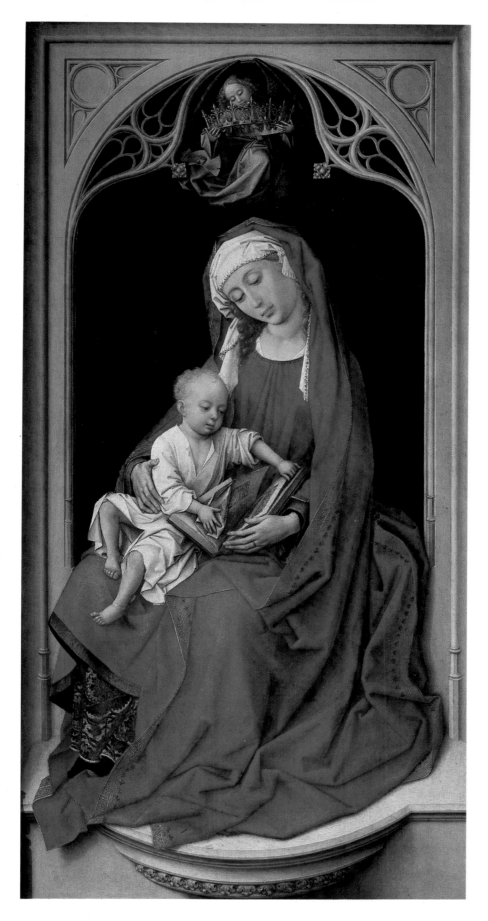

190. Rogier van der Weyden (1399/1400–1464)
The Virgin and Child [no. 2722]
Oil on board, 39 ⅜ × 20 ½″ (100 × 52 cm)

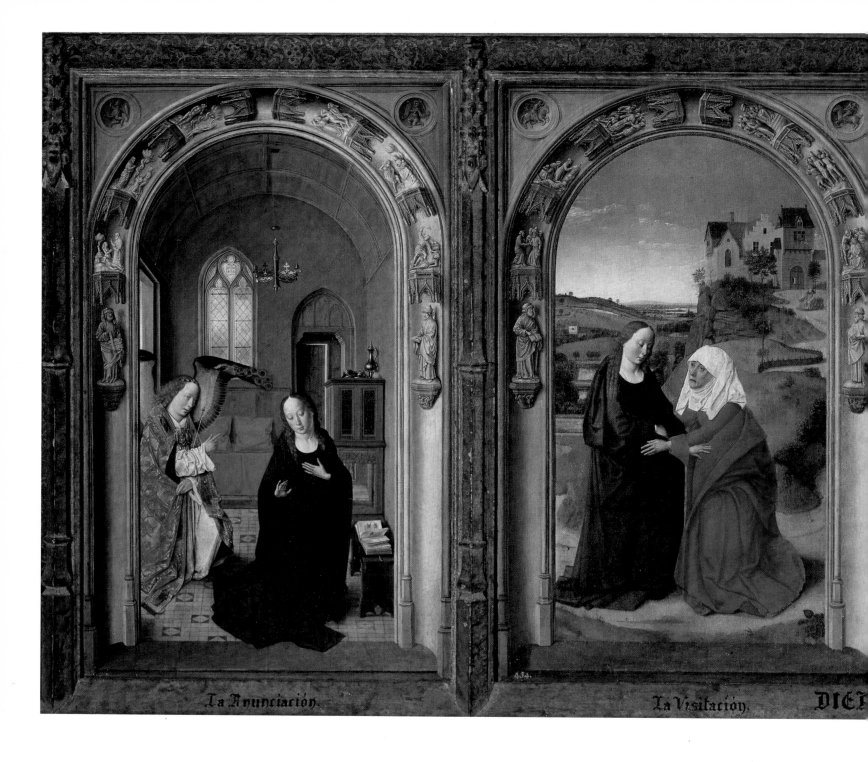

191. Dirk Bouts (c. 1420–1475)
The Annunciation–The Visitation–The Adoration of the Angels–
The Adoration of the Wise Men [no. 1461]
Oil on board, 31 ½ × 85 ⅜″ (80 × 217 cm)

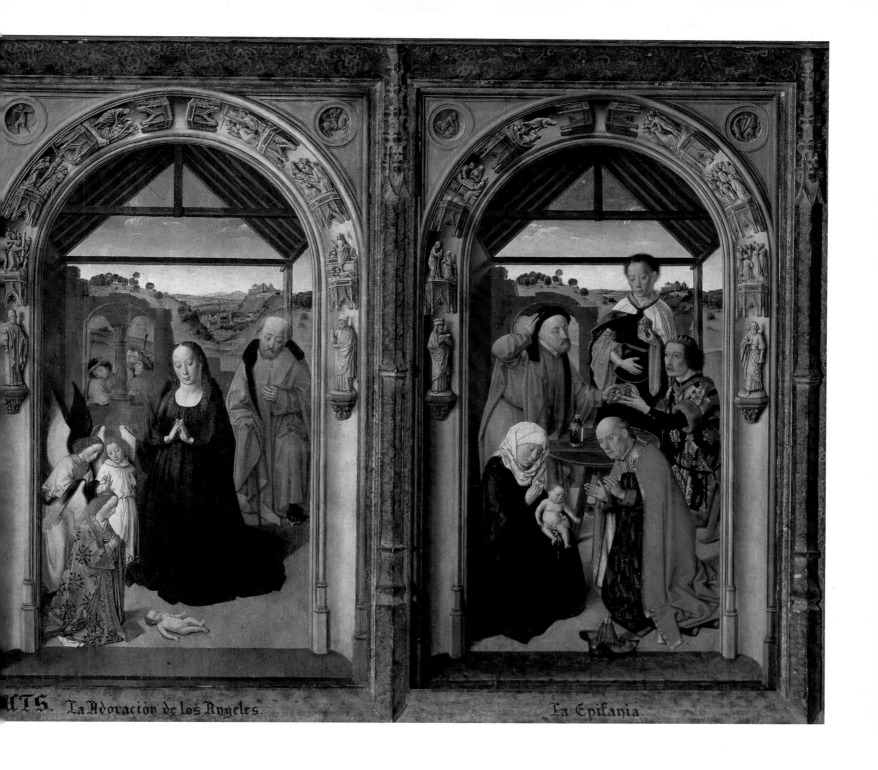

UTS. La Adoración de los Angeles.　　　　La Epifanía.

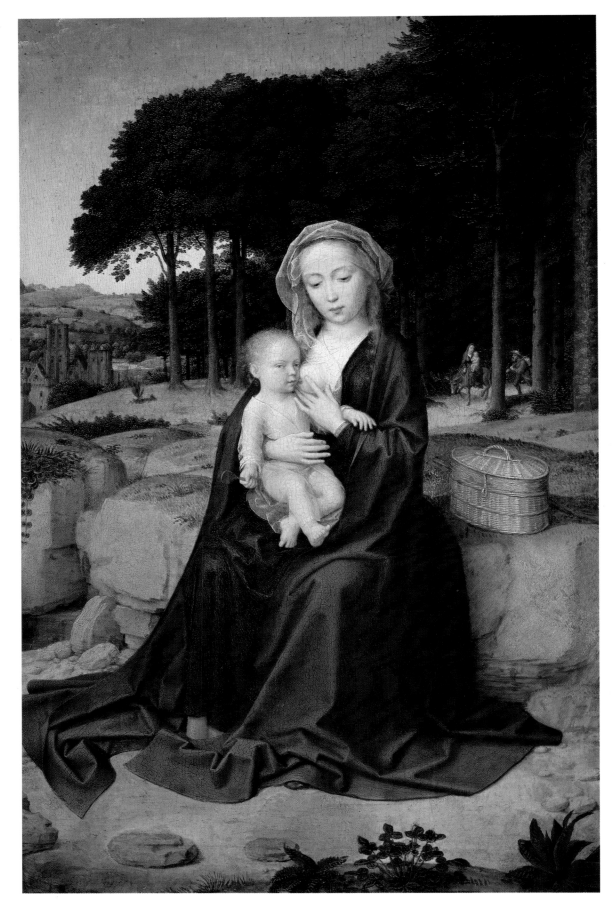

192. **Gerard David** (c. 1450/60–1523)
A Rest During the Flight from Egypt [no. 2643]
Oil on board, 23 ⅝ × 15 ⅜″ (60 × 39 cm)

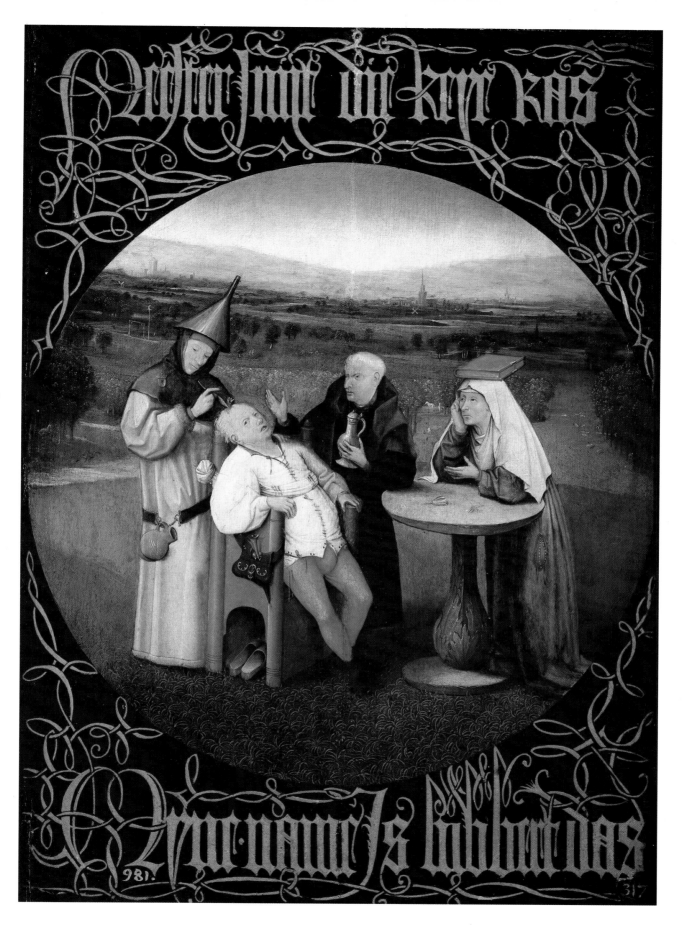

193. **Hieronymus van Aeken Bosch** (c. 1450–1516)
The Extraction of the Stone of Madness [no. 2056]
Oil on board, 18⅞ × 13¾″ (48 × 35 cm)

194. **Hieronymus van Aeken Bosch** (c. 1450–1516)
The Adoration of the Magi [no. 2048]
Oil on board, 54 3/8 × 54 3/8″ (138 × 138 cm)

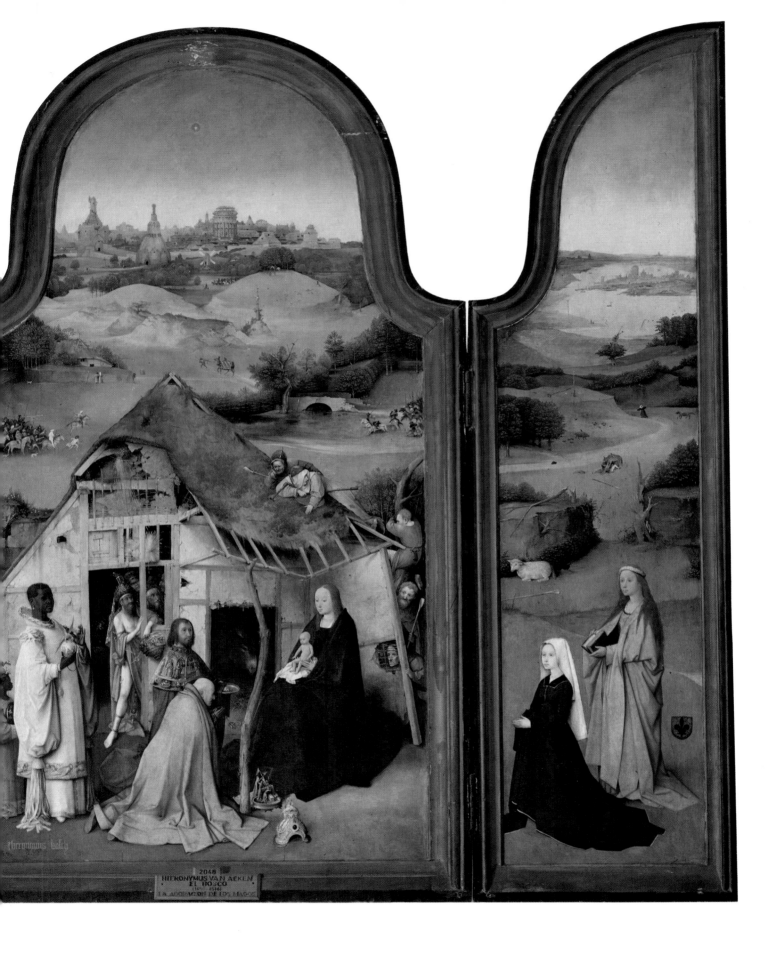

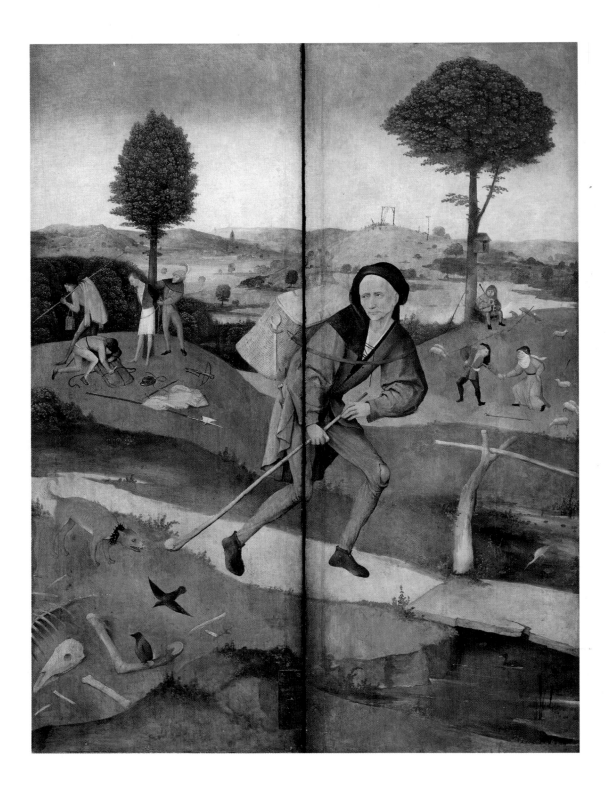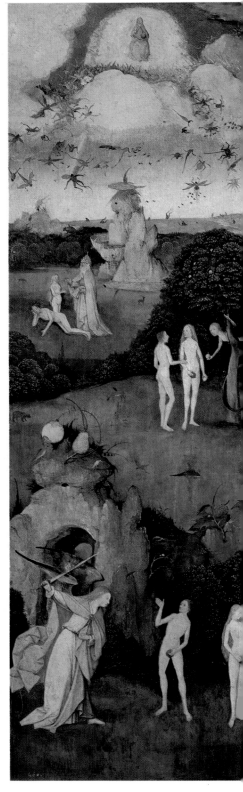

195. **Hieronymus van Aeken Bosch** (c. 1450–1516)
The Path of Life [no. 2052 closed]
Oil on board, 53 1/8 × 35 7/8″ (135 × 90 cm)

196. **Hieronymus van Aeken Bosch** (c. 1450–1516)
The Hay Wain [no. 2052 open]
Oil on board, 53 1/8 × 74 3/4″ (135 × 190 cm)

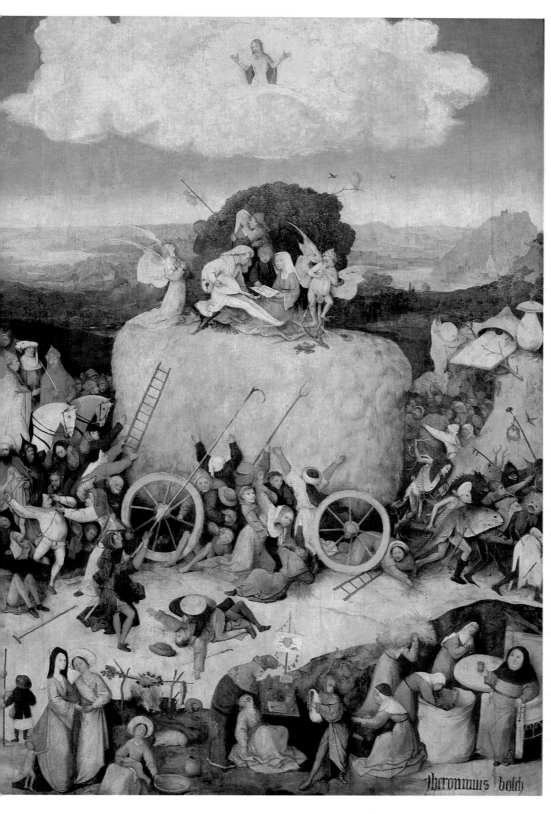
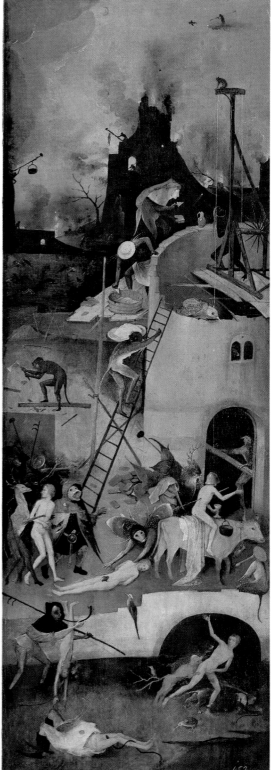

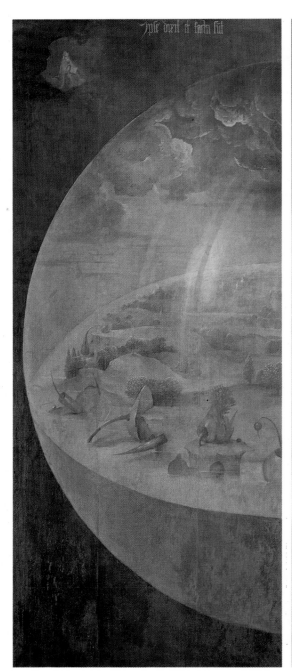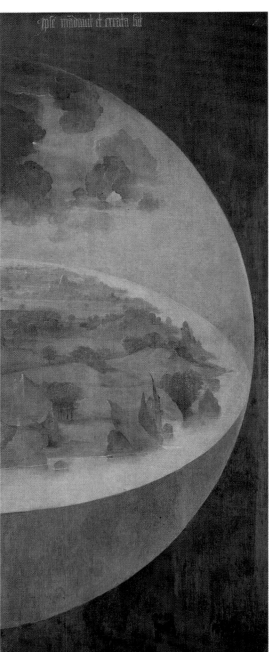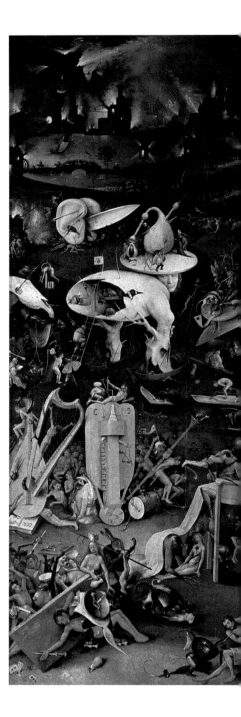

197. **Hieronymus van Aeken Bosch** (c. 1450–1516)
The Creation of the World [no. 2823 closed]
Oil on board, 76 3/4 × 43 1/4″ (195 × 110 cm)

198. **Hieronymus van Aeken Bosch** (c. 1450–1516)
The Garden of Delights [no. 2823 open]
Oil on board, 76 3/4 × 86 5/8″ (195 × 220 cm)

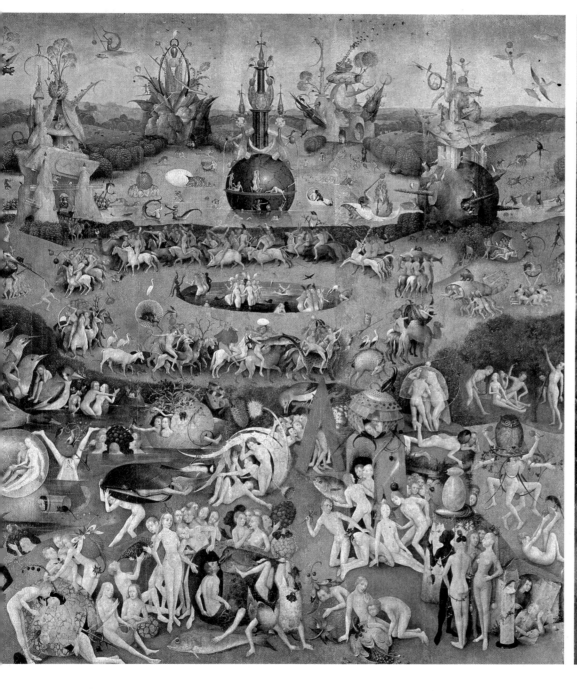
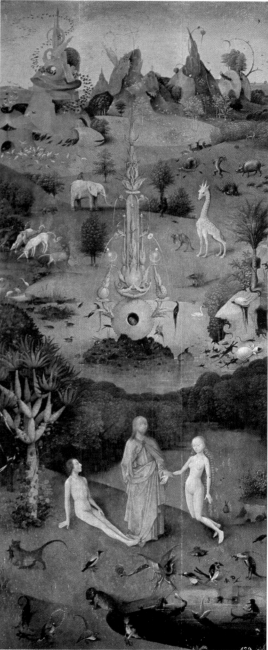

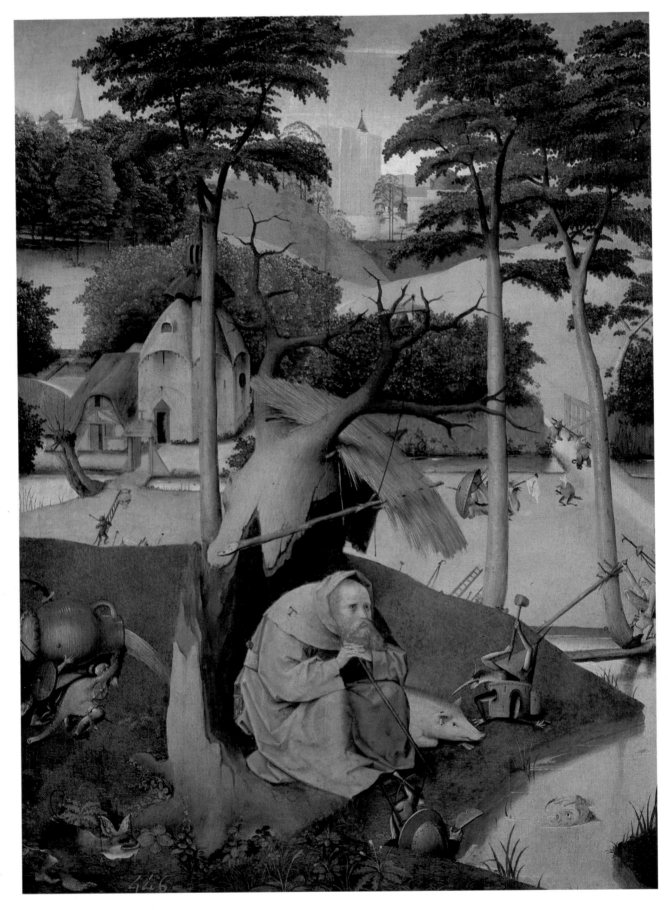

199. **Hieronymus van Aeken Bosch** (c. 1450–1516)
The Temptations of Saint Anthony [no. 2049]
Oil on board, 27 ½ × 20 ⅛″ (70 × 51 cm)

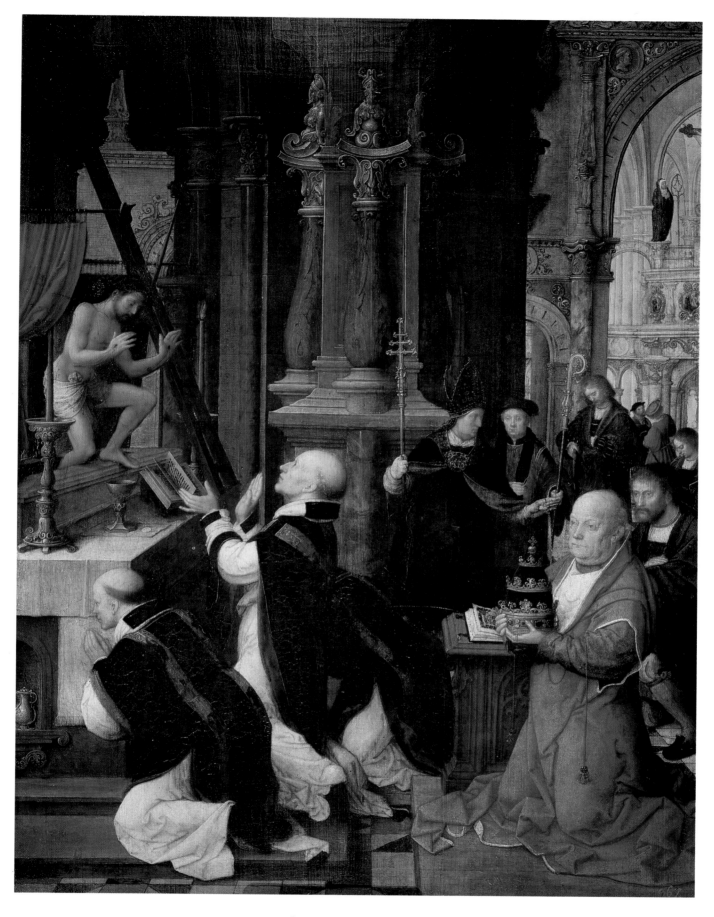

202. **Adriaen Isenbrandt** (. . . 1510–1551)
The Mass of Saint Gregory [no. 1943]
Oil on canvas, 28 3/8 × 22″ (72 × 56 cm)

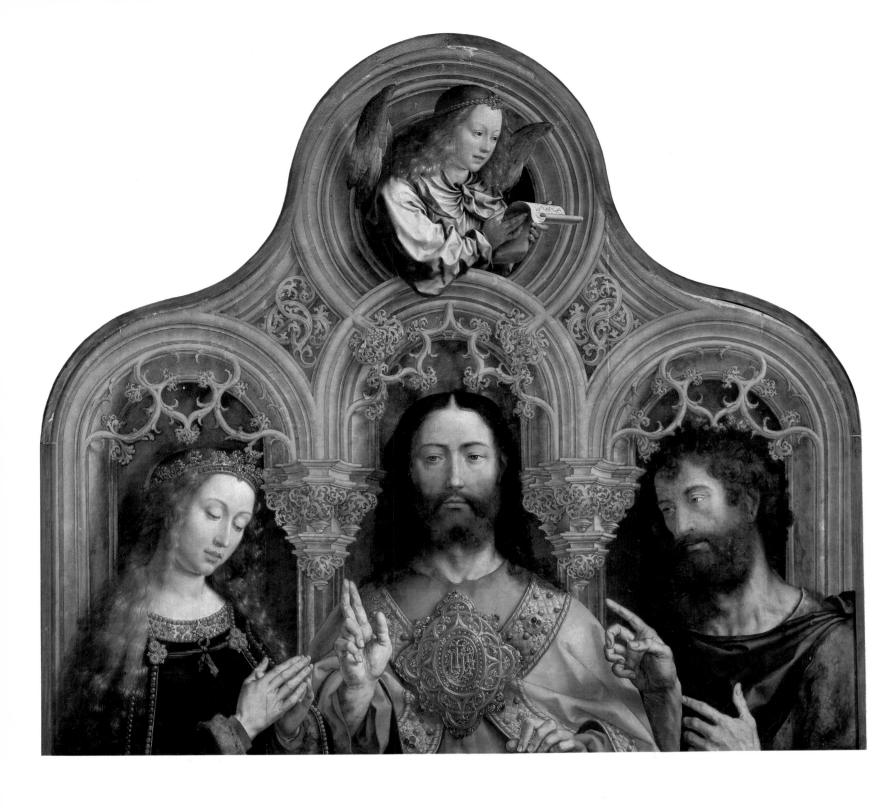

203. **Jan Gossaert,** called **Mabuse** (c. 1478–1533/36)
Christ Between the Virgin Mary and Saint John the Baptist [no. 1510]
Oil on board, 48 × 52 ³/₈″ (122 × 133 cm)

354

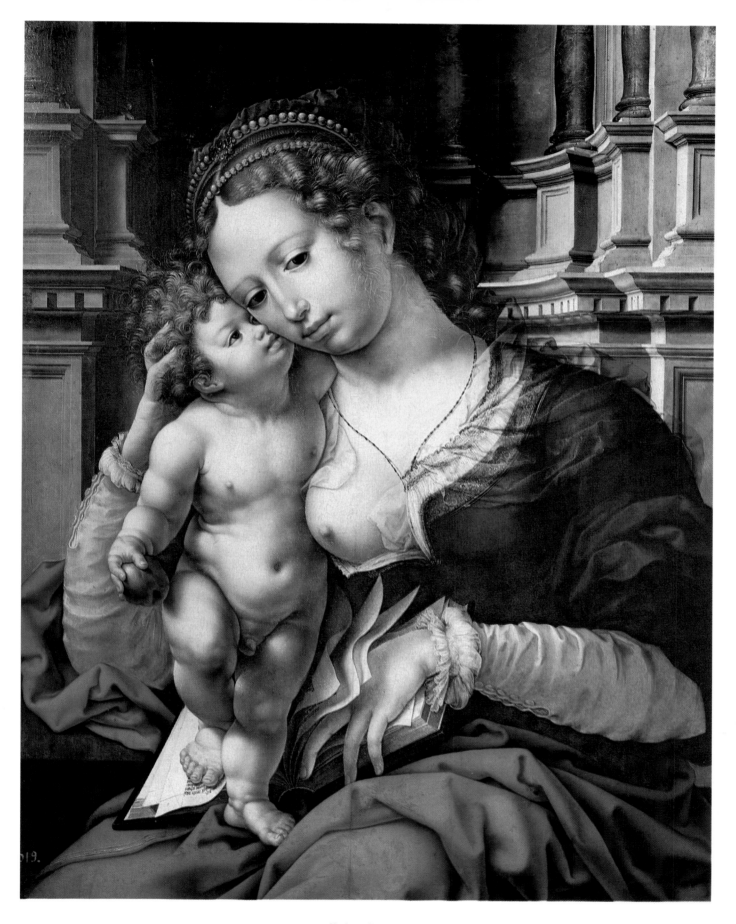

204. **Jan Gossaert,** called **Mabuse** (c. 1478–1533/36)
The Virgin and Child [no. 1930]
Oil on board, 24 ¾ × 19 ⅝″ (63 × 50 cm)

355

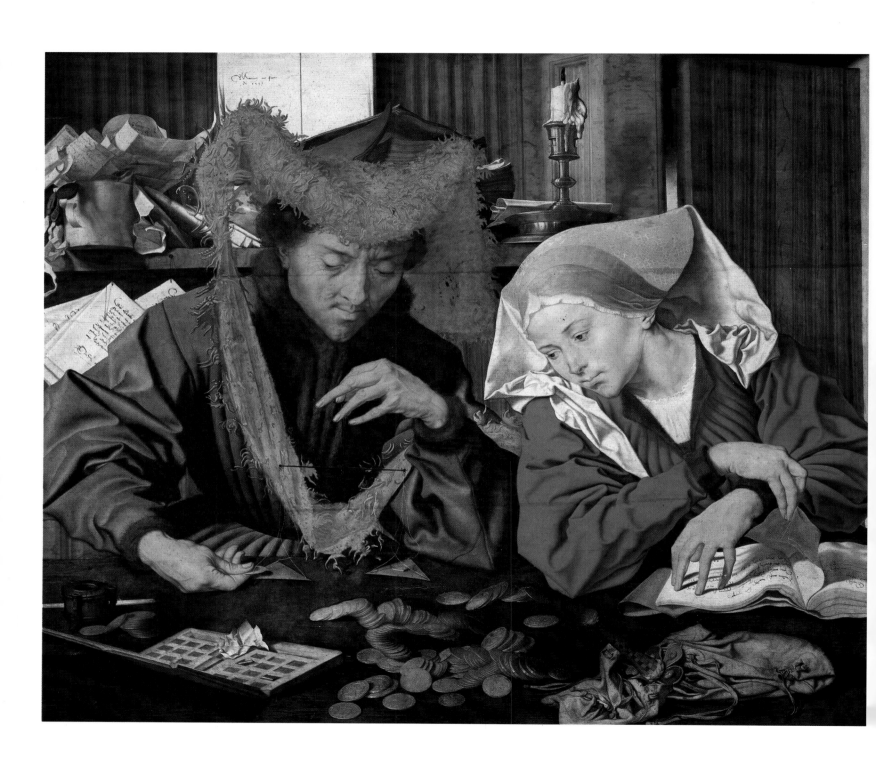

205. **Marinus Claeszon van Reymerswaele** (end of 15th century–1567)
The Moneychanger and His Wife. 1539 [no 2567]
Oil on board, 32 ⅝ × 38 ¼″ (83 × 97 cm)

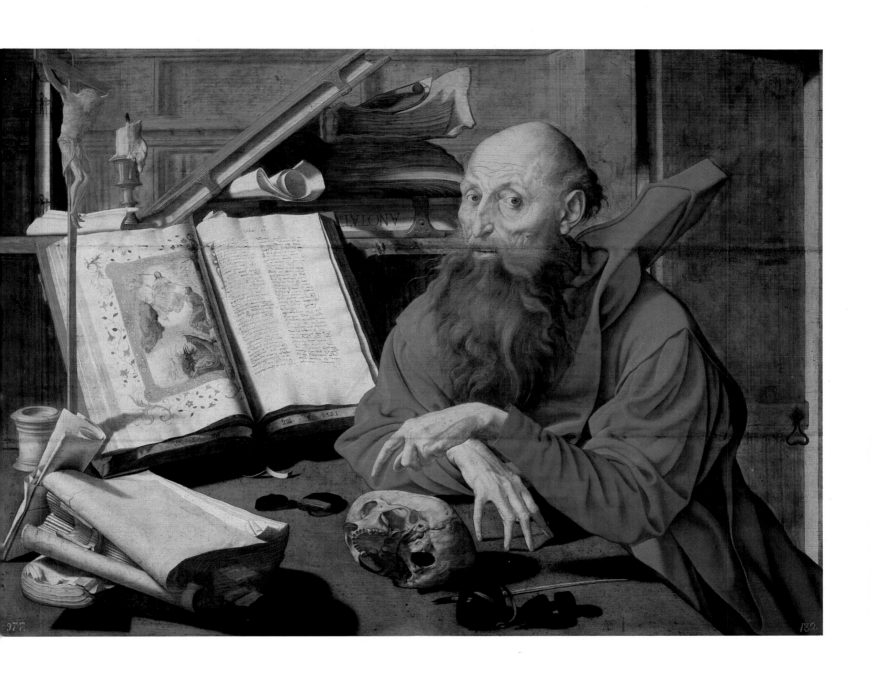

206. **Marinus Claeszon van Reymerswaele** (end of 15th century–1567)
Saint Hieronymus. 1551 [no. 2100]
Oil on board, 29 ½ × 39 ¾″ (75 × 101 cm)

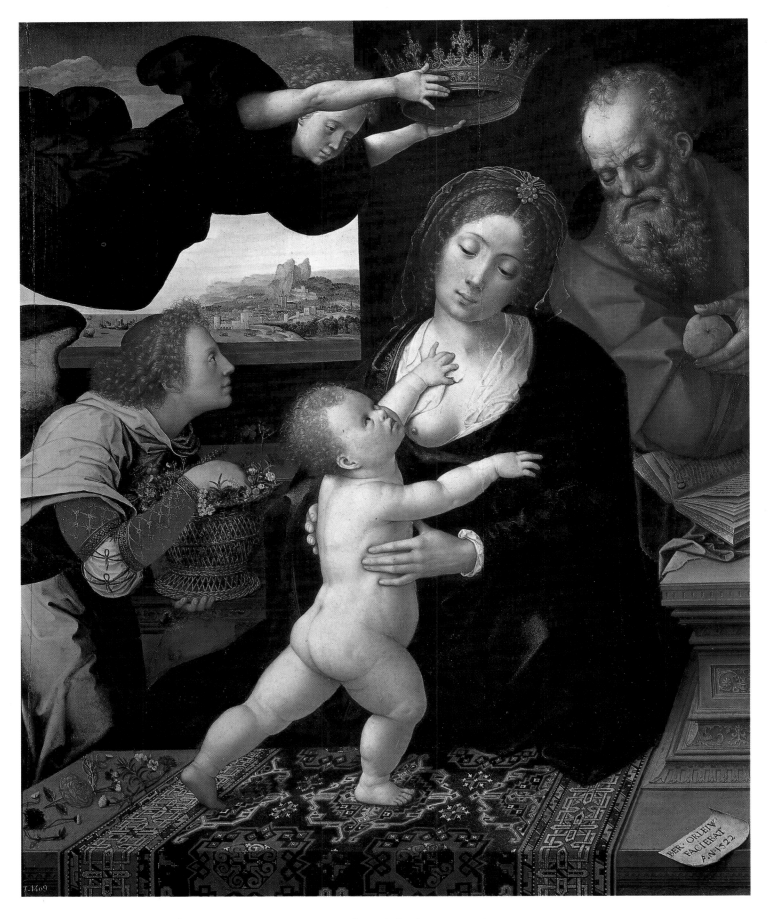

207. **Bernard van Orley** (c. 1492–1542)
The Holy Family. 1522 [no. 2692]
Oil on board, 35 ³/₈ × 29 ¹/₈″ (90 × 74 cm)

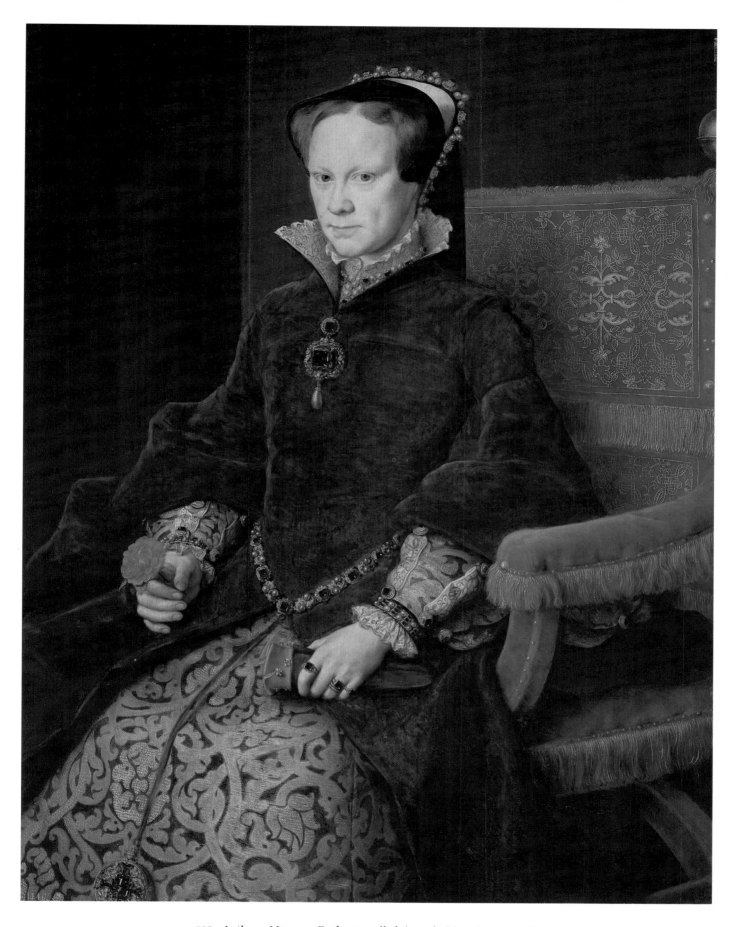

208. **Anthony Mon van Dashorst**, called **Antonio Moro** (1519–1576)
Queen Mary of England, Second Wife of Philip II. 1554 [no. 2108]
Oil on board, 42 ⅞ × 33 ⅛″ (109 × 84 cm)

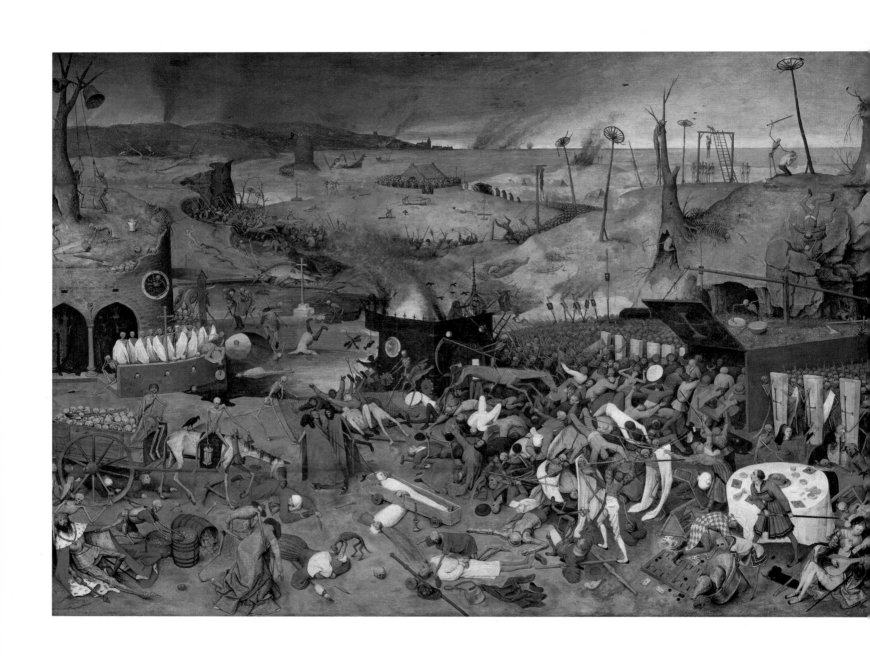

209 & 210. **Pieter Brueghel "the Elder"** (c. 1525/30–1569)
The Triumph of Death [no. 1393]
Oil on board, 46 × 63 ¾″ (117 × 162 cm)

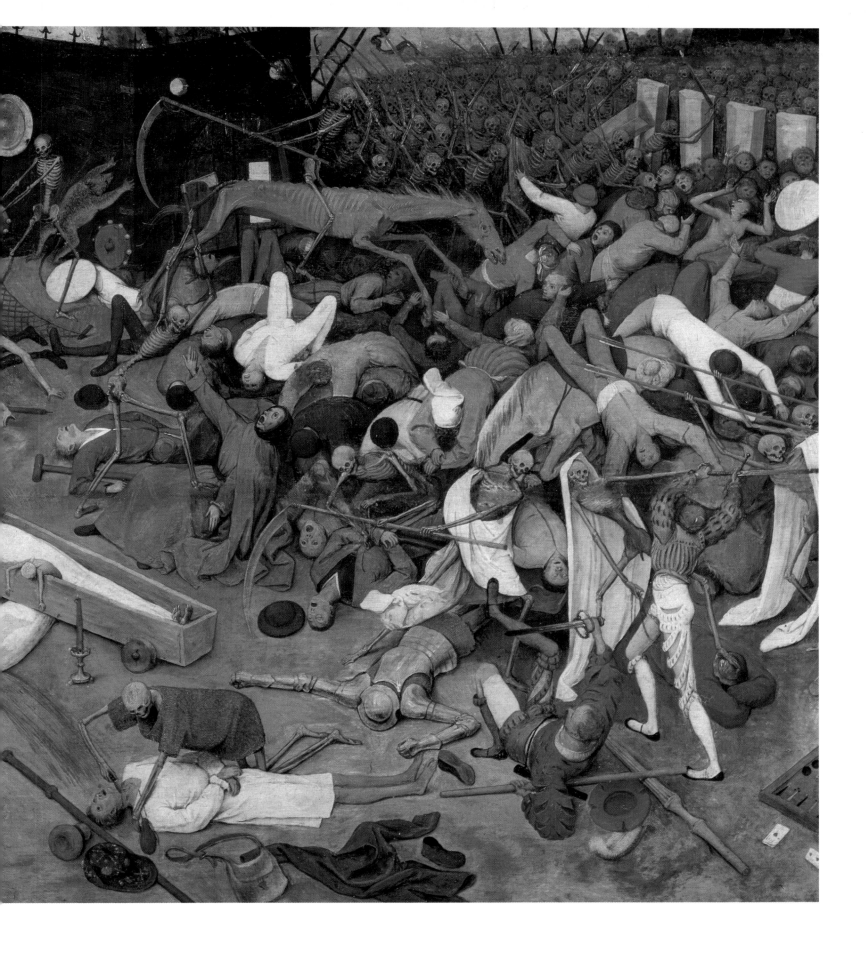

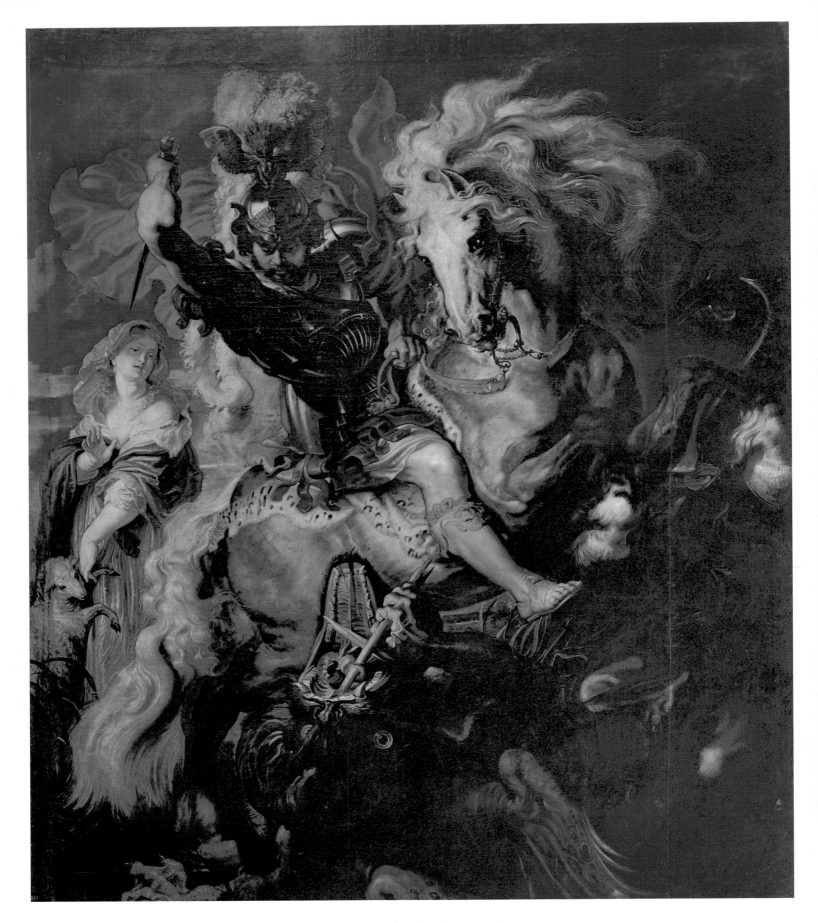

211. **Peter Paul Rubens** (1577–1640)
Saint George's Fight with the Dragon [no. 1644]
Oil on canvas, 119 ⅝ × 100 ¾″ (304 × 256 cm)

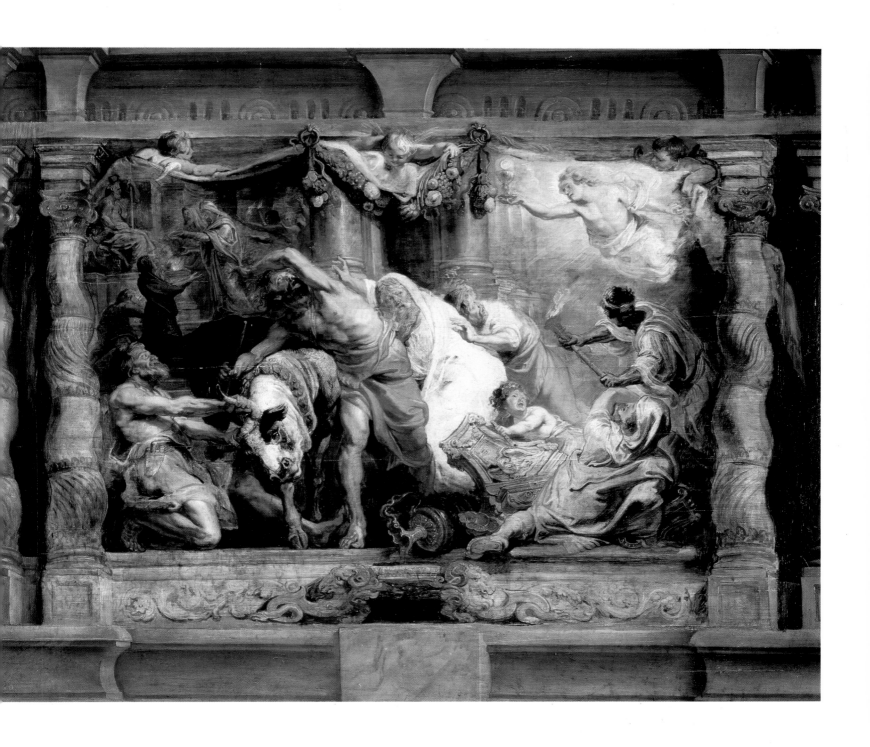

212. **Peter Paul Rubens** (1577–1640)
The Victory of Eucharistic Truth over Heresy. c. 1626 [no. 1699]
Oil on board, 33 7/8 × 41 3/8″ (86 × 105 cm)

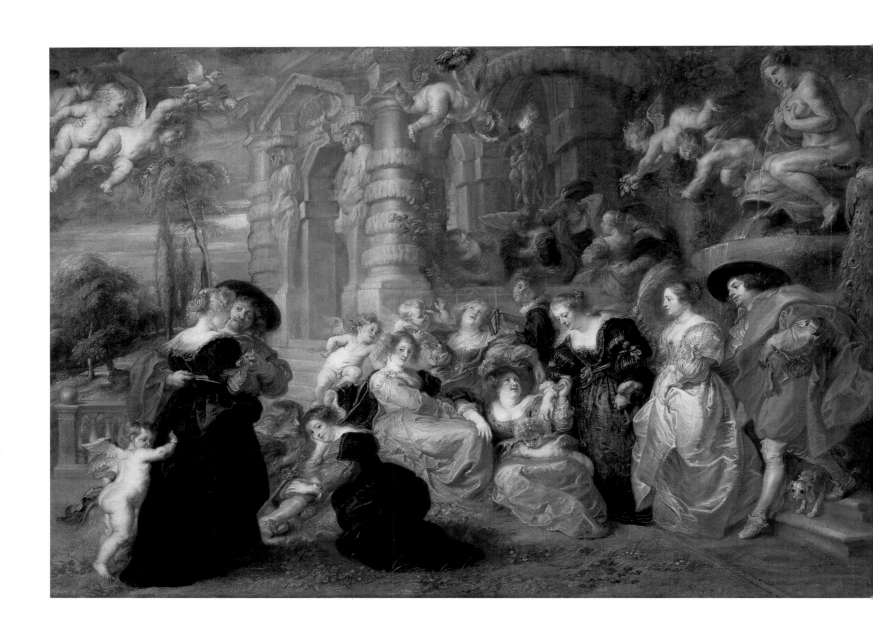

213. **Peter Paul Rubens** (1577–1640)
The Garden of Love. c. 1630–32 [no. 1690]
Oil on canvas, 78 × 111 ³/₈″ (198 × 283 cm)

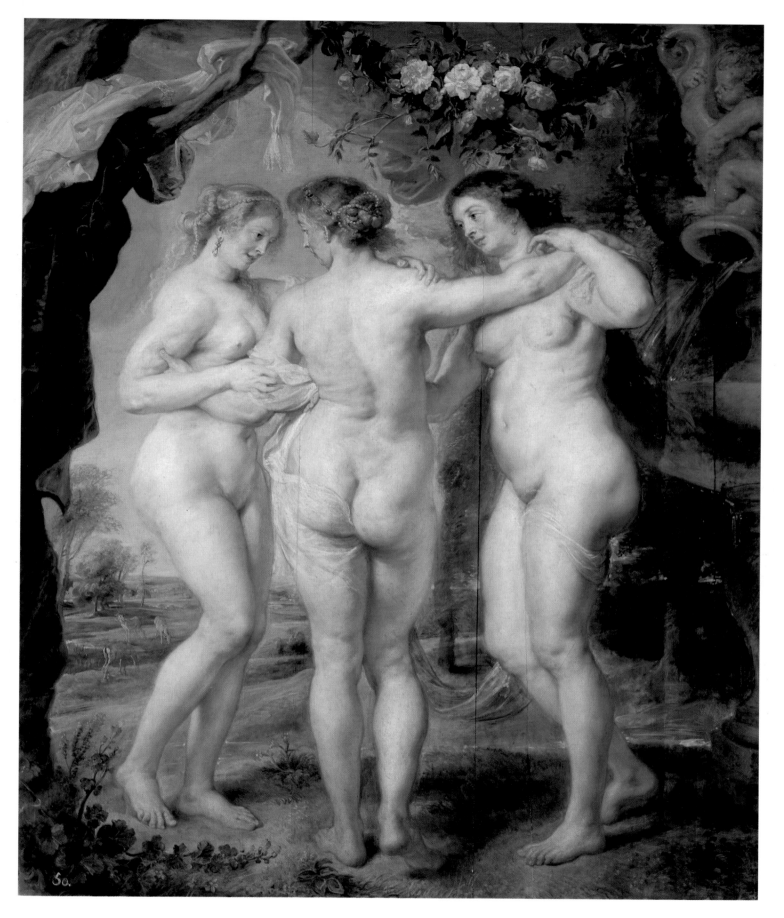

214. **Peter Paul Rubens** (1577–1640)
The Three Graces [no. 1670]
Oil on canvas, 87 × 71 ¼″ (221 × 181 cm)

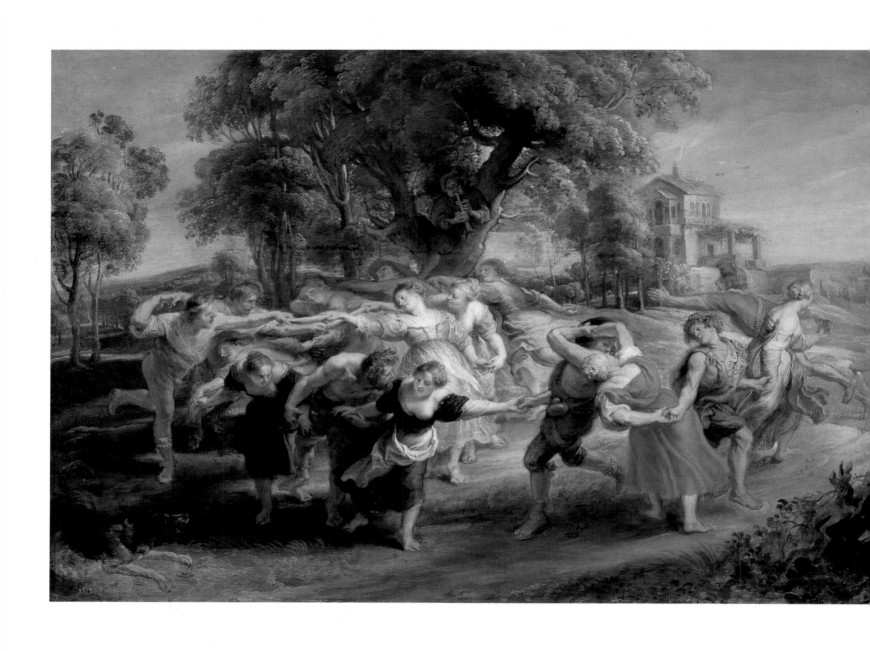

215. **Peter Paul Rubens** (1577–1640)
Dance of the Villagers. c. 1636 [no. 1691]
Oil on board, 28 3/4 × 41 3/4″ (73 × 106 cm)

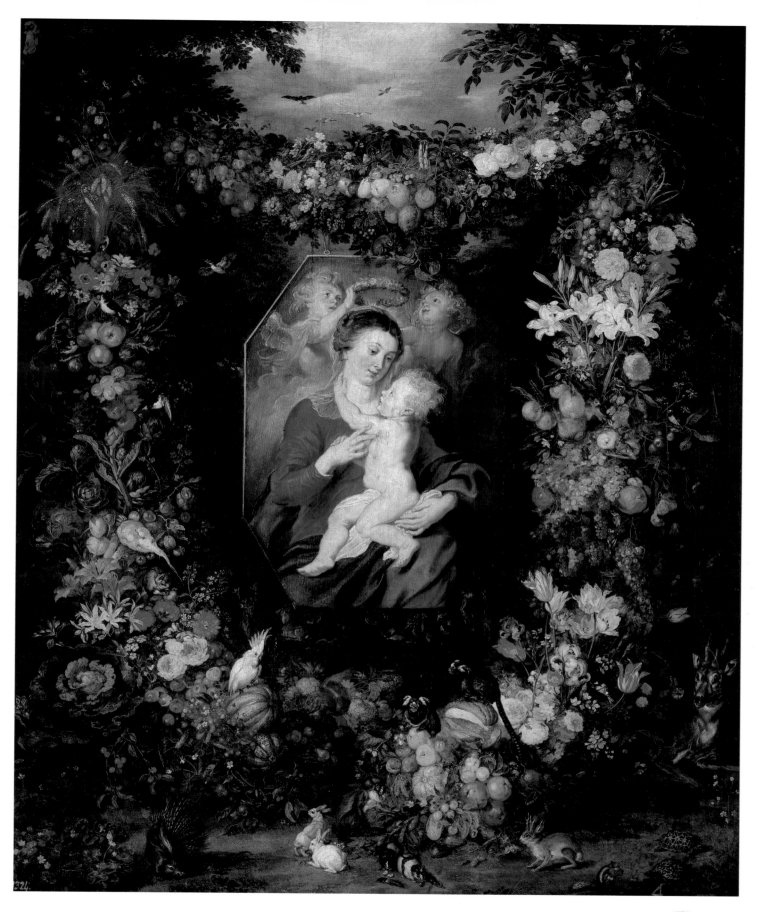

218. **Jan Brueghel de Velours** (1568–1625) and **Peter Paul Rubens** (1577–1640)
The Virgin and Child in a Manger Surrounded by Flowers and Fruit [no. 1418]
Oil on board, 31 ⅛ × 25 ½″ (79 × 65 cm)

369

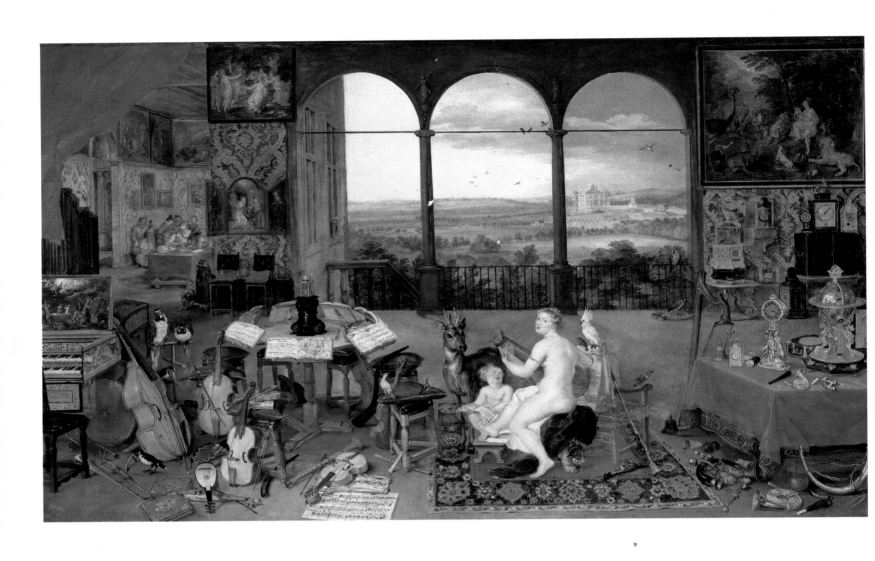

219. **Jan Brueghel de Velours** (1568–1625)
Hearing [no. 1395]
Oil on board, 25 ½ × 42 ⅛" (65 × 107 cm)

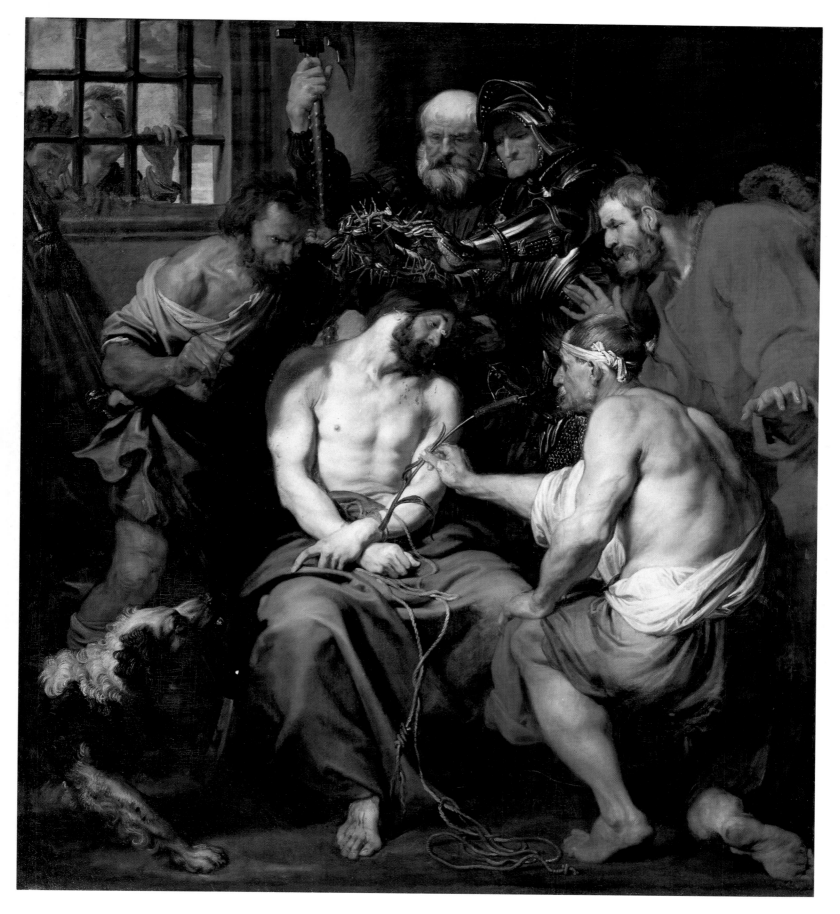

222. **Anthony van Dyck** (1599–1641)
The Crowning with Thorns. 1620 [no. 1474]
Oil on canvas, 87 ¾ × 77 ⅛″ (223 × 196 cm)

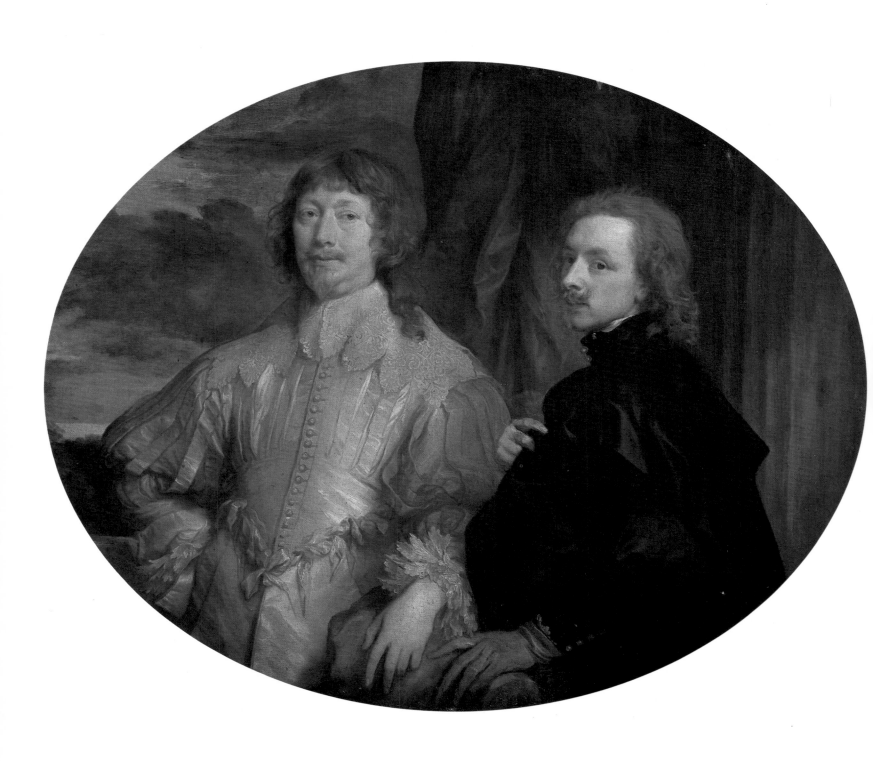

223. **Anthony van Dyck** (1599–1641)
The Artist with Sir Endymion Porter. c. 1635 [no. 1489]
Oil on canvas, 46 ⅞ × 56 ¾″ (119 × 144 cm)

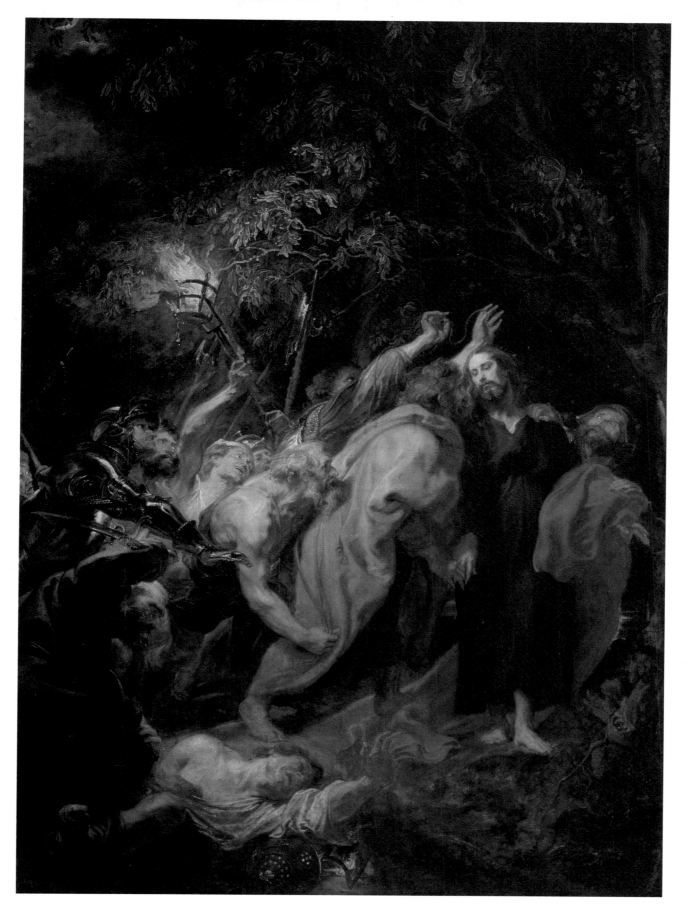

224. **Anthony van Dyck** (1599–1641)
The Capture, or *The Betrayal of Christ* [no. 1477]
Oil on canvas, 135 ³/₈ × 98″ (344 × 249 cm)

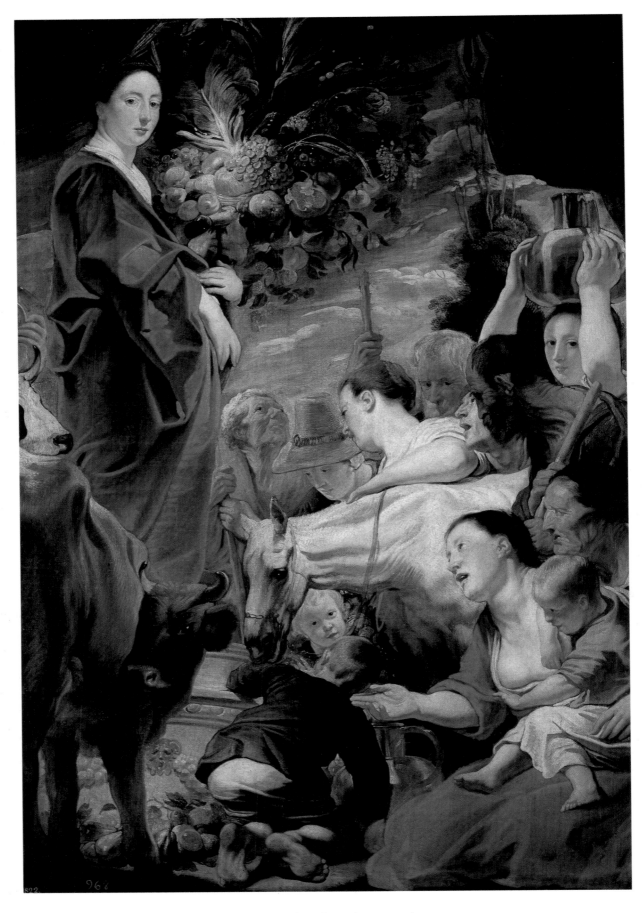

225. **Jacob Jordaens** (1593–1678)
Offerings to Ceres [no. 1547]
Oil on canvas, 65 × 44 ⅛″ (165 × 112 cm)

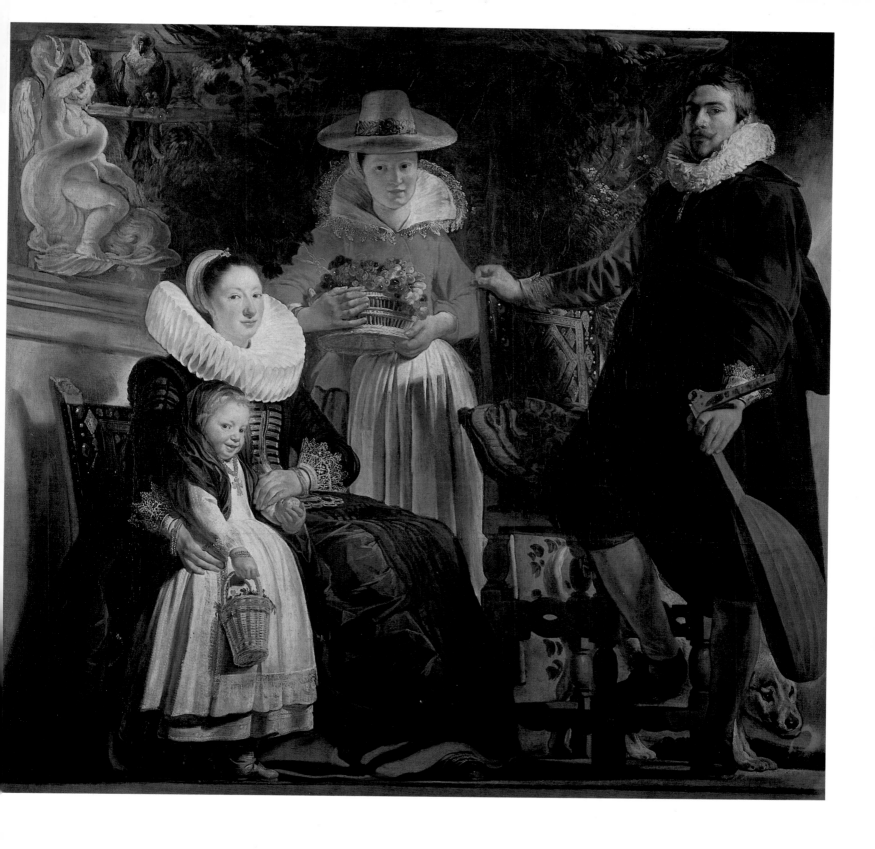

226. **Jacob Jordaens** (1593–1678)
The Artist and His Family in a Garden [no. 1549]
Oil on canvas, 71 1/4 × 73 5/8″ (181 × 187 cm)

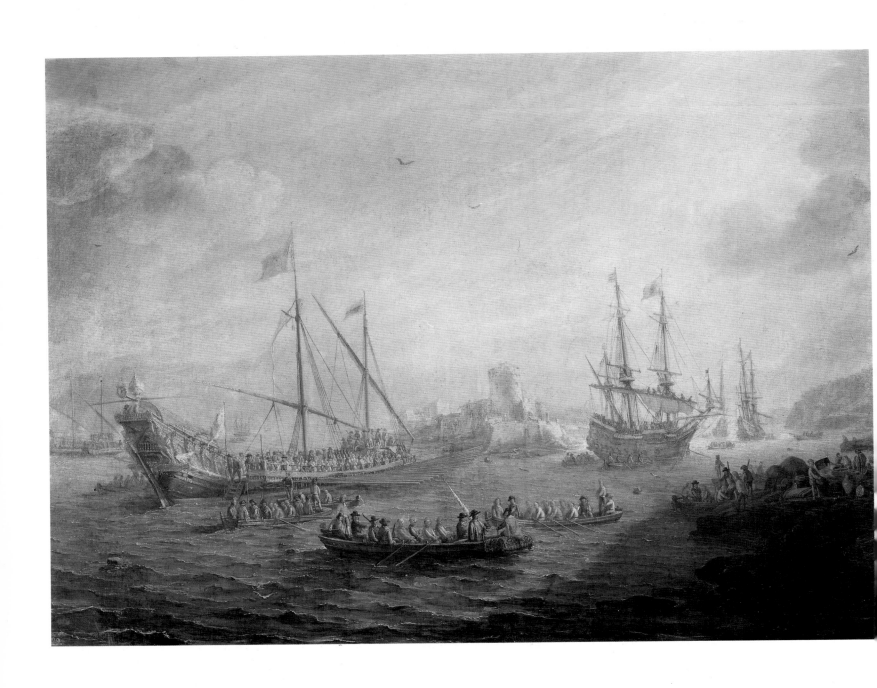

227. **Gaspard van Eyck** (1613–1679)
Seascape [no. 1509]
Oil on canvas, 34 ¼ × 42 ½" (87 × 108 cm)

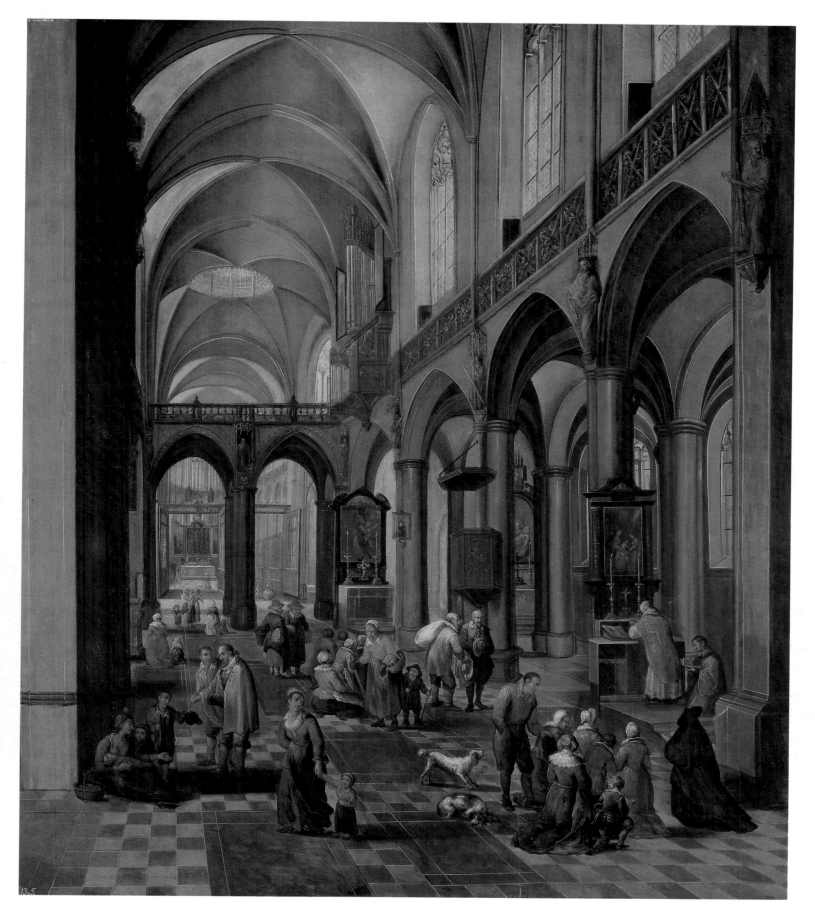

228. Peter Neefs "the Elder" (1577/78–1651/56)
The Interior of a Flemish Church [no. 1599]
Oil on board, 33 ⅛ × 28 ⅜″ (84 × 72 cm)

229. **David Teniers** (1610–1690)
Village Fête [no. 1785]
Oil on copper, 27 1/8 × 33 7/8″ (69 × 86 cm)

230. **David Teniers** (1610–1690)
The Old Man and the Maid [no. 1799]
Oil on canvas, 21 ⅝ × 35 ⅜″ (55 × 90 cm)

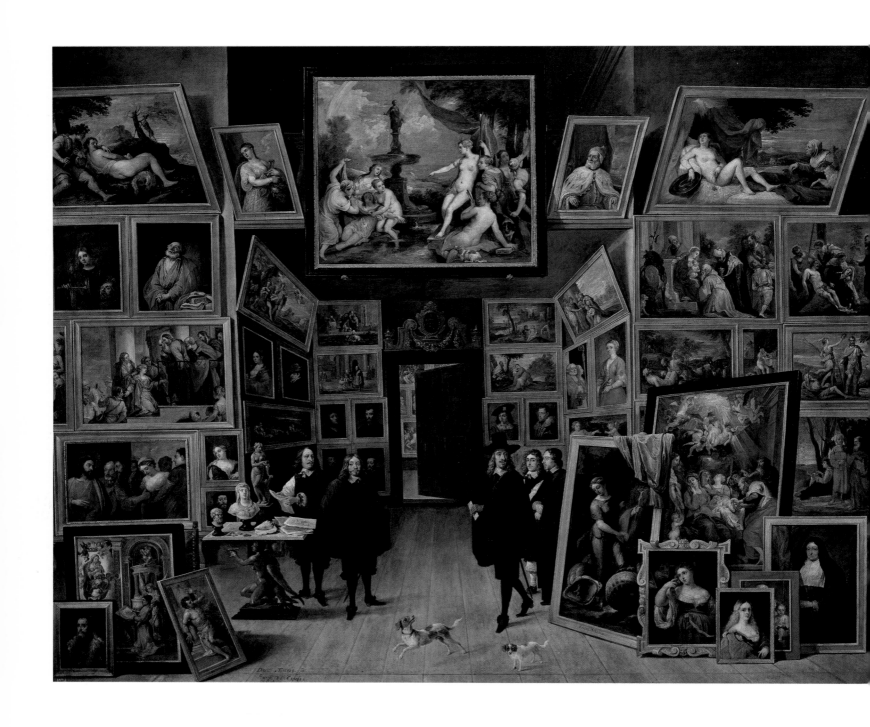

231. **David Teniers** (1610–1690)
The Archduke Leopold Wilhelm in His Gallery of Paintings in Brussels. c. 1647 [no. 1813]
Oil on copper, 41 ¾ × 50 ¾″ (106 × 129 cm)

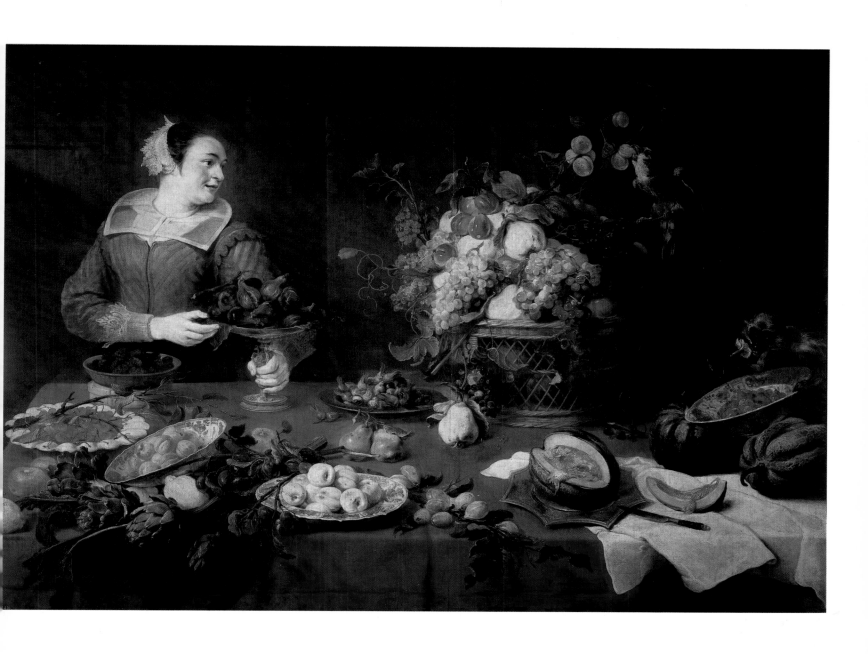

232. **Frans Snyders** (1579–1657)
The Fruit Bowl [no. 1757]
Oil on canvas, 60 ¼ × 84 ¼″ (153 × 214 cm)

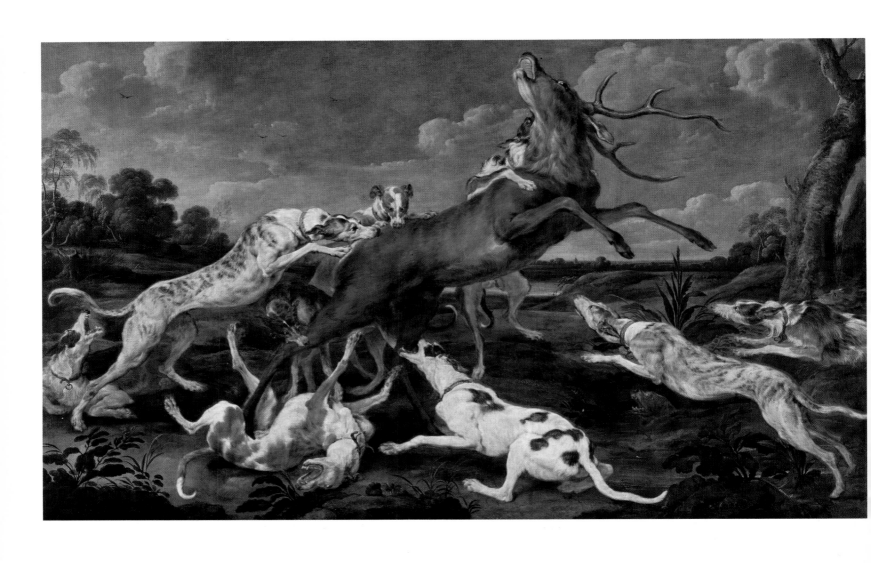

233. **Paul de Vos** (c. 1596–1678)
Deer Cornered by a Pack of Hounds [no. 1870]
Oil on canvas, 83 ½ × 136 ⅝″ (212 × 347 cm)

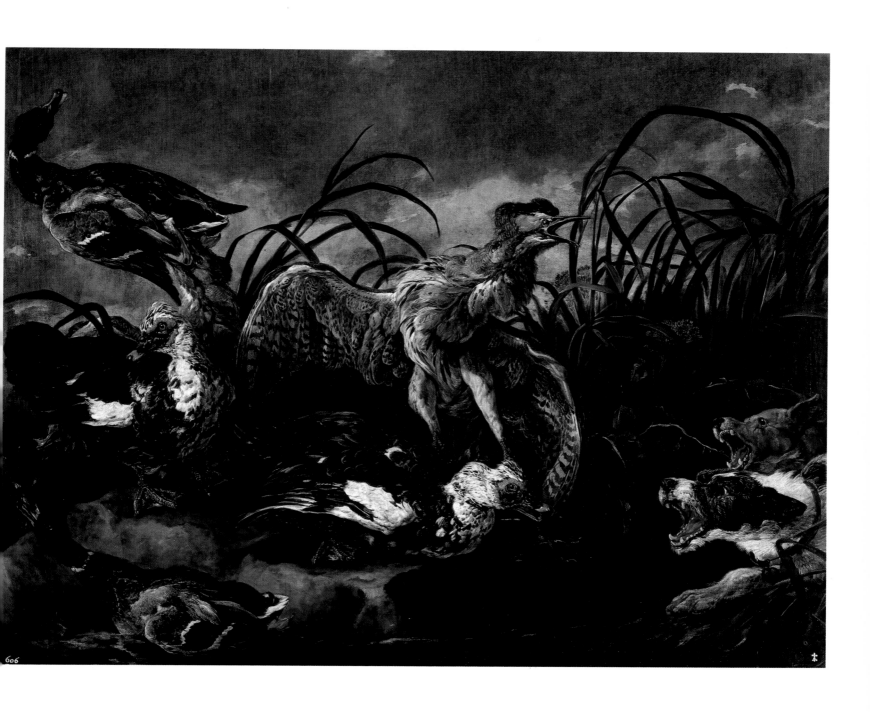

234. **Jan Fyt** (1611–1661)
Ducks and Water Hens Surprised by Dogs [no. 1531]
Oil on canvas, 50 × 64 ⅛″ (127 × 163 cm)

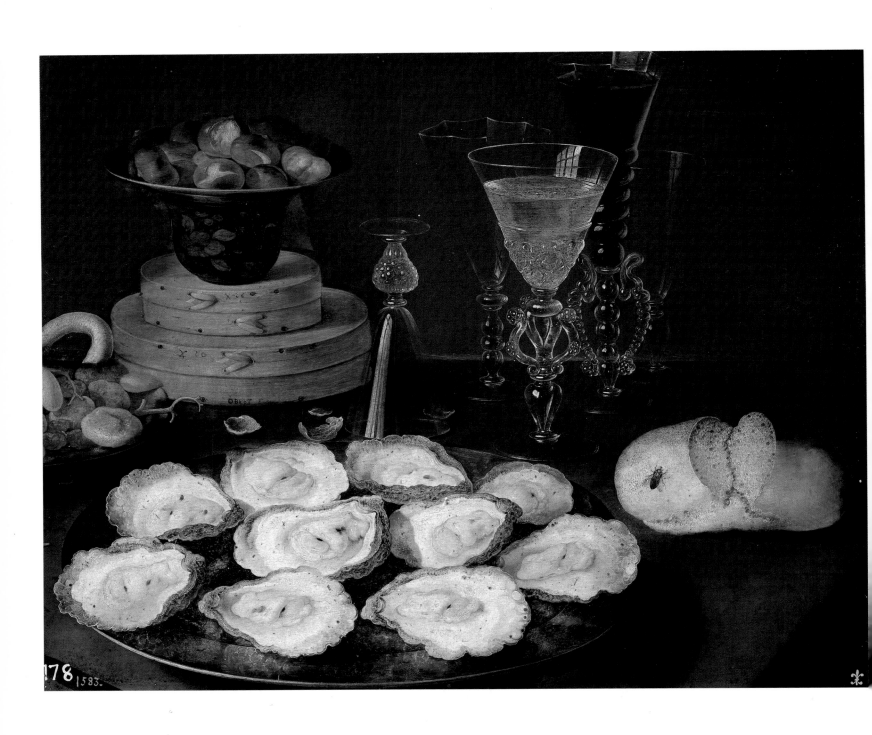

235. **Osias Beet** (1580–1624)
Still Life [no. 1606]
Oil on board, 16⅞ × 21¼″ (43 × 54 cm)

236. **Daniel Seghers** (1590–1661)
Jesus and Saint Teresa in a Garland of Flowers [no. 1991]
Oil on canvas, 51 ⅛ × 41 ⅜″ (130 × 105 cm)

GERMAN SCHOOL

Contrary to what one might expect, painting developed in the Germanic countries, so closely related to the Spanish crown from the sixteenth to the eighteenth centuries, is not very well represented in this museum. Two great artists, who opened and closed this period, are of special note. Albrecht Dürer (1471–1528) was a fundamental figure in German art. In his *Self-Portrait* from 1498 (plate 237) he gazes confidently and aristocratically at the spectator. Essential works are his *Adam* and *Eve* from 1507 (plates 238 and 239), simple though masterly pretexts to expound his theory on the correct proportions of the human body, and the *Portrait of a Man* (plate 240), an example of concentration of content. In two compositions (plates 241 and 242) Dürer's friend and pupil Hans Baldung Grien (1484/5–1545) gave graphic expression to the profound notion, with roots in medieval Germany, that links feminine youth and beauty with death. Another good example of the quality of portrait painters from this school is offered by Hans Holbein "the Younger" with his *Portrait of an Old Man* (plate 243). No less demonstrative of this spirit are the two panels depicting *Hunting Party in Honor of Charles V in Torgau* (plate 244), highly characteristic of the style of Lucas Cranach (1472–1553) and signed by him in 1544.

After an obligatory separation forced by the religious wars, in the eighteenth century there again appears, in the person of Anton Raphael Mengs (1728–1779), an artistic link between the Spanish monarchy and German art. In his written treatises and his pictorial works, frescoes, or oils on canvas, Mengs established the basis for Neoclassicism, which was to take the place of the Baroque. For many years he resided in Spain, where he left a prominent impression, and in Italy. Many of his portraits are preserved in the Prado — works from the time of Charles III, of this king and his family (*Prince Charles IV*, plate 245), of members of the court of Naples and of the Austrian Empire — and all evidence a refined technique and masterly transcription of countenances and details. Other of Mengs's works, of a religious nature, can also be admired in the Prado, as can several by Angelica Kauffmann (1741–1807), for example a portrait in an internationally aristocratic style.

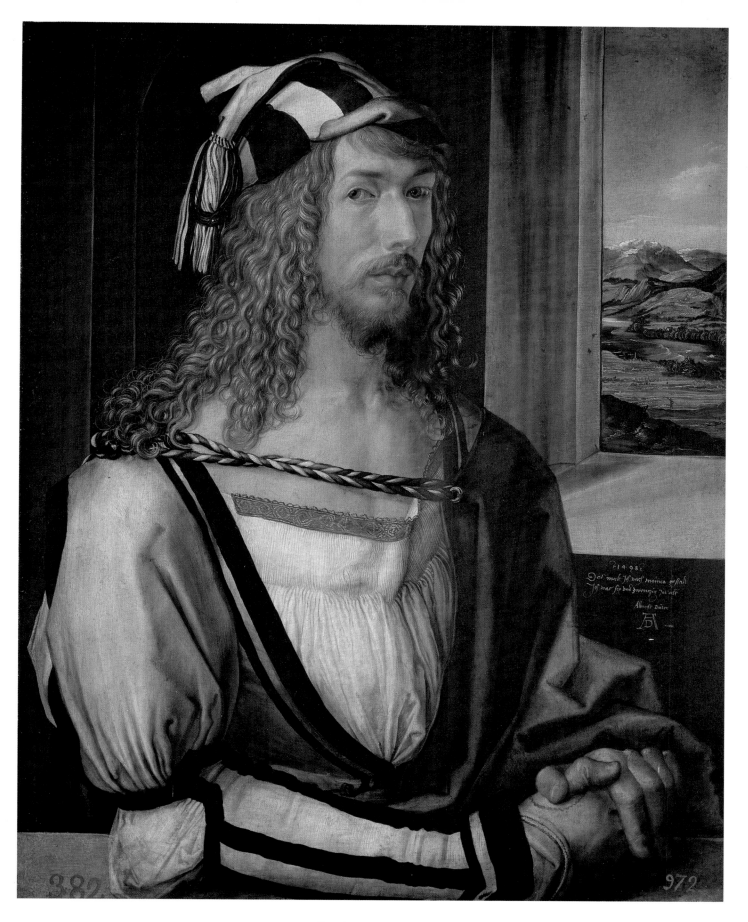

237. **Albrecht Dürer** (1471–1528)
Self-Portrait. 1498 [no. 2179]
Oil on board, 20½ × 16⅛″ (52 × 41 cm)

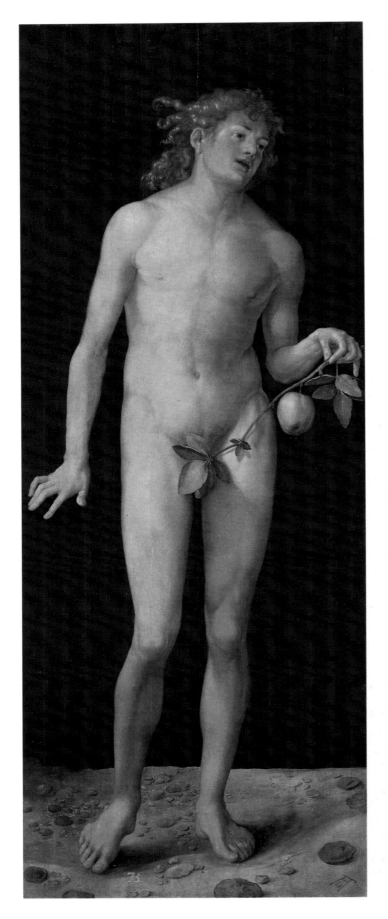

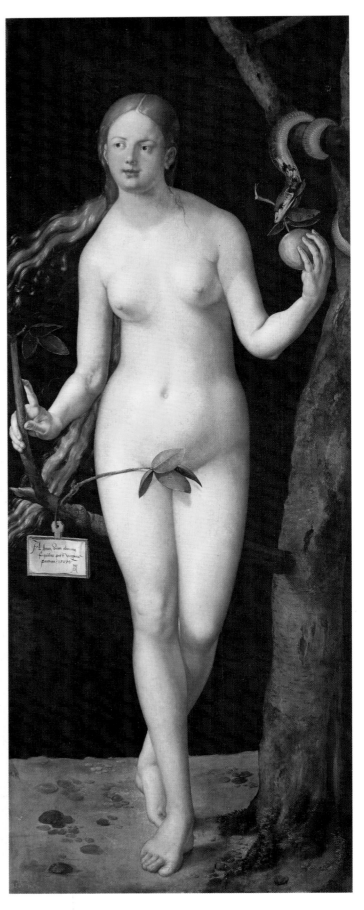

238. Albrecht Dürer (1471–1528)
Adam. 1507 [no. 2177]
Oil on board, 82 ¼ × 31 ⅞″ (209 × 81 cm)

239. Albrecht Dürer (1471–1528)
Eve. 1507 [no. 2178]
Oil on board, 82 ¼ × 31 ½″ (209 × 80 cm)

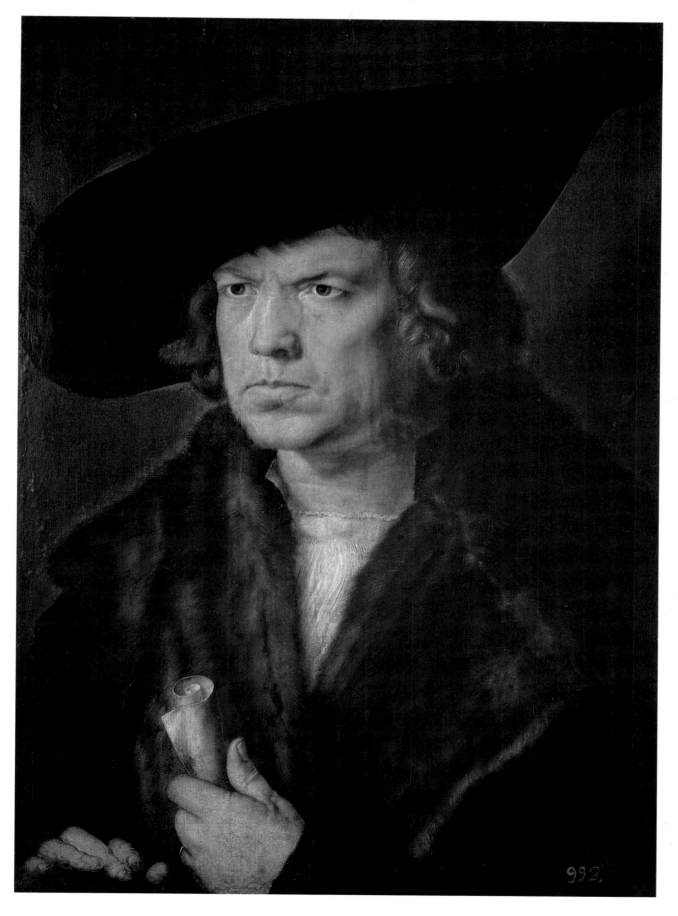

240. **Albrecht Dürer** (1471–1528)
Portrait of a Man. 1524 [no. 2180]
Oil on canvas, 19⅝ × 14⅛″ (50 × 36 cm)

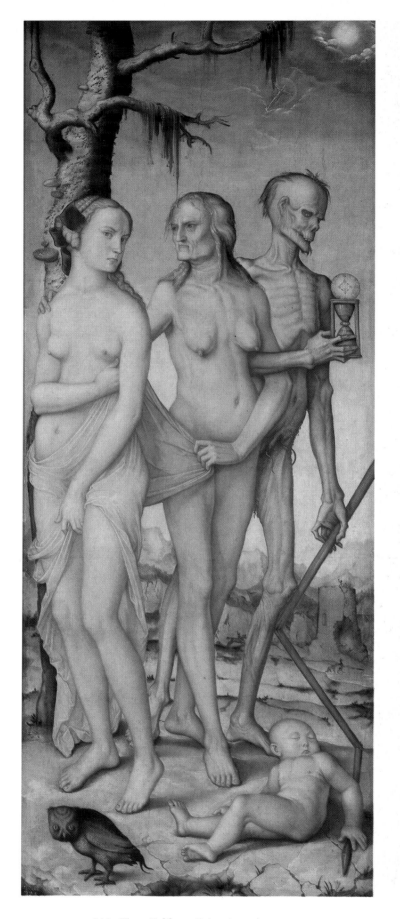

241. Hans Baldung Grien (1484/85–1545)
The Three Ages and Death [no. 2220]
Oil on board, 59 ½ × 24″ (151 × 61 cm)

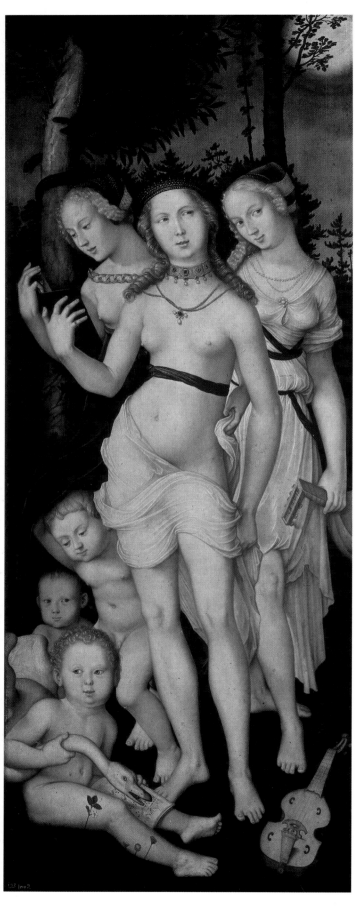

242. Hans Baldung Grien (1484/85–1545)
The Three Graces [no. 2219]
Oil on board, 59 ½ × 24″ (151 × 61 cm)

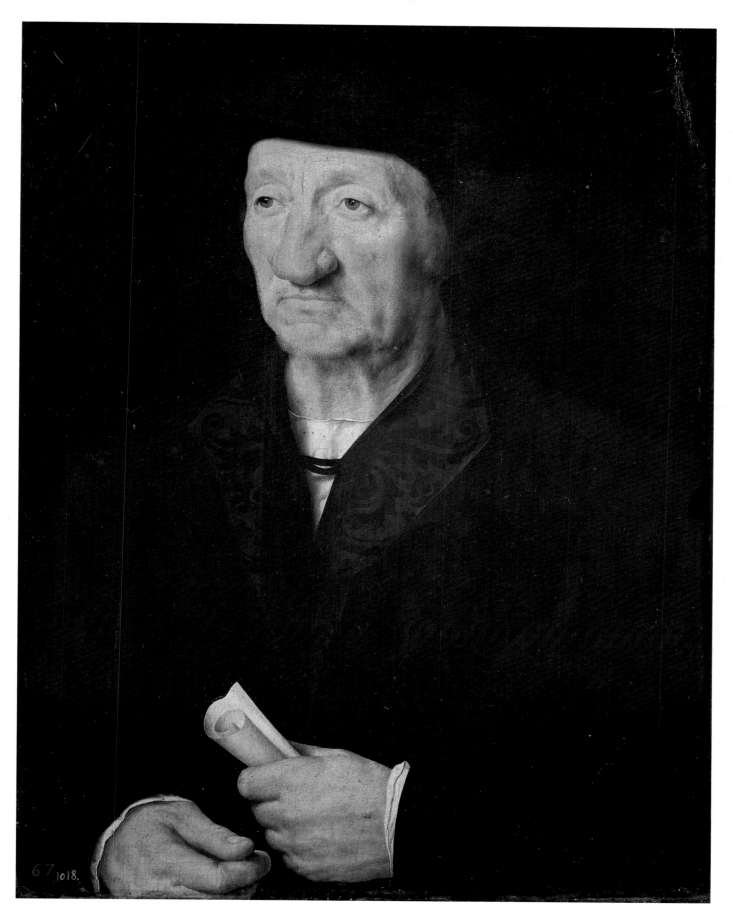

243. Hans Holbein "the Younger" (1497/98–1543)
Portrait of an Old Man [no. 2182]
Oil on board, 24 3/8 × 18 1/2" (62 × 47 cm)

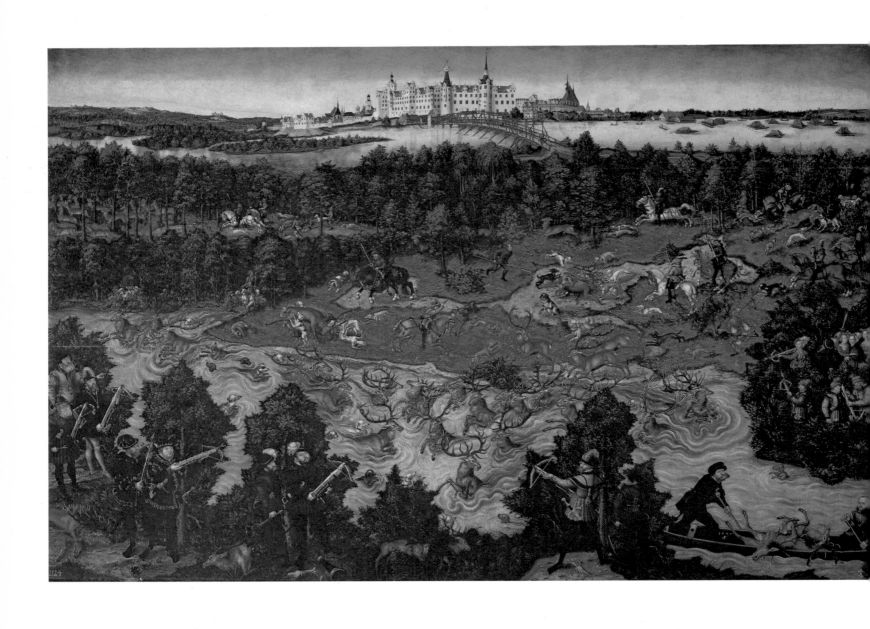

244. **Lucas Cranach** (1472–1553)
Hunting Party in Honor of Charles V in Torgau. 1544 [no. 2176]
Oil on board, 46 ½ × 69 ⅝″ (118 × 177 cm)

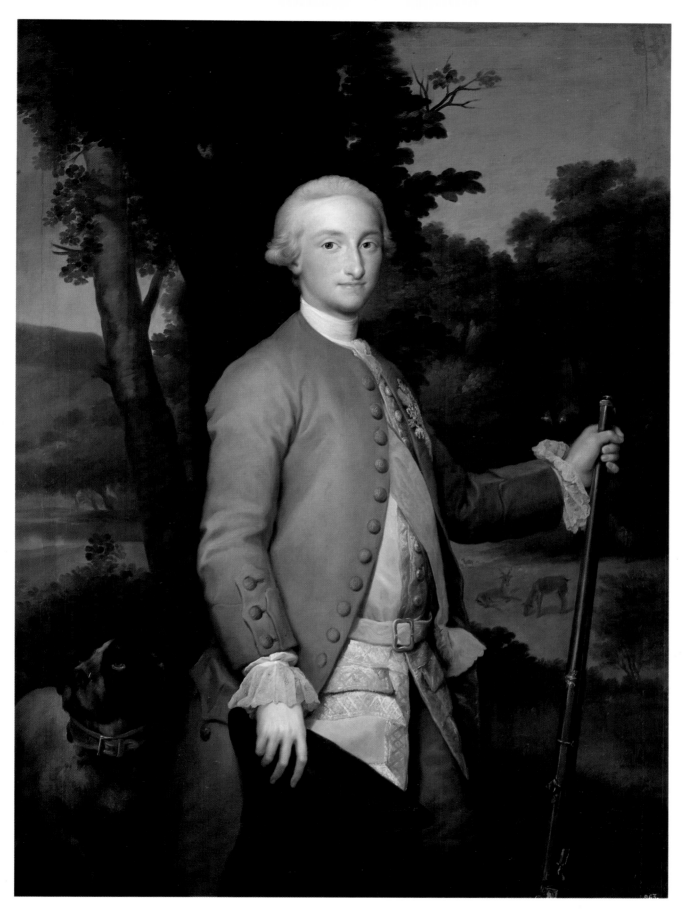

245. **Anton Rafael Mengs** (1728–1779)
Prince Charles IV [no. 2188]
Oil on canvas, 59⅞ × 43¼″ (152 × 110 cm)

DUTCH SCHOOL

The unusual circumstances that led to the creation of Holland as a political entity in the Spanish Low Countries — in fact since 1609 and by law since 1648 — and the strengthening of power in this territory, sustained basically by an active commercial and industrial bourgeoisie with political, economic, religious, and cultural ideals completely opposite to those that predominated in contemporary Spain, help to explain the poor representation in the Prado Museum of the unique pictorial production that developed throughout the seventeenth century in such active centers as Amsterdam, Haarlem, Dordrecht, Delft, and Utrecht. It was not until the eighteenth century that an attempt was made to offset the extreme dearth of Dutch painting in the royal collections. In a small way this was achieved, and what has been gathered here permits the visitor to appreciate a little of what was a rich and varied pictorial panorama of genres such as landscapes and seascapes, only sparsely cultivated by Spanish artists, and of the group portrait.

Naturally enough, this section begins with reference to a painting by Rembrandt (1606–1669), even though *Artemis* (plate 246) is not a work that figures among the artist's best. Simple in composition, it reveals the singular light, color, and suggestive atmosphere characteristic of Rembrandt, also recalled here in works by some of his pupils and followers. A worthy reference to the category of Dutch still life can be found in the work of Pieter Claesz (c. 1596–1661) with the habitual presence of costly glassware, precious metals, and imported fruits, and in that of Willem Claesz Heda (1593/4–1680/2, plate 247). Moralizing intentions can be detected in the elements of sober composition of works by Pieter

van Steenwijck and Jan Davidsz de Heem (1606–1683/84). Gabriel Metsu (1629–1667) reaches utmost simplification in *A Dead Cock* (plate 251).

Strong personality and a clear sense of the avant-garde are to be found in the Dutch landscape painters of the seventeenth century, several of whom are well represented here. Jan van Goyen (1596–1656) offers his lyrical interpretation of the essential values of nature, without the need to present it as the backdrop to human activity. Other values, such as the light and shade in *A Forest* (plate 249), were what interested Jacob van Ruysdael (1628/9–1682), while winter tones, with subtle nuances characteristic of ice and snow, attracted Joost Cornelis Droochsloot (1586–1666) and Hendrik Dubbels (1620–1676). Landscape painting combined with a confident interpretation of farm animals can be seen in the canvas (plate 250) by Paulus Potter (1625–1654).

Genre painting, which allows us to observe so many aspects of daily life in the Dutch towns or countryside of that century, is represented by Philips Wouwerman (1619–1668) with canvases such as *Coming Out of an Inn* (plate 248), *Stop before a Tavern*, *The Hare Hunt*, and *Combat Between Lancers and Foot Soldiers*. Popular scenes are common in the extensive oeuvre of Adrien van Ostade (1610–1685), including themes of *Villagers Singing*, a *Rustic Concert* (plate 252), and a *Village Kitchen*. The portrait has its own specific characteristics, with its reflection of psychology, attire, and other distinctive elements of that well-to-do Dutch bourgeoisie in such paintings as *Petronella de Waert* by Gerard Ter Borch (1617–1681) and *Portrait of a Man* by Jacob Gerritsz Cuyp (1594–1652).

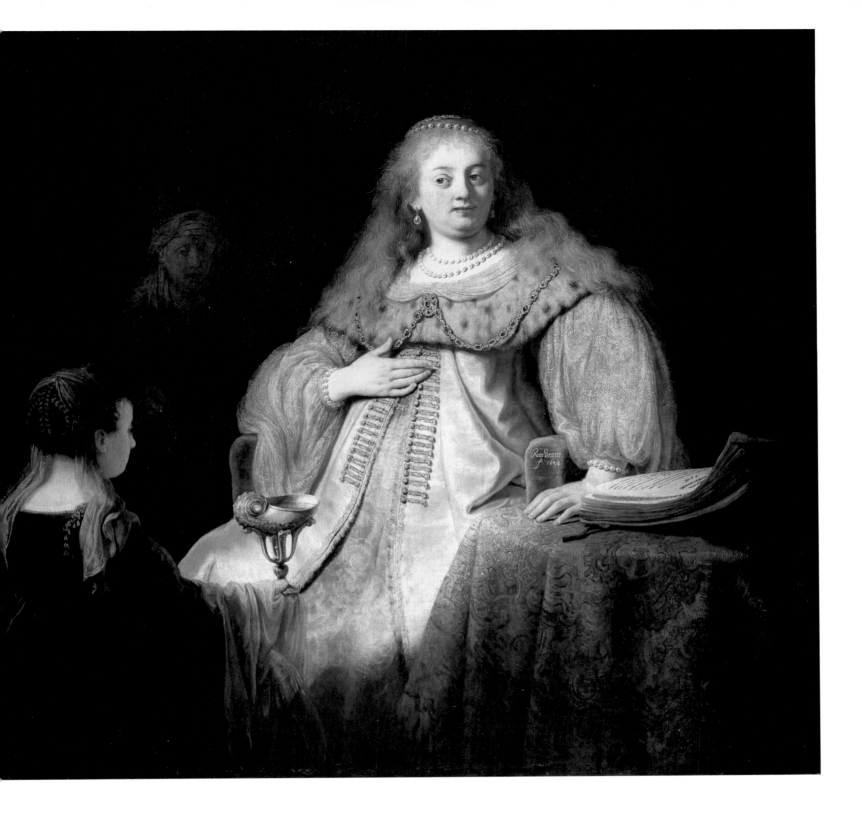

246. **Rembrandt Harmensz van Rijn** (1606–1669)
Artemis. 1634 [no. 2132]
Oil on canvas, 55⅞ × 59⅞″ (142 × 152 cm)

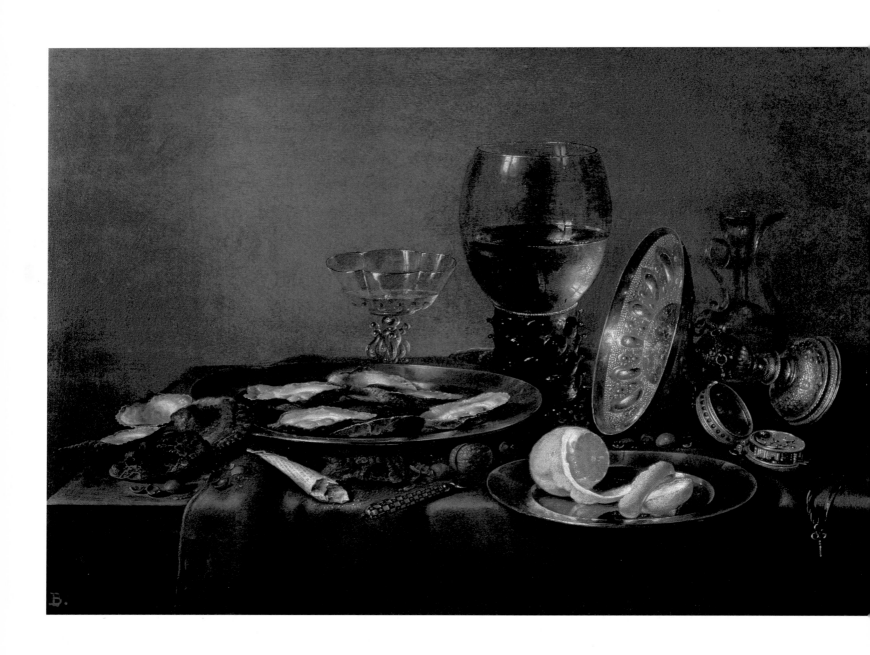

247. **Willem Claesz Heda** (1593/94 – 1680/82)
Still Life [no. 2756]
Oil on canvas, 20 ½ × 28 ¾″ (52 × 73 cm)

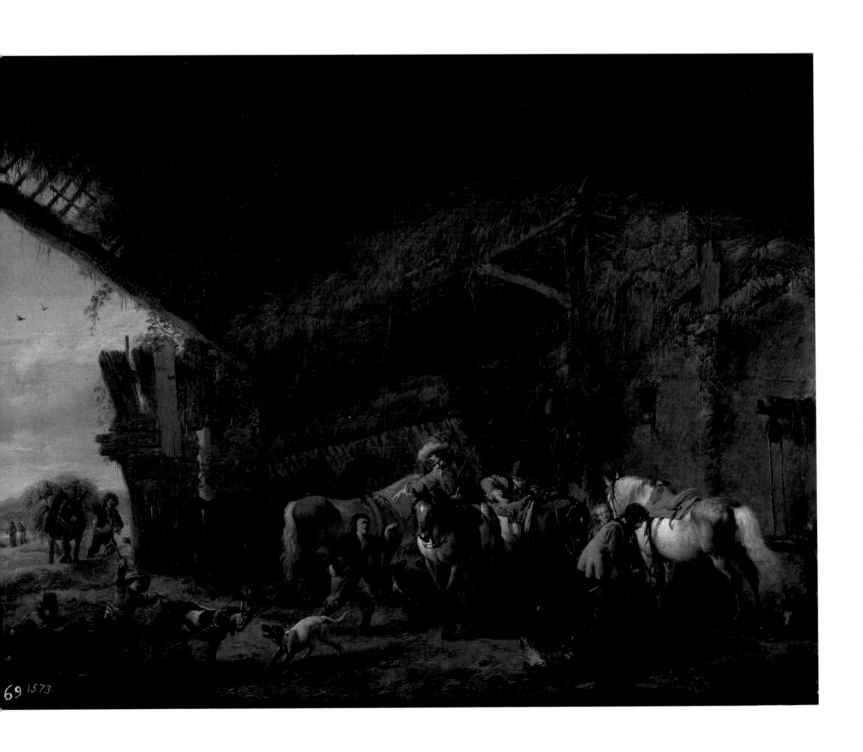

248. **Philips Wouwerman** (1619–1668)
Coming out of an Inn [no. 2151]
Oil on canvas, 14 5/8 × 18 1/2″ (37 × 47 cm)

249. **Jacob van Ruisdael** (1628/29–1682)
A Forest [no. 1729]
Oil on canvas, 24 × 24″ (61 × 61 cm)

250. **Paulus Potter** (1625–1654)
Landscape with Two Cows and a Goat [no. 2131]
Oil on board, 11¾ × 13¾″ (30 × 35 cm)

251. Gabriel Metsu (1629–1667)
A Dead Cock [no. 2103]
Oil on board, 22 ½ × 15 ¾″ (57 × 40 cm)

252. **Adrien von Ostade** (1610–1685)
Rustic Concert [no. 2121]
Oil on board, 14 5/8 × 11 3/4″ (37 × 30 cm)

FRENCH SCHOOL

Even though the Prado Museum cannot boast the same abundance of great French figures as it can Italian or Flemish, this school is without doubt of more importance than what can be seen in this establishment. Not many major works produced in France during the fifteenth century are exhibited here, nor can the visitor form but a vague idea of the singular contributions of Renaissance works from the Fontainebleau school except through anonymous works corresponding to that period. It is not until we reach the seventeenth century that we discover canvases of a certain interest, such as the "Caravaggesque" *Martyrdom of Saint Laurence* (plate 253) by Jean de Boullogne, called Valentin (1594–1632), a member of a creatively restless group of young French painters who, around 1620, developed interesting derivations from works by Caravaggio. This line was also followed initially by Simon Vouet (1590–1649), who later added rich facets from the schools of Bologna and Venice, the reason for his triumph in Paris on his return in 1627. This was the year of his allegory of *Time Defeated by Hope, Love, and Beauty* (plate 254), a key element in the prelude to the Baroque. Within this tendency in its classicist version stands out the group of works by Nicolas Poussin (1594–1665), who worked in Rome almost all his life. There he developed an erudite and intellectual art of refined forms (*Bacchanal; Bacchanalian Scene; The Triumph of David*, plate 256; *Parnassus*, plate 255; *The Hunt of Meleagrus; Noli Me Tangere*) as well as several idealized landscapes. Related to Poussin we find Jean le Maire (1598–1659), very personal in *Hermit among Ruins* and *Landscape with Ruins*, and Gaspard Dughet (1615–1675), who developed his own interpretation of landscapes animated with figures (*A Landscape with Magdalene Worshiping the Cross*, plate 257; *Landscape with Shepherd; Landscape with Waterfall; The Hurricane; The Storm*). Among the most outstanding works in this section are the landscapes by Claude Gellée, called Claude Lorrain (1600–1682), known for his very studied light and poetic use of space (*The Return of the Flock; Ford over a River; The Temptations of Saint Anthony Abbot*; and *The Embarkation of Saint Paula Romana in Ostia*, plate 258). Completing this group with their personalized interpretations are Sebastien Bourdon (1616–1671), with his *Cavalry Battle in Sweden* and *The Metal Snake* (plate 260),

and Jacques Courtois (1621–1676), with his *Battle Between Christians and Moslems* (plate 259).

A single canvas of excellent quality, the profoundly realistic *Vanitas* represents the work of Jacques Linard (c. 1600–1645). As the French court was one of the European centers in which crystallized the idea of what official portraits should be, this genre is widely represented in the museum. The progression is clear from Philippe de Champaigne (1602–1674), with his *Louis XIII*, of great stringency in contrast to the gentler works by the brothers Charles (1604–1674) and Henri Beaubrun (1603–1677), who show no traces of the sumptuous Baroque in their portraits of *Maria de Medicis, Anne of Austria, Anne Marie Louise d'Orléans*, and *The Grand Dauphin, Louis de Bourbon*. Jean Nocret (1615–1672) remains sober in his versions of *Louis XIV* and the *Duke of Orléans*, while a more spectacular representation is achieved by Pierre Mignard (1612–1695) with his excellent *Saint John the Baptist*.

The dawning of the eighteenth century in France is marked by Antoine Coypel (1661–1722), author of a tapestry cartoon with *Susan Accused of Adultery*, and by the culmination of the work of court portrait painters such as François de Troy (1645–1730, *Mariana of Bavaria*) and especially the Catalan Hyacinthe Rigaud (1659–1743), who with great brilliance established the characteristics of the official portrait, here represented by *Philippe IV* and *Louis XIV* (plate 263). The genre was further developed by Nicolas de Largillière (1656–1746) with the portrait of *Marie Anne Victoria de Bourbon* and Pierre Gobert (1662–1744), who incorporated mythological themes into *The Duchess of Burgundy and Her Children* and a varied typology into the portraits of the *Princess of Conti* and *Louis XV*.

A richer spirit gave character to this century of great French painting in the persons of such artists as Antoine Watteau (1616–1721), who reveals all the poetry of his art in *The Marriage Contract* (plate 261) and the feeling of courtly festivals in *Party in a Park* (plate 262), luminous and ethereal. Several contemporaries of his, despite working in Madrid in the service of the new dynasty, kept the characteristics of their origins, and in some fortunate cases surpassed their official activities as portrait painters. One example is Michel-Ange Houàsse

(1680–1730), who worked in Madrid since 1715. His are portraits such as *Louis I*, a *Holy Family* and other religious works, several tapestry cartoons depicting mythological scenes (*Bacchanalia*, plate 266), and a fine *View of the Monastery of El Escorial* (plate 265). Only portraits represent the work of Jean Ranc (1659–1743), who correctly interpreted the effigies of Philip V and members of his family (*Prince Ferdinand VI*, plate 264), and of Louis-Michel van Loo (1707–1771), remembered particularly for *The Family of Philip V* (plate 267), which is useful as both the reflection of an era and a point of comparison with *The Family of Charles IV* by Goya.

The panorama of French painting during the fifty-odd years of the middle of this century is too complex for all its facets to be fully represented in the museum. Corresponding to this period are portraits of the Count and Countess of Castelblanco by Jean-Baptiste Oudry (1686–1755) and the interesting landscapes and seascapes (see plate 268) by Claude-Joseph Vernet (1714–1789), many of which he painted during his stay in Rome. Hubert Robert (1733–1808) shows an interest in archaeology (*The Colosseum in Rome*), and Jean Pillement (1728–1808) traveled around Spain to capture the rich colors of the country's landscape (see plate 269). Signs of the arrival of Neoclassicism can be detected in works by artists such as Jean Antoine Julien (1736–1799), Elisabeth Vigée-Le Brun (1755–1842), with her portrait paintings at the court of Naples, and François Gerard (1770–1837), who endeavored with the court effigy of Charles X to link with the tradition of Louis XIV.

In a purely incidental way the museum acquired several paintings of a number of succeeding tendencies in French painting during the nineteenth century. A feminine nude on the beach entitled *The Pearl and the Wave* is an excellent example of the studio painting of Paul Baudry (1828–1886). Though professionally correct, Baudry's work lacks the vital impulse that characterizes that of his contemporary Gustave Courbet, for example. No less correct are the paintings by Jean-Louis Ernest Meissonnier (1815–1891). One, a portrait of the *Marchioness of Manzanedo* (plate 270), reflects the painter's skillful capturing of physiological traits and his careful transcription of the surroundings, from the elegant attire to the furniture; another, *Portrait of a Lady*, is remarkable for the liveliness of the model, evoked through the use of a sober palette and assured brushstrokes.

253. **Jean de Boullogne,** called **Jean Valentin** (1594–1632)
The Martyrdom of Saint Lawrence [no. 2346]
Oil on canvas, 76 ¾ × 102 ¾″ (195 × 261 cm)

254. **Simon Vouet** (1590–1649)
Time Defeated by Hope, Love, and Beauty. 1627 [no. 2987]
Oil on canvas, 42 ⅛ × 55 ⅞″ (107 × 142 cm)

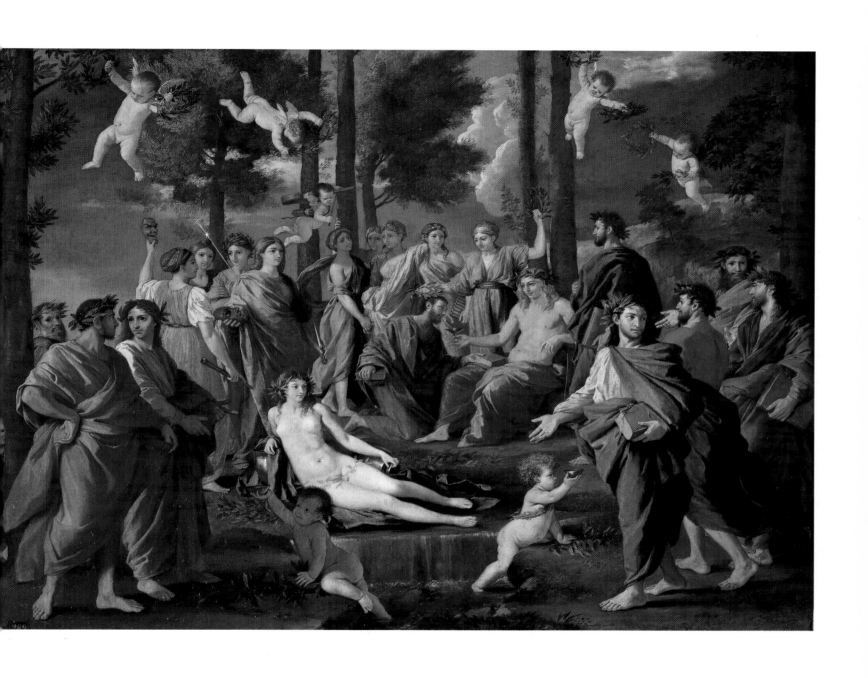

255. **Nicolas Poussin** (1594–1665)
Parnassus [no. 2313]
Oil on canvas, 57 ⅛ × 77 ½″ (145 × 197 cm)

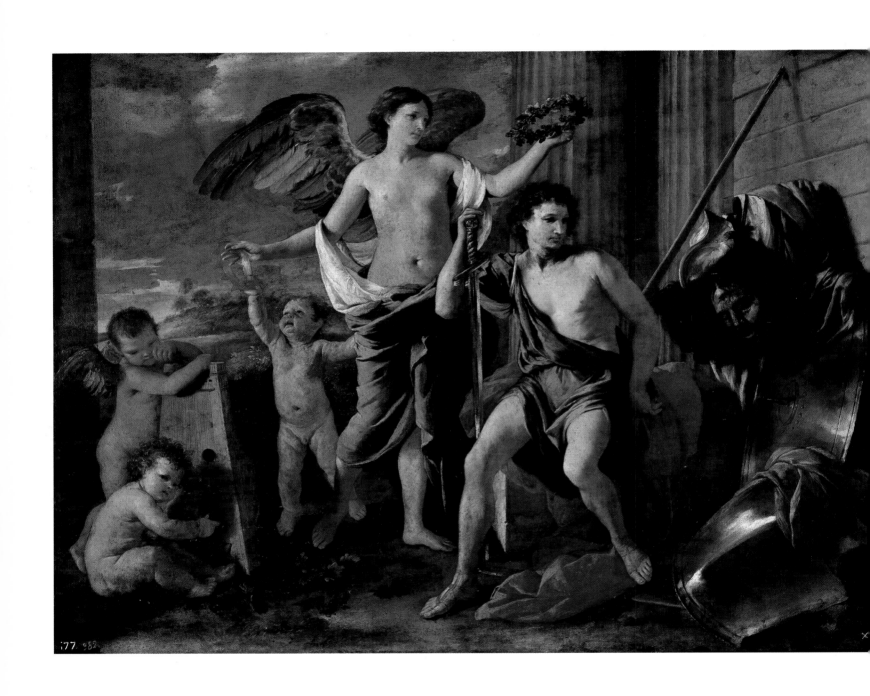

256. **Nicolas Poussin** (1594–1665)
The Triumph of David [no. 2311]
Oil on canvas, 39 3/8 × 51 1/8″ (100 × 130 cm)

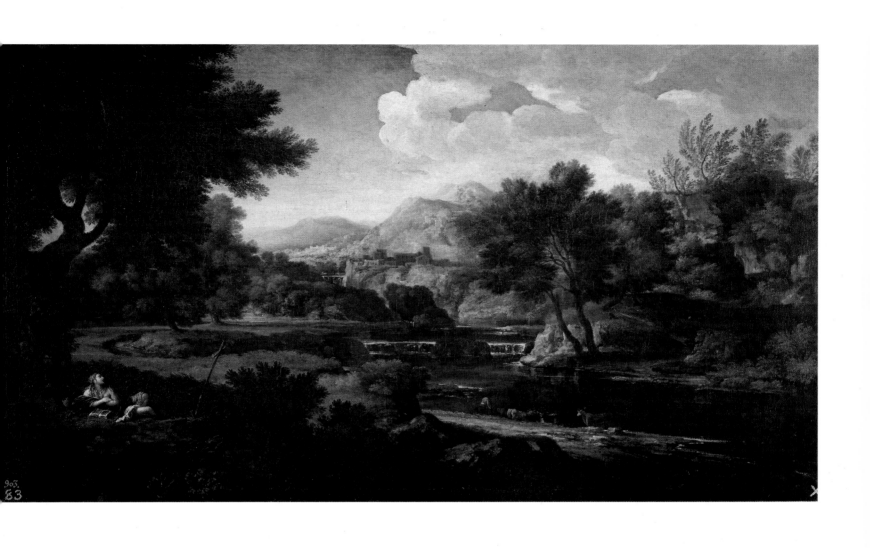

257. **Gaspard Dughet** (1615–1675)
A Landscape with Magdalene Worshiping the Cross [no. 136]
Oil on canvas, 29⅞ × 51⅛″ (76 × 130 cm)

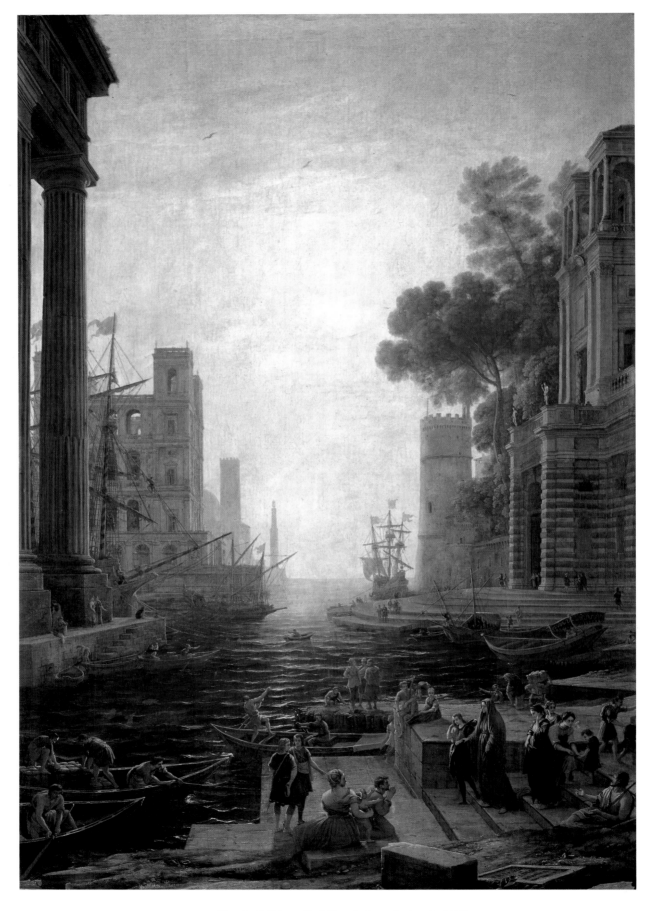

258. **Claude Gellée**, called **Claude Lorrain** (1600–1682)
The Embarkation of Saint Paula Romana in Ostia [no. 2254]
Oil on canvas, 83 ⅛ × 57 ⅛″ (211 × 145 cm)

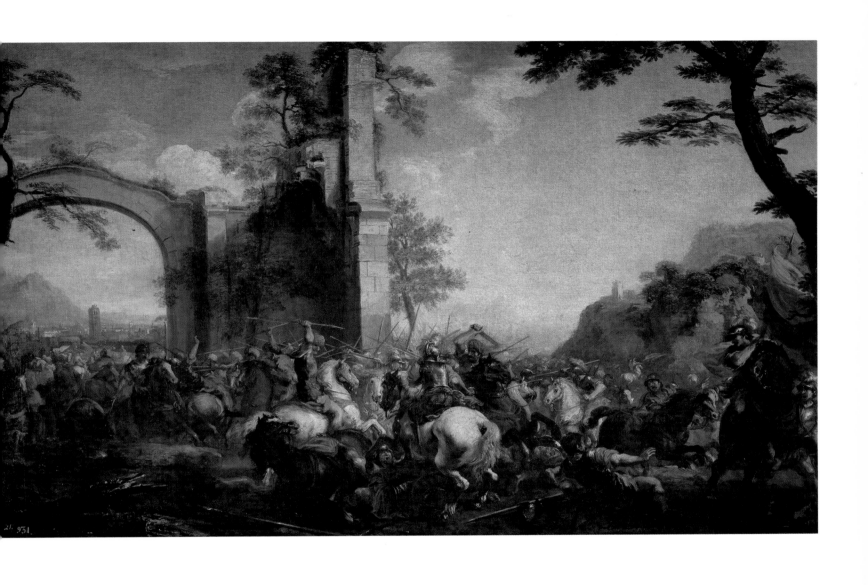

259. **Jacques Courtois "le Bougignon"** (1621–1676)
Battle Between Christians and Moslems [no. 2242]
Oil on canvas, 37 ¾ × 59 ⅞" (96 × 152 cm)

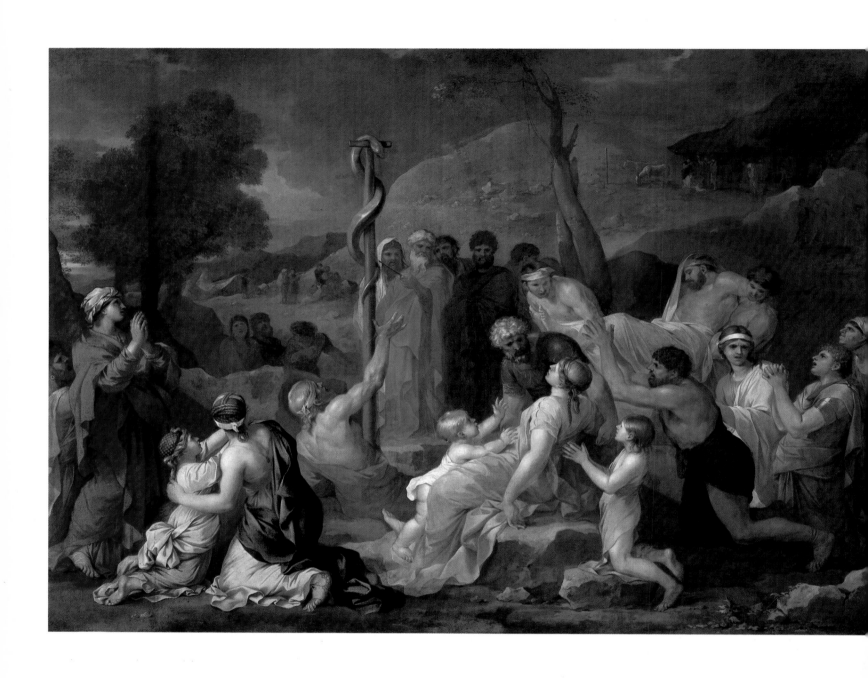

260. **Sebastien Bourdon** (1616–1671)
The Metal Snake [no. 4717]
Oil on canvas, 44 ½ × 59 ½″ (113 × 151 cm)

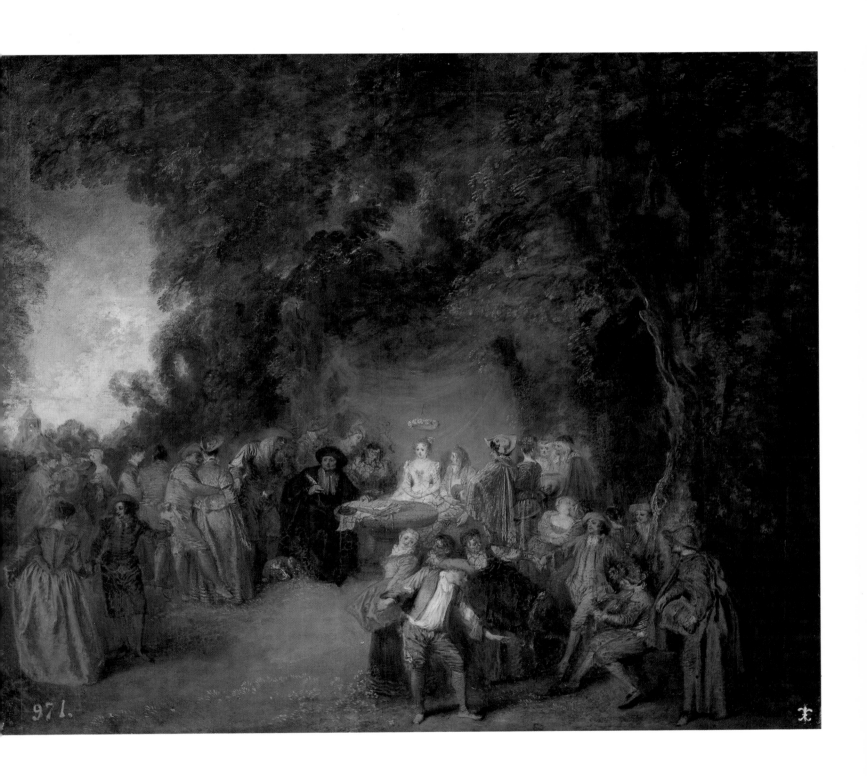

261. **Antoine Watteau** (1684–1721)
The Marriage Contract [no. 2353]
Oil on canvas, 18 1/2 × 21 5/8″ (47 × 55 cm)

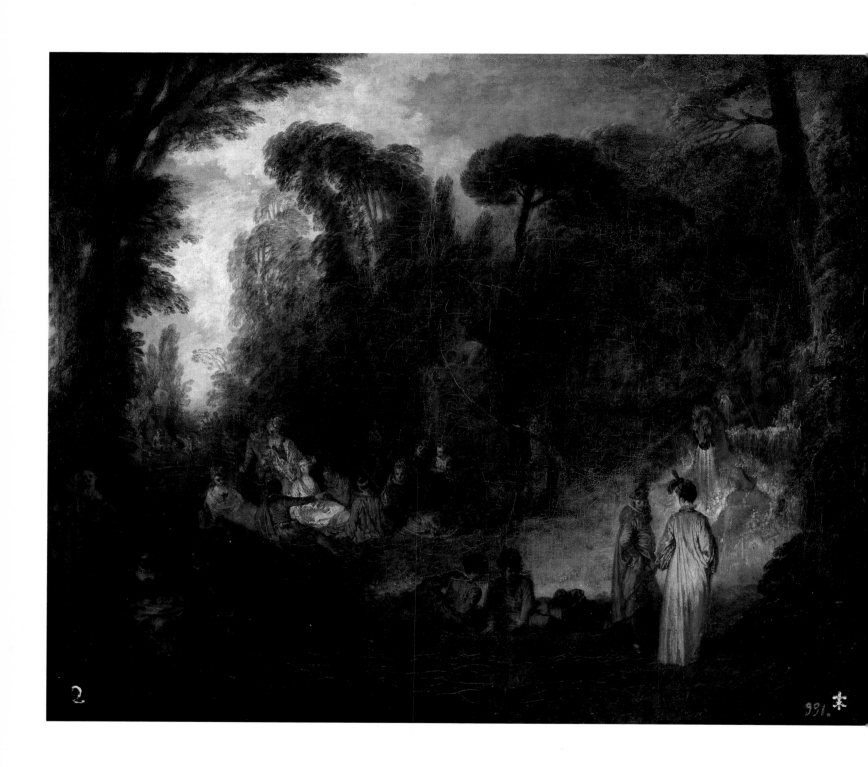

262. **Antoine Watteau** (1684–1721)
Party in a Park [no. 2354]
Oil on canvas, 18⅞ × 22″ (48 × 56 cm)

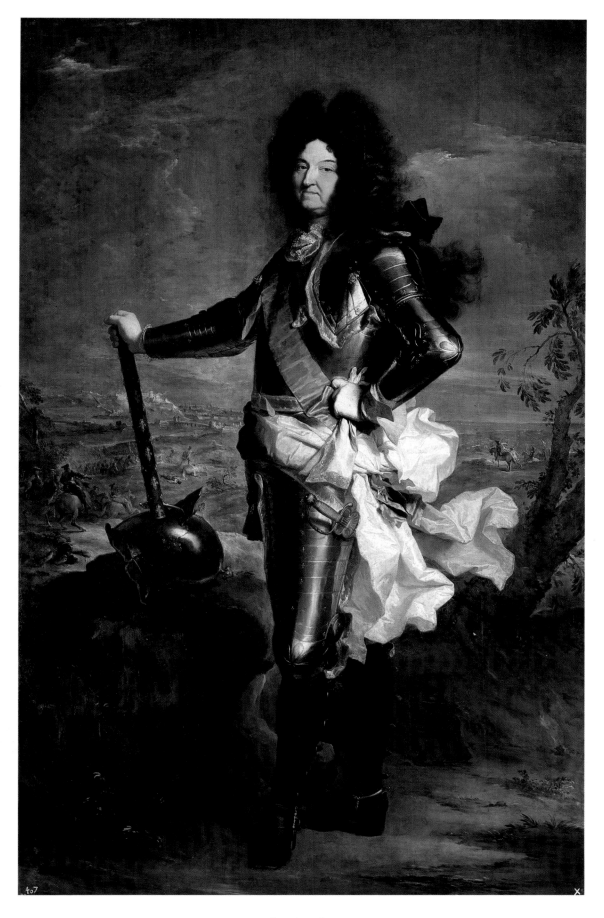

263. **Hyacinthe Rigaud** (1659–1743)
Louis XIV. 1701 [no. 2343]
Oil on canvas, 93 ¾ × 58 ⅝″ (238 × 149 cm)

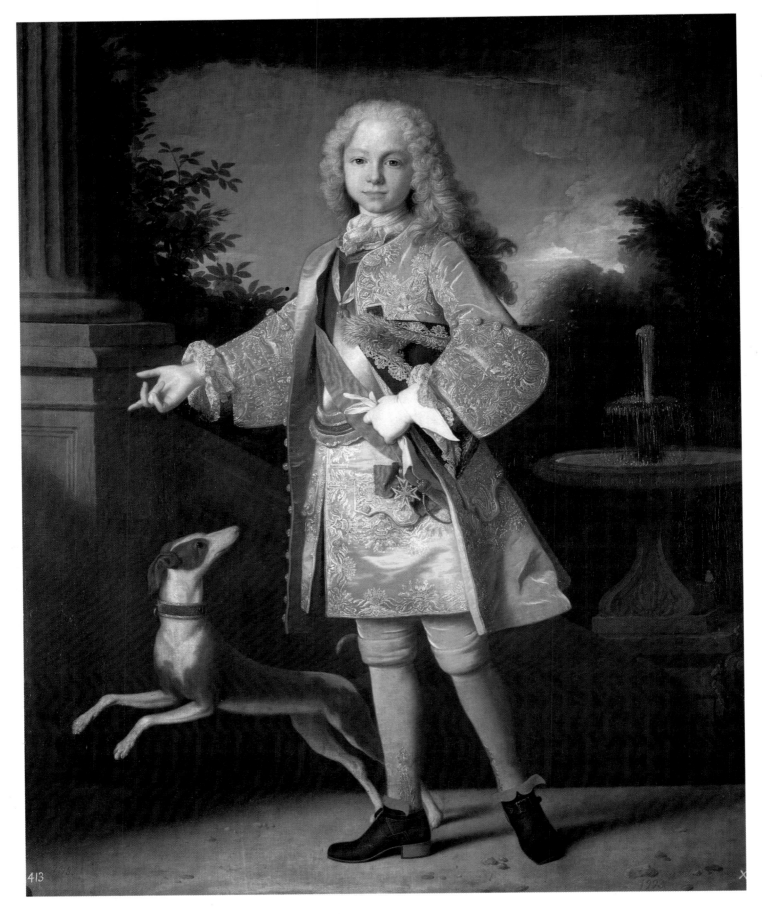

264. Jean Ranc (1659–1743)
Prince Ferdinand VI [no. 2333]
Oil on canvas, 56¾ × 45⅝" (144 × 116 cm)

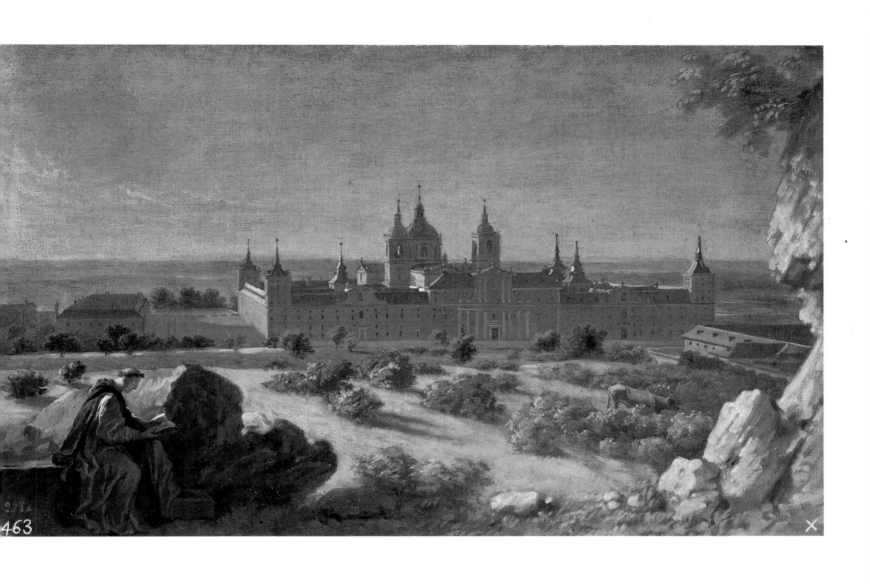

265. **Michel-Ange Houàsse** (1680–1730)
View of the Monastery of El Escorial [no. 2269]
Oil on canvas, 19⅝ × 32¼″ (50 × 82 cm)

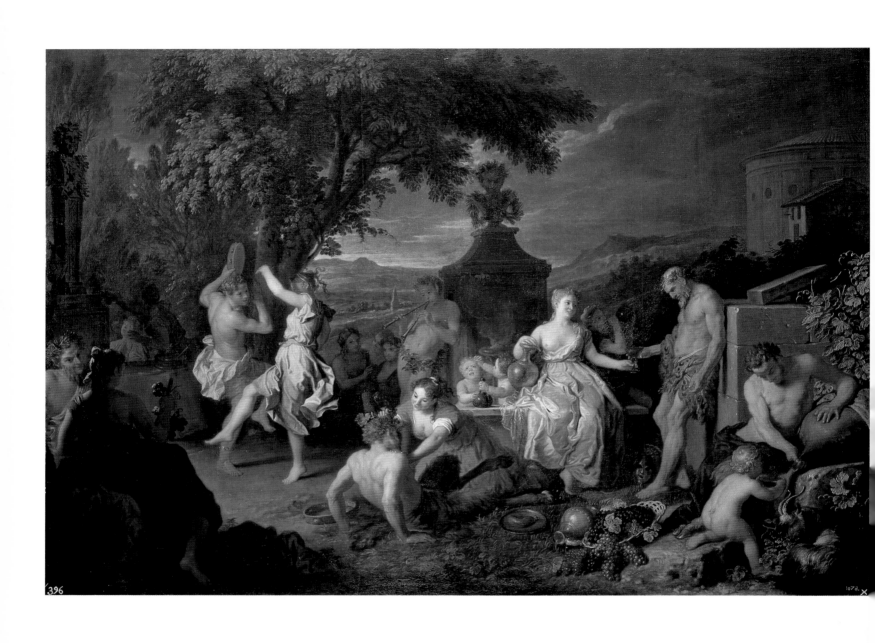

266. **Michel-Ange Houàsse** (1680–1730)
Bacchanalia. 1719 [no. 2267]
Oil on canvas, 49 ¼ × 70 ⅞″ (125 × 180 cm)

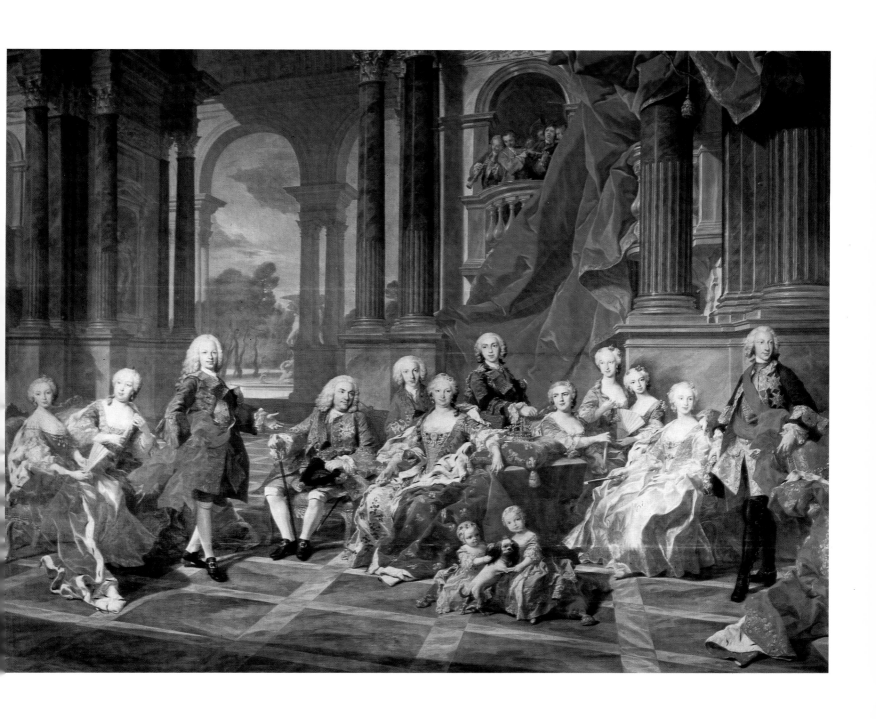

267. **Louis-Michel van Loo** (1707–1771)
The Family of Philip V. 1743 [no. 2283]
Oil on canvas, 159 7/8 × 201 1/8″ (406 × 511 cm)

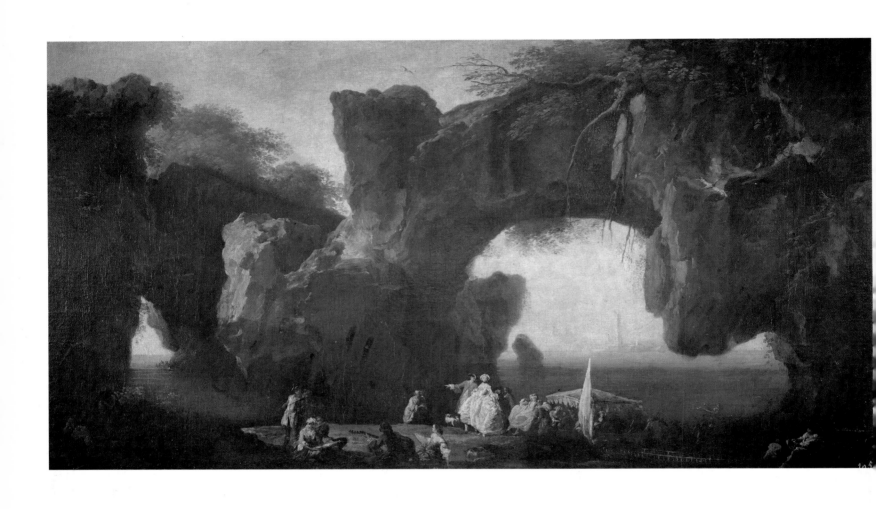

268. Claude-Joseph Vernet (1714–1789)
Seascape, View of Sorrento [no. 2350]
Oil on canvas, 23 ¼ × 42 ⅞″ (59 × 109 cm)

426

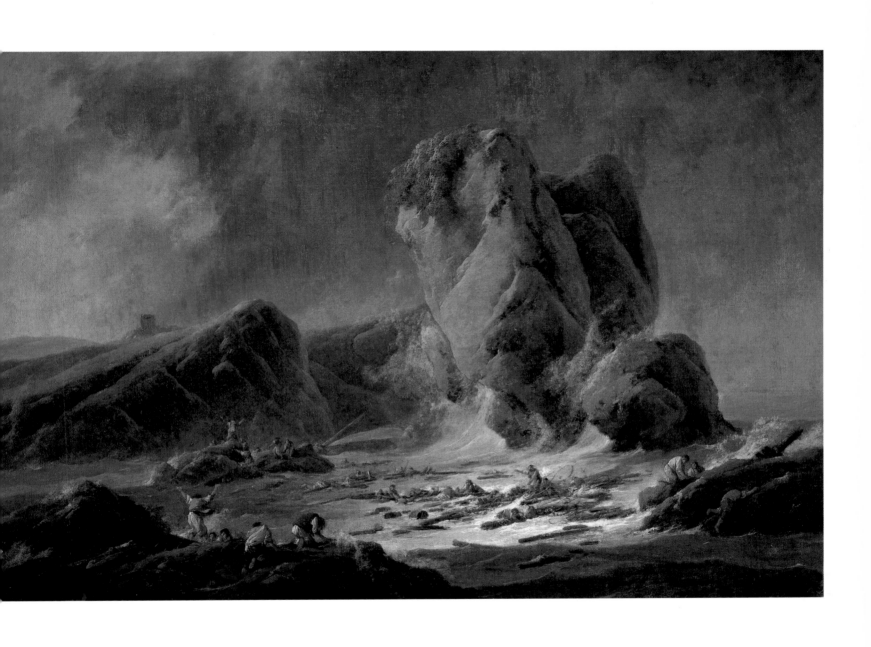

269. **Jean Pillement** (1728–1808)
Shipwrecked Sailors Coming Ashore [no. 7021]
Oil on canvas, 22 × 31 ½″ (56 × 80 cm)

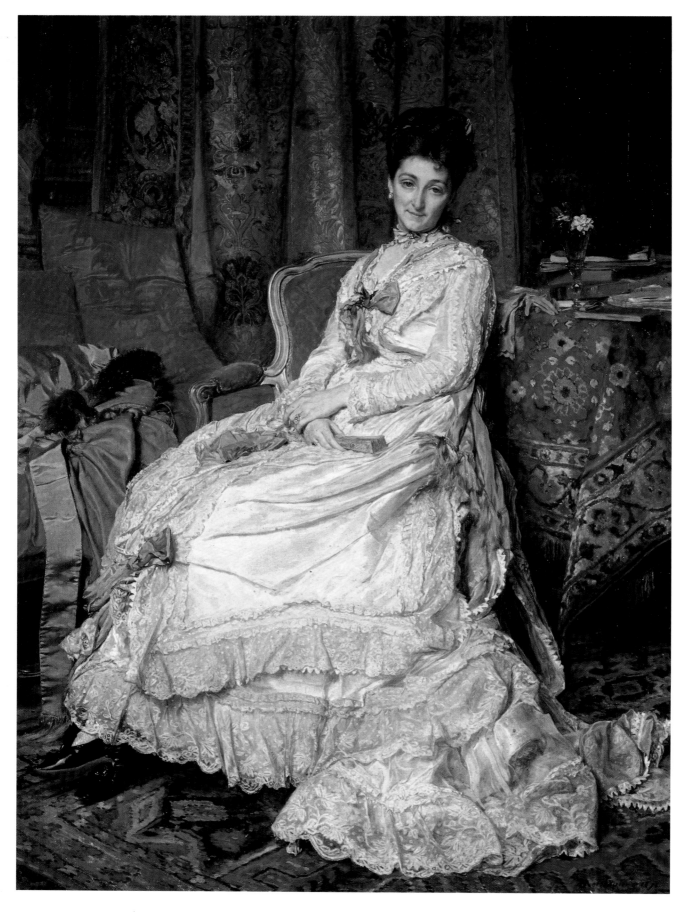

270. Jean-Louis-Ernest Meissonier (1815–1891)
The Marchioness of Manzanedo [no. 2628]
Oil on canvas, 23 ¼ × 19 ¼″ (59 × 49 cm)

BRITISH SCHOOL

The few periods in which relations between the Spanish and English crowns could be described as cordial did not coincide with the opportunity to exchange paintings. This is true to the extent that almost all the British works in the Prado were acquired in this century, with the idea of bridging this gap as much as possible. An attempt was made to obtain a discrete representation of the important group of eighteenth-century portrait painters, and thanks to this effort two paintings (see plate 271) by Joshua Reynolds (1723–1792) can be admired. Thomas Gainsborough (1727–1788) is also represented by two works, in a more refined style that comes closer to that Van Dyck as a reminder of his long stay in the English court (see plate 272). There are also two samples of this genre by George Romney (1734–1802), three by Thomas Lawrence (1769–1830, see plate 273), and one by Martin Archer Shee (1769–1850, plate 274). In this way an acceptable point of reference was reached, useful for the study of the roots of Spanish artists who devoted themselves to portrait painting during the last decades of that century.

In a very different genre, the three paintings by the Scotsman David Roberts (1769–1864) are of special interest. The artist was a prototype of the travelers who captured the Spanish landscape with a romantic vision, clearly perceptible in his interpretations of *The Castle of Alcalá de Guadaira* (plate 275), the Sevillian *Torre del Oro*, and the *Mezquita of Córdoba*. At the other extreme we must place *Pompeian Scene* by Lawrence Alma Tadema (1836–1912) for its meticulous transcription of reality and the sense of serenity and equilibrium provided by the predominant horizontals of the composition.

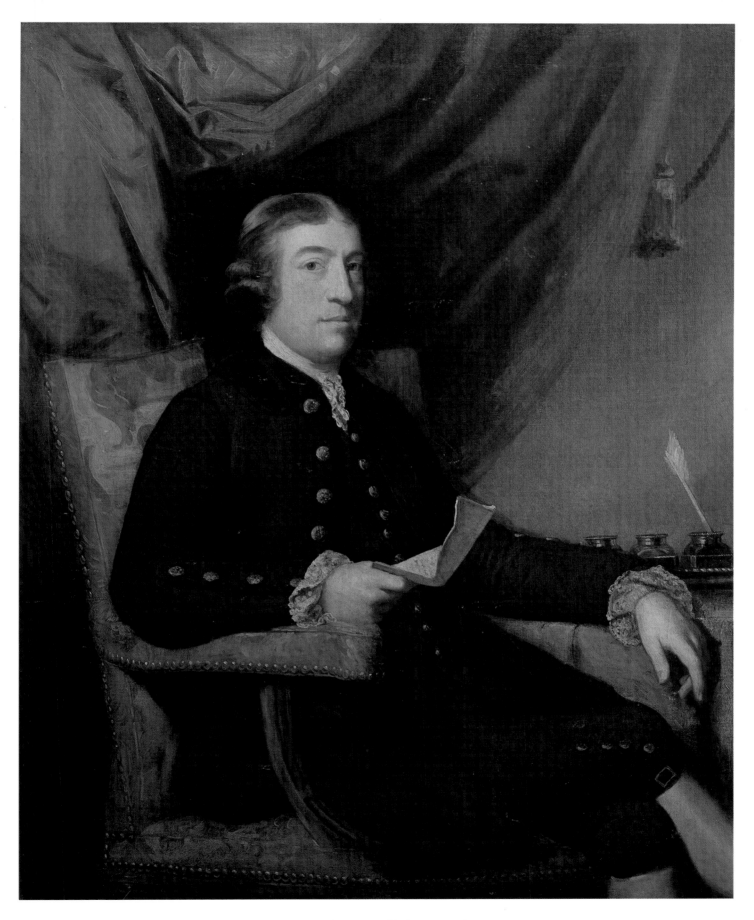

271. **Joshua Reynolds** (1723–1792)
Mr. James Bourdieu. 1765 [no. 2986]
Oil on canvas, 50⅜ × 40½″ (128 × 103 cm)

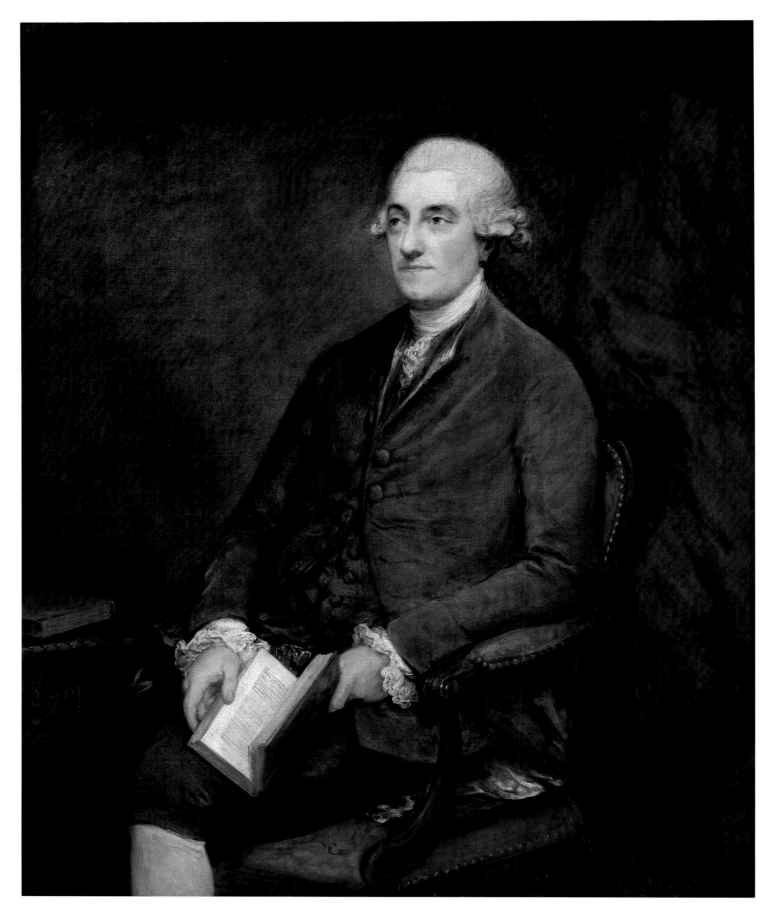

272. **Thomas Gainsborough** (1727–1788)
Isaac Henrique Sequeira [no. 2979]
Oil on canvas, 50 × 40 ⅛″ (127 × 102 cm)

432

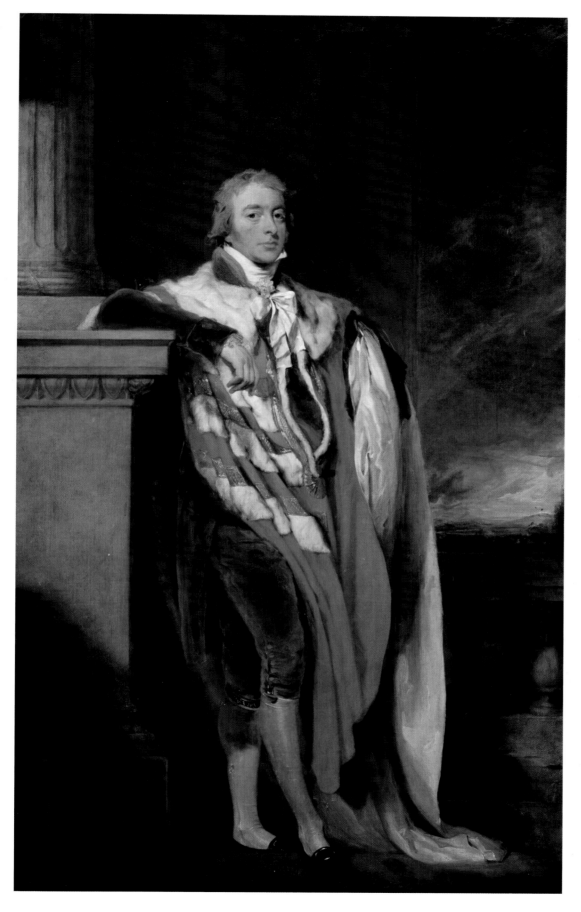

273. **Thomas Lawrence** (1769–1830)
John Fane, Tenth Count of Westmorland [no. 3001]
Oil on canvas, 97 1/4 × 57 7/8″ (247 × 147 cm)

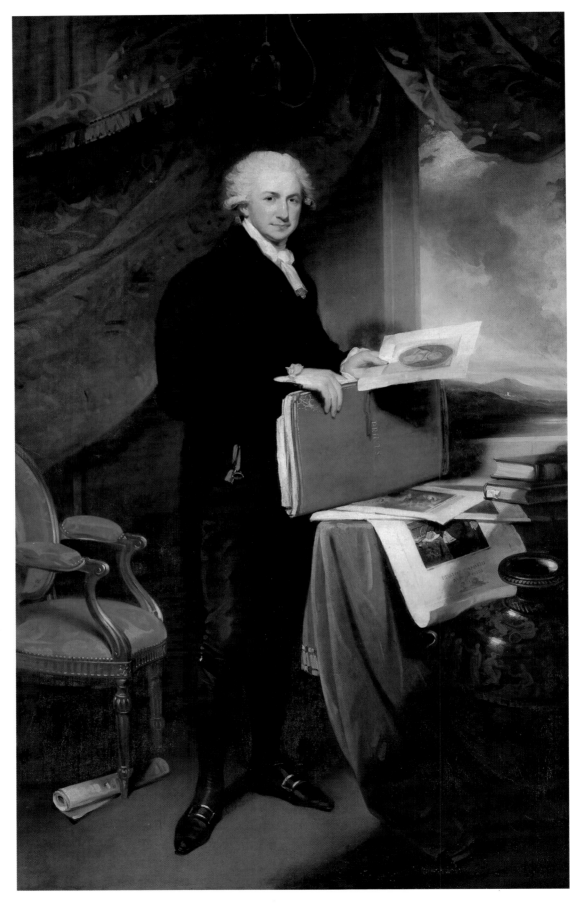

274. **Martin Archer Shee** [1769–1850]
Mr. Storer [no. 3000]
Oil on canvas, 94 ½ × 58 ¼″ (240 × 148 cm)

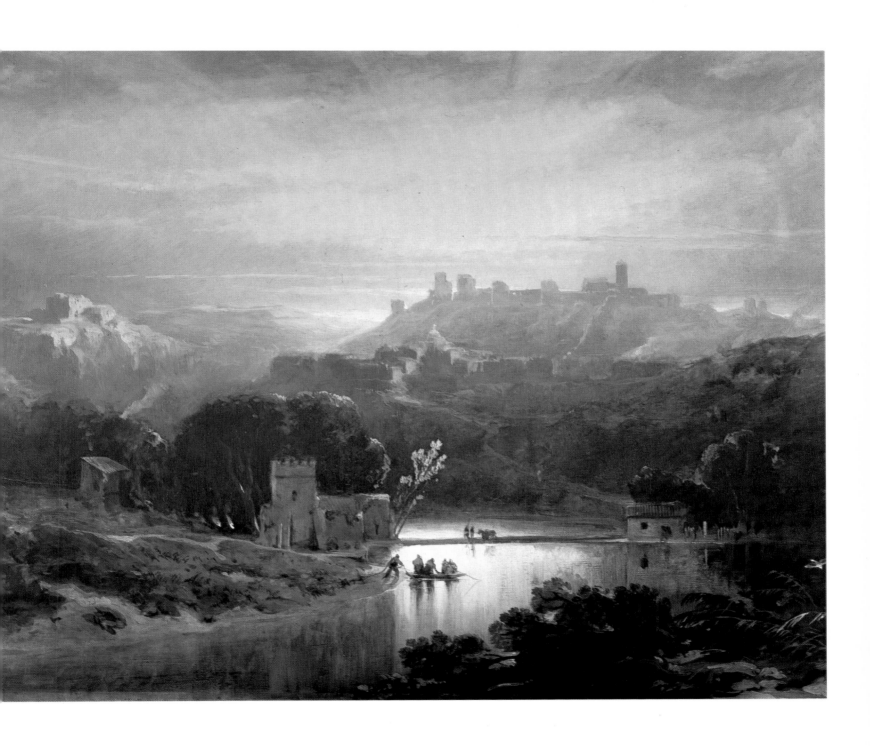

275. **David Roberts** (1769–1864)
The Castle of Alcalá de Guadaira [no. 2852]
Oil on canvas, 15 ¼ × 18 ⅞″ (40 × 48 cm)

APPENDIX

*Royal Decree 1432/1985 dated August 1 by which the
Autonomous Organism the "National Museum of El Prado" is
constituted and its statutory regulations established.*

Since it was inaugurated on November 19, 1819, the National Museum of El Prado has been governed by successive sets of statutory regulations of high technical rigor for their time that have endowed this institution with its own tradition and identity in its regimes of government, administration, and function.

Worthy of special mention among these are the Royal Decree of June 7, 1912, which created the Board of Trustees of what was then called the "National Painting and Sculpture Museum"; the Royal Decree of May 7, 1920, by which the establishment was named the "National Museum of El Prado," and the regulations approved that have remained in force until this day; and the Royal Decree-Law of April 4, 1927, which granted the museum its own legal status and functional autonomy, which it preserved until, by the order of the Ministry of Education and Science of August 31, 1968, it came under the jurisdiction of the *Patronato Nacional de Museos.*

In accordance with this singularity characteristic of our foremost painting gallery, recognized as such throughout its history, article 87.2 of Law 50/1984 dated December 30 of the General State Budget for 1985 determined that the National Museum of El Prado be constituted independently as an autonomous organism assigned to the Ministry of Culture.

In consequence, and in view of the experience acquired since the aforementioned regulations were established and of comparisons with the legal and organizational schemes of major museums in other countries, it has been deemed advisable to grant the National Museum of El Prado, in its renewed condition as an autonomous organism, a set of updated statutory norms by virtue of which, in accordance with its specific tradition and respecting its singular character, a new period of modernization and efficiency in the scientific and economic-administrative management of the museum should begin.

With this end in view, the present Royal Decree defines and limits the functions of the museum's governing organs; provides a backbone for the basic structure of assessment and museological management through the scientific council, the subdepartment of conservation and research, the departments of conservation and restoration; and finally creates the management department, whose functions include stimulating and coordinating the economic-administrative organization of the museum and the potentiation of the funds assigned to it.

These measures are designed to make effective the legislator's mandate by which the National Museum of El Prado should be endowed with the juridical and organizational regime which, subject to further development, will allow it to fulfill the lofty mission of preserving, exhibiting, and enriching the collections and works of art that are its patrimony and that, closely linked to the history of Spain, constitute one of the highest manifestations of artistic expression of recognized universal value.

By virtue of this, and on the initiative of the Ministry of Culture, on the proposal of the Ministers of the Presidency and of Economy and Finance, subsequent to the deliberation of the Council of Ministers which met on July 31, 1985,

I stipulate the following:

Article 1. *Nature, classification, and legal regime*:

One. The National Museum of El Prado, by virtue of what is stipulated in article 87.2 of Law 50/1984 dated December 30 of the General State Budget for 1985, is an administratively autonomous organism of the kind established in section a), number 1 of article 4 of Law 11/1977 dated January 4 of the General State Budget, and is assigned to the Ministry of Culture, depending directly upon the Minister himself.

Two. The National Museum of El Prado enjoys its own administrative status and the capacity to work toward fulfilling its objectives, being governed by what is established in the Law concerning the Juridical Regime of Autonomous State Entities, in the Law of the General Budget, in the Law of the Historical Patrimony of Spain, in legislation in force concerning state museums, and in remaining dispositions applying to autonomous organs.

Art. 2. *Objectives and functions*:

It is the mission of the National Museum of El Prado to carry out and fulfill the following functions and objectives:

a) To guarantee the protection and preservation and promote the enrichment and improvement of the artistic and real estate assets of historical value that constitute its patrimony.

b) To exhibit in an orderly fashion the collections in such conditions that they might be properly contemplated and studied.

c) To foster access to the collections on the part of both Spanish and foreign visitors and provide researchers with facilities with which to study them, within the limits of whatever restrictions may be deemed necessary for their proper preservation.

d) To provide information concerning the works and the cultural entity of the artistic patrimony of the museum.

e) To provide services of assessment, information, and scientific or technical study either requested by the competent State Administration Organs or deriving from agreements or contracts signed with public or private entities or individuals, according to what is stipulated in the regulations.

f) To contribute to the training of personnel specializing in museography and museology, to attend to both the needs and services of the museum itself, and to satisfy demands from other sectors.

g) To develop programs of research and establish relations of collaboration and cooperation with other museums, universities, research centers, and national or foreign cultural institutes in order to foster exchange of experiences and knowledge, organize temporary exhibitions, and develop joint activities that will contribute to better attainment of their respective aims.

Art. 3. *Governing and advisory organs*:

1. The governing Organs of the National Museum of El Prado are the following:
— The President.
— The Royal Board of Trustees.
— The Director of the Museum.
2. As a superior advisory Organ there will also be a Scientific Council acting as consultant and museological assessor of the Museum's Governing Organs.

Art. 4. *The President*:

One. The President of the Prado Museum is the Minister of Culture.
Two. The President's functions are:
1. To direct the organism.
2. To approve the general plans of action of the same.
3. To call and preside over those sessions of the Royal Board of Trustees he deems it opportune to attend.

Art. 5. *The Royal Board of Trustees*:

One. The Royal Board of Trustees is the collegiate governing Organ of the National Museum of El Prado.
Two. The Royal Board of Trustees, constituted under the Honorary Presidency of Their Majesties the King and Queen of Spain, consists of the following:
1. Ex officio members:
— The President of the Autonomous Community of Madrid.
— The Mayor of Madrid.
— The Director General of the State Patrimony.
— The Director General of Fine Arts.
— The Director of State Museums.
— The Director of the National Museum of El Prado.
— The Honorary Directors of the National Museum of El Prado.
2. Designated members:
— Two academics, one elected by the Royal Academy of History and the other by the San Fernando Academy of Fine Arts.
— Two representatives of the Professional Association of Museum Curators, appointed by the Minister of Culture.
— Up to twelve members assigned by the Minister of Culture, among people of recognized prestige or competence in matters related to the Spanish Historical Patrimony or people who have offered distinguished services or aid to the museum.
3. The designated members will fulfill their functions for a period of three years from the date of their respective appointments.
Three. The Royal Board of Trustees acts as Permanent and Plenary Committees:
1. The Plenary Committee is composed of all members, both ex officio and designated.
2. The Permanent Committee consists of the President and Vice-president of the Royal Board of Trustees, the Director of the Museum, and four members designated by the Plenary Committee.
Four. It is the function of the Plenary Committee of the Royal Board of Trustees to:
1. Define the main lines of action of the museum and ensure the correct fulfillment of the functions assigned to it.
2. Prepare the museum's annual General Plan of Action and the Report of Activities.
3. Approve the preliminary plan of the museum and requests for concession of the opportune modifications to the budget.
4. Prepare and present to the Minister of Culture the projects for the set of regulations governing the function of the museum, or inform of those which competent organs of the Government propose, within the parameters of the present Royal Decree.
5. Foster and stimulate the participation of society in enriching the museum collections and sustaining the establishment.

6. Accept subsidies, contributions, donations, bequests, or legacies in favor of the museum.
7. Authorize acquisition of works of art by the museum or present to the Ministry of Culture proposals of acquisition and accept deposits in the museum.
8. Request from the Ministry of Culture authorization for the granting and signing of contracts for the deposit of works of art belonging to the museum.
9. Agree, when the need arises, on modifications to the arrangement of the museum's collections.
10. Authorize extraordinary or especially important treatments in order to preserve or restore works of art in the museum.
11. Request the assignment of buildings to the museum and approve, with prior consent from the Ministry of Culture, the projects for work to be carried out on them referred to in article 19 of the Law of the Spanish Historical Patrimony.
12. Authorize the museum to organize temporary exhibitions and assign committees or commissioners to be responsible for their realization and installation.
13. Approve the general sales conditions for publications and any other class of objects, on the museum premises, and those of reproductions of artistic works in accordance with what is stipulated in legislation concerning copyright.
14. Express their opinion concerning the appointment of the Director of the museum and the Subdirector of Conservation and Research.
15. Inform the procedure for engaging permanent museum employees as well as selection processes for candidates applying for the first time to fill vacant posts, according to the terms stipulated in legislation in force concerning public function.
16. Propose to the Minister of Culture, by a majority vote of two-thirds of the members of the Plenary Committee, the appointment of Honorary Directors of the museum in recognition of exceptional services to the establishment.
17. Propose to the Minister of Culture the designation of museum benefactors in the persons of those who have distinguished themselves through their services to the establishment.
18. Assign individual members of the Plenary Committee to carry out special missions or errands.
19. Request, through the Director, whatever information, antecedents, reports, and studies deemed necessary for the correct attainment of objectives.
Five. It is the function of the Permanent Committee to:
1. Study, discuss, and inform the proposals to be submitted for approval by the Plenary Committee of the Royal Board of Trustees.
2. Ensure that the agreements adopted by the Royal Board of Trustees are met, developed, and executed.
3. Agree to the departure, whatever may be their destination, of works of art from the museum itself or from deposits dependent upon the institution and to request authorization for the same, accompanied with a report by the Head of the Department of Conservation of the collection in question, from the Ministry of Culture, presented by the Director of the museum.
4. Assume whatever other functions assigned to it by the Plenary Committee of the Royal Board of Trustees, except those contained in subsections 2, 3, 4, 14, and 16 of point four of this article.
5. Inform the Plenary Committee of the Royal Board of Trustees of agreements adopted in the exercise of the aforementioned faculties.
Six.
1. The Royal Board of Trustees has a President and Vice-president elected by the Plenary Committee from among the designated members and those enjoying the position of Honorary Directors of the museum, and appointed by the Minister of Culture for a term of three years.
2. The President will by replaced in the exercise of his functions by either the Vice-president or, when this is not possible, by the oldest member of the board.
3. The Royal Board of Trustees will appoint a secretary who will have no right to vote.

Art. 6. *Regime of function*:

One. The sessions of the Plenary and Permanent Committees may be both ordinary and extraordinary:
1. The ordinary sessions of the Plenary Committee will be held at least every three months, while those of the Permanent Committee will take place monthly.

2. The extraordinary sessions will be held when requested by the President of the Royal Board of Trustees, on the initiative of the Committee, or when requested by a two-thirds majority of the members or by the Director of the museum.

Two. 1. The Plenary Committee of the Royal Board of Trustees may form special commissions from its own members for special functions, appointing the president of and members forming them.

2. The Royal Board of Trustees and its Committees may agree upon heads of departments or experts, whether employed by the museum or not, attending certain sessions when it is considered that their presence is desirable by virtue of the matter to be discussed.

Three. Regarding whatever is not anticipated in this Royal Decree concerning the function of the aforementioned organs, what is stipulated in the Law of Administrative Procedure as regards the function of collegiate organs will be applied in a supplementary way.

Art. 7. *The Director of the Museum*:

One. The Director of the museum is appointed by Royal Decree agreed upon by the Council of Ministers after the proposal by the Minister of Culture.

Two. The functions of the Director of the museum are to:

1. Be responsible for the running of the museum and supervise its staff.
2. Coordinate, foster, and inspect the museum services.
3. Act as the ordinary representative of the museum.
4. Propose to the Royal Board of Directors the general plans of action of the museum and execute agreements.
5. Present to the Royal Board of Trustees the annual report of the museum's activities.
6. Prepare the preliminary project for the organism's budget.
7. Engage staff on behalf of the organism and supervise its expenditure and payments.
8. Adopt the measures necessary to guarantee the protection of the museum's artistic patrimony and approve, with prior authorization from the Royal Board of Trustees, treatment for the conservation or restoration of works of art.
9. Submit for approval to the Royal Board of Trustees modifications in the grouping and arrangement of the collections, propose the acquisition of works of art, and decide which of them should be on permanent exhibition.
10. Submit to the Royal Board of Trustees requests for authorization to organize temporary exhibitions in the museum, propose the appointment of Committees or Commissioners who will supervise their realization and installation, and decide which works should be exhibited.
11. Provide the Ministry of Culture with whatever information is requested concerning the register of the museum's real estate assets of an historical nature, as stipulated in article 60 of the Law of the Spanish Artistic Patrimony.
12. Foster and formalize agreements of cooperation and collaboration with other museums and similar institutions and organize educational activities of a cultural and scientific nature both at home and abroad.
13. Approve programs of professional development and optimization.
14. Assume other functions not expressly entrusted to the remaining organisms of the museum and which fall under the dispositions generally applied to directors of autonomous organisms.

Art. 8. *Basic Structure*:

One. The following units, on the organic level of General Subdepartments, depend upon the Director of the museum:

1. The Subdepartment of Conservation and Research.
2. The Management Office.

Two. The Subdepartment of Conservation and Research.

The functions of this General Subdepartment are to:

1. Foster and prepare research programs, coordinate their development and execution, and anticipate the suitable means by which to take advantage of and divulge the results.

2. Prepare plans of action for the preservation, consolidation, and restoration of the museum's artistic patrimony, study those works to be the object of treatment, and request from the museum Director authorization to carry out conservation and restoration work.

3. Negotiate and develop agreements of cooperation and technical and scientific collaboration with other museums, universities, and research centers.

4. Coordinate the activities of the museum's departments of Conservation and Restoration and the technical laboratories.

5. Organize and direct the museum services of central archive, documentation, register of real estate assets of an historical nature, library, and photograph library.

6. Coordinate preparation of the scientific catalogs, and propose the museum's annual publications and library acquisitions plans.

7. Propose and elaborate the programs of professional training of the museum's scientific and technical staff.

8. Assist the Director of the museum in the carrying out of his functions and fulfill any other functions delegated to it.

Three. 1. The departments of conservation and restoration depend upon this general subdepartment.

2. The departments of conservation and restoration are the essential units entrusted with the scientific development of programs of conservation, consolidation, and improvement of the Museum's artistic patrimony, and with the development and execution of research programs.

3. With regard to the collections in their care, the mission of the Department of Conservation is essentially to:

— Assume immediate responsibility for their care and preservation, and indicate to the Conservation Subdirector those works in need of consolidation or restoration.

— Propose scientific criteria for their arrangement and exhibition.

— Execute tasks of study, documentation, research, and cataloguing.

— Prepare whatever scientific reports are requested of them.

— Submit to the Plenary Committee of the Royal Board of Trustees the annual report of the department activities.

4. The mission of the museum's Department of Restoration is basically to:

— Propose those treatments for the consolidation or restoration of the museum's works of art determined by the Subdirector of Conservation and Research.

— Direct and organize the workshops, determine the scope of action of each restorer, and supervise the application of treatments.

— Submit to the Plenary Committee of the Royal Board of Trustees the annual report of the Department's activities.

Four. The Management Office.

The function of this general subdepartment is to:

1. Foster and coordinate the economic and administrative running of the museum.

2. Propose objectives and programs aimed at improving the results of economic management and obtaining maximum benefit from the resources assigned to the museum.

3. Negotiate and supervise contracts for services of maintenance of the museum installations.

4. Exercise the functions of administration of the staff, labor relations, and collective negotiation in accordance with public function legislation currently in force.

5. Exercise administrative control over the assets and values constituting the museum's patrimony and register juridical acts and contracts referred to in the additional provision no. 5, I, of this Royal Decree.

6. Prepare the Account of Liquidation of the Budget to be presented to the Accounts Tribunal through the General State Auditing Department.

7. Assist and advise the Director of the museum in economic or financial matters.

8. Carry out whatever other functions delegated to the department by the Director of the museum.

Art. 9. *Assets and economic resources*:

The assets and economic resources of the National Museum of El Prado are the following:

1. The assets and values constituting its patrimony and the products and revenues from this.

2. Transfers and subsidies assigned to the establishment annually in the General State Budget.

3. Corresponding income from public or private rights.

4. Subsidies, voluntary contributions, donations, bequests, and legacies from private individuals or public entities.

ADDITIONAL PROVISIONS

First. — One. As determined in article 85.13, b), of Law 50/1985, dated December 30, of the General State Budget, the autonomous organism the National Board of Museum Trustees ceases to exist, its legal status being nullified as from the date of this Royal Decree's coming into effect.

Two. The functions corresponding to the aforementioned Autonomous Organism are assumed by the *Dirección General de Bellas Artes y Archivos* and other Administrative Centers of the General Services of the Ministry of Culture, according to their respective scopes of jurisdiction.

Three. The functions corresponding to the aforementioned Autonomous Organism in matters concerning the National Museum of El Prado will be assumed by the newly created Autonomous Organism the National Museum of El Prado.

Four. Henceforth, and in accordance with what is stipulated in article 12 of Law 10/1983, dated August 16, both the level of the Administrative Organs of the Autonomous Organism, the National Museum of El Prado, and the basic organic structure of the institution may be modified at the discretion of the Minister of the Presidency on the initiative of the Minister of Culture, by means of the corresponding Royal Decree agreed upon by the Council of Ministers.

Second. — One. The staff of the Autonomous Organism the National Board of Museum Trustees will be incorporated into the newly created Autonomous Organism, the National Museum of El Prado, or into the units corresponding to the Ministry of Culture, in accordance with the functions assumed respectively by each of them, as stipulated in the regulations established by articles 95 and 96 of Law 50/1984, dated December 30, with the provision that staff may be reassigned when this is deemed expedient.

Two. To the effects anticipated in article 98 of the Law quoted in the previous subsection, the staff organization of the former Autonomous Organism is detailed in appendix no. 1 of this present Royal Decree.

Third. — One. All the assets, rights, and obligations forming the Patrimony of the former Autonomous Organism, the National Board of Museum Trustees, not ascribed to the Museum of El Prado, will come to form part of the State Patrimony, possibly affecting subsequently the units of the Ministry of Culture which effectively assume its functions.

Two. All the assets, rights, and obligations forming the Patrimony of the nullified Autonomous Organism, the National Board of Museum Trustees, not included in the previous subsection will be incorporated into the Patrimony of the Autonomous Organism, the National Museum of El Prado.

Three. The General State Administration and the Autonomous Organism, the National Museum of El Prado, are subrogated in the titularity of the aforementioned assets, rights, and obligations as from the date of the present Royal Decree coming into effect.

Fourth — One. The real estate assets in particular, contained in the nullified National Board of Museum Trustees, ascribed traditionally to the National Museum of El Prado, consisting of the main building by Villanueva and adjoining sites and of the Casón del Buen Retiro, in Madrid, will come to form part of the Patrimony of the Autonomous Organism, the National Museum of El Prado, as will the recently incorporated Villahermosa Palace, Madrid.

Two. The cultural assets of historical value belonging to the State and contained in the museum installations or held in trust by other private individuals or public entities that figure in the museum inventories as belonging to the same

will similarly become integrated into the Patrimony of the Autonomous Organism, the National Museum of El Prado.

Fifth. — One. 1. The National Museum of El Prado will proceed within the space of one year maximum from the coming into effect of the present Royal Decree to update the register of cultural assets of historical value either contained in its Patrimony or whose custody and conservation have been entrusted to the establishment.

2. In the aforementioned register the following circumstances will be noted:
a) Identification and location of the works.
b) Their state of conservation.
c) Treatments carried out to consolidate and restore them.
d) Juridical acts and contracts relative to the works.

Two. The Royal Board of Trustees, with the prior approval of the Plenary Committee, will present to the Minister of Culture the conclusions and, where appropriate, recommendations considered necessary for the protection, conservation, and improvement of the aforementioned works.

Three. The competent administrative authorities and those responsible for the Centers, Institutions, or Entities in which works of art forming part of the Patrimony of the National Museum of El Prado are deposited will collaborate with the members designated by the museum in the fulfillment of the functions assigned to them in each case.

TEMPORARY PROVISIONS

First. — Without prejudice to the immediate use of the assets formerly pertaining to the former National Board of Museum Trustees by the new Autonomous Organism, the National Museum of El Prado, and by the Ministry of Culture, as they gradually assume their functions, the Services of the Ministry of Finance and the Treasury will proceed to formalize the definitive attachment of these assets, within the space of three months as from the publication of the present Royal Decree.

Second. — The administrative units of an organic level below that of General Subdepartment of the former Autonomous Organism, the National Board of Museum Trustees, are assigned provisionally to the Autonomous Organism, the National Museum of El Prado, and to the the Services of the Ministry of Culture, which will assume their functions, unless measures are adopted or provisions established in the space of three months from the publication of the present Royal Decree.

Third. — The administrative situation of all staff affected by the disappearance of the Autonomous Organism, the National Board of Museum Trustees, will be respected and they will continue to be fully remunerated until the development measures of this Royal Decree are published and the resulting budget modifications introduced.

Fourth. — As soon as this present Royal Decree comes into effect the members of the Royal Board of Trustees will be appointed and the Board immediately constituted as the Collegiate Governing Organ of the new Autonomous Organism, the National Museum of El Prado.

Fifth. — One. The newly created Autonomous Organism, the National Museum of El Prado, and the Ministry of Culture will assume, as from the date this present Royal Decree comes into effect and until the end of this present economic year, the budgets of the former Autonomous Organism not affected by recognized obligations, in accordance with the assumption of functions established in the first additional provision contained in the present Royal Decree, assuming the new obligations charged to the budget endowments of the former National Board of Museum Trustees.

Two. With total separation of the realization of new operations with application to the budgets of the former Autonomous Organism, these latter will be liquidated and its patrimonial situation, rights, obligations, and situation of the execution of budgets at the moment of extinction made clear.

Three. Similarly, the elaboration and rendition of accounts of liquidation of the Budget of 1985 will be carried out separating the management activities car-

ried out by the former Autonomous Organism from those carried out by the Organs of the Ministry of Culture and the Autonomous Organism, the National Museum of El Prado, which assumes these functions.

FINAL PROVISIONS

First. — One. The Minister of Culture, with prior approval from the President of the Government, will dictate the necessary provisions for the exercise and fulfillment of the functions stipulated in the present Royal Decree.

Two. By order of the Minister of Culture, the composition, jurisdiction, and function will be regulated of the Scientific Council to which reference is made in no. 2 of article 3 of this present Royal Decree.

Three. Similarly the number, level, organic structure, and functions will be determined of the units to which reference is made in subsection three of article 8 of the present Royal Decree.

Second. — The Ministry of Finance and the Treasury will make the necessary budget modifications in order to carry out the stipulations contained in this present Royal Decree.

Third. — All provisions of equal or inferior rank contradicted by what is established in this present Royal Decree are hereby repealed, especially the following:

Royal Decree of May 14, 1920.
Decree 383/1970, dated February 14.
Royal Decree 2985/1978, dated November 3.
Royal Decree 3001/1979, dated November 23.
Palma de Mallorca, August 1, 1985.

JUAN CARLOS R.

The Minister of the Presidency
JAVIER MOSCOSO DEL PRADO Y MUÑOZ

NOTES

Additional sources appear in the Selected Bibliography.

1. Vicente Carducho, *Diálogos de la Pintura. Su defensa, origen esencia. Definición, modos y diferencias* (printed under licence by Frco. Martínez, 1633). Edition supervised by Francisco Javier Sánchez Cantón, *Fuentes literarias para la historia del arte español. Vol. II, siglo XVII. Pablo de Céspedes — Juan de Butrón — Vicencio Carducho — Francisco Pacheco — Fr. Francisco de los Santos — Lázaro Díaz del Valle* (Madrid: C. Bermejo, Printer, 1933), pp. 105, ff.

2. Duchess of Berwick and Alba, *Documentos escogidos*, p. 492. Collected by Jonathan Brown, *Velázquez, pintor y cortesano* (Madrid: Alianza Editorial, 1986), p. 233.

3. Pedro Beroqui, "Apuntes para la historia del Museo del Prado," in *Boletín de la Sociedad Española de Excursiones*, XXXVIII, 1930, p. 201.

4. Alfonso E. Pérez Sánchez, *Pasado, presente y futuro del Museo del Prado* (Madrid: Fundación Juan March, 1976), p. 18.

5. Fr. Andrés Ximénez, *Descripción del Real Monasterio de San Lorenzo del Escorial, su magnífico Templo, Panteón y Palacio* (Madrid: Antonio Marín, 1764), p. 439.

6. Mariano de Madrazo, *Historia del Museo del Prado: 1818–1868* (Madrid: C. Bermejo, 1945), p. 44.

7. Antonio Ponz, *Viaje de España*. Letter from Antonio Raphael Mengs…, § 49 (Madrid: Joaquim Ibarra, Printer, 1776) (Reprinted, Madrid: M. Aguilar Editor, 1947), p. 574.

8. Beroqui (1930), p. 256; Juan Antonio Gaya Nuño, *Historia del Museo del Prado 1819–1969* (León: Editorial Everest, 1969), p. 44.

9. Beroqui (1930), p. 257.

10. Beroqui (1930), p. 257.

11. Beroqui (1930), p. 256.

12. Beroqui (1930), p. 257.

13. Beroqui (1930), p. 264; Pedro Beroqui, "Apuntes…" XL, 1932, document I.

14. Beroqui (1932), document II.

15. *Correspondance du Comte de La Forest*, published by M. Geoffroy de Grandmaison, vol. V, p. 263; Beroqui (1930), p. 265.

16. For the bibliographic facts by Isidoro Montenegro, see Pedro Beroqui, "Apuntes…" XXXIX, 1931, pp. 106, 108.

17. Palace archive, personal dossier; Beroqui (1931), p. 107.

18. *Gaceta de Madrid*, July, 9, 1814; Beroqui (1931), p. 30; Valentin de Sambricio, "El Museo Fernandino. Su creación. Causa de su fracaso. El Palacio de Buenavista," *Archivo Español de Arte*, vol. XV (Madrid), 1942, pp. 132–146, 262–283, 320–335.

19. Frédéric Quilliet.

20. Treasury Archive, Godoy confiscation, File 4.° (5.° in the report), destroyed November 1936; Beroqui (1931) pp. 32–34.

21. Beroqui (1931), p. 94; Gaya Nuño, p. 50.

22. Beroqui (1931), p. 94.

23. One by Mengs (*The Eternal Father*); six by Velázquez (*Mars, The Redbearded Jester, Portrait of the Infante Don Carlos, Portrait of Queen Mariana of Austria, Portrait of Don John of Austria*, and *Pablo de Valladolid*); one by Ribera (*The Blessing of Jacob*); one by Murillo (*The Annunciation*); one by Mazo (*Prince Baltasar Carlos*, thought to be by Velázquez); three by Luca Giordano (*Samson Fighting the Lion, Solomon Praying*, and *A Fable*); two by Rubens (*Adam* and *Eve*, copies of originals by Titian); two by David Teniers (military trophies); two by Tiepolo (portraits in pastel).

24. "In the museum founded by the late queen, there was already a beautiful collection of original paintings with more than 200 from the Spanish School, and 1,100 from other countries, and if Her Majesty had lived longer we would without doubt have had the satisfaction of seeing a project concluded which was of such great advantage to us and so honorable and useful to the capital" (Madrid: 1819, n. 20, p. 62); Beroqui (1931), p. 192.

25. Richard Ford, *A Hand-Book for Travellers in Spain, and Readers at Home. Describing the Country and Cities, the Natives and their Manners; the Antiquities, Religion, Legends, Fine Arts, Literature, Sports, and Gastronomy; with Notices on Spanish History* (London: John Murray, 1845).

26. Ian Robertson, *Los curiosos impertinentes. Viajeros ingleses por España desde la accesión de Carlos III hasta 1855* (Madrid: Serbal/Centro Superior de Investigaciones Científicas, 1988), pp. 206–37.

27. *Apuntes biográficos del Excmo. Sr. Comisario general de la Cruzada, D. Manuel de Saralegui* (Madrid: 1904); Beroqui (1931), p. 104.

28. Michael J. Quin, *Memorias históricas sobre Fernando VII* (translated by Joaquín García, Valencia: Gimeno, n.d.), pp. 287, 449–50; Beroqui (1931), pp. 106–7.

29. O. Sandoval, according to Beroqui (1932), p. 14.

30. Antonio Rumeu de Armas, *Origen y Fundación del Museo del Prado* (Madrid: Instituto de España, 1980).

31. *Gaceta de Madrid*, March 3, 1818; Beroqui (1931), pp. 190–91.

32. Beroqui (1931), p. 190.

33. Beroqui (1931), p. 191.

34. Palace Archive, personal file; Beroqui (1931), p. 267, n. 4.

35. For more information on Luis Eusebi, see Enrique Pardo Canalis, "Noticias y escritos de Luis Eusebi," *Revista de Ideas Estéticas*, XXVI, 1962, p. 179.

36. Prado Museum archive; Beroqui (1932), document IX; Mariano de Madrazo, p. 93.

37. Prado Museum archive; Beroqui (1931), p. 192; (1932), document X.

38. Beroqui (1931), p. 192.

39. *Gaceta de Madrid*, February 5, 1819; Beroqui (1931), p. 193.

40. *Gaceta de Madrid*, September 28, 1819; Beroqui (1931), p. 192; (1932), document XI.

41. *Gaceta de Madrid*, November 18, 1819; Beroqui (1932), appendix XII.

42. Beroqui (1932), p. 10; *Museo del Prado Catálogo*, 1920 and following; Francisco Javier Sánchez Cantón, *Escultura y pintura del siglo XVIII: Francisco Goya*, "Ars Hispaniae," vol. XVII (Madrid: Editorial Plus Ultra, 1958), p. 320.

43. Ceferino Araujo Sánchez, *El Museo del Prado*. Manuscript dated May 3, 1887. Prado Museum Library, register no. 8793, catalogue no. 19.1608, p. 12; Pérez Sánchez (1977), p. 8; Beroqui (1931), p. 199.

44. Beroqui (1931), p. 262.

45. Beroqui (1932), pp. 7–8.

46. Beroqui (1931), p. 264.

47. See note 23.

48. Two by Juan Pantoja de la Cruz (*The Birth of Saint John the Baptist* and *The Birth of Jesus Christ*); one by Francisco Collantes (*The Vision of Ezekiel*); one by Eugenio Cajés (*The Recovery of San Juan de Puerto Rico*, attributed to Carducho); one by Juan Bautista Maíno (*The Recovery of the Bay of Brazil*).

49. Beroqui (1931), p. 268.

50. *Gaceta de Madrid*, March 17, 1828; Beroqui (1931), pp. 272–73.

51. The numeration goes from 1 to 755, but numbers 533 and 538 are repeated.

52. *Gaceta de Madrid*, September 4, 1828.

53. Mariano de Madrazo, p. 117.

54. Mariano de Madrazo, p. 151.

55. Juan Rico y Amat, *Historia política y parlamentaria de España* (Madrid: 1860–61), pp. 366, 487.

56. Mariano de Madrazo, pp. 124–25.

57. Pascual Madoz, *Diccionario geográfico-estadístico-histórico de España y sus posesiones de ultramar*, vol. X (Madrid: 1850), p. 849.

58. Mariano de Madrazo, p. 130.

59. Mariano de Madrazo, p. 129.

60. Beroqui (1932), p. 87.

61. Mariano de Madrazo, p. 129.

62. Mariano de Madrazo, p. 129.

63. Mariano de Madrazo, pp. 152–53.

64. Mariano de Madrazo, pp. 152–53.

65. Mariano de Madrazo, pp. 152–53.

66. Mariano de Madrazo, p. 153.

67. Gaya Nuño (1969), p. 81.

68. Mariano de Madrazo transcribes the paragraph from the letter but does not indicate where it was written. It is probably from Seville, as Enrique Valdivieso has found an official letter, signed by José Musso y Valiente, dated in the Andalusian capital August 1, 1835, and addressed to the governor of the province.

69. Unpublished correspondence by José Musso y Valiente to José Madrazo; Mariano de Madrazo, p. 154.

70. It seems there was even the intention to use the paintings from the museum as collateral to obtain a loan from foreign countries. José Madrazo writes in a letter dated March 23, 1839, of "the attempt by Mendizábal, when he wanted to mortgage the paintings belonging to the Royal Museum to foreign countries, for two hundred million, which if they had not been in the Royal Museum and belonging to the Royal Patrimony, would have left Spain" (unpublished correspondence by José Madrazo); Mariano de Madrazo, p. 176.

71. Mariano de Madrazo, pp. 155–56.

72. Mariano de Madrazo, p. 160.

73. Mariano de Madrazo, p. 161.

74. Mariano de Madrazo, p. 159.

75. Unpublished correspondence by José Madrazo; Mariano de Madrazo, p. 160.

76. Unpublished correspondence by José Madrazo, August 18, 1838; Mariano de Madrazo, p. 159.

77. Unpublished correspondence by José Madrazo, August 24, 1838; Mariano de Madrazo, p. 160.

78. Unpublished correspondence by José Madrazo; Mariano de Madrazo, p. 162.

79. Unpublished correspondence by José Madrazo; Mariano de Madrazo, pp. 164–66.

80. Unpublished correspondence by José Madrazo, October 13, 1838; Mariano de Madrazo, p. 164.

81. Unpublished correspondence by José Madrazo; Mariano de Madrazo, pp. 163–64.

82. Unpublished correspondence by José Madrazo, November 26, 1838; Mariano de Madrazo, p. 166.

83. Unpublished correspondence by José Madrazo, February 9, 1839; Mariano de Madrazo, pp. 173–74.

84. Mariano de Madrazo, p. 169.

85. Unpublished correspondence by José Madrazo, April 20, 1839; Mariano de Madrazo, pp. 176–77.

86. Mariano de Madrazo, p. 169.

87. Unpublished correspondence by José Madrazo; Mariano de Madrazo, pp. 174–75.

88. Unpublished correspondence by José Madrazo; Mariano de Madrazo, pp. 175–76.

89. Mariano de Madrazo, p. 175; Diego Angulo Iñíguez, *Catálogo de las alhajas del Delfín* (Madrid: Museo del Prado, 1944), pp. 9–10.

90. Unpublished correspondence by José Madrazo, March 9, 1839; Mariano de Madrazo, pp. 174–75.

91. "But there still remains another spectacle, which has surprised everyone, and which, as it is said, was prepared and carried out in great part by the old Board of Directors, and which has been completed by the present Director. We are talking about the Sculpture Gallery…"; *Gaceta de Madrid*, May 2, 1839; Mariano de Madrazo, p. 285, appendix no. 15.

92. Mariano de Madrazo, pp. 170–71.

93. Mariano de Madrazo, p. 285, appendix no. 15.

94. *Gaceta de Madrid*, May 2, 1839; Mariano de Madrazo, pp. 282–85, appendix no. 15.

95. Mariano de Madrazo, p. 183.

96. Beroqui (1932), pp. 89–90.

97. Mariano de Madrazo, p. 131.

98. Beroqui (1932), p. 92, gives the date as November 22, while Mariano de Madrazo, p. 131, gives it as November 28.

99. Mariano de Madrazo, pp. 189–90.

100. Mariano de Madrazo, p. 188.

101. Mariano de Madrazo, p. 204.

102. Mariano de Madrazo, p. 209.

103. Araujo Sánchez (1887), p. 6; Pérez Sánchez (1976), p. 9.

104. Mariano de Madrazo, p. 221.

05. Mariano de Madrazo, pp. 227–28.

06. Beroqui (1932), p. 92; Mariano de Madrazo, p. 131.

07. Mariano de Madrazo, pp. 228–29.

08. Adrián Espí Valdés, ''Gisbert, primer Director del Museo Nacional del Prado,'' *Arte Español*, 1963–67, pp. 112–18.

09. Pérez Sánchez (1976), p. 28.

10. Mariano de Madrazo, p. 234.

11. *Catálogo ilustrado de la exposición de pinturas de Goya celebrada para conmemorar el primer centenario de la muerte del artista* (Madrid: Museo del Prado, April–May, 1928), pp. 95–96.

12. Gaya Nuño (1969), p. 103.

13. Araujo Sánchez (1887), pp. 10–11; Pérez Sánchez (1976), pp. 9, 28.

14. Adrián Espí Valdés, pp. 112–18.

15. Madoz, p. 859 (text by Eguren); Juan Antonio Gaya Nuño, ''El Museo Nacional de la Trinidad (Historia y catálogo de una pinacoteca desaparecida),'' in *Boletín de la Sociedad Española de Excursiones*, LI (Madrid: 1st. and 2nd. trimesters of 1947), pp. 19–77.

16. Madoz, p. 859 (text by Eguren).

17. Madoz, p. 748 (text by Eguren).

18. Madoz, p. 748 (text by Eguren).

19. Madoz, p. 859 (text by Eguren).

20. Madoz, p. 859 (text by Eguren).

21. Pérez Sánchez (1976), pp. 32–33.

22. Pérez Sánchez (1976), pp. 29–30.

23. Adrián Espí Valdés, pp. 117–18.

24. Pérez Sánchez (1976), p. 33.

25. Gaya Nuño (1969), p. 114.

26. A copy of this document is preserved in the archives of Barcelona University, deposited there by the widow when, as heiress of the late painter, she claimed to be owed honorariums for the paint for one of the canvases by Sans Cabot for the Paraninfo in 1880–81.

27. *La Ilustración Española y Americana*. Madrid, (May) 1875 supplement to no. XIX, p. 332.

128. One Gustavo Bauer, who possibly had some sort of link with the collection, was appointed one of the first members of the board of trustees of the Prado Museum on March 14, 1913.

129. Gaya Nuño (1969), pp. 109–10; Pérez Sánchez (1976), pp. 35–36.

130. *Gaceta de Madrid*, January 8, 1882.

131. *Enciclopedia universal ilustrada europeo-americana*, Vol. XXXIII (Barcelona: Hijos de J. Espasa, editores, n.d.), p. 529.

132. Araujo Sánchez (1887), pp. 14–18; Pérez Sánchez (1976), p. 34.

133. Mariano Cavia, ''La catástrofe de anoche. España está de luto. Incendio del Museo de Pinturas,'' in *El Liberal*, no. 4541. Madrid, November 25, 1891; Gaya Nuño (1969), pp. 114–17; Pérez Sánchez (1976), p. 10.

134. Mariano Cavia, ''Por qué he incendiado el Museo del Prado,'' in *El Liberal*, no. 4542. Madrid, November 26, 1891.

135. Pérez Sánchez (1976), p. 38.

136. Gaya Nuño (1969), pp. 131–32.

137. *Gaceta de Madrid*, June 9, 1912.

138. *Disposiciones legales referentes al Museo Nacional de Pintura y Escultura (Museo del Prado) publicadas por su Patronato*. Madrid, 1913, p. 8–9.

139. Published, as the one above, in the September 30 issue of *La Ilustración Española y Americana*.

140. Mariano Cavia, ''Intermedio estético. La dirección del Museo del Prado,'' in *El Sol*, December 4, 1918.

141. Francisco Javier Sánchez Cantón, *Museo del Prado; catálogo* (Preface) (Madrid: 1933), pp. VIII–IX.

142. Preamble to the Royal Decree 1432/1985, August 1.

143. Pedro Muguruza, ''Nueva escalera en el museo del Prado y otras reformas,'' in *Arquitectura*, October 1928, p. 307.

144. Pérez Sánchez (1976), p. 45.

145. Pérez Sánchez (1976), pp. 55–56.

146. Pérez Sánchez (1976), p. 46.

147. José Álvarez Lopera, *La Política de bienes culturales del gobierno republicano durante la guerra civil española* (Madrid: Ministerio de Cultura, Dirección General de Bellas Artes, Archivos y Bibliotecas, 1982).

148. Francisco Javier Sánchez Cantón, ''Les Premières mesures de défense du Prado au cours de la guerre civile en Espagne.'' *Mouseion*, X, 1937, no. 39–40 (III–IV), pp. 67–73.

149. Álvarez Lopera, vol. II, pp. 57–58.

150. Among the many canvases exceeding these dimensions are works by Velázquez (*The Spinners, The Forge of Vulcan, The Count-Duke of Olivares on Horseback, Las Meninas, The Lances*), Ribera (*Martyrdom of Saint Philip*), Murillo (*Foundation of Santa Maria Maggiore, Saint Isabella*), Goya (*General Palafox on Horseback, The Second of May, The Moncloa Executions, The Family of Charles IV*, and all the large cartoons for tapestries), Titian (*Charles V on Horseback in Mühlberg, The Last Supper*), Veronese (*The Assumption*), Tintoretto (*Maundy*) and Van der Weyden (*The Descent from the Cross*).

151. In fact, in the whole transfer operation only five paintings were rolled: *Saint Maurice and the Theban Legion*, by El Greco, and four tapestry cartoons by Goya (*Brawl in Venta Nueva, The Wedding, The Meadow*, and *Game of Pelota*); Álvarez Lopera, vol. II, p. 7, n. 4.

152. José Renau, ''L'Organisation de la défense du patrimoine artistique et historique espagnol pendant la guerre civile,'' *Mouseion*, X, 1937, no. 39–40 (III-IV), pp. 7–68; Álvarez Lopera, vol. I, pp. 156–59.

153. Álvarez Lopera, vol. I, p. 29, n. 39.

154. Pérez Sánchez (1976), p. 47.

155. Sánchez Cantón, ''Les premières mesures…,'' p. 67–73.

156. Álvarez Lopera, vol. II, p. 58.

157. Álvarez Lopera, vol. II, pp. 9–10, n. 19.

158. José Lino Vaamonde, *Salvamento y protección del tesoro artístico español* (Caracas: 1973); Álvarez Lopera, vol. II, pp. 21–24.

159. For example, it was not taken into account that the crates containing Titian's *Portrait of Charles V on Horseback* and *Las Meninas* by Velázquez, once loaded onto the truck, exceeded the height of the iron bridge over the Jarama. On reaching this bridge and discovering the error, it was necessary to unload the crates and take the paintings across the bridge on

rollers, in an agonizingly long night operation that lasted four hours; Gaya Nuño (1969), p. 182; Álvarez Lopera, vol. II, p. 11.

160. Álvarez Lopera (1982), vol. II, p. 11.

161. Report by the *Junta del Tesoro Artístico* to the Director General of Fine Arts, December 1936, Archivo del Servicio de Recuperación del Patrimonio Artístico Nacional; Álvarez Lopera, vol. II, p. 12.

162. Álvarez Lopera, vol. II, pp. 15–16, n. 69; p. 28, n. 161.

163. Álvarez Lopera, vol. II, p. 16, n. 67 and 68 (the date on the notes of the respective ministerial orders is January 11, 1937; however, from the context it is judged to be 1938).

164. Renau, ''L'Organisation de la défense...,'' pp. 7–68.

165. Álvarez Lopera, vol. II, pp. 54–55.

166. Sir Frederick Kenyon, ''La Protection du patrimoine artistique en Espagne.'' *Mouseion*, X, 1937, no. 37–38 (I–II), pp. 183–92.

167. Renau, ''L'Organisation de la défense...,'' pp. 7–68.

168. Sánchez Cantón, ''Les premières mesures...,'' pp. 67–73.

169. Pérez Sánchez (1976), p. 49.

170. Álvarez Lopera, vol. II, p. 51.

171. Ceferino Colinas Quiroz, ''El tesoro artístico del museo del Prado. Cómo el gobierno de la República entregó a Franco un tesoro protegido durante la Guerra Civil por los milicianos,'' in *Siempre*, no. 491, (Mexico) November 21, 1962, pp. 52–57; Álvarez Lopera, vol. II, pp. 27–29.

172. Álvarez Lopera, vol. II, p. 30.

173. Alberto del Castillo, *José María Sert; su vida y su obra* (Barcelona and Buenos Aires: Editorial Argos, 1947), pp. 270–72; Álvarez Lopera, vol. II, pp. 32–33.

174. Manuel Azaña, *Obras Completas* (ed. by Juan Marichal) (Mexico, D.F.: Ed. Oasis); Álvarez Lopera, vol. II, p. 36, n. 213.

175. Castillo, p. 272.

176. Gaya Nuño (1969), p. 189.

177. Enrique Lafuente Ferrari, ''Las primeras pinturas románicas en el Prado,'' in *Clavileño*, I, 1950, p. 52.

178. Gaya Nuño (1969), p. 206.

179. Pérez Sánchez (1976), p. 53.

180. Pérez Sánchez (1976), p. 52.

181. Gaya Nuño (1969), pp. 197, 200; Pérez Sánchez (1976), p. 55.

182. Pérez Sánchez (1976), p. 56–57.

183. Pérez Sánchez (1976), p. 59.

184. Pérez Sánchez (1976), p. 56.

185. Pérez Sánchez (1976), p. 58.

186. *Boletín del Museo del Prado*, vol. I, 1980, no. 2, pp. 127–29.

187. *Boletín del Museo del Prado*, vol. I, 1980, no. 2, pp. 127–29.

188. Gaya Nuño (1969), pp. 225–26; Pérez Sánchez (1976), p. 58.

189. Pérez Sánchez (1976), pp. 58, 59.

190. Pérez Sánchez (1976), p. 59.

191. Pérez Sánchez (1976), pp. 61, 73.

192. Pérez Sánchez (1976), p. 58.

193. Pérez Sánchez (1976), pp. 61, 70.

194. Pérez Sánchez (1976), pp. 73–74.

195. Pérez Sánchez (1976), pp. 74–75.

196. Pérez Sánchez (1976), pp. 72–73; *Boletín del Museo del Prado*, vol. I, 1980, no. 1, pp. 5–6.

197. *Boletín del Museo del Prado*, vol. I, 1980, no. 1, p. 7.

198. Xavier de Salas Bosch, ''Un boceto de Goya para la Inmaculada del Colegio de Calatrava,'' in *Archivo Español de Arte*, no. 197, Madrid, 1977, pp. 1–8.

199. Emilio Marcos Vallaure, ''El propietario del boceto de la Inmaculada de Goya (Prado, no. 3260),'' in *Boletín del Museo del Prado*, vol. VIII, 1987, no. 24, pp. 182–83.

200. *Boletín Oficial del Estado*, no. 1209, January 18, 1980.

201. *Boletín Oficial del Estado*, no. 1209, January 18, 1980; *Boletín del Museo del Prado*, vol. I, no. 2, 1980, pp. 127–28.

202. *Boletín Oficial del Estado*, no. 1214, June 5, 1980.

203. *Boletín del Museo del Prado*, vol. II, no. 4, 1981, p. 3.

204. *Boletín del Museo del Prado*, vol. II, 1981, no. 5, p. 98.

205. *Boletín del Museo del Prado*, vol. I, 1980, no. 3, p. 138; vol. II, 1981, no. 6, p. 199.

206. *Boletín del Museo del Prado*, vol. I, 1980, no. 1, p. 6, no. 2, p. 65.

207. *Boletín del Museo del Prado*, vol. I, 1980, no. 1, p. 7, no. 2, p. 65.

208. *Boletín del Museo del Prado*, vol. I, 1980, no. 1, pp. 5–6, no. 2, p. 65, no. 3, p. 137; vol. II, 1981, no. 4, p. 3, no. 5, p. 97; vol. III, 1982, no. 7, pp. 65–69.

209. *Boletín del Museo del Prado*, vol. I, 1980, no. 3, p. 137; vol. II, 1981, no. 4, p. 3, no. 5, p. 97.

210. *Boletín del Museo del Prado*, vol. I, 1980, no. 2, p. 65; no. 3, p. 137; vol. II, 1981, no. 4, p. 3, no. 5, pp. 97–98.

211. *Boletín del Museo del Prado*, vol. I, 1980, no. 1, p. 7–8, n. 3.

212. *Boletín del Museo del Prado*, vol. II, 1981, no. 5, p. 97.

213. ''Noticias del Prado. El legado de don José Giner,'' in *Boletín del Museo del Prado*, vol. I, 1980, no. 1, pp. 60–61.

214. Douglas Cooper, ''Picasso's *Guernica* installed in the Prado,'' in *The Burlington Magazine*, vol. CXXIV, May 1982, no. 950, pp. 288–92; Herschel B. Chipp, *Picasso's Guernica* (Berkeley, Los Angeles, and London: University of California Press, 1988).

215. *Boletín del Museo del Prado*, vol. III, 1982, no. 9, p. 214.

216. *Boletín del Museo del Prado*, vol. III, 1982, no. 7, p. 1, no. 8, p. 73.

217. *Boletín del Museo del Prado*, vol. III, 1982, no. 7, p. 71, no. 8, p. 139, no. 9, p. 213.

218. *Boletín del Museo del Prado*, vol. III, 1982, no. 7, p. 71, no. 8, p. 139, no. 9, p. 213.

219. *Boletín Oficial del Estado*, March 16, 1983.

220. *Boletín del Museo del Prado*, vol. IV, 1983, no. 10, p. 73.

221. *Boletín del Museo del Prado*, vol. IV, no. 10, 1983, p. 4.

222. Although no. 12 of the *Bulletin* is dated September–December, 1983, a delay in its publication is the only explanation for its referring to the inauguration of the exhibition "El Niño en el Museo del Prado" on December 23, 1983, as a past event, p. 200.

223. *Boletín del Museo del Prado*, vol. IV, no. 12, 1983, p. 137.

224. *Boletín del Museo del Prado*, vol. VI, no. 17, 1985, pp. 118–22.

225. *Boletín del Museo del Prado*, vol. VI, 1985, no. 18, p. 179; vol. VII, 1986, no. 19, p. 67, no. 20, p. 133; vol. VIII, 1987, no. 23, p. 143.

226. *Boletín del Museo del Prado*, vol. IV, no. 12, 1983, pp. 137, 138.

227. *Boletín del Museo del Prado*, vol. IV, 1983, no. 12, pp. 197–99; vol. VI, 1985, no. 17, p. 125; Maria del Carmen Garrido, "Algunas consideraciones sobre la técnica de las Pinturas Negras de Goya," in *Boletín del Museo del Prado*, vol. V, 1984, no. 13, pp. 4–40.

228. *Boletín del Museo del Prado*, vol. V, 1984, no. 14, pp. 85, 143–44, no. 15, p. 209; Manuela Mena Marques, "La restauración de Las Meninas de Velázquez," in *Boletín del Museo del Prado*, vol. V, 1984, no. 14, pp. 87–107.

229. *Boletín del Museo del Prado*, vol. V, 1984, no. 15, p. 209.

230. *Boletín del Museo del Prado*, vol. VI, 1985, no. 18, pp. 184–85.

231. *Boletín del Museo del Prado*, vol. VI, 1985, no. 17, p. 25, no. 18, p. 184; vol. VII, 1986, no. 20, pp. 134–35.

232. *Boletín del Museo del Prado*, vol. VII, 1986, no. 19, p. 72.

233. Garrido, pp. 4–40.

234. *Boletín del Museo del Prado*, vol. VI, 1985, no. 18, p. 185.

235. *Boletín del Museo del Prado*, vol. VI, 1985, no. 18, p. 185.

236. *Boletín del Museo del Prado*, vol. IV, 1983, no. 12, pp. 138, 199.

237. Declarations by Alfonso E. Pérez Sánchez, director of the museum, to the newspaper *El País*, March 18, 1988, p. 29.

238. "Un tesoro artístico para Madrid," in *El País*, March 18, 1988, pp. 28, 29; "Thyssen confirma su oferta a España y advierte que aún no se ha firmado un acuerdo," in *El País*, March 19, 1988, p. 24; "Firmado el acuerdo con el barón Thyssen. Dos años de tira y afloja," in *El País*, December 21, 1988, p. 38.

239. "Un tesoro artístico para Madrid," *El País*, March 18, 1988, p. 29.

240. "Una gran colección para Madrid," in *El País*, April 8, 1988, p. 27; "España pagará un canon anual de 500 millones de pesetas por la colección Thyssen," in *El País*, April 12, 1988, p. 25.

241. "Firmado el acuerdo con el barón Thyssen," in *El País*, December 21, 1988, p. 38.

242. *Boletín del Museo del Prado*, vol. IX, 1988, no. 25–27, p. 4; Miguel Angel Trenas, "Entrevista a Felipe Vicente Garín, director de la primera pinacoteca española," *La Vanguardia* (Barcelona), May 13, 1991, p. 39.

243. *Boletín del Museo del Prado*, vol. VII, 1986, no. 19, pp. 61–66.

244. Mercedes Agueda, "Novedades en torno a una serie de cartones de Goya," in *Boletín del Museo del Prado*, vol. V, no. 13, 1984, pp. 41–46.

245. Angeles García, "El legado Cooper, con obras de Picasso y Gris, se exhibe desde hoy en el Museo del Prado," in *El País*, May 16, 1986, p. 28.

246. Some of these exhibitions are: "New Acquisitions 1981–1982"; "Italian Drawing from the Seventeenth Century" (to celebrate the publication of the museum catalogue by Manuela Mena); "Centenary of Claudio de Lorena" (including two works from the Alba collection); "Seventeenth-Century Spanish Painting from the Collections of the Prado Museum"; "Eighteenth-Century Painting from the Prado Museum Collection"; "Raphael in Spain"; "Italian Itinerary of a Spanish Monarch: Charles III in Italy"; and "Italian Drawing from the Eighteenth Century."

247. A good example of this was the exhibition "El Niño en el Museo del Prado" ("The Child in the Prado Museum"), which, after being open in Madrid from December 1983 to February 1984, visited Valencia (March 10–April 20, 1984), Vigo (April 28–May 22, 1984), Málaga (June 1–24, 1984), Oviedo (June 29–July 29, 1984), Tudela (August 22–September 20, 1984), Zaragoza (December 1984), Orense (January 21–February 17, 1985), León (March 8–28, 1985), Cáceres (April 8–May 2, 1985), and Ciudad Real (mid-May–mid-June 1985), sponsored by El Corte Inglés.

248. Among these the following are worth mentioning: "Cuban Painting from the Nineteenth Century" (1983); "Drawings and Watercolors by J. M. W. Turner in the British Museum"; "The Hammer Manuscript by Leonardo da Vinci and the I and II Manuscripts from the Biblioteca Nacional de Madrid" (1984); "British Painting from Hogarth to Turner" (1988); "Masterpieces from the Masaveu Collection" (1989); "Pietro Longhi: The Paintings from the Leoni Montanari Palace" (1989); "The Century of Rembrandt" (1985); "Drawings from the Ian Woodner Collection" (December 1986–February 1987); "Delacroix" (1988); "Nineteenth-Century Russian Painters" (1987).

249. *Goya en colecciones madrileñas* (organized by the Fundación Amigos del Museo del Prado, 1983), *Pintura española de bodegones y floreros de 1600 a Goya* (1984), *Pintura napolitana del siglo XVII* (Villahermosa Palace, 1985), *Carreño, Rizi y Herrera y la pintura madrileña de su tiempo (1650–1700)*, (1986), *Juan de Flandes* (1986), *Monstruos, enanos y bufones en la Corte de los Austrias* (financed by the Fundación Amigos del Museo del Prado, 1986), *Los Ribalta y la pintura valenciana de su tiempo* (Villahermosa Palace, 1988), *Zurbarán* (1988), *Goya y el espíritu de la Ilustración* (Villahermosa Palace, 1988), *Velázquez* (sponsored by the Fundación Banco Hispano Americano, 1990), and *Sánchez Coello* (sponsored by the AGEPASA group, 1990).

250. María Moliner, *Diccionario de uso del español* (Madrid: 1980).

251. *El País*, February 13, 1991, p. 36 (Barcelona edition).

252. "El nuevo director del Prado mejorará la capacidad científica del museo," in *El País*, April 23, 1991; "La ampliación del Museo del Prado, tema prioritario para su nuevo responsable," in *La Vanguardia* (Barcelona), April 23, 1991.

SELECTED BIBLIOGRAPHY

Not included in this bibliography are the many catalogues and inventories of the collections, acquisitions, and exhibitions of the Prado Museum published by the museum itself, or articles published in the *Boletín del Museo del Prado*, except those to which reference is made in the notes.

Águeda, Mercedes. "Novedades en torno a una serie de cartones de Goya." In *Boletín del Museo del Prado*. Vol. V, no. 13, 1984, pp. 41–46.

Álvarez Lopera, José. *La política de bienes culturales del gobierno republicano durante la guerra civil española*. Madrid: Ministerio de Cultura, Dirección General de Bellas Artes Archivos y Bibliotecas, 1982.

Angulo Iñíguez, Diego. *Catálogo de las alhajas del Delfín*. Madrid: Museo del Prado, 1944 (pp. 9–10).

Araujo Sánchez, Ceferino. *Los museos de España*. Madrid: 1875.

———. *El Museo del Prado*. Manuscript dated May 3, 1887, from a lecture given at the Ateneo Científico y Literario, in Madrid, on March 8, 1888. Prado Museum Library, register no. 8793, catalogue no. 19.1608.

Azaña, Manuel. *Obras completas*. Mexico City: Ed. Oasis.

Bahamonde, José Lino, *see* Vaamonde, José Lino.

Barrón, Eduardo. *Catálogo de la escultura (del Museo del Prado)*. Madrid: 1908.

Beroqui, Pedro. "Apuntes para la historia del Museo del Prado" [originally entitled "El Museo del Prado (notas para su historia)". In *Boletín de la Sociedad Española de Excursiones*. Vol. XXXVIII, 1930, pp. 33–48, 112–27, 189–203, 252–66; vol. XXXIX, 1931, pp. 20–34, 94–108 , 190–204, 261–74; vol. XL, 1932, pp. 7–21, 85–97, 213–20 (published in a single volume in 1933).

Berwick and Alba, Duchess of. *Documentos escogidos de la Casa de Alba*. Madrid: 1891.

Blanco, Antonio. *Museo del Prado. Catálogo de la Escultura. I. — Esculturas clásicas. II. — Esculturas, copias e imitaciones de las antiguas (siglos XVI–XVIII)*. Madrid: 1957.

Boix, Félix. "El Prado de San Jerónimo. Un cuadro costumbrista del siglo XVII." In *Arte Español*, XVIII, vol. X, no. 4, 4th. trimester 1929, pp. 502–11.

Brans, J. V. L. *Isabel la Católica y el arte hispano-flamenco*. Madrid: Ediciones Cultura Hispánica, 1952.

Brown, Jonathan. *Velázquez. Pintor y cortesano*. Madrid: Alianza Editorial, 1986.

Buendía, J. Rogelio. *El Prado básico*. Madrid: Sílex, 1985.

Carducho, Vicente. *Diálogos de la Pintura. Su defensa, origen essencia. Definición, modos y diferencias*. Printed under licence by Frco. Martinez, 1633. (Edition supervised by Francisco Javier Sánchez Cantón: *Fuentes literarias para la historia del arte español. Vol. II. — siglo XVII. Pablo de Céspedes — Juan de Butrón — Vicencio Carducho — Francisco Pacheco — Fr. Francisco de los Santos — Lázaro Díaz del Valle*. Madrid: C. Bermejo, 1933.)

Castillo, Alberto del. *José María Sert: Su vida y su obra*. Barcelona and Buenos Aires: Editorial Argos, 1947.

Catálogo ilustrado de la exposición de pinturas de Goya celebrada para conmemorar el primer centenario de la muerte del artista. Madrid: Museo del Prado, April–May, 1928.

Cavia, Mariano de. "La catástrofe de anoche. España está de luto. Incendio del Museo de Pinturas." *El Liberal* (Madrid), no. 4541, November 25, 1891.

———. "Porqué he incendiado el Museo del Prado." *El Liberal* (Madrid), no. 4542, November 26, 1891.

———. "Intermedio estético. La dirección del Museo del Prado." *El Sol*, December 4, 1918.

Chipp, Herschel B. *Picasso's Guernica*. Berkeley, Los Angeles, and London: University of California Press, 1988.

Chueca Goitia, Fernando. *El Museo del Prado*. Misiones de Arte. Madrid: Guiones de Arquitectura, 1952.

———. *Madrid y Sitios Reales*. Arte de España. Barcelona: Editorial Seix y Barral, 1958.

Colinas Quiroz, Ceferino. "El tesoro artístico del Museo del Prado. Cómo el gobierno de la República entregó a Franco un tesoro protegido durante la Guerra Civil por los milicianos." *Siempre* (Mexico), no. 491, November 21, 1962, pp. 52–57.

Cooper, Douglas. "Picasso's 'Guernica' Installed in the Prado." *The Burlington Magazine*. Vol. CXXIV, May 1982, no. 950, pp. 288–92.

Cos-Gayón, Fernando. *Historia jurídica del Patrimonio Real*. Madrid: 1881.

Espí Valdés, Adrián. "Gisbert, primer Director del Museo Nacional del Prado." *Arte Español*, 1963–67, pp. 112–18.

Eusebi, Luis. *Noticia de los cuadros que se hallan colocados en la Galería del Museo del Rey Nuestro Señor, sito en el Prado de esta Corte*. Madrid: 1828.

Fernández Balbuena, R. "Agonía y recuperación del Museo del Prado" (Lecture given at the Ateneo Español de México, on June 14, 1956, extensively commented upon in *Boletín de Información de la Unión de Intelectuales Españoles*, no. 1, August 15, 1956).

Garrido, María del Carmen. "Algunas consideraciones sobre la técnica de las Pinturas Negras de Goya." In *Boletín del Museo del Prado*, vol. V, 1984, no. 13, pp. 4–40.

Gaya Nuño, Juan Antonio. *Madrid*. Guías Artísticas de España. Barcelona: Editorial Aries, 1944.

———. "El Museo Nacional de la Trinidad (Historia y catálogo de una pinacoteca desaparecida)." In *Boletín de la Sociedad Española de Excursiones*. Vol. LI, 1st. and 2nd. trimesters, 1947, pp. 19–77.

———. "Notas al catálogo del Museo del Prado (El Prado disperso e inédito)." In *Boletín de la Sociedad Española de Excursiones*. Vol. LVIII, 1954, pp. 101–42.

———. *Historia del Museo del Prado (1819– 1969)*. León: Editorial Everest, 1969.

Kenyon, Sir Frederick. "La protection du patrimoine artistique en Espagne." *Mouseion*, X, 1937, no. 37–38 (I–II), pp. 183–92.

Lafuente Ferrari, Enrique. "Las primeras pinturas románicas en el Prado." *Clavileño*, I, 1950, p. 52.

López Aguado, Antonio. "Madrid artístico; el museo." *Semanario Pintoresco Ilustrado* (Madrid), June 23, 1839.

Luca de Tena, Consuelo, and Mena, Manuela. *Guía del Prado*. Madrid: Sílex, 1986.

Luna, Juan José. *Guía actualizada del Prado*. Madrid: Alfiz, 1985.

———. "Una nota más para la historia del Museo del Prado." In *Boletín del Museo del Prado*. Vol. VIII, 1987, no. 24, pp. 186–88.

Madoz, Pascual. *Diccionario geográfico-estadístico-histórico de España y sus posesiones de Ultramar*. Vol. X. Madrid: 1850.

Madrazo, Mariano de. *Historia del Museo del Prado: 1818–1868*. Madrid: C. Bermejo, 1945.

Madrazo, Pedro de. *Catálogo de los cuadros del Real Museo de Pintura y Escultura de S.M.* Madrid: 1843 (2nd. ed. 1845, 3rd. ed. 1850).

———. *Viaje artístico de tres siglos por las colecciones de cuadros de los Reyes de España*. Barcelona: Biblioteca Artes y Letras, 1884.

Marcos Vallaure, Emilio. "El propietario del boceto de la Inmaculada de Goya (Prado, no. 3260)." In *Boletín del Museo del Prado*. Vol. VIII, 1987, no. 24, pp. 182–83.

Martínez Friera, Joaquín. *Un Museo de Pinturas en el Palacio de Buenavista. Proyecto de la Real Academia de las Nobles Artes de San Fernando*. Madrid: 1942.

Medina, Pedro de. *Grandezas y cosas memorables de España*. 1560.

Mesonero Romanos, Ramón de. *Nuevo Manual Histórico y Topográfico y Estadístico de la Villa de Madrid*. Madrid: 1854.

———. *El antiguo Madrid*. Madrid: 1861.

Monreal y Tejada, Luis. *La pintura en los grandes museos, vol. I: Museo de Arte de Cataluña, Museo del Prado, Pinacoteca Vaticana, Museo de São Paulo*. Barcelona: Editorial Planeta, 1975.

Muguruza, Pedro. "Nueva escalera en el museo del Prado y otras reformas." *Arquitectura*. October 1928, p. 307.

Pantorba, Bernardino de. *Guía del Museo del Prado. Estudio histórico y crítico*. Madrid: Compañía Bibliográfica Española, 1962.

Pardo Canalis, Enrique. "Noticias y escritos de Luis Eusebi." *Revista de Ideas Estéticas*, XXVI, 1962, p. 179.

Pérez Sánchez, Alfonso E. *Pasado, presente y futuro del Museo del Prado*. Madrid: Fundación Juan March, 1976.

———. *Museo del Prado*. Grandes Museos del Mundo. Barcelona: Editorial Océano, 1989.

Pérez Sánchez, Alfonso E.; Mena Marques, Manuela; Díaz Padrón, Matías; Luna, Juan José; and Puente, Joaquín de la. *El Prado*. Madrid: Aguilar, 1988.

Polero y Toledo, Vicente. *Breves observaciones sobre la utilidad y conveniencia de reunir en uno solo, los dos museos de pintura de Madrid, y sobre el verdadero estado de conservación de los cuadros que constituyen el Museo del Prado*. Madrid: Eduardo Cuesta, printer, 1868.

Ponz, Antonio. *Viaje de España*. Madrid: Joaquim Ibarra Impresor, 1772–93; rep. Madrid: M. Aguilar Editor, 1947.

Quintet, Edgar. *Mis vacaciones en España*. Madrid: 1931 (1st. French ed., 1857).

Renau, José. "L'Organisation de la défense du patrimonie artistique et historique espagnol pendant la guerre civile." *Mouseion*, X, 1937, no. 39–40 (III–IV), pp. 7–68.

Reyero Hermosilla, Carlos. "Noticias biográficas y artísticas del pintor cuadetano Cosme Algarra, último director del Museo Nacional de la Trinidad." *Acta s del Congreso de Historia de Albacete (8–11 dic. 1983). Vol. IV — Edad Contemporánea* (pp. 553–71). Albacete: Instituto de Estudios Albacetenses, 1984.

Rumeu de Armas, Antonio. *Origen y fundación del Museo del Prado*. Madrid: Instituto de España, 1980.

Sainz de Robles, Federico Carlos. *Historia y estampas de la villa de Madrid*. Madrid and Barcelona: Joaquín Gil Guiñón, 1933.

Salas Bosch, Xavier de. "Un boceto de Goya para la Inmaculada del Colegio de Calatrava." *Archivo Español de Arte*, no. 197, 1977, pp. 1–8.

Sambricio, Valentín de. "El Museo Fernandino. Su creación. Causa de su fracaso. El palacio de Buenavista." *Archivo Español de Arte* (Madrid). Vol. XV, 1942, pp. 132–46, 262–83, 320–35.

Sánchez Cantón, Francisco Javier. "La reorganización del Museo del Prado." *Arte Español*. Vol. VIII, 1926–27, p. 290.

———. *Museo del Prado; catálogo. (Advertencia)*. Madrid: 1933 (pp. VIII–IX).

———. "Les Premières mesures de défense du Prado au cours de la guerre civile en Espagne." *Mouseion*, X, 1937, no. 39–40 (III–IV), pp. 67–73.

———. "The Prado Museum from July 18, 1936 to March 28, 1939." *Spain* (London), no. 89–90, June 15 and 22, 1939.

———. *Libros, tapices y cuadros que coleccionó Isabel la Católica*. Madrid: Consejo Superior de Investigaciones Científicas, Instituto Diego Velázquez, 1950.

———. "Adquisiciones del Museo del Prado, 1954–1955." *Archivo Español de Arte* (Madrid), vol. XXIX, 1956, pp. 85–94.

———. *Escultura y pintura del siglo XVIII. Francisco Goya*. Ars Hispaniae. Vol. XVII. Madrid: Editorial Plus Ultra, 1958.

———. *The Prado*. London: Thames and Hudson, 1959. Revised ed. 1971.

Vaamonde, José Lino. *Salvamento y protección del tesoro artístico español*. Caracas: 1973.

Ximénez, Fr. Andrés. *Descripción del Real Monasterio de San Lorenzo del Escorial, su magnífico Templo, Panteón y Palacio*. Madrid: Antonio Marín, 1764.

LIST OF COLORPLATES

INDEX

462

473